THE COLLINS BIG BOOK OF ART

COLLINS | DESIGN

An Imprint of HarperCollinsPublishers

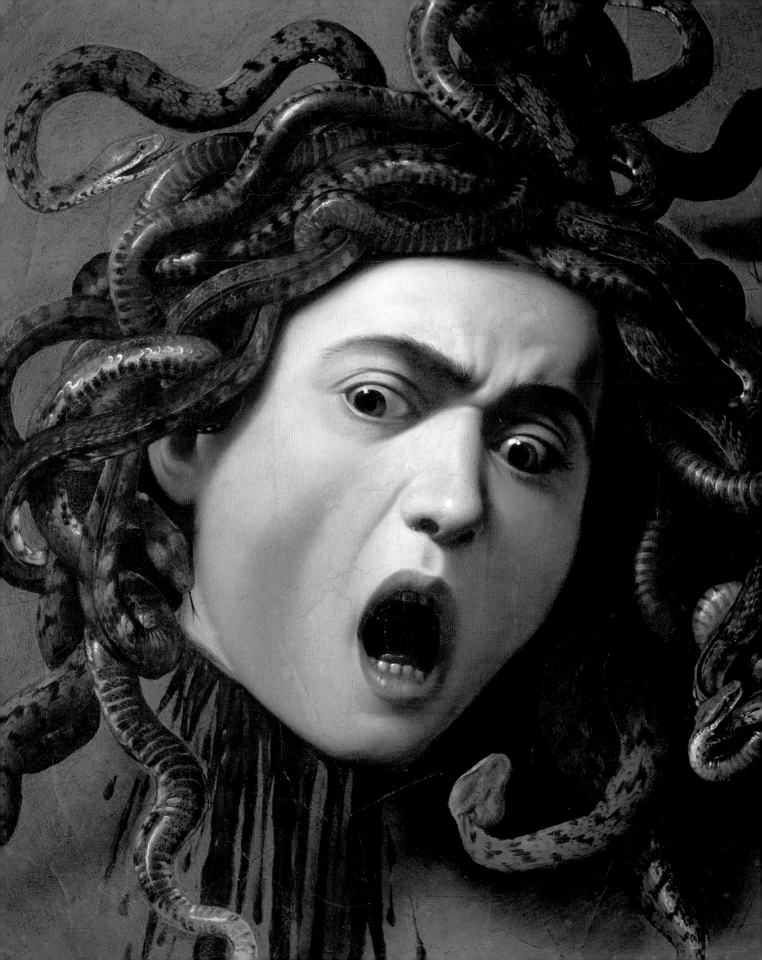

THE COLLINS BIG

FROM CAVE ART TO POP ART

BOOK

GENERAL EDITOR DAVID G. WILKINS

OF ART

The Collins Big Book of Art:
From Cave Art to Pop Art

HarperCollins books may be purchased
for educational, business, or sales
promotional use.
For information, please write:
Special Markets Department,
HarperCollins Publishers,
10 East 53rd Street,
New York, NY 10022.

ISBN: 978-0-06-083285-8
ISBN-10: 0-06-083285-1

First published in 2005 by:
Collins Design
An Imprint of HarperCollins*Publishers*
10 East 53rd Street
New York, NY 10022
Tel: (212) 207-7000
Fax: (212) 207-7654
CollinsDesign@harpercollins.com
www.harpercollins.com

Distributed throughout the world by:
HarperCollins*Publishers*
10 East 53rd Street
New York, NY 10022
Fax: (212) 207-7654

Library of Congress Cataloging-in-
Publication Data

Wilkins, David G.
 The Collins big book of art / by David G.
Wilkins and Iain Zaczek.--
1st ed.
 p. cm.
 ISBN 0-06-083285-1 (hardcover)
1. Art--History. I. Zaczek, Iain. II. Title.
N5300.W642 2005
709--dc22

 2005014812

Manufactured in China
2 3 4 5 6 7 / 11 10 09 08 07
Second Printing, 2007

The illustrations in this volume have been
supplied by the SCALA PICTURE LIBRARY,
the largest source of color transparencies
and digital images of the visual arts in the
world. More than 60,000 subjects can be
accessed at the site www.scalaarchives.it.
E-mail: archivio@scalagroup.com
The images from the SCALA PICTURE
LIBRARY that reproduce cultural
assets belonging to the Italian State
are published with the permission
of the Ministry for Cultural Heritage
and Activities.

All other credits and permissions are
gratefully acknowledged on page 528.

Designed by Atelier Works London

[previous page]
Medusa
Michelangelo da Caravaggio,
1598–1599
Baroque

[right]
Portrait of Maria de' Medici
Agnolo Bronzino, 1551
Mannerism

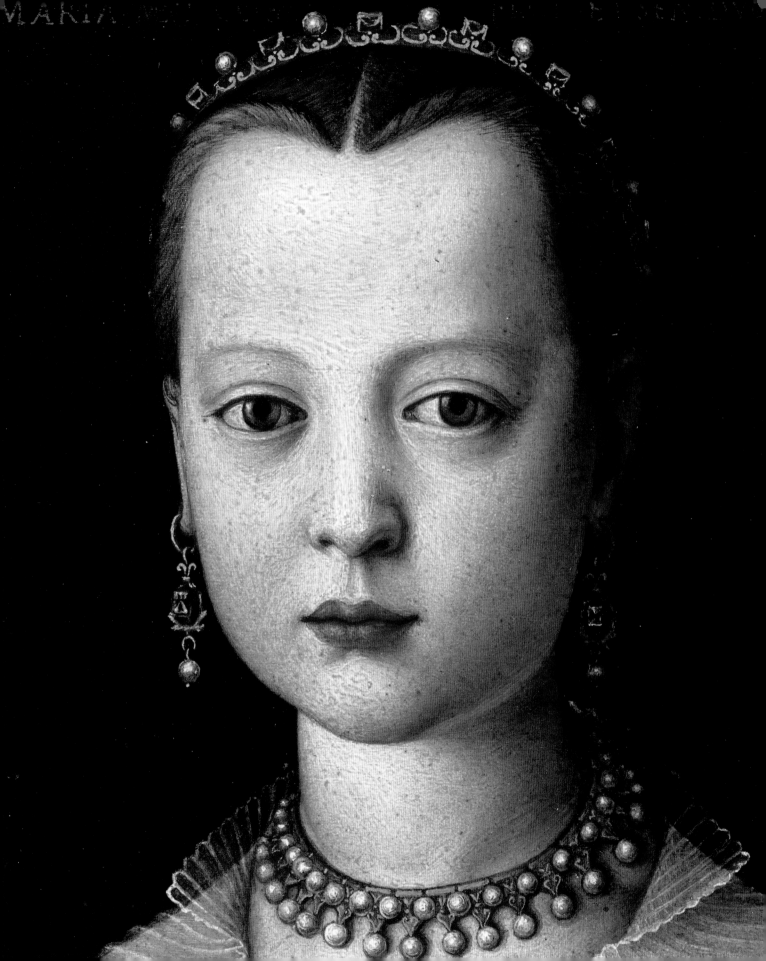

CONTENTS

THE CHRONOLOGY OF ART

THEMES IN ART

How to look at art

By David G. Wilkins

If we can define a work of art as a unique human creation that communicates visually, then there is no single approach that would be appropriate for each and every art object. This book, with its more than 1,000 images, demonstrates the overwhelming variety to be found in the world of art; understanding this diversity is the first step in learning how to look at art, for it suggests that each work will demand a unique response. Although each object raises its own issues, the communalities to be found within the world of art are also on display here. An interest in nature and in the human body, for example, can be found in the art of many cultures, and individuals in diverse societies have realized that art can be used for political purposes or to express religious ideals. In many places and at many times, people have found that art can respond to concerns about the family, about love, about war, and about death.

Because each person brings their own interests and background to the study of art, our presentation here is designed to encourage you to approach art in whatever manner and sequence is most satisfying to you. We have tried to encourage a "suit yourself" approach to this rich panorama by providing a variety of ways in which to access and understand the works in greater depth.

If you are a fan of history, you will be interested in asking yourself how a work or group of works might relate to developments in society, religion, or culture during a particular period. What kind of art was being created at the time of Christ's death (c. 33), for example, or when the Magna Carta was signed (1215), or when the Taj Mahal was being built (1630–1658), or World War I was being fought (1914–1918)? For each work that pe aks your interest you might ask: "Why was this work created at this particular time and in this particular place?" Or "How did this work of art function in its societal setting?" Or "Who paid for this work of art and why was this individual or group willing to support its creation and display?" Questions like these are always worth thinking about, even when the answers are difficult to ascertain.

At certain points in the Chronology of Art you will discover "turning points," brief explanations of how and why art changed at a certain time. Sometimes

Self-Portrait
Vincent van Gogh,
1887
Postimpressionism

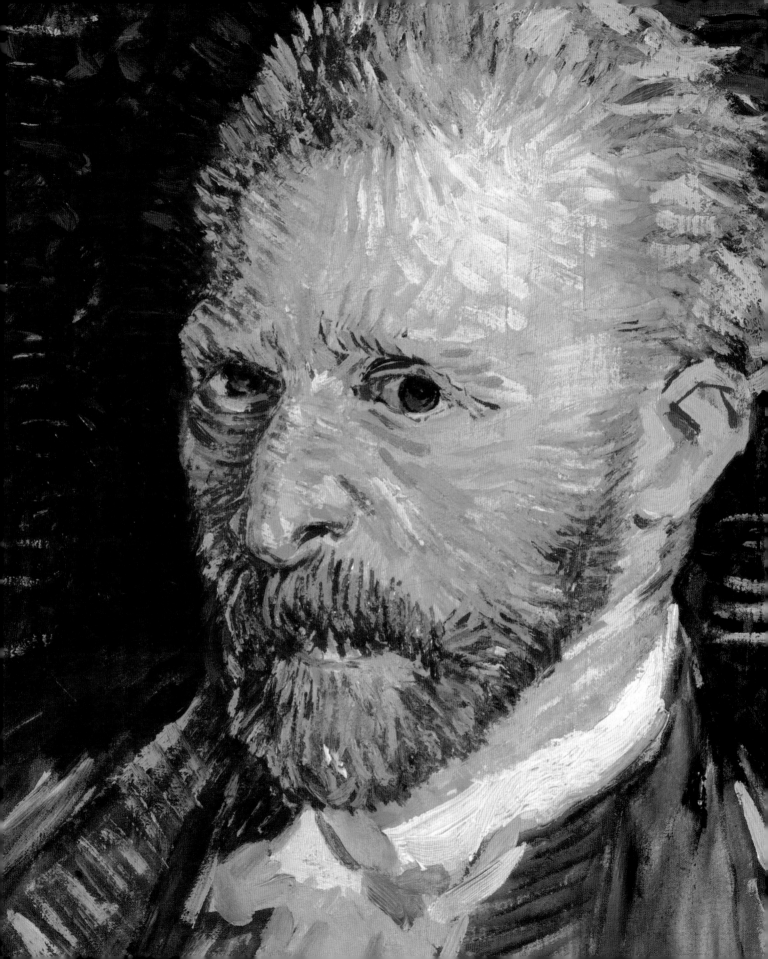

these turning points concern technical matters, such as the development of fine bronze casting in early China (c. 1200 BCE) or of perspective and the illusion of space in Renaissance Italy (c. 1420). Others can be closely connected to changes in society, such as the development of Early Christian art and subject matter (c. 300), the new naturalistic style of the Dutch Seventeenth Century (c. 1620), and the post–World War II style of Pop Art (1964). Still others discuss changes in artistic style, such as the development of the High Renaissance (c. 1505) and of Cubism (1910).

If you feel more comfortable approaching art from the point of view of subject matter, turn to Themes in Art, where Portraiture, Still Life, Mythology, Allegory, and other subjects are discussed, accompanied by illustrations that demonstrate how artists have interpreted each theme during different periods and in different parts of the globe. After reading about a theme, you will want to turn back to the Chronology of Art to look for examples; for most works, one or two themes are listed.

Another way to look at works of art is to study what are called their "formal qualities," such as composition, color, and materials. In studying painting, the illusion of space is an important formal category. For some sculpture, the interrelationship with architecture is crucial in understanding composition; if a sculpture is freestanding, however, you will want to ask yourself how the forms created by the artist are related to the space around them.

To study formal issues, you might leaf through the Chronology of Art to see how one formal quality has changed over time. To study how the choice of colors can change over time, for example, start in the chronology c. 1850 and leaf forward in time, looking at paintings created in France. Notice how the colors become lighter and brighter at the time of Impressionism; if you continue, you'll see how bold contrasts of strong color were introduced by van Gogh, who then influenced Matisse at the beginning of the twentieth century. Academic artists during this period continued to use color in a restrained manner.

Because the materials with which each work was made are listed, you can scan the Chronology of Art to trace sculptures cast in bronze, for example, comparing ancient Chinese ritual bronzes with Renaissance works in this medium by Donatello and Cellini or with African portrait heads from the Benin culture.

In those cases where an artist's work can be identified with a broader style, the name of that style is given in the caption; Leonardo's *Last Supper* is an example of High Renaissance style, for example, while Monet is an Impressionist and van Gogh and Cézanne are Postimpressionists.

A brief definition for each style can be found in the Glossary of Art Styles. The Index of Artists and General Index guide you back to the Chronology of Art and Themes in Art sections and will help you locate all the works in the Gothic style, for example, or to find those by Michelangelo, Rembrandt, or Picasso.

Works of art—the products of human effort and genius—are unpredictable and of an infinite variety. Because there are so many ways to approach this great trajectory of human creativity, you are invited to devise your own ways of exploring the riches presented here. Once you start, you will discover that looking at art is like eating chocolates; one sample is never enough. Art is so personal that each of us will probably use this book in a different way. I guarantee that you will enjoy the experience.

THE CHRONOLOGY OF ART

C. 37000–11000 BCE
Spain

C. 30000 BCE
France

C. 25000–18000 BCE
France

1 *Horse's Head*
Artist unknown
Earth pigments,
part of cave painting
Chimenas (Spain),
Chimenas Caves
Paleolithic

ANIMALS

2 *Bone Flute*
Artist unknown
Bone, length: 5" (12.4 cm)
London (UK), British Museum
Paleolithic

LEISURE

3 *Venus of Lespugue*
Artist unknown
Mammoth ivory,
height: 5¾" (14.6 cm)
Paris (France),
Museum of Mankind
Paleolithic

THE BODY
RELIGION

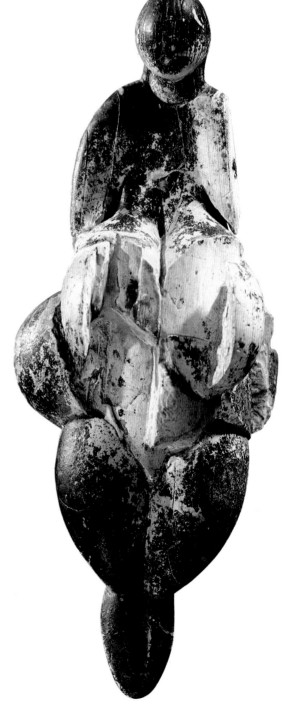

C. 20000–18000 BCE
France

C. 16000–9000 BCE
Spain

C. 12000–6000 BCE
Tanzania

4 *Venus of Laussel*
Artist unknown
Limestone, height: 17" (43 cm)
Bordeaux (France),
Museum of Aquitaine
Paleolithic

THE BODY
RELIGION

5 *Bison*
Artist unknown
Earth pigments,
part of cave painting
Altamira (Spain),
Altamira Caves
Paleolithic

ANIMALS

6 *Sandawe Trance Dance*
Artist unknown
Earth pigments,
part of cave painting
Dar es Salaam (Tanzania),
Tanzania National Museum
Paleolithic

ANIMALS
THE BODY

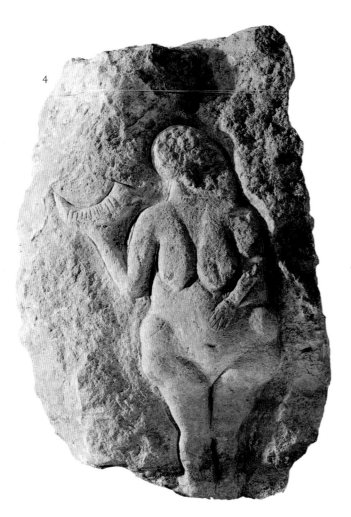

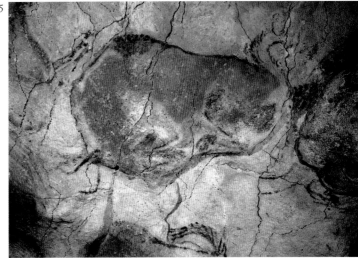

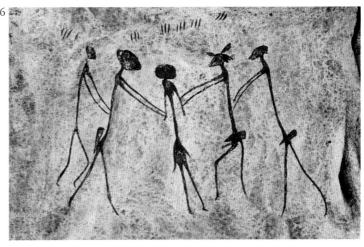

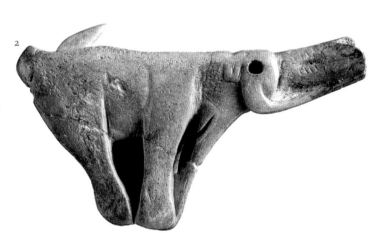

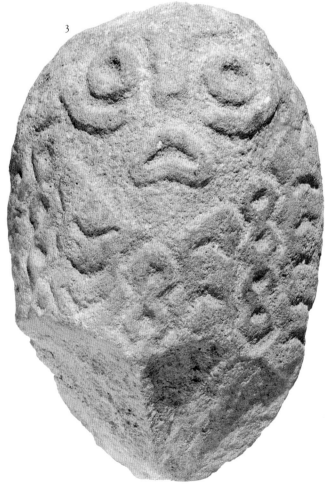

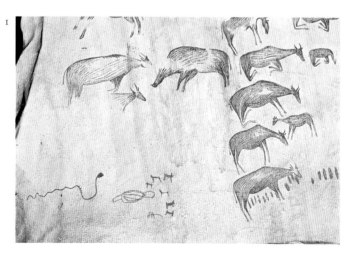

C. 4000–3000 BCE
Iraq

C. 3150–3125 BCE
Egypt

C. 3000 BCE
Iraq

4 *Snake-Headed Woman*
Holding a Child
Artist unknown
Terracotta, height: 5½" (14 cm)
Baghdad (Iraq), Iraq Museum
Sumero-Akkadian

RELIGION

5 *The Palette of Narmer*
Artist unknown
Schist, height: 25" (64 cm)
Cairo (Egypt), Egyptian Museum
Ancient Egyptian

POLITICS
PORTRAITURE

6 *Man and Woman Embracing*
Artist unknown
Stone/plaster
Baghdad (Iraq), Iraq Museum
Sumero-Akkadian

RELIGION

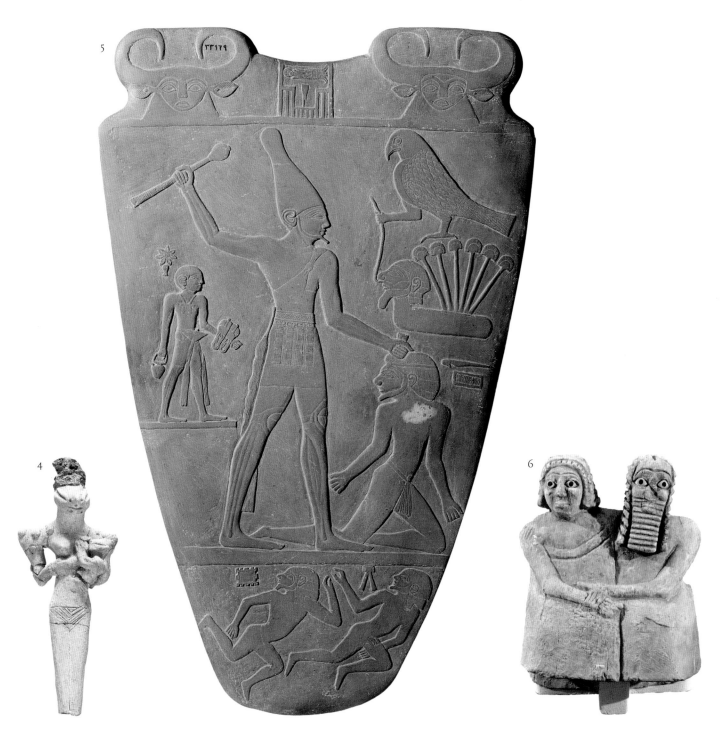

C. 2700–2400 BCE
Greece

C. 2620 BCE
Egypt

C. 2613–2494 BCE
Egypt

1 *The Harpist*
Artist unknown
Marble, height: 8" (20.3 cm)
Athens (Greece), National
Archaeological Museum
Cycladic

RELIGION

2 *Rahotep and Nofret*
Artist unknown
Painted limestone, with inlaid
eyes, height: 47½" (1.21 m)
Cairo (Egypt), Egyptian Museum
Ancient Egyptian

DEATH
PORTRAITURE

3 *Seated Scribe*
Artist unknown
Limestone, partly painted, eyes:
rock crystal, carbonate of
magnesium, copper, arsenic,
height: 21" (53.7 cm)
Paris (France), Louvre
Ancient Egyptian

DEATH
PORTRAITURE

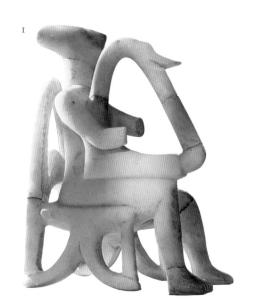

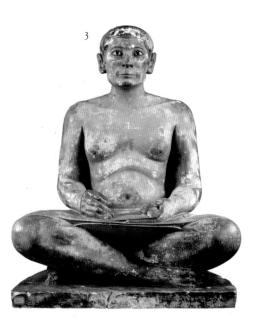

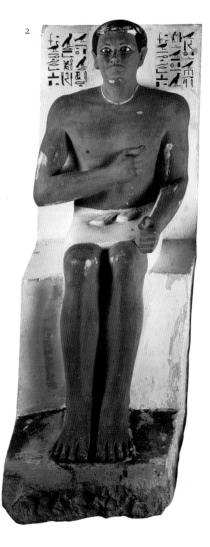

4 *Ram in a Thicket, from Ur*
Artist unknown
Wood (perished) with precious
metals, stones, shell,
height: 21½" (54.5 cm)
London (UK), British Museum
Sumerian

RELIGION
ANIMALS

5 *Plaque, from Ur*
Artist unknown
Shell, height: 1¾" (4.4 cm)
London (UK), British Museum
Sumerian

ANIMALS

6 *Head of Sargon, from Ninevah*
Artist unknown
Bronze, height: 14¼" (36 cm)
Baghdad (Iraq), Iraq Museum
Mesopotamian/Akkadian

POLITICS
PORTRAITURE

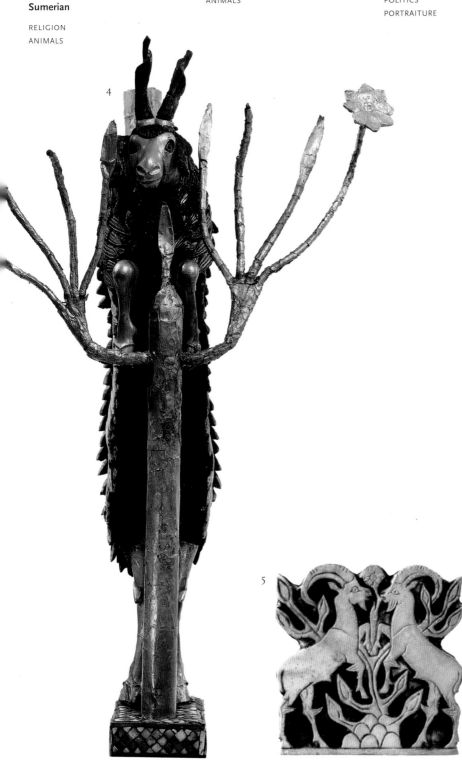

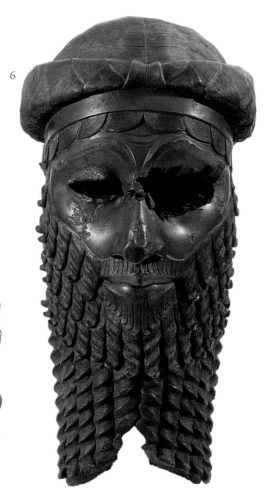

C. 2500 BCE
Iraq

C. 2500–2300 BCE
Turkey

C. 2300–1750 BCE
Pakistan

1 *Statues of the God Abu and his Consort, from Tall al-Asmar*
Artist unknown
Stone, height of Abu: 2' 3" (68 cm)
Baghdad (Iraq), Iraq Museum
Sumerian

RELIGION

2 *A Sword Swallower and Two Acrobats*
Artist unknown
Stone relief, detail
Alaca Huyuk (Turkey),
Archaeological area
Alaca Huyuk

LEISURE

3 *Seals with Buffalo*
Artist unknown
Steatite, seal heights vary from ¾"
(2 cm) to 3" (7.6 cm)
New Delhi (India), National
Museum
Indus Valley

ANIMALS

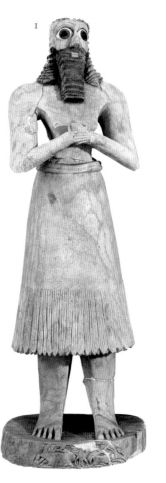
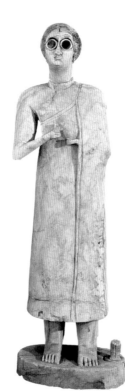
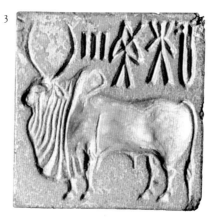
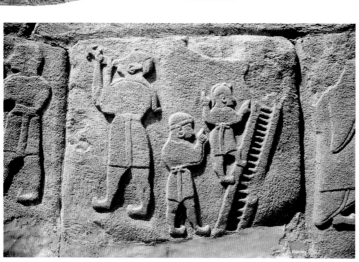
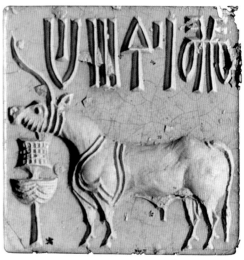

C. 2250 BCE
Iraq

C. 2150 BCE
Iraq

C. 2000—1500 BCE
Iraq

4 *Stele with the Victory of*
 King Naram-Sin
 Artist unknown
 Sandstone, height: 6' 6" (2 m)
 Paris (France), Louvre
 Akkadian

 WAR
 PORTRAITURE
 POLITICS

5 *Statue of Gudea Praying*
 Artist unknown
 Dolomite, height: 24" (61 cm)
 Paris (France), Louvre
 Babylonian

 RELIGION
 PORTRAITURE

6 *Lion from Tall Abu Harmal*
 Artist unknown
 Terracotta
 Baghdad (Iraq), Iraq Museum
 Assyro-Babylonian

 ANIMALS

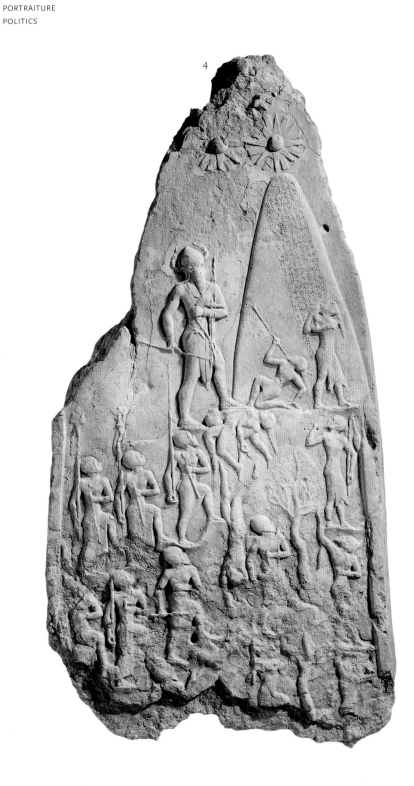

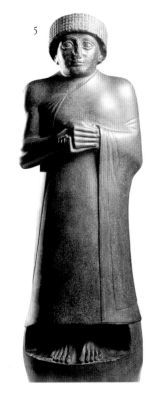

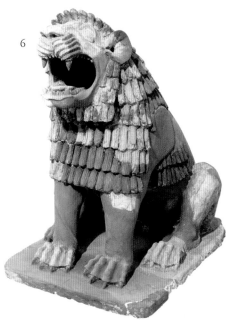

Harappan artisans are among the first to combine words and images

Cities sprang up along the Indus Valley in India and Pakistan beginning around 3000 BCE. Distinctive seals produced there are some of the most sophisticated of the world's early works of art.

The achievements of the Indus Valley civilization are as mysterious as they are impressive. First discovered less than a hundred years ago, they seemed to be the stuff of legend because many archaeologists doubted that there were actual civilizations dating back that far in this area. Then in the 1920s, excavations revealed a huge, sprawling network of cities, stretching across present-day India, Pakistan, and Afghanistan. It became clear that these settlements were highly organized and that their inhabitants had developed to a level of sophistication that included their own form of writing. Scripts discovered there remain one of the great mysteries of the ancient world since no one has been able to decipher their meaning. Debate still rages over why, and how, this civilization suddenly disappeared.

The twin capitals were Harappa, in the Indian Punjab, and Mohenjo Daro, on the west bank of the Indus River in Pakistan. Excavations of Mohenjo Daro show evidence of urban planning, including the earliest known example of a grid street plan. The rectangular houses enclosed a central courtyard, and the broad avenues of the city contained elaborate drainage systems. The settlement was dominated by a large citadel, which encircled the main public buildings, an assembly hall, a sizeable granary, and a great bath that was probably used for rituals. Most surprising to archaeologists are the things that were *not* found—no magnificent temple, no grand palace, nor any evidence of military activity.

It seems that the citizens of these early cities led peaceful, well-ordered lives, based around agriculture and trade. In fact, trading prompted the cities to produce their most notable artworks—small stamp seals made out of steatite (a type of soapstone). These seals are roughly square and feature simple images, together with a brief inscription. They are one of the world's first examples of combining pictures and writing.

The designs were incised or carved into the surface so that the image could be transferred when the seal was pressed into a soft material, such as wax or clay. They were clearly linked with the city's trading activities, since seals have also been found in Mesopotamia, where the merchants of the Indus Valley had established trading links. The most likely explanation is that they were used to identify goods and to show who owned them, either stamped onto merchandise or onto identification tags. Most seals have a perforation at the back, where a cord can be attached. They were produced in large numbers—more than 4,200 seals have been recovered.

Most of the designs portray animals. Often, these are domestic creatures, such as humped cattle, but others are more exotic, and some appear to be mythical, such as a creature resembling a unicorn. Some seals display miniature scenes of activities such as wrestling and the sport of bull-vaulting, whereby men attempted to leap over bulls. The most remarkable examples depict religious icons and rituals, including a goddess supervising an animal sacrifice, a beast with three heads, and a horned man seated in a yogic position, who has been interpreted as an early prototype of the Hindu god Shiva.

Seal
Artist unknown,
c. 2300–1750 BCE
Indus Valley

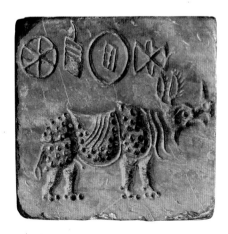

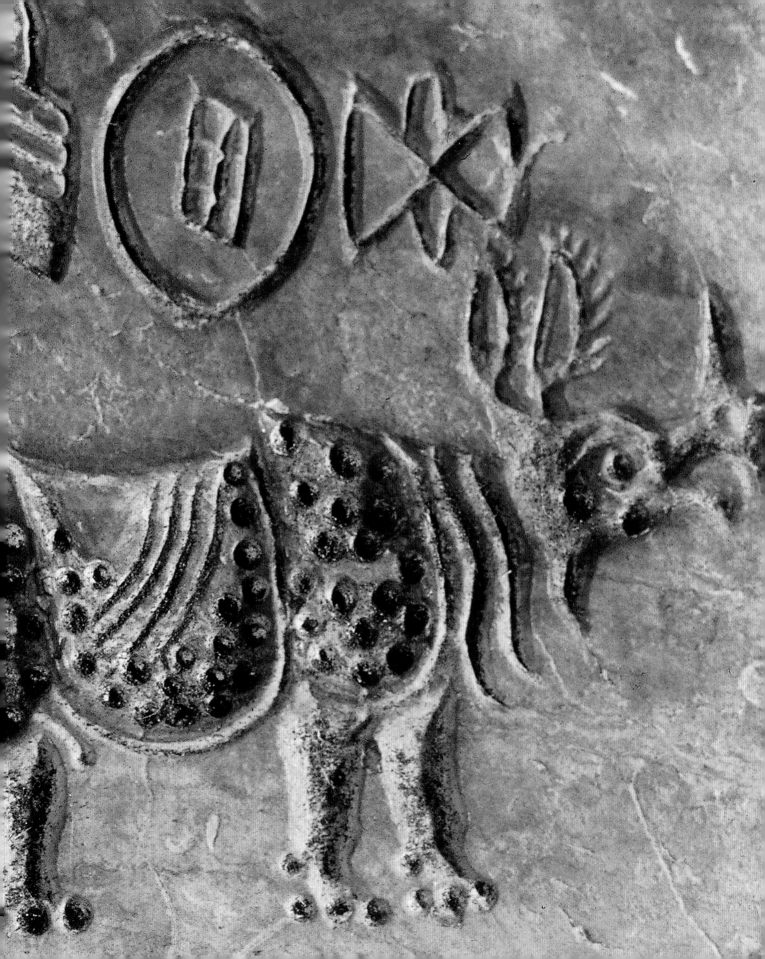

C. 2000–1500 BCE
Greece

C. 2000–1750 BCE
Pakistan

C. 2000–1650 BCE
Egypt

1 *Boys Boxing, from Thera*
Artist unknown
Painted plaster, height: 9' (2.75 m)
Athens (Greece), National
Archaeological Museum
Minoan

THE BODY
LEISURE

2 *Seated Male or Priest King, from
Mohenjo Daro*
Artist unknown
White low-fired steatite,
height: 9" (23 cm)
Karachi (Pakistan), National
Museum of Pakistan
Indus Valley

RELIGION
PORTRAITURE

3 *Standing Hippopotamus*
Artist unknown
Blue faience,
height: 4½" (11.4 cm)
Cairo (Egypt), Egyptian Museum
Ancient Egyptian

ANIMALS
DEATH

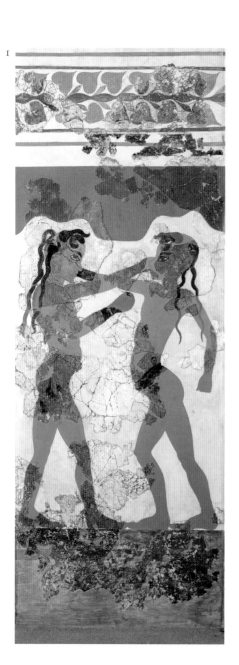

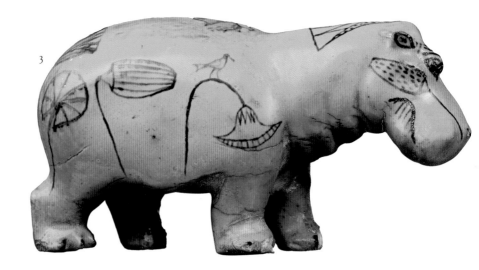

4 *The Book of the Dead of Padiamenet*
Artist unknown
Papyrus, detail
London (UK), British Museum
Ancient Egyptian

DEATH
RELIGION

5 *Bull Leaping*
Artist unknown
Fresco, height: 33¾" (86 cm)
Heraklion (Greece), Museum of
Archaeology
Minoan

ANIMALS
LEISURE

4

5

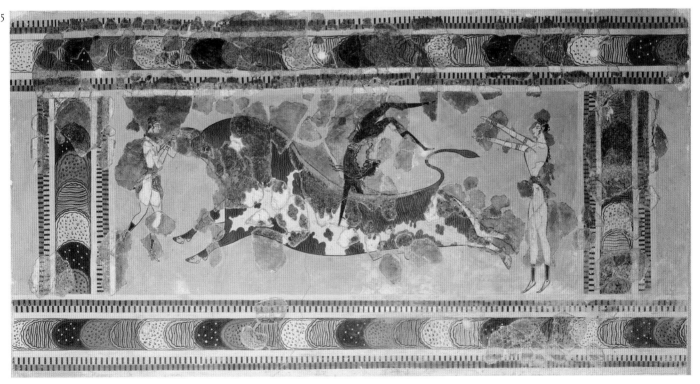

C. 1400–1300 BCE

Greece

C. 1390–1352 BCE

Egypt

C. 1390–1352 BCE

Egypt

1 *Stemmed Bowl Decorated with Riders in Chariots*
Artist unknown
Painted pottery,
height: 16½" (42 cm)
London (UK), British Museum
Mycenaean

WAR
ANIMALS

2 *Fowling in the Marshes, from the Tomb of Nebamun*
Artist unknown
Wall painting, height: 32¾" (83 cm)
London (UK), British Museum
Ancient Egyptian

DEATH
RURAL LIFE

3 *Banquet Scene, from the Tomb of Nebamun*
Artist unknown
Wall painting, detail
London (UK), British Museum
Ancient Egyptian

DEATH
LEISURE

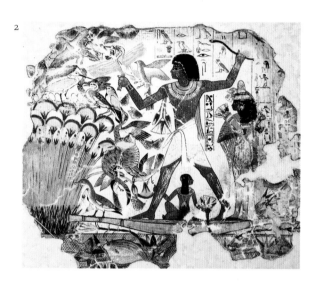

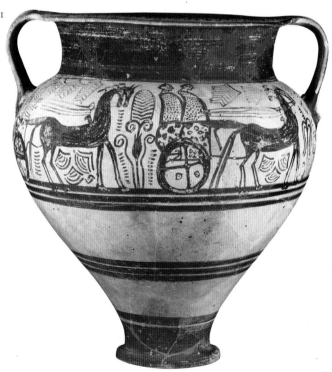

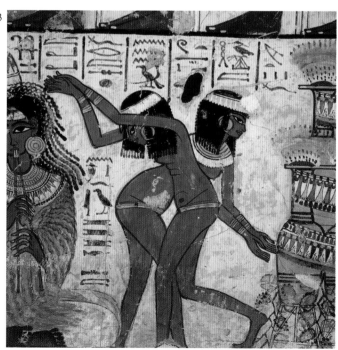

4 *King Thutmose IV, Kneeling and*
 Making Offerings
 Artist unknown
 Bronze, height: 5¾" (14.7 cm)
 London (UK), British Museum
 Ancient Egyptian

 DEATH
 PORTRAITURE

5 *Tutankhamen's Funerary Mask*
 Artist unknown
 Gold inlaid with stones and glass,
 height: 21¼" (54 cm)
 Cairo (Egypt), Egyptian Museum
 Ancient Egyptian

 DEATH
 PORTRAITURE

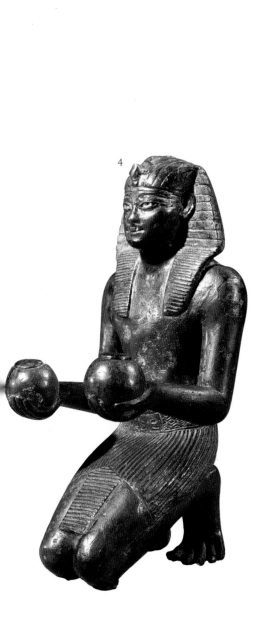

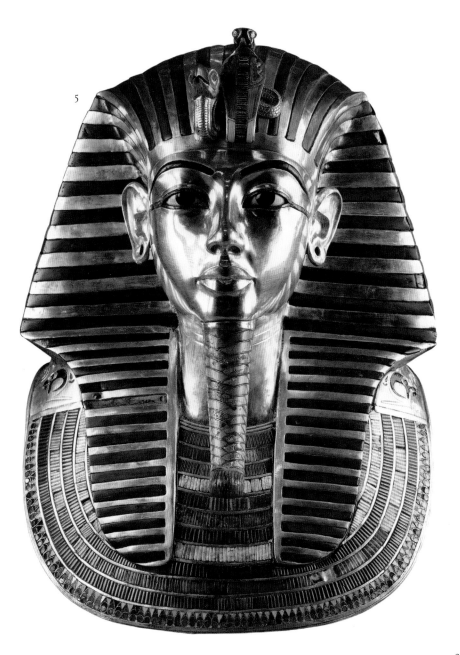

The Chinese perfect the art of bronze casting

During the Bronze Age, people in many regions of the world generated metal tools for the first time, but in China artworks of the highest order were produced.

Ancient people across the globe cast simple tools and weapons in bronze, a major breakthrough for human development. When the technique was developed in China it inspired far more than mere blades. Bronze Age craftsmen there created bronze castings of elegant shapes adorned with detailed patterns.

The finest of these castings are the ritual vessels that were produced during the era of the Shang rulers, the first major Chinese dynasty, who came to power in about 1500 BCE. These lavish objects contained offerings of food and drink during ceremonies where rulers and ancestors were worshiped. Large numbers of these vessels, filled with sacrificial offerings for the afterlife, were buried in tombs alongside the dead. It was hoped that the spirits of the dead would watch over the fortunes of their descendants.

These elaborate ritual ceremonies reflect the power and political organization the Shang rulers imposed in an era when most of the world's peoples were just beginning to form structured communities. The materials used in China were scarce and costly, and the casting process was labor-intensive and required highly skilled craftsmen. Varied ranges of vessel designs were used. More than twenty different types have been identified. The shapes of many of the ritual vessels were based on everyday utensils, often originally made in earthenware, that had been in use since Neolithic times. These simple objects were transformed into sophisticated artworks. The *ding*—a form of cauldron—eventually became the most important. The shape appears to have originated as a pottery basin. At a later stage, three legs were added to the basin, so that it could be heated over a fire. The other types of vessels included a *xian* (steamer), a *yu* (bucket), and a *gu* (goblet).

Chinese craftsmen developed a distinctive bronze alloy, adding lead to the usual mixture of copper and tin. This endowed the finished article with an attractive gray sheen. Their preferred technique was piece-mold casting. In this process, a model was initially fashioned out of clay. From this, a number of molds were taken. After the original model was released, molds were reassembled to form a final mold, into which the molten bronze was poured. The piece-mold technique was time-consuming, but it allowed craftsmen to carve or stamp decorative elements directly onto the inner surface of the mold, enabling them to achieve an unparalleled degree of sharpness in their intricate designs.

The decorations on Shang bronze-ware are both complex and mysterious. Many are based on animal forms. Some are highly naturalistic and related, perhaps, to the creatures that were sacrificed in the ceremonies. Others are far more symbolic—strange birds with hooks along their plumage, the dragon-like *kui*, and the all-pervasive mythical beast *taotie*, usually seen on masks, with its bulging eyes and fierce, protruding jaws. Many of the Shang vessels feature brief, dedicatory inscriptions. In addition to providing invaluable information about the owners and the purpose of the objects, these inscriptions also constitute some of the earliest known examples of Chinese writing.

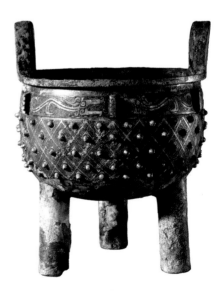

Ding
Artist unknown,
c. 1200–1100 BCE
Shang Dynasty

1 *Cup with Monster Motif*
Artist unknown
Electrum, height: 4½" (11.4 cm)
Paris (France), Louvre
Ancient Persian

ANIMALS

2 *Lady in Waiting*
Artist unknown
Wall painting, fragment
Athens (Greece), National
Archaeological Museum
Mycenaean

DOMESTIC LIFE

3 *Vase with Warriors*
Artist unknown
Painted pottery,
height: 16½" (42 cm)
Athens (Greece), National
Archaeological Museum
Mycenaean

WAR

1

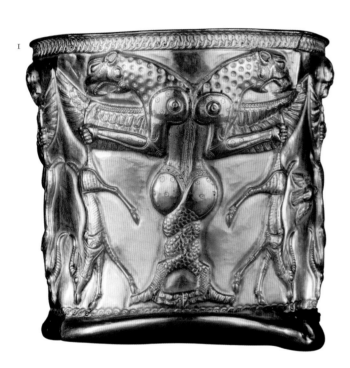

2

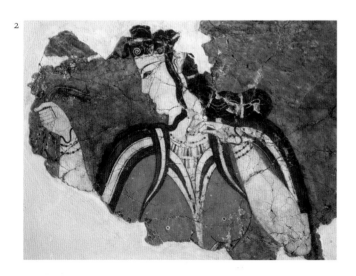

3

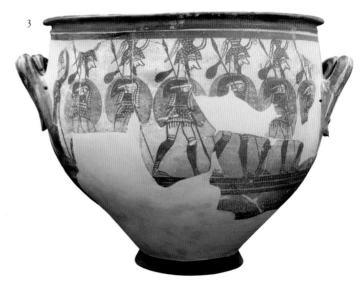

C. 1000 BCE
Iran

C. 1000–700 BCE
Italy

C. 900–800 BCE
Italy

4 *Humpbacked Bull*
Artist unknown
Pottery, height: 6½" (16.8 cm)
London (UK), British Museum
Amlash culture

ANIMALS

5 *Tribal Chief, from Uta*
Artist unknown
Bronze
Cagliari (Italy), Archaeological
Museum
Nuraghic culture

POLITICS

6 *Toy Wagon in the Shape of a Bird*
Artist unknown
Terracotta
Este (Italy), Atestino National
Museum
Villanovan

LEISURE
ANIMALS

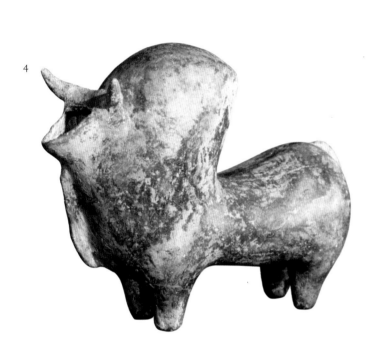

4

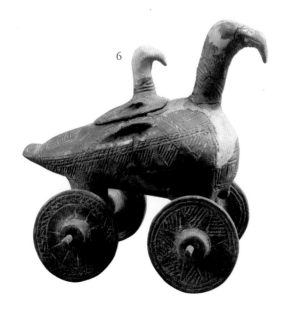

6

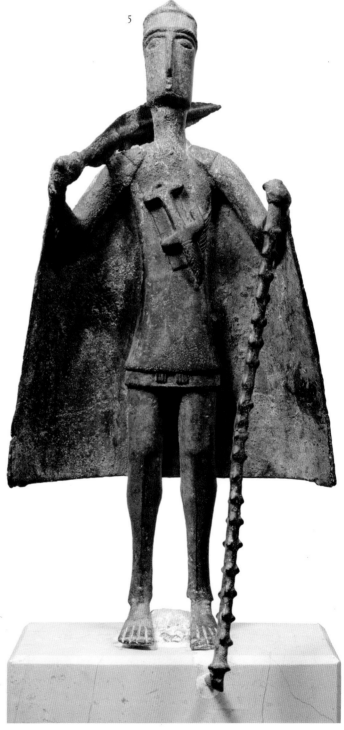

5

c. 825 BCE
Greece

c. 800–700 BCE
Italy

c. 721–705 BCE
Iraq

1 *Horse, from the Fusco Necropolis*
Artist unknown
Bronze
Syracuse (Italy), Regional
Archaeological Museum
Ancient Greek

ANIMALS

2 *Vessel in the form of an Ox and Rider*
Artist unknown
Fictile with impressed decoration,
height: 7" (17.7 cm)
Bologna (Italy), Civic Museum
Villanovan

RURAL LIFE
ANIMALS

3 *Head of Woman, from Nimrud*
Artist unknown
Ivory
Baghdad (Iraq), Iraq Museum
Neo-Assyrian

PORTRAITURE

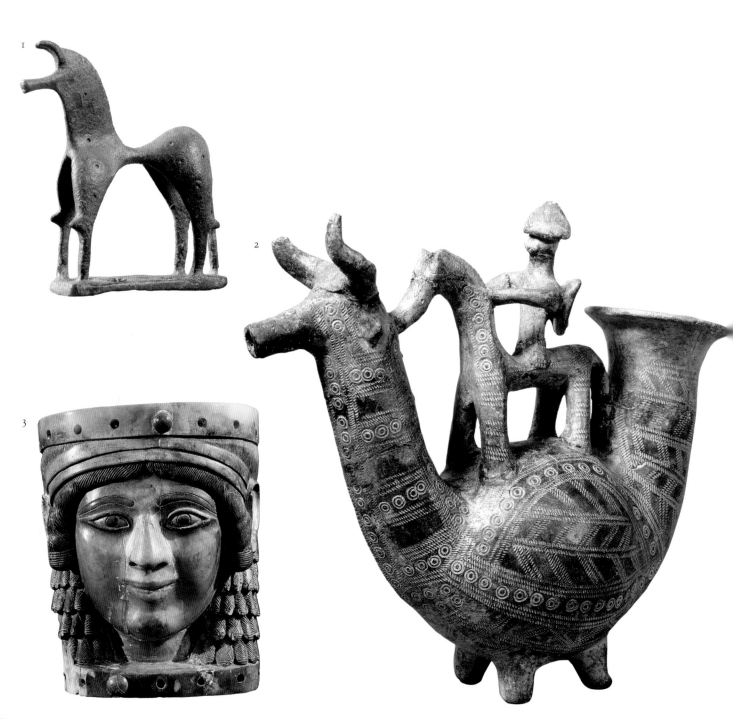

C. 720 BCE
Iraq

C. 650–600 BCE
Italy

C. 530 BCE
Italy

4 *Winged Bull with Human Face,*
 from the Palace of Sargon II
 Artist unknown
 Gypsum, height: c. 13' 6" (4.2 m)
 Baghdad (Iraq), Iraq Museum
 Assyrian

 ANIMALS
 POLITICS

5 *Ash Urn*
 Artist unknown
 Terracotta, height: 1' 6" (45 cm)
 Florence (Italy), Archaeological
 Museum
 Etruscan

 DEATH

6 *Amphora with Ajax and Achilles*
 Playing a Game
 Exekias (potter and painter)
 Black-figure terracotta,
 height: 24" (61 cm)
 Vatican (Vatican City), Gregorian
 Museum of Etruscan Art
 Ancient Greek

 WAR
 LEISURE

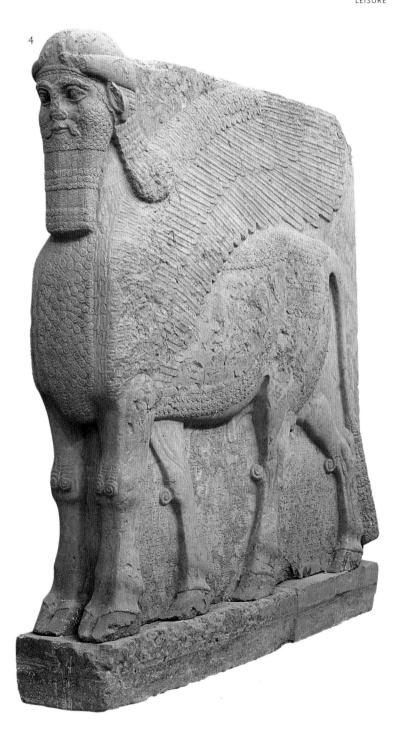

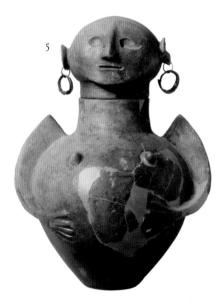

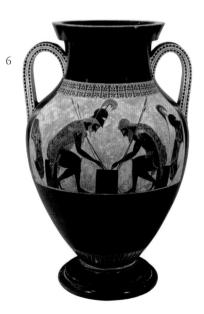

C. 530–520 BCE
Italy

C. 525–500 BCE
Italy

C. 520 BCE
Greece

1 *Wrestlers*
Artist unknown
Fresco, detail
Tarquinia (Italy),
Tomb of the Auguries
Etruscan

DEATH
LEISURE

2 *Sarcophagus of Reclining Couple*
Artist unknown
Terracotta (once painted),
length: 6' 7" (2 m)
Rome (Italy), Villa Giulia Museum
Etruscan

DEATH

3 *Funerary Statue of Kroisos*
Artist unknown
Marble, height: 6' 4" (1.9 m)
Athens (Greece), National
Archaeological Museum
Ancient Greek

DEATH
THE BODY

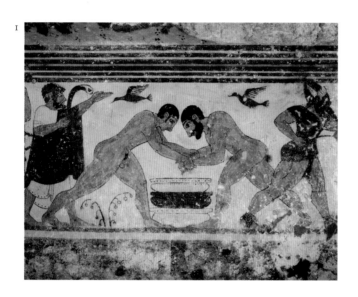

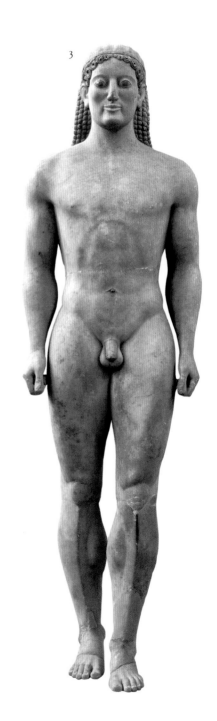

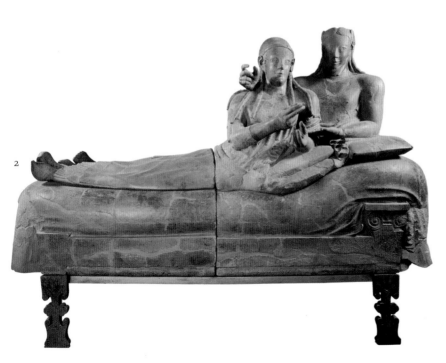

C. 510 BCE
Greece

C. 500–400 BCE
Greece

C. 480 BCE
Greece

4 *Kore (Maiden), from Chios*
Artist unknown
Stone, height: 22" (56 cm)
Athens (Greece), Acropolis
Museum
Ancient Greek

RELIGION

5 *Perfume Container in the
Form of a Duck*
Artist unknown
Terracotta
Fiesole (Italy), Archaeological
Museum
Ancient Greek

ANIMALS
DOMESTIC LIFE

6 *Kouros (Youth)*
Kritios
Marble, height: 36" (91.4 cm)
Athens (Greece), Acropolis
Museum
Ancient Greek

DEATH
THE BODY

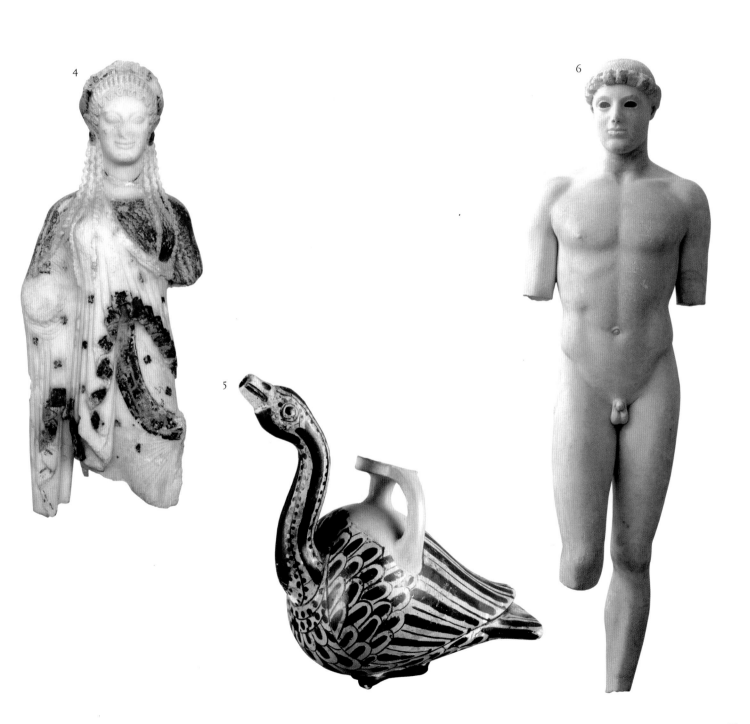

1 *Capitoline She-Wolf*
 (Figures of Romulus and Remus
 a Renaissance addition)
 Artist unknown
 Bronze, height: 33½" (85 cm)
 Rome (Italy), Capitoline Museums
 Etruscan

 MYTHOLOGY
 ANIMALS

2 *Mater Matuta, Cinerary Statue*
 Artist unknown
 Limestone, height: 39½" (1 m)
 Florence (Italy), Archaeological
 Museum
 Etruscan

 RELIGION

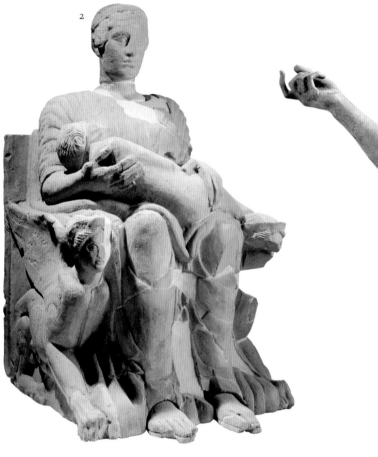

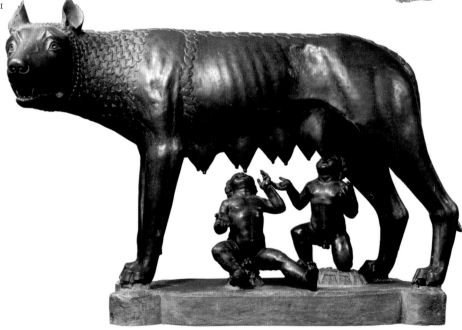

C. 500 BCE
Iraq

C. 460 BCE
Italy

C. 450–425 BCE
Greece

3 *The Archers of Darin*
Artist unknown
Enameled brick,
height: 6' 6" (1.98 m)
Paris (France), Louvre
Babylonian

WAR
POLITICS

4 *Diver, from Sarcophagus of the Diver*
Artist unknown
Painting on plastered limestone,
height: 6' 9" (2.1 m)
Paestum (Italy), National Museum
Ancient Greek

DEATH
LEISURE

5 *Zeus (or Poseidon)*
Artist unknown
Bronze, height: 6' 10" (2.08 m)
Athens (Greece), National
Archaeological Museum
Ancient Greek

MYTHOLOGY
THE BODY

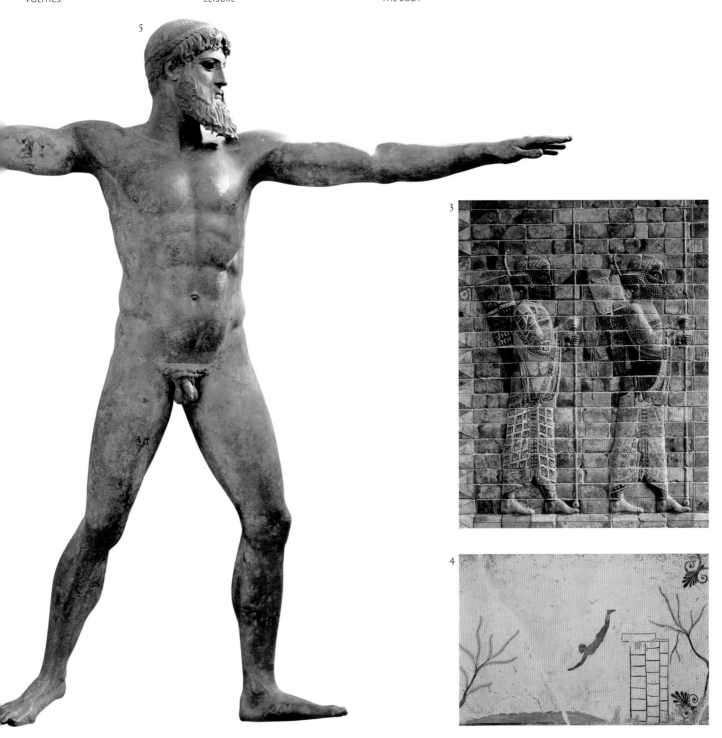

In Ancient Greece artists create ideal human figures

The Greek quest to define the ideal proportions of the human body formed the basis of the classical tradition and changed the course of Western art.

Ancient Greece entered a golden age in the fifth century BCE. In order to win a lengthy war against the Persians, the Greek states formed an alliance for the first time. This resulted not only in the defeat of their enemies but also in a period of national self-confidence. Athens became the dominant city-state. Democracy was born in this era and the arts flourished. The outstanding intellectuals remain cultural icons to this day: Aeschylus, Sophocles, and Euripides, the dramatists; Plato and Socrates, the philosophers; and Herodotus and Thucydides, the historians. This was also the classical period of Greek art and the exceptional work of Greek artists set the standard by which fine art and architecture has been measured in the West ever since. The Greek statue was perhaps the pinnacle of their achievement.

The kouros, nude male figure, and the kore, draped female figure, were already established in Greek sculpture and often used as grave markers. Though beautifully crafted, the poses were rigid and symmetrical. Sculptors of the classical era dramatically improved on these figures and altered forever the way the human form was treated in art. They understood anatomy and how the human body moved, so could make their figures fluid and natural. Yet they wanted to achieve more than mere naturalism. The search for an ideal human form was linked to important philosophical debates in this period. Artists were inspired to analyze and define the nature of ideal beauty, using the human figure as their template.

The high level of intellectual inquiry through philosophy, science, and mathematics affected all areas of the arts in Greece. Major artists such as the influential sculptor Polyclitus of Argos, who was active in the mid-fifth century BCE, contributed as well as reacted to the debates. He wrote a defining treatise on proportion and harmony, *The Canon*, in which he stresses the importance of using a system of mathematical proportions (*symmetria*). He is reported to have said "beauty does not consist in the elements but in the symmetry of the parts, the proportion of one finger to another, of all the fingers to the hand. . . ." His statue of the *Doryphorus* (Spear Carrier) is a perfect example of the classical proportions he defined.

Polyclitus chose an athlete to demonstrate his ideal body. The Greeks highly valued physical and sporting prowess and athletes competed to achieve the ultimate human physique. Sporting events were staged as part of religious festivals, and statues of victorious sportsmen were frequently sited in temple precincts, dedicated to the gods. The most celebrated games were the Olympics, which were held in honor of Zeus, but similar events took place in all the major cities. The frieze on the Parthenon, produced under the supervision of Phidias, depicts a scene from the Panathenaea, the festival devoted to the goddess Athena. This section features Poseidon, Apollo, and Artemis, who are among the deities watching the procession, which includes the popular spectacle of athletes leaping on and off a moving chariot. The figures combine vitality with an air of serene majesty, and they conform to the ideal the Greeks had established for the human form.

Poseidon, Apollo, and Artemis,
Fragment of Relief from The Parthenon
Phidias and unknown artists,
C. 438–432 BCE
Ancient Greek

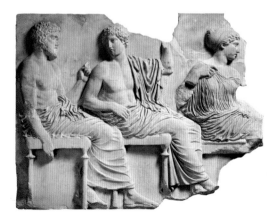

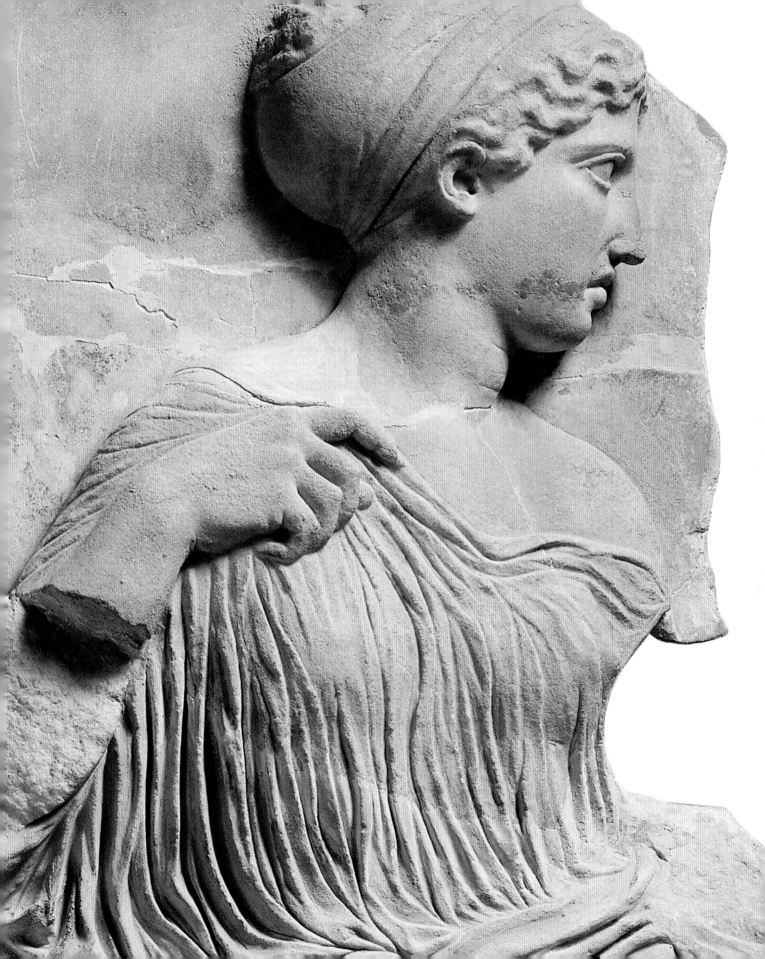

C. 450 BCE
Greece

C. 400–300 BCE
China

C. 350 BCE
Italy

1 *Spear Carrier (Roman copy of a*
 Greek bronze statue)
 Original by **Polyclitus**
 Marble, height: 6' 4½" (1.94 m)
 Vatican (Vatican City),
 Chiaramonti Museum
 Ancient Greek

 THE BODY

2 *Guardian Figure, Possibly a Shaman*
 Artist unknown
 Wood, height: 17" (43.2 cm)
 London (UK), British Museum
 Eastern Zhou

 RELIGION

3 *Women Performing a Funeral Dance,*
 from Ruvo
 Artist unknown
 Wall painting, detail
 Naples (Italy), National
 Archaeological Museum
 Etruscan

 DEATH
 LEISURE

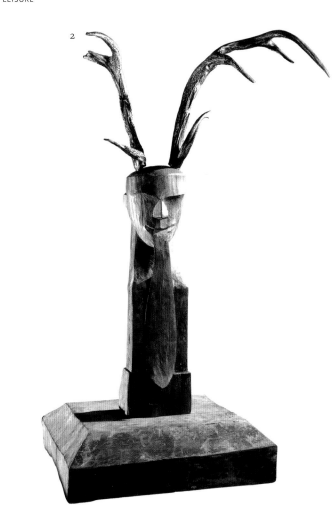

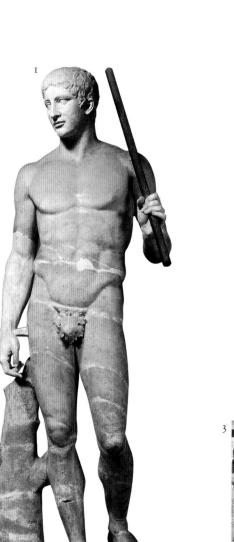

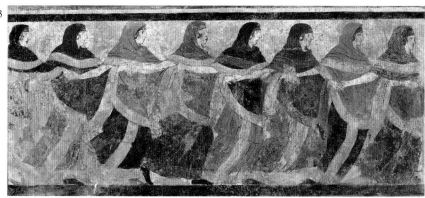

C. 350 BCE
Greece

C. 330 BCE
Greece

C. 300–200 BCE
Italy

4 *Silenus Holding the Young Bacchus*
(Roman copy of a Greek statue)
Original attributed to **Lysippus**
Marble
Vatican (Vatican City),
Chiaramonti Museum
Ancient Greek

MYTHOLOGY
THE BODY

5 *Apollo Belvedere*
(Roman copy of a Greek statue)
Artist unknown
Marble, height: 7' 4" (2.2 m)
Vatican (Vatican City),
Pio-Clementino Museum
Ancient Greek

THE BODY
MYTHOLOGY

6 *Shadow of the Evening*
Artist unknown
Bronze, height: 22½" (57.5 cm)
Volterra (Italy), Guarnacci
Etruscan Museum
Etruscan

THE BODY

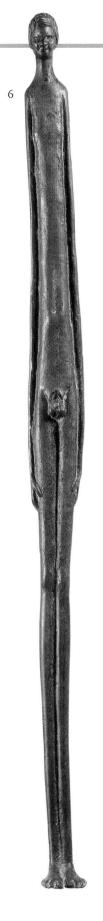

6

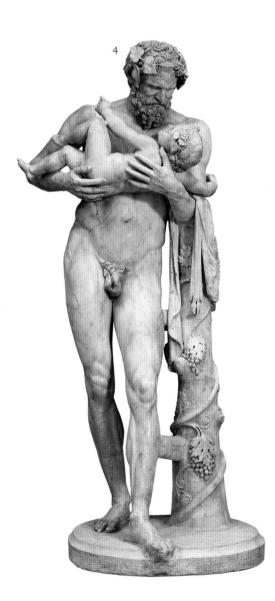

4

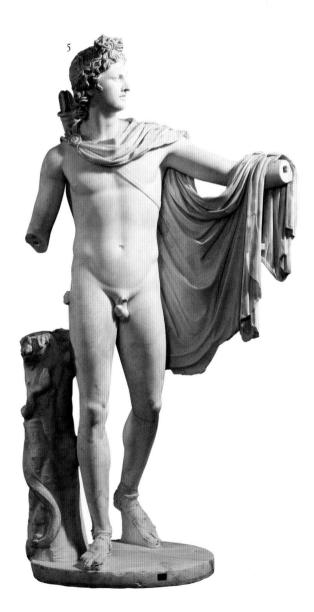

5

1 *Reclining Woman, from Seleucia*
Artist unknown
Marble
Baghdad (Iraq), Iraq Museum
Ancient Persian

THE BODY

2 *Funerary Figure
Representing a Horse*
Artist unknown
Fired clay
Rome (Italy),
Museum of Oriental Art
Han dynasty

DEATH
ANIMALS

3 *Vase with Faces*
Artist unknown
Painted pottery,
9" x 5¼" (23 x 13.5 cm)
London (UK), British Museum
Nascan culture

DOMESTIC LIFE

4 *Portrait of Julia, Daughter of Titus*
Artist unknown
Marble, height: 17¼" (44 cm)
Florence (Italy), Uffizi
Ancient Roman

PORTRAITURE

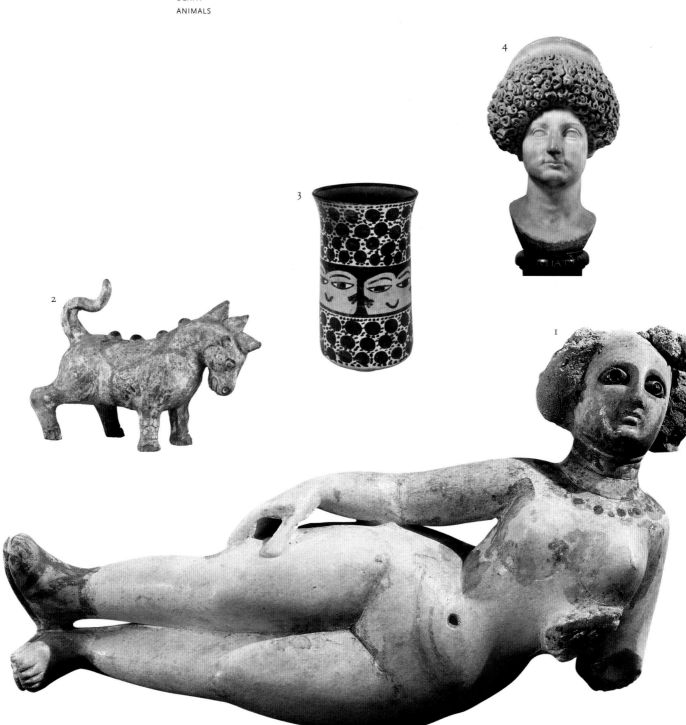

5 *African Boxers*
Artist unknown
Pottery, height: 10¼" and 9½"
(26.3 cm and 24.4 cm)
London (UK), British Museum
Ancient Roman

LEISURE
THE BODY

6 *Roman Gladiators*
Artist unknown
Terracotta
Taranto (Italy),
Archaeological Museum
Ancient Roman

LEISURE
THE BODY

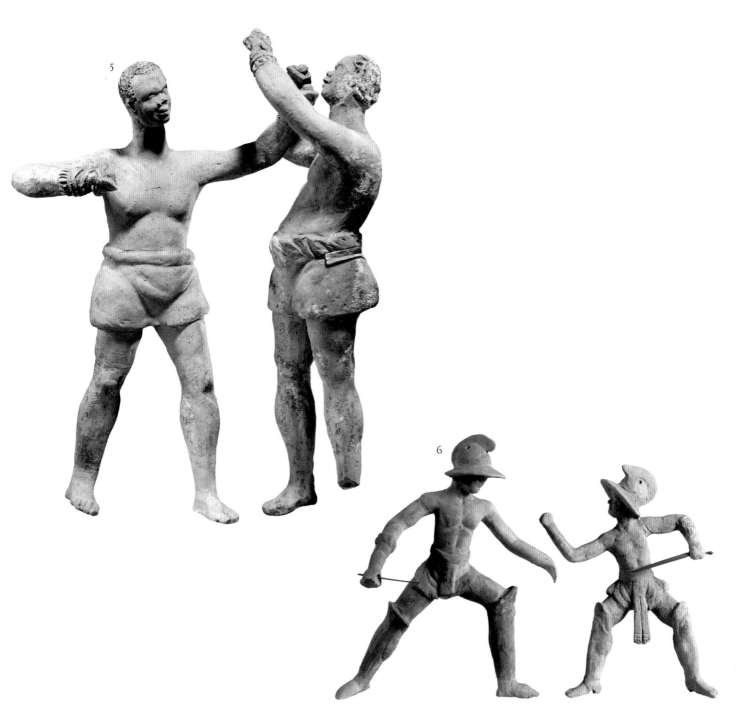

C. 200–100 BCE
Italy

C. 190 BCE
Greece

C. 150 BCE
Greece

1 *Strolling Musicians (Roman mosaic copy of lost Greek painting)*
Original by **Dioskurides of Samos**
Mosaic, height: 17" (43 cm)
Naples (Italy), National
Archaeological Museum
Ancient Greek

LEISURE
URBAN LIFE

2 *Victory of Samothrace*
Artist unknown
Marble, height: 10' 9" (3.3 m)
Paris (France), Louvre
Ancient Greek

WAR
ALLEGORY

3 *Aphrodite of Melos, the Venus of Milo*
Artist unknown
Marble, height: 7' 10" (2.4 m)
Paris (France), Louvre
Ancient Greek

THE BODY
MYTHOLOGY

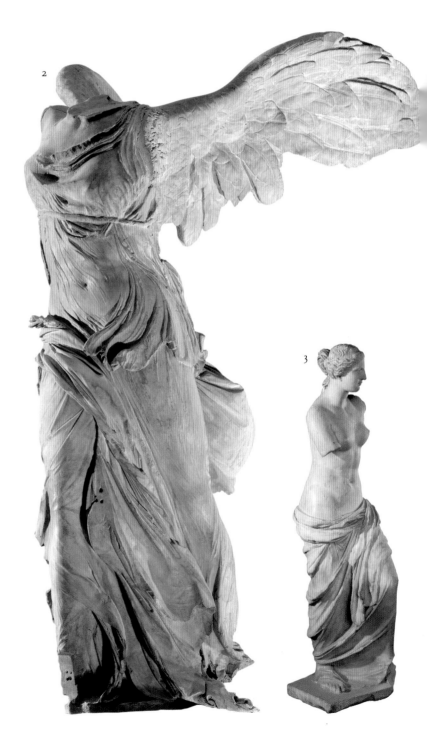

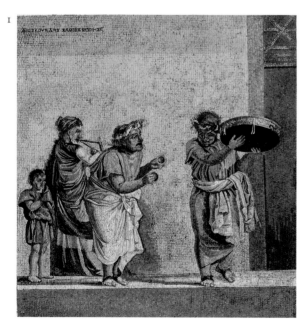

C. 100 BCE
Italy

C. 100 BCE
India

C. 100 BCE
Italy

4 *Room of the Masks*
Artist unknown
Fresco
Rome (Italy), Palatine Hill,
Domus Augustana
Ancient Roman

DOMESTIC LIFE

5 *Enlightenment of Buddha*
Artist unknown
Carved limestone drum slab,
height: 49" (1.25 m)
London (UK), British Museum
Indian

RELIGION

6 *Cato and Portia*
Artist unknown
Marble
Vatican (Vatican City),
Pio-Clementino Museum
Ancient Roman

PORTRAITURE
DEATH

6
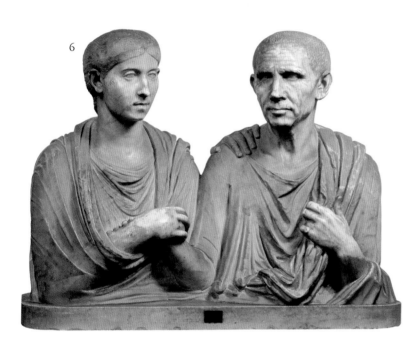

4
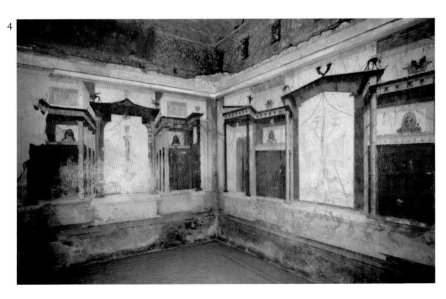

5

C. 100 BCE
Italy

C. 100 BCE–CE 300
Mexico

C. 50–40 BCE
Italy

C. 30 BCE
Italy

1 *Flooding of the Nile*
Artist unknown
Mosaic, detail
Palestrina (Italy),
Archaeological Museum
Ancient Roman

LANDSCAPE

2 *Dog*
Artist unknown
Fired earthenware,
height: 16½" (42 cm)
Rome (Italy), Pigorini Prehistoric
and Ethnographic Museum
Colima culture

ANIMALS

3 *Scene from the Odyssey:*
Lestrygonians Preparing to Attack
Ulysses's Ships, from a House on the
Esquiline Hill, Rome
Artist unknown
Fresco
Vatican (Vatican City), Library
Ancient Roman

WAR

MYTHOLOGY

4 *Reading of the Ritual (detail)*
Artist unknown
Fresco, height of figures:
c. 5' (1.5 m)
Pompeii (Italy),
Villa of the Mysteries
Ancient Roman

RELIGION

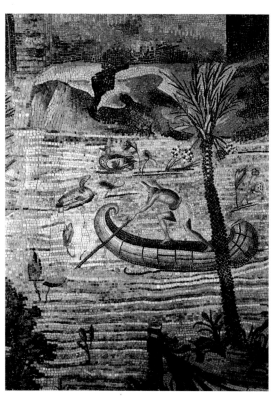

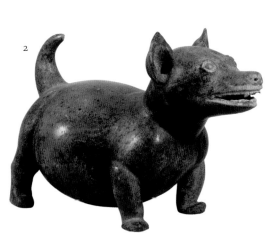

5 *Laocoön*
**Hagesander,
Polydorus, and Athenodorus**
Marble, height: 8' (2.4 m)
Vatican (Vatican City), Pio-
Clementino Museum
Ancient Roman

THE BODY
MYTHOLOGY

6 *Augustus as Emperor, from the
Villa of Livia at Primaporta*
Artist unknown
Marble, height: 6' 7" (2.4 m)
Vatican (Vatican City),
Chiaramonti Museum
Ancient Roman

POLITICS
PORTRAITURE

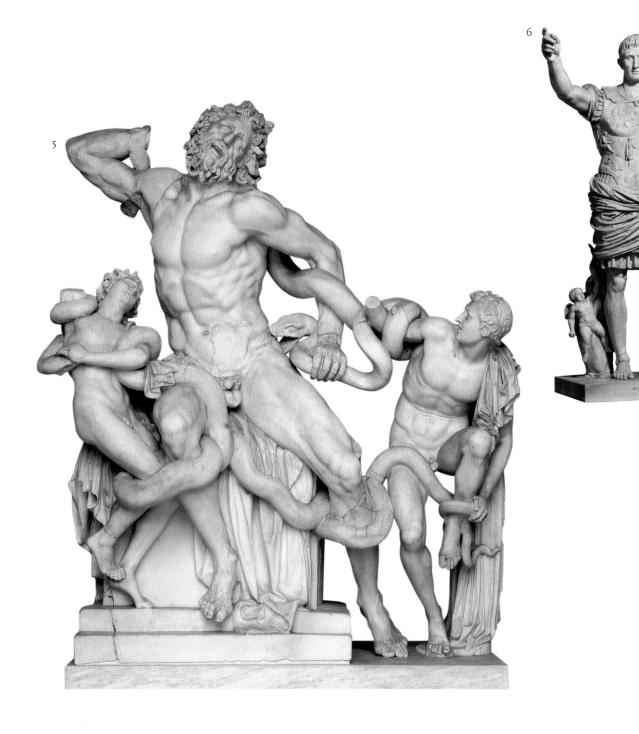

The Buddha is carved for the first time in human form

Buddha's followers were reluctant to produce realistic images of their holy leader. It was more than 500 years after his death that artists took the giant step of portraying him in human form.

Early Buddhist artists represented his being rather than depicting the Buddha himself. They showed the bodhi tree, one of his stupas, the soles of his feet, or an empty throne. Each of these had a specific relevance to his life and teaching. He was seated under a bodhi tree when he attained a state of enlightenment. The stupas were symbolic structures that housed relics of Buddha himself or of one of the great Buddhist teachers. In common with Vishnu, Buddha was frequently represented by the soles of his feet, usually adorned with the "Wheel of the Law"—the symbol of Buddha's teaching. Buddha's footprints were also used, and a small stool bearing the Buddha's footprints often accompanied the symbolic empty throne. The prints were highly stylized, with toes of precisely the same length.

The historical Buddha was Siddhartha Gautama, who was born c. 563 BCE. Little is known in detail about his life, other than that he lived in northern India and was a member of the Shakya tribe. The transition that led to human depictions of the Buddha was aided by the fact that he was, to his followers, a man rather than a god. The reluctance to show him as mere man, however, can be easily understood. Artists were anxious to ensure that his image could not be confused with that of an ordinary mortal. They were assisted in this by the thirty-two *lakshanas*—distinguishing features—specified in early Buddhist texts. Artists were able to incorporate them into their carvings as stylized, symbolic features that identified the Buddha and set him apart.

The *lakshanas* included the *ushnisha*, a distinctive cranial bump on the top of the head, signifying both wisdom and spiritual enlightenment. On some occasions, a small flame rather than a bump represented this. The *urna*, a small tuft of hair between the eyebrows, was another mark of wisdom. Buddha was also portrayed with long, slender earlobes. This feature was derived from the ancient Indian rulers, who wore heavy earrings that stretched the lobes. Further aspects of the Buddha's teaching were symbolized by his *mudras* (hand gestures) and his *asanas* (postures). In any single statue, enormous meaning was instilled through the Buddha's pose and his features.

Human images of Buddha were pioneered in two main areas: the Mathura region, in northern India, in the vicinity of Agra, and the vast Gandhara region, in present-day Afghanistan, northwest India, and Pakistan. The Gandhara figures, such as this one, were undoubtedly influenced by the art of the classical world. Alexander the Great brought his armies here in the fourth century BCE, and local artists inherited the classical techniques of presenting the human figure and its garments in a strikingly realistic yet posed style. As a result, Gandharan sculptures are significantly different from the Mathuran sculptures, which show a portly, relaxed figure, in the Indian tradition. In Gandharan statuettes, Buddha is elegantly slim, is often shown wearing a classical toga, and his hair is usually arranged into wavy curls and lacks the traditional cranial bump on his forehead.

Standing figure of Buddha from Gandhara
Artist unknown, C. CE 1–100
Pakistani

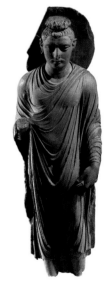

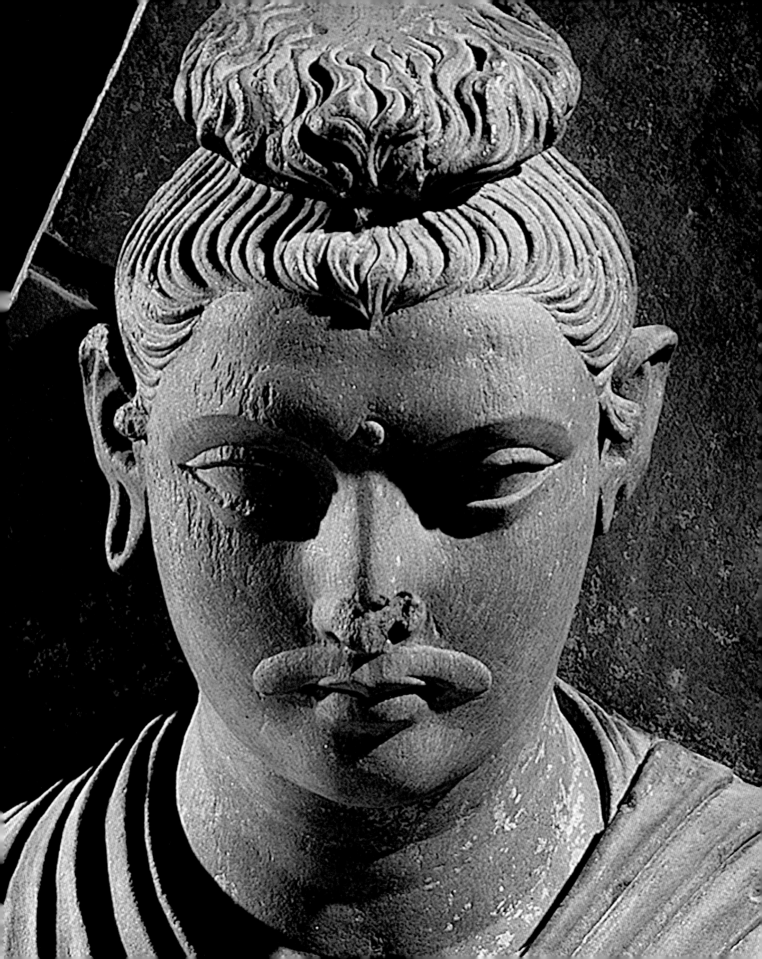

CE 50–51
Italy

C. CE 50
Italy

C. CE 50
Italy

1 *Coin of the Emperor Claudius*
Artist unknown
Silver, diameter: 1" (2.7 cm)
London (UK), British Museum
Ancient Roman

PORTRAITURE
POLITICS

2 *Flora or Primavera, from Stabiae*
Artist unknown
Wall painting,
15¼" x 12½" (39 x 32 cm)
Naples (Italy), National
Archaeological Museum
Ancient Roman

ALLEGORY

3 *Portrait of a Man and His Wife,
from Pompeii*
Artist unknown
Fresco, 25½" x 22¾" (65 x 58 cm)
Naples (Italy), National
Archaeological Museum
Ancient Roman

PORTRAITURE

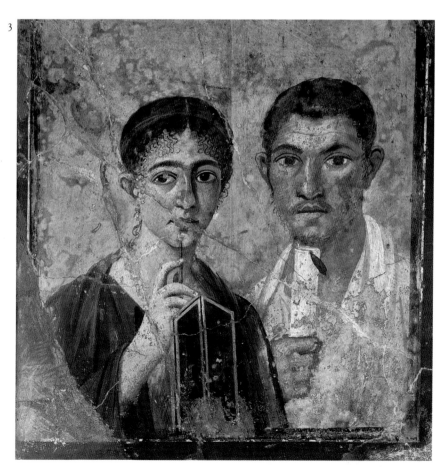

C. CE 50
Italy

C. CE 6–220
China

C. CE 1–100
India

4 *The God Mithras Slaying the Bull*
Artist unknown
Marble
Vatican (Vatican City),
Pio-Clementino Museum
Ancient Roman

RELIGION

5 *A Model for the Afterlife: Pond with
Figures and Creatures*
Artist unknown
Glazed pottery,
height: 13" (32.8 cm)
London (UK) , British Museum
Han dynasty

DEATH
LANDSCAPE

6 *Yakshi, from Stupa Gateway
at Sanchi*
Artist unknown
Sandstone,
height: 25½" (64.5 cm)
London (UK), British Museum
Indian

RELIGION
THE BODY

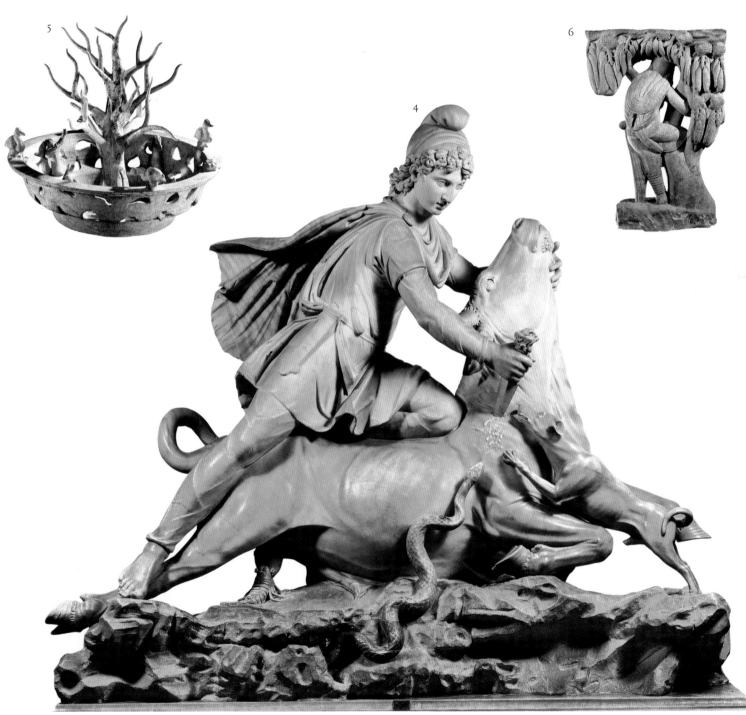

5

4

6

Roman painters master a naturalistic approach to painting

Although the Greeks are documented as having created naturalistic paintings, few of these works survive. It is in Roman examples that we find the first visual evidence for a highly naturalistic style that will become such an important part of the Western tradition of painting.

Roman artists owed a great debt to the Greeks. They inherited a dynamic and sophisticated approach to art from them, as well as techniques and styles that continue to have an impact on art and architecture to the present day. Painting in a natural style was by no means a Roman invention. In the late fifth century BCE the celebrated Greek artist Zeuxis challenged his rival Parrhasius to see which of them could produce the most natural painting. Zeuxis painted a bunch of grapes so realistic birds tried to peck at them. Triumphantly, Zeuxis turned to his rival and invited him to draw back the curtain from his painting. His joy turned to despondency, however, when he realized that the curtain itself was a painting. Gloomily, he was forced to admit defeat. Sadly, no paintings by either artist have survived. However, the Romans certainly saw, and were highly influenced by, such works.

Painting was a popular and well-respected art form in Roman times. They produced both murals and panel paintings, although virtually none of the latter has survived. The wall paintings feature a broad range of subjects, from historical and mythological subjects to still lifes, landscapes, and portraits. To modern eyes, some of the most striking Roman paintings are still lifes of fruit and other food. These have a freshness and a feeling for detail that would not be matched until the golden age of Dutch painting, 1,600 years later. When Greek artists had painted similar subjects of still life, they were dismissed as low art. Piraeicus, a specialist in this field, was given the nickname Rhyparographos, or "painter of sordid subjects." Roman taste was far more relaxed and still life developed into an important art form.

Roman artists loved to place their images of food in ingenious, trompe-l'oeil settings as an early form of interior decoration used in the villas of prominent citizens. This example, which was discovered at Herculaneum, shows faux shelves with green peaches and a beaker of water. It would not look out of place in a modern kitchen. Still life artists also portrayed writing implements, theatrical masks, purses, and torches. Occasionally they added the natural touch of a living creature: a cat stealing some fish, a mouse scurrying along a ledge, a rabbit nibbling its food.

While naturalistic still life certainly has its roots in Greek art, there is little evidence that the Greeks applied this style to portraiture. The Romans broke with the Greek tradition of idealizing their figures, preferring instead to strike a more realistic note. In part, this was due to one of their funerary practices. Highborn families used to take death masks of their loved ones, preserving them on shrines within their homes. These masks were carried in procession at funerals, to emphasize the ancestral achievements of the family. They were made of perishable materials, such as wax or plaster, so almost none survive. Portraits created as part of wall paintings were less common but several notable examples survive at Pompeii, and these provide clear evidence of highly naturalistic Roman portraits.

Still Life with Peach Bough and Glass Jar
Artist unknown, C. CE 50
Ancient Roman

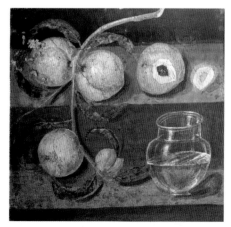

C. CE 50
Italy

C. CE 50
Italy

C. CE 59
Italy

1 *Garden with Fountain*
Artist unknown
Wall painting, detail
Pompeii (Italy), Casa del
Bracciale d'Oro
Ancient Roman

DOMESTIC LIFE

2 *Three Graces, from Pompeii*
Artist unknown
Fresco, 29½" x 23½" (75 x 60cm)
Naples (Italy), National
Archaeological Museum
Ancient Roman

MYTHOLOGY
THE BODY

3 *Brawl, The Amphitheater Riot*
of CE 59
Artist unknown
Fresco, detail
Pompeii (Italy), House near the
Amphitheater
Ancient Roman

URBAN LIFE
HISTORY

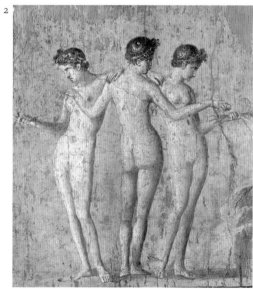

C. 100—200
Egypt

C. 100—200
Egypt

C. 100—200
India

4 *Funerary Portrait a Young Man
in a Gold Wreath*
Artist unknown
Encaustic on wood with added gold
leaf, life-size
Moscow (Russia), Pushkin
Museum
Egyptian

DEATH
PORTRAITURE

5 *Funerary Portrait of a
Woman from El Fayum*
Artist unknown
Tempera on wood, 17¼" x 7¾"
(34 x 20 cm)
Florence (Italy),
Archaeological Museum
Egyptian

DEATH
PORTRAITURE

6 *Buddhist Roundel: The Mandhata
Jataka*
Artist unknown
Limestone, diameter: 21" (53.7 cm)
London (UK), British Museum
Indian Buddhism

RELIGION

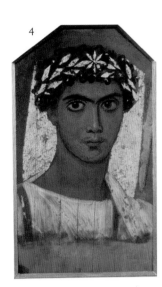

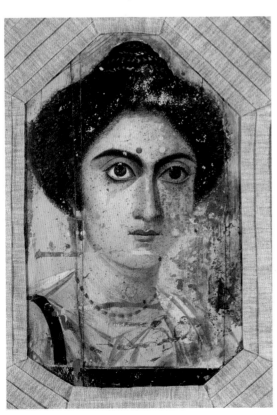

C. 100–700
Peru

100–300
Iran

C. 100–200
Italy

1 *Pot Representing a Deity*
Artist unknown
Terracotta
Rome (Italy), Pigorini Prehistoric
and Ethnographic Museum
Moche

RELIGION

2 *A Parthian Horseman*
Artist unknown
Bronze belt buckle,
2¾" x 3" (7 x 7.2 cm)
London (UK), British Museum
Parthian

ANIMALS
RURAL LIFE

3 *The Good Shepherd*
Artist unknown
Fresco, detail
Rome (Italy), Catacombs of Saint
Domitilla, Basilica of Saints
Nereus and Achilleus
Early Christian

RELIGION

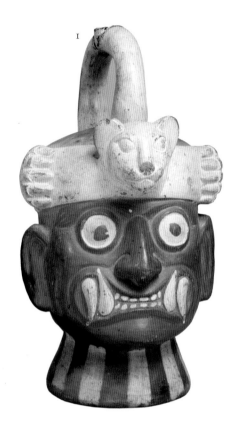

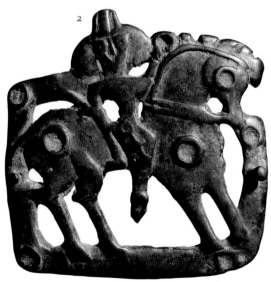

Early Christian

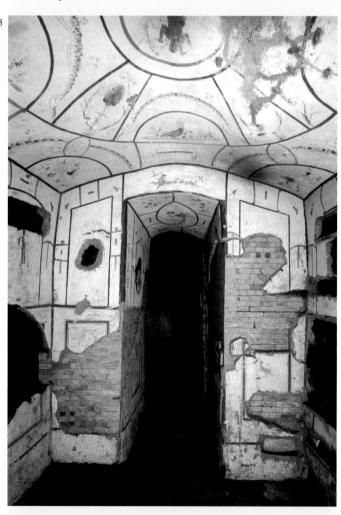

100–200
India

113–116
Italy

113–116
Italy

4 *Head from a Statue of Buddha*
Artist unknown
Dark gray schist,
height: 15¼" (38.7 cm)
London (UK), British Museum
Indian Buddhism

RELIGION

5 *Trajan's Column*
Artist unknown
Marble, height (including base):
125' (38 m)
Rome (Italy), Trajan's Forum
Imperial Roman

WAR
HISTORY

6 *Trajan's Column (detail)*
Artist unknown
Marble, height of relief bands:
36" (91 cm)
Rome (Italy), Trajan's Forum
Imperial Roman

WAR
HISTORY

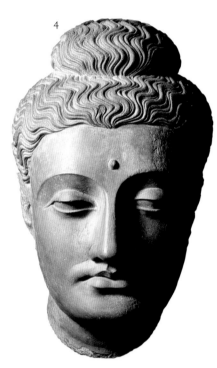

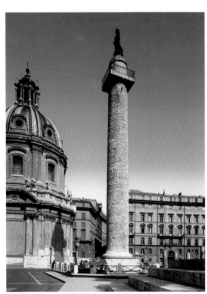

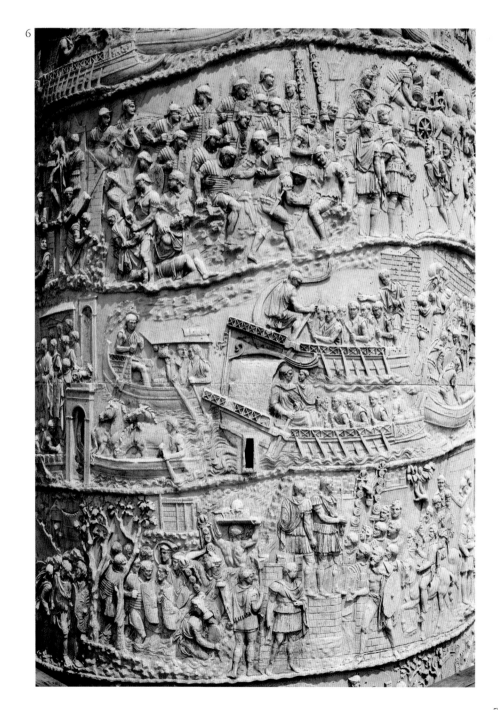

1 *Horses from a Quadriga*
Artist unknown
Bronze, life-size
Venice (Italy), Museum of
Saint Mark's Basilica
Roman

ANIMALS

2 *Equestrian Statue of Marcus Aurelius*
Artist unknown
Bronze, height: 8' 6" (3.5 m)
Rome (Italy), Capitoline Museums
Imperial Roman

PORTRAITURE
ANIMALS

c. 190–192
Italy

c. 200–300
Italy

300–400
Iran

3 *Bust of Commodus as Hercules*
Artist unknown
Marble, height: 46½" (118 cm)
Rome (Italy), Capitoline Museums
Imperial Roman

PORTRAITURE
ALLEGORY

4 *Christ as the Sun God Helios,*
from the Tomb of the Julii
Artist unknown
Mosaic, detail
Vatican (Vatican City), Saint Peter's
Basilica, Necropolis
Early Christian

RELIGION
ALLEGORY

5 *Plate showing King*
Shapur II Hunting
Artist unknown
Silver, diameter: 5" (12.8 cm)
London (UK), British Museum
Sassanian

PORTRAITURE
LEISURE

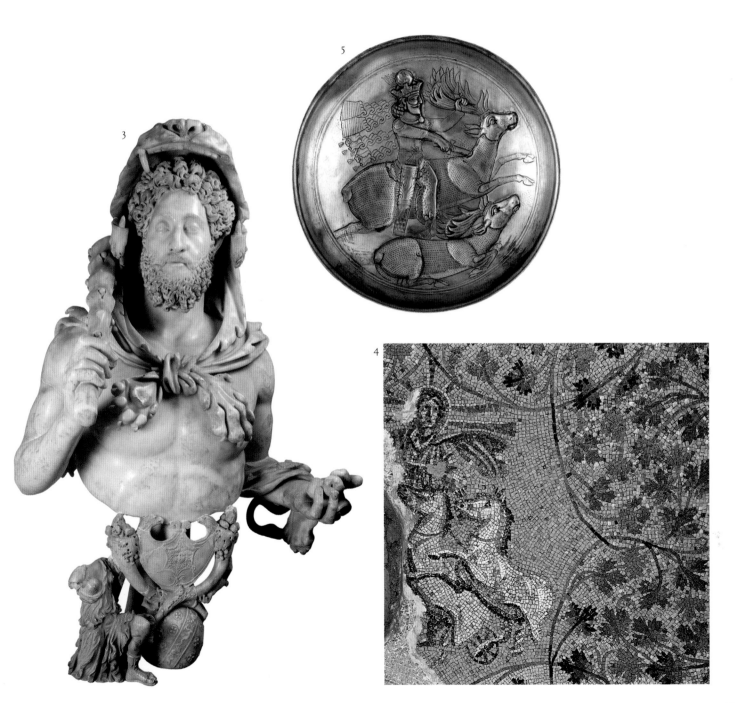

Early Christians depict Christ as a Good Shepherd

By the later Middle Ages, the Christian Church was the greatest patron of Western art. Yet Christian painting and sculpture prior to this period reflect the humble status of Christian art.

During the early years of its existence, Christian art was discreet in part because followers of Christ lived under the shadow of persecution. Martyrdom was commonplace under Roman rule, and this situation did not improve until 313 when Constantine granted full religious freedom to Christians throughout the Roman Empire.

Early Christian art developed in the catacombs, subterranean burial galleries located outside Rome. The images were very simple, often little more than symbols—a fish, a dove, an anchor, a vine, a lamb, the sign of the Cross. These stemmed from passages in the Bible. The anchor, for instance, came to represent the Christian promise of salvation: "Which hope we have as an anchor of the soul, both sure and steadfast" (Hebrews VI: 19). The vine symbol derives from Christ's comment: "I am the true vine" (John XV: 1).

The modest scale of early Christian art reflected the way the religion developed. Services were held in secret, inside private houses, using portable altars. Prior to the reign of Constantine from 313, those linked to the religion would find their career ambitions and social standing threatened. As a result, most Christians had neither the finances nor the incentive to commission artworks. Also, since there were no public places of worship, art could not be displayed.

The visual image of Christ was slow to evolve. In common with the artists of several other religions, Christians were initially wary of depicting God in human form, for fear that this might be interpreted as idolatry. In addition, there was a strong reluctance to portray the Crucifixion, the central episode of the faith, since there was such a stigma attached to this type of execution. It was reserved for slaves and non-Romans. The identification of Christ as the Good Shepherd marked a significant first stage in depicting the messiah. The Christian adoption of a man carrying an animal on his shoulders is in stark contrast to its appearance in Mesopotamian and Hittite art, in which the animal is intended for sacrifice. This statue of the Good Shepherd is based on a classical god—Hermes, the protector of flocks, who carried a ram on his shoulders. Yet, unlike the idealized statues of classical deities, this figure portrays Christ in a plain, naturalistic manner, as a beardless youth, and conveys Christ's role as the shepherd of his flock rather than glorifying him as a god.

The Good Shepherd illustrates the parable of the lost sheep (the repentant sinner) brought back into the fold. "And when he hath found it, he layeth it on his shoulders, rejoicing" (Luke XV: 5). At the same time, sheep were closely associated with the themes of sacrifice and redemption. Christ himself was described as "the Lamb of God, who takes away the sin of the world" (John I: 29). At this time it also symbolized Christ's role as "psychopompus" (the soul's guide in the afterlife), although this task was soon transferred to the archangel Michael. The Good Shepherd proved a popular image, and is found not only in sculptures, but also in paintings, mosaics, and carvings on sarcophagi.

The Good Shepherd
Artist unknown, c. 300
Early Christian

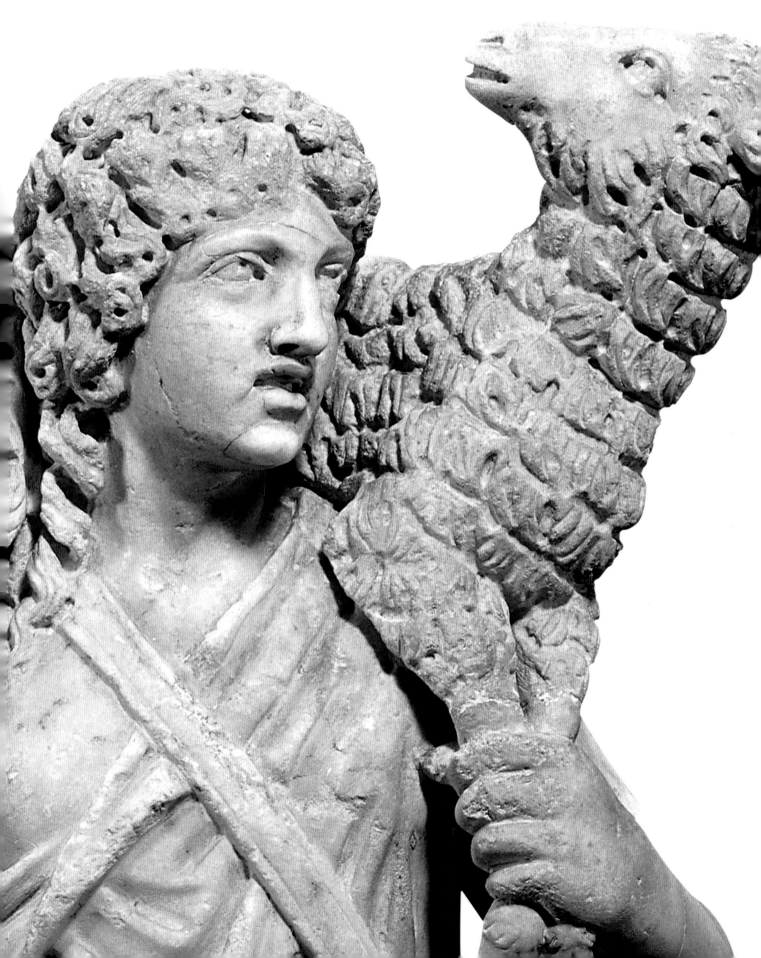

c. 300–900
Mexico

c. 300–900
Mexico

c. 300–400
Tunisia

1 *Weaver*
Artist unknown
Terracotta
Mexico City (Mexico), National
Museum of Anthropology
Mayan

DOMESTIC LIFE

2 *Chaac-mool*
Artist unknown
Stone
Mexico City (Mexico), National
Museum of Anthropology
Mayan

RELIGION

3 *Landscape with Houses*
Artist unknown
Roof tile
Tunis (Tunisia), Bardo Museum
Ancient Roman

LANDSCAPE

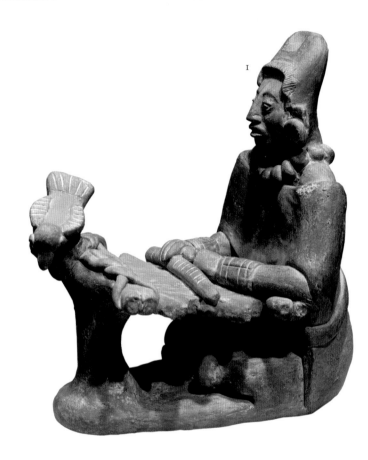

c. 300–400
Italy

4 *Tiger Attacking a Bull*
Artist unknown
Inlaid marble
Rome (Italy), Capitoline Museums
Imperial Roman

ANIMALS

c. 340
Italy

5 *Sarcophagus with Christian Symbols
and Scenes*
Artist unknown
Carved stone
Vatican (Vatican City), Pio-
Clementino Museum
Early Christian

RELIGION

DEATH

c. 340
Italy

6 *Head of Emperor Constantine I*
Artist unknown
Marble, fragment of colossal statue
Rome (Italy), Capitoline Museums
Imperial Roman

PORTRAITURE

POLITICS

6

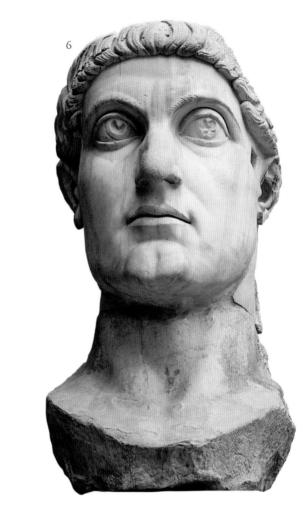

4

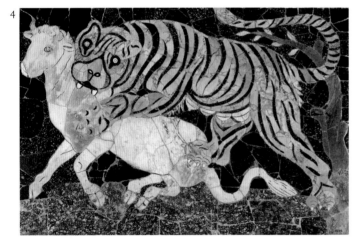

5

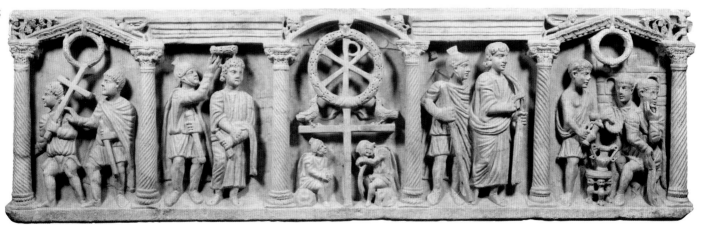

c. 375
Italy

c. 360–390
Italy

400–500
Egypt

1 *Female Gymnasts*
Artist unknown
Mosaic, detail
Piazza Armerina, Sicily (Italy),
Villa of Casale
Imperial Roman

LEISURE
THE BODY

2 *Christ Among the Apostles*
Artist unknown
Apse mosaic, detail
Milan (Italy), Basilica of
San Lorenzo Maggiore
Early Christian

RELIGION

3 *Christ Enthroned and Other Scenes*
Artist unknown
Ivory
Ravenna (Italy), National Museum
of Antiquities
Early Christian

RELIGION

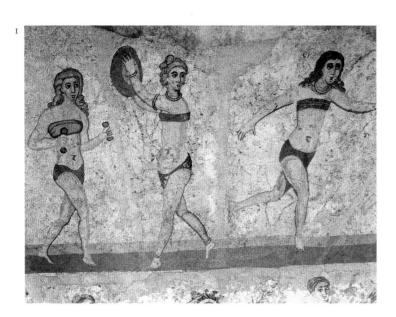

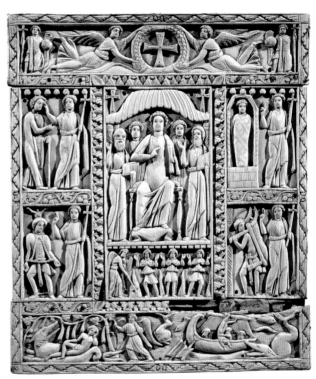

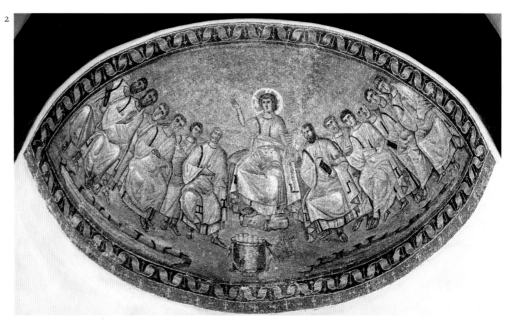

400–500
Italy

c. 425
Italy

432–440
Italy

4 *Two Apostles*
Artist unknown
Mosaic, detail
Ravenna (Italy),
Mausoleum of Galla Placidia
Byzantine

RELIGION

5 *The Crucifixion of Christ*
Artist unknown
Ivory casket
London (UK), British Museum
Early Christian

RELIGION

6 *Moses and the Israelites Crossing
the Red Sea*
Artist unknown
Mosaic, detail
Rome (Italy), Basilica of Santa
Maria Maggiore
Early Christian

RELIGION

5
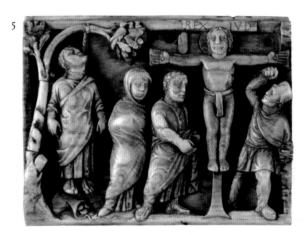

Byzantine

4
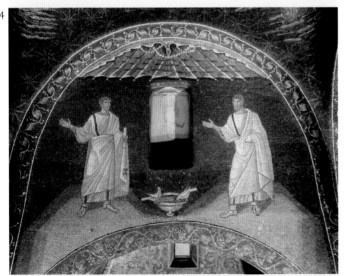

6

The Teotihuacan civilization develops outstanding ritual sculptures

The great Central American city of Teotihuacan, with its magnificent religious architecture and exceptional sculpture, reached a peak of creativity from the fifth century.

The ancient city of Teotihuacan is one of the most important archaeological sites in Mexico. Situated to the northwest of the modern town of Puebla, the settlement dates back to around the second century. It developed rapidly and, at the peak of its influence (c. 550), it was believed to be home to as many as 200,000 people, which would have made it the sixth largest city in the world at the time. Teotihuacan remained a dominant force in the region until c. 800, when it was largely abandoned. Even as a ruin, though, it exerts a powerful influence on the imagination. The Aztecs incorporated it into their mythology, and it became a place of pilgrimage for their rulers.

Despite extensive excavations, there are still many unanswered questions about the nature of the earliest settlement. The ethnic origins of the inhabitants are unclear, while the name of the city and its buildings have only been filtered down through the records of the Aztecs. Even so, it is evident that the city functioned primarily as a religious center. Teotihuacan means "the place of those who have the road to the gods." A long, straight avenue, known as the Way of the Dead, linked its three main buildings—the Pyramid of the Sun, the Pyramid of the Moon, and the Temple of the Plumed Serpent. This avenue was evidently used for ritual processions, and was also deliberately aligned toward Cerro Gordo, a mountainous, dead volcano.

At Teotihuacan, archaeologists have identified the workshops of around 500 craftsmen, who produced goods that were exported throughout Mexico. The city itself was notable for its brightly painted murals and its sculpture, representing religious practices, which revolved around the gruesome business of human sacrifice.

The iconic figure Xipe Totec, "our lord the flayed one," was the god of Spring, linked primarily with the renewal of crops. As such, the rituals surrounding his worship were designed to ensure the fertility of the land. During the second month of the year, the *Tlacaxipehualiztli*, "the flaying of men," the priests sacrificed their victims by removing their hearts. The bodies were then flayed and the skins dyed yellow. These "golden clothes" (*teocuitlaquemitl*) were then worn by young devotees, until they rotted away. The idea behind this was to mimic the growth of a maize kernel, with the new plant emerging from the husk of an old seed.

These sacrificial practices were reflected in the many cult images of Xipe Totec, which usually take the form of masks or statues, such as this one. Invariably, they show the god or one of his priests wearing the skin of a freshly flayed victim. Artists took delight in highlighting the gory details. The closed lips of the figure are often visible behind the gaping mouth of the pelt. Similarly, the flayed hands of the victim are often depicted dangling limply from the wrists of the wearer, so that the figure appears to have an extra pair of hands.

Priest of the Cult of Xipe Totec
Artist unknown, c. 400–500
Mexican

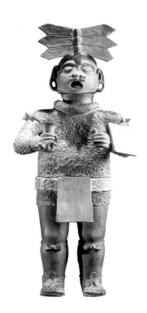

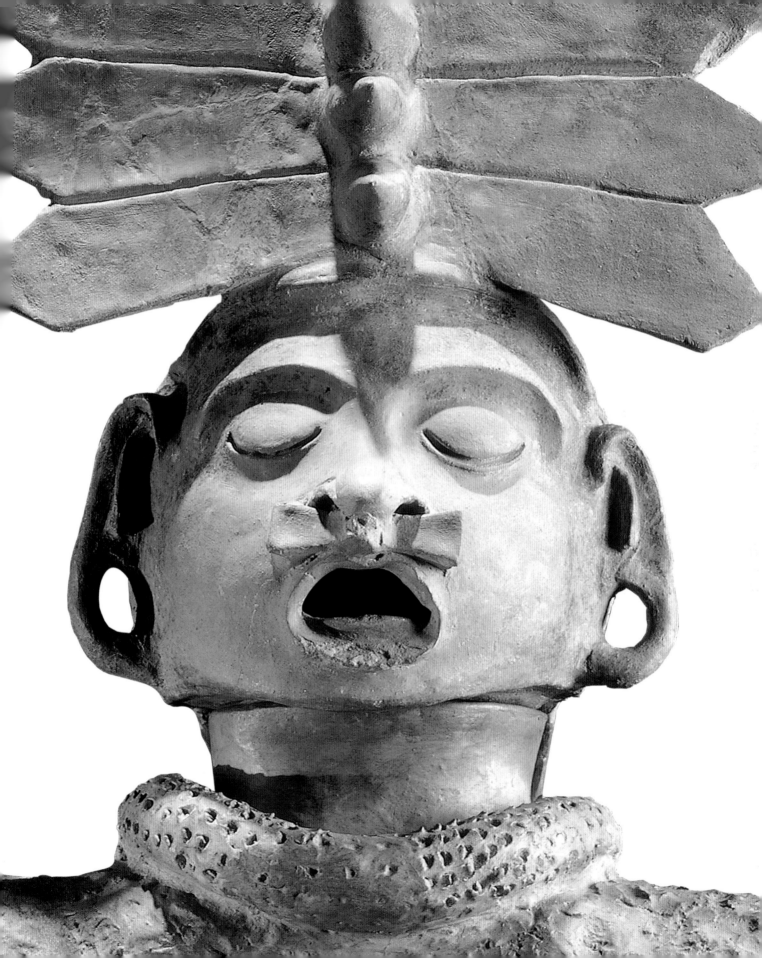

494–519
Italy

c. 500–600
Japan

c. 500–600
Egypt

1 *Christ as a Warrior*
 Artist unknown
 Mosaic, detail
 Ravenna (Italy), Archbishop's
 Palace
 Byzantine

 RELIGION

2 *Haniwa, from a Tomb Complex*
 Artist unknown
 Terracotta, height: 21½ " (55 cm)
 London (UK), British Museum
 Japanese

 RELIGION
 DEATH

3 *Madonna and Child with Saints*
 Artist unknown
 Fresco, detail
 Cairo (Egypt), Coptic Museum
 Coptic

 RELIGION

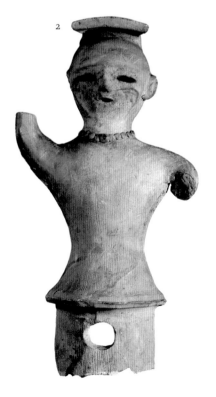

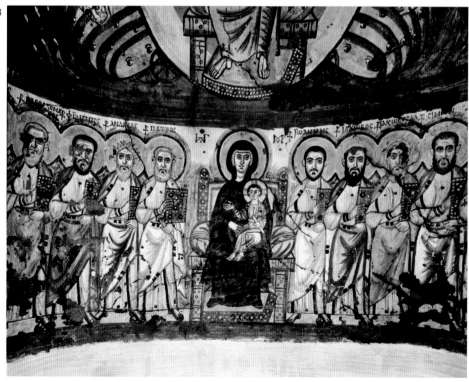

c. 547
Italy

c. 547
Italy

c. 500–600
Egypt

4 *The Emperor Justinian and His Court*
Artist unknown
Mosaic, detail
Ravenna (Italy),
Church of San Vitale
Byzantine

PORTRAITURE
POLITICS

5 *The Empress Theodora and Her Court*
Artist unknown
Mosaic, detail
Ravenna (Italy),
Church of San Vitale
Byzantine

PORTRAITURE
POLITICS

6 *Apollo and Daphne*
Artist unknown
Ivory, 4¾" x 3¼" (12.4 x 8.7 cm)
Ravenna (Italy), National Museum
of Antiquities
Byzantine

MYTHOLOGY
THE BODY

4
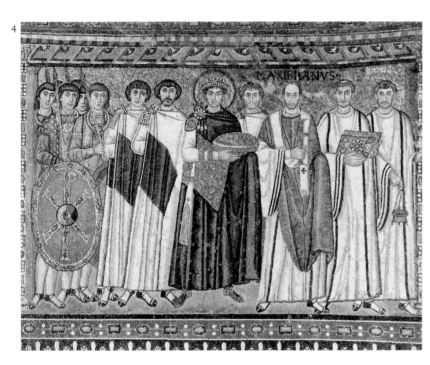

5
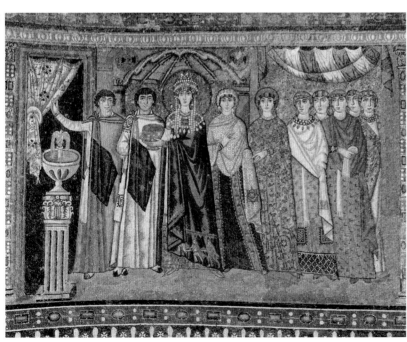

6
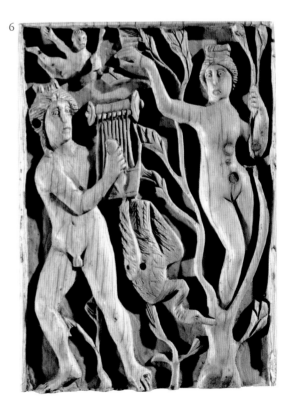

The style of the ancient Celts influences Northern European artisans

The Celts were one of the many peoples of central and northern Europe whose artistic traditions were overshadowed by the classical art of the Greeks and Romans. Yet the richness and diversity of their style was widely influential and is important to the evolution of western art.

From the sixth century BCE, central Europe was a cultural melting pot of tribes and settlers with ancestry and traditions from both the east and west. The dominating culture to emerge was that of the Celts. At their peak, these powerful people managed to occupy Rome (386 BCE) and Delphi (279 BCE) but, as the Roman Empire expanded, the Celts were pushed westward, until they settled on the fringes of the continent in Ireland, Scotland, Wales, and Brittany in present-day France. Their artistic heritage is as rich, complex, and enduring, as the people who created it. When Northern Europeans produced superbly crafted ornaments and accessories in the seventh century, their work reflected a style inherited from the Celts, and is quite distinct from the influence of the classical ancient civilizations.

The style is essentially abstract, full of densely packed spirals, knots, and mazes interlaced to form hypnotic patterns. Stylized heads with bulging eyes were another feature, and this may reflect their practice of headhunting. Ribbon-like creatures with fierce, snarling jaws were images from their own fables, which brought the fire-breathing dragons of the east into western mythology. These patterns had important symbolic meanings. Spirals are linked with sun worship and thought to represent the motion of the sun as it passes through the sky. They are found on ancient tombs known to have solar alignments. Knot designs were used to offer protection against curses and spells, and were believed to be particularly effective in warding off the evil eye. The more complicated the knot, the greater the degree of protection it provided, so it was common to wear a complex knot design as a clasp or buckle. Examples of fine Celtic metalwork have been found buried in graves, or deposited in lakes and rivers, where they were given as offerings to the gods.

The abstract nature of the designs meant that they could easily be absorbed into very different cultures contemporary to the Celts, including Anglo-Saxon, Scandinavian, and Germanic tribes. In England, the discovery of two remarkable ship burials at Sutton Hoo in East Anglia yielded a rich array of armor and jewelry. These Anglo-Saxon artifacts had many affinities with Celtic designs, as is particularly noticeable in this sumptuous golden buckle buried with a king. The Celtic influence is seen in the coiled interlacing and stylized bird-heads. Similar designs using motifs of this type are also common in Scandinavia.

The wide diffusion and enduring nature of this style was due, above all, to its adaptability. The ancient Celts may have focused initially on metalwork, but their descendants adapted the patterns to use on a wide variety of artwork. In Britain and Ireland, Celtic interlace was featured on crosiers, chalices, stone crosses, and Biblical manuscripts. While the components of barbarian ornament came from pagan beliefs and had magical overtones, Christian Celtic artists were happy to claim them for their own. Giraldus Cambrensis wrote in the thirteenth century of one Celtic piece: "Here you will see intricacies so fine and subtle, so exact and yet so rich in detail, so full of knots and coils, with colors so bright and fresh, that you will not hesitate to declare that you have gazed upon the work not of man, but of angels."

Belt Buckle from the Ship Burial at Sutton Hoo
Artist unknown, c. 600
Anglo Saxon

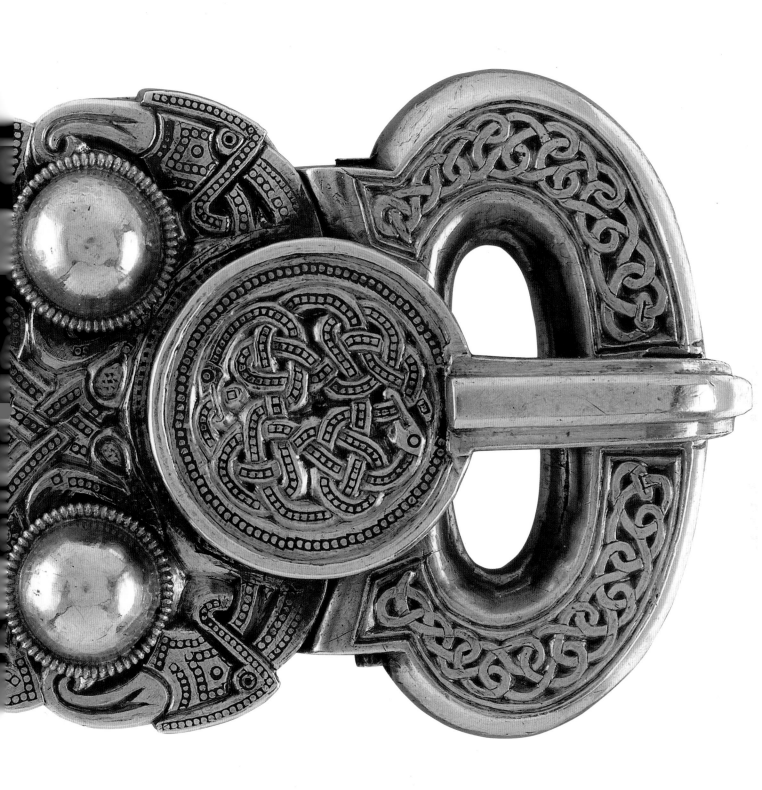

c. 549
Italy

c. 585
China

c. 600–700
India

1 *Apse with Christian Themes*
Artist unknown
Mosaic, detail
Ravenna (Italy), Church of
Sant'Apollinare in Classe
Byzantine

RELIGION

2 *Buddha*
Artist unknown
Marble, 19' x 6' 6" (5.8 x 1.98 m)
London (UK), British Museum
Sui dynasty

RELIGION

3 *Two Large Elephants, from Descent
of the Ganges*
Artist unknown
Rock carving, detail
Mahalipuram (India),
Mahalipuram Temple
Hinduism

RELIGION
ANIMALS

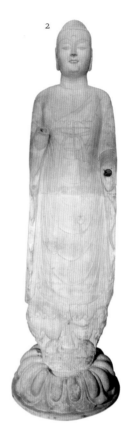

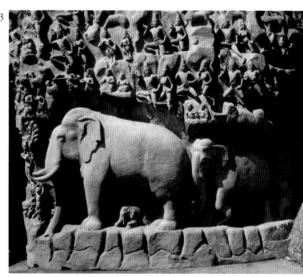

c. 600–700
France

c. 600–800
Guatemala

c. 600–750
India

4 *Fibula in the Shape of a Fish*
Artist unknown
Metal with inlay
Florence (Italy), Archaeological
Museum
Merovingian

ANIMALS

5 *Mayan Ritual Vessel*
Artist unknown
Polychrome ceramic,
height: 6¾" (17.2 cm)
London (UK), British Museum
Mayan

RELIGION

6 *Shiva Dancing in Front of His Bride*
Artist unknown
Rock carving, detail
Ellora (India), Ellora Temple
Hinduism

RELIGION
THE BODY

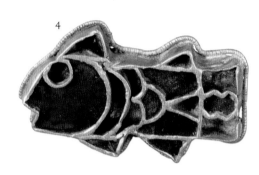

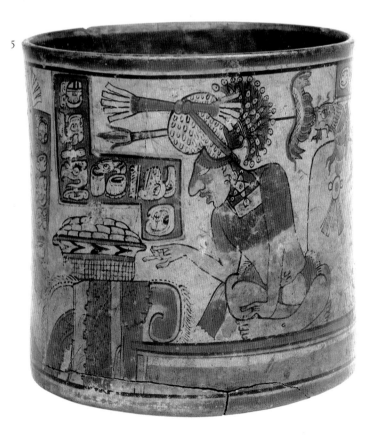

c. 618
China

c. 700–750
China

c. 700
France

1 *Woman Playing Polo*
 Artist unknown
 Painted ceramic
 Paris (France), Cermuschi
 Museum
 Tang dynasty

 LEISURE
 ANIMALS

2 *Group of Tomb Figures*
 Artist unknown
 Terracotta, height: 43" (109 cm)
 London (UK), British Museum
 Tang dynasty

 DEATH
 RELIGION

3 *The Three Marys at the Tomb*
 Artist unknown
 Ivory book cover
 Florence (Italy), Bargello Museum
 Medieval

 RELIGION

1

Medieval

3

c. 750
India

c. 800–900
Japan

c. 823–877
France

4 *Ganesha Dancing*
Artist unknown
Sandstone, height: 50" (127 cm)
Philadelphia (USA), Philadelphia
Museum of Art
Hinduism

RELIGION
ANIMALS

5 *Zocho Ten, Who Protects the
Region of the South*
Artist unknown
Wood, height: 46½" (118 cm)
Newark (USA), Newark Museum
Early Heian

RELIGION

6 *Scenes from Story of Adam and Eve,
from the Bible of Charles the Bald*
Artist unknown
Manuscript illustration
Rome (Italy), Basilica of San Paolo
fuori le Mura
Carolingian

RELIGION
THE BODY

5

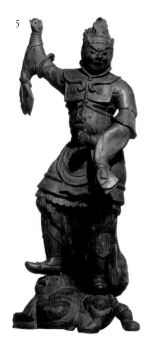

Carolingian

4

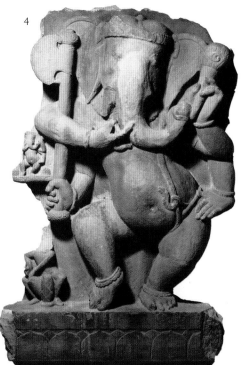

6

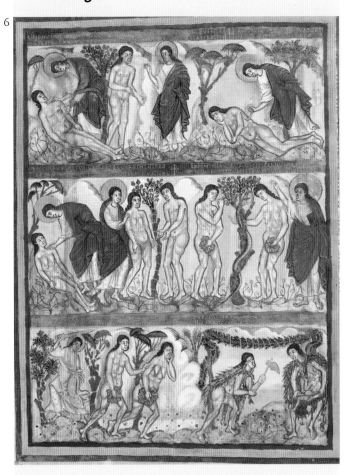

Calligraphers use their artistic skills to communicate the Word of God

The first books were written and illustrated by hand. Many of the most exquisite examples with detailed illustrations were designed for religious use, expressing the Word of God. Those who wrote these books, called calligraphers, were extremely accomplished and highly valued for the skills they developed.

For centuries, the art of calligraphy was one of the most important of all human skills. The ability to communicate through writing carried enormous power and influence. A small elite could read and even fewer could write. To have the ability to write beautifully was to have a very high status. Books were extremely rare, and with the development of the major religions, those rare books that contained the Word of God were considered to be sacred objects.

The codex, a precursor to the book, was made from specially prepared animal skins, known as vellum or parchment. Extremely expensive to create, the skin of a single animal, such as a sheep, provided just one double sheet of the codex, so a sizeable flock was required for a complete book. They were magnificently hand bound in leather, metal, ivory, and other precious materials and were often embellished with jewels, gold, and silver.

Decorations were added to the text to highlight the calligraphy. This helped the readers to find their way around the lengthy texts. In the case of the Bible, for example, the division of the text into chapters and verses did not appear until the thirteenth century, so the use of large, ornamental initials was extremely helpful. Similarly, in manuscripts of the Qu'ran, the earliest adornments were decorative markings, separating the verses. These were followed by designs at the head of individual *Surahs* (chapters), and to emphasize important passages.

Decorative calligraphy also stressed the importance of the individual letters and words placed on the page. These words were the basis of belief and the unifying factor in many religions. The aim of the calligrapher was to stress the beauty and importance of the words, by making them appear as sumptuous as possible. Sacred books were designed to create a sense of awe, rather than simply to be read. This was especially true in the Qu'ran, since for Muslims the words themselves are divine and immutable. The act of reciting from the Qu'ran became a specialized art form in its own right, and calligraphic sections of text were used as decorative panels in Islamic architecture. In some early versions of the Bible, the decoration on individual letters is so extravagant that they are sometimes almost illegible to all but those who created and used them. With Hebrew books, the scribe, or *sofer,* designed the layout of the entire manuscript, while the artist who embellished his work played a secondary role. For Muslims, too, calligraphers were far more important than mere artists, and their work fetched high prices.

The example illustrated here comes from the surviving pages of an early tenth-century Qu'ran, which was probably produced in Iraq. In 911, the book was presented by 'Abd al-Mun'im ibn Ahmad to the Great Mosque of Damascus. The text is written on vellum, using Kufic lettering (the oldest form of Arabic script). The elaborate calligraphy is in gold, outlined in black, with pyramids of six gold disks marking the end of each verse. This particular sheet depicts the heading of *Surah* 29 of the sacred text.

Page from the Qu'ran
Artist unknown, c. 910
Islamic

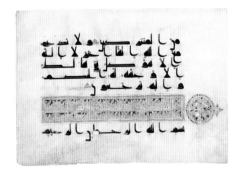

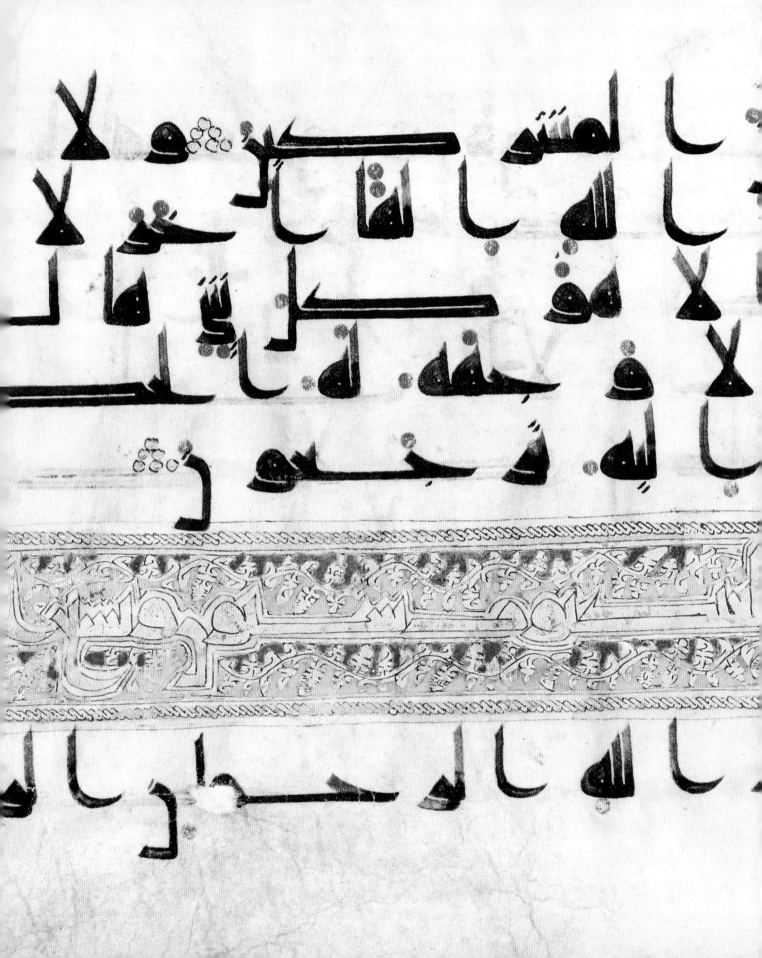

الله ... لا

لا ... بالله

لا ... قالوا

لا ... فـ

... جعلناه ... فجعلـ

... لا ... الحـ ... الـ

1 *Moses Receives the Tablets of the Law, Illustration from Moutier-Grandval Bible*
Artist unknown
Manuscript illustration
London (UK), British Library, Manuscripts Collection
Carolingian

RELIGION

2 *Icon of the Archangel Michael and Other Saints*
Artist unknown
Metal and enamel with precious stones
Venice (Italy), Treasury of Saint Mark's Basilica
Byzantine

RELIGION

3 *Crucifixion*
Artist unknown
Stone pillar
Silos (Spain), Monastery of Santo Domingo da Silos
Romanesque

RELIGION
THE BODY

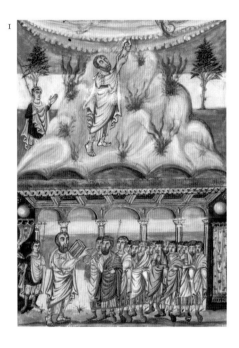

Romanesque

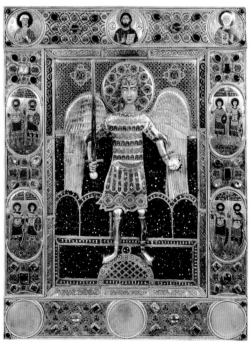

c. 940–945
Spain

c. 1000
Spain

c. 1000–1100
Japan

4 *The Heavenly New Jerusalem, from Commentary on the Apocalypse by Beatus*
Maius
Manuscript illustration,
folio: 15" x 11" (38.5 x 28 cm)
New York (USA), Pierpont Morgan Library
Romanesque

RELIGION

5 *Hunting Hares*
Artist unknown
Fresco, detail
Madrid (Spain), Prado
Romanesque

LEISURE

6 *Figure of Kichijôten, Deity of Fortune*
Artist unknown
Wood, height: 43¼" (111 cm)
London (UK), British Museum
Heian

RELIGION

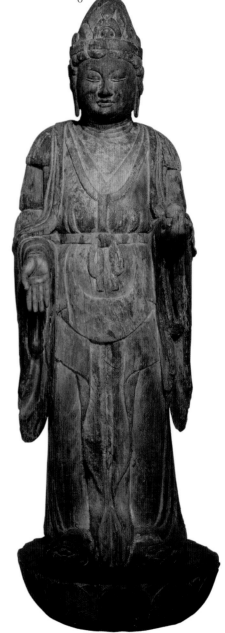

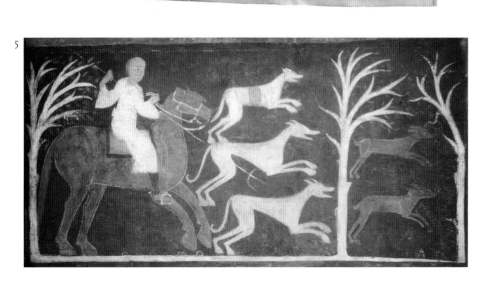

C. 1000
India

C. 1000–1100
Sweden

C. 1000–1100
Italy

1 *Vishnu with His*
Consorts Bhu and Shri
Artist unknown
Bronze, height of Vishnu:
17¾" (45 cm)
London (UK), British Museum
Hinduism

RELIGION
THE BODY

2 *Brooch with Animal Entwined with*
Tendrils
Artist unknown
Copper alloy, length: 2¼" (5.5 cm)
London (UK), British Museum
Medieval

ANIMALS

3 *Eagle, on the Cope of Saint Albonius*
Artist unknown
Silk, detail
Bressanone (Italy),
Diocesan Museum
Romanesque

RELIGION
ANIMALS

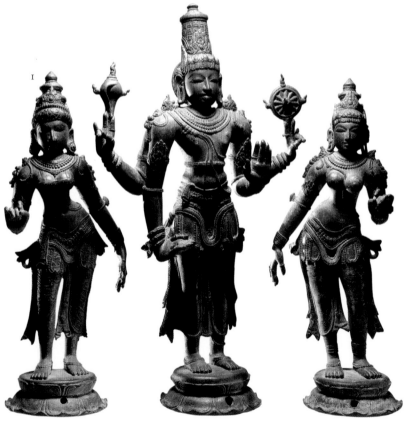

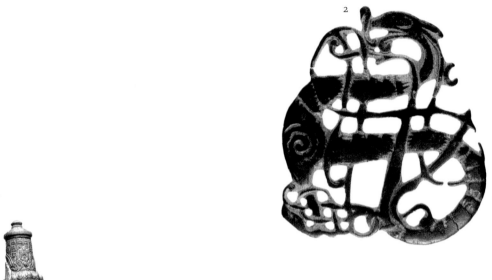

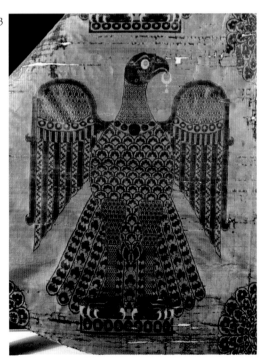

4 *Christ Enthroned with Emperor Otto and His Family*
Artist unknown
Ivory
Milan (Italy), Castello Sforzesco Museum
Ottonian

RELIGION
POLITICS

5 *Brooch with Entwined Animal and Snake in Combat*
Artist unknown
Gilded bronze,
diameter: 1½" (3.9 cm)
London (UK), British Museum
Medieval

ANIMALS

6 *William Duke of Normandy's Fleet Crossing the Channel, from the Bayeux Tapestry*
Artist unknown
Wool embroidered onto linen, detail
Bayeux (France), Tapestry Museum
Romanesque

WAR
POLITICS

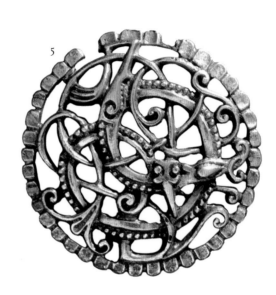

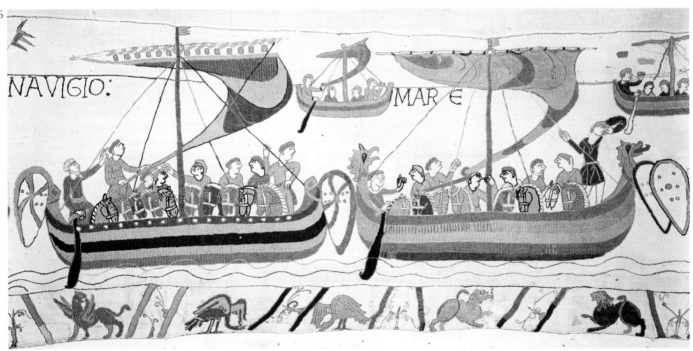

The Chinese paint landscapes for spiritual inspiration

In the tenth century, Chinese artists perfected a new form of landscape, one that transcended a straightforward copy of a scene to emphasize more profound philosophical associations.

The Daoist beliefs that dominated Chinese culture placed great emphasis on harmony with the natural world. The term for landscape was composed of the two characters for mountains and water. These same symbols also represented the male and female—the yang and the yin. Written together, the characters signified a balance in nature. Landscape was considered to be sacred, symbolic, and charged with spiritual meaning. As the painter Guo Xi declared: "The virtuous man above all delights in landscapes."

Chinese landscape art was not intended to record a specific place or depict a pleasant scene. It had a far higher prestige than that of a mere picture. Its purpose was to provide an aid to contemplation and meditation. The paintings were designed to enrich the spirit of the individual who looked at them by revealing the essence of a universal, natural order. For this reason, landscape painters avoided bright colors, which were deemed too sensual and transitory. Instead, their pictures were notable for their muted tones and were sometimes almost monochromatic.

In seeking to probe beneath the surface of things, landscape painters shunned the use of a single, fixed perspective, opting instead to create multiple viewpoints within the picture. This encouraged the eye to move around the composition, exploring individual highlights, similar to a traveler passing through a country scene. The Chinese described this approach to landscape with the term *woyou*, which means "wandering while lying down."

Chinese landscapes were created to be handled and used in rituals. They were painted on silk and mounted on hand scrolls or hanging scrolls. These could be rolled up and stored away, ready to be brought out during festivals and other special occasions. The unrolling process itself was often carried out in a dignified, ceremonial fashion. As each new section was revealed, the previous one was covered up. This meant, once again, that the landscape was experienced as a type of journey.

With its spiritual status, the art of landscape painting was an important part of life for those in the higher ranks of society. Apart from scrolls, landscapes were also produced on fans and albums. These were generally painted as gifts, and often featured inscriptions from friends and family. The combination of painting and calligraphy worked well as, in China, these two art forms were very closely related. A certain type of leaf, for example, would always be represented by a specific brushstroke, with the same precision that a calligrapher would employ when depicting a character from the Chinese alphabet. In albums, landscapes were often accompanied by poems with as much emphasis on the quality of the calligraphy as on the beauty of the painting.

The painters themselves were frequently also poets and enjoyed a high status in Chinese society. They earned their living as imperial court officials, but were respected principally for their artistic and intellectual gifts. Their paintings were not purchased or commissioned, but were created as gifts for an educated elite, who alone would be able to appreciate their value.

Autumn Sky about Valleys and Mountains
Kuo His, c. 1020–1090
Sung Dynasty

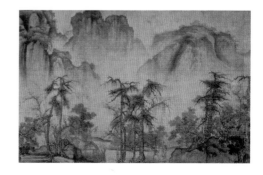

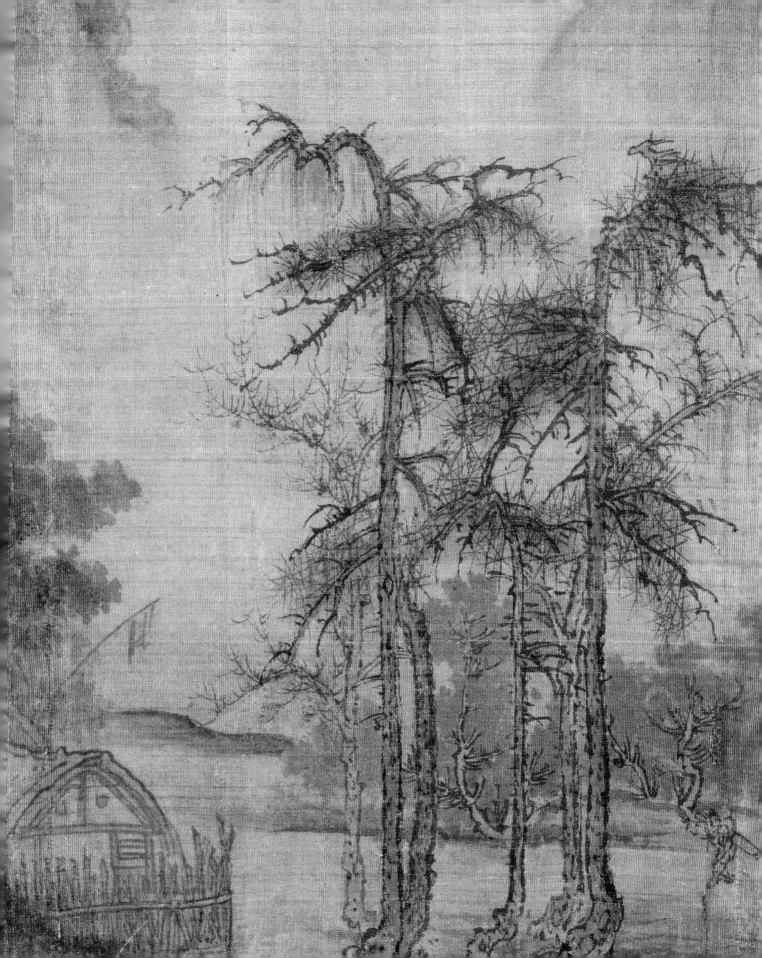

1100
Morocco

C. 1090–1109
Spain

C. 1100–1200
Sri Lanka

1 *Page of Calligraphy from the Qu'ran*
Artist unknown
Gazelle skin
Rabat (Morocco), Royal Library
Islam

RELIGION

2 *The Four Horsemen of the Apocalypse*
(The Opening of the First Four Seals)
Prior Petrus
Manuscript illustration,
14½" x 9¾" (37.5 x 24.8 cm)
London (UK), British Library
Romanesque

RELIGION
DEATH

3 *Reclining Buddha*
Artist unknown
Granite, length: 46' (11.5 m)
Polonnaruwa (Sri Lanka), Shrine
of Gal Vihare
Buddhism

RELIGION
THE BODY

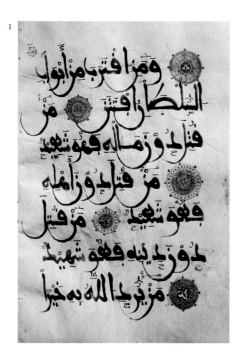

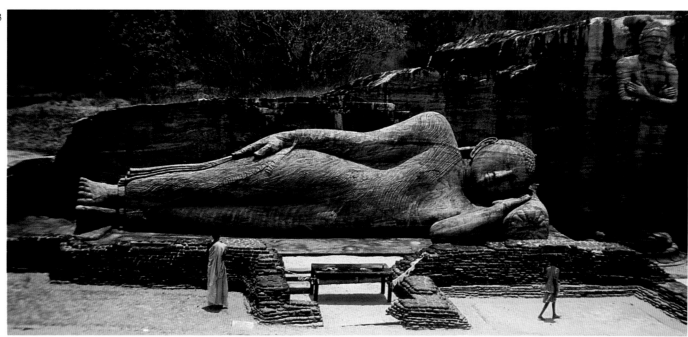

c. 1100
India

1100
Bosnia-Herzegovina

1120–32
France

4 *Shiva as Nataraja, the Lord of the Dance, in a Ring of Fire*
Artist unknown
Bronze, height: 35¼" (89.5 cm)
London (UK), British Museum
Hinduism

RELIGION
THE BODY

5 *Death of the Virgin*
Artist unknown
Wall painting, detail
Gracanica (Bosnia-Herzegovina),
Gracanica Parish Church
Byzantine

RELIGION

6 *Mystic Winepress*
Artist unknown
Carved stone capital, detail
Vézelay (France), Basilica of
La Madeleine
Romanesque

RELIGION
ALLEGORY

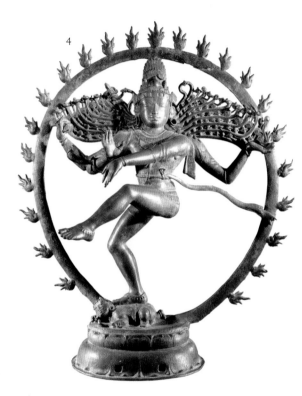

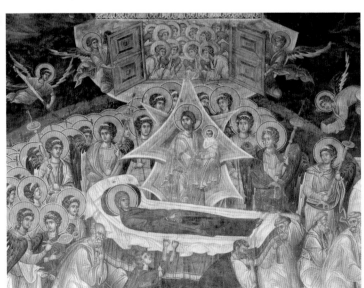

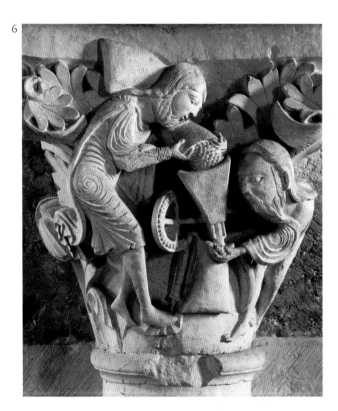

1 *Last Judgement (detail from tympanum of entrance portal)*
Gisleburtus
Carved stone
Autun (France), Church of Saint Lazare
Romanesque

RELIGION

2 *Coronation of King Roger*
Artist unknown
Mosaic, detail
Palermo (Italy), Church of the Martorana
Byzantine

RELIGION
POLITICS

3 *Soloman and the Queen of Sheba, Portal of the King*
Artist unknown
Carved stone, detail
Chartres (France), Chartres Cathedral
Gothic

RELIGION

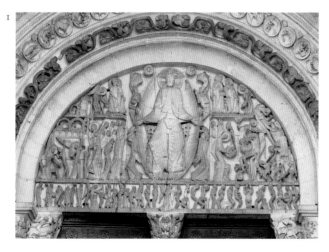

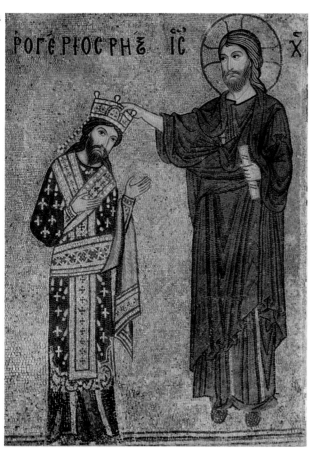

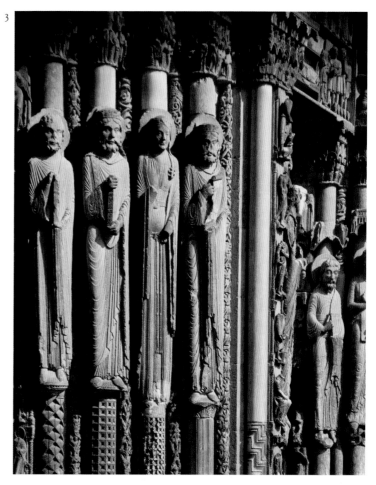

c. 1155
Italy

c. 1196
Italy

c. 1200–1235
France

4 *Christ Pantocrator*
Artist unknown
Mosaic, detail
Cefalù (Italy), Cefalù Cathedral
Byzantine

RELIGION

5 *Horses Trampling Grain,
Representing the Month of July*
Benedetto Antelami
Marble, life-size
Parma (Italy), Parma Baptistery
Romanesque

RURAL LIFE
ANIMALS

6 *Legend of Saint Cheron*
Master of Cheron
Stained glass window, detail
Chartres (France), Chartres
Cathedral
Gothic

RELIGION

5

Gothic

6

4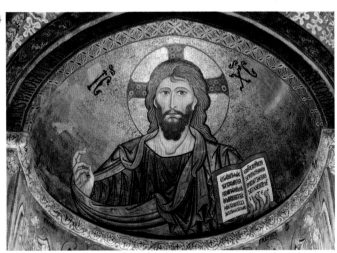

1 *Nandi, the Sacred Bull of Shiva*
Artist unknown
Schist, length: 31¾" (80.6 cm)
Philadelphia (USA), Philadelphia
Museum of Art
Hinduism

RELIGION
ANIMALS

2 *Saint Mark Arriving in Venice*
Artist unknown
Mosaic, detail
Venice (Italy), Saint Mark's Basilica
Byzantine

RELIGION

3 *Saints from the Portal of the Kings*
Artist unknown
Carved stone, detail
Chartres (France),
Chartres Cathedral
Gothic

RELIGION
THE BODY

4 *Portal of the Golden Virgin*
Artist unknown
Stone, detail
Amiens (France),
Amiens Cathedral
Gothic

RELIGION

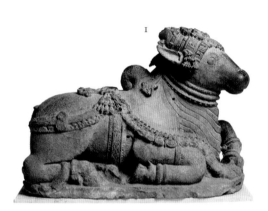

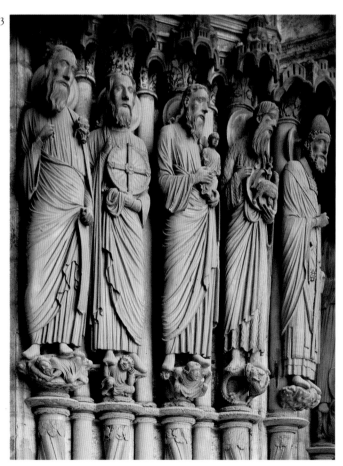

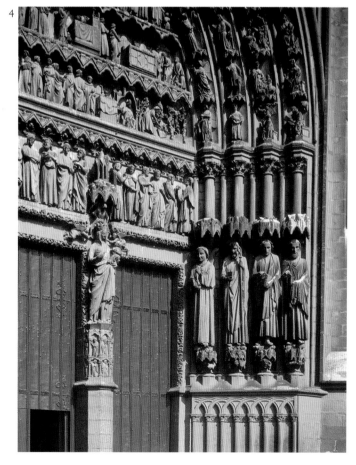

5 *The Rider*
Artist unknown
Sandstone, life-size
Bamburg (Germany), Bamburg
Cathedral
Gothic

RELIGION
ANIMALS

6 *Saint Francis and Scenes from His Life*
Bonaventura Berlinghieri
Tempera on panel
Pescia (Italy), Church of San Francesco
Early Italian

RELIGION

7 *Fortitude* or *Hercules*
Nicola Pisano
Marble pulpit, detail
Pisa (Italy), Pisa Baptistery
Early Italian

RELIGION

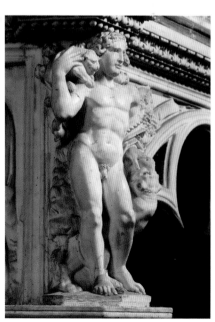

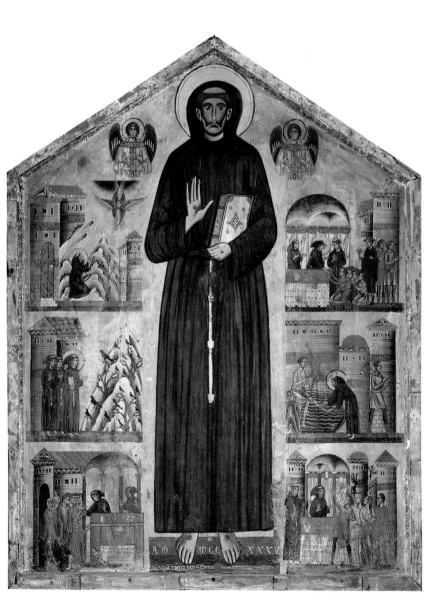

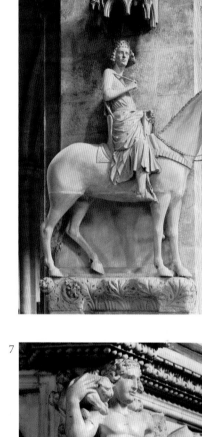

1260
Italy

c. 1275
Italy

c. 1285
Italy

1 *Nativity (detail from pulpit)*
Nicola Pisano
Marble pulpit, detail
Pisa (Italy), Pisa Baptistery
Early Italian

RELIGION

2 *Crucifix*
Cimabue
Tempera and gold on wood,
11' x 8' 9" (3.25 x 2.67 m)
Arezzo (Italy), Church of
San Domenico
Early Italian

RELIGION
THE BODY

3 *Madonna and Child with Angels*
Duccio di Buoninsegna
Tempera on wood,
14' 8" x 9' 5" (4.5 x 2.9 m)
Florence (Italy), Uffizi
Early Italian

RELIGION

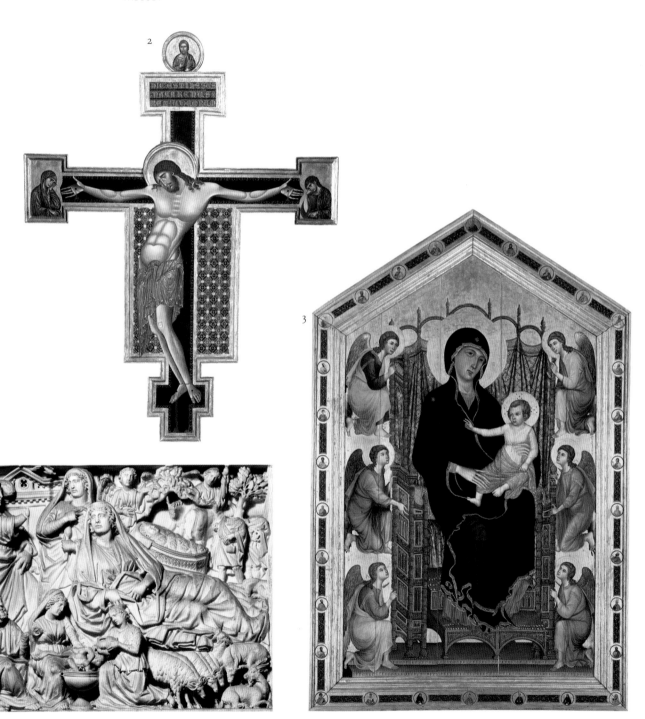

1290
China

C. 1293
Italy

C. 1294–1300
Italy

4 *Young Nobleman on Horseback*
Qian Xuan
Handscroll painting,
11½" x 29¾" (29.7 x 75.6 cm)
London (UK), British Museum
Yuan dynasty

LEISURE
ANIMALS

5 *Last Judgement (Four Saints)*
Pietro Cavallini
Fresco, detail
Rome (Italy), Convent of Santa
Cecilia in Trastevere
Early Italian

RELIGION

6 *Pope Boniface VIII*
Arnolfo di Cambio
Marble, height: 9' (2.8 m)
Florence (Italy),
Opera del Duomo Museum
Gothic

RELIGION
PORTRAITURE

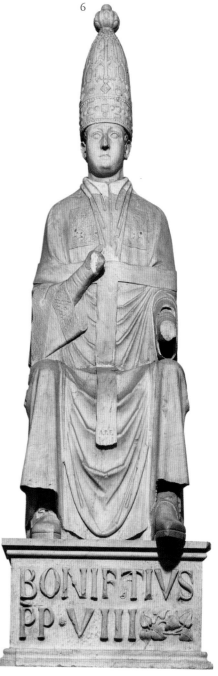

1297–1300
Iran

c. 1300–1350
France

c. 1306
Italy

1 *Simurgh (Bird Akin to the Phoenix)*
on an Island, from "Advantages
to be Derived from Animals'"
by Ibn Bakhtishu
Artist unknown
Illumination on paper,
6" x 7½" (15.1 x 19.2 cm)
New York (USA),
Pierpont Morgan Library
Persian

ANIMALS

2 *God Creates Earth, from the*
"Petite Bible Historiale"
Artist unknown
Manuscript illustration, detail
London (UK), British Library
Manuscripts Collection
Gothic

RELIGION
LANDSCAPE

3 *Last Judgement*
Giotto di Bondone
Fresco, c. 33' x 27' 6" (10 x 8.4 m)
Padua (Italy),
Arena (Scrovegni) Chapel
Early Italian

RELIGION
DEATH

1

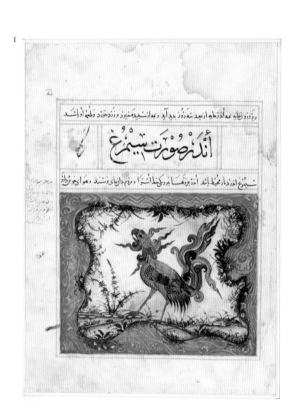

3

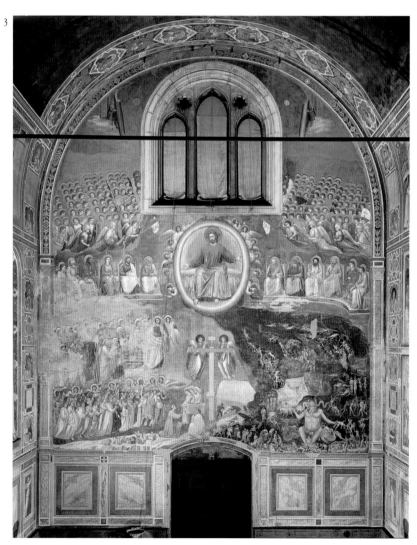

2

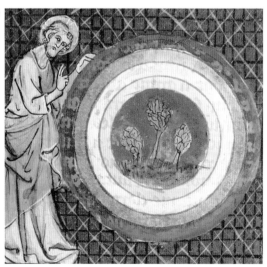

c. 1306
Italy

1308–1311
Italy

1308–1311
Italy

4 *Lamentation over the Dead Christ*
Giotto di Bondone
Fresco, c. 6' x 6' 6" (1.8 x 2 m)
Padua (Italy),
Arena (Scrovegni) Chapel
Early Italian

RELIGION
DEATH

5 *Last Supper (detail from back
of the panel of Maestà)*
Duccio di Buoninsegna
Tempera on wood,
17" x 18¹/₈" (43 x 46 cm)
Siena (Italy),
Opera del Duomo Museum
Early Italian

RELIGION

6 *Detail from Maestà
(Madonna in Majesty): Angel*
Duccio di Buoninsegna
Tempera on wood, detail
Siena (Italy),
Opera del Duomo Museum
Early Italian

RELIGION

4
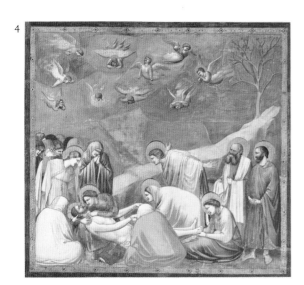

5
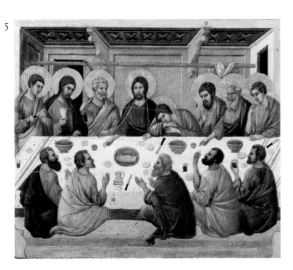

6
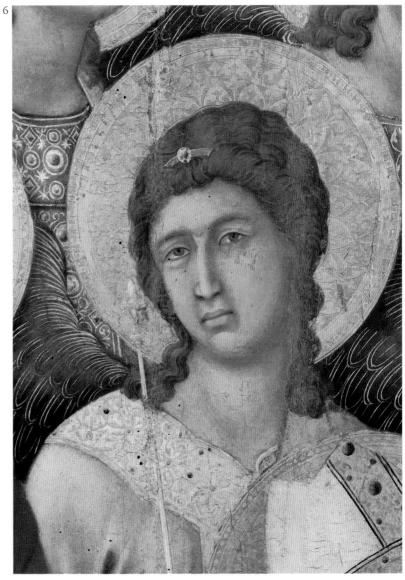

C. 1310
Italy

C. 1315
Italy

1321
China

1 *Madonna in Majesty*
(The Ognissanti Maestà)
Giotto di Bondone
Tempera on wood,
10' 7" x 6' 7" (3.25 x 2.4 m)
Florence (Italy), Uffizi
Early Italian

RELIGION

2 *Last Supper*
Pietro Lorenzetti
Fresco, 8' x 10' 2" (2.4 x 3.1 m)
Assisi (Italy),
Church of San Francesco
Early Italian

RELIGION

3 *Fascination of Nature*
Xie Chufang
Handscroll painting, detail
London (UK), British Museum
Yuan dynasty

STILL LIFE

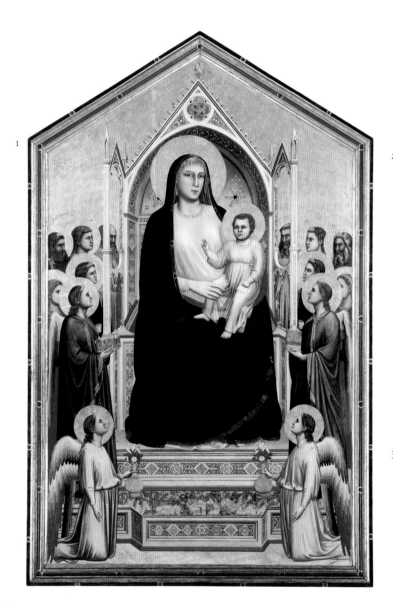

1

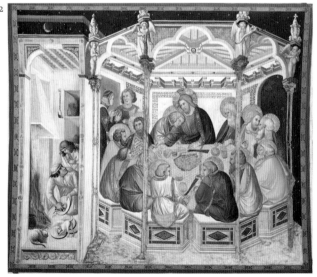

2

3

4 *Equestrian Statue of*
Cangrande della Scala
Maestro del Cangrande
Tufa, statue height:
6' 4¾" (1.95 m)
Verona (Italy),
Castelvecchio Museum
Gothic

PORTRAITURE

WAR

5 *John the Baptist in Prison*
Visited by His Disciples
Andrea Pisano
Bronze relief on door
19¼" x 17" (48 x 43 cm)
Florence (Italy), Florence
Baptistery
Gothic

RELIGION

6 *Guidoriccio da Fogliano*
Besieging Monte Massi
Simone Martini
Fresco, detail
Siena (Italy), Palazzo Pubblico
Early Italian

WAR

ANIMALS

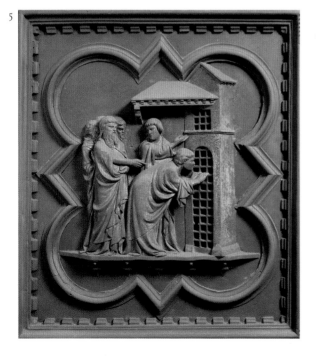

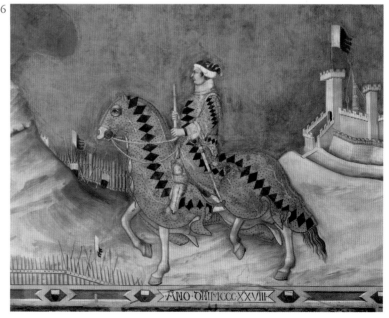

1 *Annunciation with Two Saints and Four Prophets*
Simone Martine and **Lippo Memmi**
Tempera on wood,
72½" x 6' 10" (1.84 x 2.1 m)
Florence (Italy), Uffizi
Early Italian

RELIGION

2 *Effects of Good Government in the City*
Ambrogio Lorenzetti
Fresco
Siena (Italy), Sala della Pace,
Palazzo Pubblico
Early Italian

ALLEGORY
URBAN LIFE

3 *Effects of Good Government in the Country*
Ambrogio Lorenzetti
Fresco
Siena (Italy), Sala della Pace,
Palazzo Pubblico
Early Italian

ALLEGORY
RURAL LIFE

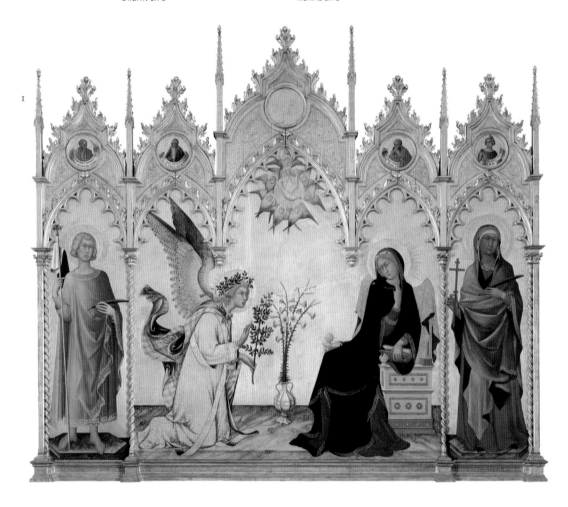

1349–1359
Italy

1375–1381
France

1400–1410
France

4 *Tabernacle*
Andrea Orcagna (di Cione)
Marble, glass (*Madonna and Child
with Angels* by Bernardo Daddi)
Florence (Italy), Church of
Orsanmichele
Gothic

RELIGION

5 *The Heavenly Jerusalem,
from a Series Depicting the
Visions of Saint John*
Nicholas Bataille and **Hennequin
de Bruges**
Wool tapestry, height: 8' 6" (2.6 m)
Angiers (France), Tapestry
Museum
Gothic

RELIGION
THE CITY

6 *The Holy Thorn Reliquary of Jean,
Duc de Berri*
Artist unknown
Gold, pearl, and precious stones,
height: 12" (30.5 cm)
London (UK), British Museum
Gothic

RELIGION

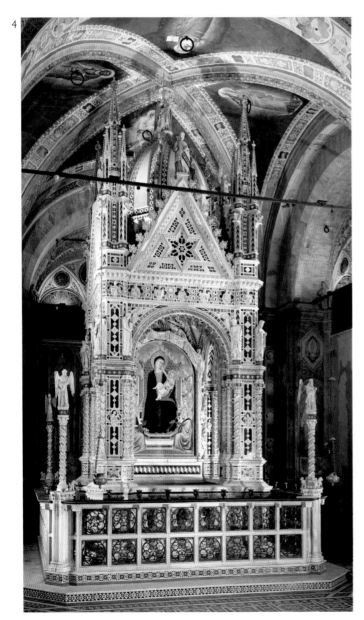

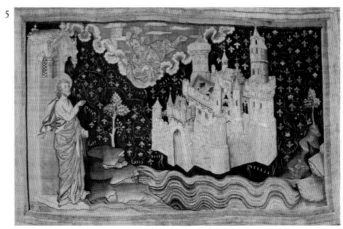

c. 1409–1417
Italy

c. 1410
Italy

c. 1410–1420
Russia

1 *Four Saints*
Nanni di Banco
Marble, figures
height: approx. 6' (1.83 m)
Florence (Italy),
Church of Orsanmichele
Early Renaissance

RELIGION

2 *Madonna with Angels in
a Rose Garden*
Stefano da Zevio (da Verona)
or **Michelino (de Molinari)
da Besozzo**
Tempera on wood,
transferred to canvas,
50¾" x 37½" (129 x 85 cm)
Verona (Italy),
Castelvecchio Museum
International Gothic

RELIGION
LANDSCAPE

3 *Holy Trinity*
Andrei Rublev
Tempera on wood,
5' x 3' 9" (1.42 x 1.14 m)
Moscow (Russia),
Tretyakov State Gallery
Byzantine

RELIGION

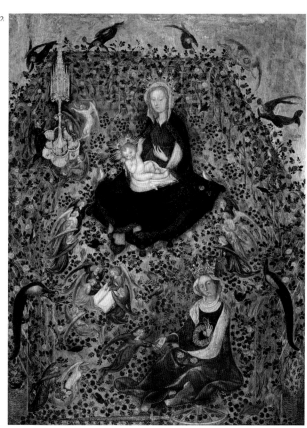

Early Renaissance

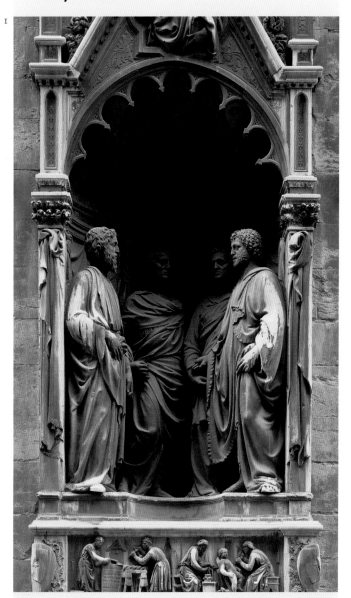

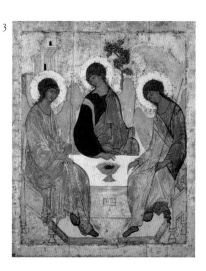

4 *Saint George Slaying the Dragon, from Breviary of John the Fearless*
Artist unknown
Manuscript illustration, detail
London (UK), British Library,
Manuscripts Collection
Gothic

RELIGION

5 *The Angel of the Annunciation, Gabriel*
Jacopo della Quercia
Polychromed wood, life-size
San Gimignano (Italy),
Collegiate Church
International Gothic

RELIGION

6 *Our Lady of the Annunciation*
Jacopo della Quercia
Polychromed wood, life-size
San Gimignano (Italy),
Collegiate Church
International Gothic

RELIGION

7 *Justice (detail of Triptych of Justice)*
Jacobello del Fiore
Tempera and gilt on wood,
height: 6' 10" (2.08 m)
Venice (Italy),
Accademia Gallery
International Gothic

POLITICS
ALLEGORY

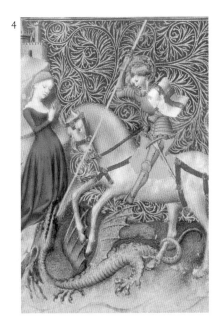

4

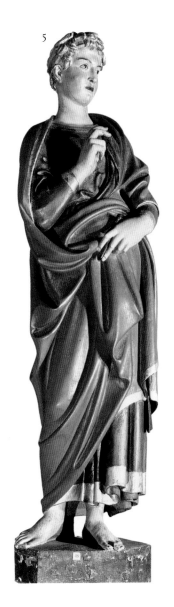

5

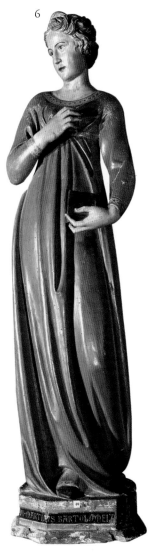

6

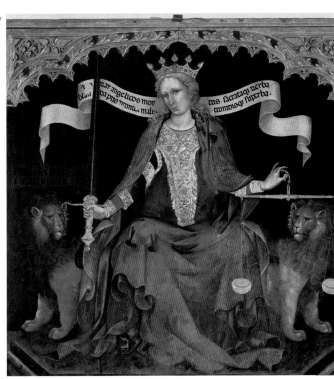

7

Italian artists develop and master the use of the rules of perspective

The ability to give works of art an illusion of perspective enables artists to show the world as it appears. When systems for understanding perspective were devised in the early fifteenth century, they paved the way for the immense artistic achievements of the Renaissance.

When we talk about "getting things into perspective" we mean seeing issues in proportion and understanding how one thing relates to another. The same is true in art. A vast mountain is diminished in stature if it is in the distance while a small child can dominate a composition if placed at the front. Using laws of perspective means that the world can be depicted as spacious and with figures, structures, plants, and objects that fit realistically into their setting. There is a sense of depth, and landscapes stretch away to the horizon.

Great artists in the ancient world followed rules of proportion but they rarely took on large scenes with distant landscapes. Throughout the middle ages, Christian art was dominant in the West and artists were focussed on the symbolic meanings of their work rather than on depicting reality. As the subjects of art became broader and religious constraints less rigid, artists became more interested in showing the world as it actually appears. It was not until the fifteenth century, however, that the "laws" of perspective were codified for artists to follow. As soon as they were devised, artists began to use them and Western art was transformed.

The invention of a reliable system of perspective is credited to the Florentine architect Filippo Brunelleschi. He demonstrated his ideas in two celebrated pictures of local buildings. Brunelleschi's theories were adapted for painters by another architect, Leon Battista Alberti, in his famous treatise *On Painting* (1435). Alberti translated space into a graph in which a series of diagonal lines converged on a single point called the vanishing point. These diagonals were combined with parallel horizontal lines to create a geometric graph with which artists could estimate the correct size and position of objects within their pictures.

One of the first artists to use the new system was the Florentine sculptor Donatello. In his *Feast of Herod* it is clear that the artist is fascinated with the new techniques. Herod receives the head of John the Baptist on a platter, while Salome dances on the right, but this is not the usual Biblical scene of this period. The table slopes forward and Herod's outstretched hands push out dramatically from the scene. Strong architectural features are used to show the room diminishing into the distance. This is further emphasized by the heads of the musicians in the adjoining chamber becoming smaller the further away they are placed, as well as by the converging lines of the stone slabs on the floor.

The tightly knit artistic circle in Florence soon ensured that the principles of perspective were eagerly taken up. Artists regarded them as if a magic formula. In a letter, German artist Albrecht Dürer described how he traveled to Bologna to learn "the secret art of perspective." Once they had acquired this crucial technique, Renaissance painters were able to use their new vision of the world.

Feast of Herod
Donatello, 1423–1427
Early Renaissance

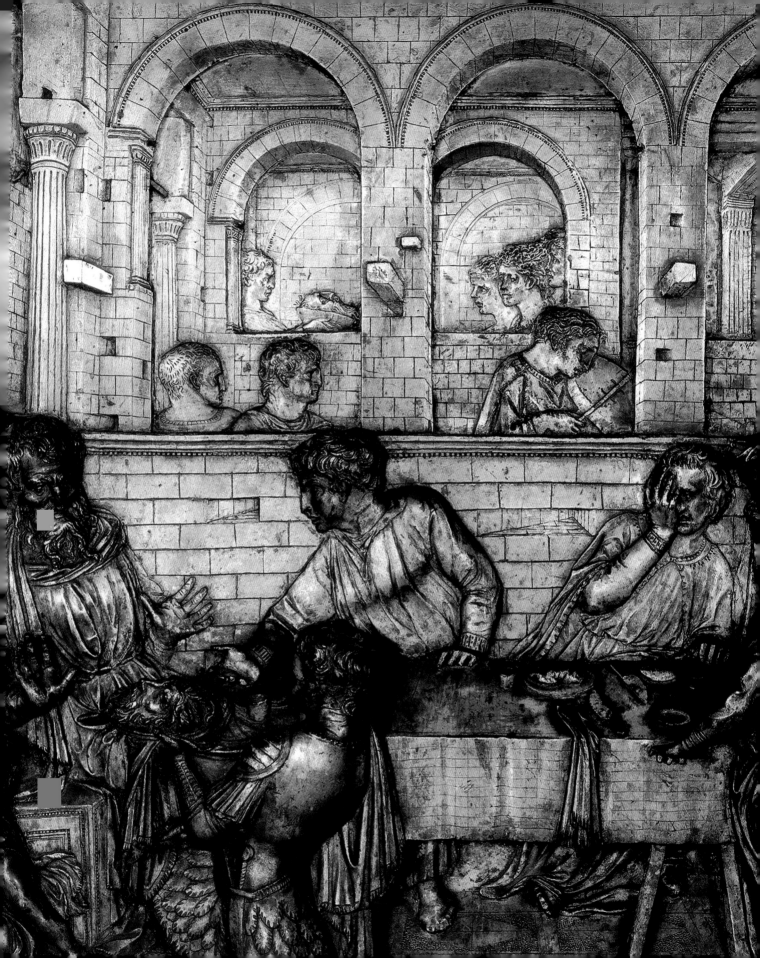

1423
Italy

c. 1425–1427
Italy

c. 1427
Italy

1 *Adoration of the Magi and Other Scenes*
Gentile da Fabriano
Tempera on wood,
9' 9" x 9' 4" (3 x 2.8 m)
Florence (Italy), Uffizi
International Gothic

RELIGION
LANDSCAPE

2 *Holy Trinity*
Masaccio
Fresco, 21' 10" x 10' 5"
(6.67 x 3.17 m)
Florence (Italy), Church of Santa Maria Novella
Early Renaissance

RELIGION

3 *Tribute Money*
Masaccio
Fresco, height: 8' (2.44 m)
Florence (Italy),
Church of Santa Maria del Carmine, Brancacci Chapel
Early Renaissance

RELIGION
LANDSCAPE

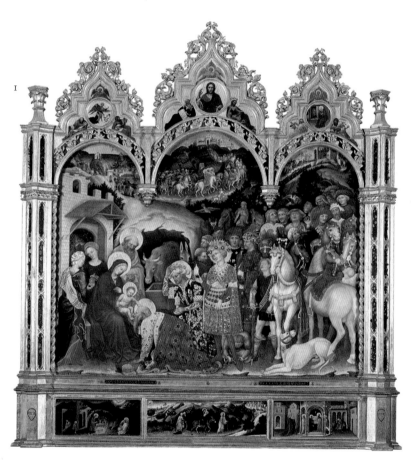

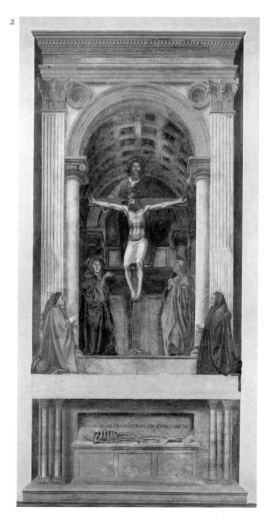

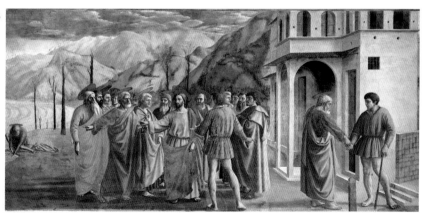

c. 1430
Netherlands

1430–1440
Switzerland

1431–1438
Italy

4 *Holy Trinity*
Robert Campin, Master of Flémalle
Oil on oak,
13½" x 9½" (34.3 x 24.5 cm)
Saint Petersburg (Russia),
State Hermitage Museum
Northern Renaissance

RELIGION
THE BODY

5 *Virgin and Child with Saints*
Conrad Witz
Oil on wood,
24½" x 16" (62 x 41 cm)
Naples (Italy),
Capodimonte Museum
Northern Renaissance

RELIGION

6 *Young Tambourine Players,
from the Singing Gallery*
Luca della Robbia
Marble, 37" x 37" (94 x 94 cm)
Florence (Italy),
Opera del Duomo Museum
Early Renaissance

RELIGION

6
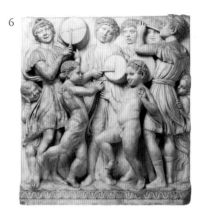

Northern Renaissance

4
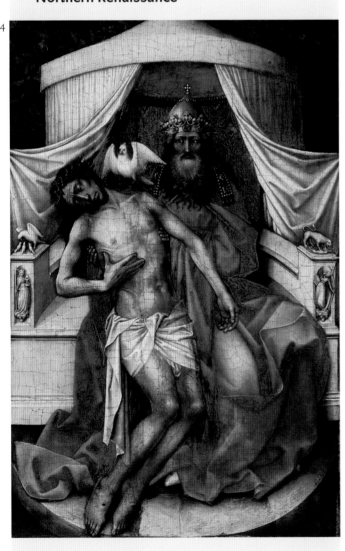

5
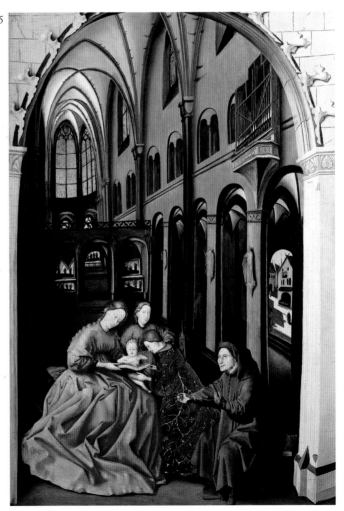

1432
Netherlands

1435–1440
Italy

c. 1435–1438
Netherlands

1 *Adoration of the Mystic Lamb, from the Ghent Altarpiece*
Jan van Eyck
Oil on wood, detail
Ghent (Belgium),
Church of Saint Bavo
Northern Renaissance

RELIGION
ALLEGORY

2 *Annunciation*
Fra Angelico
Fresco, 7' 6" x 10' 6" (2.3 x 3.2 m)
Florence (Italy),
San Marco Museum
Early Renaissance

RELIGION

3 *Deposition*
Roger van der Weyden
Oil on oak,
7' 2" x 8' 6" (2.2 x 2.6 m)
Madrid (Spain), Prado
Northern Renaissance

RELIGION
THE BODY

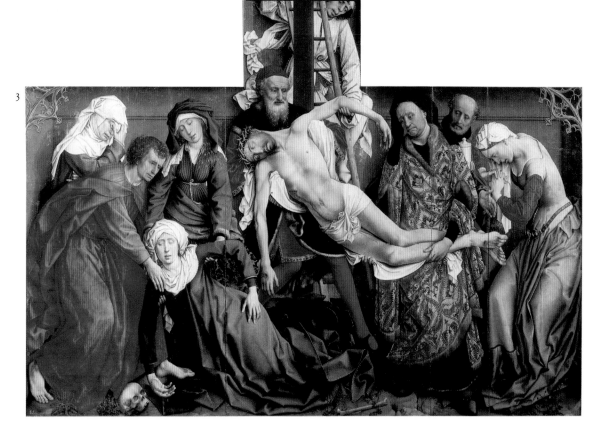

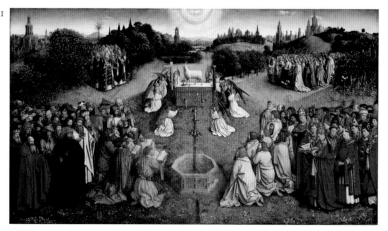

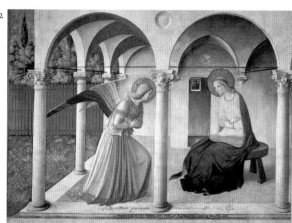

1435–1440
Germany

1436
Italy

1437–1438
Italy

4 *Madonna of the Rose Bower*
Stefan Lochner
Oil on wood,
20" x 15¾" (51 x 40 cm)
Cologne (Germany),
Wallraf-Richartz Museum
International Gothic

RELIGION

5 *Sir John Hawkwood*
Paolo Uccello
Fresco transferred to canvas,
24' x 13' 3" (7.32 x 4.04 m)
Florence (Italy), Florence Cathedral
Early Renaissance

PORTRAITURE
WAR

6 *Saint George and the Princess*
Antonio Pisanello
Fresco, detail
Verona (Italy), Church of
Sant'Anastasia, Pellegrini Chapel
Early Renaissance

RELIGION
THE CITY

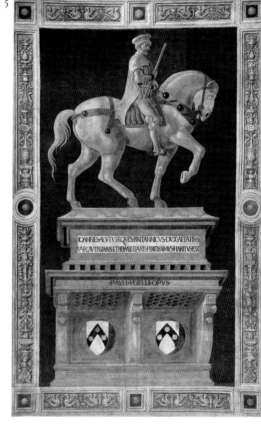

5

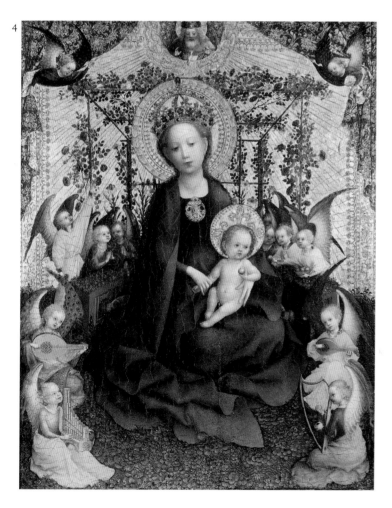

4

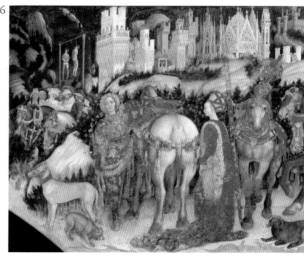

6

Oil provides artists with a magnificent new type of paint

Easily blended, long lasting, slow drying, and offering a far broader range of colors than had previously been possible, oil paint was one of the cornerstones of the Renaissance artistic revolution.

Artists are as dependent upon the materials they use as they are on their talents, training, and technical skills. Paint is basically tiny particles of color, the pigment, held together by a binding substance. The two are mixed and applied to a surface when wet then left to dry. Tempera, which is made by mixing pigments with egg yolks or gum, was the main type of paint in use until the fifteenth century. It is easy to imagine the consistency of beaten egg, mixed with colored powder, and then allowed to dry. It was effective but highly restrictive to use. Colors could not be blended on the picture surface, but were mixed ahead of time, then used swiftly before they dried. The artist had to decide precisely which color went where, and the speed at which work had to be completed was often achieved only with teams of assistants.

Finding a slower drying, more flexible alternative to the egg was a major challenge. Oil that blended when liquid but hardened when dry seemed the perfect solution. Almond and olive oil proved unsatisfactory because they did not become sufficiently hard. Other oils caused the paint to become too hard and were prone to cracking. Poppy, walnut, and sunflower oil worked reasonably, but linseed oil worked far more effectively than any other. It was easy to blend with pigments, and it dried without direct heat or sunlight to a strong, lasting finish. In addition, colors did not alter significantly when the paint dried. Artists could mix the paint on the surface as they worked, knowing that when they were dry the appearance would be as they intended. This enabled far more creativity, as painters could work with the paint as they applied it.

Oil paint became established first in Northern Europe and was vital to the style of painting that emerged in the Low Countries during this period. Jan Van Eyck mastered the use of oil with a skill that was unsurpassed. This portrait of a couple seems to comment on the sanctity of their union through their stern expressions and a range of religious symbols. Using oil, the artist could show these symbols in minute detail. These include the scenes of the Passion of Christ around the mirror, the carving of St. Margaret, the patron saint of childbirth, on the top of the chair, and the single marriage candle, which was used in processions, in the chandelier. With oil paints Van Eyck also had the flexibility to produce ingenious effects, incorporating the finest brushwork and layers of translucent glazes. He could show the subtlest alteration in a ray of light as it enters the room. He was able to depict contrasting textures, including rich fabrics, burnished brass, the grain on the wooden floor, and the dog's shaggy coat. With oil he could add a virtuoso flourish to his work by depicting the reflection in the mirror. It captures the scene in curved reverse, revealing two figures coming through the door, one of them perhaps the artist himself.

Portrait of Giovanni Arnolfini and His Wife
Jan van Eyck, 1434
Northern Renaissance

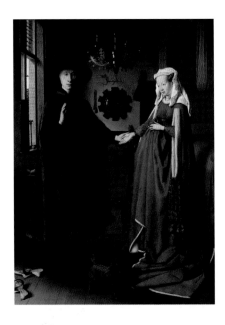

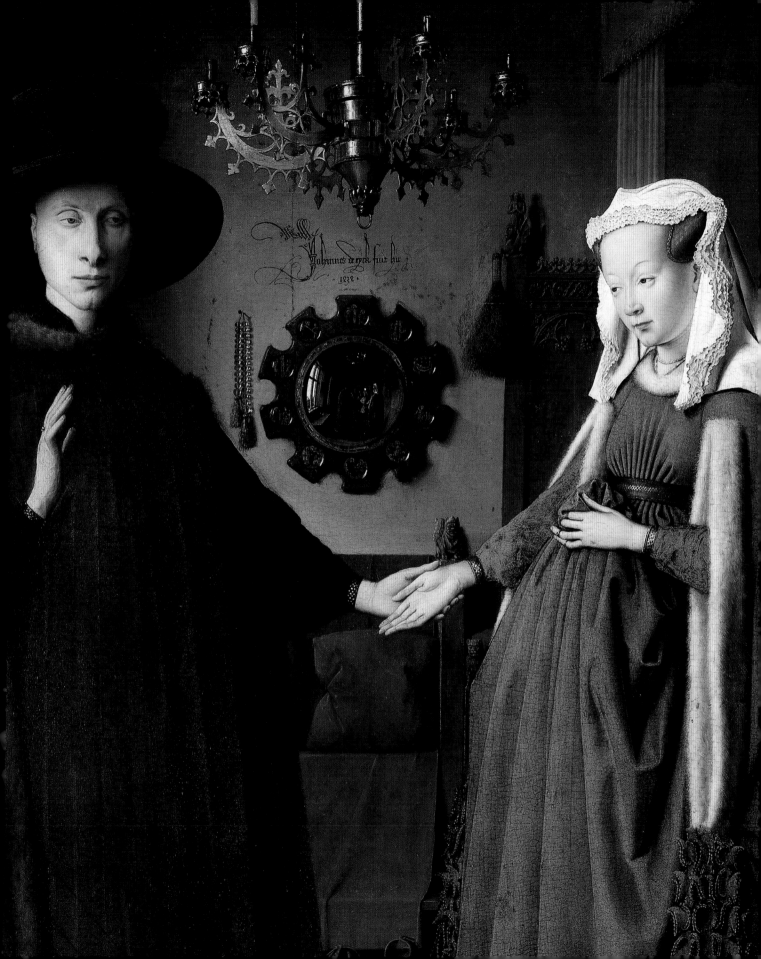

1 *David*
Donatello
Bronze, height: 6' ¾" (1.85 m)
Florence (Italy), Bargello Museum
Early Renaissance

THE BODY
RELIGION

2 *Medal of Filippo Maria Visconti with Portrait*
Antonio Pisanello
Bronze, diameter: 4" (10.2 cm)
Florence (Italy), Bargello Museum
Early Renaissance

PORTRAITURE
POLITICS

3 *Reverse of Medal of Filippo Maria Visconti with Duke in Armor*
Antonio Pisanello
Bronze, diameter: 4" (10.2 cm)
Florence (Italy), Bargello Museum
Early Renaissance

POLITICS

4 *Battle between Soldiers Riding Camels*
Artist unknown
Illustration from manuscript of the "Khamsah" by Nizami
London (UK), British Library, Manuscripts Collection
Persian

WAR
ANIMALS

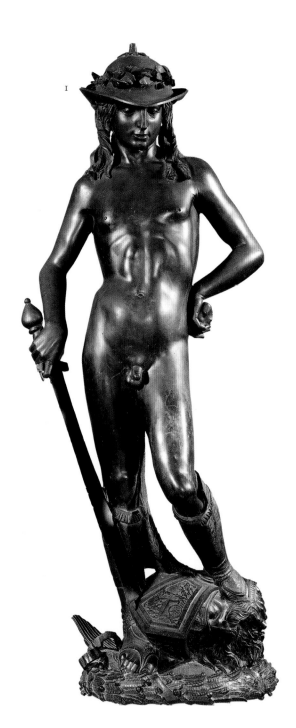

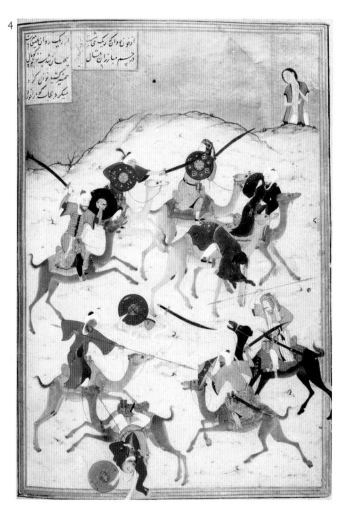

1446–1447
Italy

1447
Italy

1447–1453
Italy

5 *Tournament*
Antonio Pisanello
Fresco, detail
Mantua (Italy), Ducal Palace
High Renaissance

LEISURE
ANIMALS

6 *Last Supper*
Andrea del Castagno
Fresco, width of wall: 32' (9.76 m)
Florence (Italy), Convent of
Sant'Apollonia
Early Renaissance

RELIGION

7 *Equestrian Monument*
to Gattamelata
Donatello
Bronze, height: 11' (3.4 m)
Padua (Italy), Piazza del Santo
Early Renaissance

PORTRAITURE
DEATH

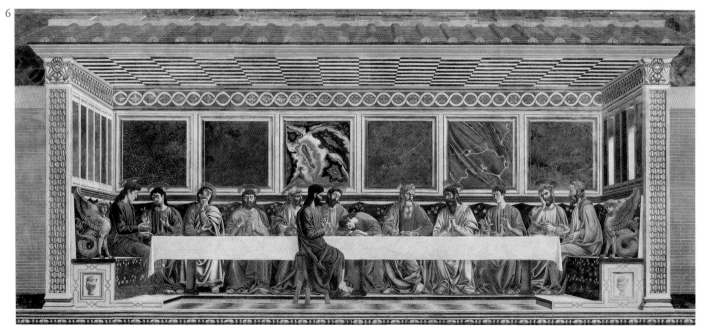

1 *Pippo Spano*
Andrea del Castagno
Fresco transferred to wood,
8' 2" x 6' ½" (2.5 x 1.53 m)
Florence (Italy), Uffizi
Early Renaissance

WAR

2 *Triumph of Death*
Artist unknown
Fresco,
Palermo (Italy),
Regional Gallery of Sicily
Early Renaissance

DEATH
ANIMALS

3 *Scene of Pharmacy, from Avicenna's "Canon of Medicine"*
Artist unknown
Illumination, detail
Bologna (Italy), University Library
Early Renaissance

THE CITY
URBAN LIFE

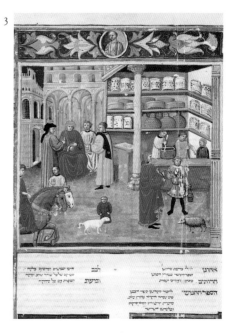

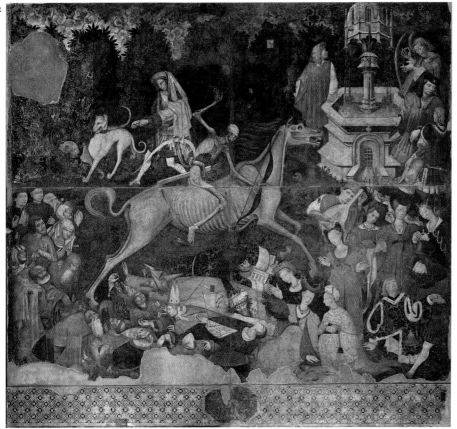

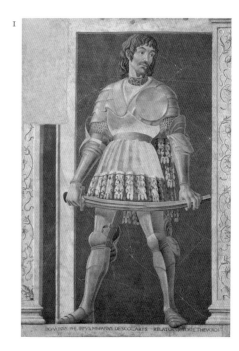

c. 1450
Italy

c. 1450
Turkey

1453
Italy

4 *Madonna and Child Adored by Lionello d'Este*
Jacopo Bellini
Oil and tempera on wood,
23 ½" x 15 ¾" (60 x 40 cm)
Paris (France), Louvre
Early Renaissance

RELIGION
PORTRAITURE

5 *Woman in Garden*
Artist unknown
Manuscript illustration
Istanbul (Turkey),
Topkapi Museum
Herat School

LEISURE

6 *Tomb of Cardinal Federighi*
Luca della Robbia
Marble and glazed terracotta,
8' 9" x 9' (2.7 x 2.75 m)
Florence (Italy),
Church of Santa Trinita
Early Renaissance

DEATH
PORTRAITURE

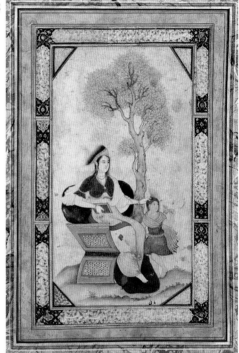

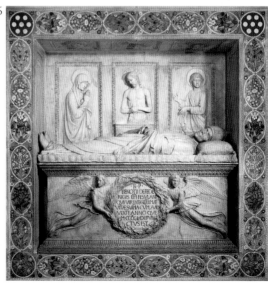

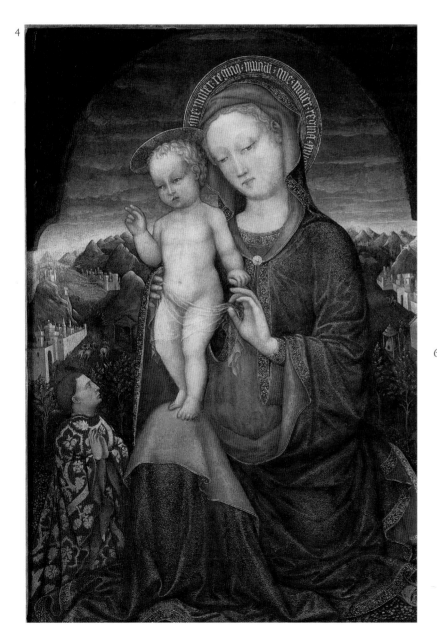

c. 1459
Italy

c. 1459
Italy

c. 1456–1460
Italy

1 *Procession of the Magi*
Benozzo Gozzoli
Fresco
Florence (Italy), Medici Palace,
Medici Family Private Chapel
Early Renaissance

RELIGION
PORTRAITURE

2 *Interior of Medici Family*
Private Chapel
Frescos by **Benozzo Gozzoli**
Fresco, marble, and porphyry
Florence (Italy), Medici Palace
Early Renaissance

RELIGION

3 *Saint Mary Magdelene*
Donatello
Polychrome and gilt wood,
height: 6' (1.83 m)
Florence (Italy),
Opera del Duomo Museum
Early Renaissance

THE BODY
RELIGION

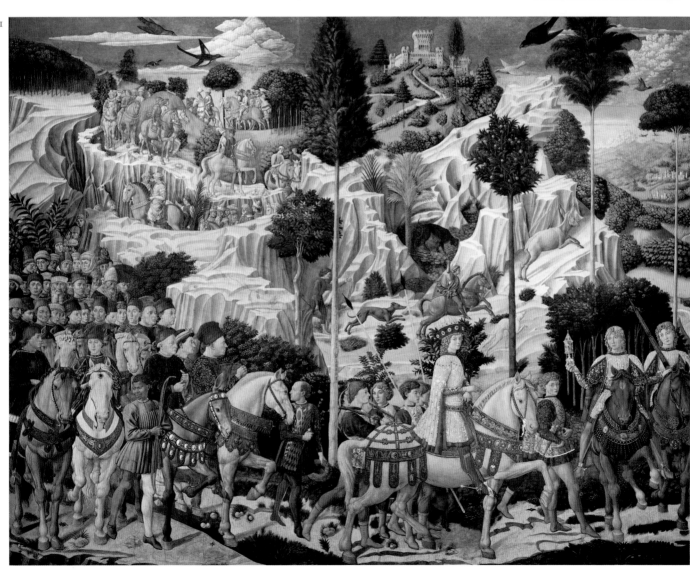

1459
Italy

1462
Italy

1463–1465
Italy

4 *Crucifixion, from the*
San Zeno Altarpiece
Andrea Mantegna
Tempera on wood,
26½" x 36½" (67 x 93 cm)
Paris (France), Louvre
Early Renaissance

RELIGION
LANDSCAPE

5 *Adoration of the Magi*
Andrea Mantegna
Tempera on wood,
30" x 29¾" (76 x 75.5 cm)
Florence (Italy), Uffizi
Early Renaissance

RELIGION
LANDSCAPE

6 *Resurrection*
Piero della Francesca
Fresco, 7' 5" x 6' 6" (2.25 x 2 m)
Sansepolcro (Italy), Civic Museum
Early Renaissance

RELIGION

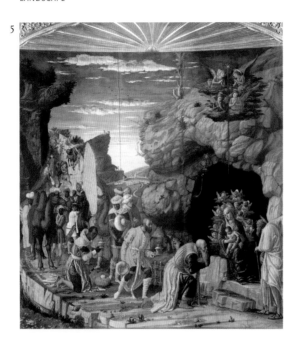

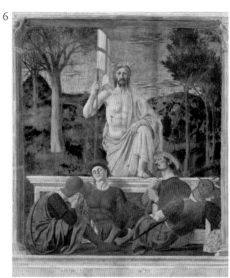

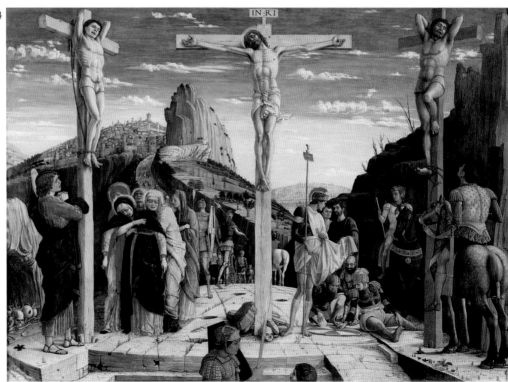

1464–1477
Netherlands

1465
Italy

1465
Italy

1 *Last Supper Triptych*
Dieric Bouts
Oil on wood, central panel:
6' ¾" x 4' 11" (1.85 x 1.50 m)
Louvain (Belgium), Church of
Saint Peter
Northern Renaissance

RELIGION

2 *Dante Reading from the
"Divine Comedy"*
Domenico di Michelino
Fresco
Florence (Italy), Florence Cathedral
Early Renaissance

PORTRAITURE
RELIGION

3 *Madonna and Child with Two Angels*
Fra Filippo Lippi
Tempera on wood, 37 ½" x 24 ½"
(95 x 62 cm)
Florence (Italy), Uffizi
Early Renaissance

RELIGION

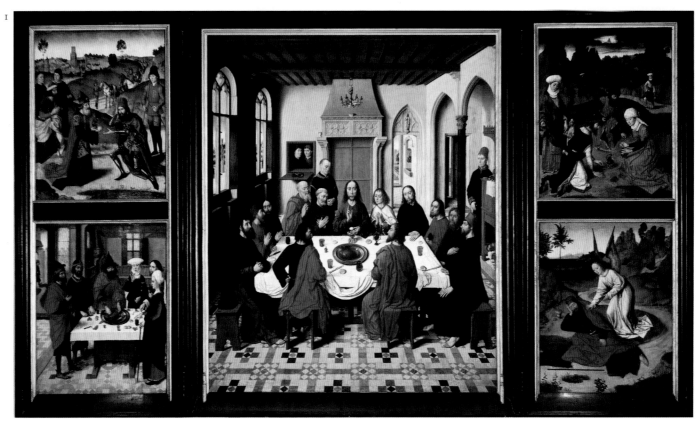

1465–1474
Italy

1465–1474
Italy

c. 1466
Italy

4 *Family and Court of
Ludovico Gonzaga*
Andrea Mantegna
Fresco, detail
Mantua (Italy), Ducal Palace,
Camera Picta
Early Renaissance

PORTRAITURE
POLITICS

5 *Ceiling Oculus*
Andrea Mantegna
Fresco, diameter of central part:
8' 10" (2.7 m)
Mantua (Italy), Ducal Palace,
Camera Picta
Early Renaissance

6 *Portrait of Cardinal de' Medici*
Andrea Mantegna
Tempera on wood,
16" x 11½" (40.5 x 29.5 cm)
Florence (Italy), Uffizi
Early Renaissance

PORTRAITURE
POLITICS

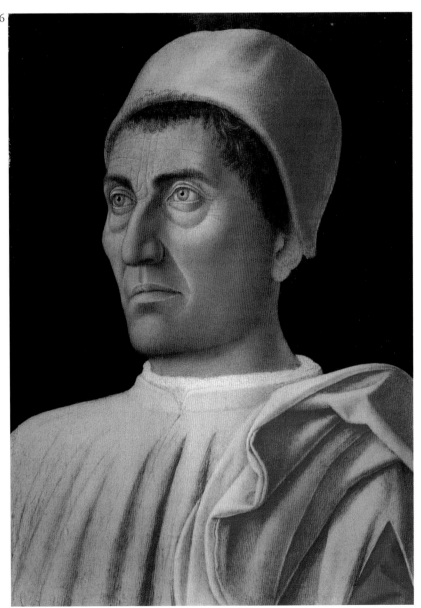

c. 1470
Italy

c. 1470
Italy

1467–1470
Italy

1 *Hercules and Antaeus*
Antonio del Pollaiuolo
Bronze, height: 17 ¾" (45 cm)
Florence (Italy), Bargello Museum
Early Renaissance

MYTHOLOGY
THE BODY

2 *Ideal City*
Artist unknown
Oil on wood,
23 ½" x 6' 6" (60 x 200 cm)
Urbino (Italy), Ducal Palace
Early Renaissance

THE CITY

3 *Portrait of the Duke and*
Duchess of Montefeltro
Piero della Francesca
Tempera on wood,
each: 18 ½" x 13" (47 x 33 cm)
Florence (Italy), Uffizi
Early Renaissance

PORTRAITURE
LANDSCAPE

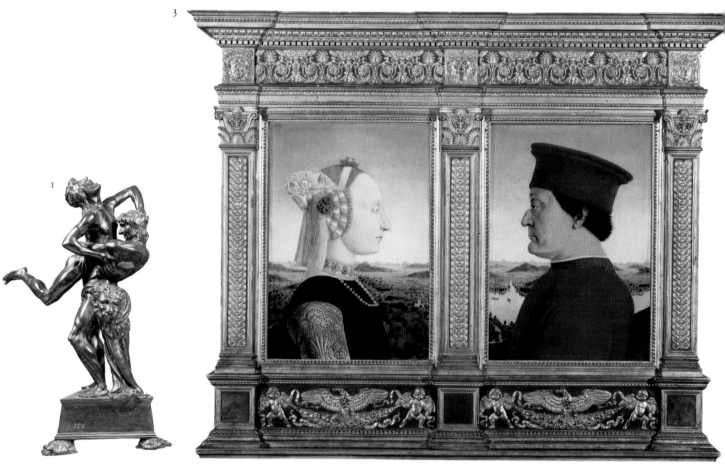

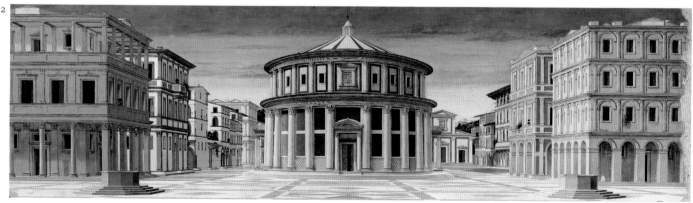

1467–1471
Netherlands

c. 1475
Italy

c. 1475
Italy

4 *Last Judgement*
Hans Memling
Oil on wood, central panel:
7'4" x 5' 3½" (2.21 x 1.61 m),
each wing: 7' 4" x 28½" (2.2 x 0.72 m)
Gdansk (Poland), Pomorskie
Museum
Northern Renaissance

RELIGION
THE BODY

5 *Battle of the Nudes*
Antonio del Pollaiuolo
Engraving
Florence (Italy), Uffizi
Early Renaissance

THE BODY

6 *David*
Andrea del Verrocchio
Bronze, height: 4' 1½" (1.26 m)
Florence (Italy), Bargello Museum
Early Renaissance

RELIGION

6
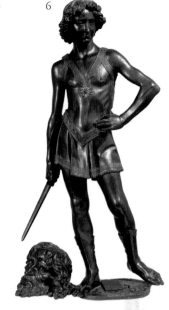

5
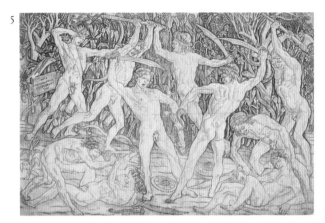

4
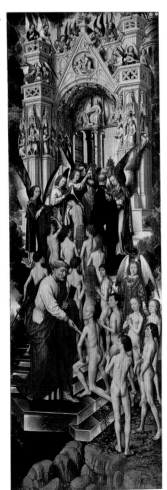

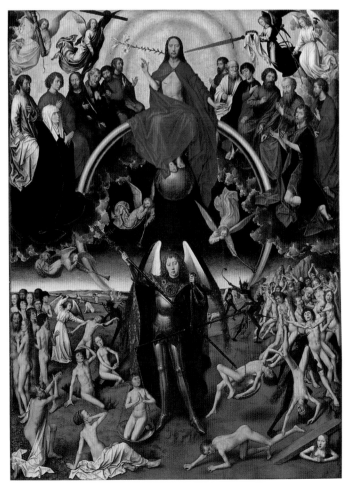

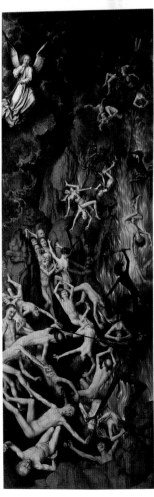

1 *Sixtus IV Founding the
Vatican Library*
Melozzo da Forlì
Fresco transferred to canvas,
12' 2" x 7' 3" (3.7 x 2.2 m)
Vatican (Vatican City), Vatican
Library
Early Renaissance

PORTRAITURE

2 *Portinari Triptych*
Hugo van der Goes
Oil on wood, height: 8' 2" (2.53 m)
Florence (Italy), Uffizi
Northern Renaissance

RELIGION
PORTRAITURE

3 *Christ Giving the Keys to Saint Peter*
Perugino
Fresco, 11' 5½" x 18' 8½"
(3.5 x 5.7 m)
Vatican (Vatican City),
Sistine Chapel
Early Renaissance

RELIGION
PORTRAITURE

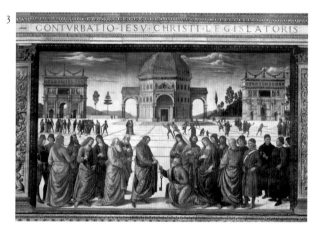

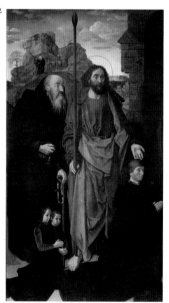

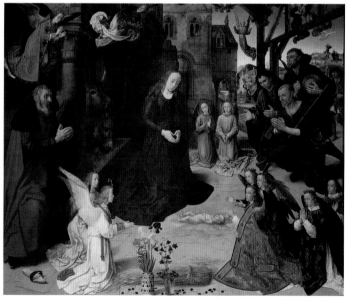

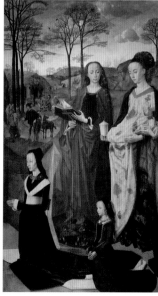

1480–1481
Italy

c. 1480–1482
Italy

c. 1480
Italy

4 *Federico da Montefeltro, Duke of
Urbino, with His Son Guidobaldo*
Pedro Berruguete
Oil on wood,
48" x 32¾" (122 x 83 cm)
Urbino (Italy), Ducal Palace
Early Renaissance

PORTRAITURE

5 *Portrait of Simonetta Vespucci*
Piero di Cosimo
Oil on wood,
22½" x 16½" (57 x 42 cm)
Chantilly (France), Condé Museum
Early Renaissance

PORTRAITURE

6 *Foreshortened Christ*
Andrea Mantegna
Tempera on canvas,
26¾" x 32" (68 x 81 cm)
Milan (Italy), Brera Gallery
Early Renaissance

RELIGION
THE BODY

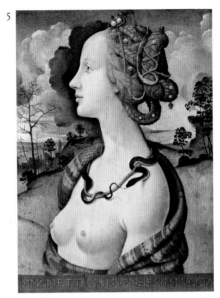

5

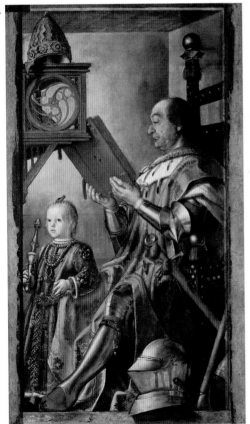

4

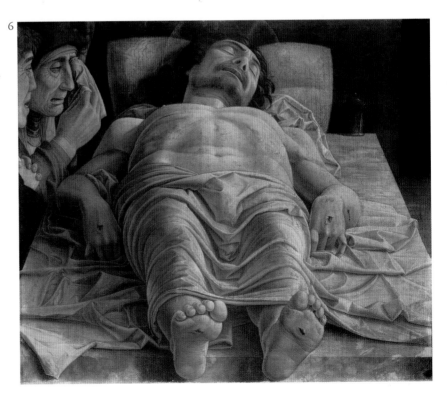

6

c. 1480
Spain

c. 1480–1500
Spain

1481–1482
Italy

1 *Scenes from the Life of Saint Dominic: The Burning of the Books*
Pedro Berruguete
Oil on wood,
48" x 32 ¾" (122 x 83 cm)
Madrid (Spain), Prado
Early Renaissance

RELIGION
HISTORY

2 *Self-Portrait*
Pedro Berruguete (?)
Oil on canvas,
14" x 9½" (36 x 24 cm)
Madrid (Spain),
Lazaro Galdiano Museum
Early Renaissance

PORTRAITURE

3 *Primavera (Spring)*
Sandro Botticelli
Tempera on wood with oil glazes,
6' 6" x 10' 2" (2 x 3.14 m)
Florence (Italy), Uffizi
Early Renaissance

MYTHOLOGY
THE BODY

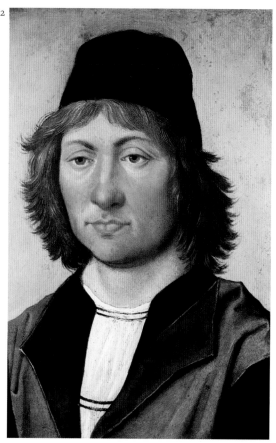

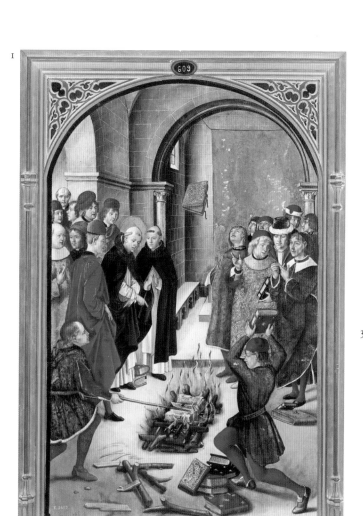

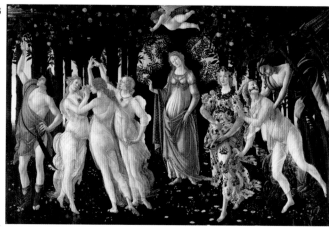

c. 1484
Italy

1486
China

c. 1489
Netherlands

4 *Birth of Venus*
Sandro Botticelli
Tempera on linen,
68" x 9' (1.72 x 2.78 m)
Florence (Italy), Uffizi
Early Renaissance

MYTHOLOGY
THE BODY

5 *Laughing Buddha*
Artist unknown
Glazed stoneware,
height: 47" (1.19 m)
London (UK), British Museum
Ming dynasty

RELIGION

6 *Shrine of Saint Ursula*
Hans Memling
Gilded oak, painted carvings,
and painted panels, panels:
36" x 16½" (91.5 x 41.5 cm)
Bruges (Belgium), Memling
Museum, Saint John's Hospital
Northern Renaissance

RELIGION

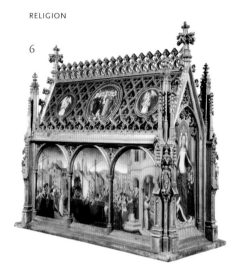

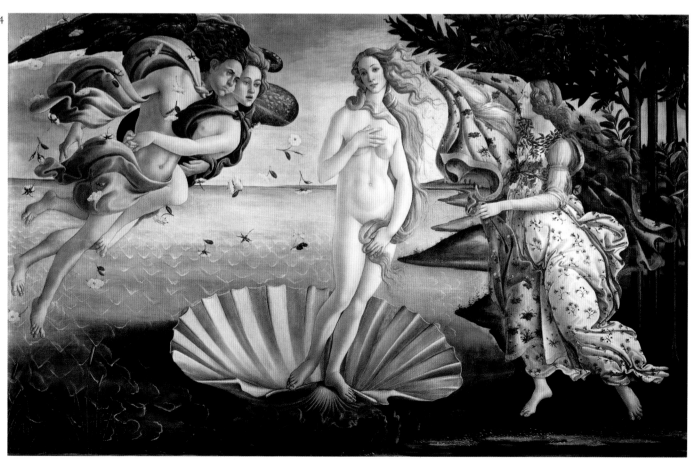

c. 1492
Italy

1494
Italy

1494–1495
Iran

1 *Vitruvian Man: Scheme of the Proportions of the Human Body*
Leonardo da Vinci
Pen, ink, watercolor, and metalpoint on paper,
13½" x 9½" (34.3 x 24.2 cm)
Venice (Italy), Accademia Gallery
High Renaissance

THE BODY

2 *Cure of a Lunatic by the Patriarch of Grado*
Vittore Carpaccio
Oil on canvas,
12' x 12' 9" (3.65 x 3.89 m)
Venice (Italy), Accademia Gallery
Early Renaissance

RELIGION
THE CITY

3 *The Death of Majnun on Layla's Grave, from the "Khamsa" by Nazami*
Artist unknown
Manuscript illustration
London (UK), British Library, Manuscripts Collection
Herat School

MYTHOLOGY
LANDSCAPE

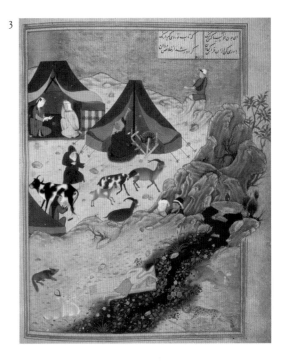

High Renaissance

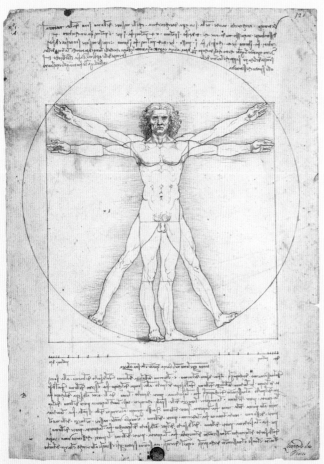

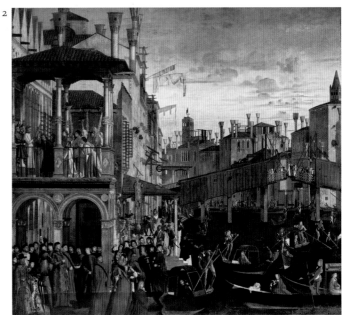

1496–1497
Italy

1497
Italy

1499–1504
Italy

4 *Drunken Bacchus*
Michelangelo Buonarroti
Marble, height: 6' 6" (2.1 m)
Florence (Italy), Bargello Museum
High Renaissance

MYTHOLOGY
THE BODY

5 *Last Supper*
Leonardo da Vinci
Tempera, 13' 9" x 29' 10"
(4.2 x 9.1 m)
Milan (Italy), Convent of Santa
Maria delle Grazie
High Renaissance

RELIGION

6 *The Damned Sent to Hell*
Luca Signorelli
Fresco, width: approx. 23' (7 m)
Orvieto (Italy), Orvieto Cathedral,
Chapel of San Brizio
Early Renaissance

RELIGION
DEATH

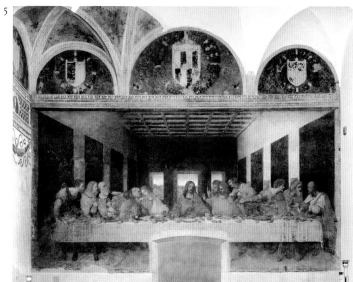

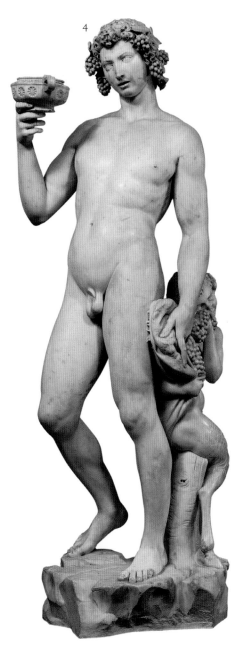

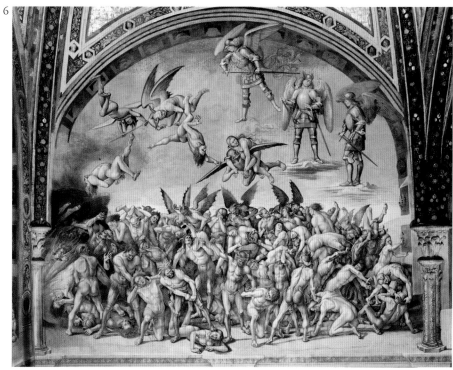

123

Printing makes art accessible to a wider audience

The invention of printing had a profound impact on culture. It enabled the transmission and communication of ideas through the printed word. Artists could share their work with one another as well as with a far wider audience than had previously been possible.

Until artists were able to make prints, the only pictures that most people were able to see were those on display in local churches. For aspiring artists, aware only of the works of the master who trained them, the lack of exposure to the work of other artists was a major obstacle to their development. A small and privileged minority were able to travel—a dangerous, expensive, and time consuming undertaking–in order to expand their knowledge. The Northern Renaissance artist Albrecht Dürer made the artistic pilgrimage—in his case traveling twice from his native Germany to Italy—to experience the work of the High Renaissance masters. His journeys had a significant influence on him. His figures became more solid and monumental, his colors became brighter, and he became aware of the laws of perspective and proportion.

Dürer was also privileged in being exposed to printing techniques. He grew up in Nuremberg, a major center for printing. His godfather, Anton Koberger, was a leading publisher. His teacher, Michael Wolgemut, pioneered the use of woodcuts for book illustrations. Dürer soon adopted printing as part of his repertoire and his first great success was *The Apocalypse* (1498), a series of fifteen large woodcuts. It had enormous appeal since many people feared that the world would end in 1500. His prints were also appealing in terms of technique. Prior to that time the woodcut process had been used mainly for cheap religious prints and playing cards. The *Apocalypse* series raised woodcut prints into a genuine art form because Dürer's were unusually large and exquisitely detailed, displaying all the skills he had acquired on his travels.

Dürer then perfected his abilities in a more sophisticated printing method, that of copper engraving. With woodcuts, the blank area was cut away, leaving the area that was to be printed standing out on the woodblock. This method worked well for book illustrations, since they could be printed together with text. With engravings, the printed area is incised into the copper plate and has far greater artistic potential, as the stronger surface allows the engraver to produce more subtle details. With this new technique the artist could, in effect, draw on copper and reproduce his drawings time and time again.

Artists were now able to see their fellow artists' work. Dürer's wife sold his prints in the market square in Nuremberg, as well as at fairs in other German cities. One contemporary noted "the merchants of Italy, France, and Spain are purchasing Dürer's engravings as models for the painters of their homelands." A great painter, Dürer now turned down commissions for paintings, preferring to work on prints. In a letter he explained that this was "because it is much more profitable." Artists were becoming independent and able to stand aside from the church and wealthy patrons. They could work for themselves, producing the art they wanted to create, reaching an audience who had not before been able to afford to buy art. And if the artists were outstanding, they also reached aspiring young painters and sculptors, eager to learn without the need to travel.

Four Horsemen of the Apocalypse
Albrecht Dürer, 1498
Northern Renaissance

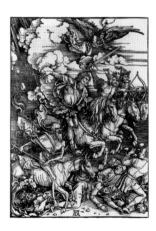

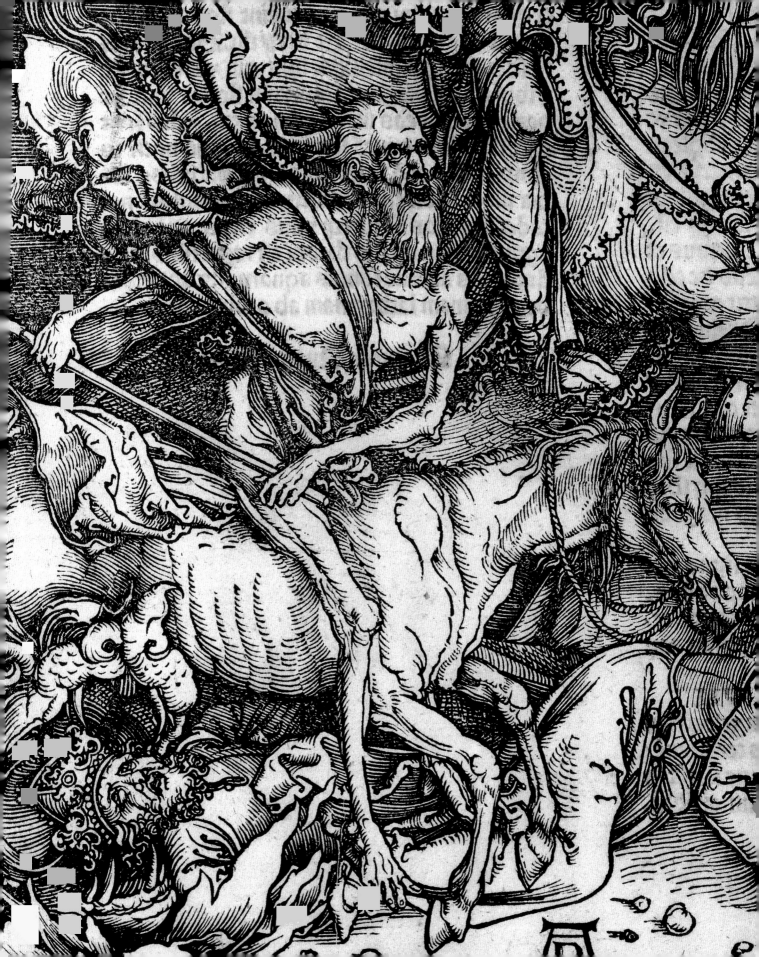

1499
Germany

c. 1500
Mexico

1500
Germany

1 *Portrait of Oswolt Krel*
Albrecht Dürer
Oil on limewood,
19½" x 15¼" (49.6 x 39 cm)
Munich (Germany),
Alte Pinakothek
Northern Renaissance

PORTRAITURE

2 *Grasshopper, from Chapultepec*
Artist unknown
Carnelian stone,
length: 7¾" (19.5 cm)
Mexico City (Mexico),
National Museum of Anthropology
Aztec

ANIMALS

3 *Self-Portrait with Fur Coat*
Albrecht Dürer
Oil on limewood, 26½" x 19½"
(67.3 x 49.5 cm)
Munich (Germany),
Alte Pinakothek
Northern Renaissance

PORTRAITURE

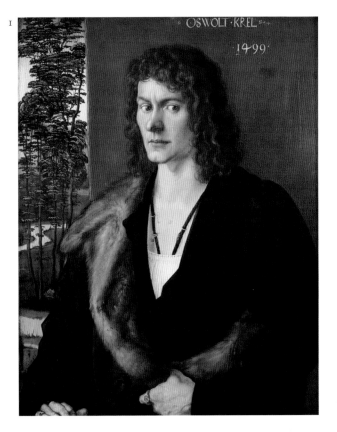

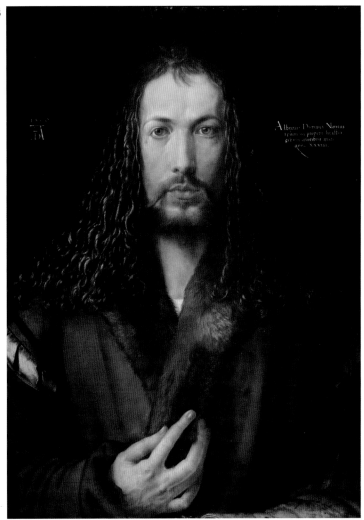

4 *Miracle of the True Cross*
Gentile Bellini
Oil on canvas,
10' 6" x 14' (3.2 x 4.3 m)
Venice (Italy), Accademia Gallery
Early Renaissance

RELIGION
PORTRAITURE

5 *Procession in Piazza San Marco*
Gentile Bellini
Tempera and oil on canvas,
12' x 24' 5" (3.67 x 7.45 m)
Venice (Italy), Accademia Gallery
Early Renaissance

RELIGION
THE CITY

4
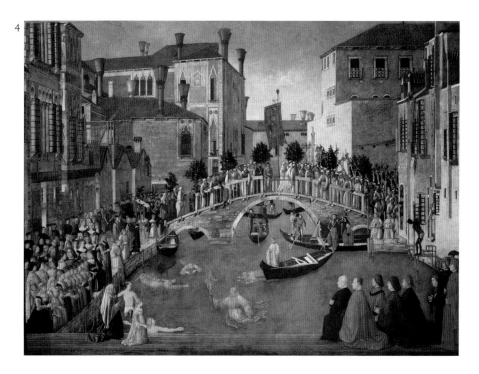

5
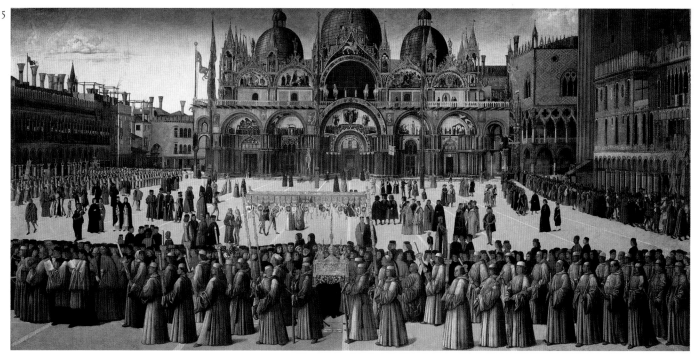

Queen Idia of Benin is commemorated in an idealized African sculpture

The brass heads produced in the kingdom of Benin are one of the highlights of early African art. They display a calm grandeur that reflects their purpose as symbols of both royal and spiritual power.

The kingdom of Benin, situated in the southern part of present-day Nigeria, produced some of the earliest surviving masterpieces of African art. The most imposing pieces were designed for altars and shrines devoted to ancestor worship. Among other things, these included decorated ivory tusks, bronze plaques of historical scenes, and, most impressive of all, large brass heads of royal figures.

The technique of brass casting is said to have come from the neighboring Ife people in the late thirteenth century, although the earliest surviving Benin heads appear to date from the early fifteenth century. Initially, most of the heads were thought to have represented the leaders of fallen enemies. Soon, however, artists began to portray the heads of the *oba*, or ruler, of the kingdom of Benin. These sculptures were designed to symbolize the wisdom, power, and destiny of these authority figures.

The sculptures of Idia have a special place within this tradition. Historically, she was the first woman in Benin to enjoy wide-ranging political privileges, through her position as the *iyoba* or "queen mother." Idia was the mother of Oba Esigie, whose rule in the early sixteenth century was threatened by civil war, following an uprising by his brother Aruaran in the city of Udo. At the same time, tribesmen from the neighboring Igala region took advantage of the situation by launching an invasion, hoping to seize Benin's northern territories. However, Esigie managed to counter this dual threat and re-establish royal control over the country. He dedicated these victories to Idia, believing that her wise counsel and her magical powers had been responsible for his success. Her contribution was also commemorated in the saying: "Women do not go to war, apart from Idia."

As a reward, Esigie created the new post of *iyoba* for Idia within the court. She was given a private palace, along with the right to commission her own ritual objects. Images of the *iyoba* were incorporated into royal ceremonies designed to dispel evil forces. These images usually took the form of ivory masks worn as pendants, hanging from the hip. After Idia's death, a memorial head was cast in brass and placed, along with carved ivory tusks, on the royal, ancestral altar. This became a tradition, followed by later *iyobas*.

These heads are not straightforward portraits. Most have serene expressions that have been compared with the idealizing tendencies of Western, classical art. They also feature a number of symbolic elements, underlining the protective role of the *iyoba*. Depictions of Idia usually show her with two vertical scarification marks between her eyebrows. These scars were filled with medicinal charms, which were thought to be the source of her mystical powers. Royal figures were also shown with iron irises, indicating that their power had divine origins and referring to the notion that royal leaders conveyed their authority through a mystical stare. Idia's distinctive headgear of a peaked crown of coral beads, known as a "chicken's beak," was another royal emblem. Overall, the sculptures of Idia's head serve as reminders of her achievements, while also acting as a bridge between the spirit realm and the ordinary world.

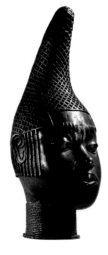

Queen Idia, Mother of Oba Esigie
Artist unknown, c. 1500–1525
Benin

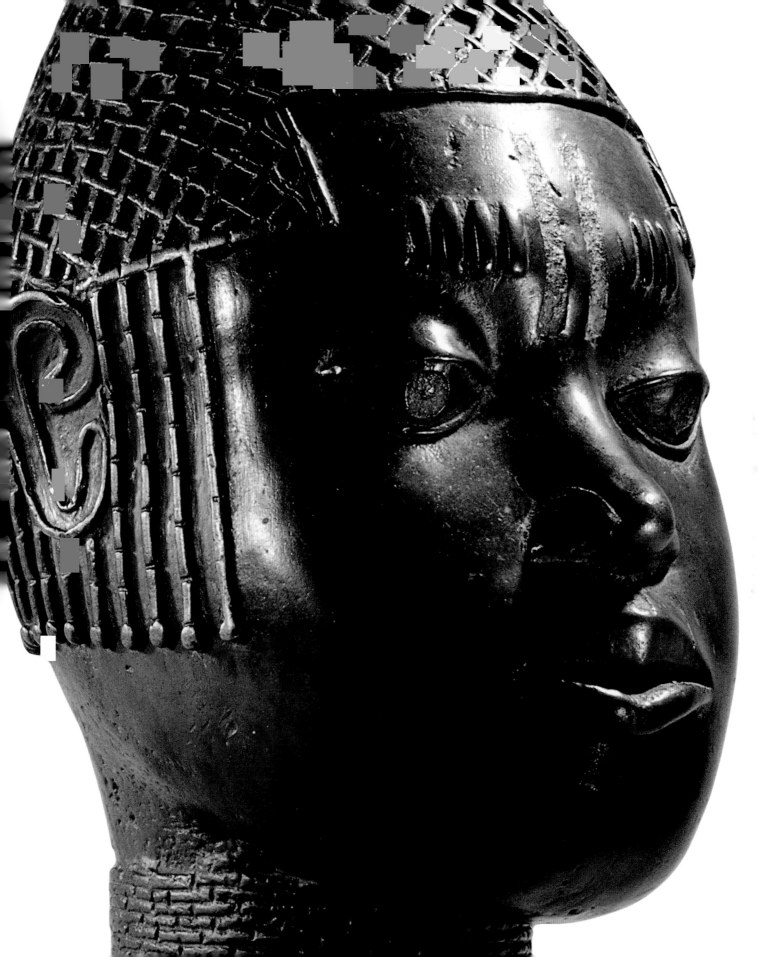

c. 1500–1600
Benin

c. 1500–1600
Benin

1498–c. 1500
Italy

1 *Mask*
Artist unknown
Ivory, 9 ½" x 5" (24.5 x 12.5 cm)
London (UK), British Museum
Benin

RELIGION

2 *Oba of Benin with Attendants*
Artist unknown
Brass, 20" x 14 ½" (51 x 37 cm)
London (UK), British Museum
Benin

POLITICS
PORTRAITURE

3 *Pietà*
Michelangelo Buonarroti
Marble, height: 5' 8" (1.72 m)
Vatican (Vatican City),
Saint Peter's Basilica
High Renaissance

RELIGION
THE BODY

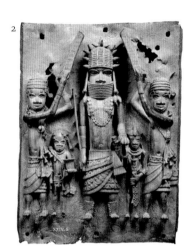

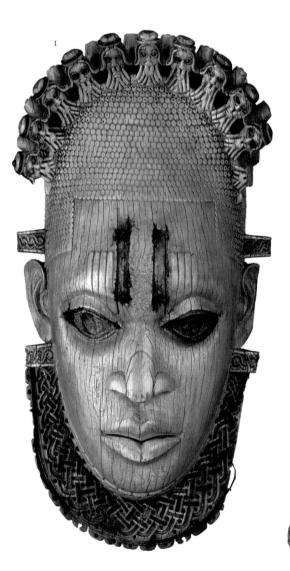

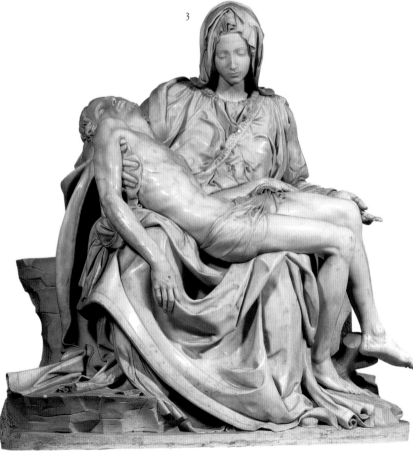

4 *David*
Michelangelo Buonarroti
Marble, 17' (5.17 m)
Florence (Italy),
Accademia Gallery
High Renaissance

THE BODY
RELIGION

5 *Saint Augustine in His Study*
Vittore Carpaccio
Oil on canvas,
4' 7 ½" x 6'10" (1.4 x 2 m)
Venice (Italy), Confraternity of
San Giorgio degli Schiavoni
Early Renaissance

DOMESTIC LIFE
RELIGION

6 *Holy Family (Doni Tondo)*
Michelangelo Buonarroti
Tempera on panel,
diameter: 3' 11¼" (1.2 m)
Florence (Italy), Uffizi
High Renaissance

RELIGION
THE BODY

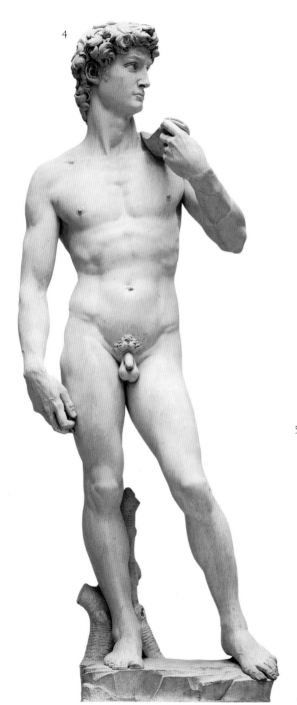

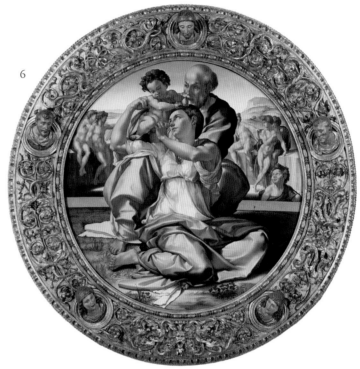

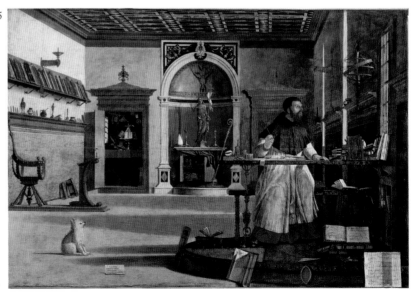

1 *Mona Lisa*
Leonardo da Vinci
Oil on wood,
30¼" x 21" (77 x 53 cm)
Paris (France), Louvre
High Renaissance

PORTRAITURE

2 *The Tempest*
Giorgione
Oil on canvas,
32 ½" x 28¾" (83 x 73 cm)
Venice (Italy),
Accademia Gallery
High Renaissance

LANDSCAPE
THE BODY

3 *Creation of Adam*
Michelangelo Buonarroti
Fresco,
detail: 9' 2" x 18' 8" (2.8 x 5.7 m)
Vatican (Vatican City), Sistine
Chapel
High Renaissance

RELIGION
THE BODY

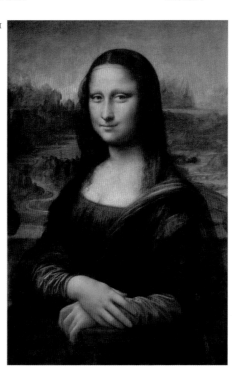

1

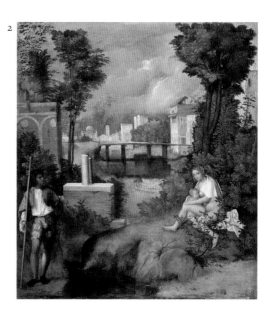

2

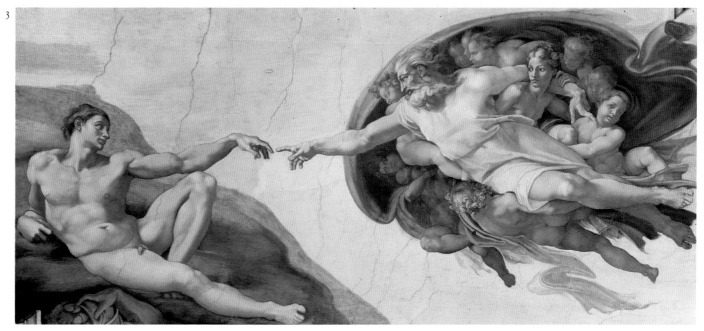

3

1508–1512
Italy

1508–1511
Italy

c. 1510
Netherlands

4 *Ceiling of the Sistine Chapel*
Michelangelo Buonarroti
Fresco, 128' x 45' (39 x 13.75 m)
Vatican (Vatican City), Sistine
Chapel
High Renaissance

RELIGION
THE BODY

5 *Concert*
Titian
Oil on canvas,
43¼" x 54¼" (110 x 138 cm)
Paris (France), Louvre
High Renaissance

THE BODY

6 *Triptych of the Epiphany*
Hieronymus Bosch
Oil on wood,
height: 54¼" (138 cm)
Madrid (Spain), Prado
Northern Renaissance

RELIGION

4
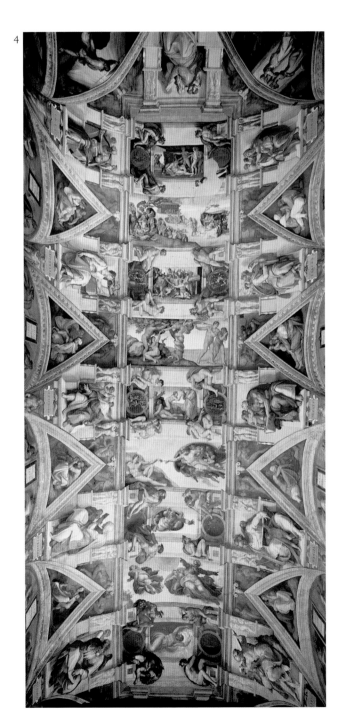

5
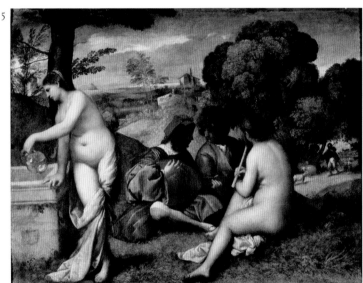

6
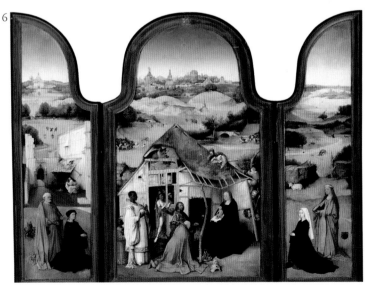

133

| 1510 | C. 1510–1515 | C. 1510–1515 |
| Iran | Netherlands | Netherlands |

1 *Iskander Meets with the Sages, from the "Khamsa" of Nizami*
Artist unknown
Manuscript illustration,
13" x 7¾" (33 x 20 cm)
New York (USA),
Pierpont Morgan Library
Persian

LITERATURE

2 *Triptych of the Garden of Earthly Delights*
Hieronymus Bosch
Oil on wood, height: 7' 2" (2.2 m)
Madrid (Spain), Prado
Northern Renaissance

RELIGION
THE BODY

3 *Christian Allegory*
Jan Provost
Oil on wood,
19¾" x 15¾" (50 x 40 cm)
Paris (France), Louvre
Northern Renaissance

ALLEGORY
RELIGION

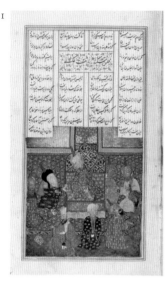

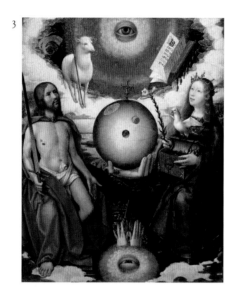

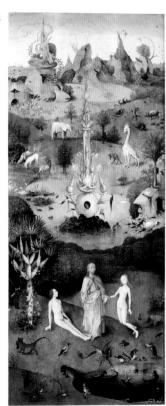

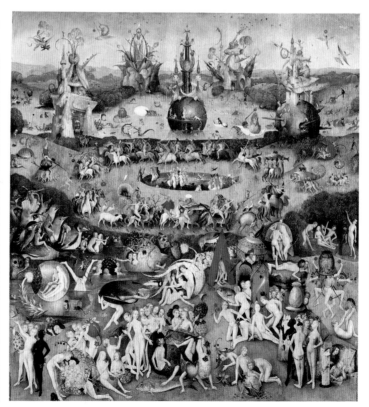

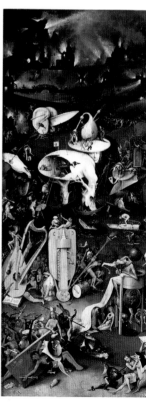

1510–1515
Germany

1510–1515
Germany

1512–1514
Italy

4 *Isenheim Altar: Allegory of the Nativity*
Mathis Grünewald
Wood, 8' 10" x 11' 2½"
(2.7 x 3.43 m)
Colmar (France),
Unterlinden Museum
Northern Renaissance

RELIGION

5 *Isenheim Altar: Crucifixion*
Mathis Grünewald
Wood, 8' 10" x 11' 2½"
(2.7 x 3.43 m)
Colmar (France),
Unterlinden Museum
Northern Renaissance

RELIGION
THE BODY

6 *The Deliverance of Saint Peter from Prison*
Raphael
Fresco, width at base: 16' 7" (6 m)
Vatican (Vatican City),
Stanza di Eliodoro
High Renaissance

RELIGION

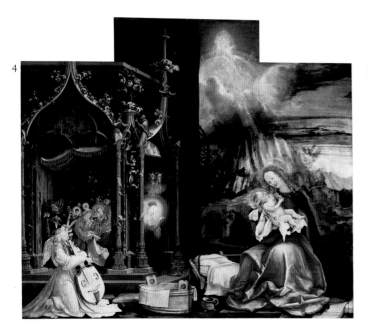

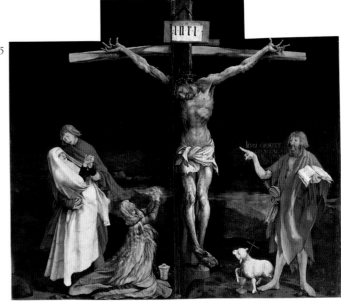

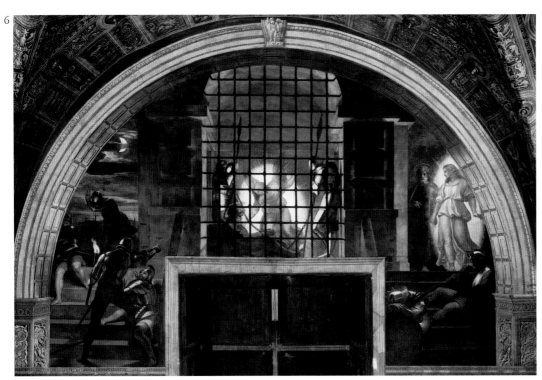

Italy witnesses an explosion of artistic excellence

During the Renaissance, painters, sculptors, and architects returned to, and revived, the lessons of the classical age. Using inspiration from a glorious past coupled with important new techniques, artists reached a pinnacle of creativity.

Renaissance means "rebirth," lending its name to the momentous upsurge in all branches of the arts. This movement reached a crescendo in the early years of the sixteenth century, the High Renaissance period. The Renaissance centered on an interest in the culture of the classical ancient world. It is no accident that this explosion of creativity occurred in Italy, where Roman architectural remains were a constant reminder of past glories. Many believed that this golden age could be restored. The revival of interest in all things classical was heightened by the rediscovery of ancient texts in the fourteenth century, which, as a result of the invention of printing, became widely available.

Artists were awakened to the wonders of the classical world, and sought not only to emulate them but also to better them, using new techniques, including perspective and oil paint. As ancient statues were unearthed, painters and sculptors mimicked the heroic poses. This in turn gave rise to the study of anatomy, and the nude quickly became a staple feature of Renaissance painting.

For centuries, the Church had been the principal patron of the arts, but now the wealthy ruling families of Italy's city-states were keen to be at the forefront of the latest intellectual trends, and to display their power by dominating artistic patronage. There was a growing tendency toward secular subjects and portraits became important. Biblical scenes remained prominent, often featuring the leading members of society, but patrons also commissioned paintings of mythological subjects for their sumptuous private villas. Some of these were straightforward illustrations of classical texts, while in other cases the legends were used as a pretext for complex, philosophical allegories.

The glorification of classical, even pagan, themes was perfectly respectable, even in Church circles. Raphael's *School of Athens* was designed for one of the papal apartments in the Vatican. In essence, it is a tribute to the learning of the ancient world. At the heart of the composition are Plato and Aristotle, the two giants of Greek philosophy. Around them, scientists and mathematicians—including Euclid, Pythagoras, and Ptolemy—discuss their theories.

The *School of Athens* dates from the heady period when Rome had become a magnet for the leading artists of the day, drawn by the patronage of Pope Julius II. Within a five-year period, between 1504 and 1509, he commissioned the great architect Donato Bramante to rebuild Saint Peter's Basilica, Michelangelo to paint the Sistine Chapel ceiling, and Raphael to create other paintings in the Vatican.

The status of the artist had risen dramatically. Before this time, even the greatest painters had been regarded as craftsmen, but now the notion of genius came into play. Raphael did not hesitate to equate the great thinkers of antiquity with major Renaissance artists. In the *School of Athens*, Plato is thought to bear the likeness of Leonardo, and the brooding figure in the foreground is Michelangelo, while Raphael himself is the youth standing second from the right.

School of Athens
Raphael, 1510–1512
High Renaissance

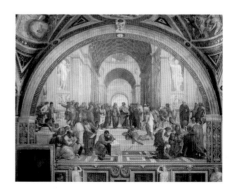

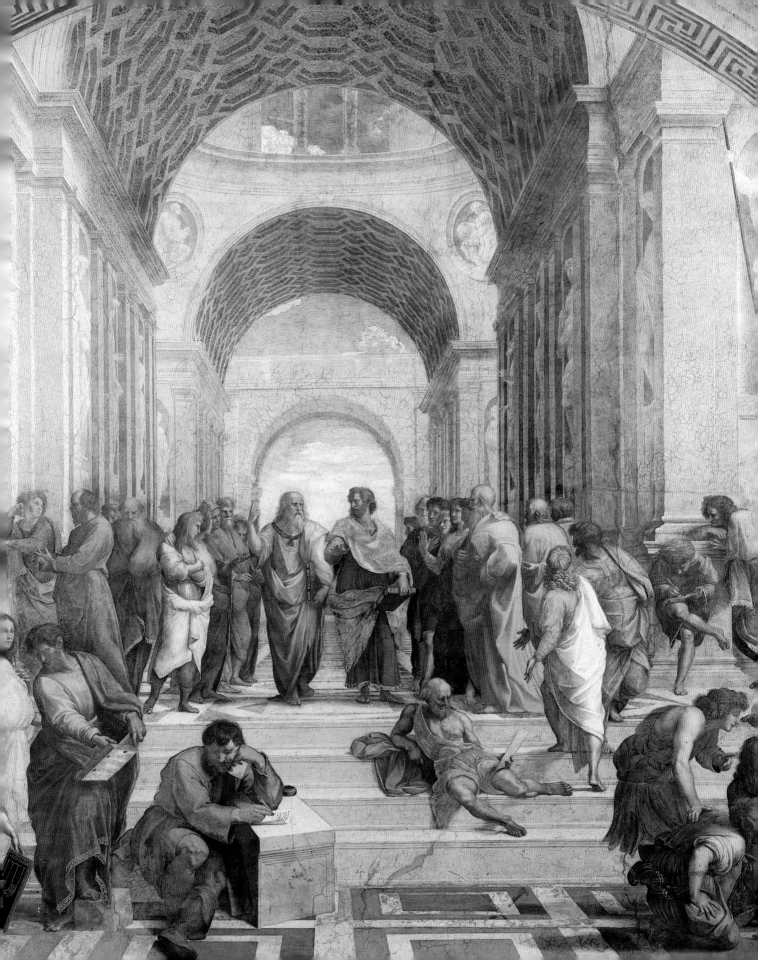

1513
Italy

1513–1514
Italy

1513–1516
Italy

1 *Triumph of Galatea*
Raphael
Fresco, 9' 8" x 7' 5" (2.9 x 2.3 m)
Rome (Italy), Villa Farnesina
High Renaissance

MYTHOLOGY
THE BODY

2 *The Sistine Madonna*
Raphael
Oil on wood,
8' 8" x 6' 7" (2.65 x 2.1 m)
Dresden (Germany),
State Art Collections
High Renaissance

RELIGION

3 *Moses, from the Tomb of Julius II*
Michelangelo Buonarroti
Marble, height: 7' 8" (2.35 m)
Rome (Italy),
Church of San Pietro in Vincoli
High Renaissance

RELIGION

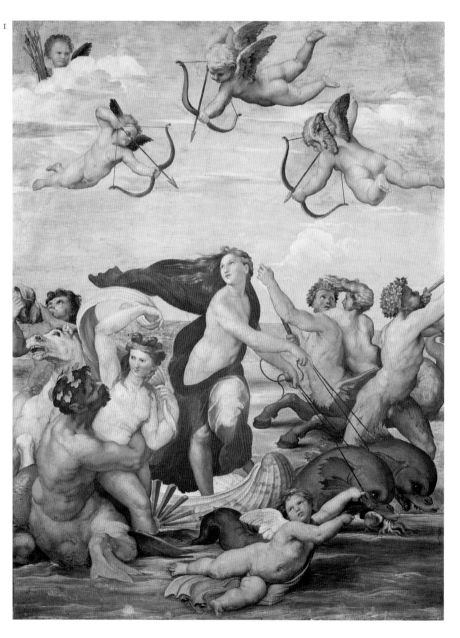

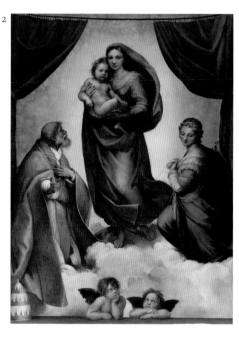

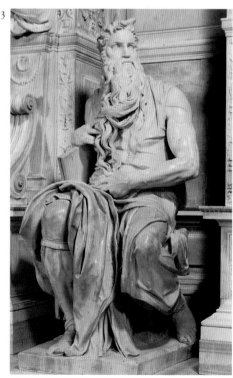

1514
Italy

1514
Netherlands

c. 1514
Germany

4 *Madonna of the Chair*
Raphael
Oil on wood, diameter: 28" (71 cm)
Florence (Italy), Pitti Palace,
Palatine Gallery
High Renaissance

RELIGION

5 *The Money Changer and His Wife*
Quentin Massys
Oil on wood,
29" x 26¾" (74 x 68 cm)
Paris (France), Louvre
Northern Renaissance

URBAN LIFE

6 *Melancholia*
Albrecht Dürer
Engraving,
9½" x 7½" (24 x 19 cm)
Corte di Mamiano (Italy),
Magnani Rocca Foundation
Northern Renaissance

ALLEGORY

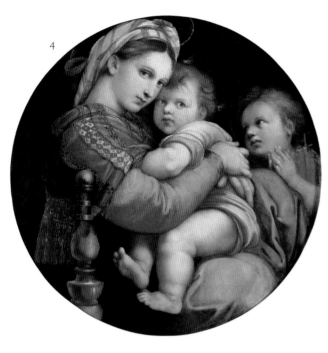

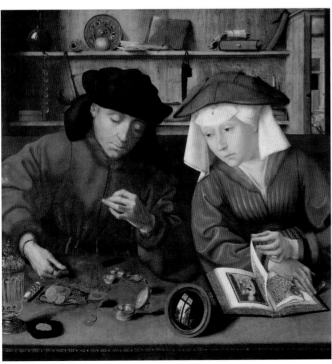

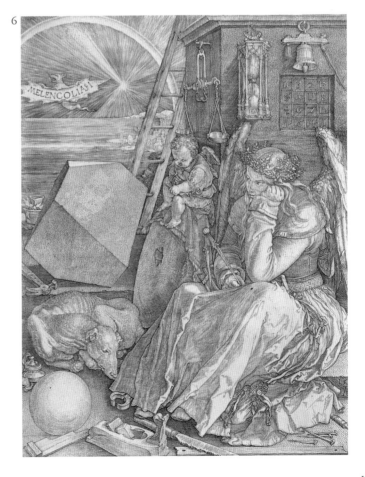

c. 1514
Italy

1515
Italy

c. 1515
Netherlands

1 *Portrait of Count*
Baldassare Castiglione
Raphael
Oil on wood, transferred to canvas,
30¼" x 26½" (82 x 67 cm)
Paris (France), Louvre
High Renaissance

PORTRAITURE

2 *Sacred and Profane Love*
Titian
Oil on canvas,
3' 10½" x 9' (1.18 x 2.8 m)
Rome (Italy), Borghese Gallery
High Renaissance

ALLEGORY
THE BODY

3 *January, from the Da Costa*
Book of Hours
Simon Bening
Manuscript illustration,
6¾" x 5" (17.2 x 12.5 cm)
New York (USA),
Pierpont Morgan Library
Northern Renaissance

URBAN LIFE

1
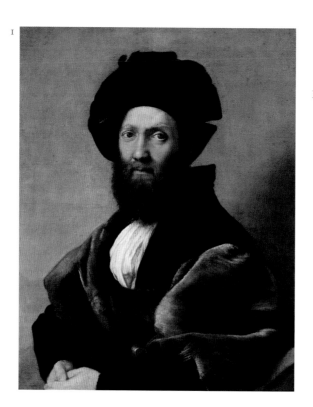

3
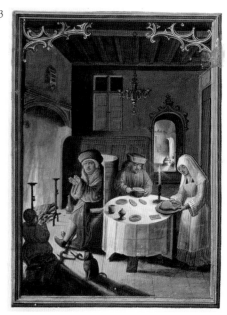

2
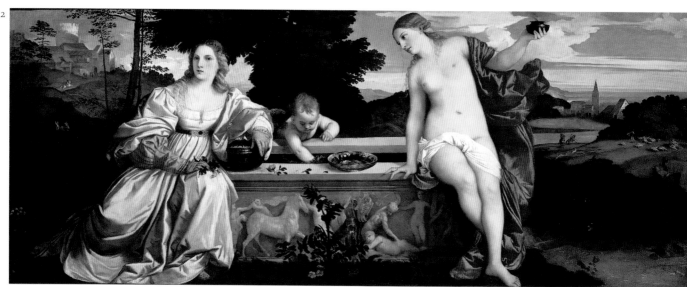

1515–1516
Netherlands

1516–1518
Italy

c. 1516
Netherlands

4 *Christ Carrying the Cross*
Hieronymus Bosch
Oil on wood, 24" x 32" (74 x 81 cm)
Ghent (Belgium),
Museum of Fine Arts
Northern Renaissance

RELIGION

5 *Assumption of the Virgin*
Titian
Oil on wood,
22' 7" x 11' 9" (6.9 x 3.6 m)
Venice (Italy), Church of the Frari
High Renaissance

RELIGION

6 *Virgin of Louvain*
Jan Gossart (Mabuse)
Oil on wood,
17¾" x 15¼" (45 x 39 cm)
Madrid (Spain), Prado
Northern Renaissance

RELIGION

4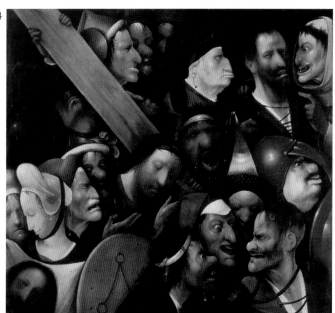

5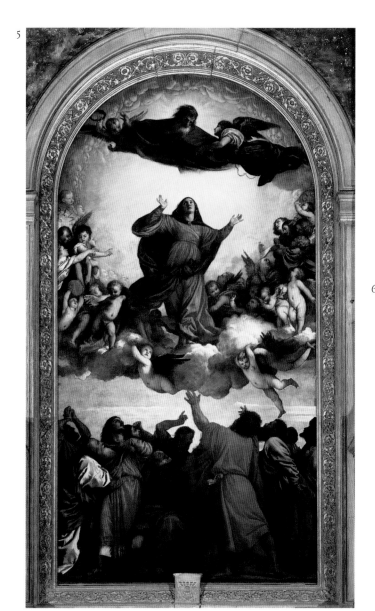

6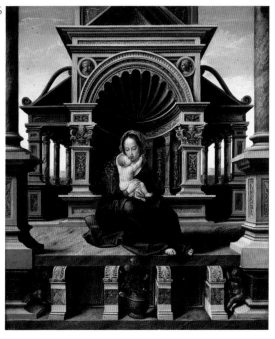

1517
Netherlands

1518–1520
Italy

c. 1520
Netherlands

1 *Portrait of Erasmus*
Quentin Massys
Oil on wood, transferred to canvas,
22¼" x 18¼" (59 x 46.5 cm)
Rome (Italy), National Gallery of
Art of the Past
Northern Renaissance

PORTRAITURE

2 *Transfiguration*
Raphael
Oil on wood, 13' x 9' (4 x 2.78 m)
Vatican (Vatican City),
Picture Gallery
High Renaissance

RELIGION

3 *The Virgin with the Bowl of Milk*
Gerard David
Oil on oak, 13¾" x 11½" (35 x 29 cm)
Brussels (Belgium), Royal
Museums of Fine Arts
Northern Renaissance

RELIGION

1
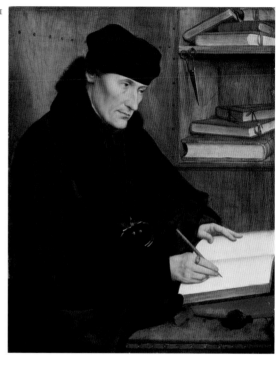

2
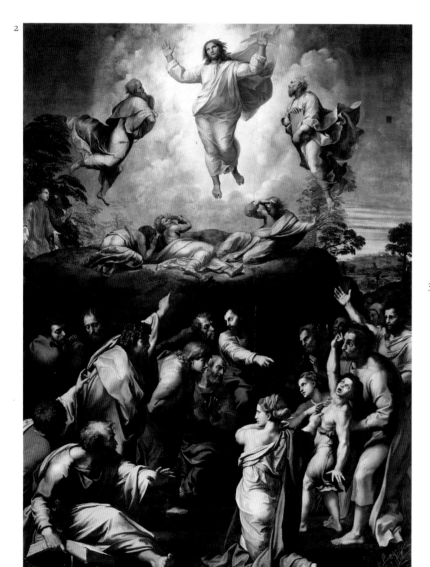

3
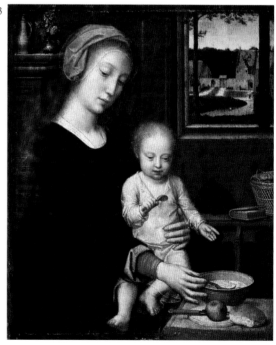

4 *Venus and Cupid with a Satyr*
Antonio Correggio
Oil on canvas,
6' 2" x 4' 1½" (1.88 x 1. 25 m)
Paris (France), Louvre
High Renaissance

MYTHOLOGY
THE BODY

5 *Tomb of Giuliano, Duke of Nemours*
Michelangelo Buonarroti
Marble, height of seated figure:
5' 10" (1.8 m)
Florence (Italy), Church of San
Lorenzo, New Sacristy
Mannerism

DEATH
PORTRAITURE

4

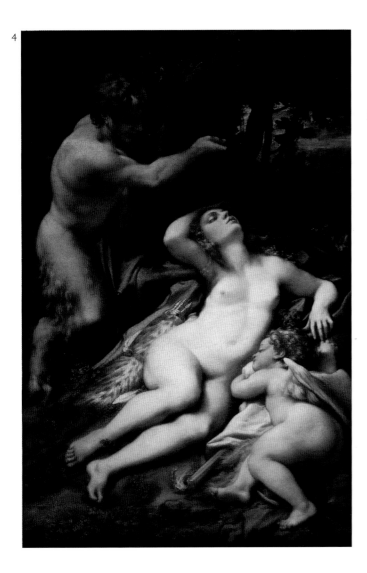

Mannerism

5

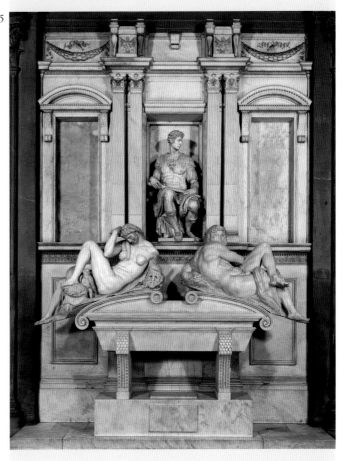

c. 1524	c. 1527	1526–1530
Italy	Italy	Italy

1 *Saint Michael*
Domenico Beccafumi
Oil on wood,
11'4½" x 7' 4" (3.5 x 2.2 m)
Siena (Italy), Church of San
Niccolò al Carmine
Mannerism

RELIGION

2 *Annunciation*
Lorenzo Lotto
Oil on canvas,
5' 5½" x 3' 8¾ " (166 x 114 cm)
Recanati (Italy), Civic Museum
High Renaissance

RELIGION
ANIMALS

3 *Assumption of the Virgin*
Antonio Correggio
Fresco, detail
Parma (Italy), Parma Cathedral
High Renaissance

RELIGION

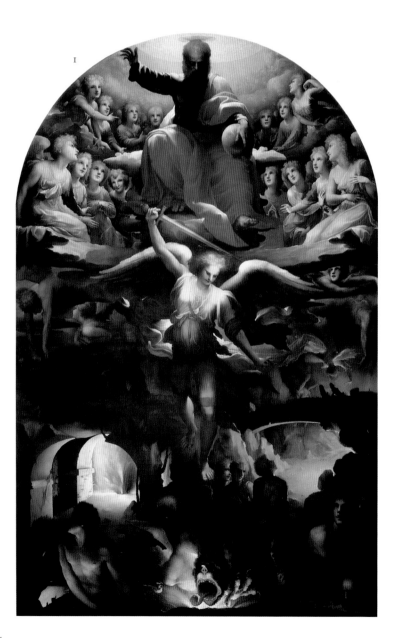

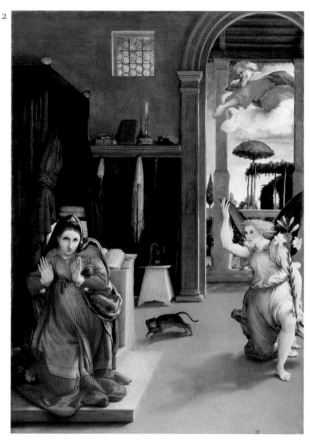

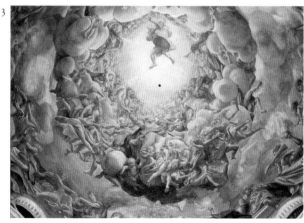

1528
Italy

1528
Switzerland

c. 1528
Italy

4 *Wedding Feast of Cupid and Psyche*
Giulio Romano
Fresco
Mantua (Italy), Palazzo del Te
High Renaissance

MYTHOLOGY
THE BODY

5 *Portrait of Nikolaus Kratzer*
Hans Holbein
Tempera on oak,
32½" x 26¼" (83 x 67 cm)
Paris (France), Louvre
Northern Renaissance

PORTRAITURE

6 *Deposition*
Jacopo Pontormo
Oil on wood,
10' 3" x 6' 3½" (3.13 x 1.92 m)
Florence (Italy),
Church of Santa Felicità
Mannerism

RELIGION
PORTRAITURE

5

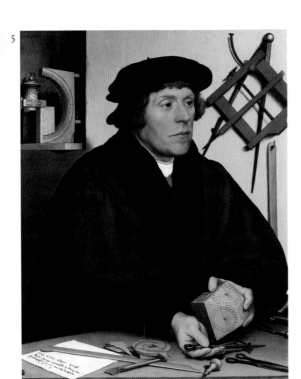

6

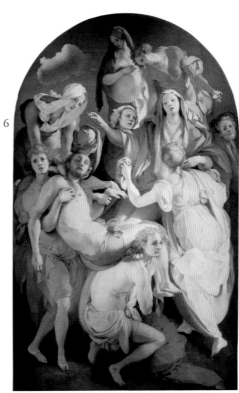

4

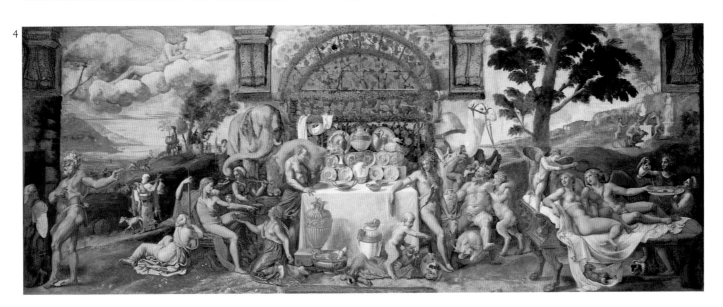

1529
Germany

1529
Germany

c. 1530
Italy

1 *Victory of Alexander over Darius,
King of the Persians*
Albrecht Altdorfer
Oil on wood,
62" x 47¼" (158 x 120.3 cm)
Munich (Germany),
Alte Pinakothek
Northern Renaissance

HISTORY
LANDSCAPE

2 *Portrait of Martin Luther*
Lucas Cranach the Elder
Oil on wood
Florence (Italy), Uffizi
Northern Renaissance

PORTRAITURE
RELIGION

3 *Portrait of a Young Woman*
Parmigianino
Oil on wood,
26½" x 21" (67 x 53 cm)
Parma (Italy), National Museum
Mannerism

PORTRAITURE

1531
Germany

c. 1532
France

1532–1534
Italy

4 *Venus and Cupid Carrying a Honeycomb*
Lucas Cranach the Elder
Oil on wood,
5' 6½" x 2' 2½" (170 x 67 cm)
Rome (Italy), Borghese Gallery
Northern Renaissance

MYTHOLOGY
THE BODY

5 *Detail of the Bedchamber of the Duchesse d'Estampes*
Francesco Primaticcio
Fresco and high-relief stucco
Fontainebleau (France),
Fontainebleau Palace
Mannerism

THE BODY

6 *The Giants Hurled Down from Olympus*
Giulio Romano
Fresco, detail
Mantua (Italy), Palazzo del Te
Mannerism

MYTHOLOGY

5
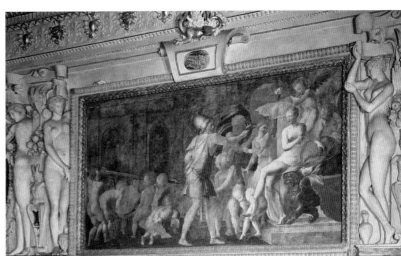

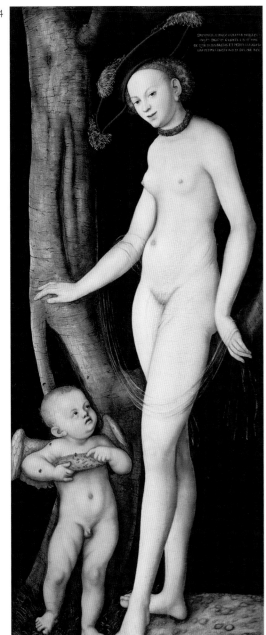

6
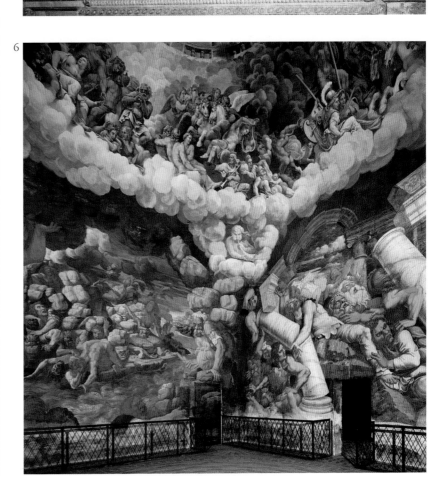

147

1 *The Penitent Magdalen*
Titian
Oil on wood,
33½" x 26¾" (85 x 68 cm)
Florence (Italy), Pitti Palace,
Palatine Gallery
High Renaissance

RELIGION
THE BODY

2 *Iskander Comforting the Dying
Dara, from the "Khamsa" of Nizami*
Artist unknown
Manuscript illustration
London (UK), British Library
Herat

DEATH
WAR

3 *Last Judgement*
Michelangelo Buonarroti
Fresco, detail
Vatican (Vatican City),
Sistine Chapel
Mannerism

RELIGION
DEATH

1

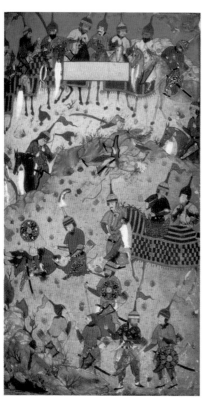

2

3

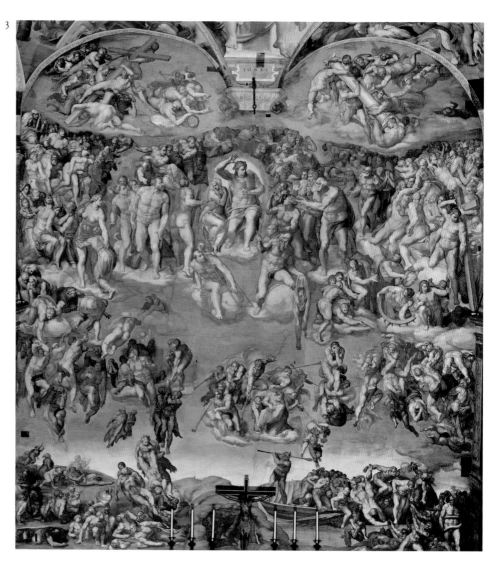

1538
Italy

1538
Netherlands

c. 1540
France

4 *The Venus of Urbino*
Titian
Oil on canvas,
3' 10¾" x 5' 5" (1.19 x 1.65 m)
Florence (Italy), Uffizi
High Renaissance

THE BODY

5 *A Moneychanger and His Wife*
Marinus van Reymerswaele
Oil on wood,
31" x 42" (79 x 107 cm)
Madrid (Spain), Prado
Northern Renaissance

URBAN LIFE

6 *Portrait of Francis I on Horseback*
François Clouet
Oil on canvas,
10¾" x 8¾" (27.5 x 22.5 cm)
Florence (Italy), Uffizi
High Renaissance

PORTRAITURE

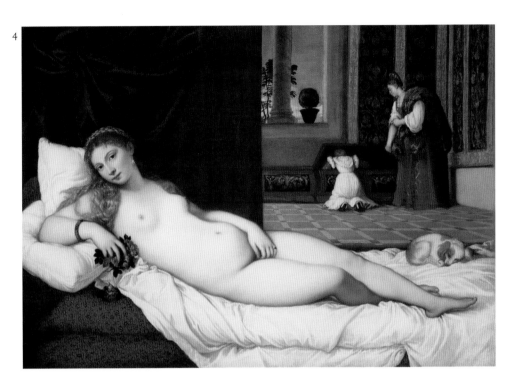

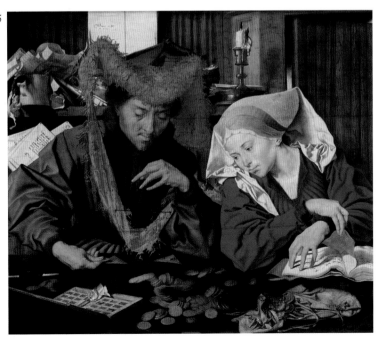

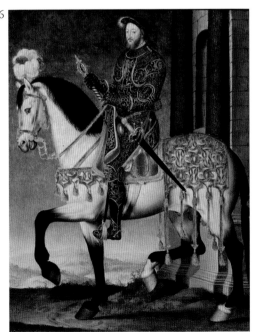

C. 1543
Japan

1544–1545
Italy

C. 1545–1554
Italy

1 *Landscape with Mountains*
Kantei
Hanging scroll,
19½" x 12½" (50 x 31.7 cm)
London (UK), British Museum
Japanese, Muromachi period

LANDSCAPE

2 *Portrait of Eleonora of Toledo with
Her Son Giovanni de' Medici*
Agnolo Bronzino
Oil on wood,
45¼" x 37¾" (115 x 96 cm)
Florence (Italy), Uffizi
Mannerism

PORTRAITURE

3 *Perseus*
Benvenuto Cellini
Bronze statue on marble stand
with bronze figurines, height with
stand: 18' (5.5 m)
Florence (Italy), Loggia dei Lanzi
Mannerism

MYTHOLOGY
THE BODY

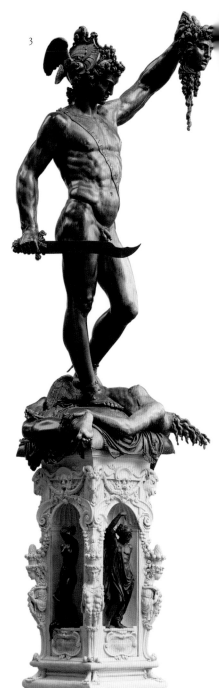

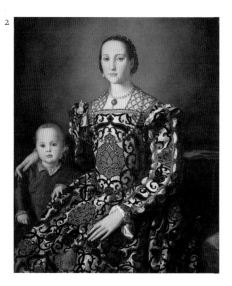

4 *Hare*
Hans Hoffmann after **Albrecht Dürer**
Parchment transferred to wood,
22½" x 19¼" (57 x 49 cm)
Rome (Italy),
National Gallery of Art of the Past
Northern Renaissance

ANIMALS

5 *Bust of Cosimo I*
Benvenuto Cellini
Bronze, height: 41¾" (106 cm)
Florence (Italy),
Bargello Museum
Mannerism

PORTRAITURE

6 *Pietà*
Michelangelo Buonarroti
Marble, height: 7' 6" (2.3 m)
Florence (Italy),
Opera dell'Duomo Museum
Mannerism

RELIGION
PORTRAIT

5

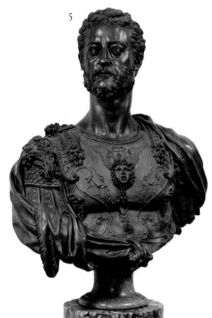

6

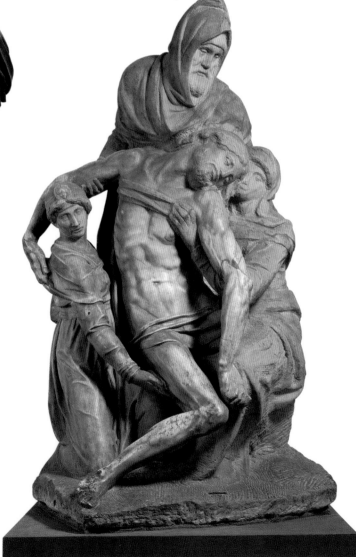

4

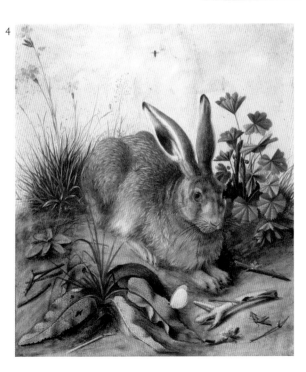

1548
Italy

1548
Italy

1549
Italy

1 *Equestrian Portrait of Charles V*
Titian
Oil on canvas,
10' 9" x 9' (3.32 x 2.79 m)
Madrid (Spain), Prado
High Renaissance

PORTRAITURE

2 *Miracle of Saint Mark*
Freeing the Slave
Jacopo Tintoretto
Oil on canvas,
13' 6" x 17' 9" (4.15 x 5.41 m)
Venice (Italy),
Accademia Gallery
Mannerism

RELIGION

3 *Portrait of Philip II in Armor*
Titian
Oil on canvas,
6' 4" x 3' 7¾" (1.93 x 1.11 m)
Madrid (Spain), Prado
High Renaissance

PORTRAITURE

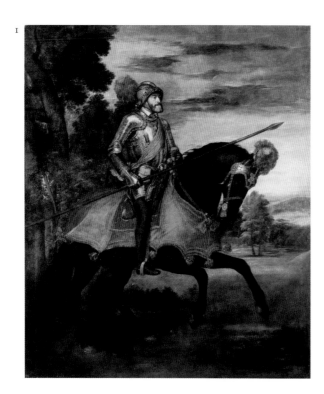

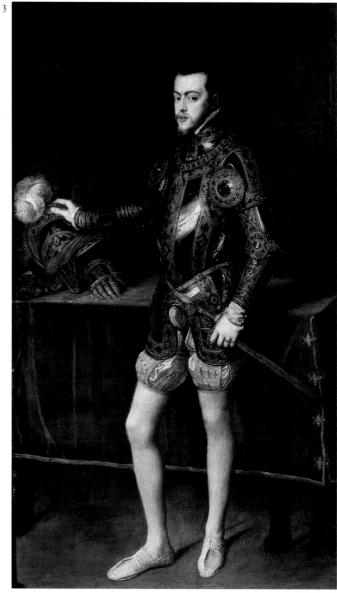

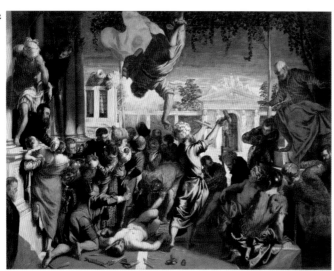

c. 1550
Japan

1559
Italy

1560–1570
Japan

4 *Pavilions in a Mountain Landscape*
Artist unknown
Ink and watercolor on paper,
5' x 3' 2" (152 x 97 cm)
Philadelphia (USA),
Philadelphia Museum of Art
Japanese, Muromachi period

LANDSCAPE

5 *Self-Portrait at the Spinet*
Sofonisba Anguissola
Oil on wood,
23" x 19½" (58.5 x 49.5 cm)
Naples (Italy),
Capodimonte Museum
High Renaissance

PORTRAITURE

6 *Illustration to the "Tale of Monkeys"*
Artist unknown
Painted handscroll, detail
London (UK), British Museum
Japanese, Muromachi period

ANIMALS

4
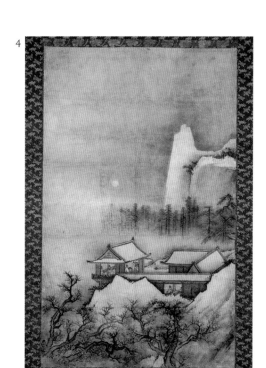

5
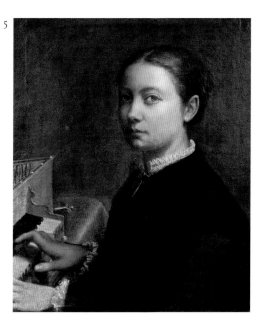

6
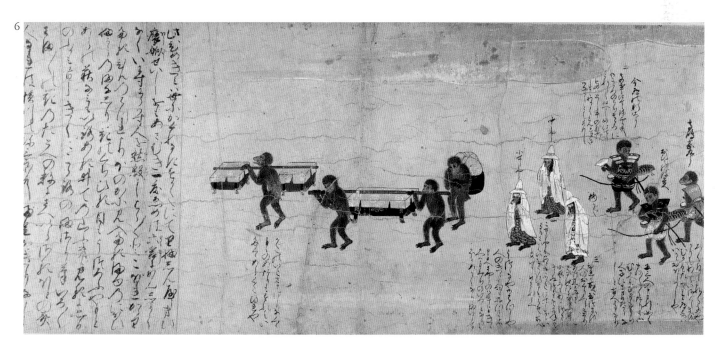

1562
Netherlands

1563–1565
Italy

c. 1565
Italy

1 *Fall of the Rebel Angels*
Pieter Bruegel the Elder
Oil on wood,
3' 10" x 5' 3¾" (1.17 x 1.62 m)
Brussels (Belgium), Royal
Museums of Fine Arts
Northern Renaissance

RELIGION

2 *Taking of Pisa*
Giorgio Vasari and assistants
Fresco, detail
Florence (Italy), Palazzo Vecchio,
Salone del Cinquecento
Mannerism

HISTORY

3 *Mercury*
Giambologna
Bronze, height: 6' 1½" (1.87 m)
Florence (Italy),
Bargello Museum
Mannerism

MYTHOLOGY
THE BODY

3

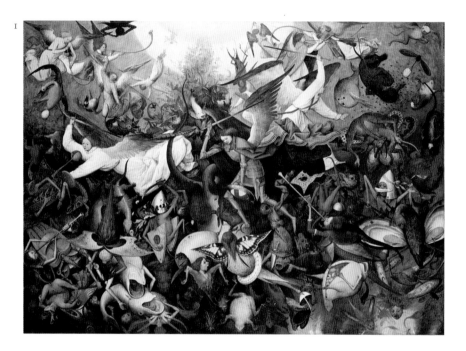

1

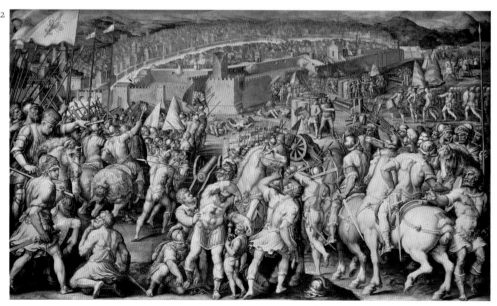

2

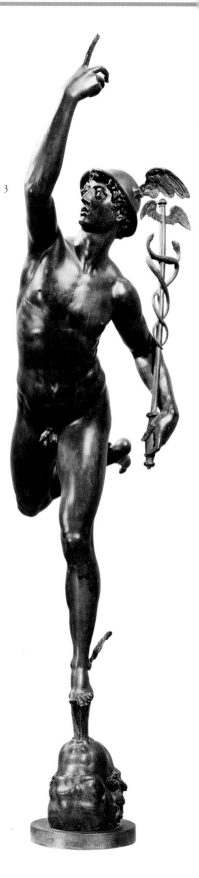

1565
Netherlands

1566
Netherlands

1566–1568
Italy

4 *Haymaking (July)*
Pieter Bruegel the Elder
Oil on canvas,
4' x 5' 3½" (1.21 x 1.6 m)
Prague (Czech Republic),
National Gallery
Northern Renaissance

RURAL LIFE

5 *Triumph of Death*
Pieter Bruegel the Elder
Oil on wood,
3' 10" x 5' 3¾" (117 x 162 cm)
Madrid (Spain), Prado
Northern Renaissance

DEATH

6 *Self-Portrait*
Giorgio Vasari
Oil on wood,
39½" x 31½" (100 x 80 cm)
Florence (Italy), Uffizi
Mannerism

PORTRAITURE

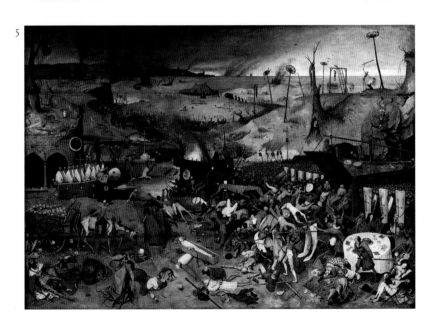

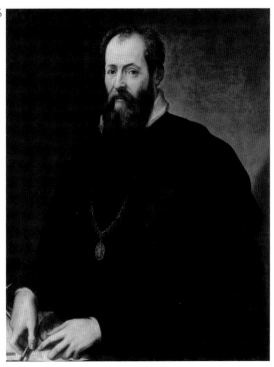

1567–1568
Netherlands

1568
Netherlands

1568
Netherlands

1 *Landscape with the Fall of Icarus*
Pieter Bruegel the Elder
Oil on wood, transferred to canvas,
29" x 44" (73.7 x 112 cm)
Brussels (Belgium),
Royal Museums of Fine Arts
Northern Renaissance

LANDSCAPE
MYTHOLOGY

2 *The Beggars*
Pieter Bruegel the Elder
Oil on wood, 7" x 8¼" (18 x 21 cm)
Paris (France), Louvre
Northern Renaissance

URBAN LIFE
THE BODY

3 *Parable of the Blind Leading
the Blind*
Pieter Bruegel the Elder
Tempera on canvas,
2' 10" x 5' ½" (86 x 154 m)
Naples (Italy),
Capodimonte Museum
Northern Renaissance

RELIGION

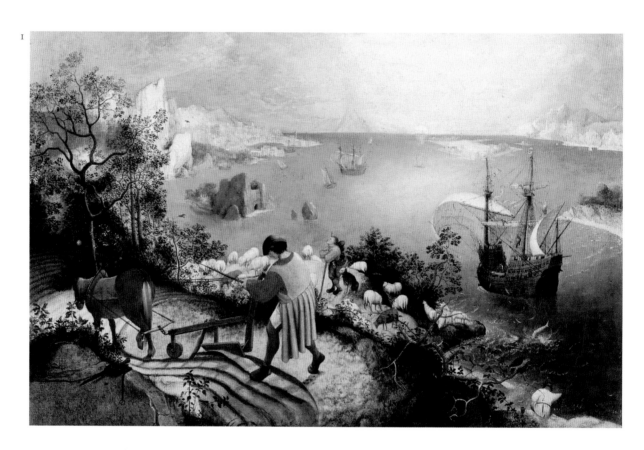

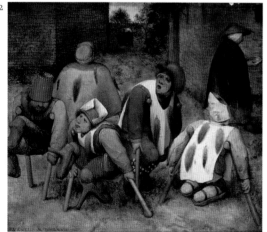

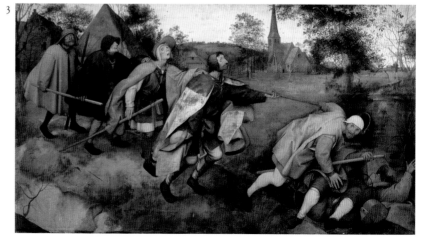

4 *Ornamental endpiece*
from a Qur'an
Artist unknown
Manuscript page
London (UK), British Library
Arabic

RELIGION

5 *The Wool Factory*
Mirabello Cavalori
Oil on panel,
4' 2" x 2' 11¾" (127 x 91 cm)
Florence (Italy),
Palazzo Vecchio, Studiolo
Mannerism

WORK
THE BODY

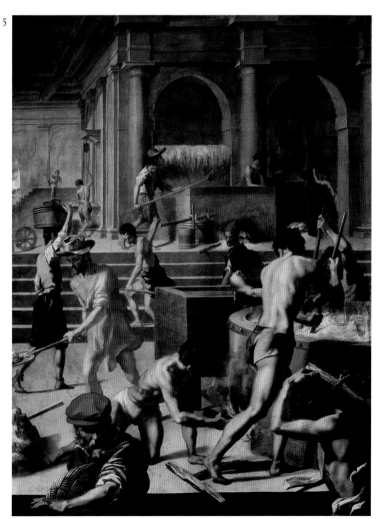

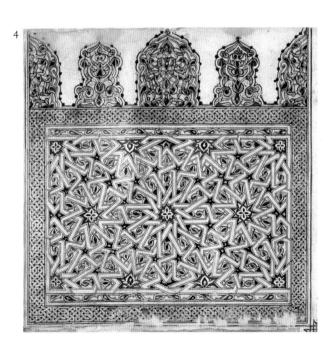

1573
Italy

1573
Italy

1573
Italy

1573
Italy

1 *Spring*
Giuseppe Arcimboldo
Oil on canvas,
30" x 25" (76 x 63.5 cm)
Madrid (Spain), San Fernando
Royal Academy of Fine Arts
Mannerism

STILL LIFE
FANTASY

2 *Summer*
Giuseppe Arcimboldo
Oil on canvas,
30" x 25" (76 x 63.5 cm)
Paris (France), Louvre
Mannerism

STILL LIFE
FANTASY

3 *Autumn*
Giuseppe Arcimboldo
Oil on canvas,
30" x 25" (76 x 63.5 cm)
Paris (France), Louvre
Mannerism

STILL LIFE
FANTASY

4 *Winter*
Giuseppe Arcimboldo
Oil on canvas,
30" x 25" (76 x 63.5 cm)
Paris (France), Louvre
Mannerism

STILL LIFE
FANTASY

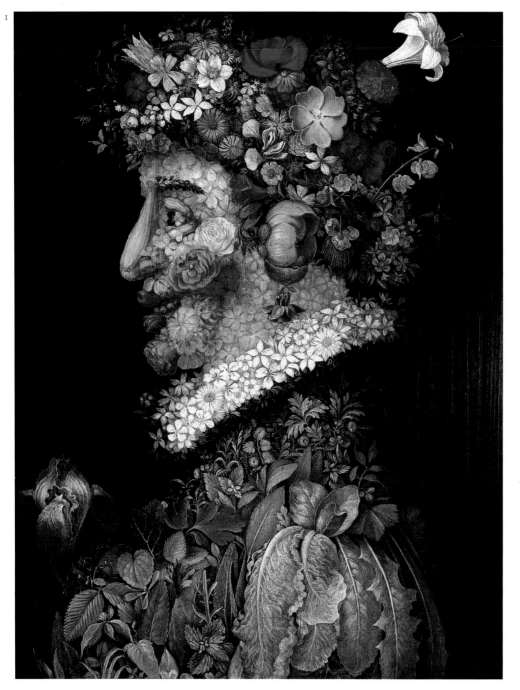

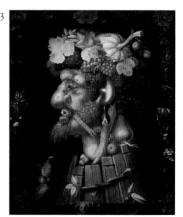

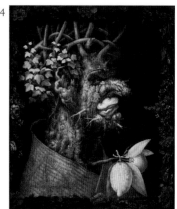

1573
Italy

c. 1575
Japan

1576
Italy

5 *Feast in the House of Levi*
Paolo Veronese
Oil on canvas,
18' 1" x 42' (5.55 x 12.8 m)
Venice (Italy), Accademia Gallery

RELIGION

6 *The Four Seasons with the Sun
and the Moon (detail)*
Artist unknown
Four folds of a six-fold screen
painting, with gold and silver leaf,
entire screen:
4' 10" x 9' 10" (1.47 x 3 m)
London (UK), British Museum
Japanese, Momoyama period

LANDSCAPE

7 *Bacchus and Ariadne*
Jacopo Tintoretto
Oil on canvas,
4' 9½" x 5' 3¾" (1.46 x 1.57 m)
Venice (Italy), Doge's Palace
Mannerism

MYTHOLOGY
THE BODY

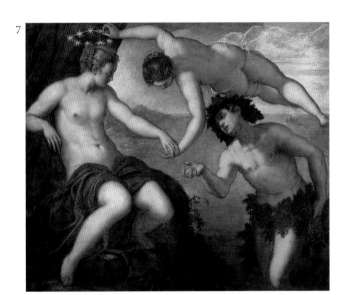

7

6

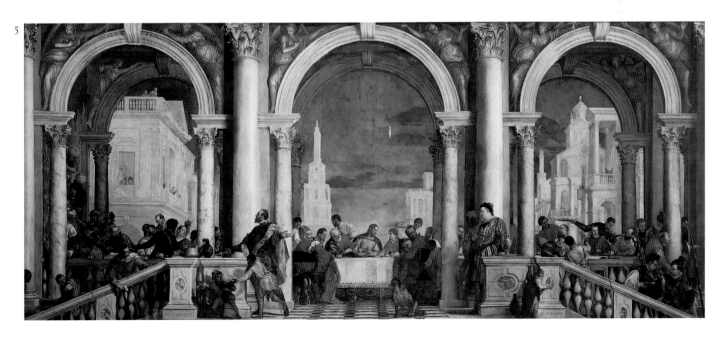

5

1576
Italy

1578
Italy

c. 1580
France

1 *Pietà*
Titian
Oil on canvas,
11' 6½" x 11' 5" (3.52 x 3.49 m)
Venice (Italy), Accademia Gallery

RELIGION
DEATH

2 *Self-Portrait*
Lavinia Fontana
Oil on wood,
10¾" x 9¾" (27.5 x 24.9 cm)
Florence (Italy), Uffizi
Mannerism

PORTRAITURE

3 *Our Lady of Sorrows*
Germain Pilon
Terracotta, height: 6' 6" (1.68 m)
Paris (France), Louvre

RELIGION

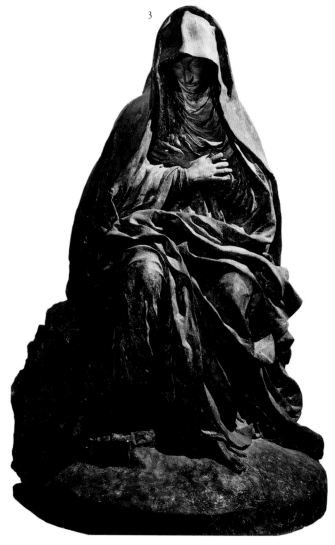

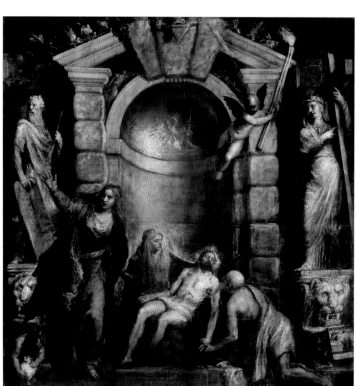

c. 1580
Italy

1580
Italy

c. 1580–1600
England

4 *Portrait of Niccolò Macchiavelli*
Santi di Tito
Oil on canvas
Florence (Italy), Palazzo Vecchio

POLITICS
PORTRAITURE

5 *Fountain of the Apennines*
Giambologna
Stone
Pratolino (Italy), Villa Demidoff
Mannerism

ALLEGORY
LANDSCAPE

6 *Portrait of Elizabeth I*
Artist unknown
Oil on wood, 5' 9¼" x 4' 8¾"
(1.76 x 1.44 m)
Florence (Italy), Pitti Palace,
Palatine Gallery

PORTRAITURE
POLITICS

5

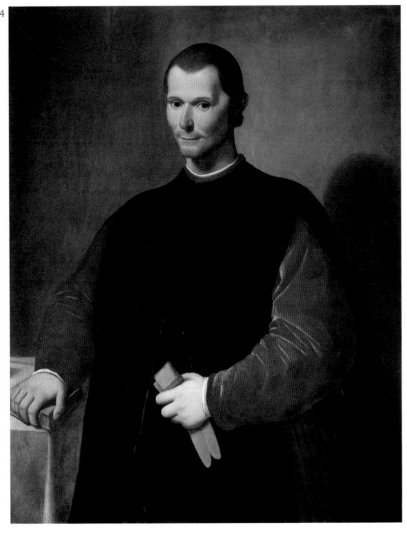

4

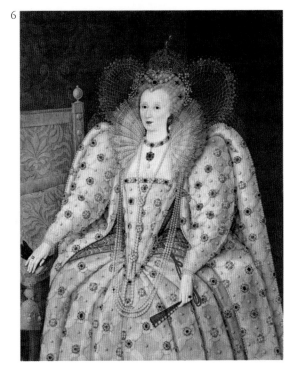

6

1582
Italy

1 *Rape of the Sabine Woman*
Giambologna
Marble, height: 13' 6" (4.1 m)
Florence (Italy), Loggia dei Lanzi
Mannerism

MYTHOLOGY
HISTORY

1583–1584
Italy

2 *The Bean Eater*
Annibale Carracci
Oil on canvas,
22½" x 26¾" (57 x 68 cm)
Rome (Italy), Colonna Gallery

RURAL LIFE

1586–1588
Spain

3 *The Burial of Count of Orgaz*
El Greco
Oil on canvas,
13' 2"x 10' (4.6 x 3.6 m)
Toledo (Spain),
Church of San Tomé
Mannerism

DEATH
PORTRAITURE

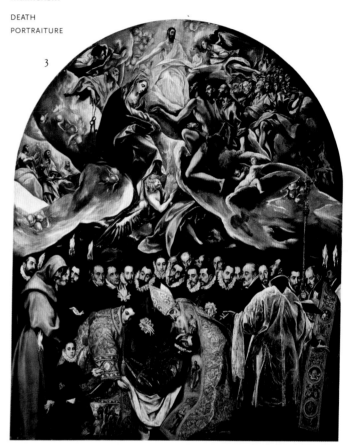

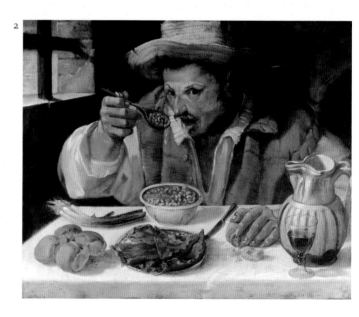

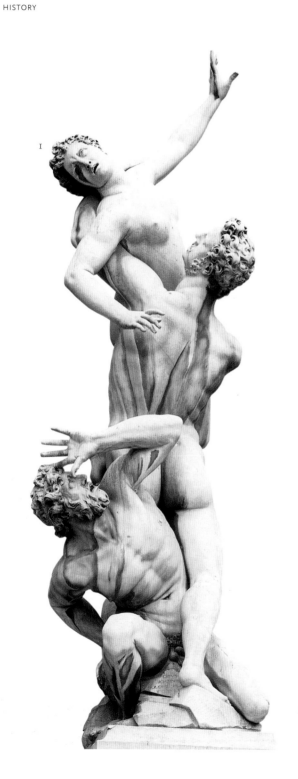

c. 1590
France

c. 1590
Italy

1592–1594
Italy

4 *Gabrielle d'Estrées and Her Sister,*
the Duchesse de Villars
Artist unknown
Oil on wood,
37¾" x 49¼" (96 x 125 cm)
Paris (France), Louvre
Mannerism

PORTRAITURE
THE BODY

5 *Vegetables in a Bowl* or
The Vegetable Gardener
Giuseppe Arcimboldo
Oil on wood,
13¾" x 9½" (35 x 24 cm)
Cremona (Italy), Civic Museum
Mannerism

STILL LIFE
FANTASY

6 *Last Supper*
Jacopo Tintoretto
Oil on canvas,
12' x 8' 7" (3.65 x 5.68 m)
Venice (Italy),
Church of San Giorgio Maggiore
Mannerism

RELIGION

4
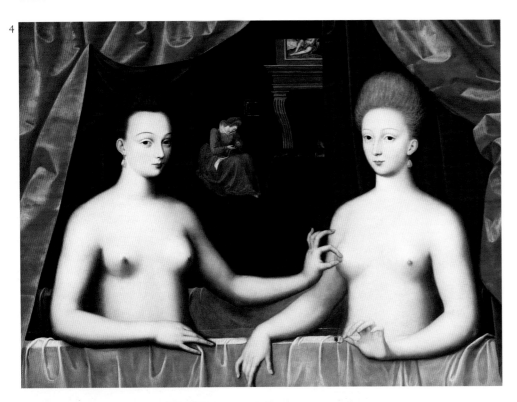

5
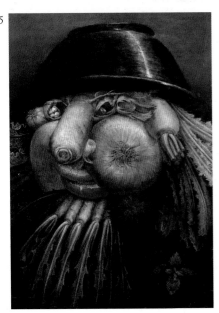

6
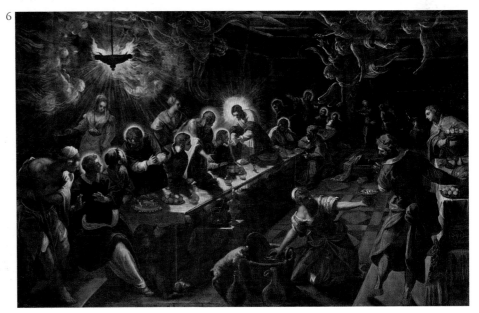

1 *Saint Catherine*
Michelangelo da Caravaggio
Oil on canvas,
5' 8 " x 4' 4¼" (1.73 x 1.33 m)
Madrid (Spain), Thyssen-
Bornemisza Museum
Baroque

RELIGION

2 *Nativity*
Federico Barocci
Oil on canvas,
4' 4½" x 3' 5¼" (1.34 x 1.05 m)
Madrid (Spain), Prado
Baroque

RELIGION

Baroque

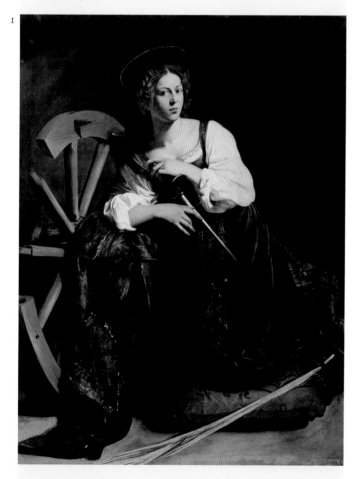

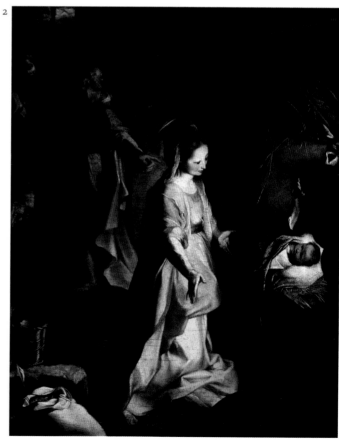

1597–1602
Italy

1598–1599
Italy

c. 1600
Turkey

3 *Triumph of Bacchus and Ariadne*
Annibale Carracci
Fresco, detail
Rome (Italy), Farnese Palace
Baroque

MYTHOLOGY
BODY

4 *Medusa*
Michelangelo da Caravaggio
Oil on canvas mounted on
a convex poplar shield,
23½" x 21¾" (60 x 55 cm)
Florence (Italy), Uffizi
Baroque

MYTHOLOGY

5 *A Young Prince on Horseback*
Artist unknown
Manuscript illustration
London (UK), British Library
Ottoman/Tabriz

ANIMALS
PORTRAITURE

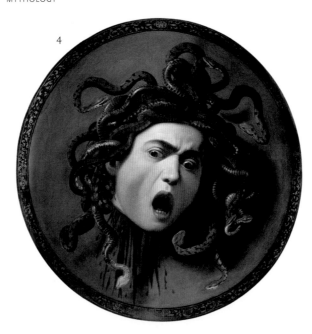
4

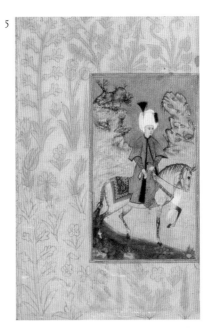
5

3

c. 1600–1700
Japan

c. 1600
Italy

1600–1601
Italy

1 *Writing Box*
Artist unknown
Black lacquer, height: 1¾" (4.5 cm)
London (UK), British Museum
Japanese, Edo period

LANDSCAPE

2 *Family Portrait*
Lavinia Fontana
Oil on canvas,
33½" x 41½" (85 x 105 cm)
Milan (Italy), Brera Gallery
Mannerism

PORTRAITURE

3 *Conversion of Saint Paul*
Michelangelo da Caravaggio
Oil on canvas,
7' 6" x 5' 9" (2.3 x 1.75 m)
Rome (Italy), Church of Santa
Maria del Popolo
Baroque

RELIGION
ANIMALS

3
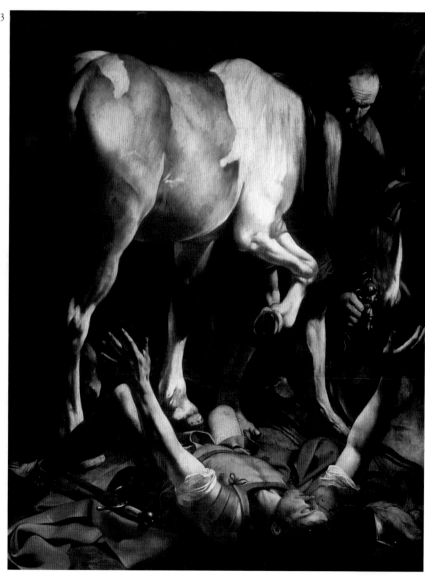

1

2
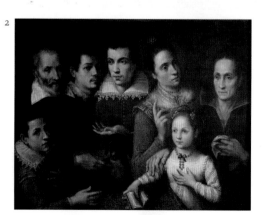

c. 1600–1610
Japan

c. 1600–1800
Japan

c. 1600–1605
Spain

4 *Poetess Onono-Komaki*
Artist unknown **(Tosa School)**
Scroll painting
Genoa (Italy), Chiossone Museum
Japanese, Edo period

PORTRAITURE

5 *Game Box Decorated with Scenes*
from the "Tale of Genji"
Artist unknown
Wood covered with paper,
height: 14" (35.6 cm)
London (UK), British Museum
Japanese, Edo period

LITERATURE

6 *Agony in the Garden*
El Greco
Oil on canvas,
5' 7" x 3' 8¼" (1.7 x 1.12 m)
Cuenca (Spain),
Diocesan Museum
Mannerism

RELIGION

4

5

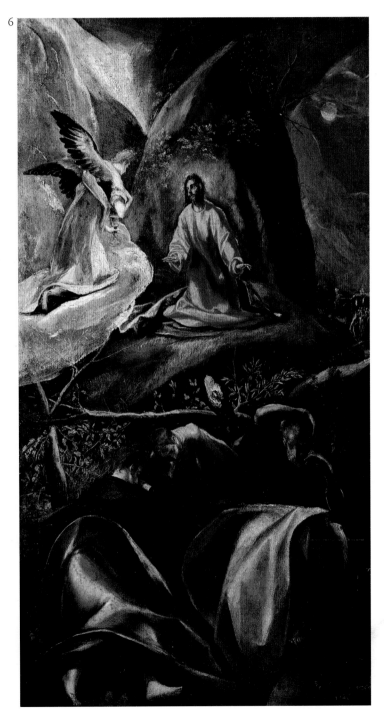

6

1602–1603
Italy

c. 1603
Spain

1609
Netherlands

1 *Entombment of Christ*
Michelangelo da Caravaggio
Oil on canvas,
9' 10" x 6' 7" (3.2 x 2.3 m)
Vatican (Vatican City),
Picture Gallery
Baroque

RELIGION

2 *Portrait of the Artist's Son,*
Jorge Manuel Greco
El Greco
Oil on canvas,
32" x 22" (81.3 x 55.8 cm)
Seville (Spain),
Museum of Fine Arts
Mannerism

PORTRAITURE

3 *Self-Portrait with His First Wife,*
Isabella Brant
Peter Paul Rubens
Oil on canvas
5' 10½" x 4' 5½" (1.79 x 1.36 m)
Munich (Germany),
Alte Pinakothek
Baroque

PORTRAITURE

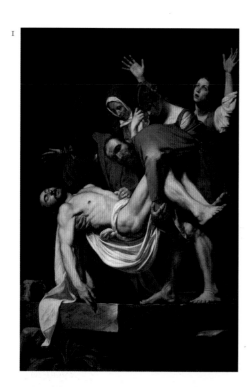

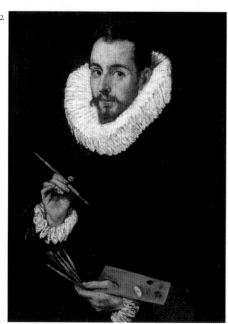

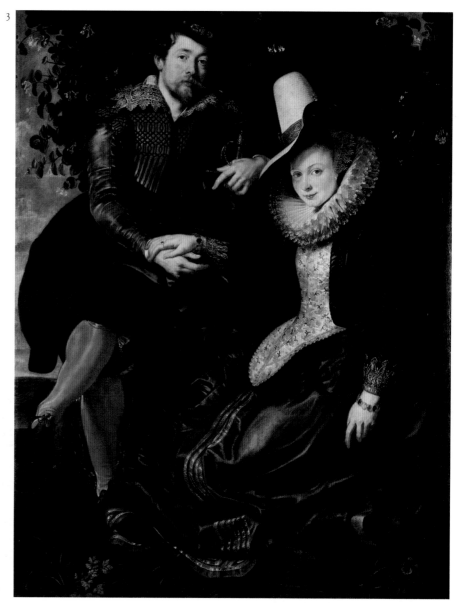

1611–1612
Italy

1615
Germany

1616–1617
Italy

4 *Judith Beheading Holofernes*
Artemisia Gentileschi
Oil on canvas,
5' 2½" x 4' 1½" (1.6 x 1.25 m)
Naples (Italy),
Capodimonte Museum
Baroque

RELIGION

5 *Still Life with Parrot*
Georg Flegel
Oil on wood, transferred to canvas,
11¾" x 14¾" (30 x 37.5 cm)
Nuremberg (Germany),
Germanisches Museum
Baroque

STILL LIFE
ANIMALS

6 *Assumption*
Guido Reni
Oil on canvas,
15' 6" x 9' 3" (4.4 x 2.9 m)
Genoa (Italy), Church of
Sant'Ambrogio
Baroque

RELIGION

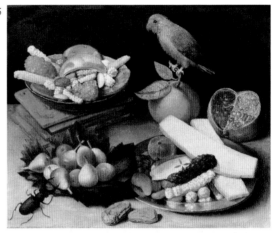

5

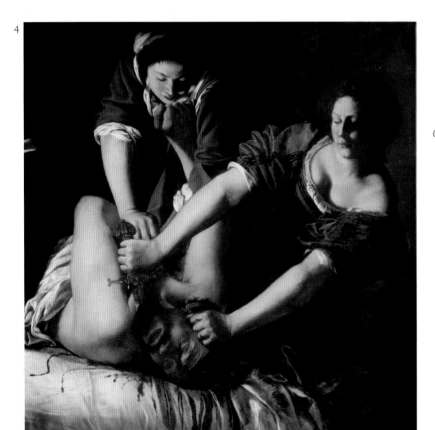

4

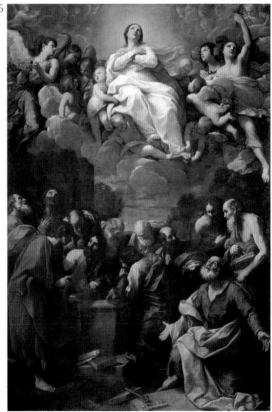

6

Dutch art reflects the society's joy in everyday life

With the rise of the Dutch republic, new forms of art became popular. The emergent wealthy merchant class chose to spend their money on portraits, landscapes, scenes of Dutch life, and still-life pictures.

The Netherlands had been part of the Spanish empire until the northern provinces finally gained independence in 1606. Holland, the richest of the provinces, rose rapidly, becoming a major maritime power in the seventeenth century, with extensive colonies. The Dutch spent much of their new wealth on the arts. Visitors to the country were amazed, both at the number of pictures that they saw, as well as the people who bought them. The diarist John Evelyn noted: "'Tis an ordinary thing to find a common farmer lay out 2,000 or 3,000 pounds in this commodity; their houses are full of them." Another traveler observed: "All in general strive to adorn their houses, especially the outer or street room, with costly pieces."

The fact that owning art was commonplace had a profound impact on the type of art that was produced. Relatively few commissions came from powerful aristocrats or high-ranking churchmen, so there was little demand for the grandiose historical or allegorical scenes that filled the palaces in other parts of Europe. Calvinism, an austere form of Protestantism that opposed the decoration of churches with costly trappings, was the prevailing religion. Bourgeois patrons, who wanted comparatively small pictures, suitable for their modest town houses, dominated the art market instead. They preferred paintings that reflected their everyday lives and the world they inhabited.

Dutch landscape painting denied all forms of pretension, keeping as close as possible to nature itself. Dutch painters dispensed with idealized shepherds and architectural follies, spectacular panoramas and glowing sunsets. Instead, they concentrated on the simplest of scenes: a tranquil river, a field with cattle, an avenue of poplars. They lavished the same care and attention on nature in a smaller scale. The term still life originated in Holland (*stilleven*) and some artists specialized in arrangements of fruit, fish, shells, breakfast tables, and banquet scenes. Passionate about horticulture, the Dutch invested huge sums of money in rare plants, and they adored flower arrangements, both real and pictorial. There may even be a grain of truth in the anecdote that flower still lifes were popular because those who could not afford to buy the actual flowers commissioned them.

Portraiture was also important and the Dutch prized candor and vitality above dignity and grandeur in their portraits. The first Dutch artist to give his portraits a freshness, intimacy, and spontaneity was Frans Hals. His sitters appear relaxed, friendly, and approachable. They are often captured smiling or laughing, and he shows them turning around or looking up, as if he has just interrupted them. This *Group of Children* is typical of his work, depicting ordinary people and celebrating their joy of life. Hals perfectly reflected a society that was proud of its way of living and integrated art as an essential aspect of its way of life.

The Group of Children
Frans Hals, c. 1620
Dutch Seventeenth Century

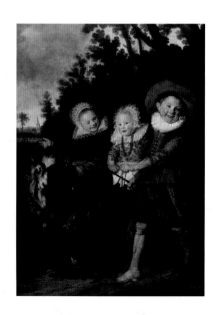

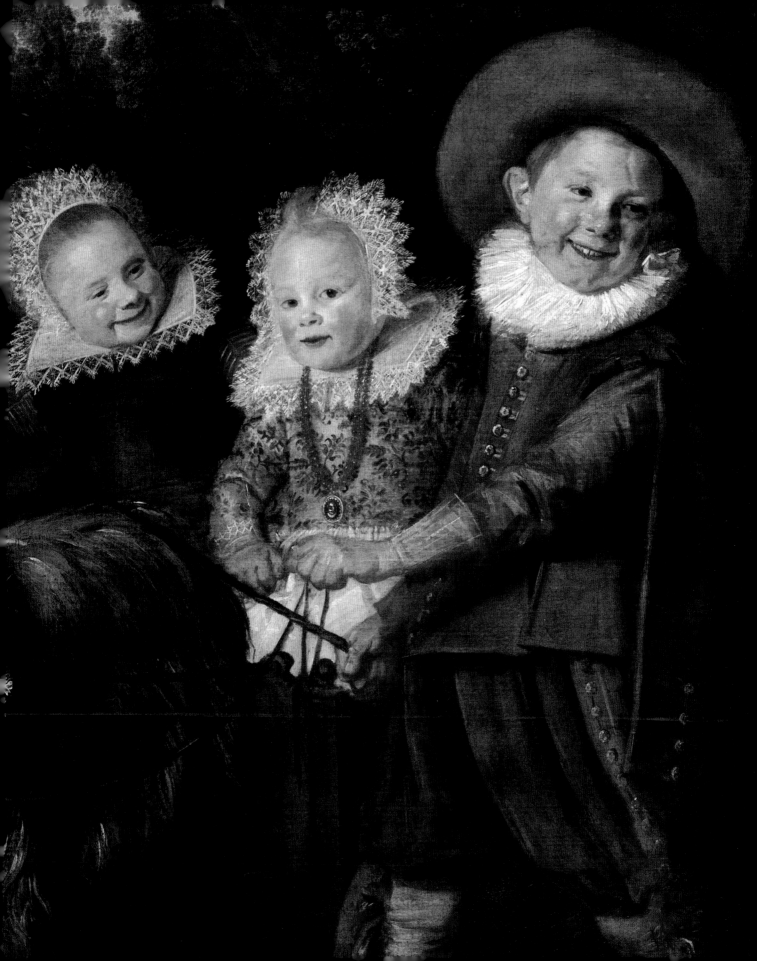

1618–1622
Italy

1621–1622
Italy

1622–1624
Italy

1 *Et in Arcadia Ego*
Il Guercino (Francesco Barbieri)
Oil on canvas,
32¼" x 35¼" (82 x 91 cm)
Rome (Italy),
National Gallery of Art of the Past
Baroque

MYTHOLOGY

2 *Pluto and Proserpina*
Giovanni Lorenzo Bernini
Marble, height: 9' 8" (2.95 m)
Rome (Italy), Borghese Gallery
Baroque

MYTHOLOGY
THE BODY

3 *Apollo and Daphne*
Giovanni Lorenzo Bernini
Marble, height: 8' (2.43 m)
Rome (Italy), Borghese Gallery
Baroque

MYTHOLOGY
THE BODY

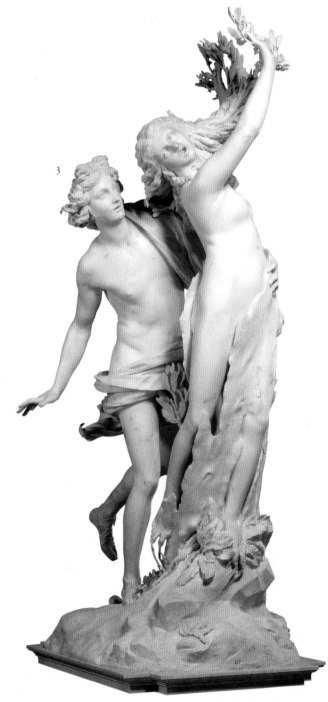

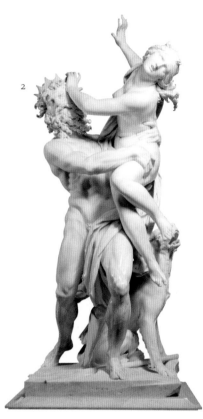

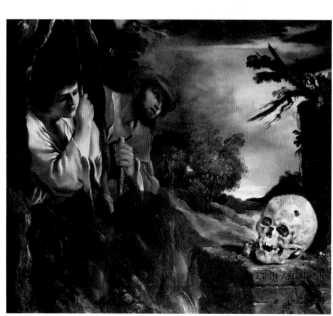

1623
Netherlands

1625–1628
Italy

1628
Netherlands

4 *The Merry Company*
Dirck Hals
Oil on wood,
17" x 18½" (43 x 47 cm)
Saint Petersburg (Russia),
State Hermitage Museum
Dutch Seventeenth Century

LEISURE

5 *Allegory of Water, from*
The Four Elements
Francesco Albani
Oil on wood,
diameter: 5' 10¾" (1.8 m)
Turin (Italy), Sabauda Gallery
Baroque

ALLEGORY

6 *Alexander the Great Visiting the*
Studio of Apelles
Guillam van Haecht
Oil on wood,
3' 5½" x 4' 11" (1.05 x 1.49 m)
The Hague (The Netherlands),
Mauritshuis
Dutch Seventeenth Century

HISTORY

5

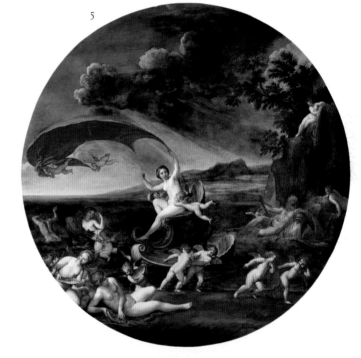

Dutch Seventeenth Century

4

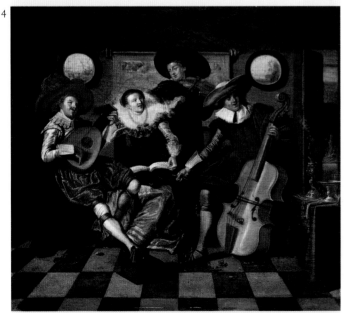

6

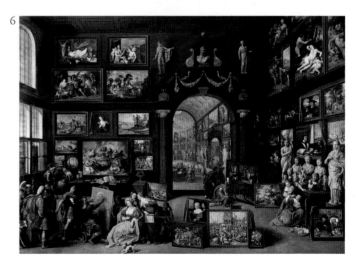

173

1629
Netherlands

1629
Spain

c. 1630
Iran

1 *Still Life*
Willem Claesz Heda
Oil on wood,
18" x 27¼" (46 x 69 cm)
The Hague (The Netherlands),
Mauritshuis
Dutch Seventeenth Century

STILL LIFE

2 *Appearance of Saint Peter to Saint Peter of Nolasco*
Francisco de Zurbarán
Oil on canvas,
5' 10½" x 7' 4" (1.79 x 2.23 m)
Madrid (Spain), Prado
Baroque

RELIGION
PORTRAITURE

3 *Lovers Observed by an Astonished Youth*
Muhammad Yusuf al-Husaini
Manuscript illustration,
9½" x 5½" (24.6 x 14.5 cm)
New York (USA),
Pierpont Morgan Library
Persian

DOMESTIC LIFE

1
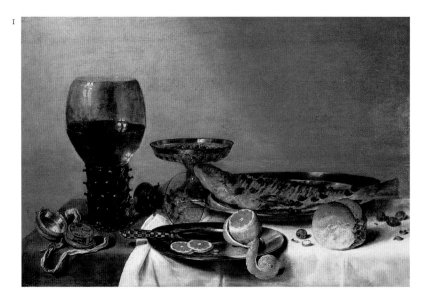

3
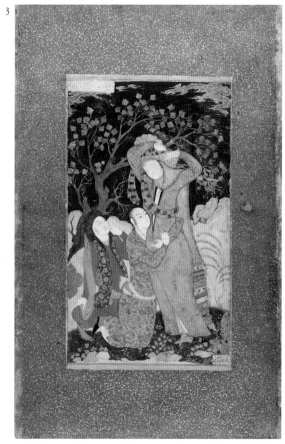

2
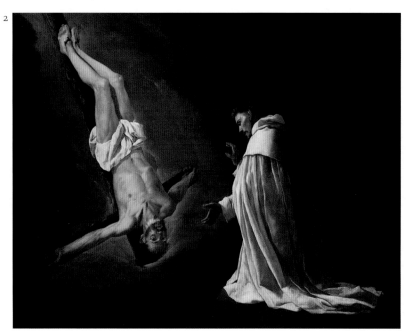

1630
Netherlands

c. 1630
France

c. 1630
India

4 *Interior of the Church of Saint Bavo
in Haarlem*
Pieter Saenredam
Oil on wood,
16" x 14½" (41 x 37 cm)
Paris (France), Louvre
Dutch Seventeenth Century

RELIGION
URBAN LIFE

5 *Cimon and Iphigenia*
Jacques Blanchard
Oil on canvas,
5' 7¼" x 7' 1" (1.71 x 2.16 m)
Paris (France), Louvre
Baroque

MYTHOLOGY
THE BODY

6 *Shah Jahan Riding on an Elephant
Accompanied by His Son Dara
Shukoh Mughal*
Govardhan
Watercolor on paper,
10½" x 7¼" (26.6 x 18.5 cm)
London (UK), Victoria and Albert
Museum
Mughal

PORTRAITURE
POLITICS

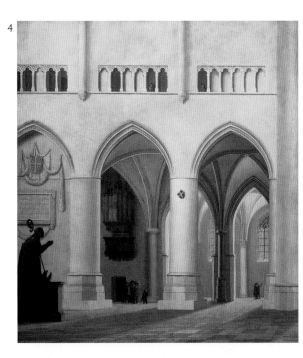

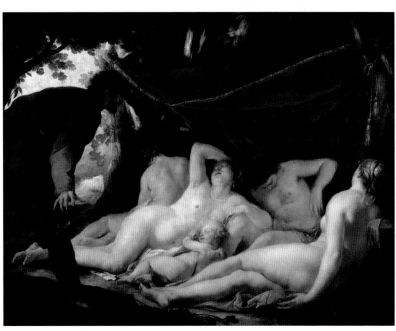

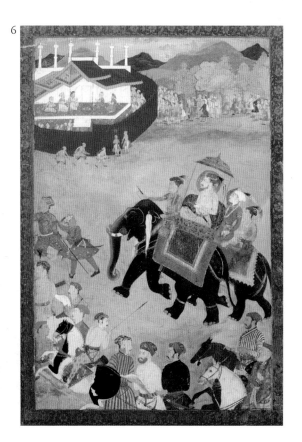

1 *The Inspiration of the Epic Poet*
Nicolas Poussin
Oil on canvas,
6' ½" x 7' (1.84 x 2.14 m)
Paris (France), Louvre
Baroque

ALLEGORY

2 *Garden of Love*
Peter Paul Rubens
Oil on canvas,
6' 6" x 9' 3½" (1.98 x 2.83 m)
Madrid (Spain), Prado
Baroque

ALLEGORY
PORTRAITURE

3 *The Proposition*
Judith Leyster
Oil on canvas,
12¼" x 9½" (30.9 x 24.2 cm)
The Hague (The Netherlands),
Mauritshuis
Dutch Seventeenth Century

DOMESTIC LIFE

4 *Equestrian Portrait of Gaspar de Guzman, Duke of Olivares*
Diego Velázquez
Oil on canvas,
10' 3" x 7' 10" (3.13 x 2.39 m)
Madrid (Spain), Prado
Baroque

PORTRAITURE

1

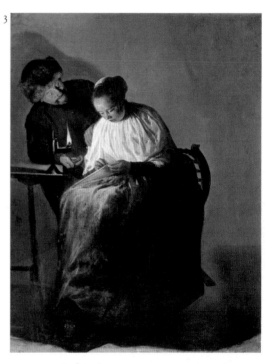

3

2

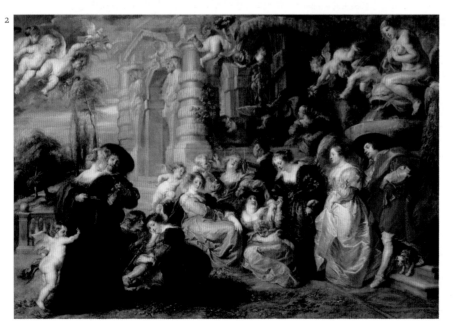

4

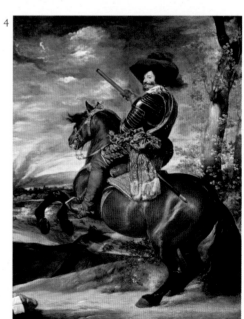

1632
Netherlands

The Anatomy Lesson of
Dr. Nicolaes Tulp
Rembrandt van Rijn
Oil on canvas,
5' 6½" x 7' 2" (1.69 x 2.16 m)
The Hague (The Netherlands),
Mauritshuis
Dutch Seventeenth Century

PORTRAITURE
THE BODY

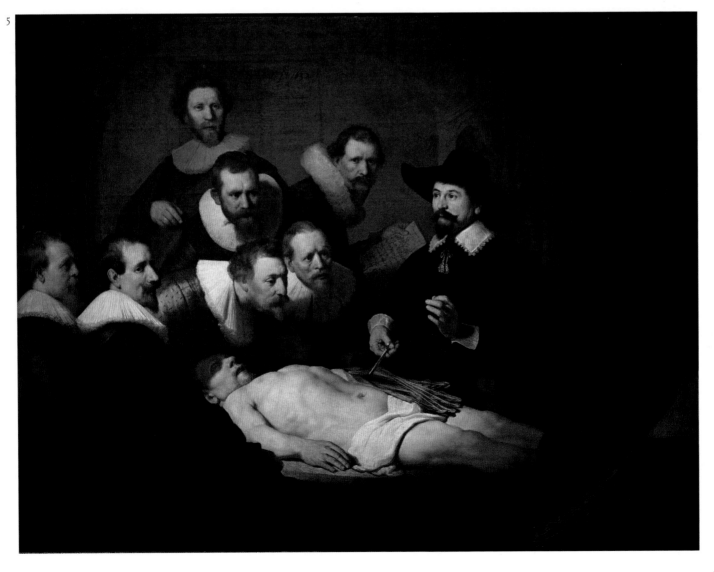

5

1633–1640
Spain

c. 1634–1635
Spain

1635
England

1 *Still Life*
Francisco de Zurbarán
Oil on canvas,
18" x 33" (46 x 84 cm)
Madrid (Spain), Prado
Baroque

STILL LIFE

2 *Surrender of Breda*
Diego Velázquez
Oil on canvas,
10' x 12' 4" (3.05 x 3.76 m)
Madrid (Spain), Prado
Baroque

HISTORY
PORTRAITURE
WAR

3 *Portrait of the Children of Charles I
of England*
Sir Anthony van Dyck
Oil on canvas,
4' 11½" x 5' ½" (1.51 x 1.54 m)
Turin (Italy), Sabauda Gallery
Baroque

PORTRAITURE
POLITICS

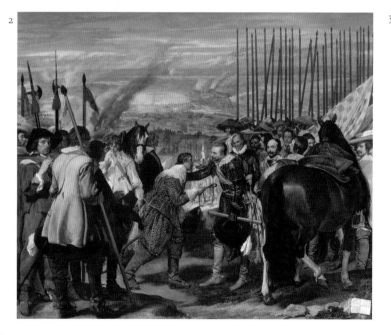

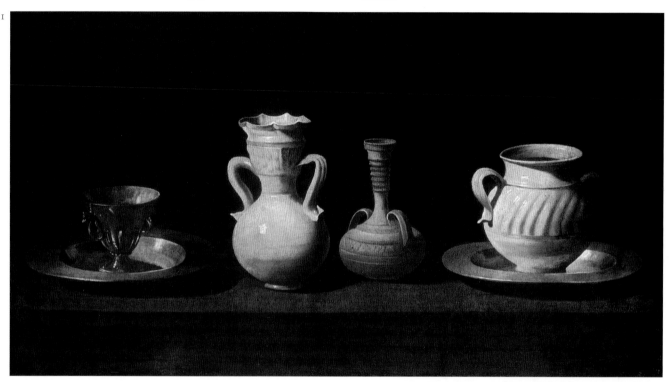

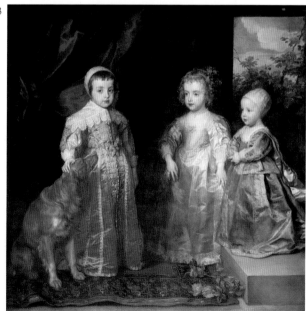

1636
Netherlands

1638
Netherlands

c. 1638
Netherlands

4 *Danae*
Rembrandt van Rijn
Oil on canvas
6' 2" x 7' 7" (1.88 x 2.57 m)
Saint Petersburg (Russia),
State Hermitage Museum
Dutch Seventeenth Century

THE BODY
MYTHOLOGY

5 *The Burgomasters of Amsterdam*
Gathered for the Arrival of Queen
Marie des Médicis of France
Thomas de Keyser
Oil on wood,
11¼" x 15" (28.5 x 38 cm)
The Hague (The Netherlands),
Mauritshuis
Dutch Seventeenth Century

PORTRAITURE

6 *Portrait of Willem van Heythusen*
Frans Hals
Oil on wood,
18½" x 14¾" (46.9 x 37.5 cm)
Brussels (Belgium),
Royal Museums of Fine Art
Dutch Seventeenth Century

PORTRAITURE

4

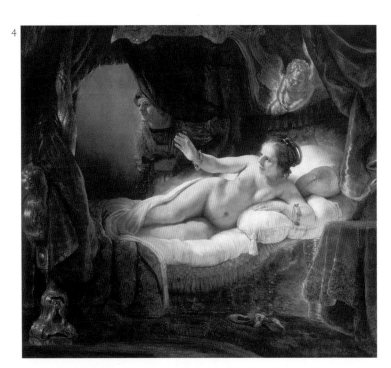

6

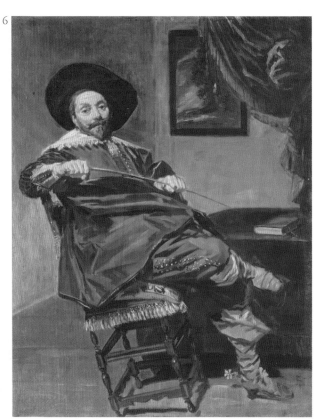

5

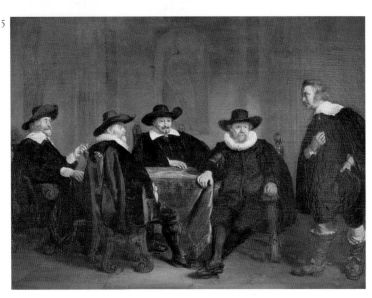

1 *The Three Graces*
Peter Paul Rubens
Oil on wood,
7' 3" x 6' 11¼" (28.5 x 38 cm)
Madrid (Spain), Prado
Baroque

BODY
MYTHOLOGY

2 *Judgement of Paris*
Peter Paul Rubens
Oil on wood,
6' 6¼" x 12' 5" (1.99 x 3.79 m)
Madrid (Spain), Prado
Baroque

MYTHOLOGY
THE BODY

1

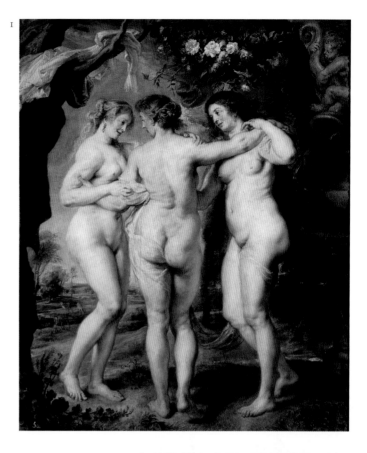

2

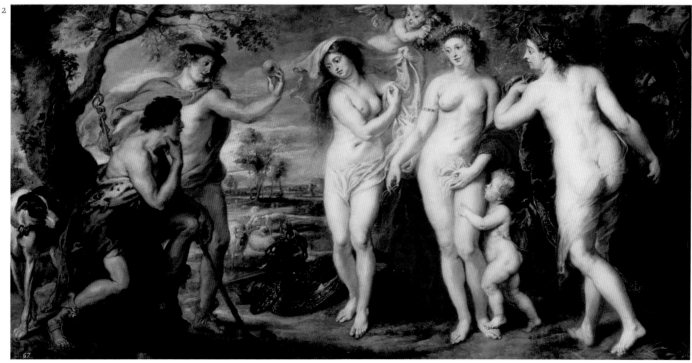

c. 1639
Netherlands

1640
France

c. 1640
France

3 *Landscape with Rainbow*
Peter Paul Rubens
Oil on canvas,
37" x 48½" (94 x 123 cm)
Munich (Germany), Alte
Pinakothek
Baroque

LANDSCAPE

4 *Landscape with Saint Matthew
and the Angel*
Nicolas Poussin
Oil on canvas,
3' 3" x 4' 5¼" (1 x 1.35 m)
Berlin (Germany), Staatliche
Museen, Picture Gallery
Baroque

LANDSCAPE
RELIGION

5 *Christ with Saint Joseph
in the Carpenter's Shop*
Georges de La Tour
Oil on canvas,
4' 6" x 3' 4¼" (1.37 x 1.02 m)
Paris (France), Louvre
Baroque

RELIGION

3
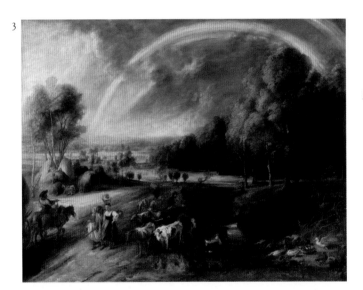

5
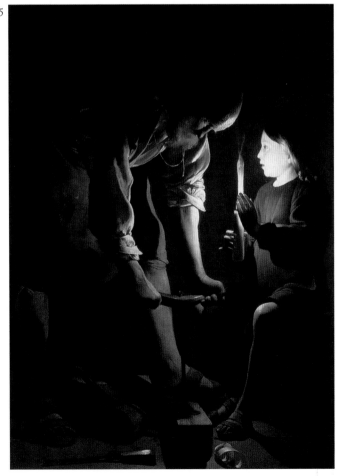

4
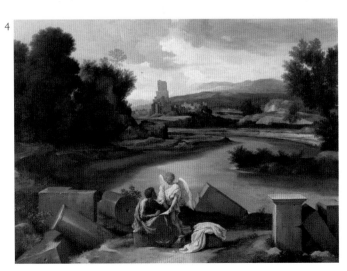

c. 1640
France

c. 1645–1649
France

1647–1652
Italy

1 *The Peasant Family*
Louis or **Antoine Le Nain**
Oil on canvas,
3' 8½" x 5' 2½" (1.13 x 1.58 m)
Paris (France), Louvre
Baroque

RURAL LIFE

2 *Annunciation*
Simon Vouet
Oil on wood,
47½" x 34" (120 x 86 cm)
Florence (Italy), Uffizi
Baroque

RELIGION

3 *Ecstasy of Saint Theresa*
Giovanni Lorenzo Bernini
Marble, height: 11' 5" (3.5 m)
Rome (Italy), Church of Santa
Maria della Vittoria, Cornaro
Chapel
Baroque

RELIGION

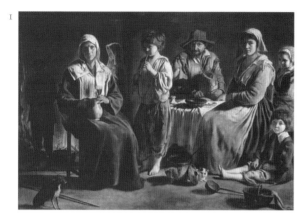

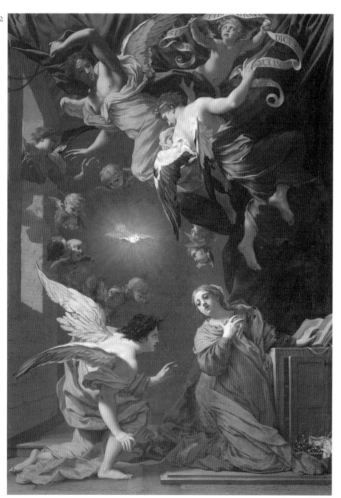

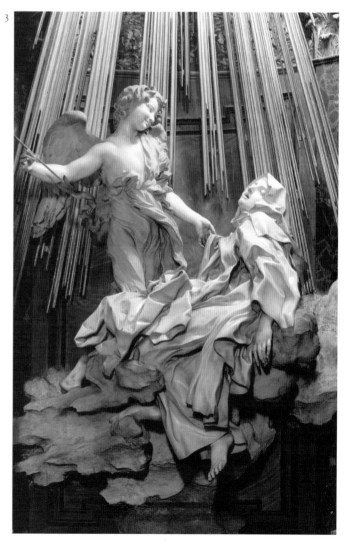

4 *Waking up Kumbhakarna,*
from the "Ramayana"
Sahib Din
Manuscript illustration
London (UK), British Library
Indian

RELIGION

5 *Bathsheba with David's Letter*
Rembrandt van Rijn
Oil on canvas,
4' 8" x 4' 8" (1.42 x 1.42 m)
Paris (France), Louvre
Dutch Seventeenth Century

RELIGION
PORTRAITURE

6 *Interior of the Oude Kerk*
in Amsterdam
Emanuel de Witte
Oil on canvas,
20" x 16½" (50.5 x 41.5 cm)
The Hague (The Netherlands),
Mauritshuis
Dutch Seventeenth Century

URBAN LIFE
RELIGION

4
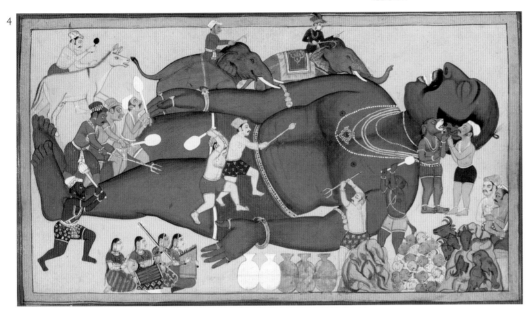

5
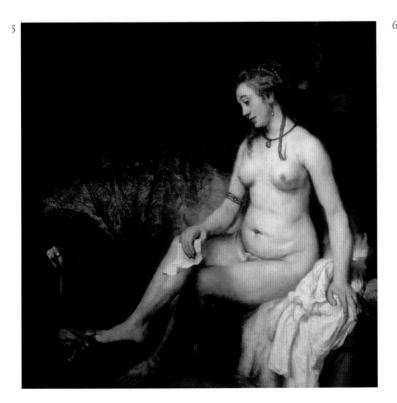

6
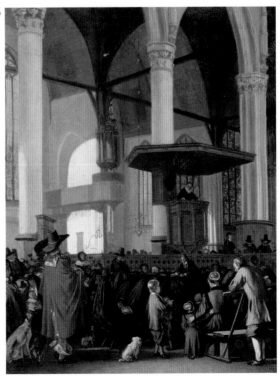

1656
Spain

1655–1657
France

c. 1660
Netherlands

1 *Las Meniñas (The Maids of Honor)*
Diego Velázquez
Oil on canvas,
10' 5" x 9' (3.18 x 2.76 m)
Madrid (Spain), Prado
Baroque

PORTRAITURE

2 *Portrait of Chancellor Seguier*
Charles Lebrun
Oil on canvas,
9' 8" x 11' 6" (2.95 x 3.51 m)
Paris (France), Louvre
Baroque

PORTRAITURE

3 *View of Delft from the
Rotterdam Canal*
Jan Vermeer
Oil on canvas,
38¾" x 46¼" (98.5 x 117.5 cm)
The Hague (The Netherlands),
Mauritshuis
Dutch Seventeenth Century

THE CITY
LANDSCAPE

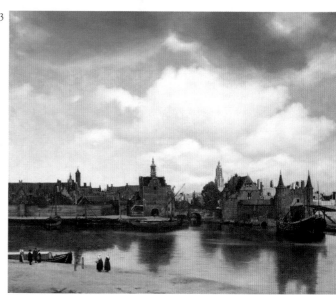

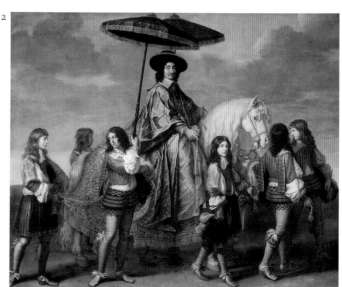

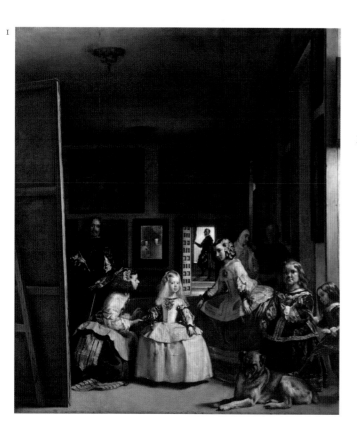

| c. 1660 | 1662 | 1662 |
| Netherlands | Netherlands | France |

4 *The Lovesick Woman*
Jan Steen
Oil on canvas,
24" x 22½" (61 x 52 cm)
Munich (Germany),
Alte Pinakothek
Dutch Seventeenth Century

DOMESTIC LIFE

5 *Girl at the Window*
Gerrit Dou
Oil on wood,
15" x 11½" (38 x 29 cm)
Turin (Italy), Sabauda Gallery
Dutch Seventeenth Century

DOMESTIC LIFE

6 *Votive Offering of 1662: Mother*
Catherine Agnès and Sister Catherine
Sainte-Suzanne
Philippe de Champaigne
Oil on canvas,
5' 1½" x 7' 4" (1.56 x 2.25 m)
Paris (France), Louvre
Baroque

RELIGION
PORTRAITURE

4

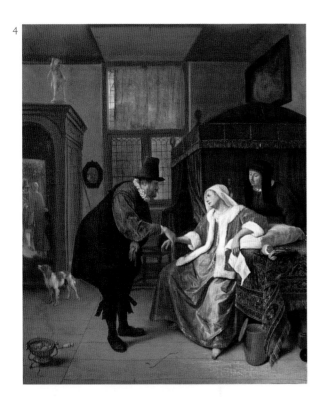

5

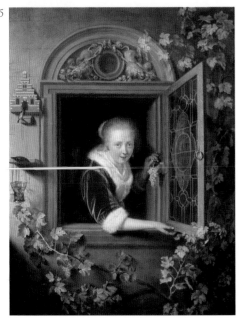

6

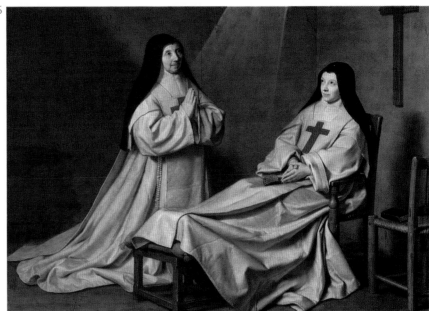

1662–1670
Japan

c. 1663
Netherlands

c. 1663
Italy

1 *Nisho-no-tai (West Wing),*
from the "Tales of Ise"
Sumiyoshi Jokei
Ink on paper,
7¾" x 6¾" (19.6 x 17.3 cm)
London (UK), British Museum
Japanese, Edo period

LITERATURE
LANDSCAPE

2 *As the Old Sing, So Twitter the Young*
Jan Steen
Oil on canvas,
4' 4¼" x 5' 4" (1.34 x 1.63 m)
The Hague (The Netherlands),
Mauritshuis
Dutch Seventeenth Century

DOMESTIC LIFE

3 *Saint Sebastian*
Pierre Puget
Marble
Genoa (Italy), Church of Santa
Maria Assunta di Carignano
Baroque

RELIGION
THE BODY

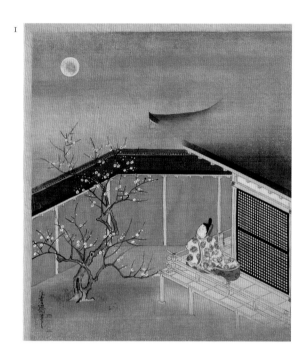

1

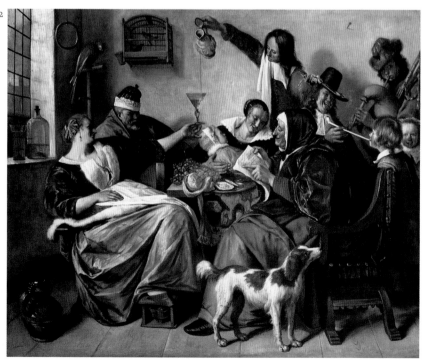

3

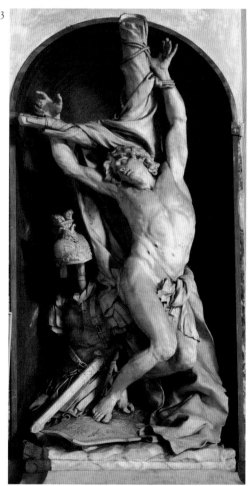

2

c. 1665
Netherlands

c. 1665
Netherlands

1667
Netherlands

4 *Boy Catching Fleas on His Dog*
Gerard Ter Borch the Younger
Oil on canvas,
13¾" x 10½" (35 x 27 cm)
Munich (Germany),
Alte Pinakothek
Dutch Seventeenth Century

DOMESTIC LIFE

5 *Head of a Young Woman*
Jan Vermeer
Oil on canvas,
18¼" x 15¾" (46.5 x 40 cm)
The Hague (The Netherlands),
Mauritshuis
Dutch Seventeenth Century

PORTRAITURE

6 *The City Hall in Amsterdam*
Jan van der Heyden
Oil on canvas,
33½" x 36¼" (85 x 92 cm)
Florence (Italy), Uffizi
Dutch Seventeenth Century

THE CITY

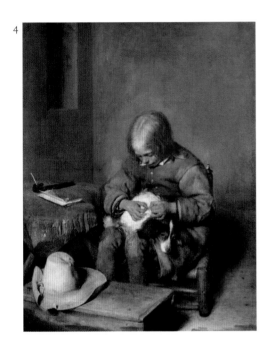

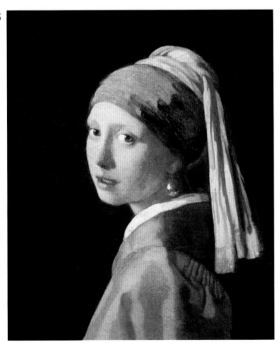

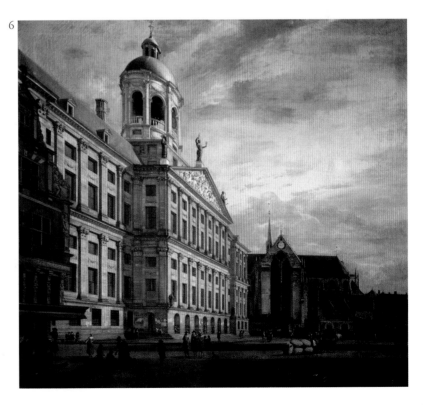

Using a camera obscura enables artists to represent reality as never before

The use of mechanical aids has always been a controversial issue in the art world. Jan Vermeer created paintings of exceptional, almost photographic, clarity. Did he use a device called a camera obscura?

Enormous speculation surrounded Jan Vermeer in his own lifetime, when his work was valued for its superb detail and clarity. He was secretive about his own techniques, however, and there is no hard evidence that he owned a device called a camera obscura, but the quality of his work certainly is in keeping with the use of the invention. Two hundred years later, after the invention of photographs, critics consistently commented on his work's photographic quality. In 1861, the Goncourt brothers described him as "the only master who has made a living daguerreotype."

Camera obscura, meaning a "dark chamber," refers to the discovery that, when a tiny hole is made in the wall of a darkened room, under certain lighting conditions an image of the scene outside will be formed, upside down, on the opposite wall. This basic principle had been known since antiquity by astronomers, who used it to observe the sun safely. In the sixteenth century, scientists experimented by placing a glass lens across the hole. The results were startling. The lens inverted the image so that it was right side up, and also brighter and sharper. The "camera" itself came in various shapes and sizes. Some, such as tents, booths, or shuttered rooms, genuinely resembled a chamber. The more practical, portable version of the instrument that was developed later came in a rectangular box, and the image was viewed from above.

A Dutch art lover who witnessed the device in action in 1622 said, "All painting is dead in comparison, for here is life itself, or something more elevated, if only there were words for it. Shape, contour, and movement come together naturally, in a way that is altogether pleasing." It would be centuries before those fleeting images could be captured and preserved as a photograph. However, by using a mirror artists could project an image onto a canvas and trace their chosen scene or subject with incredible accuracy. Vermeer almost certainly did so.

Vermeer would have had access to the latest optical devices, as he knew Anton van Leeuwenhoek, the pioneer of the microscope. No preliminary drawings or sketches for many of Vermeer's finest paintings have been found, which is a surprise, given the complexity of his compositions. Some details in his paintings are amazingly sharp, while others have a blurred, soft-focus appearance, in keeping with viewing a subject through a lens. In *The Lacemaker* this contrast between soft focus and sharp details is noticeable in the threads hanging from the cushion. The way the shadow and light fall show an extraordinary level of observation. It seems that Vermeer was able to build up his pictures in light and tone, rather than relying solely on drawing. All evidence suggests the use of a camera obscura.

This does not undermine Vermeer's brilliance as an artist. For him the camera was far more than a copying device. It gave him a different view of the natural world and he used this to extraordinary effect. His skill is not only in his painting but his composition, his subject matter, and his delicate sensitivity to the everyday and the ordinary.

The Lacemaker
Jan Vermeer, 1679
Dutch Seventeenth Century

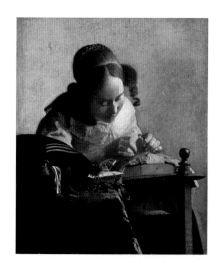

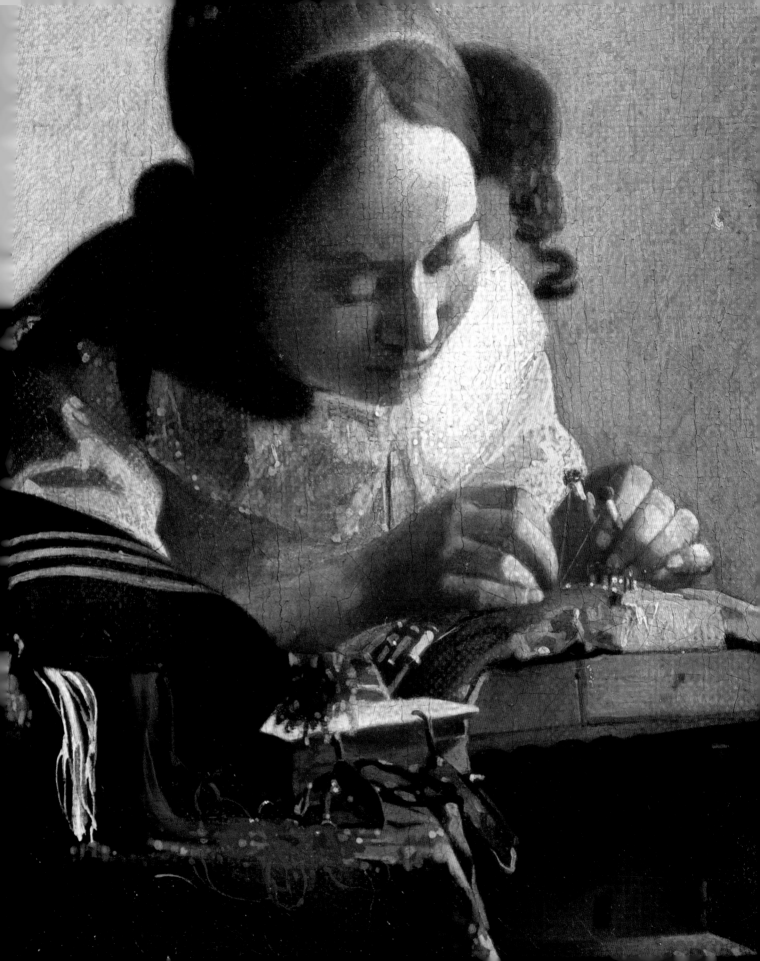

c. 1669
Netherlands

1672
Spain

c. 1680
England

1 *Return of the Prodigal Son*
Rembrandt van Rijn
Oil on canvas,
8' 8" x 6' 10" (2.65 x 2. 83 m)
Saint Petersburg (Russia),
State Hermitage Museum
Dutch Seventeenth Century

RELIGION

2 *Allegory of Death*
Juan de Valdes Leal
Oil on canvas,
7' 3" x 7' (2.2 x 2.16 m)
Seville (Spain), Charity Hospital
Baroque

DEATH
ALLEGORY

3 *View of London*
Jean Griffier the Elder
Oil on canvas
Turin (Italy), Sabauda Gallery
Dutch Seventeenth Century

THE CITY

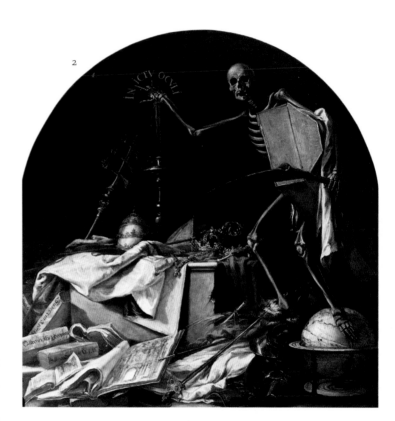

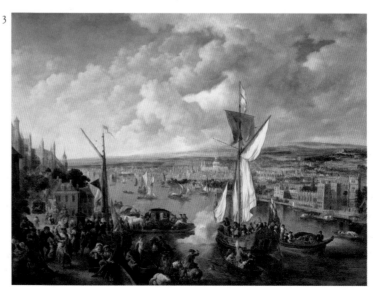

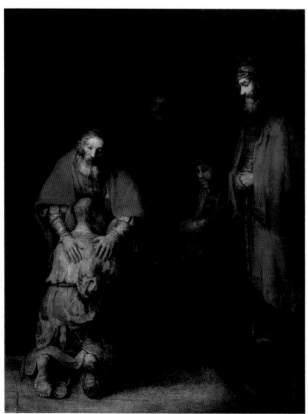

1693
Netherlands

1685
Japan

Great Market in Haarlem
Gerrit Berckheyde
Oil on wood,
21¼" x 25¼" (56 x 64 cm)
Florence (Italy), Uffizi
Dutch Seventeenth Century

THE CITY

5 *Scenes in a Theater Teahouse*
Hishiwaka Moronobu
Handscroll painting,
12½" x 58" (31.5 x 147 cm)
London (UK), British Museum
Japanese, Edo period

LEISURE

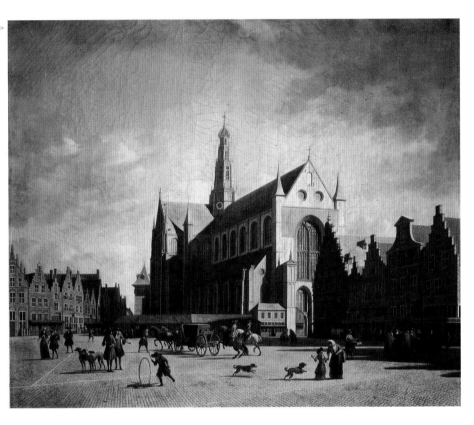

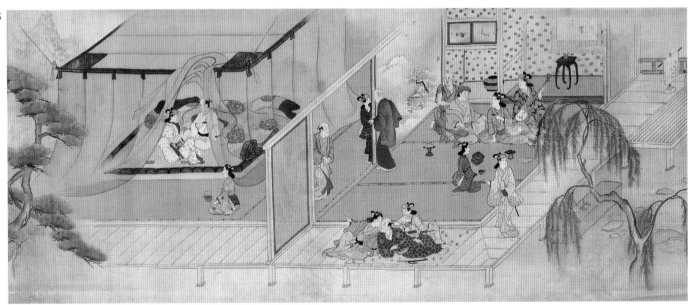

1700–1800
Turkey

1701
France

c. 1710
Russia

1 *Warriors on Horseback, from an*
"Epic of the Caliph Ali"
Artist unknown
Manuscript illustration
London (UK), British Library

WAR
ANIMALS

2 *Louis XIV, King of France*
Hyacinthe Rigaud
Oil on canvas,
9' x 6' 4½" (2.74 x 1.94 cm)
Paris (France), Louvre
Baroque

POLITICS
PORTRAITURE

3 *Peter the Great at the*
Battle of Potlava
Johann Gottfried Tannauer
Oil on canvas
Saint Petersburg (Russia),
State Hermitage Museum
Rococo

PORTRAITURE
WAR

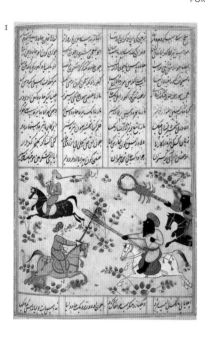

Rococo

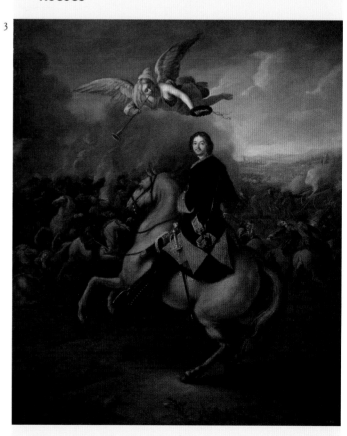

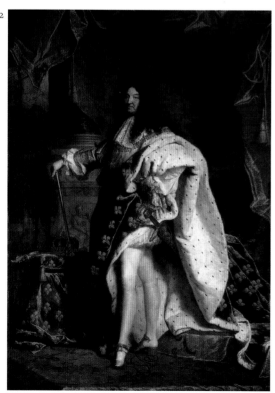

1711–1720
Italy

c. 1713–1715
France

1716
Netherlands

4 *Astronomical Observations: Sun*
Donato Creti
Oil on canvas,
20" x 13¾" (51 x 35 cm)
Vatican (Vatican City),
Picture Gallery
Rococo

LANDSCAPE

5 *Louis XIV, King of France*
Antoine Coysevox
Marble, life-size
Paris (France),
Cathedral of Notre Dame
Rococo

PORTRAITURE
RELIGION

6 *Flowers and Fruit*
Rachel Ruysch
Oil on canvas,
35" x 27" (89 x 68.5 cm)
Florence (Italy), Pitti Palace,
Palatine Gallery
Rococo

STILL LIFE

5

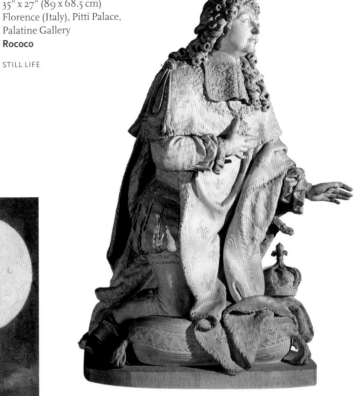

4

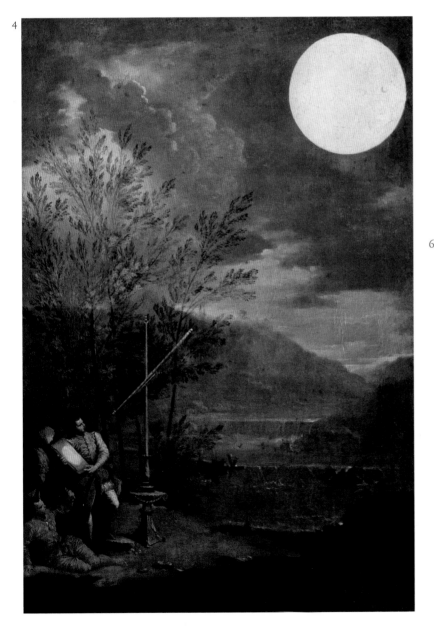

6

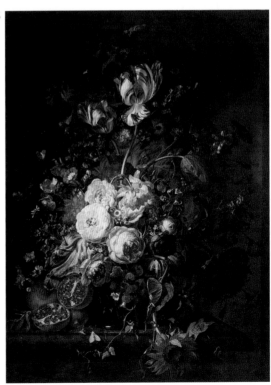

1717
France

c. 1718–1719
France

1720
France

1 *Embarkation from Cythera*
Jean-Antoine Watteau
Oil on canvas,
4' 2¾" x 6' 4½" (1.29 x 1.94 m)
Paris (France), Louvre
Rococo

LANDSCAPE

2 *Gilles* or *Pierrot*
Jean-Antoine Watteau
Oil on canvas,
6' ½" x 4' 10¾" (1.85 x 1.5 m)
Paris (France), Louvre
Rococo

LEISURE

3 *The Gersaint Shop Sign*
Jean-Antoine Watteau
Oil on canvas,
5' 3" x 10' (1.63 x 3.6 m)
Berlin (Germany),
Charlottenburg Palace
Rococo

URBAN LIFE

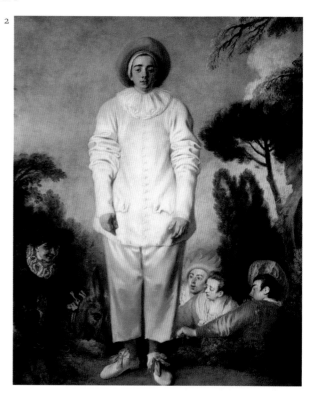

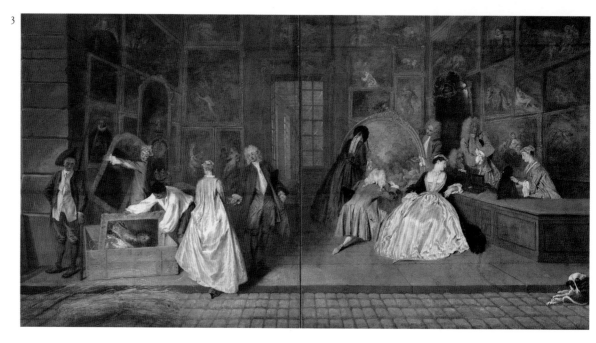

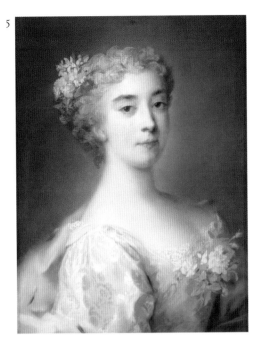

4 *Solemn Session of the Parliament for
King Louis XIV, February 22, 1723*
Nicolas Lancret
Oil on canvas
Paris (France), Louvre

HISTORY
PORTRAITURE

5 *Portrait of Anna Sofia
Enrichetta of Modena*
Rosalba Carriera
Pastel on paper,
23½" x 18¼" (59.5 x 46.5 cm)
Florence (Italy), Uffizi
Rococo

PORTRAITURE

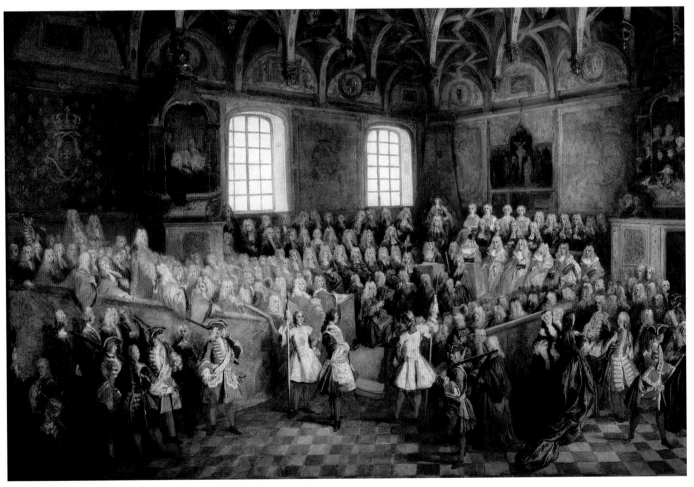

1727
China

c. 1731
France

c. 1732
Italy

1 *The Ancient Pine of Dongmou*
Gao Fenghan
Painted fan, width: 21" (53 cm)
London (UK), British Museum
Qing dynasty

LANDSCAPE

2 *Hercules and Omphale*
François Boucher
Oil on canvas,
35½" x 29" (90 x 74 cm)
Moscow (Russia), Pushkin
Museum
Rococo

MYTHOLOGY
THE BODY

3 *Abraham and the Angels*
Giambattista Tiepolo
Oil on canvas,
4' 7" x 3' 11¼" (1.4 x 1.2 m)
Venice (Italy),
Confraternity of San Rocco
Rococo

RELIGION

1
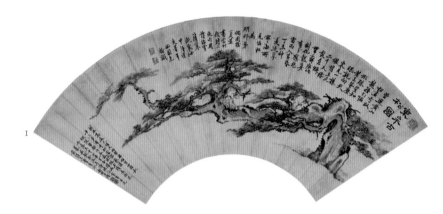

2
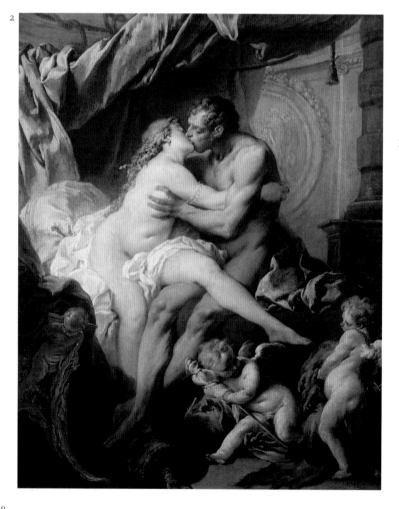

3
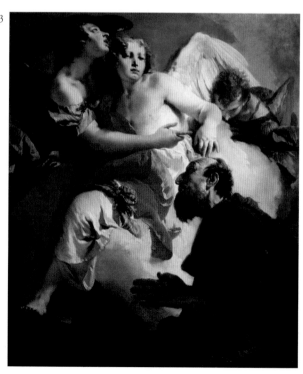

c. 1740
India

4 *Celestial Procession with*
Indra Riding His Elephant
Artist unknown
Illustration on paper,
9" x 15" (23 x 38.2 cm)
New York (USA),
Pierpont Morgan Library
Indian

RELIGION
ANIMALS

1744
France

5 *Grace before Dinner*
Jean-Baptiste-Siméon Chardin
Oil on canvas,
19½" x 15" (49.5 x 38.4 cm)
Saint Petersburg (Russia),
State Hermitage Museum
Rococo

DOMESTIC LIFE

1745
France

6 *Marie Adelaide of France*
Represented as Diana
Jean-Marc Nattier
Oil on canvas,
37½" x 50½" (95 x 128 cm)
Florence (Italy), Uffizi
Rococo

PORTRAITURE
ALLEGORY

4

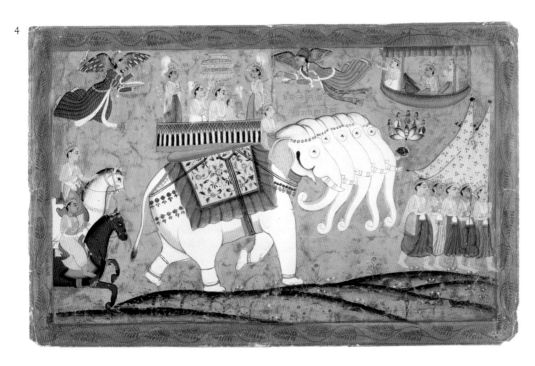

5

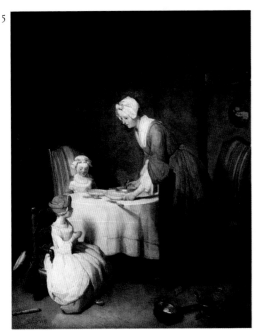

6

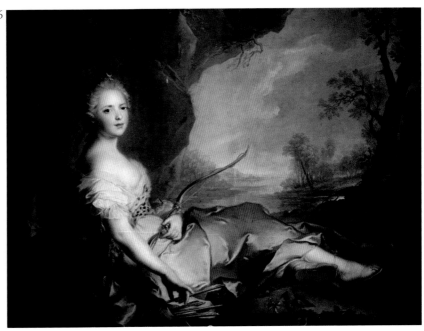

In Britain, satirical art is used to comment on social behavior

In an era when political and moral satire became a popular subject for writers, William Hogarth took the mood of the times and created a new kind of satirical art, combining topical subjects with biting humor and moral indignation.

The withering satire on contemporary life found in John Gay's *The Beggar's Opera*, first performed in London in 1728, was both phenomenally successful and highly influential. During the same period, the popular satirical verse of Jonathan Swift and Alexander Pope was widely distributed. The artist William Hogarth was to do for art what these authors had done for literature. Hogarth originally aspired to produce grandiose history paintings, but he found that there was little interest in this type of subject in Britain at the time. The public was clearly more interested in the present than in the past. Hogarth was particularly impressed by Gay's work, which inspired him to create a new type of art form—a sequence of pictures that told a story in a way he described as "similar to representations on the stage."

In parodies on one of the most famous books in the English language, John Bunyan's *The Pilgrim's Progress* (1678), Hogarth ventured into satire with a series entitled *A Harlot's Progress* and *A Rake's Progress*. While Bunyan described a progress to faith and spirituality, Hogarth's sequences tell of the journey into moral decline. The rake is Tom Rakewell, who inherited a fortune from his miserly father, squandered it thoughtlessly, was imprisoned for debt, and ended up in a madhouse. In this, the second of eight scenes, Tom has just received his inheritance, and is immediately surrounded by a bevy of people ready to relieve him of his money. A dancing master, a fencing master, and a landscape gardener, among others, surround him, coaxing him into wasting his inheritance on indulgent, fashionable pursuits.

Hogarth devised a novel way of financing this type of project. Customers were invited to buy a subscription ticket in advance, at a cost of 10 guineas (a guinea was a pound and a shilling) for the full series of eight engravings. The artist first produced the scenes as paintings, which then became the basis for the prints. Hogarth displayed the paintings in his studio to boost the sale of tickets, but otherwise made no great effort to sell the original paintings. He kept the *Rake's Progress* paintings for a decade before selling them at auction, where they fetched only a fraction of the amount he had earned from the prints. Hogarth sought to maximize his income by campaigning vigorously for a copyright act, which would protect prints from being pirated. This legislation, for a time known as "Hogarth's Act," was finally passed in 1735, just as *A Rake's Progress* was being published.

Hogarth was able to incorporate an enormous amount of humorous detail in his work, while still ensuring that the overall scene looked fairly realistic, and was executed with care and skill. Prints were important, as they enabled artists to earn a decent living without having to rely on state commissions or wealthy patrons. With this came the independence they needed to select their own subjects, and comment on society as they chose.

A Rake's Progress II: The Rake's Levée
William Hogarth, 1733
Original painting (left) and print based on it

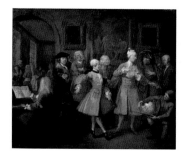 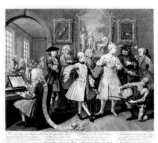

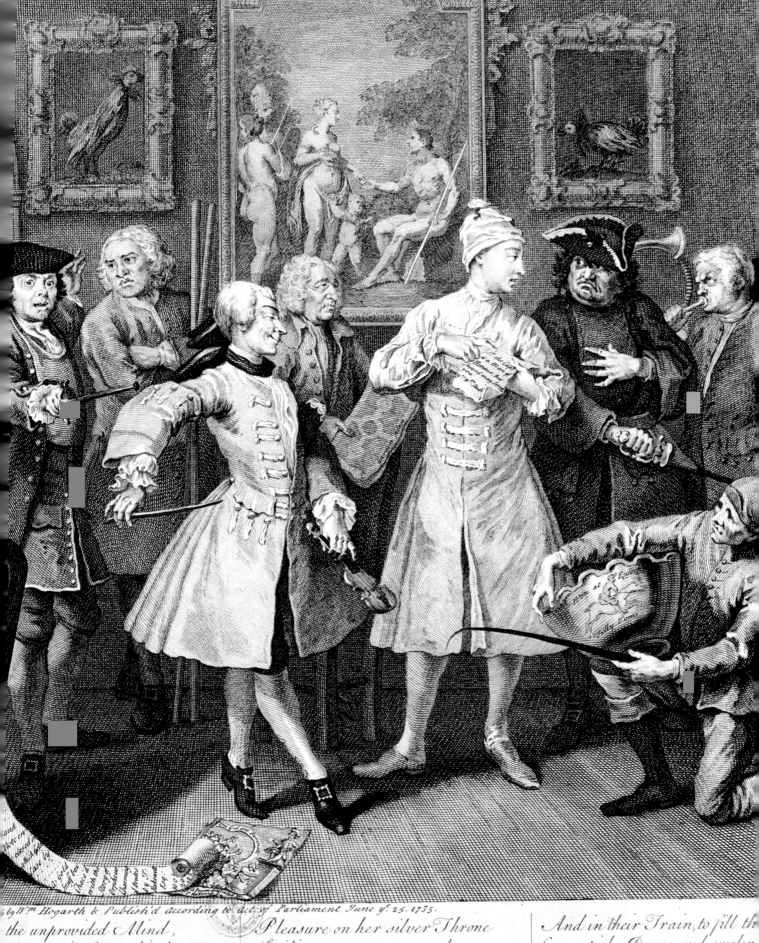

by Wm. Hogarth & Publish'd according to Act of Parliament June ye 25. 1735.

the unprovided Mind, | Pleasure on her silver Throne | And in their Train, to fill th
Memory in fetters bind. | Smiling comes, nor comes alone; | Come apish Dance, and swolen

1746
Britain

1750
Britain

c. 1750–1769
Italy

1 *Conversation in the Park*
Thomas Gainsborough
Oil on canvas,
28¾" x 26½" (73 x 67 cm)
Paris (France), Louvre
Rococo

DOMESTIC LIFE
PORTRAITURE

2 *Westminster Abbey with the Procession of the Knights of the Order of Bath*
Antonio Canaletto
Oil on canvas,
39" x 40" (99 x 102 cm)
London (UK), Westminster Abbey

CITY
PORTRAITURE

3 *Portrait of Armellino the Cat with Sonnet*
Artist unknown
Oil on canvas
Rome (Italy),
National Museum of Rome
Rococo

ANIMALS

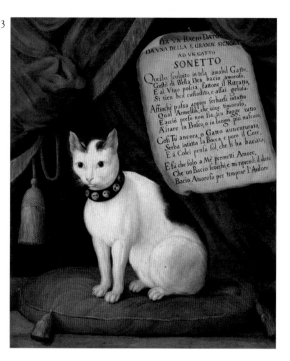

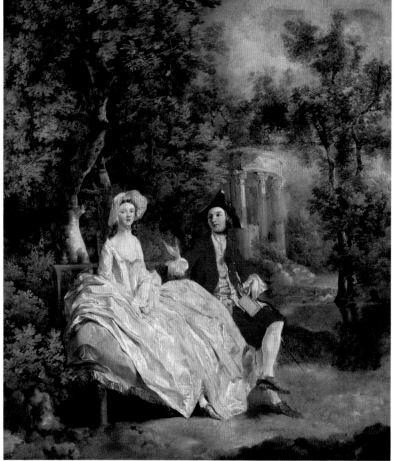

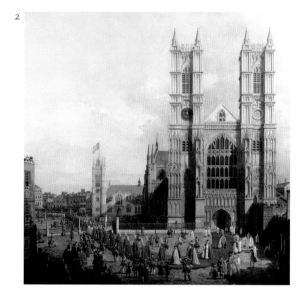

1750–1850
Cook Islands

c. 1750
Japan

c. 1752
Italy

4 *Figure from Rarotonga*
Artist unknown
Polished ironwood,
height: 27" (69 cm)
London (UK), British Museum
Polynesian

RELIGION

5 *Rabbits and Autumn Grasses (detail)*
Artist unknown
Two folds of a six-fold screen
painting, entire screen:
5' ½" x 10' 8" (1.54 x 3.27 m)
London (UK), British Museum
Japanese, Edo period

ANIMALS

6 *The Spice-Vendor's Shop*
Pietro Longhi
Oil on canvas,
23½" x 19" (60 x 48 cm)
Venice (Italy), Accademia Gallery
Rococo

URBAN LIFE

5

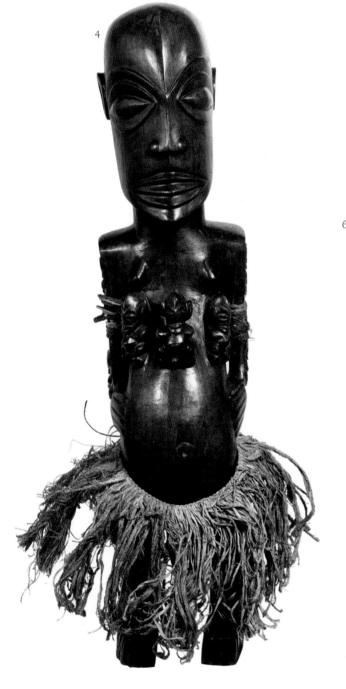

4

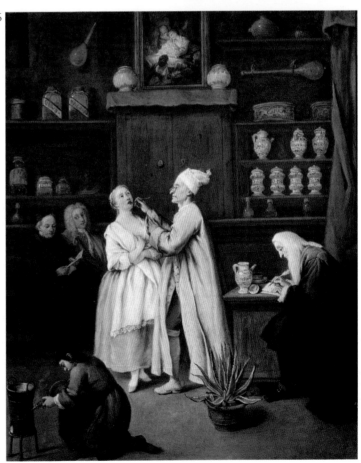

6

1753
Italy

1755
Italy

1755
France

1 *Aeneas Fleeing from Troy*
Pompeo Batoni
Oil on canvas,
30" x 37¾" (76 x 96 cm)
Turin (Italy), Sabauda Gallery
Rococo

MYTHOLOGY

2 *Interior of Saint Peter's*
Giovanni Paolo Pannini
Oil on canvas,
35½" x 52¼" (98 x 133 cm)
Venice (Italy),
Ca' Rezzonico Museum

RELIGION
URBAN LIFE

3 *Portrait of Madame de Pompadour*
Maurice Quentin de La Tour
Pastel on canvas,
5' 9" x 4' 2½" (1.75 x 1.28 m)
Paris (France), Louvre
Rococo

PORTRAITURE

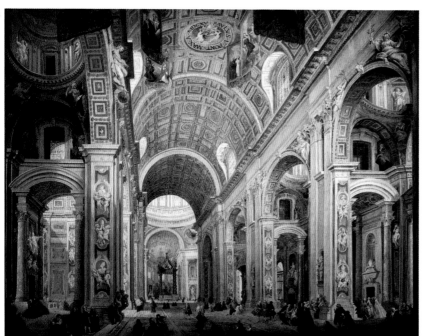

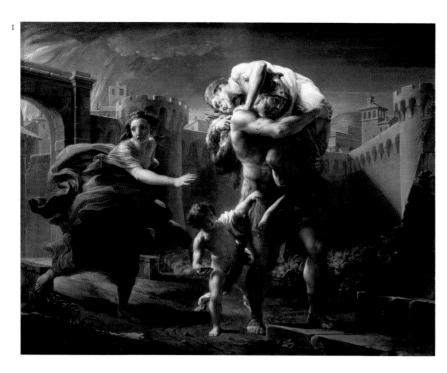

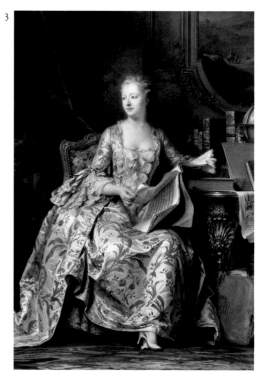

1756
Japan

c. 1757
Italy

1757–1759
Germany

4 *Two Geisha and a Boy Carrying a Shamisen Case*
Okumura Masanobu
Print on paper,
16" x 12" (42.3 x 30.2 cm)
London (UK), British Museum
Japanese, Edo period

LEISURE
URBAN LIFE

5 *Masks in the Foyer*
Pietro Longhi
Oil on canvas,
24" x 19¼" (61 x 49 cm)
Venice (Italy),
Querini Stampalia Foundation
Rococo

LEISURE

6 *Judgement of Paris*
Anton Raffael Mengs
Oil on canvas,
7' 5" x 12' 7" (2.26 x 3.85 m)
Saint Petersburg (Russia),
State Hermitage Museum
Neoclassicism

MYTHOLOGY

5

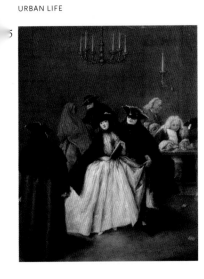

4

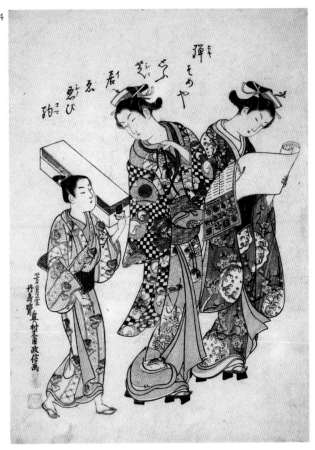

Neoclassicism

6

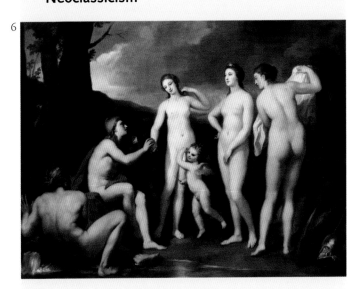

1 *The Broken Jug*
Jean-Baptiste Greuze
Oil on canvas,
42½" x 33½" (108 x 86 cm)
Paris (France), Louvre
Rococo

DOMESTIC LIFE
ALLEGORY

2 *Piazza San Marco, Looking*
Eastwards
Antonio Canaletto
Oil on canvas,
17¾" x 30" (45 x 76.2 cm)
Paris (France), Jacquemart-André
Museum

THE CITY

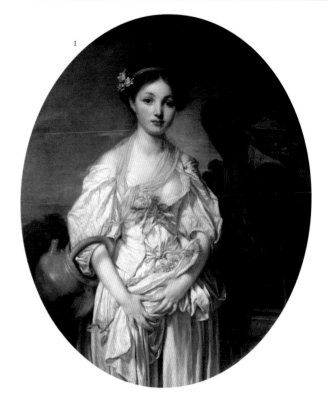

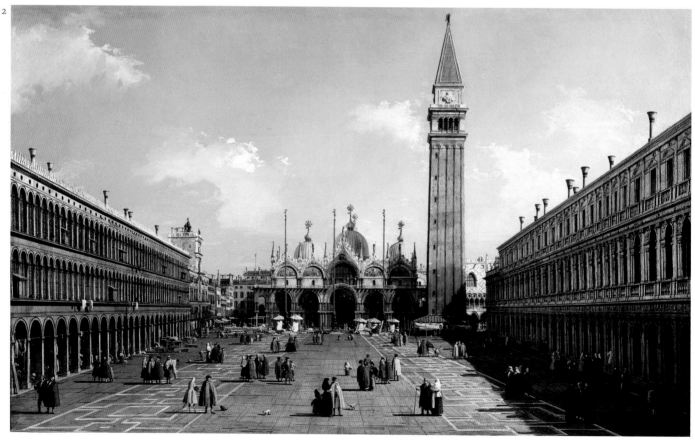

c. 1760
France

1761
France

1763
France

1763
France

3 *Dressmaker's Shop in Arles*
Antoine Raspal
Oil on canvas
Arles (France), Reattu Museum
Rococo

URBAN LIFE

4 *The Village Marriage Contract*
Jean-Baptiste Greuze
Oil on canvas,
36¼" x 46½" (92 x 118 cm)
Paris (France), Louvre
Rococo

DOMESTIC LIFE

5 *Still Life*
Jean-Baptiste-Siméon Chardin
Oil on canvas,
15" x 17¾" (38 x 45 cm)
Paris (France), Louvre
Rococo

STILL LIFE

6 *The Brioche*
Jean-Baptiste-Siméon Chardin
Oil on canvas,
18½" x 22" (47 x 56 cm)
Paris (France), Louvre
Rococo

STILL LIFE

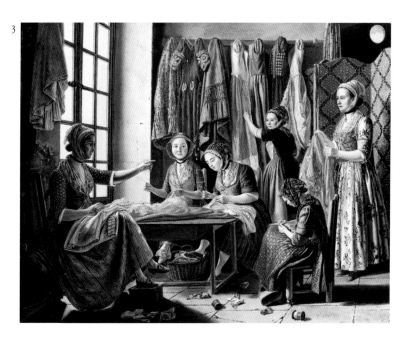

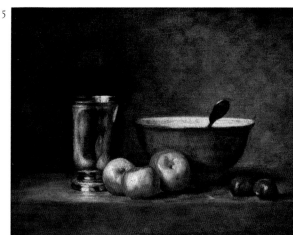

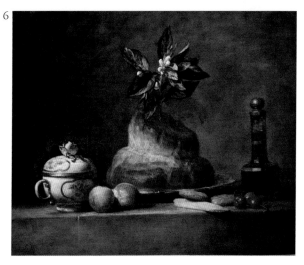

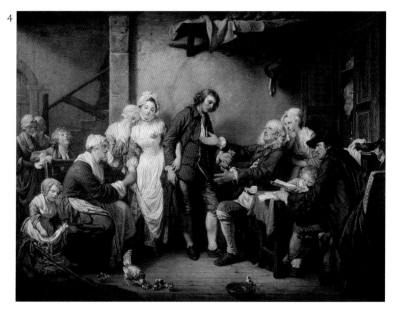

Japanese color woodblock prints depict the real world with great technical expertise

Representing scenes from everyday life, artists of the Edo period elevated the technique of woodblock printing to a pinnacle of Japanese artistic achievement. These prints were later to exert a profound influence on artists in the West.

Printmaking developed in Japan during the peaceful Edo period, which lasted from 1615 until the middle of the nineteenth century. The usual method was woodblock printing. The artist copied the original design onto transparent paper, and an artisan carved it on one or more blocks of cherry wood. A publisher then printed the impressions on a robust type of paper called *hosh,* made from the bark of the mulberry tree.

The favored subjects in the eighteenth century, when the art of printmaking reached a pinnacle of excellence, were those called ukiyo-e, or "pictures of the floating world." This refers to the transient pleasures of everyday life, described at that time as "living only for the moment . . . taking pleasure in the moon, the sun, the cherry blossoms, and the maple leaves, singing songs, drinking wine, and diverting ourselves by just floating . . . like a gourd floating along with the river current." These pleasures were to be found most easily in the bustling cities of Edo (now Tokyo), Osaka, and Kyoto, in tea houses, theaters, and brothels, and it was these locations that featured in the most popular prints. The rise of Kabuki, Japan's popular theater, led to a craze for prints of actors and scenes from the latest plays. Prints of beautiful women, usually courtesans and often shown with their lovers, were also popular.

One of the finest artists was Kitagawa Utamaro, who captured female beauty in all its forms. His publisher used powdered mother-of-pearl and gold dust to heighten the glamor of his prints. He also produced magnificent illustrations of insects, birds, and shellfish, though his career ended in controversy, after he was accused of political satire.

Suzuki Harunobu was noted for his pictures of women and lovers, and was one of the first Japanese artists to use strongly contrasting light and shade when depicting snow scenes and nocturnal images. He perfected the techniques of color printing, with a separate woodblock prepared for each color. In *Hunting for Insects* he used a style that was highly regarded—a strong velvety background was produced through overprinting several times, and against this the two lovers and their lantern are enhanced. His frail and graceful females were inspired by a waitress called O Sen.

Japanese prints began filtering through to the West in the 1850s, when the country's cultural isolation was finally broken, and by the following decade there were specialist shops in Paris selling exotic Japanese wares. Claude Monet bought his first print in 1856, and his enthusiasm was shared by Edgar Degas, James Whistler, Edouard Manet, Mary Cassatt, and many others. They adopted in their own work many of the outstanding features of the prints, including the dramatic treatment of space and form, which ignored the laws of perspective; the celebration of modern city life; the clear outlines and emphasis on graphic contrast; and the use of flat areas of color and patterns. Vincent Van Gogh said, "I envy the clarity of the Japanese. . . . Their work is as simple as breathing. . . . They do a figure in a few sure strokes, with the same ease as buttoning your coat."

Hunting for Insects
Suzuki Harunobu, c. 1776–1778
Japanese, Edo period

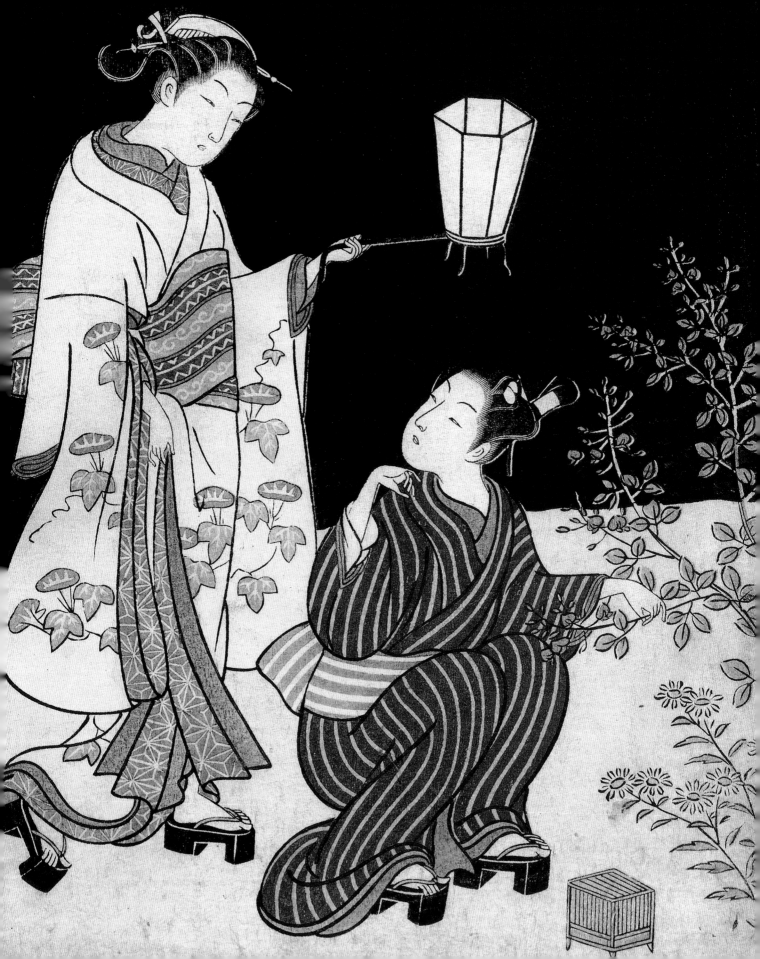

1764
France

c. 1765
USA

1767
France

1 *Morning*
François Boucher
Oil on canvas,
25½" x 32" (68 x 81 cm)
Rome (Italy), National Gallery of
the Art of the Past
Rococo

LANDSCAPE
RURAL LIFE

2 *Mrs. Joseph Scott*
John Singleton Copley
Oil on canvas,
5' 9½" x 3' 3½" (1.77 x 1 m)
Newark (USA),
Newark Museum

PORTRAITURE

3 *Portrait of Diderot*
Carle van Loo
Oil on canvas,
32" x 25½" (81 x 65 cm)
Paris (France), Louvre
Rococo

PORTRAITURE

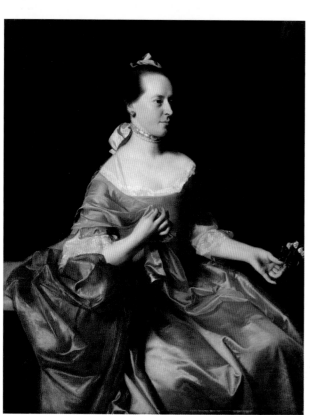

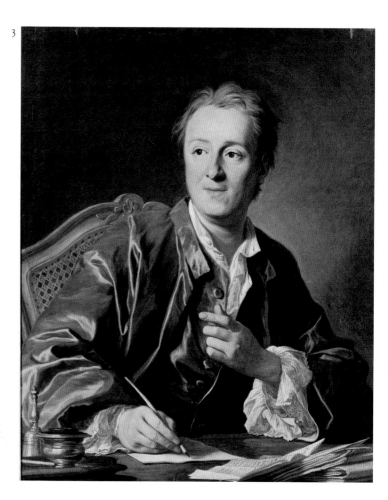

1771
France

1772
Spain

1773–1809
USA

Eruption of Mount Vesuvius
Pierre-Jacques Volaire
Oil on canvas,
5' 4" x 8' 7" (1.63 x 2.63 m)
Saint Petersburg (Russia),
State Hermitage Museum
Rococo

LANDSCAPE

5 *The Antique Store*
Luis Paret y Alcázar
Oil on wood,
19½" x 22¾" (50 x 58 cm)
Madrid (Spain),
Lazaro Galdiano Museum
Rococo

URBAN LIFE

6 *Portrait of the Peale Family*
Charles Wilson Peale
Oil on canvas,
4' 8½" x 7' 5½" (1.44 x 2.75 m)
New York (USA),
New-York Historical Society

PORTRAITURE
DOMESTIC LIFE

4

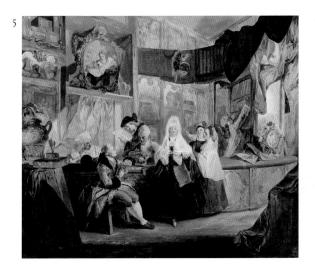

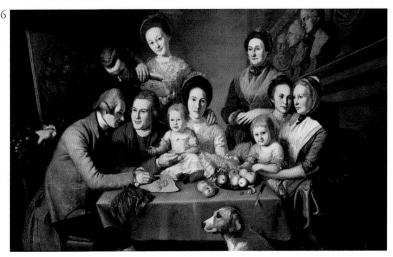

1 *Doge on the Bucentoro on Ascension Day*
Francesco Guardi
Oil on canvas,
26" x 39¾" (66 x 101 cm)
Paris (France), Louvre
Rococo

THE CITY
URBAN LIFE

2 *Self-Portrait*
Joshua Reynolds
Oil on canvas,
28" x 22¾" (71.5 x 58 cm)
Florence (Italy), Uffizi
Rococo

PORTRAITURE

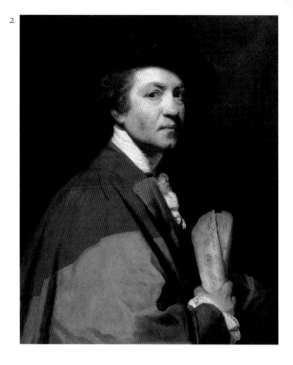

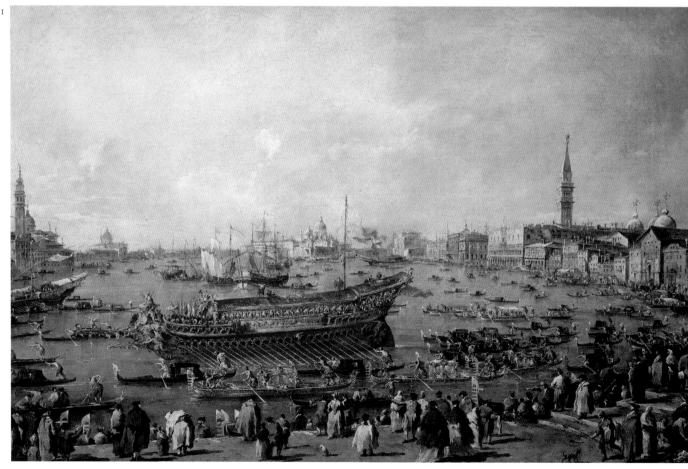

c. 1776	1776	c. 1780	1783
Germany	France	France	Russia

3 *Self-Portrait with Hourglass*
Johann Joseph Zoffany
Oil on wood,
34½" x 30½" (87.5 x 77 cm)
Florence (Italy), Uffizi

PORTRAITURE

4 *Portrait of Marie Antoinette*
Lié Louis Périn-Salbreux
Oil on canvas,
25½" x 21¼" (64.5 x 54 cm)
Rheims (France),
Museum of Fine Arts
Rococo

PORTRAITURE

5 *Sèvres Figurine with Group of Children and Dancing Dog*
Artist unknown
Biscuit porcelain
Florence (Italy), Pitti Palace,
Silver Museum
Rococo

LEISURE

6 *Portrait of Catherine II in the Guise of a Legislator in the Temple of Justice*
Dimitri Levitzky
Oil on canvas,
Moscow (Russia),
Tretyakov State Gallery
Baroque

PORTRAITURE
POLITICS

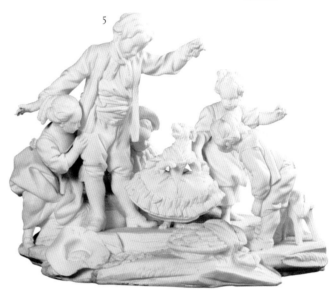
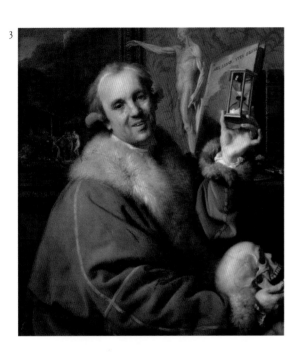
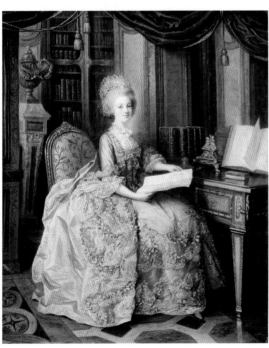
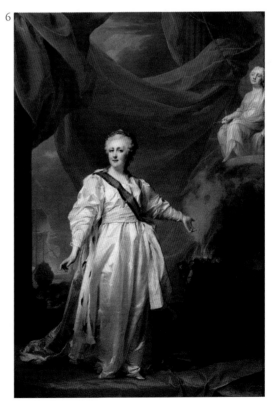

213

1 *Lady Macbeth Sleepwalking*
Henry Fuseli
Oil on canvas,
7' 3" x 5' 3" (2.21 x 1.6 m)
Paris (France), Louvre
Romanticism

LITERATURE

2 *Portrait of Peasant Woman in Russian Costume*
Ivan Argunov
Oil on canvas,
26½" x 21¼" (67 x 54 cm)
Moscow (Russia), Tretyakov State Gallery

RURAL LIFE
PORTRAITURE

3 *The Oath of the Horatii*
Jacques-Louis David
Oil on canvas,
10' 10" x 14' (3.3 x 4.27 m)
Paris (France), Louvre
Neoclassicism

HISTORY

Romanticism

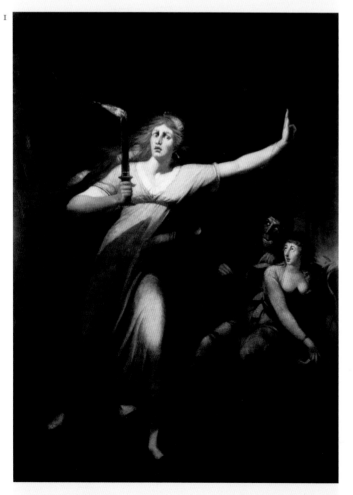

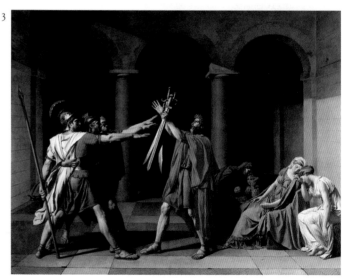

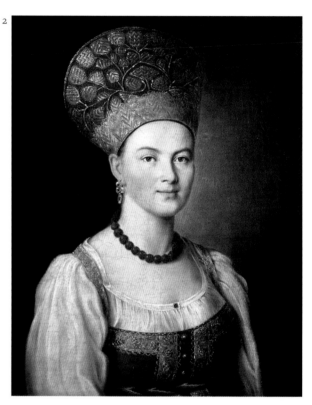

c. 1785
France

1786
France

4 *Portrait of Benjamin Franklin*
Joseph Duplessis
Oil on canvas,
28½" x 23½" (72.4 x 59.6 cm)
Washington, D.C. (USA),
National Portrait Gallery

PORTRAITURE

5 *Portrait of the Artist in His Studio
with His Daughters*
Jean-Laurent Mosnier
Oil on canvas,
7' 6½" x 5' 9" (2.3 x 1.75 m)
Saint Petersburg (Russia),
State Hermitage Museum
Rococo

PORTRAITURE

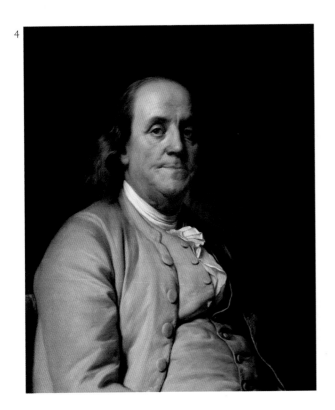

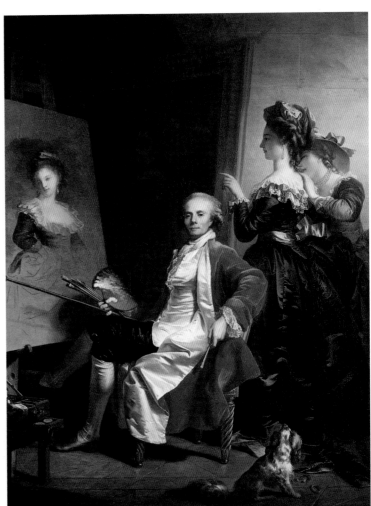

1787
Japan

1787
Italy

1787
Switzerland

1 *The Artist Sesshû Toyo*
Kashinsai Miwa
Painted and lacquered wood,
crystal eyes, height with stand:
9" (23.5 cm)
London (UK), British Museum
Japanese, Edo period

PORTRAITURE

2 *Cupid and Psyche*
Antonio Canova
Marble, height: 5' 1¾" (155 cm)
Paris (France), Louvre
Neoclassicism

MYTHOLOGY
THE BODY

3 *Self-Portrait*
Angelica Kauffmann
Oil on canvas,
50½" x 37" (128 x 93.5 cm)
Florence (Italy), Uffizi
Neoclassicism

PORTRAITURE

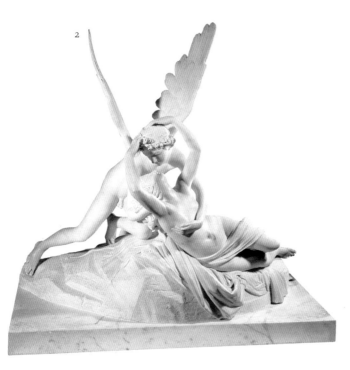

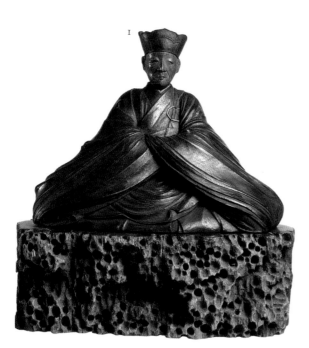

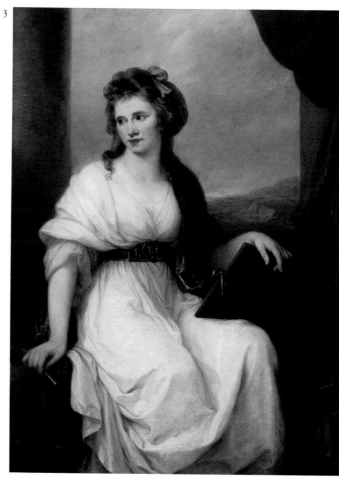

1787–1789
France

The Stolen Kiss
Jean-Honoré Fragonard
Oil on canvas,
17¾" x 21¾" (45 x 55 cm)
Saint Petersburg (Russia),
State Hermitage Museum

DOMESTIC LIFE

c. 1787
France

5 *The Maison Carrée at Nîmes*
Hubert Robert
Oil on canvas
Paris (France), Louvre
Neoclassicism

1788
Japan

6 *Lovers in an Upstairs Room, from the
"Uta Makura" ("Poem of the Pillow")*
Kitagawa Utamaro
Woodblock print,
10" x 14½" (25.5 x 36.9 cm)
London (UK), British Museum
Japanese, Edo period

LEISURE

4
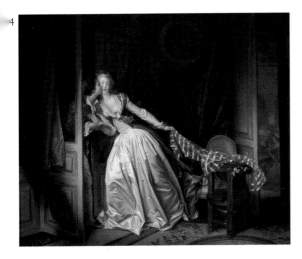

5
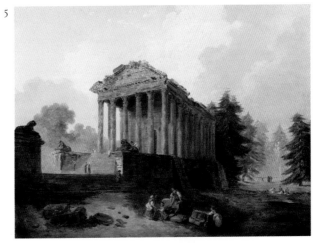

6
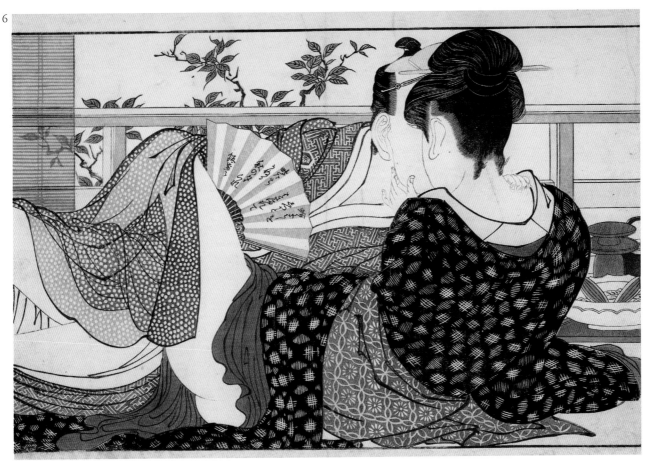

1788
France

1790
France

c. 1790
France

1 *Portrait of the Painter Hubert Robert*
Elisabeth Vigée-Lebrun
Oil on canvas,
41½" x 33½" (105 x 85 cm)
Paris (France), Louvre
Neoclassicism

PORTRAITURE

2 *Self-Portrait*
Elisabeth Vigée-Lebrun
Oil on canvas,
39½" x 32" (100 x 81 cm)
Florence (Italy), Uffizi
Neoclassicism

PORTRAITURE

3 *The Education of Achilles*
**Louis-Jean-François
Lagrenée the Elder**
Oil on canvas
Riverdale-on-Hudson (USA),
Moss Stanley collection
Neoclassicism

MYTHOLOGY

4 *The Sleep of Endymion*
**Anne-Louis Girodet de
Roucy Trioson**
Oil on canvas,
6' 6¼" x 8' 6½" (1.99 x 2.61 m)
Paris (France), Louvre
Romanticism

MYTHOLOGY
THE BODY

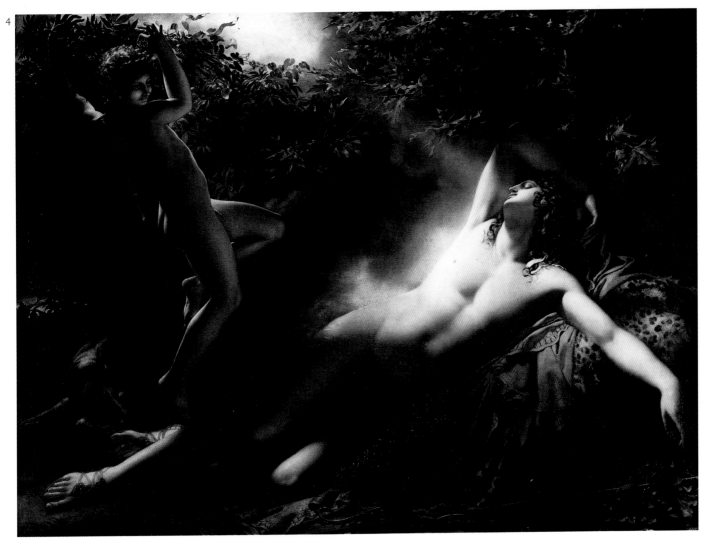

1793
France

1794
Britain

1 *Marat Assassinated in His Bath*
Jacques-Louis David
Oil on canvas,
5' 5" x 4' 2½" (165 x 128 cm)
Brussels (Belgium), Royal
Museums of Fine Arts
Neoclassicism

HISTORY
PORTRAITURE

2 *The Ancient of Days, Frontispiece
from "Europe, A Prophecy"*
William Blake
Etching, 9" x 7" (22.5 x 17.7 cm)
New York (USA), Pierpont Morgan
Library
Romanticism

RELIGION

1

2

| 1796 | c. 1796 | 1797 | 1797–1801 |
| Spain | France | Italy | Italy |

Godoy Presenting Peace to Charles IV
José Aparicio Inglada
Oil on canvas
Madrid (Spain), San Fernando
Royal Academy of Fine Arts

HISTORY
ALLEGORY

4 *View of the Grande Galerie
of the Louvre*
Hubert Robert
Oil on canvas,
13½" x 16½" (34 x 42 cm)
Paris (France), Louvre

URBAN LIFE

5 *Pulcinella in Love*
Giovanni Domenico Tiepolo
Fresco, 6' 1" x 5' 3" (1.96 x 1.6 m)
Venice (Italy),
Ca' Rezzonico Museum

LEISURE
LITERATURE

6 *Perseus*
Antonio Canova
Marble, 7' 1" (2.2 m)
Vatican (Vatican City),
Pio-Clementino Museum
Neoclassicism

MYTHOLOGY
THE BODY

6
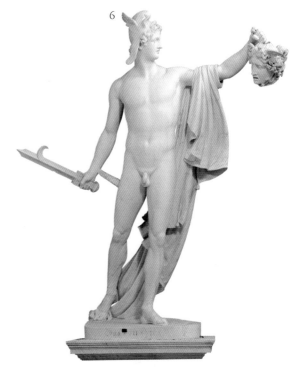

3
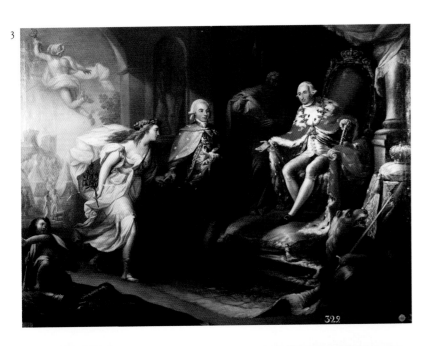

4

5

1 *The Clothed Maja*
Francesco de Goya
Oil on canvas,
3' 1½" x 6' 2¾" (95 x 190 cm)
Madrid (Spain), Prado

PORTRAITURE

2 *The Naked Maja*
Francesco de Goya
Oil on canvas,
3' 2" x 6' 4" (97 x 190 cm)
Madrid (Spain), Prado

THE BODY
PORTRAITURE

1

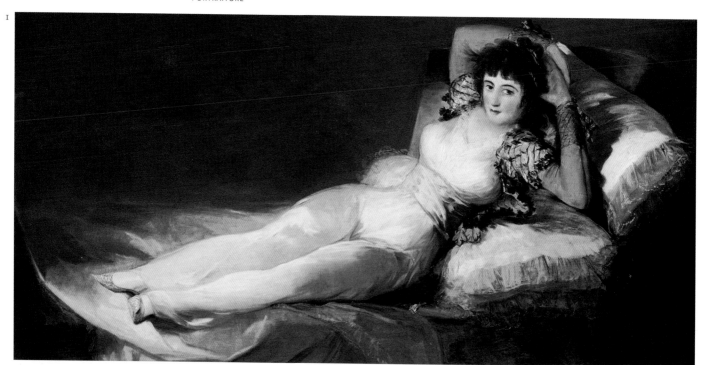

2

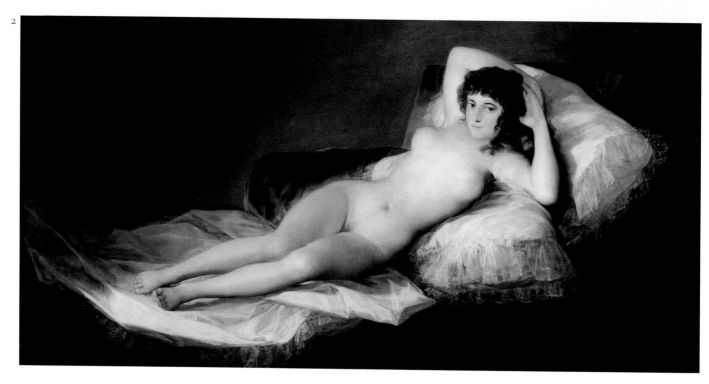

The Happiness of Being a Mother
François Gérard
Oil on canvas
Saint Petersburg (Russia),
State Hermitage Museum

DOMESTIC LIFE

4 *The Children of Ayscoghe Boucherett*
Thomas Lawrence
Oil on canvas,
6' 4½" x 4' 9" (1.94 x 1.45 m)
Paris (France), Louvre

PORTRAITURE

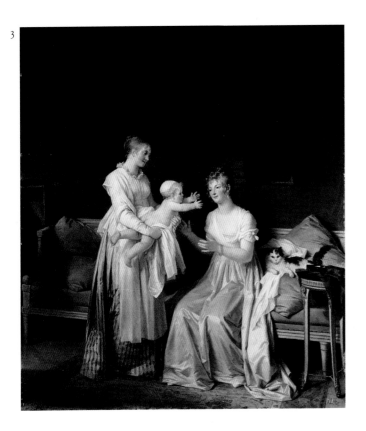

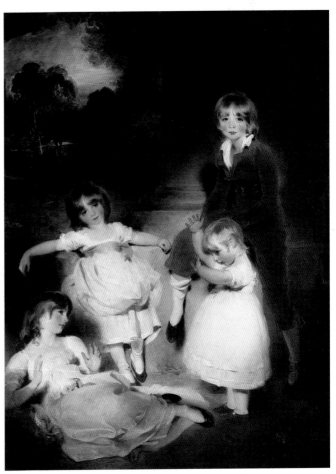

1800–1801
Spain

c. 1800–1900
Papua New Guinea

1800
France

1 *Portrait of the Family of Charles IV*
Francisco de Goya
Oil on canvas,
9' ½" x 11' (2.8 x 3.36 m)
Madrid (Spain), Prado

PORTRAITURE

2 *Panel Carved with Water Deities*
Artist unknown
Wood, height: c. 47¼" (120 cm)
Vatican (Vatican City), Missionario-
Etnologico Museum
Papua New Guinean

RELIGION

3 *Portrait of Madame Recamier*
Jacques-Louis David
Oil on canvas,
5' 7" x 7' 10½" (1.7 m x 2.40 m)
Paris (France), Louvre
Neoclassicism

PORTRAITURE

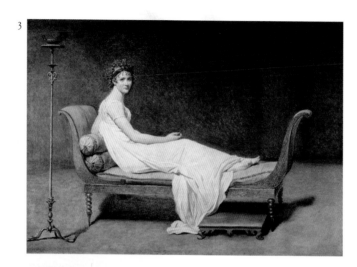

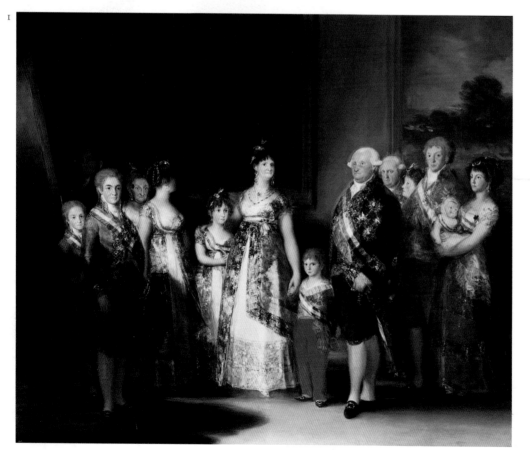

| 1800 | c. 1800 | c. 1800–1900 |
| France | India | Congo |

Self-Portrait
Elisabeth Vigée-Lebrun
Oil on canvas,
31" x 26¾" (78.5 x 68 cm)
Saint Petersburg (Russia), State
Hermitage Museum
Rococo

PORTRAITURE

5 *Scene from the "Legend of Gazi"*
Artist unknown
Scroll painting, detail
London (UK), British Museum
Indian

ANIMALS
MYTHOLOGY

6 *Mask*
Artist unknown
Wood with fiber beard and fur
horns, height: 56" (142 cm)
London (UK), British Museum
Congan, Songye

RELIGION

4

5

6

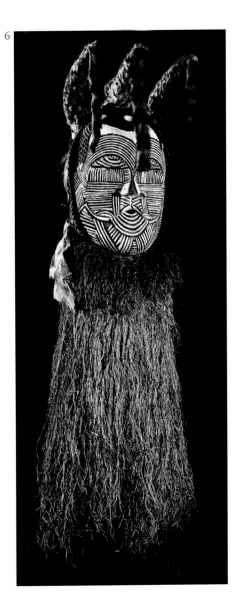

225

c. 1801
Russia

1803
Japan

1804
France

1 *Red Square in Moscow*
Fyodor Aleksyev
Oil on canvas
Moscow (Russia),
Tretyakov State Gallery

THE CITY
URBAN LIFE

2 *Courtesans, from "Mr. Aoi's Chronicle of Charm"*
Saitô Shûho
Woodblock print,
10" x 14" (25.7 x 36.4 cm)
London (UK), British Museum
Japanese, Edo period

URBAN LIFE

3 *Napoleon Visiting the Plague Victims at Jaffa, March 11, 1799*
Antoine-Jean Gros
Oil on canvas,
7' ½" x 23' 7" (5.32 x 7.20 m)
Paris (France), Louvre
Romanticism

HISTORY
PORTRAITURE

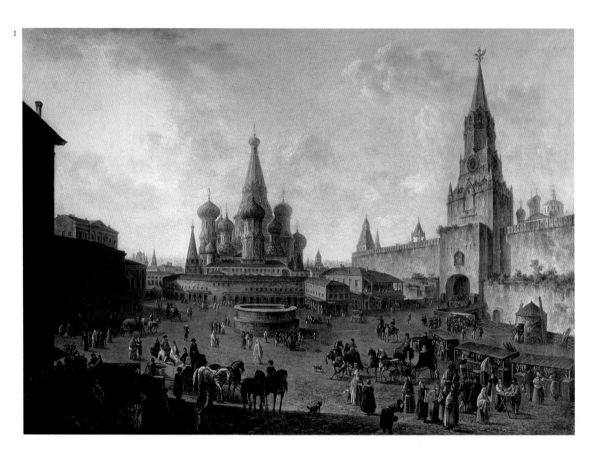

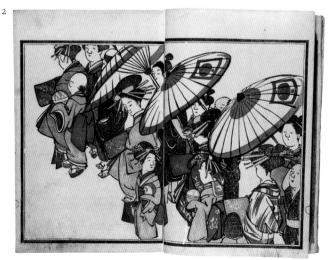

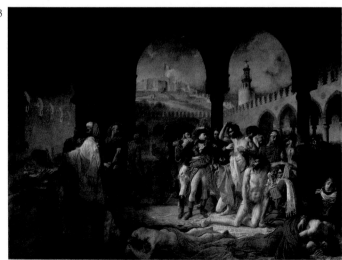

1804
France

1805–1807
France

1807
France

4 *Innocence Preferring Love to Wealth*
Pierre-Paul Prud'hon
Oil on canvas
Saint Petersburg (Russia),
State Hermitage Museum
Neoclassicism

ALLEGORY
THE BODY

5 *Coronation of Napoleon*
Jacques-Louis David
Oil on canvas,
20' x 30' 5" (6.9 x 9.27 m)
Paris (France), Louvre
Neoclassicism

POLITICS
PORTRAITURE

6 *Portrait of Napoleon Bonaparte*
François Gérard
Oil on canvas
Naples (Italy), Capidomonte
Museum
Neoclassicism

POLITICS
PORTRAITURE

4

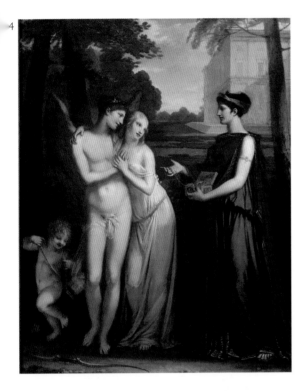

5

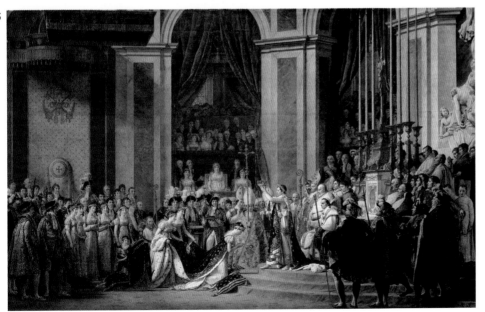

6

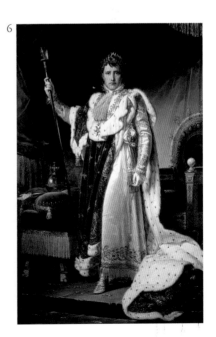

c. 1808
Spain

1808
Italy

c. 1810
Italy

1 *The Colossus* or *Panic*
Francisco de Goya
Oil on canvas,
45½" x 41½" (116 x 105 cm)
Madrid (Spain), Prado

MYTHOLOGY
ALLEGORY

2 *Pauline Borghese as Venus*
Antonio Canova
Marble with wooden base,
length: 6' 2½" (1.99 m)
Rome (Italy), Borghese Gallery
Neoclassicism

PORTRAITURE
THE BODY

3 *View of the Colosseum*
Fyodor Matveyev
Oil on canvas
Moscow (Russia),
Tretyakov State Gallery
Neoclassicism

LANDSCAPE

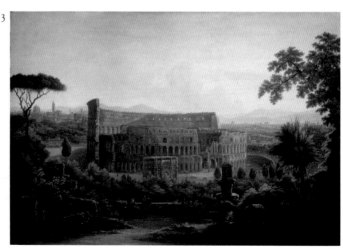

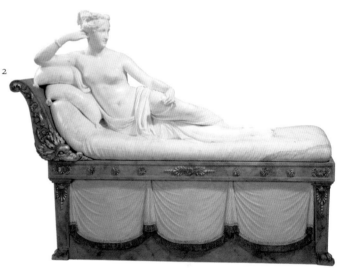

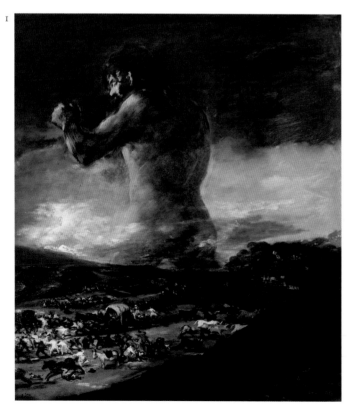

c. 1810
Russia

1814
Spain

1815
Spain

4 *Venus and Adonis*
Peter Sokolov
Oil on canvas
Saint Petersburg (Russia),
State Hermitage Museum
Neoclassicism

MYTHOLOGY
THE BODY

5 *The Third of May 1808*
Francisco de Goya
Oil on canvas,
8' 8½" x 11' 3½" (2.66 x 3.45 m)
Madrid (Spain), Prado

WAR
HISTORY

6 *Self-Portrait*
Francisco de Goya
Oil on canvas,
18½" x 13¾" (46 x 35 cm)
Madrid (Spain), Prado

PORTRAITURE

4
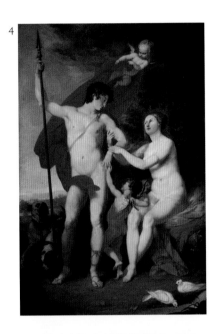

5
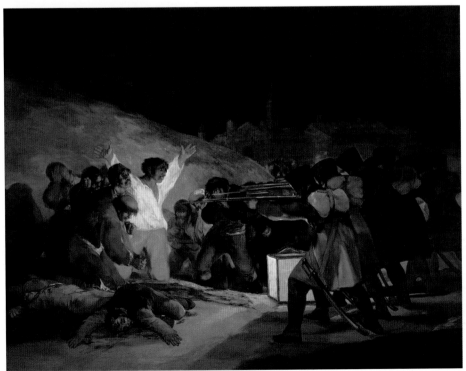

6
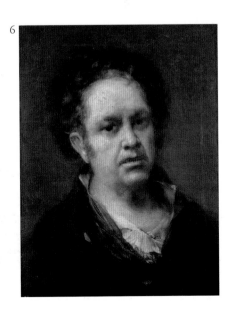

1 *Portrait of Antonio Canova*
Thomas Lawrence
Oil on canvas,
38" x 28" (96.5 x 71 cm)
Possagno (Italy),
Canova Sculpture Gallery

PORTRAITURE

2 *The Raft of the Medusa*
Théodore Géricault
Oil on canvas,
16' x 23' 6" (4.91 x 7.16 m)
Paris (France), Louvre
Romanticism

SOCIAL PROTEST
THE BODY

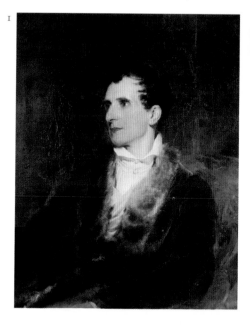

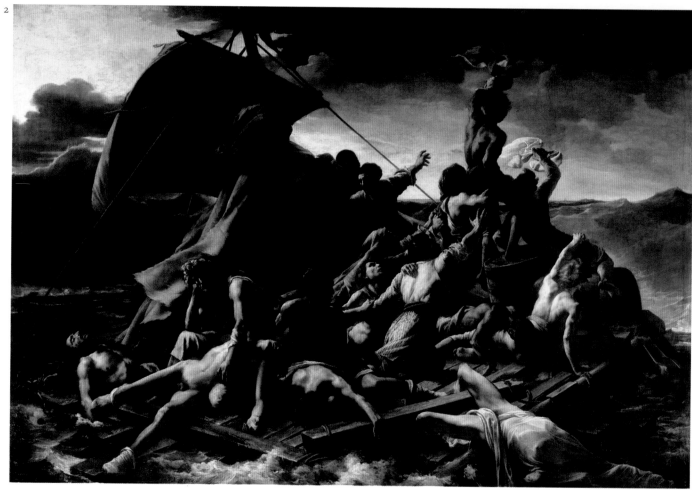

1820
Britain

1821
Norway

1822
Italy

Dedham Lock and Mill
John Constable
Oil on canvas,
21¼" x 30" (53.7 x 76.2 cm)
London (UK), Victoria and Albert
Museum
Romanticism

LANDSCAPE
RURAL LIFE

4 *Alpine Landscape*
Johan Christian Dahl
Oil on canvas
Nuremberg (Germany),
Germanisches Museum
Romanticism

LANDSCAPE

5 *Interior of Basilica of San Lorenzo*
Giovanni Migliara
Oil on canvas
Milan (Italy), Milan Museum
Romanticism

RELIGION
URBAN LIFE

3

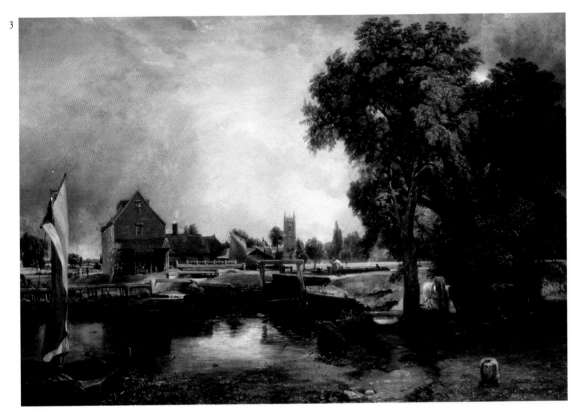

4

5

| 1822–1823 | 1823–1824 | 1823 |
| France | Germany | Britain |

1 *The Madwoman*
Théodore Géricault
Oil on canvas,
30¼" x 25½" (77 x 64.5 cm)
Paris (France), Louvre
Romanticism

PORTRAITURE

2 *Shipwreck* or *Sea of Ice*
Caspar David Friedrich
Oil on canvas,
38" x 50" (97 x 127 cm)
Hamburg (Germany), Kunsthalle
Museum
Romanticism

LANDSCAPE

3 *View of Salisbury Cathedral
Grounds from the Bishop's House*
John Constable
Oil on canvas,
34½" x 44" (87.6 x 111.8 cm)
London (UK),
Victoria and Albert Museum
Romanticism

LANDSCAPE
RURAL LIFE

2

1

3
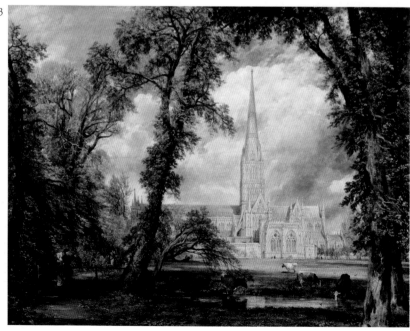

1824	1825–1831	1827
France	Italy	France

4 *The Massacer at Chios*
Eugène Delacroix
Oil on canvas,
13' 10" x 11' 6" (4.22 x 3.52 m)
Paris (France), Louvre
Romanticism

HISTORY

5 *Tomb of Pope Pius VII*
Bertel Thorvaldsen
Marble
Vatican (Vatican City),
Saint Peter's Basilica
Neoclassicism

DEATH
RELIGION

6 *Apotheosis of Homer*
Jean-Auguste-Dominique Ingres
Oil on canvas,
12' 7" x 16' 10½" (3.86 x 5.15 m)
Paris (France), Louvre
Neoclassicism

LITERATURE

5

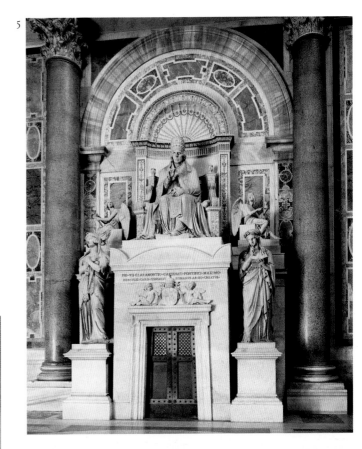

4

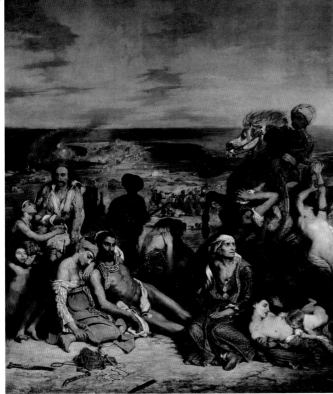

6

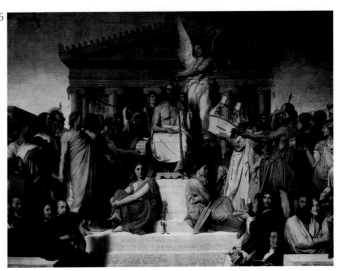

1 *The Death of Sardanapalus*
Eugène Delacroix
Oil on canvas,
12' 11" x 16' 3" (3.95 x 4.95 m)
Paris (France), Louvre
Romanticism

HISTORY
THE BODY

2 *Niagara Falls*
George Catlin
Oil on canvas,
1' 4¼" x 7' 1¼" (0.41 x 2.17 m)
Washington, D.C. (USA),
Smithsonian American Art
Museum
Hudson River School

LANDSCAPE

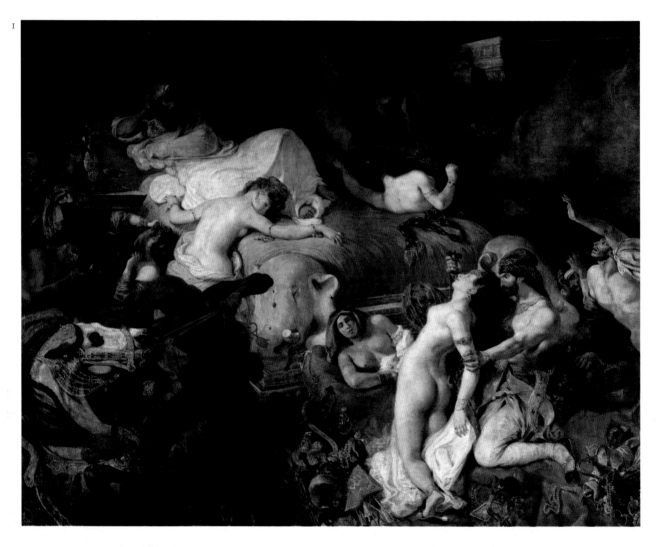

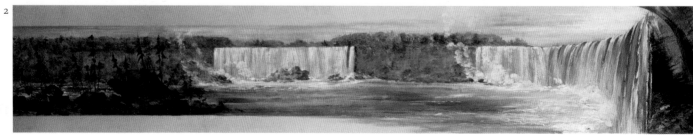

1828–1833
Russia

1830
France

1830–1833
Japan

3 *The Last Day of Pompeii*
Karl Pavlovich Bryollov
Oil on canvas,
15' x 21' 4½" (4.56 x 6.51 m)
Saint Petersburg (Russia),
State Hermitage Museum
Academic

HISTORY

4 *Liberty Leading the People,
July 28, 1830*
Eugène Delacroix
Oil on canvas,
8' 5½" x 10' 7½" (2.6 x 3.25 m)
Paris (France), Louvre
Romanticism

ALLEGORY
HISTORY

5 *Eriji in Suruga Province*
Katsushika Hokusai
Color woodblock print,
10¼" x 15" (25.9 x 38.2 cm)
London (UK), British Museum
Japanese, Edo period

LANDSCAPE

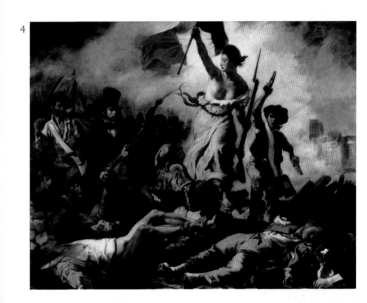

Academic

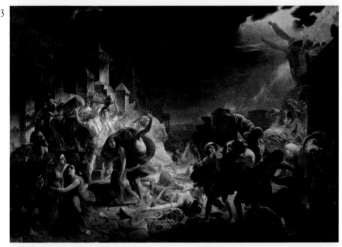

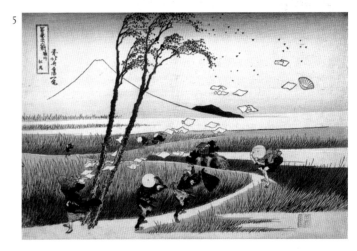

The invention of photography changes the role of the artist

The invention of photography challenged artists to find new ways of expressing their ideas and offered them both assistance and inspiration.

By the 1830s, early daguerreotype photographs were demonstrating the potential of this amazing new invention. Some artists believed it would fundamentally undermine painting. J.M.W. Turner declared, "This is the end of Art. I am glad I have had my day." Paul Delaroche echoed this remark, saying, "From today, painting is dead!" Yet, from the outset, artists derived positive benefits from the invention. It could be more effective and cheaper to work from a photograph, rather than a model. Artists such as Eugène Delacroix, Gustave Courbet, and John Millais began using photographs from as early as the 1850s.

Painters were also fascinated by what a photograph could capture. Early cameras required a long exposure, so anything that moved would appear blurred, or would leave a ghost image on the photograph. The crowds in Claude Monet's bustling street scenes are indistinct, while the foliage in Camille Corot's romantic landscapes is slightly out of focus, as if gently stirring in the breeze. These effects were inspired by "halation," in which a bright light blurs the forms of surrounding, darker shapes, as happens in photographs of sunlight filtering through leaves.

The length of exposure time reduced as photographic technology advanced and this enabled artists to see things that were not visible to the naked eye. For generations, artists had conveyed the speed of a racehorse running at full tilt by showing it with all four legs off the ground. This "flying gallop," shown vividly in the Théodore Géricault's painting of the *Epsom Derby,* became a cliché of racing and hunting pictures. However, Eadweard Muybridge's pioneering, frame-by-frame studies of moving animals, *A Horse in Motion* (1878) and *Animal Locomotion* (1887), proved that this was a fallacy, and artists were able to paint animals with new insight and naturalism. The same was true of the movement of the human figure, which was studied in photographic sequences of athletes by Eadweard Muybridge and Thomas Eakins, among others.

Photography also altered the way that painters constructed their compositions. Previously, artists had treated their pictures as self-contained units, in which the subject was presented in a clear and balanced manner. As instant photographic images became available, however, some painters adopted a more informal approach. Edgar Degas's figures are often cropped at the painting's edge, their heads are hidden behind posts, or they gaze at something unseen, beyond the confines of the picture. These images are framed fragments of a larger reality and reflect the sorts of images captured with a camera.

One of the most important impacts of photography was its ability to capture detail. Until the middle years of the nineteenth century, artistic skill was judged by the level of detail achieved. Artists were expected to finish their work to a realistic perfection. Now that cameras could achieve this, artists were able to paint in ways that produced alternative images of the world. At first the Romantics and Impressionists were deemed incompetent by many critics because they seemed to have failed to finish their work sufficiently. In time, however, their looser style and ability to offer their own interpretations of reality were valued above mere naturalism. Because photographers could capture the real world, artists were now free to change reality.

Epsom Derby
Théodore Géricault, 1821

Galloping Horse from the "Animal Locomotion" Series
Eadweard Muybridge, 1887

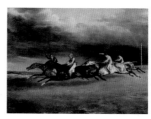

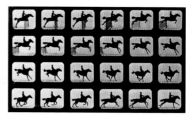

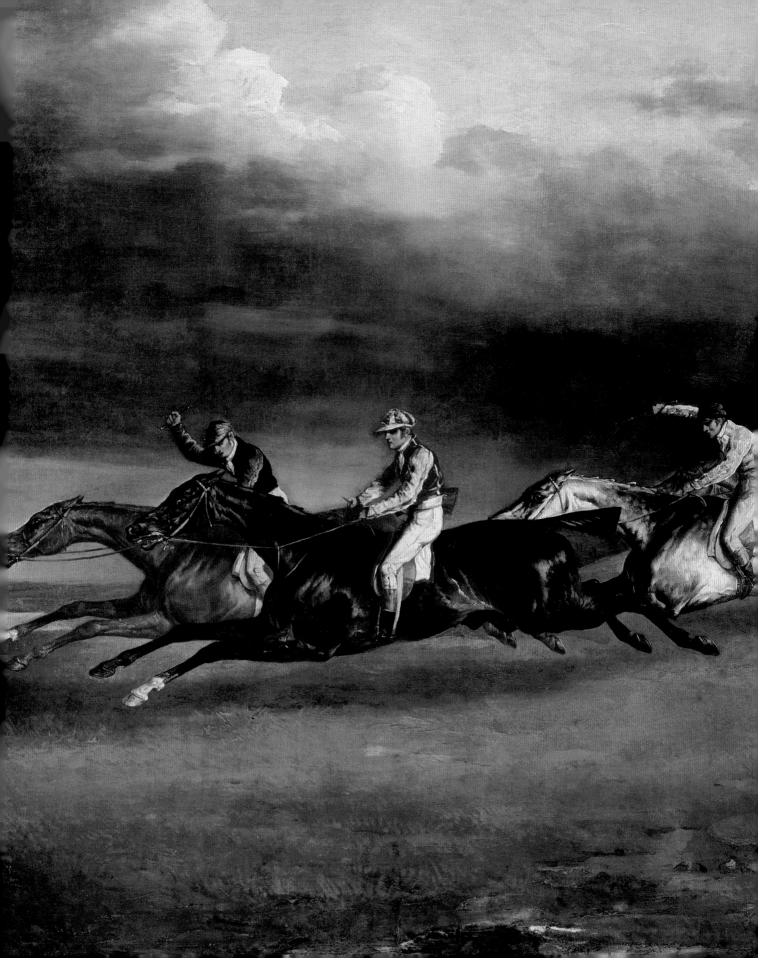

2

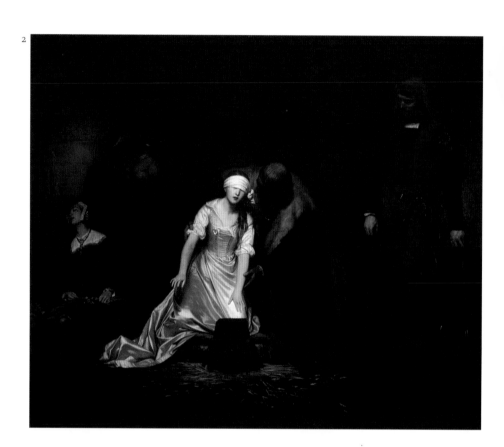

1

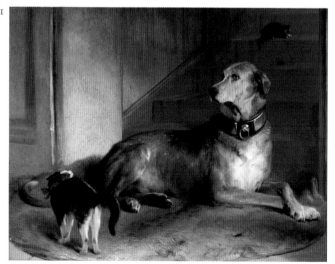

3

| c. 1835 | 1835 | 1835 |
| France | Britain | Japan |

Self-Portrait
Jean-Baptiste-Camille Corot
Oil on canvas,
13½" x 10" (34 x 25 cm)
Florence (Italy), Uffizi

PORTRAITURE

5 *Burning of the Houses
of Lords and Commons*
Joseph Mallord William Turner
Oil on canvas,
36¼" x 48½" (92 x 123 cm)
Philadelphia (USA), Philadelphia
Museum of Art
Romanticism

HISTORY
THE CITY

6 *Dragon Ascending Mount Fuji,
from "One Hundred Views of Mount
Fuji"*
Katshusika Hokusai
Woodblock print,
9" x 12" (22.7 x 31.4 cm)
London (UK), British Museum
Japanese, Edo period

LANDSCAPE

6

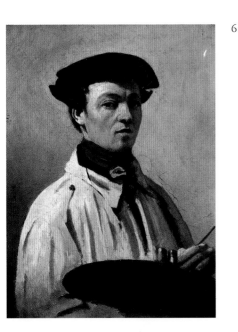

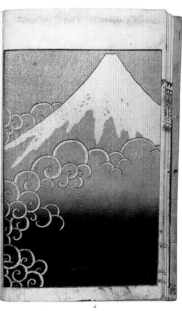

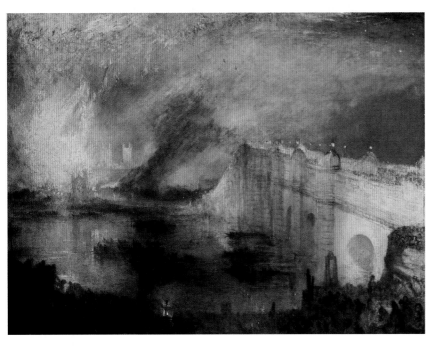

1 *Trust in God*
Lorenzo Bartolini
Marble, life-size
Milan (Italy),
Poldi Pezzoli Museum
Neoclassicism

RELIGION
THE BODY

2 *Tomb of Princess Sophia*
Zamoyska Czartoryski
Lorenzo Bartolini
Marble
Florence (Italy),
Church of Santa Croce
Neoclassicism

DEATH
PORTRAITURE

3 *Tomb of Princess Sophia*
Zamoyska Czartoryski (detail)
Lorenzo Bartolini
Marble, life-size
Florence (Italy),
Church of Santa Croce
Neoclassicism

DEATH
PORTRAITURE

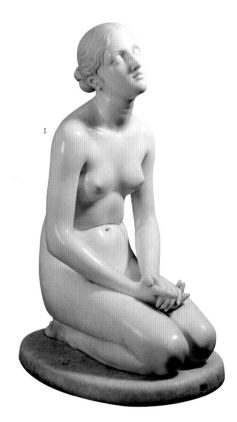

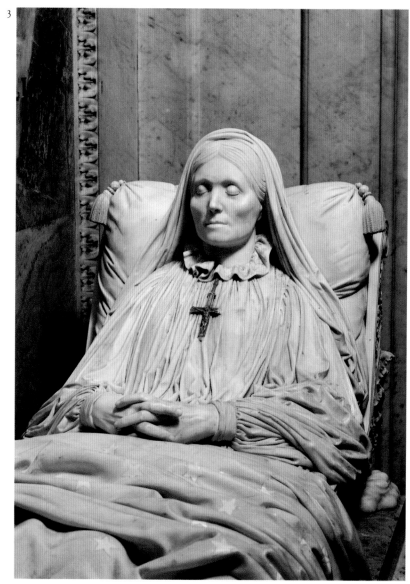

Theseus and the Minotaur
Antoine-Louis Barye
Bronze, height: 17¾" (45 cm)
Paris (France), Louvre
Academic

MYTHOLOGY
THE BODY

5 *Angelica and Roger Riding
on the Hippogryph*
Antoine-Louis Barye
Bronze, height: 20" (51 cm)
Paris (France), Louvre
Academic

MYTHOLOGY

1 *Landscape with Junction
 of the Severn and the Wye*
 Joseph Mallord William Turner
 Oil on canvas,
 36¾" x 48½" (93 x 123 cm)
 Paris (France), Louvre
 Romanticism

 LANDSCAPE

2 *Comanche Indians Chasing
 Buffalo with Lances and Bows*
 George Catlin
 Oil on canvas,
 19½" x 27½" (50 x 70 cm)
 Washington, D.C. (USA),
 Smithsonian American Art
 Museum

 RURAL LIFE
 ANIMALS

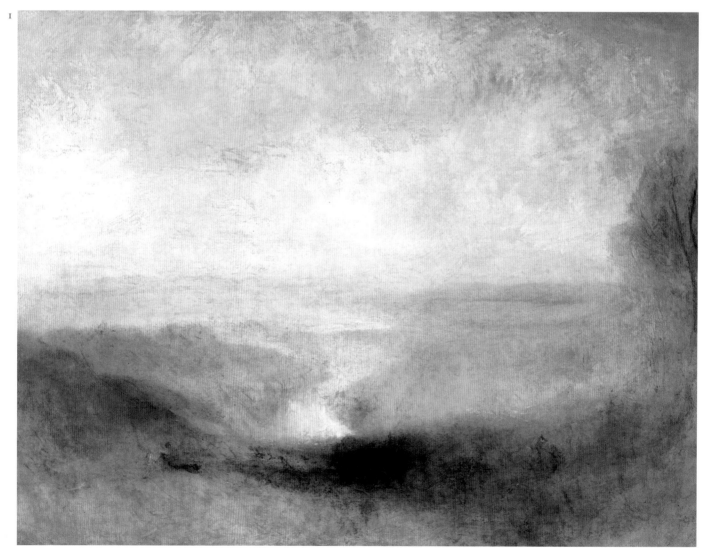

1847
France

c. 1847
Canada

1848
France

The Romans of the Decadence
Thomas Couture
Oil on canvas,
15' 5¾" x 25' 4" (4.72 x 7. 72 m)
Paris (France), Orsay Museum
Academic

HISTORY
THE BODY

4 *Wigman in Lower Canada*
Cornelius Krieghoff
Oil on canvas,
14" x 20" (35.5 x 50.9 cm)
Montreal (Canada),
McCord Museum

RURAL LIFE

5 *Remembrance of Barricades in June,
1848*
Ernest Meissonier
Oil on canvas,
11½" x 8½" (29 x 22 cm)
Paris (France), Louvre
Academic

SOCIAL PROTEST
HISTORY

3

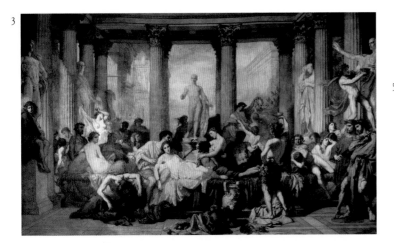

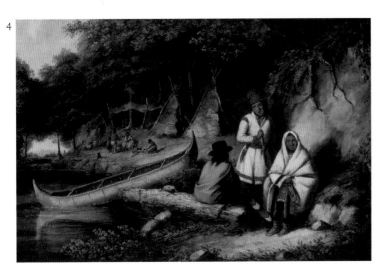

5

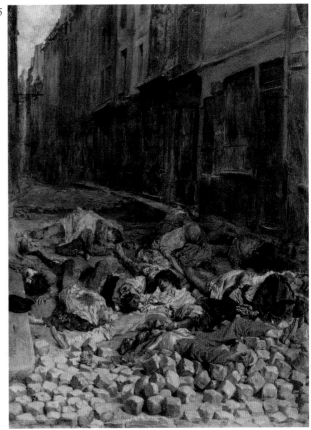

1849–1850 France	c. 1850 Spain	1856 France

1 *The Burial at Ornans*
Gustave Courbet
Oil on canvas,
10' 3½" x 21' 9" (3.14 x 6.63 m)
Paris (France), Orsay Museum
Realism

RURAL LIFE
DEATH

2 *Woman Condemned*
by the Inquisition
Eugenio Lucas y Padilla
Oil on canvas,
36¼" x 30¾" (92 x 78 cm)
Madrid (Spain), Prado

HISTORY

3 *Shepherdess* or *Woman Knitting*
Jean-François Millet
Oil on canvas,
15¼" x 11½" (38.7 x 29.2 cm)
Paris (France), Orsay Museum
Realism

RURAL LIFE
RELIGION

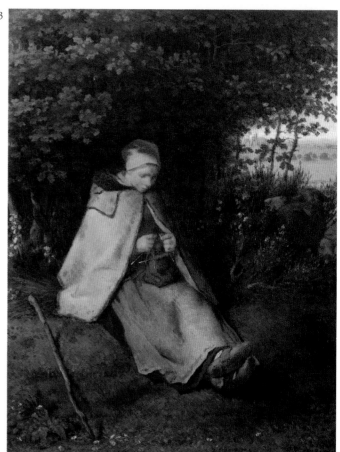

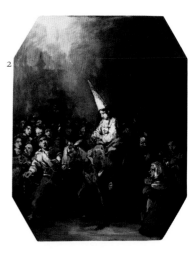

Realism

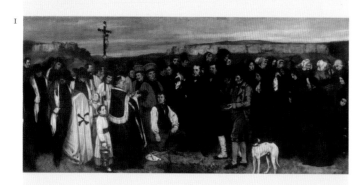

244

1857
France

1857
Italy

1857
France

4 *Spring*
Charles-François Daubigny
Oil on canvas,
37" x 76" (94 x 193 cm)
Paris (France), Louvre
Barbizon

LANDSCAPE

5 *Still Life*
Giovacchino Toma
Oil on canvas,
11½" x 16½" (29 x 42 cm)
Florence (Italy), Modern Art
Gallery

STILL LIFE

6 *The Gleaners*
Jean-François Millet
Oil on canvas,
33" x 44" (84 x 112 cm)
Paris (France), Orsay Museum
Realism

RURAL LIFE

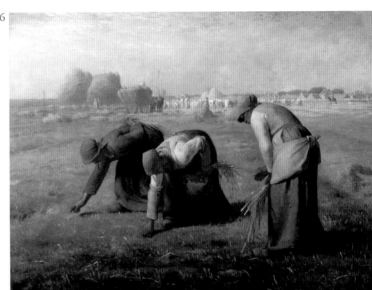

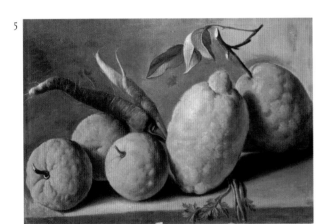

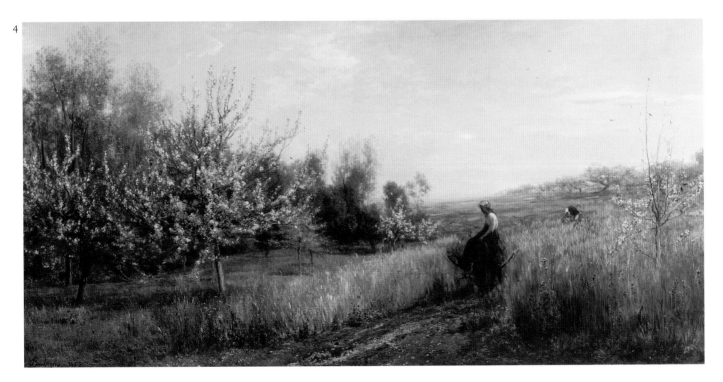

c. 1858–1860
France

1858–1860
France

1858
Japan

1 *Crispin and Scapin*
Honoré Daumier
Oil on canvas,
21¾" x 32¼" (55.2 x 81.9 cm)
Paris (France), Orsay Museum

LEISURE

2 *The Bellelli Family*
Edgar Degas
Oil on canvas,
6' 6½" x 8' 1" (2 x 2.50 m)
Paris (France), Orsay Museum

PORTRAITURE

3 *Fuji from the Gulf of Suruga*
Ando Hiroshige
Woodblock print,
13¼" x 8¾" (33.6 x 22.2 cm)
Newark (USA),
Newark Museum
Japanese, Edo period

LANDSCAPE

1

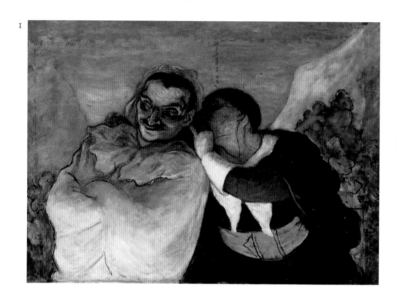

2

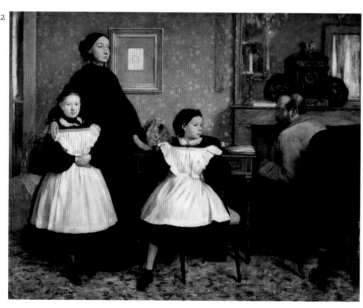

3

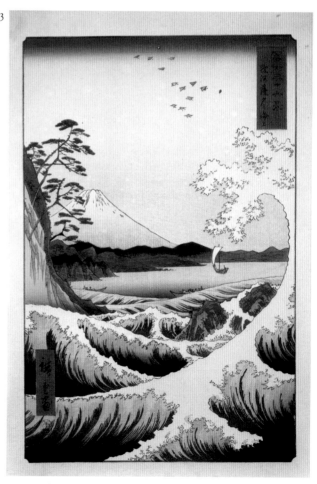

c. 1860
Italy

1861
USA

1862
France

4 *Portrait of Wagner*
Giuseppe Tivoli
Oil on canvas
Bologna (Italy), Bibliographical
Museum

PORTRAITURE

5 *Westward the Course of the Empire
Takes Its Way (study for Westward
Ho!)*
Emanuel Gottlieb Leutze
Oil on canvas,
33¼" x 43½" (84.5 x 111.2 cm)
Washington, D.C. (USA),
Smithsonian American Art
Museum
Academic

HISTORY
LANDSCAPE

6 *Turkish Bath*
Jean-Auguste-Dominique Ingres
Oil on canvas,
diameter: 42½" (108 cm)
Paris (France), Louvre
Romanticism

THE BODY

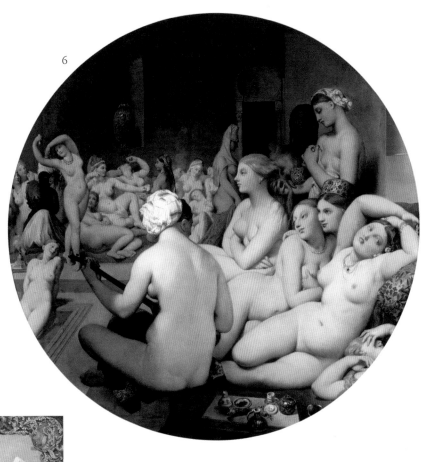

1863
France

1863
France

1863
France

1 *Le Déjeuner sur l'Herbe*
Edouard Manet
Oil on canvas,
6' 10" x 8' 8" (2.08 x 2.74 m)
Paris (France), Orsay Museum
Realism

THE BODY
URBAN LIFE

2 *Olympia*
Edouard Manet
Oil on canvas,
4' 3½" x 6' 3" (1.31 x 1.9 m)
Paris (France), Orsay Museum
Realism

THE BODY
URBAN LIFE

3 *Birth of Venus*
Alexandre Cabanel
Oil on canvas,
4' 3¼" x 7' 4½" (1.30 x 2.25 m)
Paris (France), Orsay Museum
Academic

MYTHOLOGY
THE BODY

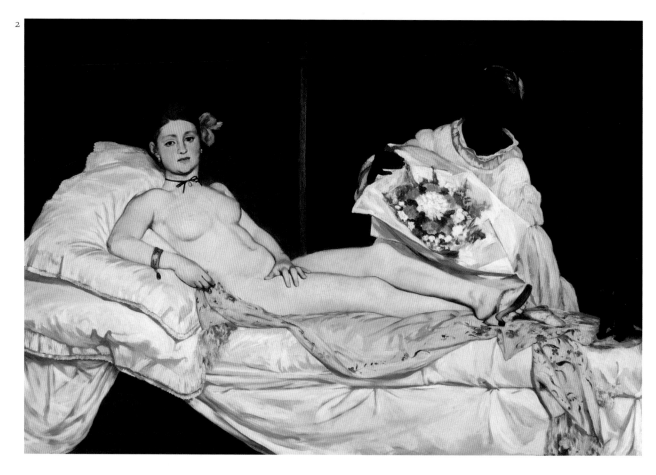

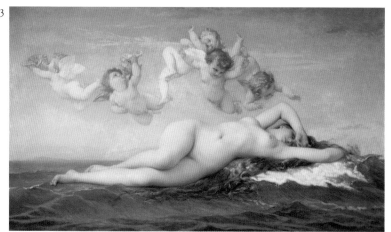

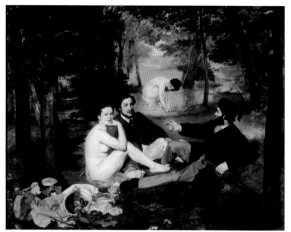

1864
France

1865–1889
France

1865
Italy

4 *Memories of Mortefontaine*
Jean-Baptiste-Camille Corot
Oil on canvas,
25¼" x 34½" (64 x 88 cm)
Paris (France), Louvre

LANDSCAPE

5 *The Dance*
Jean-Baptiste Carpeaux
Stone, height: 13' ½" (4.2 m)
Paris (France), Orsay Museum

ALLEGORY
THE BODY

6 *Department for Violent
Female Mental Patients at
San Bonifacio in Florence*
Telemaco Signorini
Oil on canvas,
26" x 23¼" (66 x 59 cm)
Venice (Italy), Modern Art Gallery
Macchiaioli

URBAN LIFE

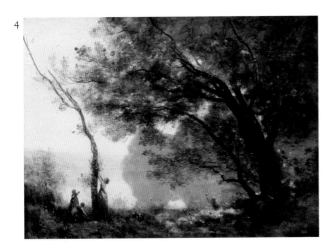

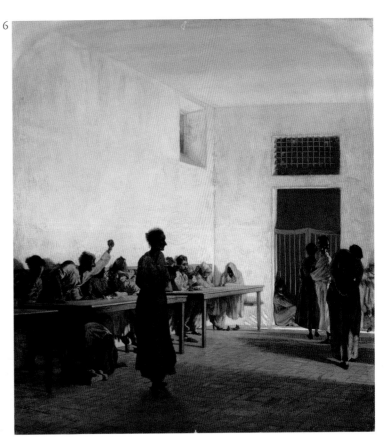

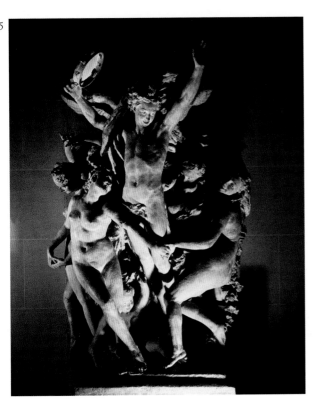

1 *The Artist in His Studio*
James Abbott McNeill Whistler
Oil on canvas, 24¾" x 18¼"
(62.9 x 47.6 cm)
Chicago (USA),
Art Institute of Chicago
Impressionism

PORTRAITURE

2 *Pierre-Joseph Prud'hon
and His Children*
Gustave Courbet
Oil on canvas,
4' 10" x 6' 6" (1.47 x 1.98 m)
Besançon (France),
Museum of Fine Arts
Realism

PORTRAITURE

3 *Orpheus*
Gustave Moreau
Oil on canvas,
5' ¼" x 3' 3¾" (1.54 x 1.01 m)
Paris (France), Orsay Museum

MYTHOLOGY

Impressionism

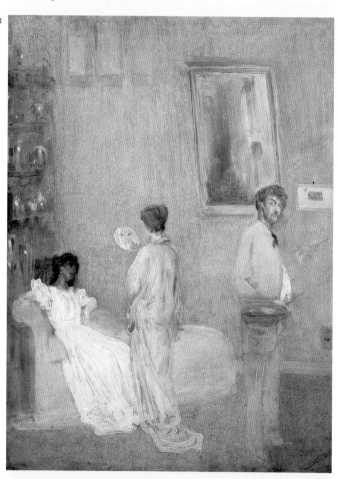

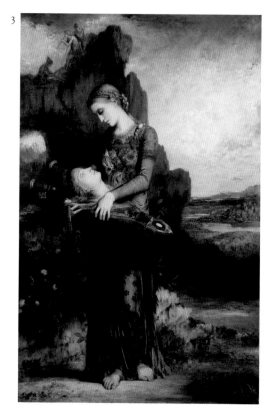

1867–1868
France

c. 1868
France

1868–1873
France

Portrait of Emile Zola
Edouard Manet
Oil on canvas,
4' 9½" x 3' 9" (1.46 x 1.14 m)
Paris (France), Orsay Museum
Realism

PORTRAITURE

5 *Lisa with Parasol*
Pierre-Auguste Renoir
Oil on canvas,
6' ¾" x 3' 9¼" (1.84 x 1.15 m)
Essen (Germany),
Folkwang Museum
Impressionism

PORTRAITURE

6 *Spring*
Jean-François Millet
Oil on canvas,
33¾" x 43¾" (86 x 111 cm)
Paris (France), Orsay Museum
Barbizon

LANDSCAPE
RURAL LIFE

5

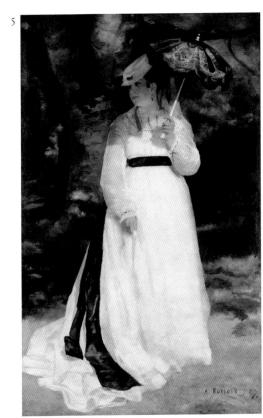

4

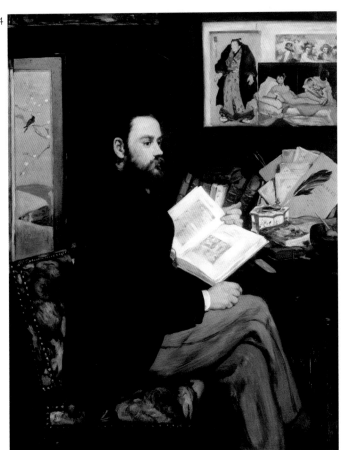

6

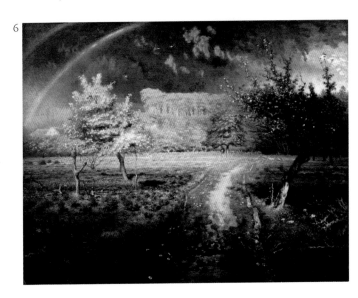

c. 1868–1869
France

1868
USA

1869
USA

1 *The Magpie*
Claude Monet
Oil on canvas,
33" x 51¼" (83.8 x 130.2 cm)
Paris (France), Orsay Museum
Impressionism

LANDSCAPE

2 *Among the Sierra Nevada Mountains*
Albert Bierstadt
Oil on canvas, 6' x 10' (1.83 x 3.5 m)
Washington, D.C. (USA),
Smithsonian American Art
Museum
Hudson River School

LANDSCAPE

3 *Newspaper Boy*
Edward Mitchell Bannister
Oil on canvas,
30" x 25" (76.6 x 63.7 cm)
Washington, D.C. (USA),
Smithsonian American Art
Museum

URBAN LIFE

1
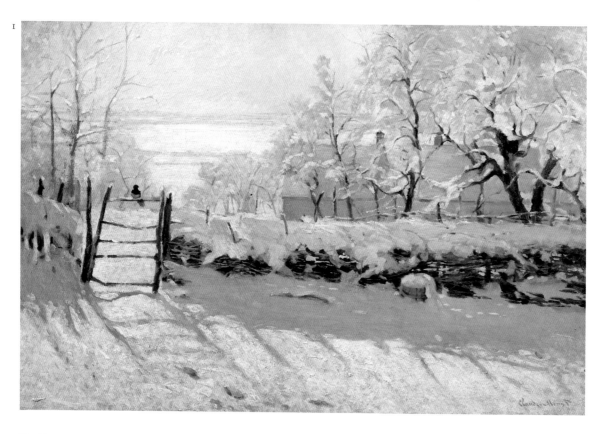

2
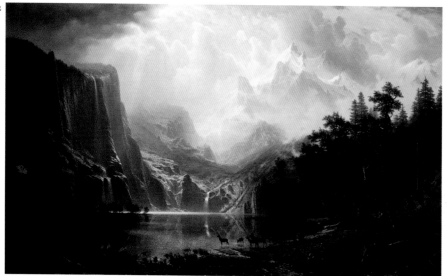

3
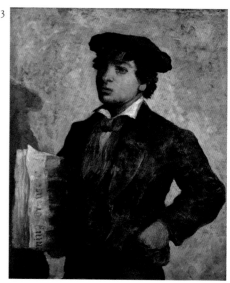

c. 1870
Italy

c. 1870
Italy

c. 1870
Italy

4 *Sleep of the Innocent*
Giovanni Dupré
Marble
Siena (Italy),
Opera del Duomo Museum
Academic

THE BODY

5 *Departure of the Conscript*
Girolamo Induno
Oil on canvas
Piacenza (Italy),
Modern Art Gallery

WAR

6 *Garibaldi at Caprera*
Vincenzo Cabianca
Oil on canvas
Florence (Italy),
Modern Art Gallery
Academic

HISTORY
PORTRAITURE

4
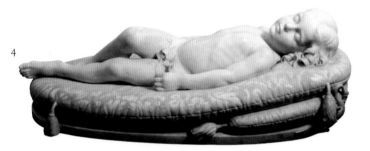

5
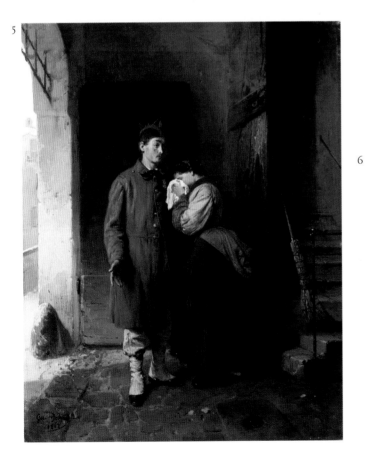

6
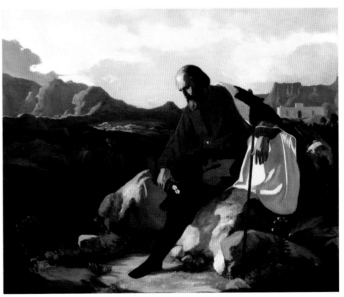

1
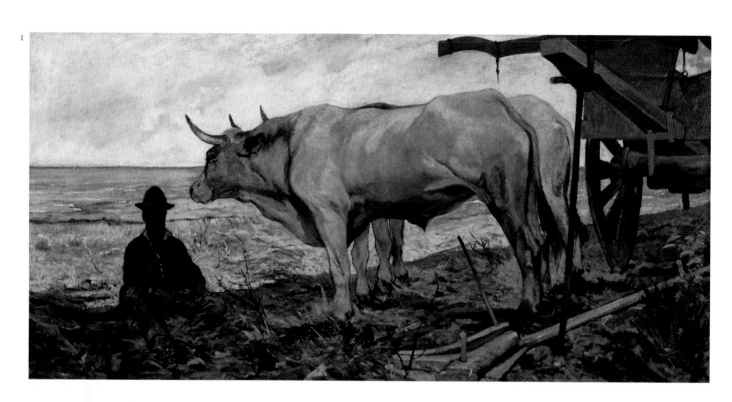

2
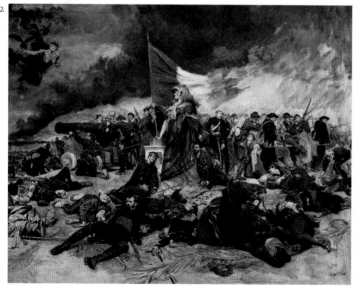

3
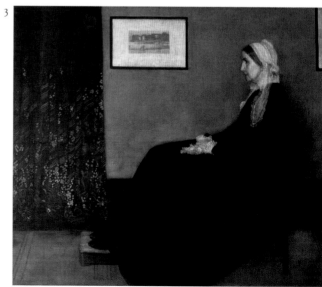

| 1871 | 1871 | 1872 |
| Russia | Russia | Russia |

Apotheosis of War
Vasievich Vereshchagin
Oil on canvas,
4' 2" x 6' 5½" (1.27 x 1.97 m)
Moscow (Russia),
Tretyakov State Gallery
Academic

WAR

5 *The Crows are Back*
Aleksei Savrasov
Oil on canvas,
24½" x 19" (62 x 48.5 cm)
Moscow (Russia),
Tretyakov State Gallery
Wanderers

LANDSCAPE

6 *Portrait of Fyodor Dostoevsky*
Vassily Perov
Oil on canvas,
39" x 31¾" (99 x 80.5 cm)
Moscow (Russia),
Tretyakov State Gallery
Academic

PORTRAITURE

4
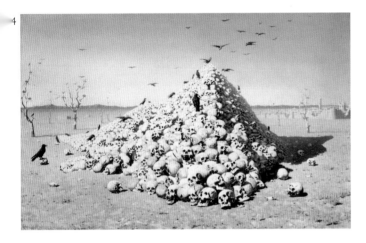

5
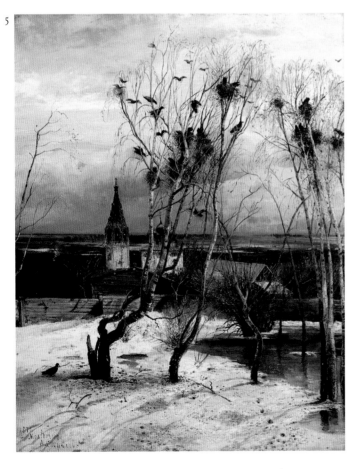

6
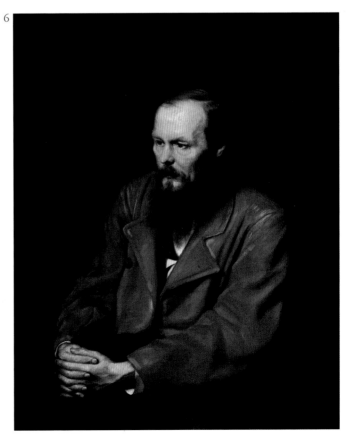

The Impressionists change the way artists paint the world around them

By going into the landscape to paint, the Impressionists were able to create new, fresher depictions of nature.

Prior to the nineteenth century, paintings were mainly produced in the artist's studio. Artists might sketch individual details outdoors, but these were only used as part of the preparatory process. Back in the studio, these details were carefully rearranged to form a realistic, highly finished, well-balanced composition.

Gradually, painters began to want to represent precise effects of light and weather. In the 1820s, John Constable sketched a detailed series of cloud studies, noting down the time of day and the prevailing wind to pinpoint the precise weather conditions. J.M.W. Turner asked to be lashed to a ship's mast in a storm to get a real sense of the sea at its wildest. Eugène Boudin argued that artists should paint outdoors, because "everything painted on the spot has a strength, a power, a vividness that cannot be recaptured in the studio."

Boudin was a friend and mentor of the young Claude Monet, who adopted the practice of open-air painting with enthusiasm, making it one of the cornerstones of his style and that of the other Impressionists. It appealed, above all, to their desire for a direct approach to nature. They avoided historical scenes or moral messages in their canvases, insisting that artists should concentrate on capturing the color intensity of the visual world before their eyes.

The Impressionist artists were fortunate that this belief coincided with the advent of technological advances that simplified painting outdoors. The availability of zinc paint tubes transformed their working methods. Previously, artists had been obliged to mix their own pigments and oils in small batches that dried up if not used quickly. The new, readymade colors were both easy to use and portable. In addition, the spread of the railways enabled the Impressionists to make day trips out of Paris, in search of suitable settings for their pictures, along the banks of the Seine. Bright colors had been expensive, but as a result of the commercial production of synthetic pigments they became affordable and enabled the artists to capture the intensity of color created by strong sunshine.

Painting outdoors presented certain problems. Conditions changed so quickly that it was hard to capture an image before it effectively disappeared. The only satisfactory solution to this was to work fast. There was no time to depict clear, well-defined contours. Instead, the Impressionists used short, fragmentary brush strokes to convey form, and graded tones to suggest perspective. Everything was condensed to its simplest visual form. In addition, they focused on the process of change itself. Rather than laboring over the physical appearance of a tree or a building, they preferred to celebrate the ways that light and color in nature were constantly changing, depicting ripples and reflections in water, or a shaft of sunlight filtering through trees.

When the Impressionists exhibited their paintings, they were received with a storm of protest. Art lovers were accustomed to seeing pictures in which even the tiniest detail was clearly defined. The work of these newcomers seemed like rough sketches. Critics condemned them as feeble "impressions"—an insult that actually gave the group its name. This hostile attitude was short-lived. Within a few years, the public had adjusted to the radically different appearance of these paintings, recognizing them as the masterpieces of a new style.

Poppies
Claude Monet, 1873
Impressionism

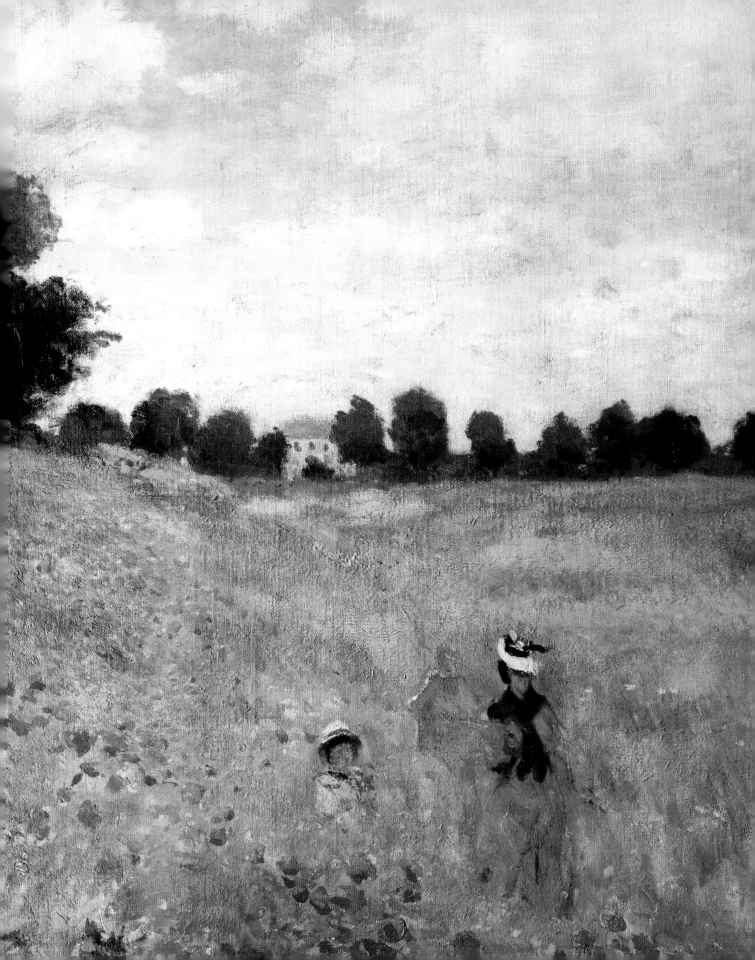

1872
France

1875
France

c. 1875
Italy

1 *The Crib*
Berthe Morisot
Oil on canvas,
22" x 18" (55.9 x 45.7 cm)
Paris (France), Orsay Museum
Impressionism

DOMESTIC LIFE

2 *La Loge (The Theater Box)*
Pierre-Auguste Renoir
Oil on canvas,
31½" x 25" (80 x 63.5 cm)
London (UK), Courtauld Institute
Impressionism

PORTRAITURE
LEISURE

3 *Sacred Music*
Luigi Mussini
Oil on canvas
Florence (Italy), Accademia Gallery
Academic

ALLEGORY

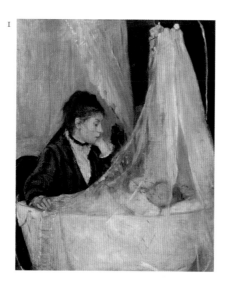

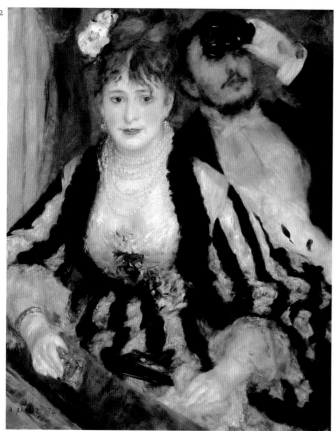

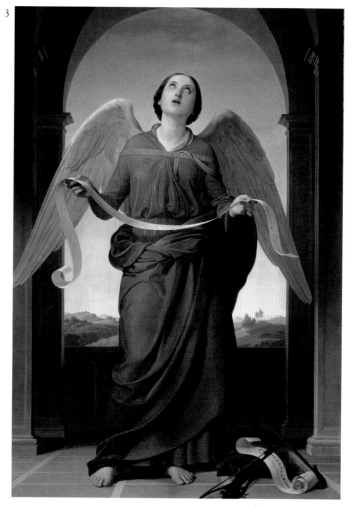

| c. 1876 | 1876 | 1877 |
| Italy | France | France |

Tomb of Duchess Maria Vittoria of Aosta
Pietro della Vedova
Marble
Turin (Italy), Basilica of Superga, Savoy Memorial Chapel

DEATH
RELIGION

5 *Dance at the Moulin de la Galette*
Pierre-Auguste Renoir
Oil on canvas,
4' 3½" x 5' 9" (1.31 x 1.75 m)
Paris (France), Orsay Museum
Impressionism

LEISURE
URBAN LIFE

6 *Saint-Lazare Station*
Claude Monet
Oil on canvas,
29¾" x 41" (75.6 x 104 cm)
Paris (France), Orsay Museum
Impressionism

URBAN LIFE

5

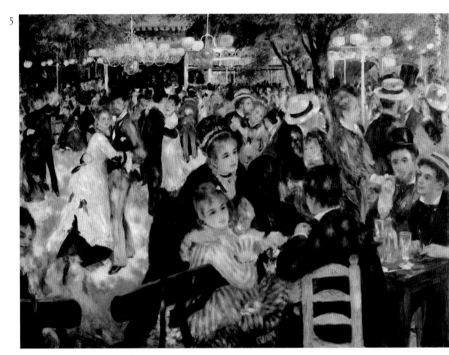

4

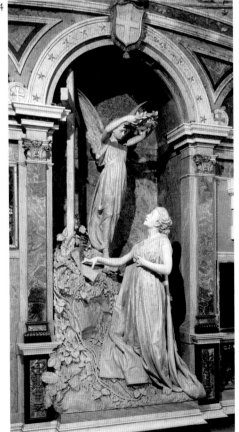

6

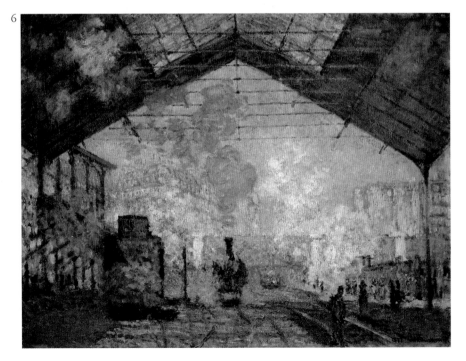

1 *The Music Lesson*
Baron Frederic Leighton
Oil on canvas,
36½" x 37½" (92.7 x 95.3 cm)
London (UK),
Guildhall Library and Art Gallery
Academic

DOMESTIC LIFE
LEISURE

2 *The Restorer*
Henri de Braekeleer
Oil on canvas,
15¼" x 24½" (40 x 62cm)
Antwerp (Belgium), Royal
Museum of Fine Arts

URBAN LIFE

3 *John the Baptist Preaching*
Auguste Rodin
Bronze, height: 6' 6¾" (2.1 m)
New York (USA),
Museum of Modern Art

RELIGION
THE BODY

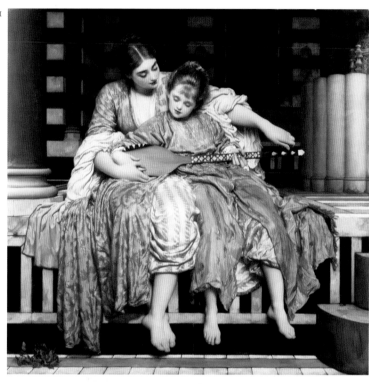

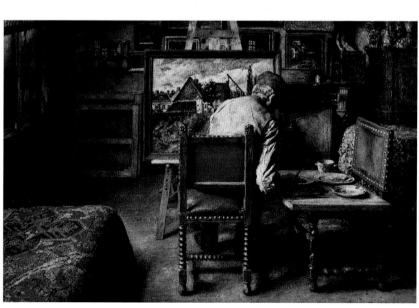

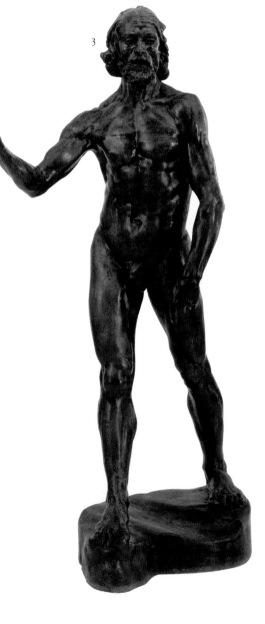

1879–1882
France

1879
France

1879
France

4 *Self-Portrait*
Paul Cézanne
Oil on canvas,
25½" x 20½" (65 x 52 cm)
Saint Petersburg (Russia),
State Hermitage Museum
Postimpressionism

PORTRAITURE

5 *Birth of Venus*
William Adolphe Bouguereau
Oil on canvas, 9' 10¼" x 7'
Paris (France), Orsay Museum
Academic

MYTHOLOGY
THE BODY

6 *A Woman and a Girl Driving*
Mary Cassatt
Oil on canvas,
35½" x 51½" (89.5 x 130.8 cm)
Philadelphia (USA),
Philadelphia Museum of Art
Impressionism

URBAN LIFE
PORTRAITURE

5

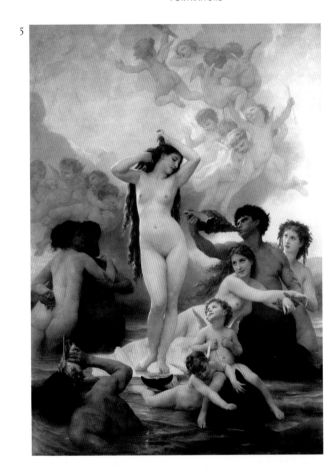

Postimpressionism

4

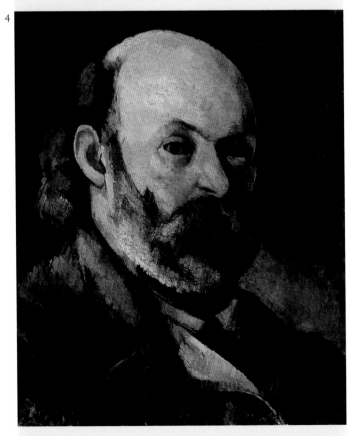

6

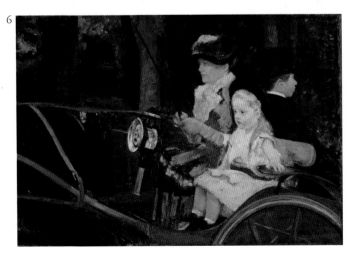

1880
Italy

c. 1880–1920
Congo

1881
Russia

1 *Rain of Ash from Vesuvius*
Giovacchino Toma
Oil on canvas,
36½" x 59" (93 x 150 cm)
Florence (Italy),
Modern Art Gallery

LANDSCAPE
HISTORY

2 *Kozo, The Two-Headed Dog*
Artist unknown
Carved wood, height: 11" (28 cm)
London (UK), British Museum
Congan

ANIMALS
RELIGION

3 *Portrait of Modest Mussorgsky*
Ilya Repin
Oil on canvas,
27¼" x 22¼" (69 x 57 cm)
Moscow (Russia),
Tretyakov State Gallery
Wanderers

PORTRAITURE

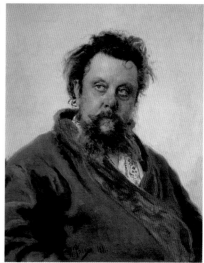

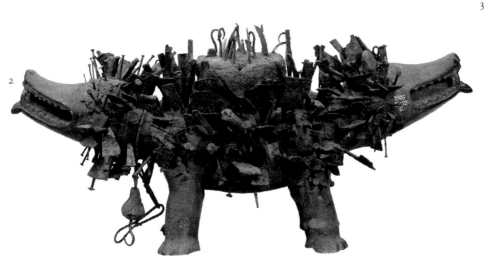

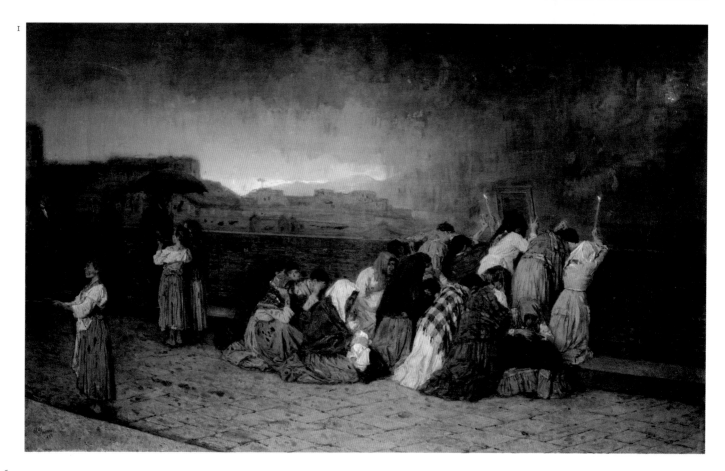

1882
Russia

1882–1885
France

1884
France

The Paladin (The Knight at the Crossroads)
Viktor Vasnetsov
Oil on canvas,
5' 5¾" x 9' 10" (1.67 x 2.99 m)
Saint Petersburg (Russia),
State Hermitage Museum
Wanderers

HISTORY

5 *L'Estaque*
Paul Cézanne
Oil on canvas,
22¾" x 28¼" (58 x 72.7 cm)
Paris (France), Orsay Museum
Postimpressionism

LANDSCAPE

6 *Eternal Springtime*
Auguste Rodin
Marble, life-size
Philadelphia (USA),
Philadelphia Museum of Art

THE BODY

5
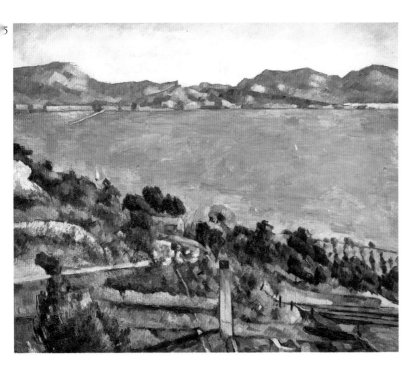

6
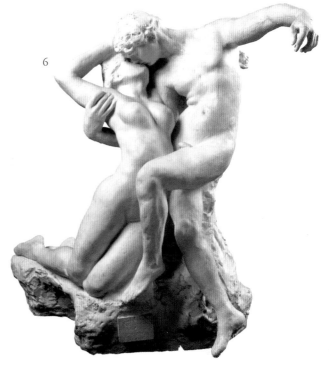

4
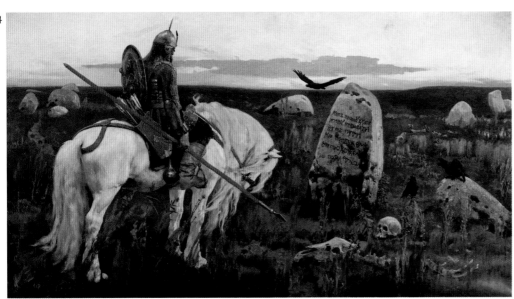

1884
USA

c. 1885
Russia

1885–1889
USA

1 *Munich Still Life*
William Michael Harnett
Oil on canvas,
14½" x 11¾" (36.8 x 29.8 cm)
Newark (USA),
Newark Museum

STILL LIFE

2 *Pine Wood Illuminated by the Sun*
Ivan Shishkin
Oil on canvas
Moscow (Russia),
Tretyakov State Gallery
Wanderers

LANDSCAPE

3 *Moonlight Indian Encampment*
Ralph Blakelock
Oil on canvas,
27" x 34" (68.6 x 86.4 cm)
Washington, D.C. (USA),
Smithsonian American Art
Museum

LANDSCAPE

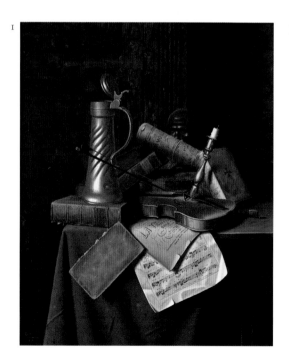

1886
Italy

1886–1887
Italy

1887
Russia

4 *Portrait of Giuseppe Verdi*
Giovanni Boldini
Pastel on paper,
25½" x 21¼" (65 x 54 cm)
Rome (Italy), Modern Art Gallery

PORTRAITURE

5 *At the Soup Kitchen of Porta Nuova*
Attilio Pusteria
Oil on canvas,
4' 6¼" x 6' 7" (138 x 202 cm)
Milan (Italy),
Modern Art Gallery

URBAN LIFE

6 *Portrait of Leo Tolstoy*
Ilya Repin
Oil on canvas
Moscow (Russia),
Tretyakov State Gallery
Academic

PORTRAITURE

1888
France

c. 1888
Italy

1888–1889
France

1 *Port-en-Bessin, Entrance
to the Harbor*
Georges Seurat
Oil on canvas,
21½" x 25½" (54.6 x 64.8 cm)
New York (USA),
Museum of Modern Art
Postimpressionism

LANDSCAPE

2 *The People of Venice Raise the
Tricolor in Saint Mark's Square*
Luigi Querena
Oil on canvas
Venice (Italy),
Risorgimento Museum

POLITICS

3 *Sunflowers*
Vincent van Gogh
Oil on canvas,
36½" x 28" (92 x 71 cm)
Philadelphia (USA),
Philadelphia Museum of Art
Postimpressionism

STILL LIFE

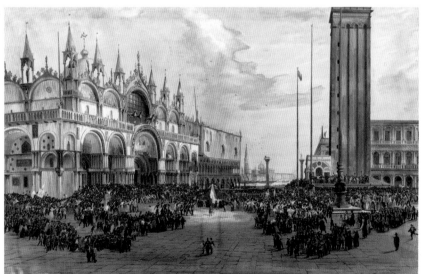

1888–1889
France

1889
France

1889–1890
France

4 *Still Life with Quinces*
Vincent van Gogh
Oil on canvas,
18" x 23½" (46 x 59.5 cm)
London (UK), Private collection
Postimpressionism

STILL LIFE

5 *La Belle Angèle*
Paul Gauguin
Oil on canvas,
36¼" x 28¾" (92 x 73 cm)
Paris (France), Orsay Museum
Postimpressionism

RURAL LIFE
PORTRAITURE

6 *The Siesta*
Vincent van Gogh
Oil on canvas,
28¾" x 33¾" (73 x 90.8 cm)
Paris (France), Orsay Museum
Postimpressionism

RURAL LIFE

4

5

6
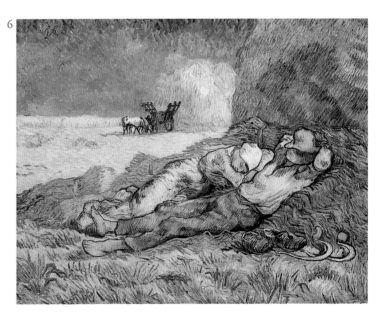

1889
France

1889
France

1889
France

1 *The Artist's Room in Arles*
Vincent van Gogh
Oil on canvas,
22¼" x 29" (56.5 x 74 cm)
Paris (France), Orsay Museum
Postimpressionism

DOMESTIC LIFE

2 *Self-Portrait*
Vincent van Gogh
Oil on canvas,
25½" x 21¼" (65 x 54 cm)
Paris (France), Orsay Museum
Postimpressionism

PORTRAITURE

3 *Starry Night*
Vincent van Gogh
Oil on canvas,
28¾" x 36¼" (73 x 92 cm)
New York (USA),
Museum of Modern Art
Postimpressionism

LANDSCAPE

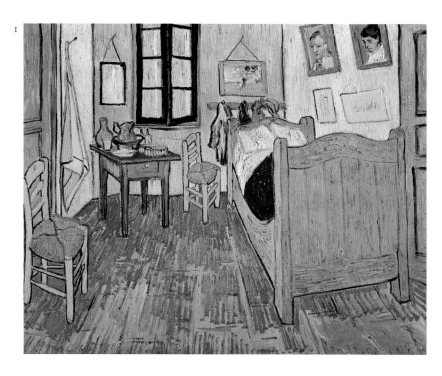

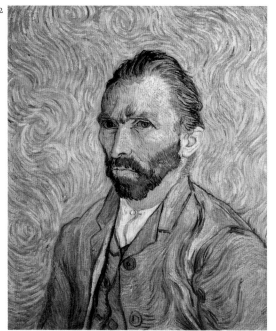

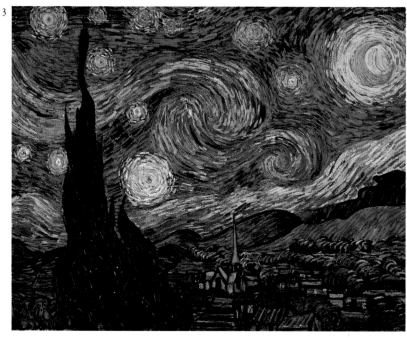

1889
USA

c. 1889
USA

1890
France

Concord Minute Man of 1775,
small version
Daniel Chester French
Bronze, height: 32¼" (81.9 cm)
Washington, D.C. (USA),
Smithsonian American Art
Museum
Academic

HISTORY

5 *End of Winter*
John Henry Twachtman
Oil on canvas,
22" x 30" (55.9 x 76.2 cm)
Washington, D.C. (USA),
Smithsonian American Art
Museum
Impressionism

LANDSCAPE

6 *Old Farmhouses*
Vincent van Gogh
Oil on canvas,
23½" x 28¾" (60 x 73 cm)
Saint Petersburg (Russia),
State Hermitage Museum
Postimpressionism

RURAL LIFE
LANDSCAPE

5

4

6

1890
France

1890–1891
France

c. 1890
Belgium

1 *Portrait of Doctor Gachet*
Vincent van Gogh
Oil on canvas,
26¾" x 20½" (67.9 x 50.9 cm)
Paris (France), Orsay Museum
Postimpressionism

PORTRAITURE

2 *The Circus*
Georges Seurat
Oil on canvas,
73" x 59¾" (185.4 x 151.8 cm)
Paris (France), Orsay Museum
Postimpressionism

LEISURE
ANIMALS

3 *The Pancakes*
Jan Stobbaerts
Oil on canvas
Tournai (Belgium),
Museum of Fine Arts
Realism

DOMESTIC LIFE

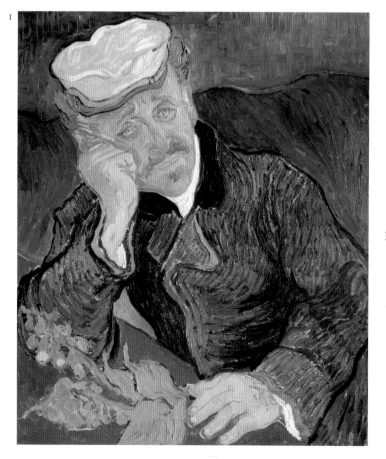

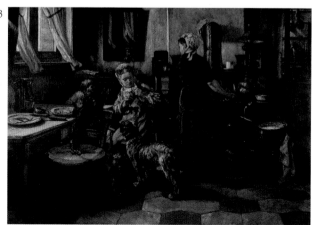

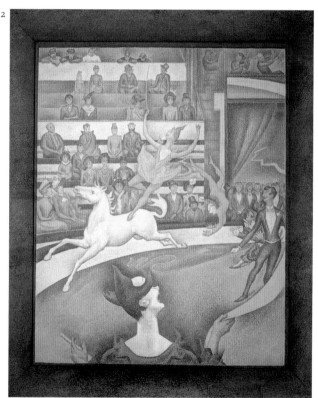

The Concert Singer
Thomas Eakins
Oil on canvas,
6' 3" x 4' 6¼" (1.90 x 1.38 m)
Philadelphia (USA), Philadelphia
Museum of Art
Realism

PORTRAITURE
LEISURE

5 *Women of Tahiti*
Paul Gauguin
Oil on canvas,
27¼" x 36" (69.2 x 91.4 cm)
Paris (France), Orsay Museum
Postimpressionism

THE BODY
RURAL LIFE

4

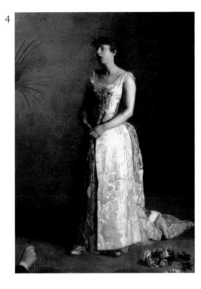

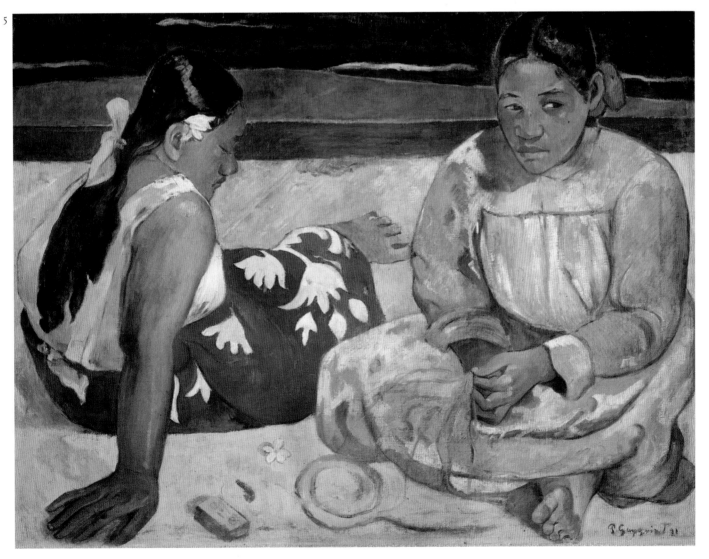

1892
Tahiti

1892
France

c. 1892
France

1 *The Spirit of the Dead Watching*
Paul Gauguin
Oil on canvas,
28¾" x 36¼" (73 x 92 cm)
New York (USA),
Albright-Knox Art Gallery
Postimpressionism

DEATH
THE BODY

2 *The Bath*
Mary Cassatt
Oil on canvas,
36½" x 26" (92.7 x 66 cm)
Chicago (USA),
Art Institute of Chicago
Impressionism

DOMESTIC LIFE

3 *Religious Panel*
Paul Gauguin
Carved polychrome wood,
24½" x 12¼" (62 x 31 cm)
Vatican (Vatican City),
Collection of Modern Religious Art
Postimpressionism

RELIGION

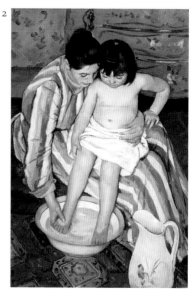

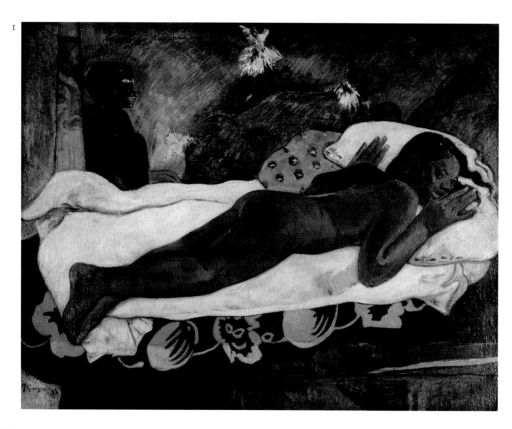

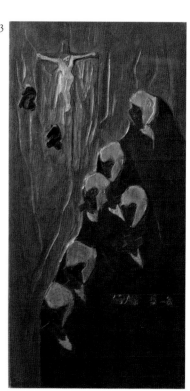

c. 1892
Italy

1892
Italy

1892
Britain

Settignano, September Morning
Telemaco Signorini
Oil on canvas,
22¾" x 24½" (58 x 62 cm)
Florence (Italy),
Modern Art Gallery
Macchiaioli

RURAL LIFE

5 Feast Day at the Trivulzio
Hospice in Milan
Angelo Morbelli
Oil on canvas,
30¾" x 48" (78 x 122 cm)
Paris (France), Orsay Museum
Macchiaioli

URBAN LIFE

6 Midas's Daughter Turned to Gold,
from Nathanial Hawthorne's
"A Wonder Book for Boys and Girls"
Walter Crane
Book illustration,
9" x 7" (22.9 x 17.8 cm)
London (UK), British Library

MYTHOLOGY

4

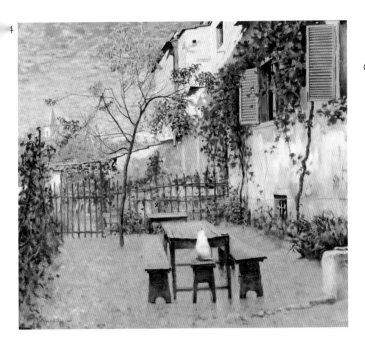

5

Symbolism

6

1 *In the Garden: Celia Thaxter
in Her Garden*
Childe Hassam
Oil on canvas,
22¼" x 18" (56.5 x 45.7 cm)
Washington, D.C. (USA),
Smithsonian American Art
Museum
Impressionism

PORTRAITURE
LANDSCAPE

2 *The Scream*
Edvard Munch
Oil on canvas,
35¾" x 29" (90.8 x 73.7 cm)
Oslo (Norway), National Gallery
Symbolism

LANDSCAPE

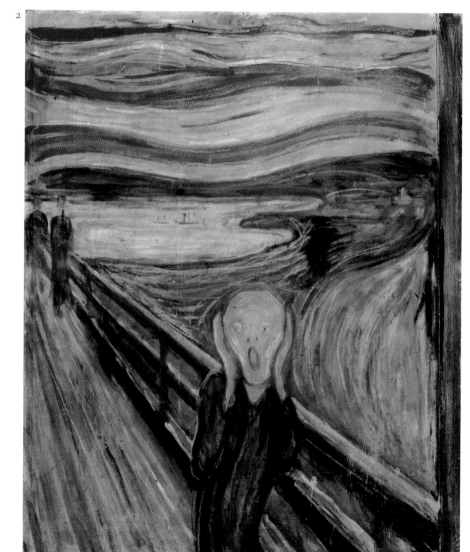

1893
France

1893
Britain

1894
USA

An Iron Forge
Fernand Cormon
Oil on canvas,
28½" x 35½" (72.4 x 90.2 cm)
Paris (France), Orsay Museum

URBAN LIFE

4 *Portrait of Elizabeth Winthrop Chanler (Mrs. John Jay Chapman)*
John Singer Sargent
Oil on canvas,
49½" x 40½" (126 x 101 cm)
Washington, D.C. (USA),
Smithsonian American Art
Museum

PORTRAITURE

5 *High Cliff, Coast of Maine*
Winslow Homer
Oil on canvas,
30¼" x 38" (75.6 x 97 cm)
Washington, D.C. (USA),
Smithsonian American Art
Museum

LANDSCAPE

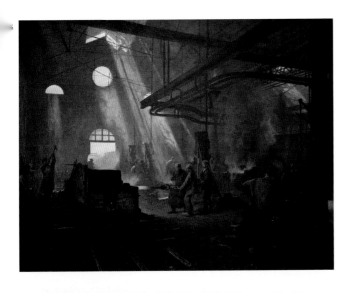

4

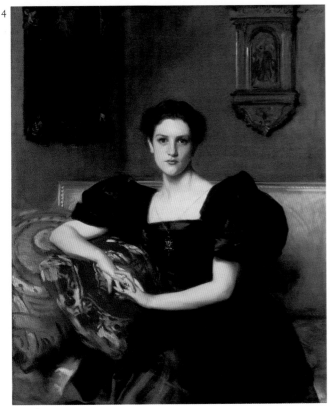

5

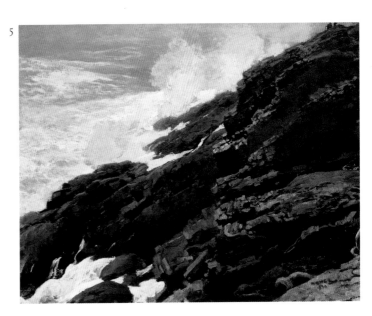

c. 1895
Spain

c. 1895
France

c. 1895
Norway

1 *Eating on the Boat*
Joaquin Sorolla y Bastida
Oil on canvas
Madrid (Spain), San Fernando
Royal Museum of Fine Arts

LEISURE

2 *Still Life with Basket*
Paul Cézanne
Oil on canvas,
25½" x 32" (65 x 81 cm)
Paris (France), Orsay Museum
Postimpressionism

STILL LIFE

3 *Self-Portrait in Hell*
Edvard Munch
Oil on canvas,
32½" x 23½" (82.5 x 59.7 cm)
Oslo (Norway), Munch Museum
Symbolism

PORTRAITURE

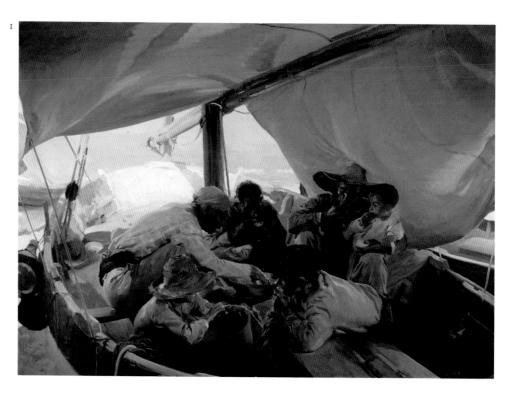

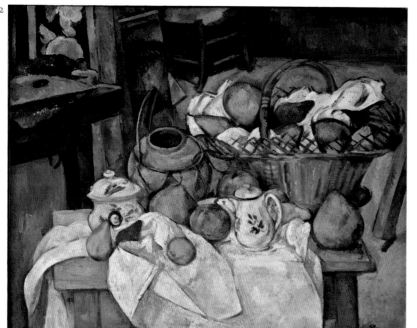

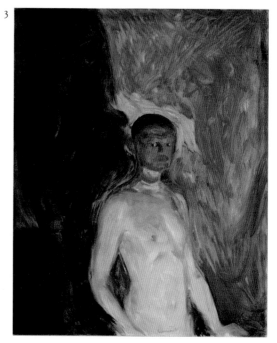

1895
France

1895–1896
France

1896
France

The Clowness Cha-u-Kao
Henri de Toulouse-Lautrec
Oil on cardboard,
24¼" x 19¼" (64 x 49 cm)
Paris (France), Orsay Museum

LEISURE
PORTRAITURE

5 *Miss Eglantine's Troupe*
Henri de Toulouse-Lautrec
Lithograph,
24¼" x 31¾" (61.6 x 80.6 cm)
New York (USA),
Museum of Modern Art

LEISURE

6 *The Seated Clowness*
(Mademoiselle Cha-u-Kao)
Henri de Toulouse-Lautrec
Lithograph,
20¾" x 16" (52.7 x 40.6 cm)
New York (USA),
Museum of Modern Art

LEISURE
PORTRAITURE

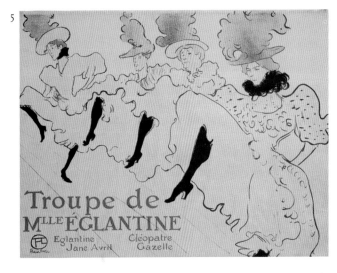

5

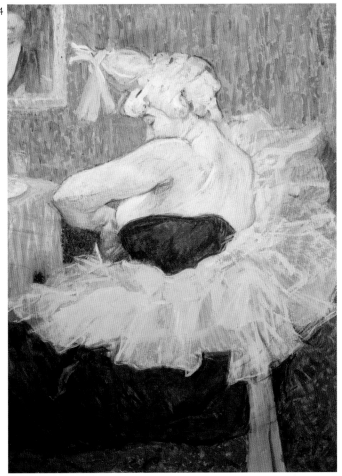

4

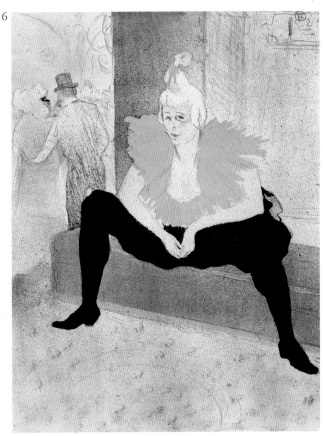

6

1 *Ponte Santa Trinita, Florence*
Childe Hassam
Oil on canvas,
22½" x 33½" (57 x 85 cm)
Washington, D.C. (USA),
Smithsonian American Art
Museum
Impressionism

THE CITY

2 *Presence of the Bad Demon*
Paul Gauguin
Oil on canvas,
29" x 36¼" (73.5 x 92 cm)
Saint Petersburg (Russia),
State Hermitage Museum
Postimpressionism

RELIGION

1

2

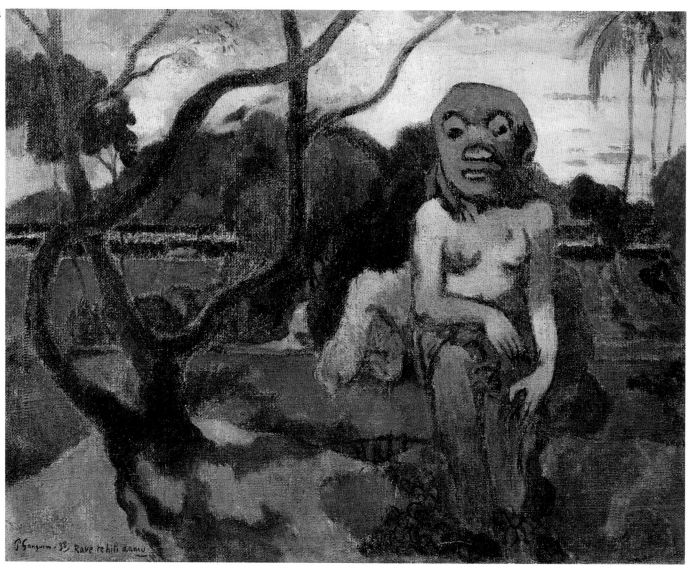

c. 1899
France

c. 1899
France

Still Life with Apples and Oranges
Paul Cézanne
Oil on canvas,
29" x 36½" (74 x 93cm)
Paris (France), Orsay Museum
Postimpressionism

STILL LIFE

4 *The Poor*
André Collin
Oil on canvas
Tournai (Belgium),
Museum of Fine Arts
Realism

URBAN LIFE

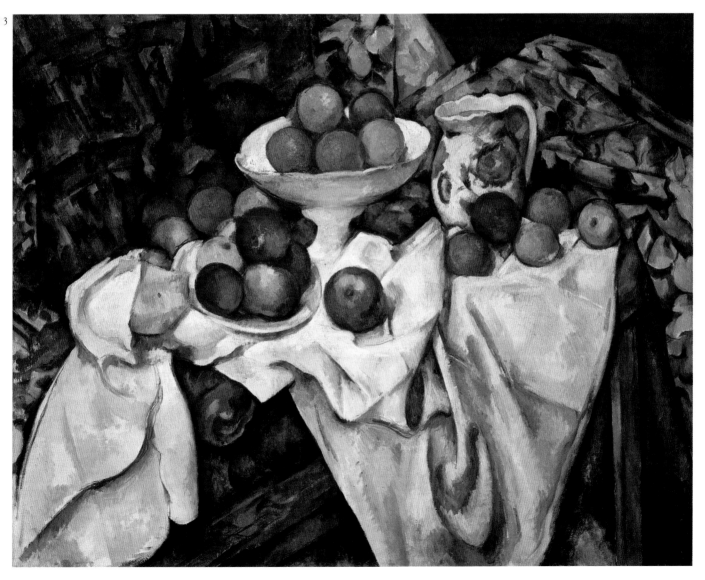

c. 1899
France

1899
Belgium

1899
Britain

1 *Dancers in Blue*
Edgar Degas
Pastel on paper,
25¼" x 25½" (64 x 65 cm)
Moscow (Russia), Pushkin
Museum
Impressionism

LEISURE

2 *Self-Portrait*
Fernand Khnopff
Oil on canvas
Florence (Italy), Uffizi
Symbolism

PORTRAITURE

3 *Isolde*
Aubrey Beardsley
Lithograph,
9¾" x 6" (24.8 x 15.2 cm)
London (UK), British Library
Art Nouveau

LITERATURE
MYTHOLOGY

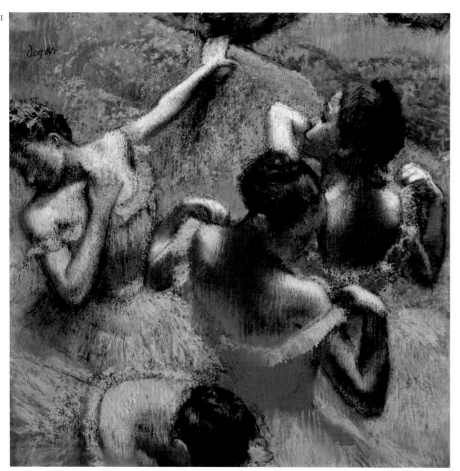

4 *Furrows under the Snow*
Maurice Denis
Oil on canvas
France, Private collection
Symbolism

LANDSCAPE

5 *The Swan Princess*
Mikhail Vrubel
Oil on canvas,
56" x 37" (142.5 x 93.5 cm)
Moscow (Russia),
Tretyakov State Gallery
Wanderers

MYTHOLOGY

1900
France

c. 1900
Ivory Coast

1901
USA

1 *Water Lily Pool, Harmony in Pink*
Claude Monet
Oil on canvas,
35¼" x 39½" (89.5 x 100 cm)
Paris (France), Orsay Museum
Impressionism

LANDSCAPE

2 *Bird Finial*
Artist unknown
Wood and metal,
height: 10" (25.4 cm)
Newark (USA),
Newark Museum
Senofu

ANIMALS

3 *The East River*
Maurice Prendergast
Oil on canvas
New York (USA),
Museum of Modern Art
Impressionism

LANDSCAPE
THE CITY

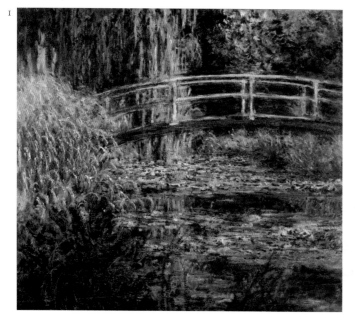

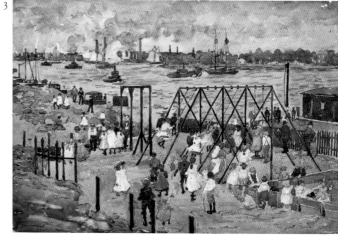

1901
Austria

1902
Italy

1902
France

Judith
Gustav Klimt
Oil on canvas,
33" x 16½" (84 x 42 cm)
Vienna (Austria),
Belvedere Gallery
Art Nouveau

RELIGION

5 *Sunset Venice*
Thomas Moran
Oil on canvas,
20¼" x 30¼" (51.4 x 76.4 cm)
Newark (USA),
Newark Museum

THE CITY
LANDSCAPE

6 *The Poker Game*
Felix Vallotton
Oil on canvas
Paris (France), Orsay Museum

LEISURE
URBAN LIFE

5

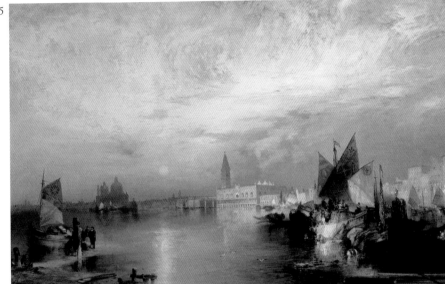

4

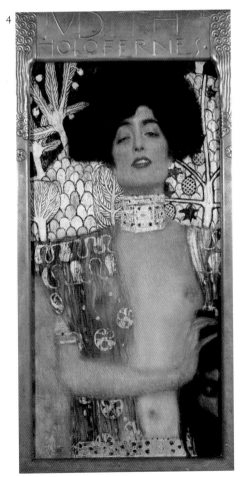

6

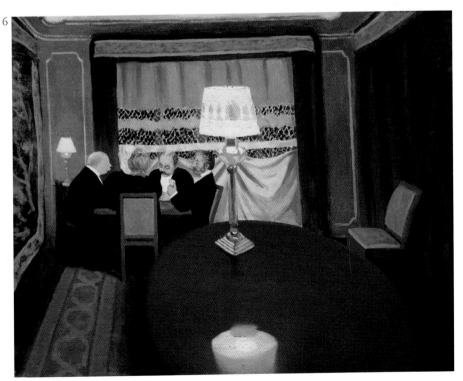

1 *La Vie (Life)*
Pablo Picasso
Oil on canvas,
77½" x 51" (196.8 x 129.5 cm)
Cleveland (USA),
Cleveland Museum of Art

DOMESTIC LIFE
SOCIAL PROTEST

2 *Westminster*
André Derain
Oil on canvas
Saint-Tropez (France),
Annonciade Museum
Fauvism

THE CITY

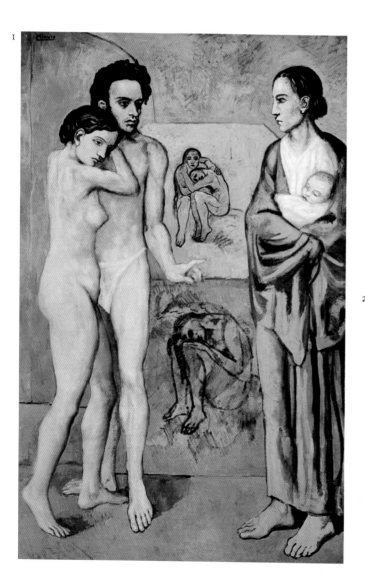

Fauvism

1905
France

1905–1906
France

1906
Sweden

*Woman in a Japanese Robe
Beside Water*
Henri Matisse
Oil on canvas,
14" x 11½" (35 x 29 cm)
New York (USA),
Museum of Modern Art
Fauvism/Abstraction

LEISURE

5 *Portrait of Gertrude Stein*
Pablo Picasso
Oil on canvas,
39¼" x 32" (100 x 81.3 cm)
New York (USA),
Metropolitan Museum of Art

PORTRAITURE

6 *Self-Portrait*
Carl Olaf Larsson
Oil on canvas,
37½" x 24¼" (95.5 x 61.5 cm)
Florence (Italy), Uffizi

PORTRAITURE

5

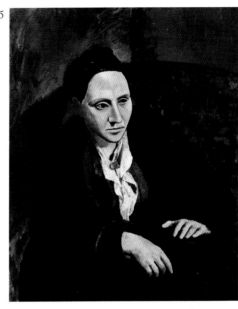

4

6

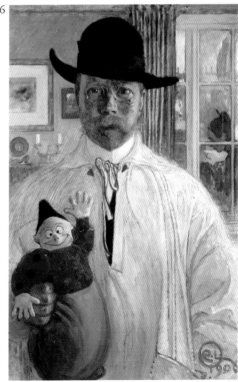

1 *Les Demoiselles d'Avignon (The Avignon Street Girls)*
Pablo Picasso
Oil on canvas,
8' x 7' 8" (2.44 x 2.36 m)
New York (USA),
Museum of Modern Art
Cubism

THE BODY

2 *Picture-Shop Window*
John Sloan
Oil on canvas,
32" x 25" (81.3 x 63.5 cm)
Newark (USA), Newark Museum
Ashcan School

URBAN LIFE

3 *The Kiss*
Gustav Klimt
Oil on canvas,
5' 10¾" x 5' 10¾" (1.8 x 1.8 m)
Vienna (Austria),
Belvedere Gallery
Art Nouveau

2

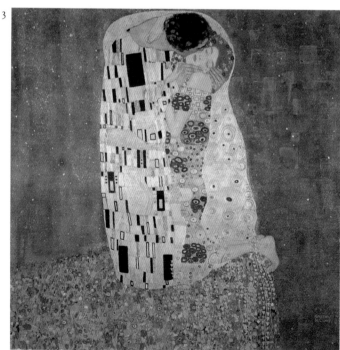

Cubism

1

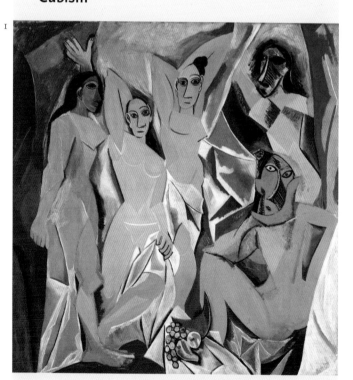

3

1909
Germany

1909
Russia

1910
France

4 *Winter, 1909*
Wassily Kandinsky
Oil on canvas,
28¼" x 38½" (71.7 x 97.8 cm)
Saint Petersburg (Russia),
State Hermitage Museum
Expressionism

LANDSCAPE

5 *Self-Portrait at the Dressing Table*
Zinaida Serebryakova
Oil on paper,
29½" x 25½" (75 x 65 cm)
Moscow (Russia),
Tretyakov State Gallery

PORTRAITURE

6 *The Dance*
Henri Matisse
Oil on canvas,
8' 6½" x 12' 10¼" (2.6 x 3.92 m)
Saint Petersburg (Russia),
State Hermitage Museum
Fauvism

THE BODY

5

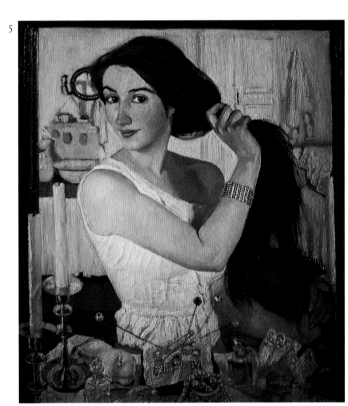

Expressionism

4

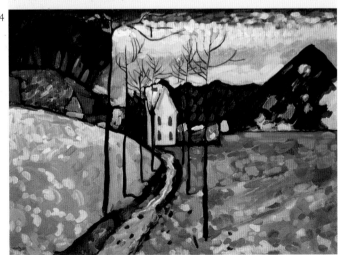

6

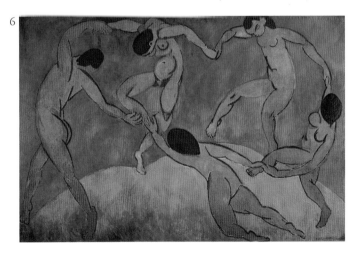

The emergence of Cubism marks a revolution in Western art

For decades, artists had been moving away from trying to make their pictures look as naturalistic and detailed as possible. The Cubists took this a stage further and depicted the world in a completely new way.

Many consider the Cubist movement to be the dawn of Modern Art, overturning the rules that governed painting. It grew out of the work of the Postimpressionists and the Fauves, but its radical departure with artistic conventions came about through a partnership between two remarkable artists, Pablo Picasso and Georges Braque. They met in Paris in 1907 and immediately struck up a friendship. Both men were anxious to experiment with new ideas. Picasso was working on *Les Demoiselles d'Avignon*, a revolutionary painting in which he abandoned conventional notions about form and space and based his angular figures on Iberian and African carvings. Braque was approaching his work from a different direction, through his interest in Paul Cézanne's technique of building up landscape with blocks of color. Cézanne's influence was crucial, for he had treated objects as geometric shapes, and showed elements separated by great distance on the same plane, already challenging ideas on the relationship between form and perspective.

Picasso and Braque enjoyed rowdy evenings in Montmartre cafés, and dressed in each other's clothes for fun, but their art was at the heart of their relationship. The two men competed and bounced ideas off each other, aware that they were working in uncharted territory. Picasso gave Braque the nickname of "Vilbure," inspired by the aviator Wilbur Wright, to emphasize his friend's pioneering qualities. Braque described how they created their new style "like mountaineers roped together." During this phase it is difficult to tell their paintings apart.

Picasso and Braque discarded totally the principles that had governed Western art since the Renaissance. They replaced a fixed perspective with multiple viewpoints. There was little modeling or shading, and no real attempt to create a sense of distance, or make the figures appear solid. Color was restricted and space flattened. Yet neither Picasso nor Braque was seeking to produce non-objective or non-representational art. The idea was to go beyond reproducing what the eye sees and to bring together on one canvas several different aspects of a subject that could not be viewed in a single glance. As Picasso explained, "I paint objects as I think them, not as I see them."

When the first results of this collaboration were shown in 1908 the critic Louis Vauxcelles noted how all the elements in the paintings were reduced "to cubes." This comment gave birth to the term Cubism, which rapidly became the accepted name for the style. The art dealer Ambroise Vollard, a tireless advocate of avant-garde painting, showcased the work of Cézanne, Picasso, and Matisse in his Paris gallery. This portrait dates from the early phase of the movement, which is generally known as Analytical Cubism. Here, natural forms were broken down, or analyzed, and then rearranged, creating a new vision of the original subject. This approach became increasingly abstract and was superseded from about 1912 by Synthetic Cubism. The new style showed an image created in collage, using familiar, everyday elements, such as stenciled lettering, a torn piece of newspaper, a fake wood-grain pattern, or a wallpaper swatch.

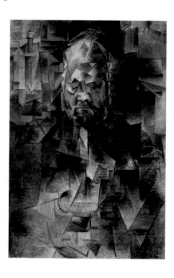

Portrait of Ambroise Vollard
Pablo Picasso, 1910
Cubism

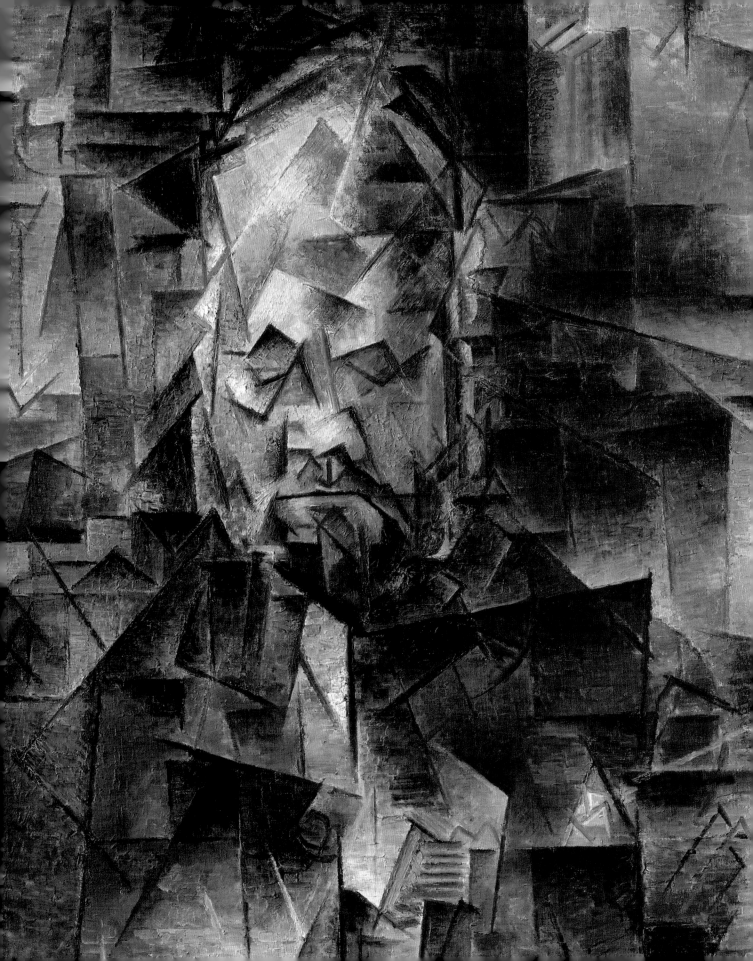

1 *The Dream*
Henri Rousseau
Oil on canvas,
6' 8½" x 9' 9½" (2.05 x 2.99 m)
New York (USA),
Museum of Modern Art

FANTASY

2 *The Dance around the Golden Calf*
Emile Nolde
Oil on canvas,
34½" x 41½" (88 x 106 cm)
Munich (Germany),
Neue Pinakothek
Expressionism

RELIGION
THE BODY

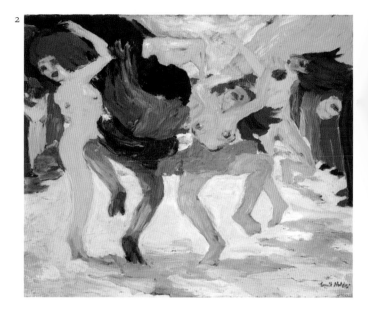

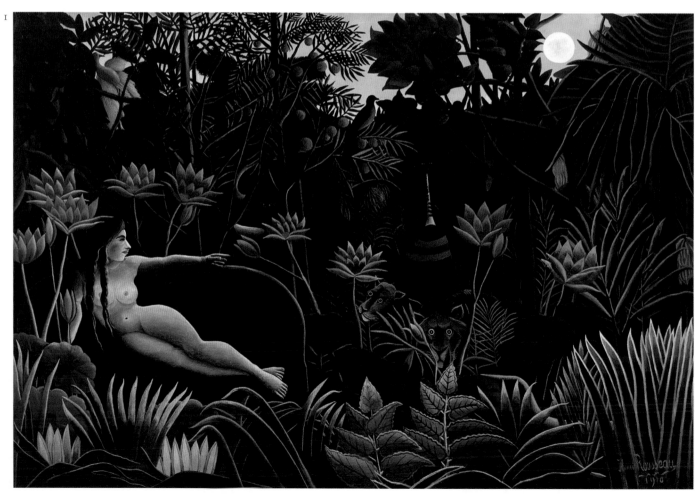

1911
France

1911
France

1912
Italy

I and the Village
Marc Chagall
Oil on canvas,
6' 3½" x 4' 11½" (1.92 x 1.51 m)
New York (USA),
Museum of Modern Art

FANTASY

4 *Still Life with Chair Caning*
Pablo Picasso
Oil and pasted oil cloth,
10½" x 13¾" (26.7 x 34.9 cm)
Paris (France), Picasso Museum
Cubism

STILL LIFE

5 *Elasticity*
Umberto Boccioni
Oil on canvas,
39½" x 39½"(100 x 100 cm)
Milan (Italy), Private collection
Futurism/Abstraction

THE BODY

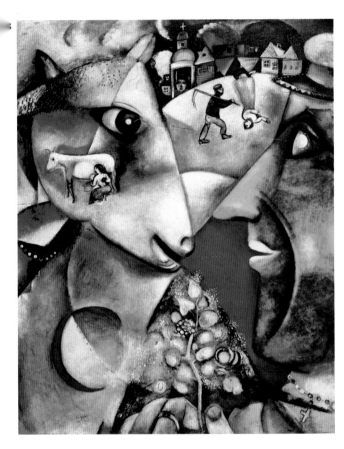

Futurism

5

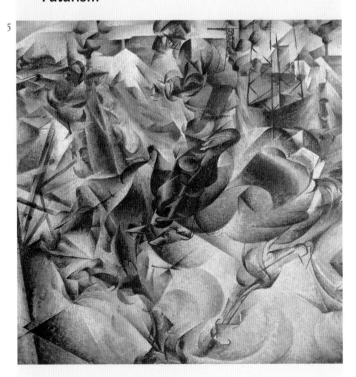

4

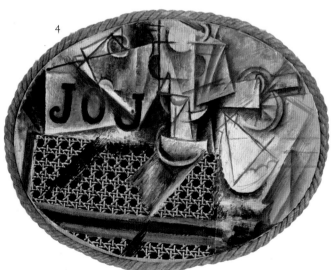

1912
France

1912
Canada

1912
USA

1 *Nude Descending a Staircase (No. 2)*
Marcel Duchamp
Oil on canvas,
58" x 35" (147 x 89 cm)
Philadelphia (USA),
Philadelphia Museum of Art
Cubism

THE BODY

2 *Indian Raven*
Emily Carr
Oil on canvas,
31½" x 16" (79.8 x 40.6 cm)
Vancouver (Canada),
Vancouver Art Gallery
Group of Seven

ANIMALS

3 *Stained-Glass Window from the
Avery Coonley Playhouse, Riverside,
Illinois*
Frank Lloyd Wright
Leaded clear and glazed glass,
18¼" x 34¼" (46.5 x 86.9 cm)
New York (USA),
Museum of Modern Art

ABSTRACTION

2

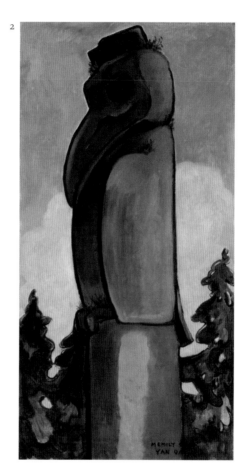

1

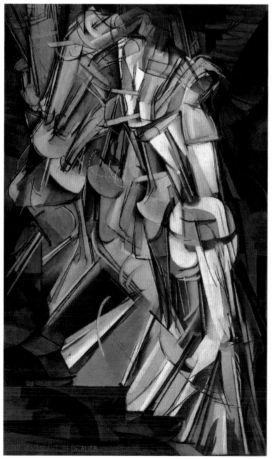

3

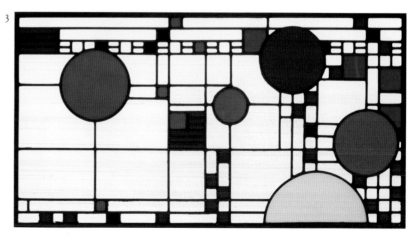

Unique Forms of Continuity in Space
Umberto Boccioni
Bronze,
44" x 35" (111.8 x 88.9 cm)
New York (USA),
Museum of Modern Art
Futurism

THE BODY

5 *Landscape*
Wassily Kandinsky
Oil on canvas,
34½" x 39½" (87.6 x 100.3 cm)
Saint Petersburg (Russia),
State Hermitage Museum
Blaue Reiter Group

LANDSCAPE
ABSTRACTION

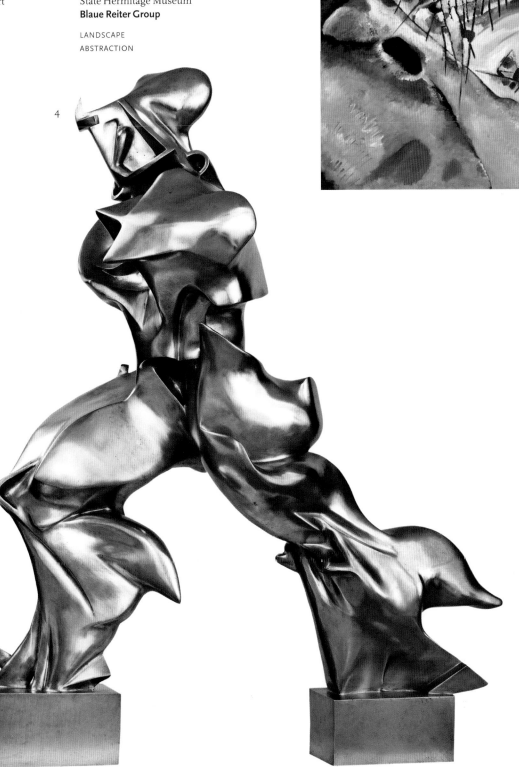

4

5

1913
France

1913
Britain

1914
Germany

1 *Bicycle Wheel*
(1951 version after lost original)
Marcel Duchamp
Metal wheel mounted on painted
wooden stool,
height: 50½" (128.3 cm)
New York (USA),
Museum of Modern Art
Dada

2 *Mother and Child*
Jacob Epstein
Marble, height:
17¼" (44 cm)
New York (USA),
Museum of Modern Art

DOMESTIC LIFE
RELIGION

3 *The Drinker* or *Self-Portrait
as a Drunkard*
Ernest Ludwig Kirchner
Oil on canvas,
47" x 35½" (119.5 x 90.5 cm)
Nuremberg (Germany),
Germanisches Museum
Expressionism

PORTRAITURE

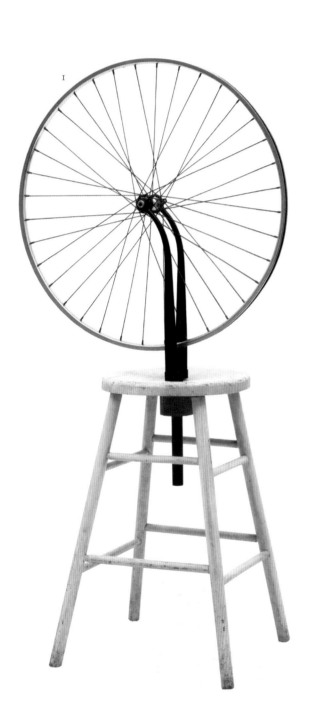

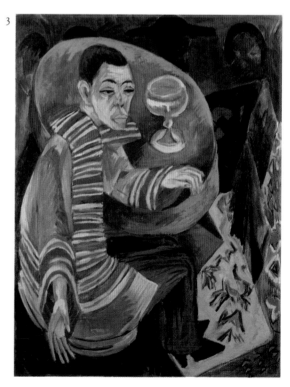

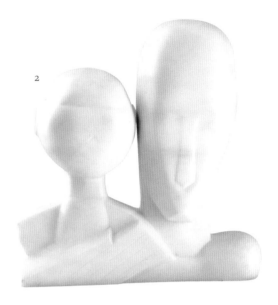

1915
Russia

c. 1915
Italy

1918
Russia

Boy with Knapsack—Color Masses in the Fourth Dimension
Kasimir Malevich
Oil on canvas,
28" x 17½" (71.1 x 44.5 cm)
New York (USA),
Museum of Modern Art
Suprematism

ABSTRACTION

5 *Head*
Amedeo Modigliani
Limestone,
height: 22¼" (56.6 cm)
New York (USA),
Museum of Modern Art

PORTRAITURE

6 *White on White*
Kasimir Malevich
Oil on canvas,
31¼" x 31¼" (79.4 x 79.4 cm)
New York (USA),
Museum of Modern Art
Suprematism

ABSTRACTION

5

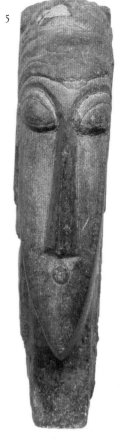

4

6

c. 1919
Italy

1920
France

1920
France

1 *Reclining Nude*
Amedeo Modigliani
Oil on canvas,
28½" x 46" (72.4 x 116.8 cm)
New York (USA),
Museum of Modern Art

THE BODY

2 *Waterlilies (left panel)*
Claude Monet
Oil on canvas,
6' 6" x 14' (2 x 4.25 m)
New York (USA),
Museum of Modern Art
Impressionism

LANDSCAPE

3 *Newborn, Version I*
Constantin Brancusi
White marble,
length: 8½" (21.6 cm)
New York (USA),
Museum of Modern Art

THE BODY

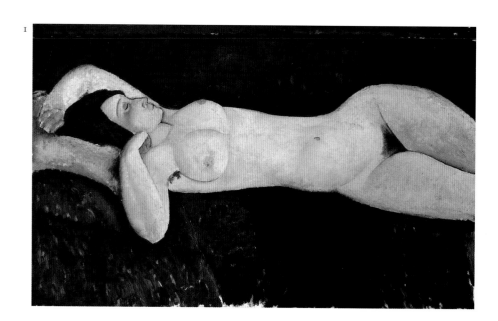

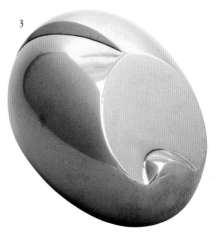

1920
Russia

1920
Canada

1921
France

4 *Bolshevik*
Boris Kustodiev
Oil on canvas
Moscow (Russia),
Tretyakov State Gallery
Social Realism

POLITICS
URBAN LIFE

5 *Algoma*
A.Y. Jackson
Oil on wood,
8¼" x 10¼" (21 x 26 cm)
Owen Sound (Canada), Tom
Thomson Memorial Art Gallery
Group of Seven

LANDSCAPE

6 *Three Musicians*
Pablo Picasso
Oil on canvas,
6' 7" x 7' 4¾" (2 x 2.23 m)
New York (USA),
Museum of Modern Art
Cubism

LEISURE

4
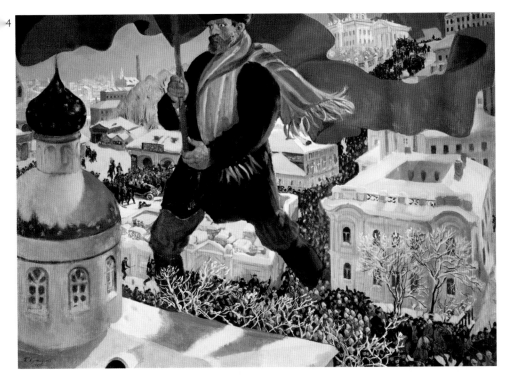

5
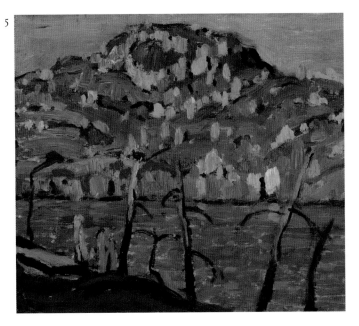

6
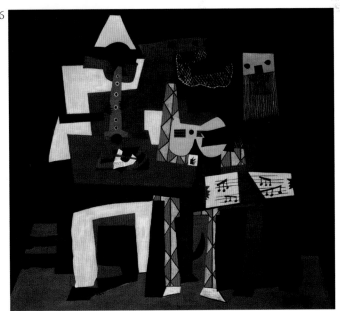

1 *Three Women (Le Grand Déjeuner)*
Fernand Léger
Oil on canvas,
6' ¼" x 8' 3" (1.84 x 2.52 m)
New York (USA),
Museum of Modern Art

THE BODY

2 *Self-Portrait with Rita*
Thomas Hart Benton
Oil on canvas,
49½" x 40" (126 x 102 cm)
Washington, D.C. (USA),
National Portrait Gallery
American Regionalism

PORTRAITURE

3 *Starry Night*
Edvard Munch
Oil on canvas,
54¾" x 46¾" (139 x 119 cm)
Oslo (Norway), Munch Museum
Symbolism

LANDSCAPE

1

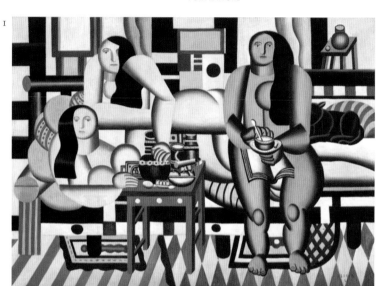

2

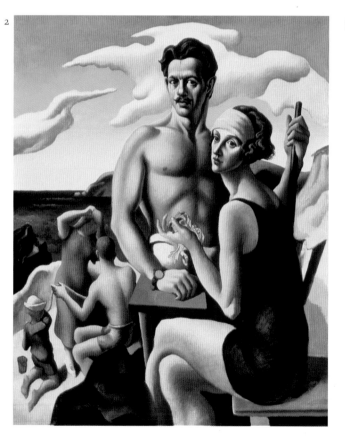

3

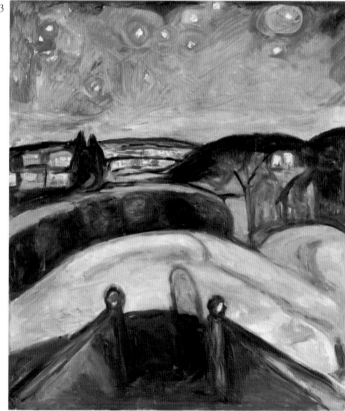

1925
USA

1926
Belgium

Flagpole
Georgia O'Keeffe
Oil on canvas,
35" x 18" (88.9 x 45.7 cm)
Santa Fe (USA),
Georgia O'Keeffe Museum

LANDSCAPE

5 *The Menaced Assassin*
René Magritte
Oil on canvas,
4' 11¼" x 6' 5" (1.5 x 1.96 m)
New York (USA),
Museum of Modern Art
Surrealism

FANTASY
DEATH

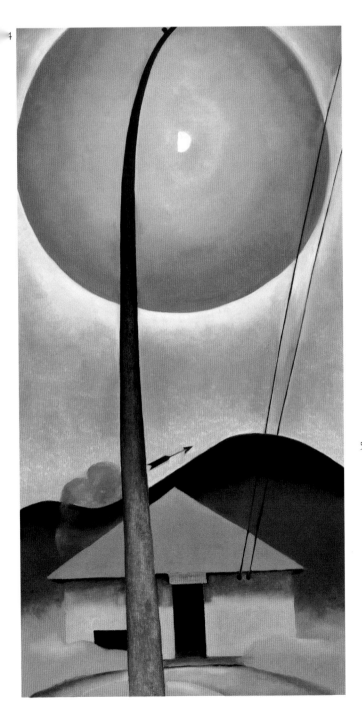

Surrealism

5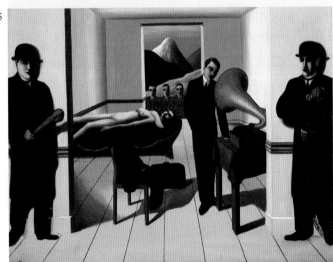

1926
Germany

1926
Germany

1927
France

1 *Sylvia von Harden*
Otto Dix
Oil on wood,
47¼" x 34½" (120 x 88 cm)
Paris (France), Centre Pompidou,
National Museum of Modern Art
Expressionism

PORTRAITURE

2 *Around the Fish*
Paul Klee
Oil on canvas,
18½" x 25" (46.9 x 63.5 cm)
New York (USA),
Museum of Modern Art

ANIMALS
ABSTRACTION

3 *Mama, Papa is Wounded!*
(Maman, Papa est Blessé!)
Yves Tanguy
Oil on canvas,
36¼" x 28¾" (92 x 73 cm)
New York (USA),
Museum of Modern Art
Surrealism

LANDSCAPE
ABSTRACTION

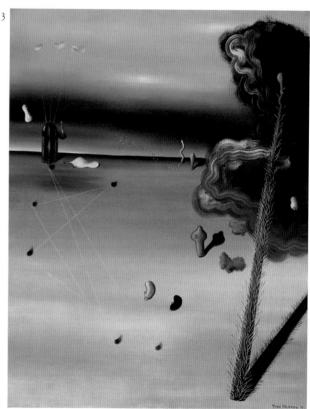

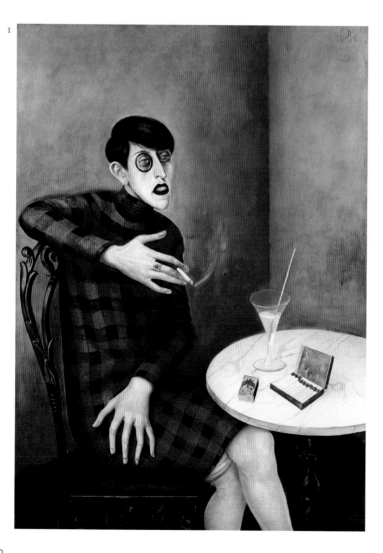

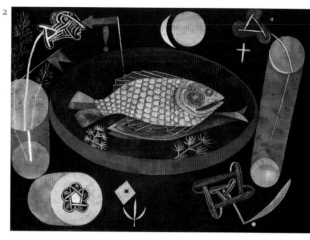

1928
USA

1928
USA

1929
USA

Reclining Nude with Guitar
Jacques Lipchitz
Black marble, height:
16½" (41.6 cm)
New York (USA),
Museum of Modern Art

THE BODY
ABSTRACTION

5 *Night Windows*
Edward Hopper
Oil on canvas,
29" x 34" (73.7 x 86.4 cm)
New York (USA),
Museum of Modern Art
American Regionalism

DOMESTIC LIFE
URBAN LIFE

6 *Self-Portrait*
John Kane
Oil on canvas over composition
board,
36¼" x 27¼" (9.8 x 68.9 cm)
New York (USA),
Museum of Modern Art

PORTRAITURE
THE BODY

4

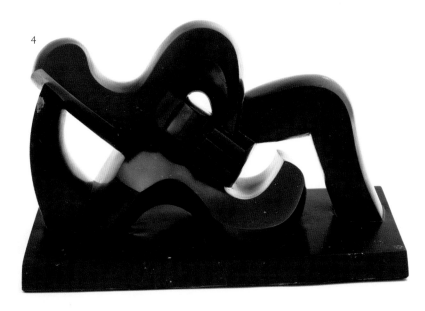

5

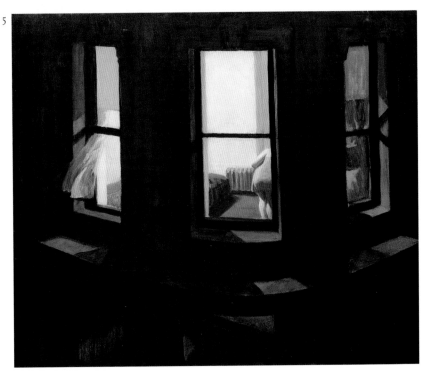

6

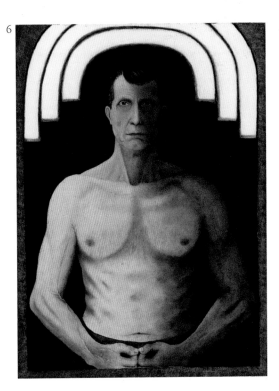

The new science of psychoanalysis inspires artists to paint from their imaginations

The theories of Sigmund Freud were intended primarily for the medical world, but they also had an important impact on many artists, who used them to create images to suggest the inner workings of the human mind.

Sigmund Freud, the founder of psychoanalysis, stressed the importance of exploring childhood memories and the unconscious mind, believing that these could provide the key to identifying repressed desires and alleviating neuroses. He developed a number of methods for probing the unconscious, most notably by looking for the hidden meaning in dreams, and using the technique of free association.

Freud's radical ideas and insights inevitably affected the work of artists, and particularly those in the Surrealist movement. André Breton, the author of the Surrealist manifesto, visited Freud in Vienna in 1921. He became fascinated by the creative possibilities of releasing the unconscious mind and he hoped that artists would merge "the previously contradictory conditions of dream and reality into an absolute reality, a super-reality." Freud used dream images as a means of decoding past experience, while for Breton the dream *was* the experience. The Surrealists experimented with "automatic" art, trying to suppress conscious control over the hand, while drawing or painting. They hoped this would enable the unconscious mind to take over, as in the psychoanalyst's technique of free association. They also tried to tap into what they saw as non-rational sources of imagery by studying the art of children and the mentally disturbed.

Of all the Surrealists, Salvador Dalí derived the most from Freud. He read Freud's *The Interpretation of Dreams* as a student, hailing it as "one of the capital discoveries of my life." He devised a special technique for creating his "hand-painted dream photographs." In what he called his "paranoiac-critical" method, he tried to simulate the mental confusion of a paranoiac, in order to bring out the hidden meanings behind his dreams and memories.

Many of Dalí's paintings possess a dreamlike quality of flux and distortion, although it is unclear just how intentionally he was striving for this effect. In *The Persistence of Memory*, for example, the imagery came from a variety of different sources, and was built up over a period of time. By the artist's own account, the painting began as a landscape of a stretch of coastline close to his home. For a while, Dalí's imagination stalled. Then one evening, after eating a ripe Camembert cheese with some friends, the idea of the soft watches suddenly came to him, and he was able to finish the picture quickly. The insects stemmed from a childhood memory, when he witnessed a swarm of ants consuming the decomposing body of a lizard. This image of decay is echoed in the melting watches, which also allude to the passage of time, and with it the fading of memories.

Some of Dalí's imagery hinted at more sexual Freudian themes. The lurid, mouthless face, partly a self-portrait and partly a copy of a local rock formation, had already appeared in an earlier painting, *The Great Masturbator*. In addition, the flaccid forms of the watches, and the broken, phallic stump of the olive tree, have been interpreted as symbolic of the artist's fear of impotence.

The Persistence of Memory
Salvador Dalí, 1931
Surrealism

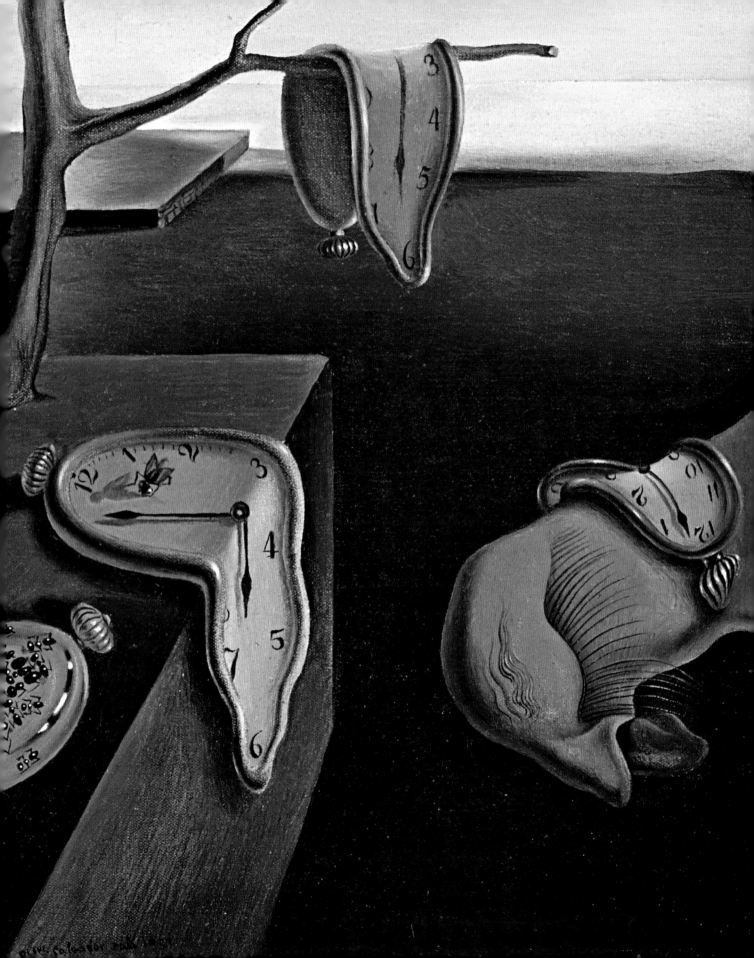

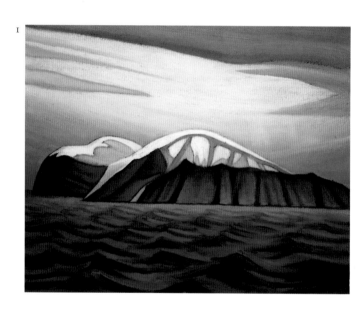

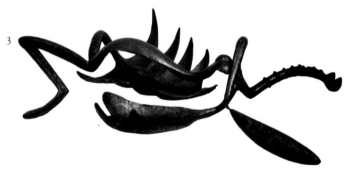

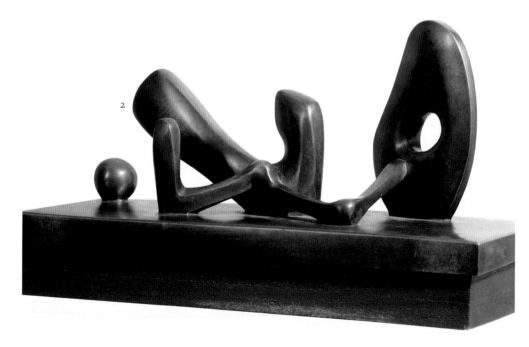

1933
Russia

The Working Woman
Kasimir Malevich
Oil on canvas
Saint Petersburg (Russia),
State Hermitage Museum
Social Realism

URBAN LIFE
PORTRAITURE

1936
France

5 *Guernica*
Pablo Picasso
Oil on canvas,
11' 5½" x 25' 6¾" (3.51 x 7.82 m)
Madrid (Spain), Reina Sofia
National Museum
Cubism

SOCIAL PROTEST
WAR

1936
Spain

6 *Soft Construction with Boiled Beans*
(Premonition of Civil War)
Salvador Dalí
Oil on canvas,
39½" x 39½" (100 x 100 cm)
Philadelphia (USA),
Philadelphia Museum of Art
Surrealism

SOCIAL PROTEST
WAR

4
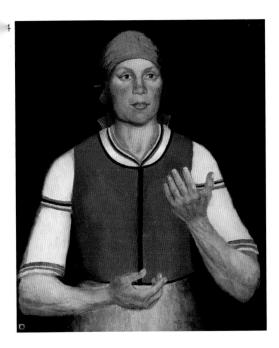

6
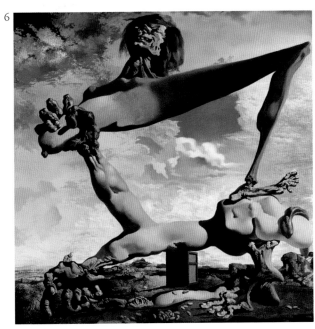

5
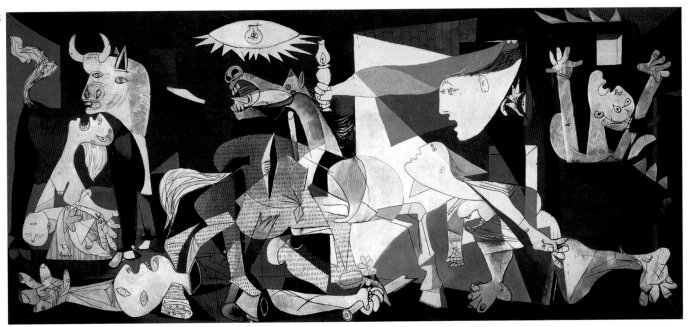

1936
France

1936
Mexico

1937
Italy

1 *Object (Le Déjeuner en Fourrure)*
Meret Oppenheim
Fur-covered cup, saucer, and
spoon, cup diameter: 4¼"
(10.9 cm), saucer diamater:
9¼" (23.7cm), spoon length:
8" (20.2 cm)
New York (USA),
Museum of Modern Art
Surrealism

FANTASY

2 *My Grandparents, My Parents, and I
(Family Tree)*
Frida Kahlo
Oil and tempera on metal,
12" x 13½" (30.5 x 34.3 cm)
New York (USA),
Museum of Modern Art

PORTRAITURE

3 *The Eternal City*
Peter Blume
Oil on composition board,
34" x 48" (86.4 x 121.9 cm)
New York (USA)
Museum of Modern Art
Surrealism

FANTASY
THE CITY

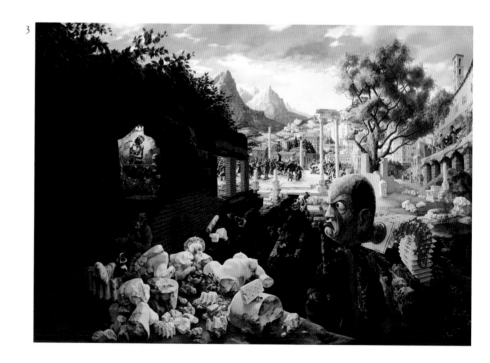

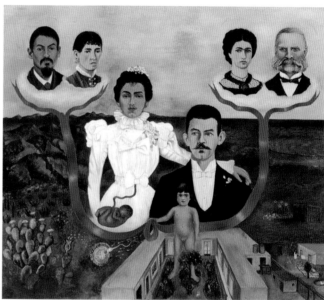

The Bo-Lo Game
Jacob Lawrence
Gouache (poster paint) on
pebbleboard,
10" x 14" (25.4 x 35.6 cm)
Newark (USA),
Newark Museum

LEISURE
URBAN LIFE

5 *Misty Day in Nikko*
Horishi Yoshida
Woodcut print,
15½" x 10½" (39.4 x 26.7 cm)
Newark (USA), Newark Museum

LANDSCAPE
RELIGION

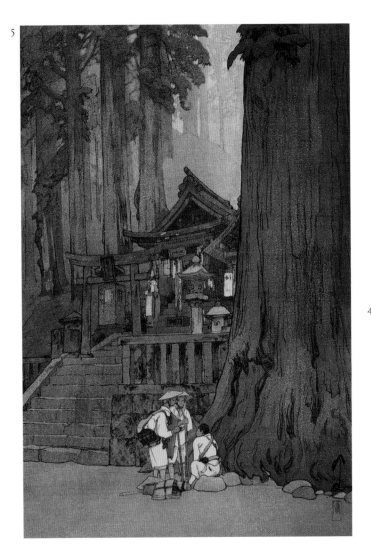

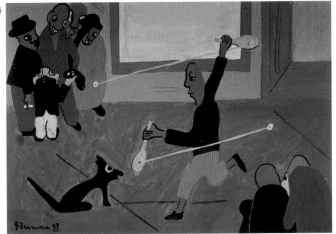

1940
USA

1942–1943
USA

1945
USA

1 *Street Life*
William H. Johnson
Oil on plywood,
45½" x 38½" (123.2 x 97.8 cm)
Washington, D.C. (USA),
Smithsonian American Art
Museum
American Regionalism

URBAN LIFE

2 *Broadway Boogie Woogie*
Piet Mondrian
Oil on canvas,
50" x 50" (127 x 127 cm)
New York (USA),
Museum of Modern Art
© 2005 Mondrian/
Holtzman Trust
c/o HCR International
Warrenton Virginia USA

THE CITY
ABSTRACTION

3 *Adoration of the Wise Men*
Romare Bearden
Oil on masonite,
22¼" x 28" (56.5 x 71.1 cm)
Newark (USA), Newark Museum
Abstraction

RELIGION

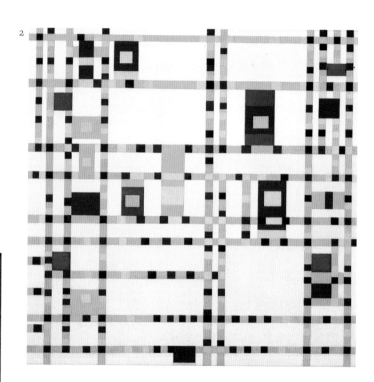

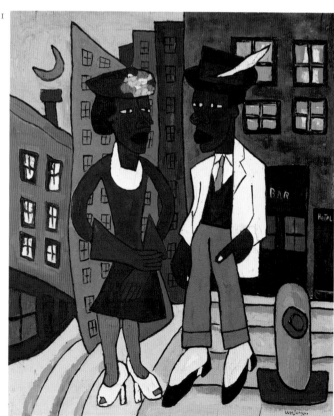

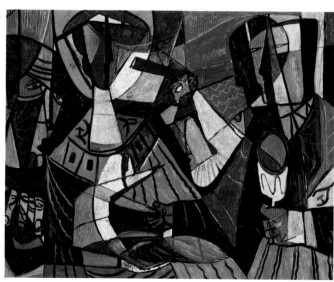

Painting
Francis Bacon
Oil and tempera on canvas,
16' x 11' (5 3 x 3.35 m)
New York (USA),
Museum of Modern Art

STILL LIFE
PORTRAITURE

5 *Full Fathom Five*
Jackson Pollock
Oil on canvas with debris,
50" x 30" (127 x 76.2 cm)
New York (USA),
Museum of Modern Art
Abstract Expressionism

ABSTRACTION

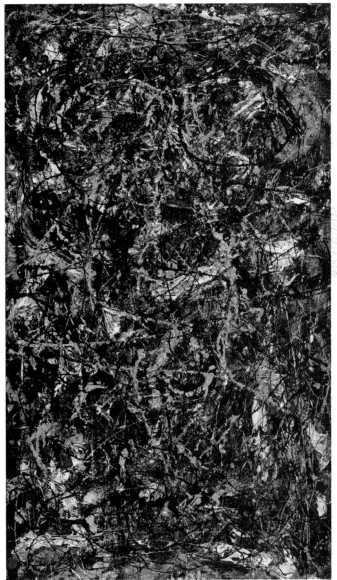

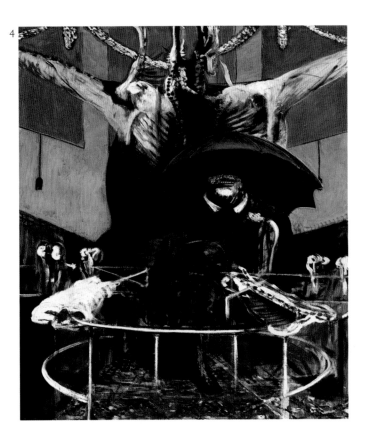

1947
France

1949
USA

1949
Italy

1 *Man Pointing*
Alberto Giacometti
Bronze, height: 5' 9½" (1.77 m)
New York (USA),
Museum of Modern Art

THE BODY

2 *Number 22*
Mark Rothko
Acrylic on canvas
New York (USA),
Museum of Modern Art
Color Field Painting

ABSTRACTION

3 *Angel of the Citadel*
Marino Marini
Bronze, height: 5' 5¾" (1.67 m)
Venice (Italy),
Guggenheim Museum

ANIMALS
BODY

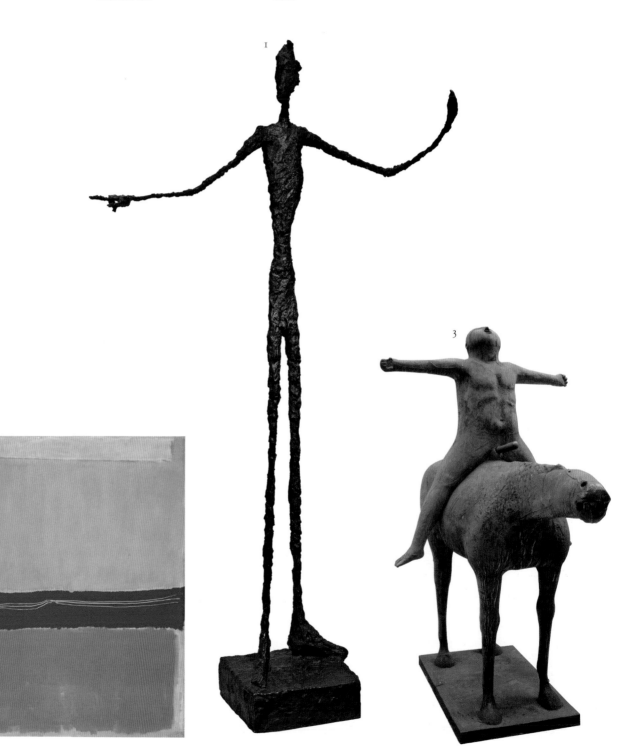

4 *Personages in the Night*
Joan Miró
Oil on canvas,
35" x 45¼" (88.9 x 114.9 cm)
New York (USA), Private collection
Surrealism

FANTASY
ABSTRACTION

5 *The Empire of Light II*
René Magritte
Oil on canvas,
31½" x 39½" (80 x 100 cm)
New York (USA),
Museum of Modern Art
Surrealism

LANDSCAPE

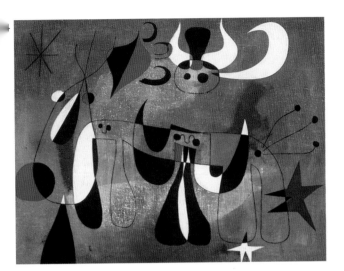

5

1950–1952
USA

1952
France

1954
Switzerland

1 *Woman 1*
Willem de Kooning
Oil on canvas,
6' 4" x 4' 10" (1.9 x 1.47 m)
New York (USA),
Museum of Modern Art
Abstract Expressionism

PORTRAITURE
THE BODY

2 *Christ*
Georges Rouault
Oil on wood,
31½" x 29" (80 x 74 cm)
Vatican (Vatican City),
Collection of Modern Religious Art

RELIGION

3 *Atomic War—No*
Hans Emi
Poster
Private collection

WAR
SOCIAL PROTEST

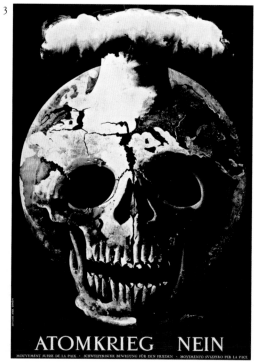

1956
USA

1957
Canada

Study for Homage to the Square
Josef Albers
Oil on masonite,
23½" x 23½" (60 x 60 cm)
New York (USA),
Museum of Modern Art

ABSTRACTION

5 *Swamp, Sawyer's Lake*
A.J. Casson
Oil on wood,
9¾" x 12" (25 x 30.5 cm)
Owen Sound (Canada), Tom
Thomson Memorial Art Gallery
Group of Seven

LANDSCAPE

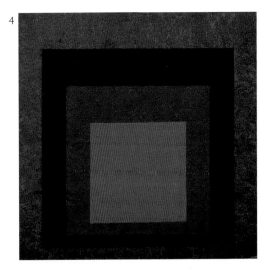

4

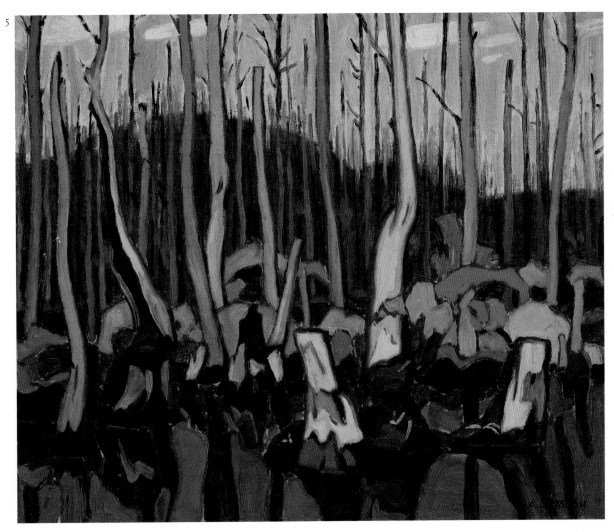

5

1958
USA

1960
USA

1961
USA

1 *Sky Cathedral*
Louise Nevelson
Wood construction, painted black,
11¼" x 18" (28.6 x 45.7 cm)
New York (USA),
Museum of Modern Art

ABSTRACTION

2 *Homage to New York*
Jean Tinguely
Fragment of mixed-media
self-destructing machine
New York (USA),
Museum of Modern Art
Kinetic Art

THE CITY

3 *Merce C.*
Franz Kline
Oil on canvas, 7' 9" x 6' 2½"
(236.2 x 189.2 cm)
Washington, D.C. (USA),
Smithsonian American Art
Museum
Abstract Expressionism

ABSTRACTION
PORTRAITURE

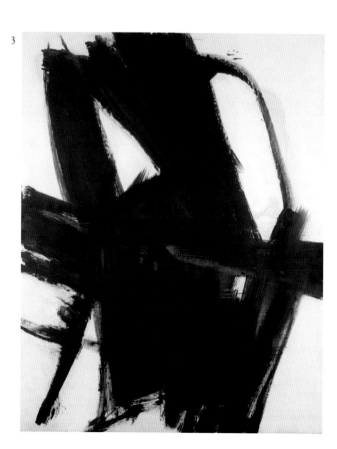

Map
Jasper Johns
Oil on canvas,
6' 6" x 10' (1.98 x 3.77 m)
New York (USA),
Museum of Modern Art

LANDSCAPE

5 *Fission*
Bridget Riley
Tempera on hardboard,
35" x 34" (88.8 x 86.2 cm)
New York (USA),
Museum of Modern Art
Op Art

ABSTRACTION

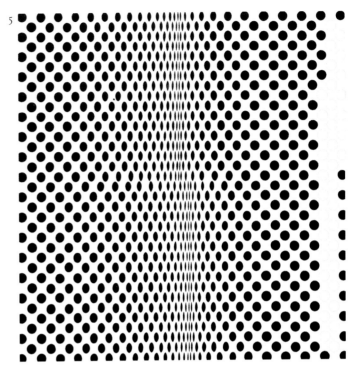

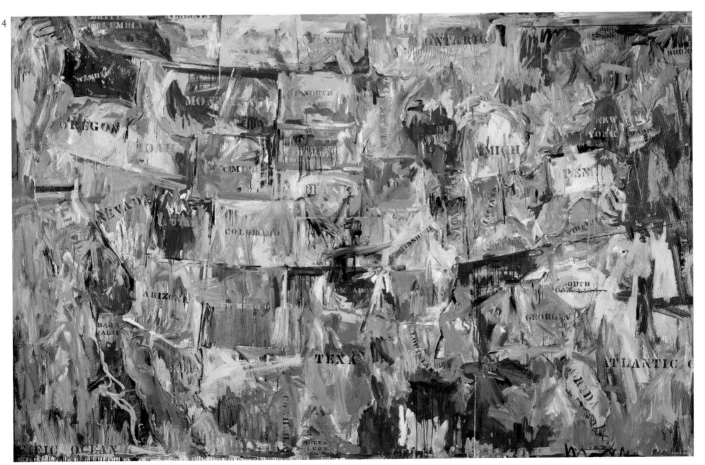

Pop Art deflates the pretensions of the art world

Pop Art came out of a desire to undermine the art establishment. No one warmed to this task more than Andy Warhol. In his pictures of soup cans, comic strips, and movie stars, he fashioned new icons for the age of consumerism.

For centuries, there were accepted hierarchies in Western art. Certain categories of painting were deemed more prestigious than others, certain styles more skilled, and certain places of exhibition more important. The Impressionists and other pioneering groups challenged these divisions, and with the rise of avant-garde movements in the early twentieth century, conventions were gradually swept away. By the 1960s, any artwork, however shocking, was considered acceptable. The artist Roy Lichtenstein has said of this period that, "It was hard to get a painting which was despicable enough so no one would hang it. Everyone was hanging everything." One kind of artistic snobbery remained unchallenged—that a piece of art that hung in a gallery was superior to the commercial art featured on food packaging, album covers, or billboards. This assumption was also overturned by a new movement, Pop Art, and most famously by the American artist Andy Warhol.

In common with many of the important figurative painters of the twentieth century, including Edward Hopper and René Magritte, Warhol began his career as a commercial artist, producing illustrations for magazines and advertisements. Warhol was painfully aware of the stigma attached to this. When he first brought dealers or gallery owners to his studio, he made sure that his commercial designs were "absolutely buried in another part of the house," because he feared that his other work would not be taken seriously. Warhol took his commercial roots with him, though, and said of his work that he "did images that anybody walking down Broadway could recognize in a split second—comics, celebrities, refrigerators, Coke bottles—all the great modern things that the Abstract Expressionists tried so hard not to notice at all."

Warhol's images of the actress Marilyn Monroe epitomized the new style. He produced his first versions in 1962, shortly after her suicide. His image started with a publicity photograph taken to promote the film *Niagara*. Warhol cropped the image and translated it into a silkscreen, using different colors and formats to emphasize the various aspects of her reputation. He placed a single head against a gold background so that the image resembled a religious icon, echoing the adoration that Marilyn inspired during her lifetime. He also alluded to her being turned into a commodity, and being packaged for the mass market, by making multiple images of her head in monotonous, rectangular grids, de-personalizing her face. He used an industrial process for his art, the silkscreen printing technique, which was widely used in the production of commercial textiles. The resulting crude slabs of color highlight Marilyn's cosmetic allure—her peroxided hair, strong eye shadow, bright red lipstick—to give the images the quality of being easily repeated, and utterly disposable.

Characteristically, Warhol was eager to take advantage of any outrageous event for publicity. In 1964, a woman calmly wandered into The Factory, his home and studio, pulled out a gun, and fired a bullet into a stack of Marilyn pictures, leaving a hole right between the eyes. Once these had been repaired, they were marketed as the *Shot Marilyns*.

Shot Red Marilyn
Andy Warhol, 1964
Pop Art

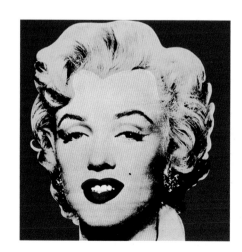

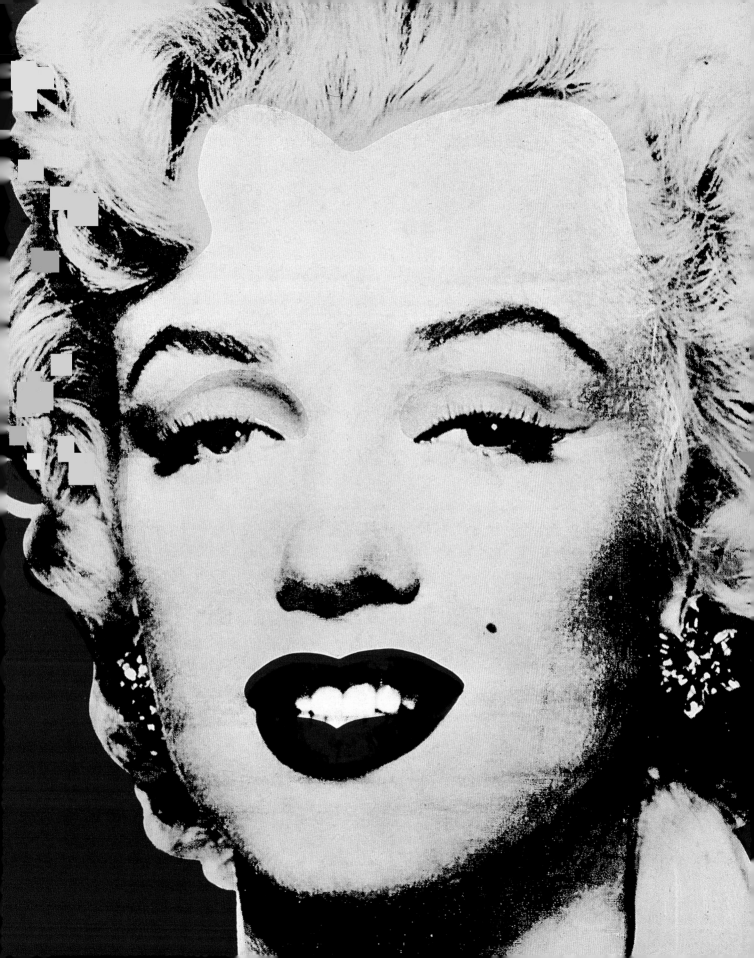

Portraiture

Portraiture is art that everyone can respond to—art that holds a mirror to humanity. What might be called the "power portrait" dominated the genre from antiquity, with images of rulers used on coins and as statues to impress their subjects and reinforce their authority. During the Renaissance, as art became more reflective of wider society, painted portraits were common, and artists started to explore character, beauty, and expression, often using models with interesting or striking features. A person of high status, however, did not expect a portrait to be anything but flattering. King Henry VIII of England is said to have been extremely displeased when he first met his fourth wife, Anne of Cleves, because the Hans Holbein portrait he had been sent of her had given a misleading impression of her appearance. Slowly, artists were able to experiment with poses and setting, and even the most powerful sitter realized that a strong gaze, a striking stance, and a setting reflecting their wealth and importance added to the impact of a portrait.

In the Netherlands in the seventeenth century portraits were radically vitalized. Here they became natural reflections of real people shown undertaking their everyday pursuits. The ability to achieve a true likeness was greatly valued until the mid-nineteenth century. However, once photographs became common, artists could use their skills to show something about the subject that no camera could match.

Mona Lisa is one of the first paintings in which a woman is allowed to look directly into the eyes of the viewer. Her hint of a smile, calm gaze, and the stillness emphasized by her beautiful hands have mesmerized art lovers for centuries. Leonardo da Vinci is said to have entertained her during her sitting. This was perhaps necessary, since her black veil suggests a recent death in her immediate family. His painting captures the essence of the portrait in that it is compelling, and the viewer feels a connection to the person who is portrayed, yet it is also mysterious. In addition to showing the person, a great portrait suggests a history, personality, mood, and feeling.

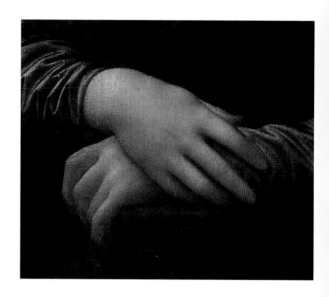

[top and opposite page]
Mona Lisa
Leonardo da Vinci, c. 1507
High Renaissance

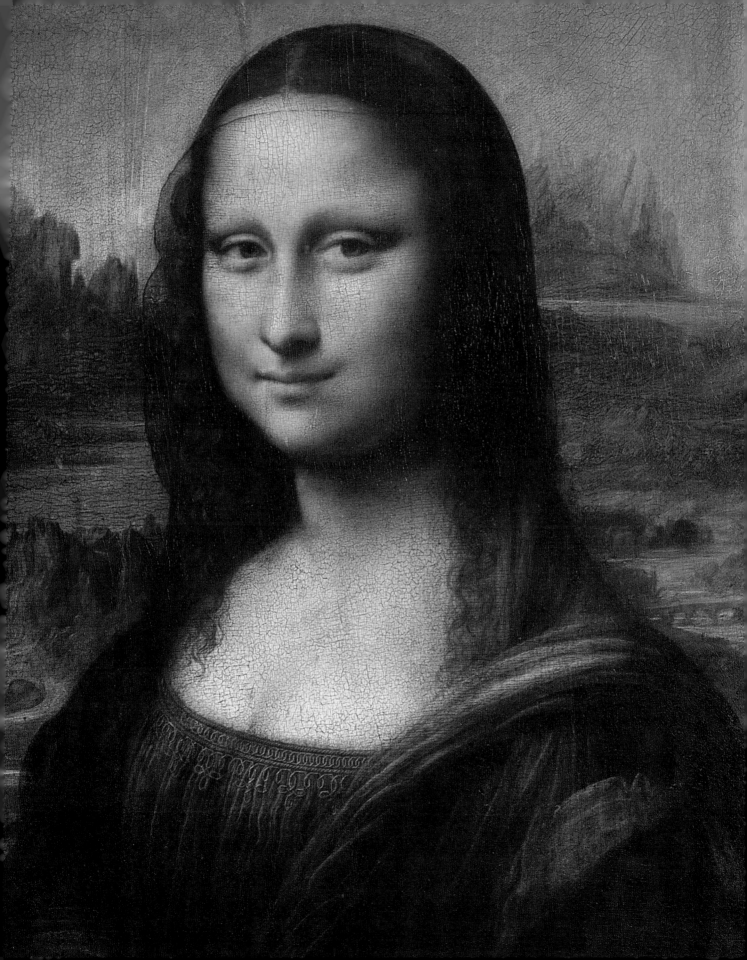

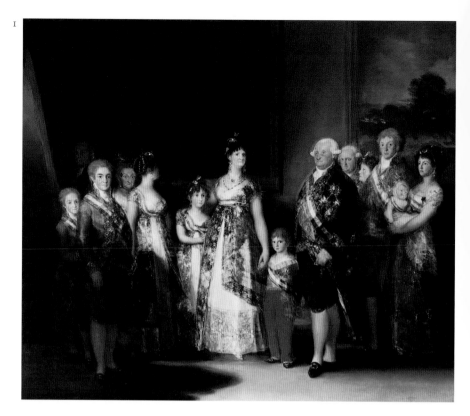

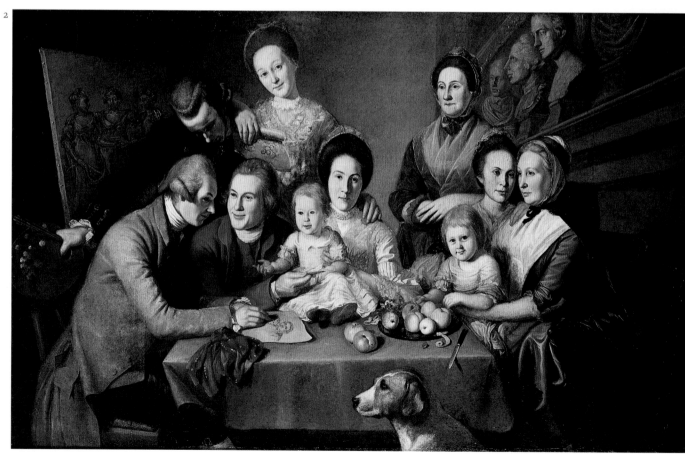

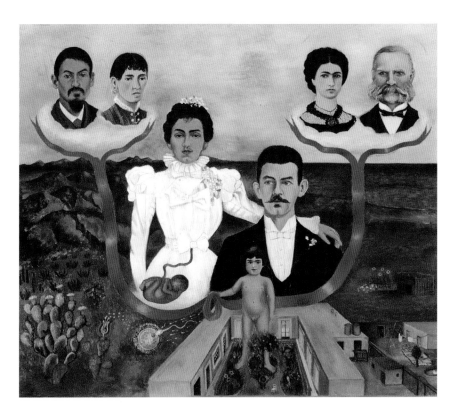

Family Portraits

When creating a successful group portrait, the artist needs to ensure that each individual has due prominence while creating a balanced composition of the group. Family portraits can be particularly challenging since they often include several generations. Frida Kahlo created a witty adaptation of a genealogical family tree to show her immediate relatives together. Francisco de Goya managed to avoid a stiff and formal depiction of the Spanish royal family but some felt he made them appear too much at ease. One critic observed that the King and Queen resemble a "corner baker and his wife, after they have won the lottery." Even so, Goya did observe the niceties of etiquette, emphasizing the King's superior status. Charles Wilson Peale's composition is even more relaxed, showing a large group of his own extended family enjoying a vibrant family reunion. Edgar Degas's portrait of the Bellelli family is a small, intimate group but with a cold atmosphere. The woman, Degas's aunt, was in mourning for her father, whose picture hangs on the wall. Her own marriage was an unhappy one and Degas has captured an air of tension between the figures, with the father outside the family unit and having to twist on his chair to show his face.

4

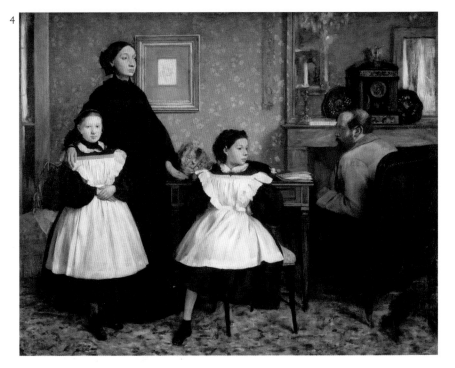

1 *Self-Portrait*
Vincent van Gogh, 1889
Postimpressionism

2 *Self-Portrait at the Dressing Table*
Zinaida Serebryakova, 1909

3 *Self-Portrait with Fur Coat*
Albrecht Dürer, 1500
Northern Renaissance

4 *Self-Portrait as a Drunkard*
Ernest Ludwig Kirchner, 1914
Expressionism

5 *Self-Portrait in Hell*
Edvard Munch, c. 1895
Symbolism

6 *Self-Portrait*
Elisabeth Vigée-Lebrun, 1790
Neoclassicism

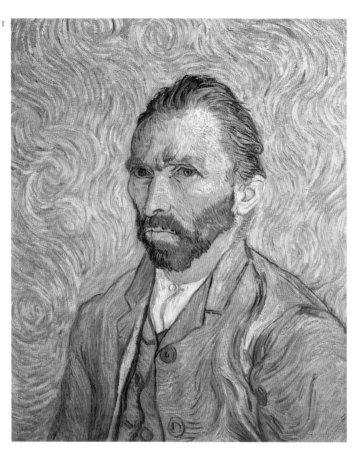

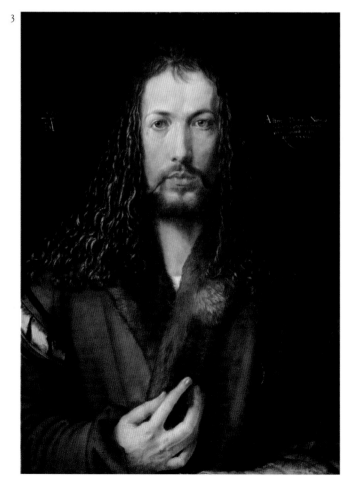

Self-Portraits

Self-portraiture has always been, and remains, a popular theme. It is convenient for artists who cannot afford to hire a professional model and gives the opportunity to make daring experiments and strong statements that are not always feasible in a commissioned portrait. For the viewer, self-portraits provide insight to the personality of the artists. The powerful, frontal pose of Albrecht Dürer's picture deliberately echoes images of Christ to affirm the artist's belief that his artistic talent was given to him by God. Elisabeth Vigée-Lebrun proclaimed her status as an artist in an age when few women were able to make a living in this field. Self-portraits can also reveal the inner life of the painter. Zinaida Serebryakova provides an intimate, confident glimpse into her domestic environment, while the other artists on these pages are using the genre to confront their demons. Ernest Ludwig Kirchner battled with addiction while Edvard Munch, who also portrayed himself on the operating table and with a skeleton arm, here displays "the flames of hell licking his body and purifying it with their flowing fire." Poignantly, Vincent van Gogh's portrait is the last that he completed before his suicide. His penetrating gaze, along with the swirling background, reflects his mental turmoil.

4

5

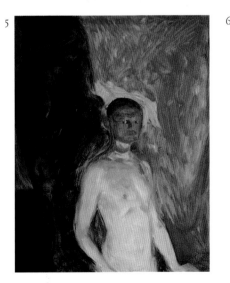

6

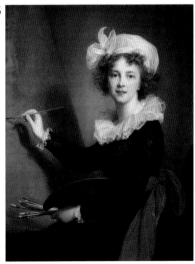

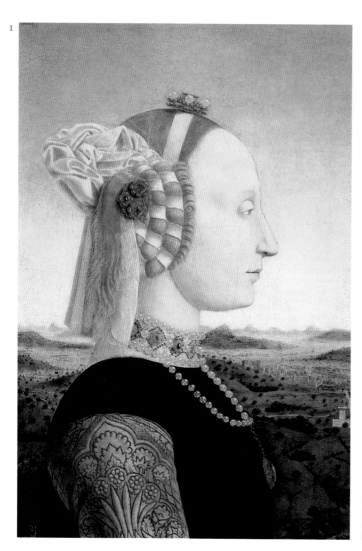

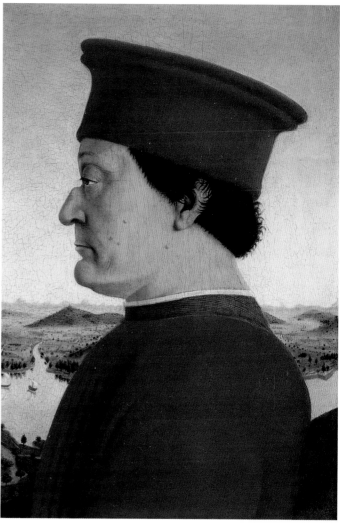

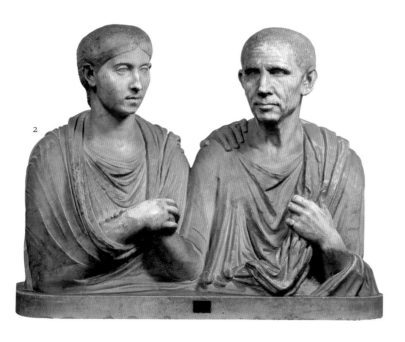

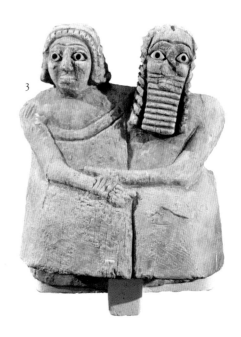

Portraits of Couples

Portraits of couples, or two individuals shown together, emphasize the relationship of the figures. In the funerary monument of Egyptian Prince Rahotep and his wife, Nofret, the couple poses formally on their thrones, indicating their power. The portraits by Piero della Francesca show another two powerful individuals, whose families were formally united through marriage. The profile portrait was a fashion of the period but it also had a practical purpose, concealing the terrible scar on the right-hand side of the Duke of Montefeltro's face—the legacy of a sword blow in a tournament. The landscapes behind the couple indicate the extent of their property, and the town in the Duchess's portrait is Borgo San Sepolcro, the artist's birthplace, which he included as a form of signature. The funerary carving of an Akkadian couple shows their marital intimacy through their clasped hands, while the formal physical embrace of the Roman sculpture is believed to show the mutual admiration and affection, as well as deep respect for family unity, between a distinguished father and daughter. In the Roman painting of a married couple from Pompeii, writing implements are featured to indicate that they were well educated, while the scroll may be their marriage contract.

1 *Portrait of the Duke and Duchess of Montefeltro*
Piero della Francesca, 1467–1470
Early Renaissance

2 *Cato and Portia*
Artist unknown, c. 100 BCE
Ancient Roman

3 *Man and Woman Embracing*
Artist unknown, c. 3000 BCE
Sumero-Akkadian

4 *Rahotep and Nofret*
Artist unknown, c. 2620 BCE
Ancient Egyptian

5 *Portrait of a Man and His Wife, from Pompeii*
Artist unknown, c. CE 50
Ancient Roman

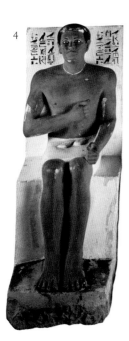
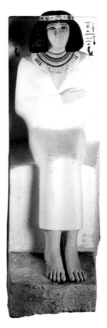

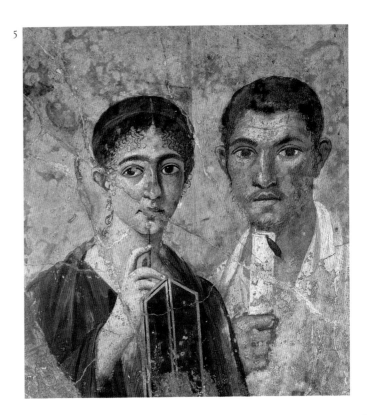

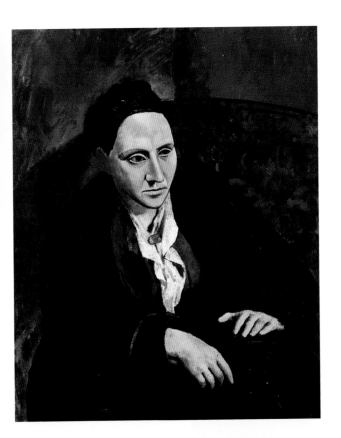

Capturing the Famous

These are portraits for public as well as private consumption and of celebrated personalities who wanted their image enhanced by the artist's talents. The all-powerful Cosimo de' Medici was Agnolo Bronzino's chief patron. When commissioned to create a portrait of the duke's eldest child, Maria, then aged eleven, Bronzino showed not a child but a formal, elegant young woman, who represents the glittering sophistication of the duke's court. King Louis XV of France was also a great patron of the arts and there was no one more important at his court than his mistress, Madame de Pompadour. Maurice Quentin de La Tour elevates her to the status of a regal beauty, flattering the king as well as his mistress in the process. While these women were famous by association, Marilyn Monroe was infamous, as well as famous, in her own right. Interest in her was particularly strong after her suicide, when Andy Warhol released his timely and iconic images of the movie star. Leo Tolstoy and Gertrude Stein were close friends of the artists who portrayed them, providing an opportunity for personal insight to these famous writers. Both are posed to express resolute and serious personalities. Tolstoy's intellect and humanity are expressed in his gentle but piercing gaze, as if looking up from reading his book. Stein's brilliance is enhanced by her appearing to be deep in intellectual conversation. She found sitting for her portrait so trying that after some eighty sessions Pablo Picasso decided to paint out her face and complete the picture from memory. When someone remarked that Stein did not look like her finished portrait, Picasso immediately quipped: "She will!"

5

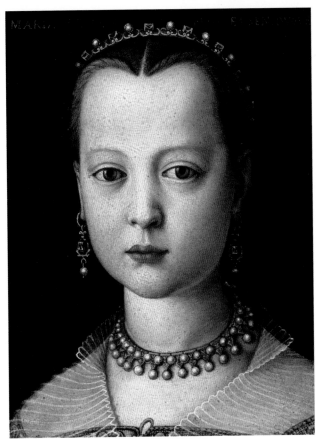

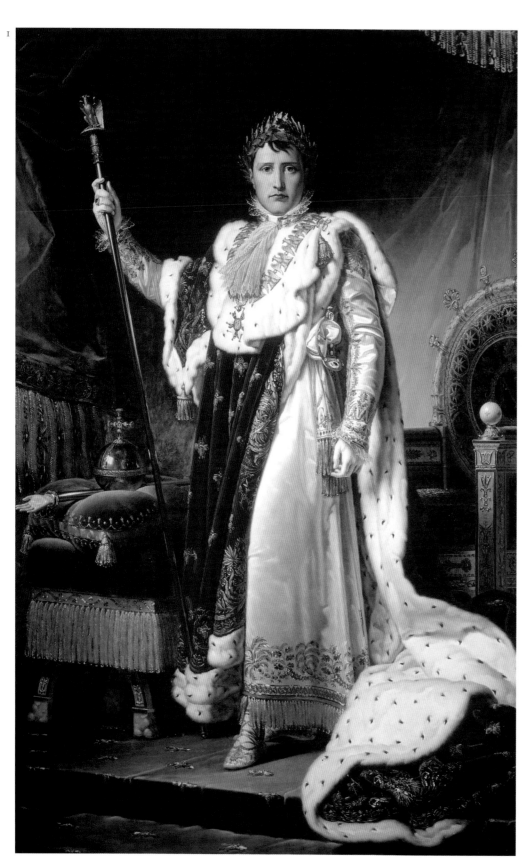

1 *Portrait of Napoleon Bonaparte*
François Gérard, 1807
Neoclassicism

2 *Portrait of Francis I on Horseback*
François Clouet, C. 1540
High Renaissance

3 *Equestrian Monument
to Gattamelata*
Donatello, 1447–1453
Early Renaissance

4 *Head of Sargon, from Ninevah*
Artist unknown, C. 2500 BCE
Mesopotamian/Akkadian

[following pages]
Procession of the Magi
Benozzo Gozzoli, C. 1459
Early Renaissance

Portraits of Power

Among the strongest images produced as portraits are those of all-powerful leaders and commanders. The magnificent bronze head of Sargon, founder of the Akkadian empire, is an ancient example of this. The empty eye sockets probably once held precious stones. In the West, equestrian portraits were a conventional image of power. The great military commander Gattamelata was given added status by Donatello when he based his memorial statue on that of a classical emperor. François Clouet, in his portrait of the French King Francis I, made the rider appear unusually tall and grand by painting the horse on a slightly smaller scale. In his fresco for the Medici Palace chapel, showing the procession of the Magi kings to Bethlehem, Benozzo Gozzoli included members of the Medici family, with Lorenzo the Magnificent on horseback in the center as one of the three kings. Napoleon was also depicted on horseback, but in this portrait François Gérard was using the striking pose and impressive imperial robes to show the status of a man who saw himself as the true successor of the Holy Roman Emperors.

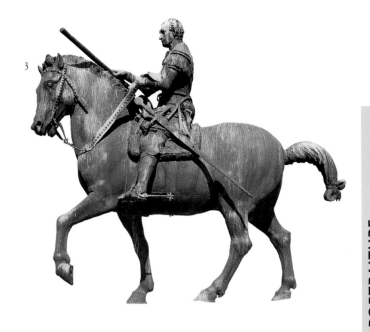

3

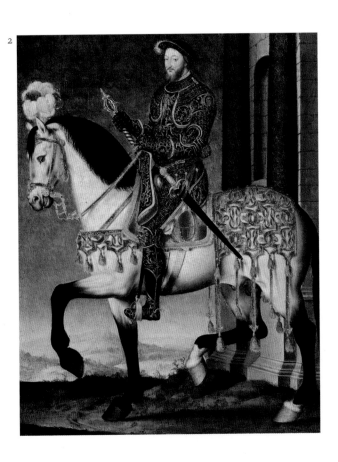

2

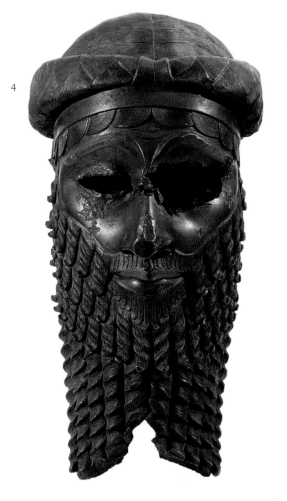

4

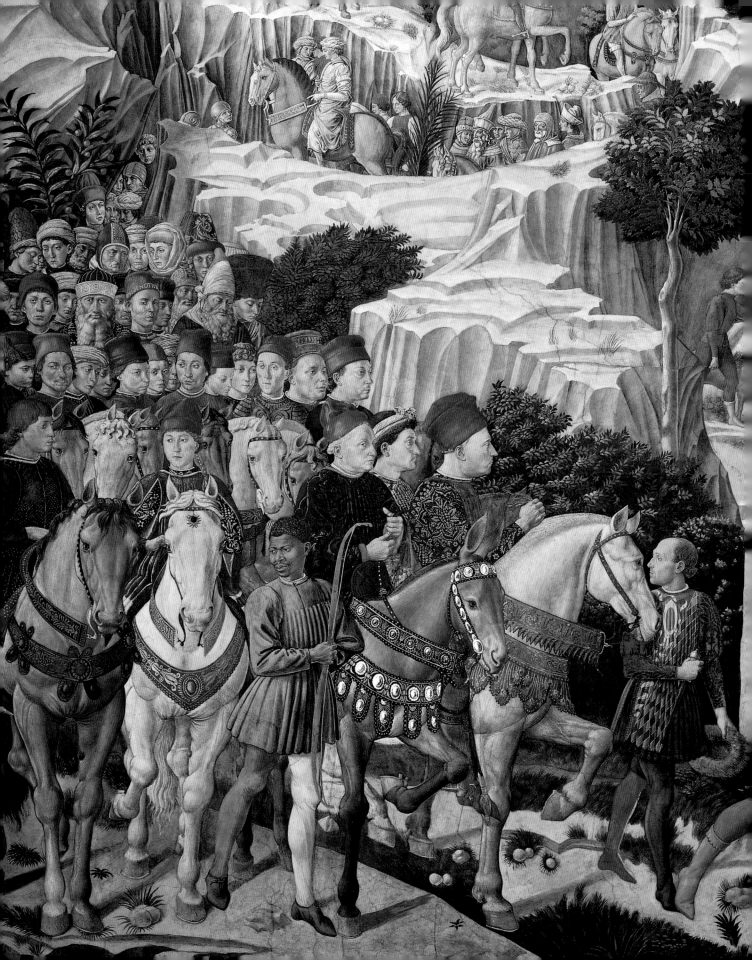

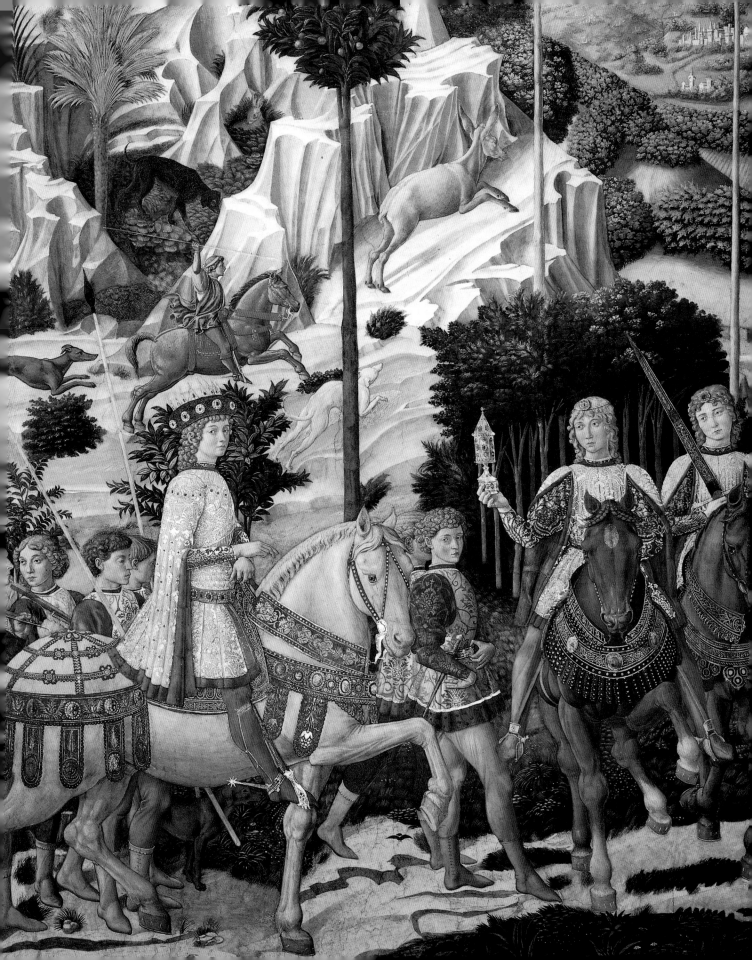

Portraits in Action

Portraits rarely show the sitter engaged in their work, but when this approach is adopted it can be extremely effective. *The Anatomy Lesson of Dr. Nicolaes Tulp* was one of Rembrandt van Rijn's earliest portrait commissions and helped to establish his reputation. His lighting effects spotlight the eminent doctor at center stage in a dramatic scene, and capture the entranced faces of Tulp's colleagues as they witness a human dissection. The picture is so realistic that scholars have been able to speculate about the identity of the textbook propped up at the foot of the corpse. Thomas Eakins was a huge admirer of Rembrandt's work and produced his own version of a surgeon performing an operation (*The Gross Clinic*). *The Concert Singer* is an equally realistic portrayal of Weda Cook, a mezzosoprano from New Jersey. One of her favorite pieces was Mendelssohn's *Elijah*, which includes the aria "O rest in the Lord." Eakins asked her to sing this every time she posed for him and the painting is so accurate that, from the shape of her mouth, experts have concluded she is singing the word "rest." Eakins carved the opening bars of the music on the picture frame.

1 *The Anatomy Lesson of Dr. Nicolaes Tulp*
Rembrandt van Rijn, 1632
Dutch Seventeenth Century

2 *The Concert Singer*
Thomas Eakins, 1890–1892
Realism

1

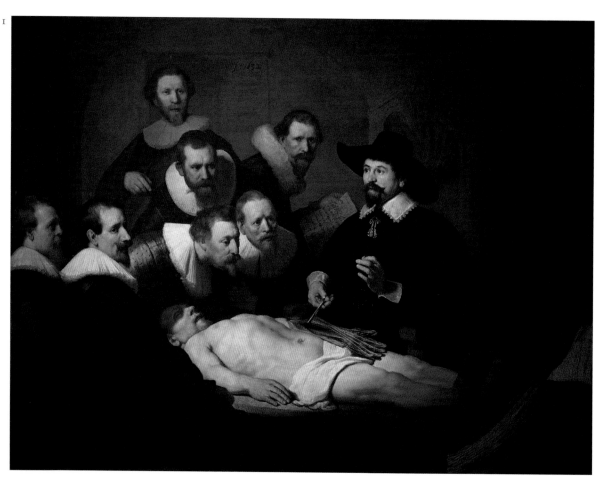

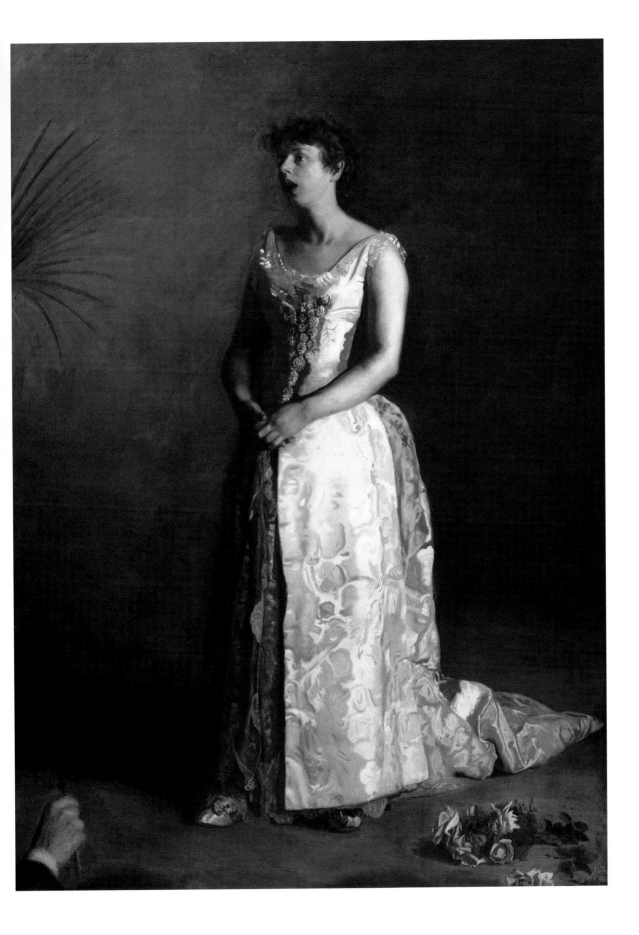

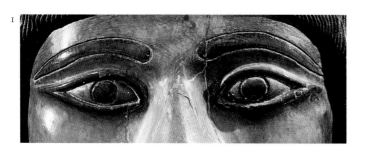

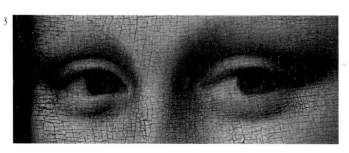

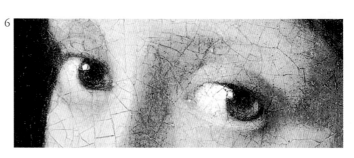

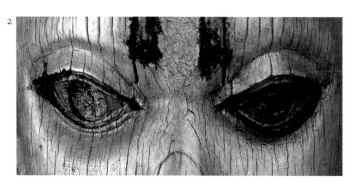

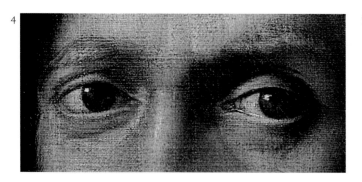

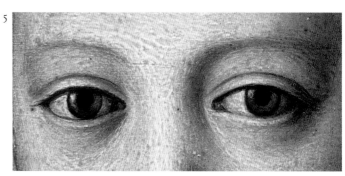

Eyes

The eyes provide the primary focus in any portrait, helping to define the relationship between the model and the viewer. In images of authority, such as the Benin mask or the portrait of Christ, the gaze often appears hieratic and sightless. There is something equally impersonal about the Gertrude Stein portrait, largely because Pablo Picasso was exploring the possibilities of primitive art at the time, and her face has the look of a tribal carving. The silkscreen of Marilyn Monroe falls into a similar category. As an icon of celebrity she was admired by millions of fans, but the eyes appear unfocused, making her seem distant. Baldassare Castiglione, the author of *The Courtier*, looks out at the spectator with the *riposo*—the serene, inner calm—that he recommended in his book. Rembrandt van Rijn admired this picture so much that he tried to buy it and cast two of his own self-portraits in the same mold. Other looks are more challenging. French art lovers found the direct gaze of the naked woman in Edouard Manet's *Le Déjeuner sur l'Herbe* unsettling, largely because they were unsure whether to interpret her as allegorical or immoral. The eyes of Vincent van Gogh, full of pain and bewilderment, are even more disturbing.

9

10

11

12

1 *Head of Woman, from Nimrud*
Artist unknown, c. 721–705 BCE
Neo-Assyrian

2 *Mask*
Artist unknown, c. 1500–1600
Benin

3 *Mona Lisa*
Leonardo da Vinci, c. 1507
High Renaissance

4 *Portrait of
Count Baldassare Castiglione*
Raphael, c. 1514
High Renaissance

5 *Portrait of Maria de' Medici*
Agnolo Bronzino, 1551
Mannerism

6 *Head of a Young Woman*
Jan Vermeer, c. 1665
Dutch Seventeenth Century

7 *Self-Portrait*
Francisco de Goya, 1815

8 *Le Déjeuner sur l'Herbe*
Edouard Manet, 1863
Realism

9 *Self-Portrait*
Vincent van Gogh, 1889
Postimpressionism

10 *Portrait of Gertrude Stein*
Pablo Picasso, 1905–1906

11 *Christ*
Georges Rouault, 1952

12 *Shot Red Marilyn*
Andy Warhol, 1964
Pop Art

Domestic Life

Before the painting of everyday subjects became commonplace in the seventeenth century, artists included the interiors of palaces and houses as a setting, rather than a subject, for their work. A room could provide an insight into the status, as well as the interests and personality, of the owner.

The Vittore Carpaccio painting showing Saint Augustine's private study looks back at an important historic and religious figure. Saint Augustine lived in the fourth century during the last years of the Roman Empire, and the painter has reconstructed his study with archaeological precision, highlighting the fascination that the ancient world held for Renaissance artists. Carpaccio used the room to convey the saint's inner struggle with his faith. Alongside Christian objects, there are scientific instruments and musical scores, reflecting Augustine's secular interests. The attentive dog, meanwhile, provides a sense of intimacy and reality.

Life in the home became a popular subject for artists in the seventeenth century, when Dutch artists in particular chose to take their subjects from everyday events to provide a simple record of daily life. Their subjects ranged from routine chores, such as preparing food or sewing, to family scenes and entertaining.

By the nineteenth century, the interior of a home had become a subject in its own right, sometimes shown without its occupants. The Comte de Mornay was an important figure in Eugène Delacroix's life. In 1832, he invited the painter to join his ambassadorial mission to Morocco—an event that raised the status of the artist and enhanced his artistic career. As a result, Delacroix was keen to stress the good taste of his patron in his painting of the Comte's elegant apartment. By contrast, Vincent van Gogh intended the picture of his bedroom to serve as an expression of his own simplicity and humility. After his breakdown, van Gogh produced replicas of the picture for his family, to suggest a mood of "peace and perfect repose."

[top]
Apartment of the Comte de Mornay
Eugène Delacroix, 1833
Romanticism

[bottom]
Saint Augustine in His Study
Vittore Carpaccio, c. 1502
Early Renaissance

[opposite page]
The Artist's Room in Arles
Vincent van Gogh, 1889
Postimpressionism

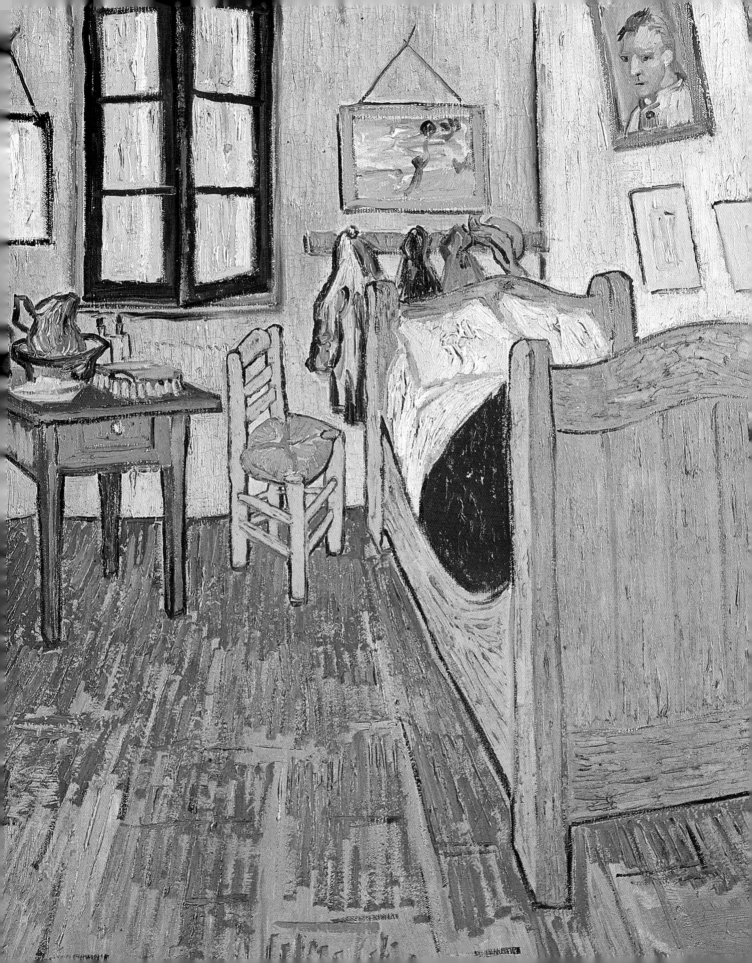

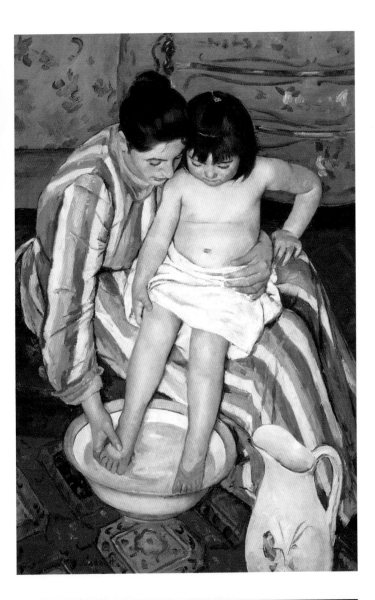

Motherhood

Prior to the nineteenth century, the theme of maternity was often tackled indirectly, under the guise of a religious or mythological subject. A painting of the Virgin and Child, although ostensibly a sacred theme, could also serve as an image of motherhood. Usually the artist added some symbolic prop to confirm the identity of the Virgin, but Gerard David has not bothered with this nicety. Attitudes began to change in the nineteenth century, when children were increasingly allowed freedom in lives of their own. Pictures set in the nursery became more common, although the results were often rather sentimental. The work of Mary Cassatt demonstrated, however, that it was possible to combine a maternal theme with the latest artistic techniques. She was closely linked with the Impressionists, participating in four of their exhibitions, and applied their style to a new type of subject matter. Although she was excluded from some of the haunts of her male colleagues— the sleazy bars and the brothels—she could draw on the details of a woman's lifestyle, which lay outside their experience.

5

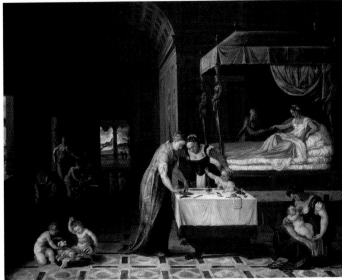

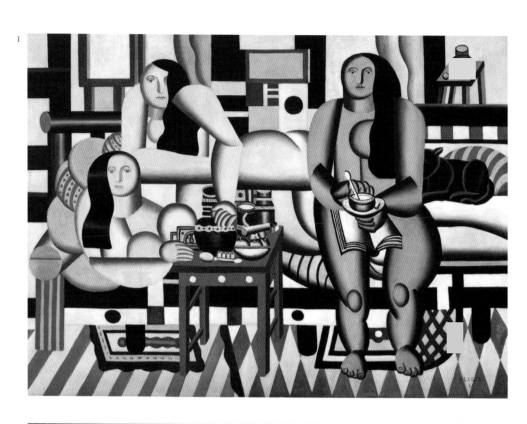

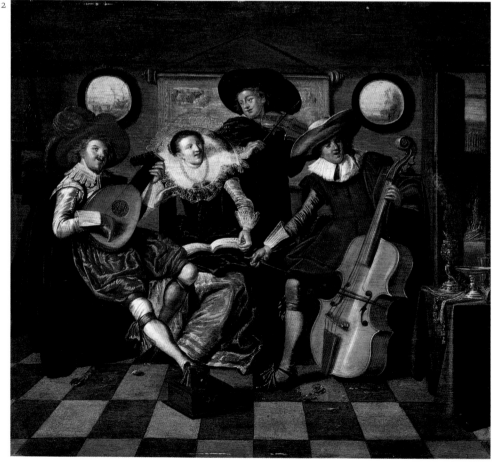

Entertaining

All seems well with the world in these scenes of laughter and merrymaking, but images of pleasure often awoke moral concerns. The "Merry Company" was a popular theme in Dutch art in the seventeenth century. Given the strict Calvinist background of the country, however, it was as much a sermon as a celebration. The music, the fine clothes, and the scattered flowers are all emblems of earthly delights, merely transient, as well as a warning against the dangers of excess. Louis-Léopold Boilly and Jean-Baptiste Greuze enjoyed successful careers under France's *ancien régime*, frequently depicting domestic scenes. The latter's were often steeped in sentimentality, while Boilly's pictures had a more lighthearted flavor. Both men fell dramatically out of favor at the time of the French Revolution. Boilly was hauled before the republican committee, where he was accused of producing paintings that were frivolous and counter-revolutionary, which could "serve at most merely to charm the boredom of our luxurious sybarites." Greuze, meanwhile, sank into obscurity and died in poverty. Kitagawa Utamaro's favorite subject was women. He showed them undertaking a wide range of activities in the home, from domestic chores to more romantic pursuits. His *Uta Makura* pillow book has been hailed as the finest example of erotic art ever produced in Japan.

3

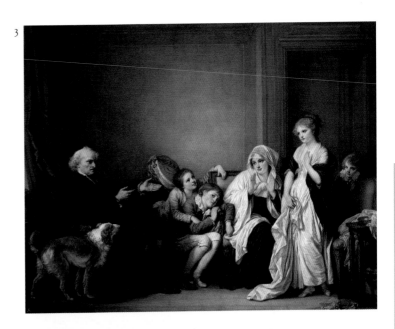

4

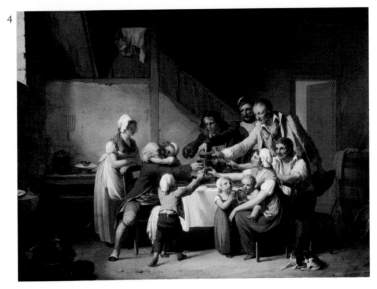

5

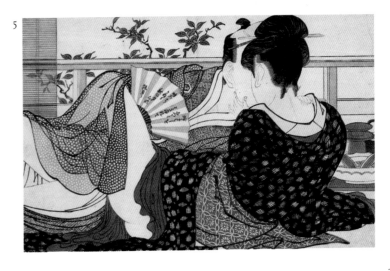

1

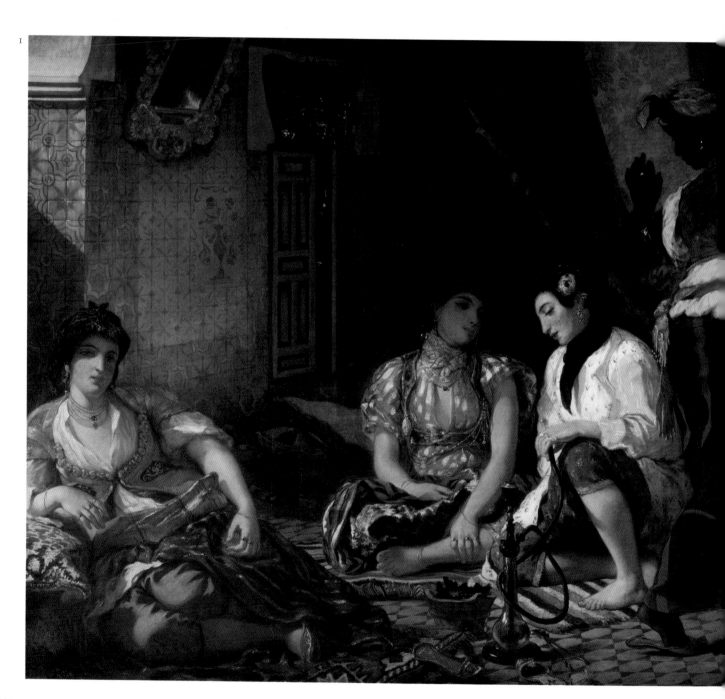

Women at Home

For many artists, one of the attractions of painting a domestic interior was the chance to depict people in a natural and unaffected manner. In portraits, the sitters were on show. In a historical or mythological scene, the models might look posed or stagy; here, in these "fly-on-the-wall" paintings, the figures appear relaxed, casual, and, occasionally, downright unglamorous. During a trip to North Africa, as part of a diplomatic mission, Eugène Delacroix persuaded a former corsair to take him inside a harem. The experience changed his preconceptions about the Arab world. In his earlier eastern subjects, he had used gaudy trinkets to create an exotic mood, but he found the reality more sober and restrained. Kitagawa Utamaro was renowned for his prints of society beauties and courtesans, but he also enjoyed depicting less formal subjects. On the left of his sewing scene, a young mother is multi-tasking, looking for tears in a piece of silk while also trying to control a wriggling child. Her image is considerably more flattering, however, than that of Guiseppe Maria Crespi's model, who has just discovered the disadvantage of allowing a dog on the bed, and of Henri de Toulouse-Lautrec's friend, Madame Poupoule, who was a prostitute and an absinthe drinker.

2

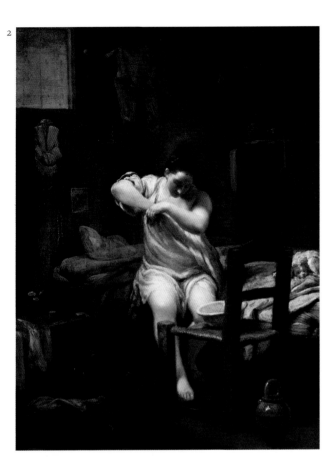

3

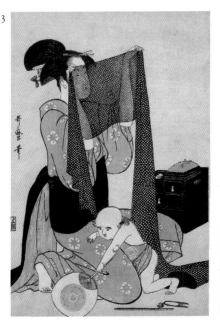
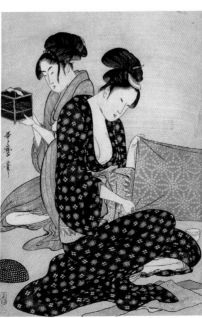
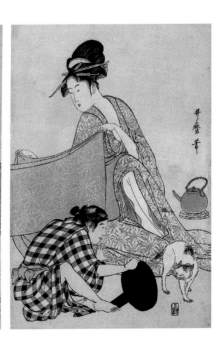

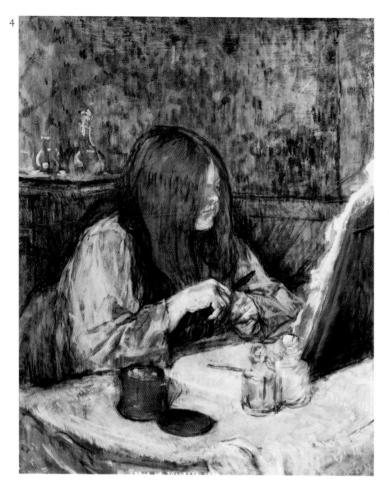

4 *At the Dressing Table:*
 Madame Poupoule
 Henri de Toulouse-Lautrec, 1898

5 *Princess Smoking a Hookah*
 Artist unknown
 Mughal Art

6 *In Bed*
 Federico Zandomeneghi,
 c. 1860–1900
 Impressionism

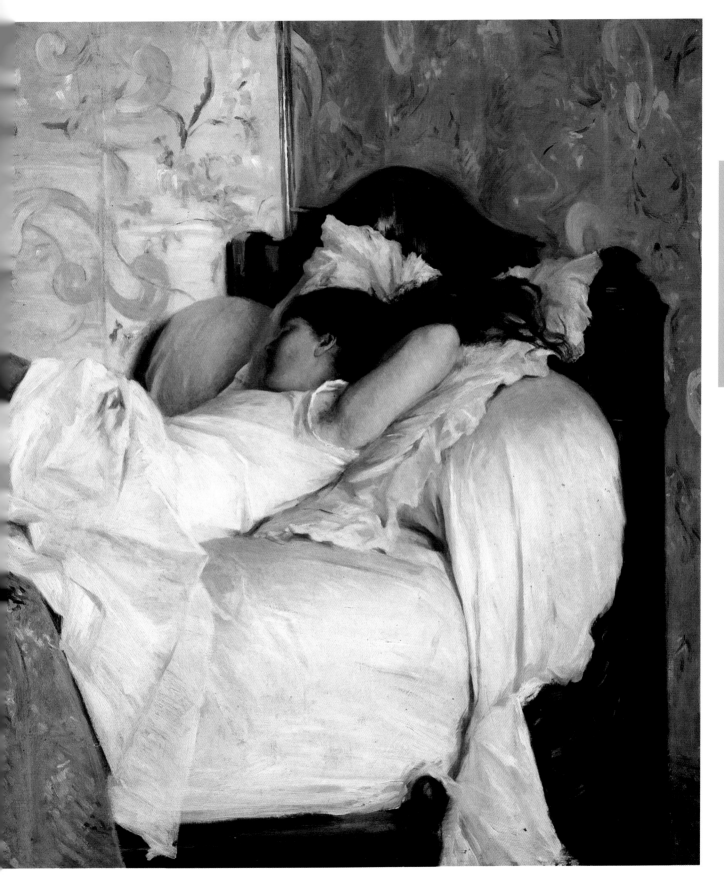

Leisure

Scenes of leisure inspired artists in ancient times, particularly activities associated with physical prowess such as athletics or gladiatorial contests. From early times in Western art, in tapestries as well as paintings and frescoes, one of the most popular subjects was hunting, enabling artists to show their versatility while portraying their patrons' wealth, land, and entourage in a beautiful setting. In later times less grandiose hunting scenes were popular as prints.

Pietro Longhi depicted the leisures of city life, chronicling the delights of his native Venice in the eighteenth century. His pictures covered an enormous range of subjects, from a duck shoot on a gondola to the spectacle of the first rhinoceros exhibited in Venice. At a notorious gambling den, the Ridotto, only people wearing masks would be admitted, and Longhi captures the spectacle of this popular location's foyer. The authorities closed the Ridotto in 1774 after professional gamblers from abroad began to relieve the local aristocrats of large sums of their money.

The Impressionists, in part inspired by Japanese prints showing sophisticated people enjoying themselves in theaters, tea rooms, and brothels, focused on the entertainments that were available in Paris. These ranged from organized events, such as concerts, the circus, and the theater, to more informal occasions, such as dancing, boating on the Seine, or simply drinking with friends at the lively bars. The viewers of the paintings are made to feel as if they too are mingling with the crowd. Auguste Renoir is typical of the Impressionists in being more interested in the audience than the event. The male figure in his painting *La Loge (The Theater Box)* is the artist's brother, scanning the audience with his opera glasses, looking for familiar, and perhaps famous, faces.

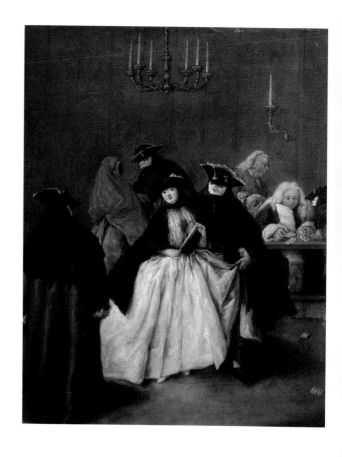

[top]
Masks in the Foyer
Pietro Longhi, c. 1757
Rococo

[opposite page]
La Loge (The Theater Box)
Auguste Renoir, 1875
Impressionism

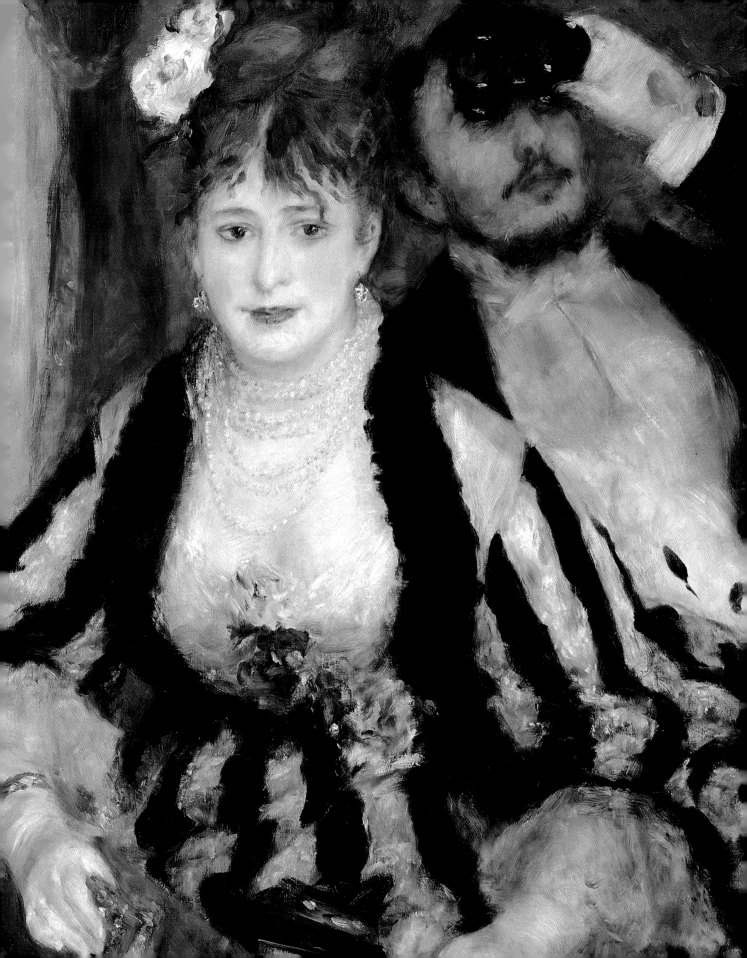

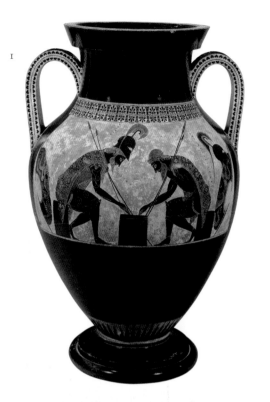

Playing Games

Felix Vallotton's picture captures the intense concentration of the card players, although in pictorial terms he seems more interested in the interplay between the lights and the patterns. The other games are less conventional. In Mathieu Le Nain's painting, the men are playing *trictrac*, a French variation of backgammon. This game was extremely popular prior to the Revolution, but it became so closely associated with the court that republicans destroyed many of the boards. Exekias's amphora shows Ajax and Achilles taking a break during the long siege of Troy, in order to play a game of *morra*. In this variant of paper-scissors-stone, contestants have to guess how many fingers their opponent will thrust out at a given signal. The game was banned in nineteenth-century Italy because it was causing too many fights. Jacob Lawrence's humorous picture was painted during the Depression, when kids on the streets of Harlem tried to earn a few coins by showing off their skills at paddle ball. One boy asks passers-by for money, while his friend mesmerizes a cartoon-like dog with his tricks.

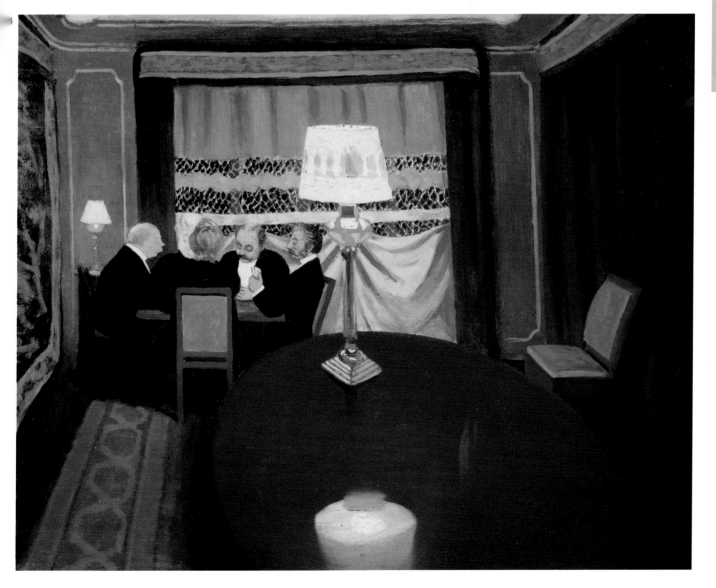

*Amphora with Ajax and Achilles
Playing a Game*
Exekias, C. 530 BCE
Ancient Greek

The Bo-Lo Game
Jacob Lawrence, 1937

3 *The Poker Game*
 Felix Vallotton, 1902

4 *The Backgammon Players*
 Mathieu Le Nain, 1648–1650
 Baroque

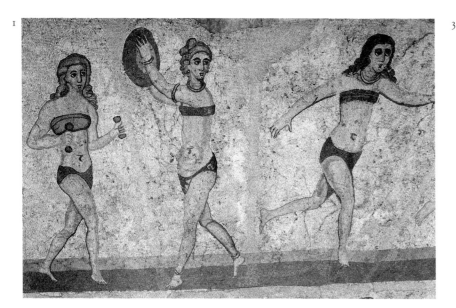

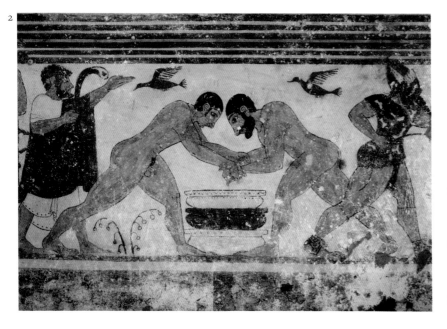

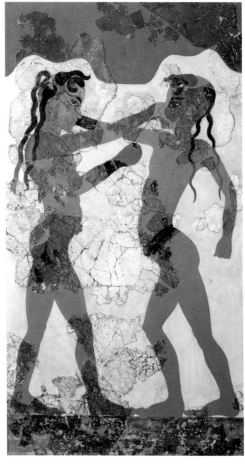

1 *Female Gymnasts*
Artist unknown, c. 375
Imperial Roman

2 *Wrestlers*
Artist unknown, c. 530–520 BCE
Etruscan

3 *Boys Boxing, from Thera*
Artist unknown, c. 2000–1500 BCE
Minoan

4 *Plate showing
King Shapur II Hunting*
Artist unknown, 300–400
Sassanian

5 *Woman Playing Polo*
Artist unknown, c. 618
Tang dynasty

6 *African Boxers*
Artist unknown, c. 200–100 BCE
Ancient Roman

7 *Roman Gladiators*
Artist unknown, c. 200–100 BCE
Ancient Roman

Ancient Sports

In the ancient world, athletic contests often had a ritual significance beyond mere sporting competitiveness. The painting of Etruscan wrestlers comes from a tomb and relates to the custom of staging funeral games. Homer mentions this practice in the *Iliad;* on some occasions, the contests would be used to settle inheritance disputes. The Romans regarded their gladiatorial bouts as a continuance of this Etruscan tradition. Even so, some sporting images were purely decorative. The mosaic of female gymnasts pictured here comes from the Villa Casale in Sicily. Ten women—nicknamed "the bikini girls" by guides—are shown exercising, with one of them receiving an award. Although most of these sports are familiar to modern spectators, the antique versions were often far more brutal. Painters in Greece, for example, were as keen to portray illegal wrestling moves as the legitimate ones. Similarly, Greco-Roman boxing, as depicted in *African Boxers*, could be a lethal affair. The boxers were professional and could win big prizes, but there was no time limit to a contest and no rest between rounds. In addition, the gloves *(caestus)* were designed to inflict great injury: they were often worn over knuckledusters. The terracotta figures of the Roman gladiators adopt a more open stance than would their modern equivalents.

5

6

7

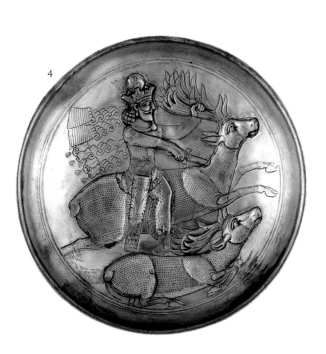

4

Music

This subject has been a perennial favorite for artists, and theorists have stressed the close relationship between painting and music. Allegories are commonplace. Titian's enigmatic painting *Concert* may be one, as is this picture by Giovanni Lanfranco. It shows Venus playing the harp, watched by two cupids. The choice of instrument was determined not by the goddess, but by the patron, the musician Marco Marazzuolli, who was nicknamed "Marco the Harp." The mosaic *Strolling Musicians* comes from the Villa of Cicero, near Pompeii. It illustrates a scene from a play—the figures are wearing theatrical masks— although it is impossible to identify the precise source. The musicians are probably meant to represent followers of Cybele, an ancient mother goddess, since the pictured instruments were traditionally associated with her cult. Nineteenth-century artists found new ways of treating the theme. Baron Frederic Leighton, for instance, decided to exploit the contemporary vogue for eastern subjects in his *Music Lesson*. The picture was meant to represent a harem scene, but in fact the painter had amassed a considerable collection of sumptuous costumes during a trip to Damascus, and had also built an authentic Arab hall in his London home, so the reality was rather less exotic. A happy outcome was that the child model went on to make a successful career as a music hall performer.

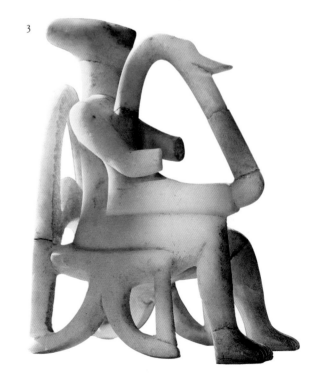

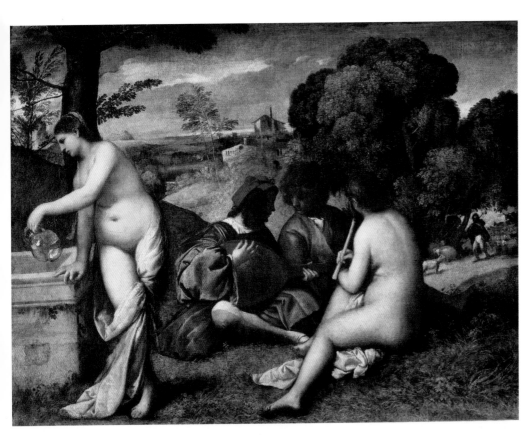

1 *Strolling Musicians*
(Roman mosaic copy of lost Greek painting)
Original by **Dioskurides of Samos**, c. 200–100 BCE
Ancient Greek

2 *The Music Lesson*
Baron Frederic Leighton, 1877
Academic

3 *The Harpist*
Artist unknown,
c. 2700–2400 BCE
Cycladic

4 *Concert*
Titian, 1508–1511
High Renaissance

5 *Music*
Giovanni Lanfranco, 1630–1634
Baroque

6 *Three Musicians*
Pablo Picasso, 1921
Cubism

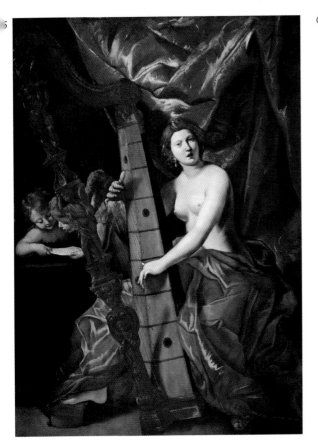

6

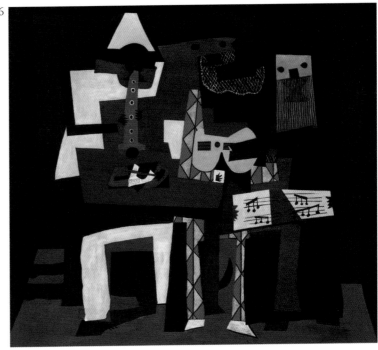

Entertainers

In Western art, there was a long tradition of portraying scenes from plays, but the theme was limiting because it required prior knowledge on the spectator's part. After the emergence of the *commedia dell'arte*, opportunities for more popular depictions opened up. With its combination of street theater and improvised, slapstick comedy, this Italian troupe's repertoire became famous throughout Europe, and its stock characters instantly recognizable. Honoré Daumier's clowns are comic servants or *zanni* (hence the word "zany"), while Jean-Antoine Watteau's *Gilles* was the sad, solitary lover. Watteau's picture was probably designed to be a theatrical billboard. In the nineteenth century, this form of advertising was superseded by the poster. Henri de Toulouse-Lautrec was a genuine pioneer in this field, largely because of his economy of design. His figures on this poster are extremely simple, almost caricatures, but they capture to perfection both the movement and the personalities of the dancers. The Impressionists made a conscious attempt to portray the popular entertainments of their day. For Edgar Degas, these were to be found at the racetrack or the ballet. In depicting the latter, he always looked for a novel slant, preferring to paint rehearsals or dance classes rather than performances. Georges Seurat, meanwhile, opted for the circus. This picture, unfinished at his death, was based on contemporary posters.

2

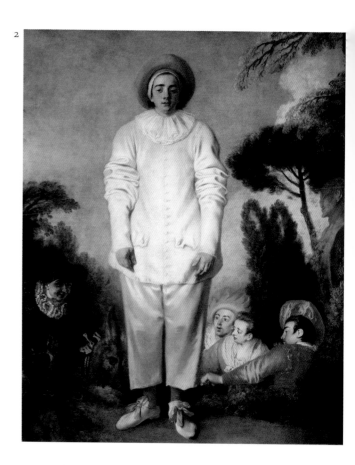

1

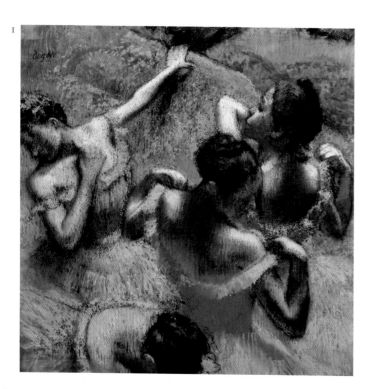

3

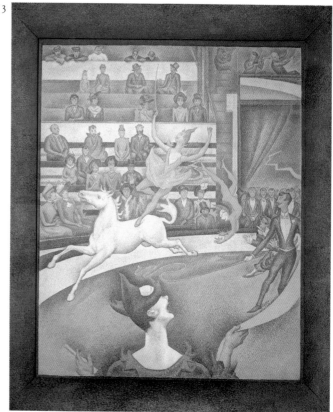

356

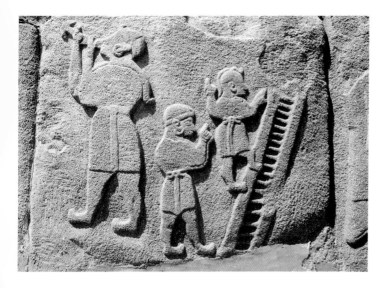

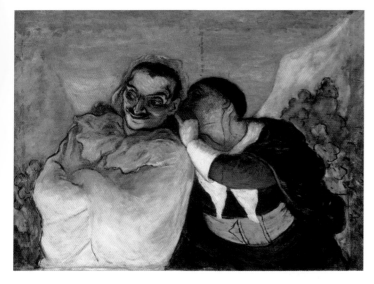

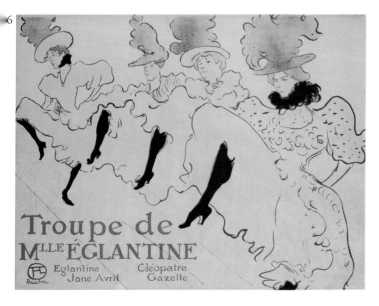

1 *Dancers in Blue*
 Edgar Degas, c. 1899
 Impressionism

2 *Gilles* or *Pierrot*
 Jean-Antoine Watteau, c. 1718–1719
 Rococo

3 *The Circus*
 Georges Seurat, 1890–1891
 Postimpressionism

4 *A Sword Swallower and Two Acrobats*
 Artist unknown,
 c. 2500–2300 BCE
 Alaca Huyuk

5 *Crispin and Scapin*
 Honoré Daumier, c. 1858–1860

6 *Miss Eglantine's Troupe*
 Henri de Toulouse-Lautrec,
 1895–1896

[following pages]
Scenes in a Theater Teahouse
Hishiwaka Moronobu, 1685
Japanese, Edo period

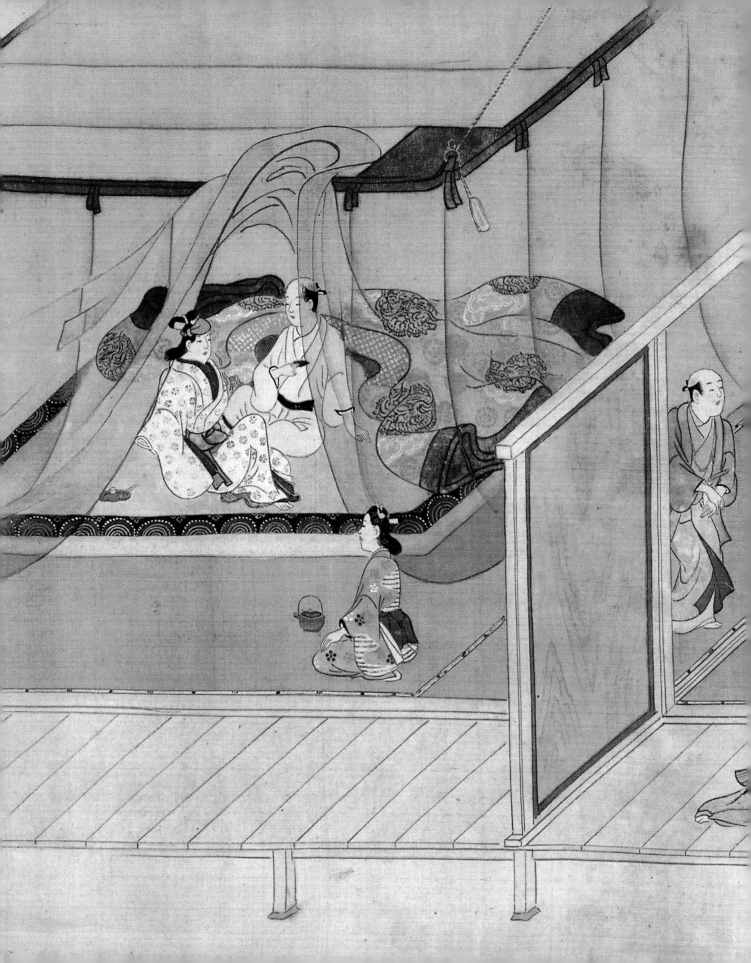

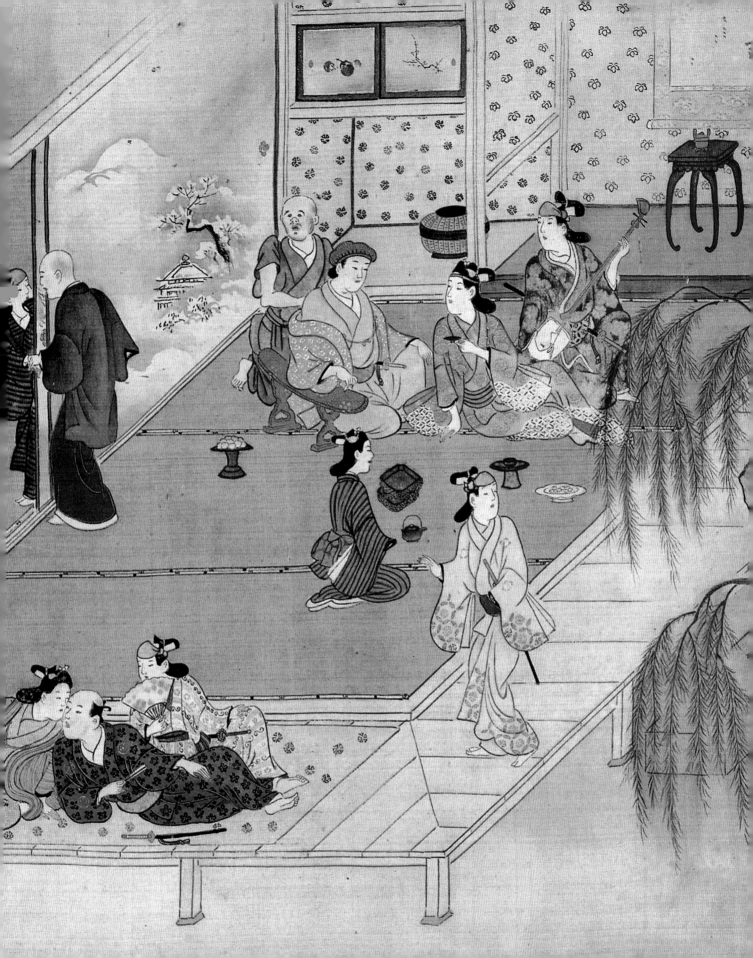

Still Life

Still life is the art of arranging and depicting inanimate objects—flowers, fruit, food, utensils, objects, furnishings, instruments, and, occasionally, small creatures, such as birds and insects. The Romans produced decorative still lifes in murals and mosaics to adorn their homes, while in China there was a long tradition from early times of painting flowers with birds, culminating in the elegant depictions of bamboo and plum flowers, created by the painters of the Yuan dynasty in the thirteenth and fourteenth centuries.

In Western art, still life began as a background element in pictures, in much the same way as landscape. Gradually, it developed a more dominant role and came to the fore in the Netherlands in the seventeenth century, during the period when Dutch artists sought to paint the world around them. Rachel Ruysch was the leading flower painter of her day. It was a natural theme for her to choose because her father was a distinguished botanist, but also it was deemed acceptable for a woman to paint pictures of flowers, unlike certain other subjects.

The reputation of still life art continued to grow through the nineteenth century, as the taste for everyday subjects in art increased. Highly realistic and detailed paintings were initially deemed the most skilful. However, as with other themes in art, the Postimpressionists and the artists of the modern movements that followed them moved away from painting still lifes realistically, seeking to emphasize other qualities. Henri Matisse, influenced by artists such as Paul Cézanne and Paul Gauguin, explored the way that intense color could be used to express both form and feeling. He described his work as "the art of arranging in a decorative manner the various elements at the painter's disposal for the expression of his feelings." Still life remained popular throughout the twentieth century—with the Cubists using it in order to deconstruct form and, later, Pop artists such as Andy Warhol and Claes Oldenburg returning to reality but with a humorous irony since they painted commercial icons such as soup cans and hamburgers.

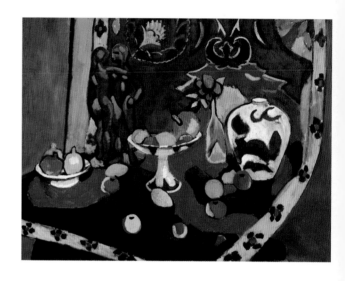

[top]
Still Life with an Oriental Rug
Henri Matisse, 1910
Fauvism

[opposite page]
Flowers and Fruit
Rachel Ruysch, 1716
Rococo

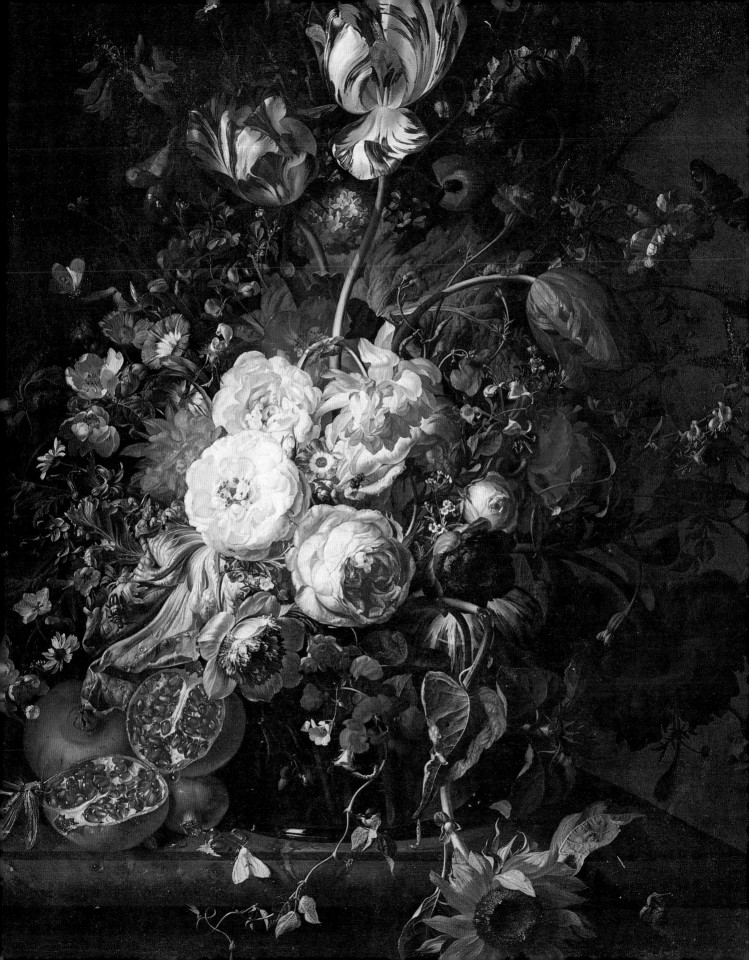

1

4

2

5

3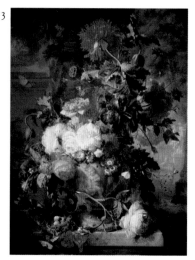

6

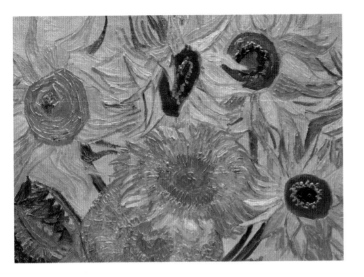

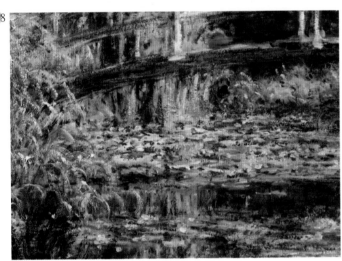

Flowers

From ancient times, in cultures as diverse as those of China, Rome, and Persia, flowers were used for decorative or symbolic purposes. The lily, for example, was a traditional attribute of the Virgin, symbolizing her purity, and was invariably included in pictures of the Annunciation. Flowers are also an essential element in many landscapes, and in all garden paintings. The flower still life, as an independent theme of art was pioneered in Holland from the late seventeenth century, and Jan van Huysum was described as "the phoenix of all flower painters." His high reputation reflected his exacting standards. He knew precisely which blooms were to be included in each composition, and on one occasion he refused to complete a commission, because he could not find the yellow rose he needed. His client had to wait until the following summer for his picture. Artists have become synonymous with individual flowers: the most obvious examples are Claude Monet's water lilies and Vincent van Gogh's sunflowers. Monet spent the latter part of his career painting in his garden at Giverny, producing ever-larger canvases of his lily ponds. Van Gogh, meanwhile, painted the most famous flower pictures of all. Unlike most artists, he painted the sunflowers exactly as he saw them, even if the heads were wilting or dead.

STILL LIFE

1 *Fascination of Nature*
Xie Chufang, 1321
Yuan dynasty

2 *Spring*
Giuseppe Arcimboldo, 1573
Mannerism

3 *Vase of Flowers*
Jan van Huysum, 1722
Rococo

4 *Wildflowers*
Odilon Redon, c. 1890
Symbolism

5 *In the Garden:*
Celia Thaxter in Her Garden
Childe Hassam, 1892
Impressionism

6 *Garden in May*
Maria Oakey Dewing, 1895
Impressionism

7 *Sunflowers*
Vincent van Gogh, 1888–1889
Postimpressionism

8 *Water Lily Pool, Harmony in Pink*
Claude Monet, 1900
Impressionism

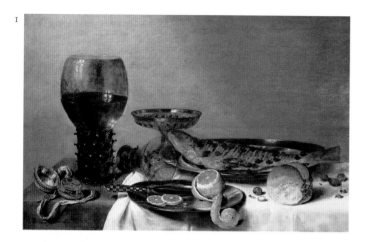

Fruit

Today we have access to fresh fruit from all over the world, all the year round. In the past, fruit was an expensive delicacy to be enjoyed only when in season, or when imported after a long and expensive journey from afar. In Roman wall paintings, fruit has pride of place, arranged in a basket or on a shelf in the manner of later still lifes. The extraordinary vision of Giuseppe Arcimboldo is as brilliantly realized in fruit as in flowers, creating a portrait of *Autumn* consisting of the fruits and plants the season brings. As with flowers, the fruit still life reached a high point in seventeenth-century Holland. Willem Claesz Heda was one of the leading figures in this field. He specialized in the *ontbijt* or breakfast piece. In this, the food could be portrayed as it was served at the table, or else half eaten, after the diner had left the room. In France, where the champion of still life was Jean-Baptiste-Siméon Chardin, the pictures are more sober and restrained than those of his Dutch colleagues, though his sense of realism was unparalleled.

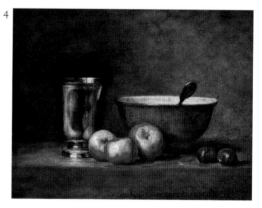

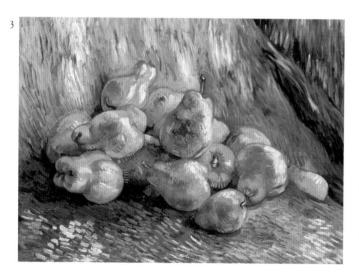

1 *Still Life*
 Willem Claesz Heda, 1629
 Dutch Seventeenth Century

2 *Still Life with Peach Bough
 and Glass Jar*
 Artist unknown, c. CE 50
 Ancient Roman

3 *Quinces*
 Vincent van Gogh, 1888–1889
 Postimpressionism

4 *Still Life*
 Jean-Baptiste-Siméon Chardin, 1763
 Rococo

5 *Still Life with Apples and Oranges*
 Paul Cézanne, c. 1899
 Postimpressionism

6 *Still Life*
 Giovacchino Toma, 1857

7 *Autumn*
 Giuseppe Arcimboldo, 1573
 Mannerism

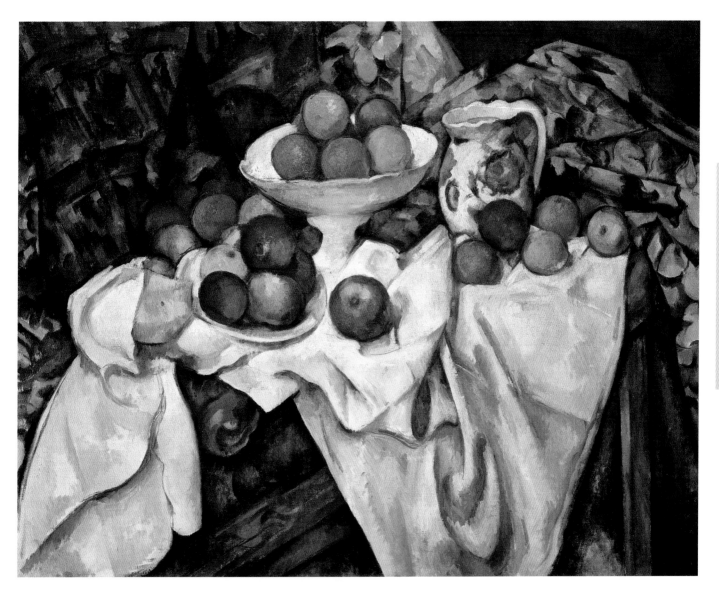

6

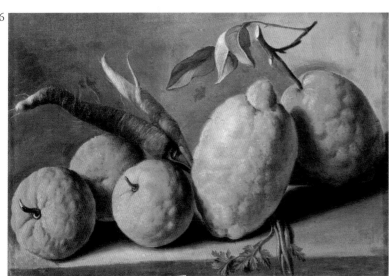

7

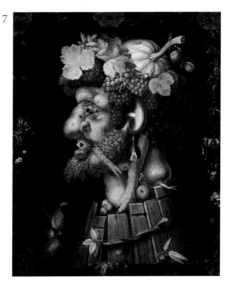

The Modern Still Life

At the end of the nineteenth century, many of the most progressive artists opted to paint still life themes, making it a decidedly avant-garde subject. In some cases, there were practical reasons for this. For Paul Cézanne, the chief attraction of still lifes was that they were easy to manipulate. "Apples don't move!" he once barked at a fidgety model. His arrangements of fruit appear accidental but, in reality, were arranged with absolute precision. The cloth was rumpled to provide interesting folds, while the apples and pears were positioned so that their tones made a pleasing contrast. When Pablo Picasso was told about an early Cubist work, *Les Demoiselles d'Avignon*, that it was hard to see what the figures were doing, he was assured the still-life elements were instantly recognizable. As a result, he began to concentrate mainly on paintings of inanimate objects as he continued his experiments with Cubism. Henri Matisse ensured strong color and movement, both essential elements of Fauvism, by arranging a patterned backdrop to his painting of goldfish. Giorgio Morandi, a brilliant still-life painter, preferred to use objects of only the most muted tones in order to concentrate on their strong forms.

1
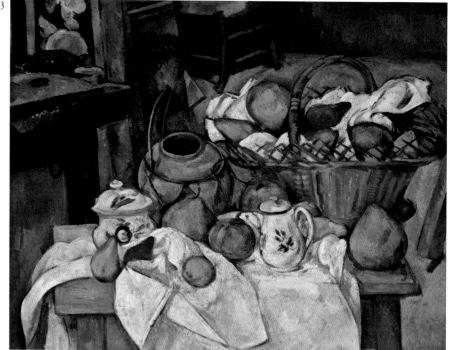

2
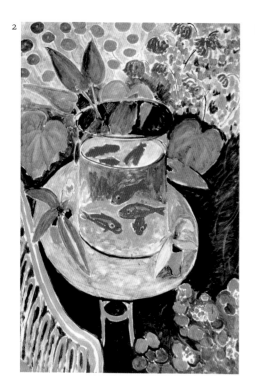

3

Still Life with Chair Caning
Pablo Picasso, 1911
Cubism

Goldfish
Henri Matisse, 1912
Fauvism

Still Life with Basket
Paul Cézanne, c. 1895
Postimpressionism

Still Life 1954
Giorgio Morandi, 1954

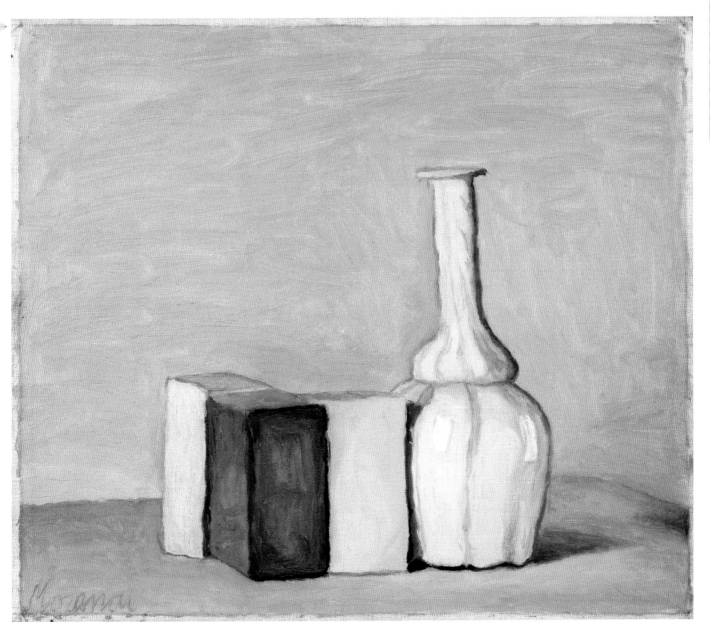

The Body

The human form has been a dominant theme all over the world throughout the history of art. The great classical artists defined perfection in the human body and this was rediscovered in the painting and sculpture of the Renaissance. Leonardo da Vinci's *Vitruvian Man* is based on a diagram by the Roman architect Vitruvius that shows the ideal human proportions as those that would fit perfectly into a square, circumscribed by a circle. For the Renaissance artist, studying ancient statues and texts was essential to their work. For centuries after they established the genre of the nude, the ability to draw the body was *the* benchmark of artistic skill. Until the mid-twentieth century, the teaching program in art schools was based around the study of the nude.

Rendering the human form involves more than mere balance of proportions. It can evoke sensuality, purity, heroism, and fertility. In Buddhist and Hindu art the *yakshi* is a female nature spirit whose voluptuous figure emphasizes her role as an emblem of fertility. It was said that she could make a tree bear fruit simply by touching it with her foot.

An ancient bronze statue placed in an Etruscan shrine could not be in greater physical contrast. The elongated figure is known as the *Shadow of the Evening*, a romantic name given to it by the poet Gabriele D'Annunzio. This slender distortion of the human form bears a close resemblance to some of the modern sculptures produced by Alberto Giacometti—his "skeletons in space."

A modern poet, W.H. Auden, summed up his appreciation of the nude, shared by many art enthusiasts, as the most expressive and skilful of all artistic genres in these lines:

> To me Art's subject is the human clay,
> And landscape's but a background to a torso;
> All Cézanne's apples I would give away
> For one small Goya or a Daumier.

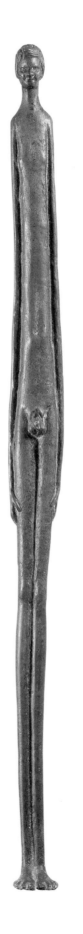

[top]
Yakshi, from Stupa Gateway at Sanchi
Artist unknown, c. CE 1–100
Indian

[left]
Shadow of the Evening
Artist unknown, c. 300–200 BCE
Etruscan

[opposite page]
Vitruvian Man: Scheme of the Proportions of the Human Body
Leonardo da Vinci, c. 1492
High Renaissance

The Reclining Female

The image of a languid reclining female was not a classical pose from Ancient Greece or Rome, though it featured in ancient art from other civilizations. Giorgione (Giorgio da Castelfranco) is believed to have used it first during the Renaissance and it was taken up by his rival, Titian, in his *Venus of Urbino*. "Venus" became a generic term for a female nude, with painters using the classical name as a means of giving respectability to an erotic picture. Edouard Manet's *Olympia* caused a public scandal since the woman depicted was far too direct in her gaze and pose. Jean-Auguste-Dominique Ingres's *Turkish Bath* reflects another iconic female nude, the odalisque, which became popular as a result of the nineteenth-century interest in Orientalism after Napoleon's Egyptian campaigns. The many travelers who followed in his army's footsteps returned with Oriental treasures and fascinating tales. Ingres's painting was directly inspired by one traveler's account, the *Letters of Lady Montagu*. Amedeo Modigliani's modern nude encapsulates the tradition of the reclining female in all its forms and is able to be openly sexual and provocative.

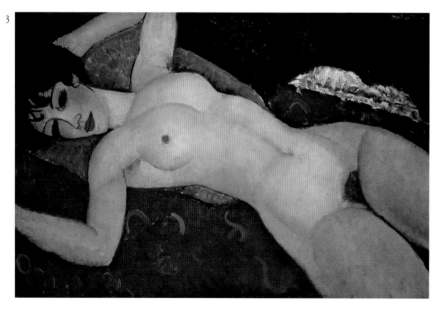

1 *Turkish Bath*
Jean-Auguste-Dominique Ingres,
1862
Romanticism

2 *Reclining Woman, from Seleucia*
Artist unknown, c. 300 BCE
Ancient Persian

3 *Nude on a Cushion*
Amedeo Modigliani, 1917–1918

4 *The Venus of Urbino*
Titian, 1538
High Renaissance

5 *Olympia*
Edouard Manet, 1863
Realism

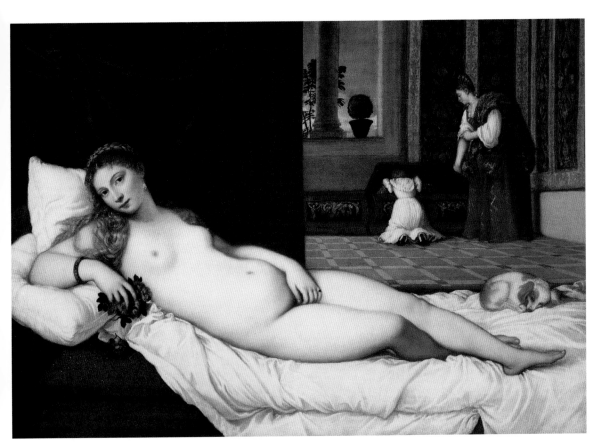

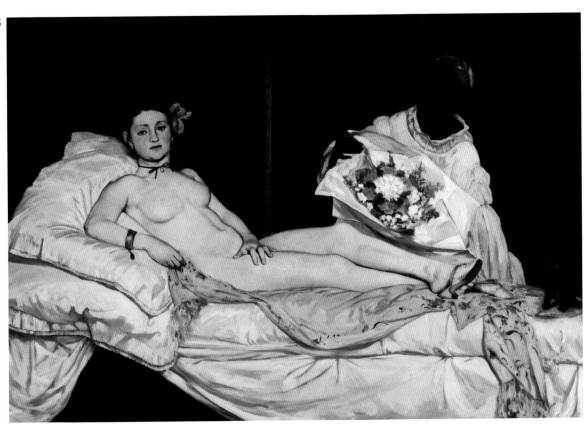

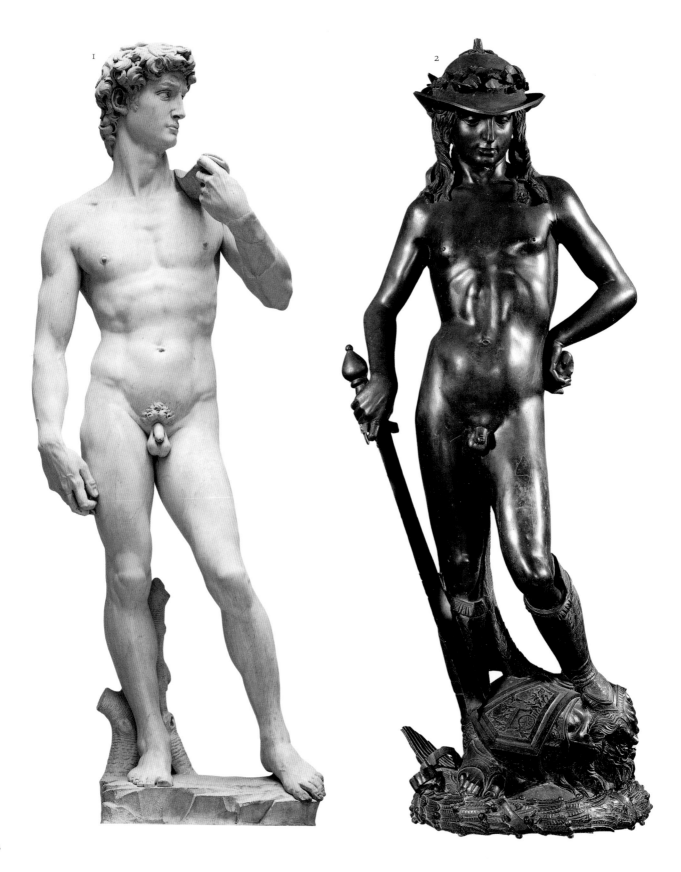

The Ideal Male

When Renaissance artists reinstated the nude as a subject for art they based their images on the idealized male form of Greek art. In doing so, they sought not only to use the same system of proportions for measuring the human body, but also to mimic the precise poses. This became one of the enduring principles of academic art. If an artist wished to make his paintings appear grand or heroic, his figures were expected to resemble the finest examples of classical art. Both Donatello and Michelangelo Buonarotti were consciously trying to re-create the sculpture of antiquity. The two classical statues here are perfect examples of the ideals the Renaissance artists hoped to achieve. The *Apollo Belvedere* was regarded as a template of male beauty and the pose was copied not only in Renaissance times but also by scores of later artists. The *Spear Carrier* is from a lost work by Polyclitus, the Greek sculpture who wrote a defining treatise on proportion and harmony and regarded this as his finest work.

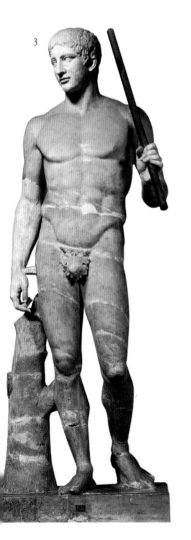

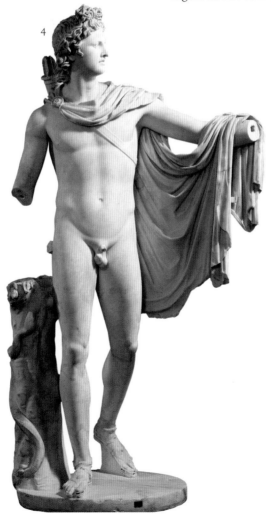

1 *David*
 Michelangelo Buonarroti,
 1501–1504
 High Renaissance

2 *David*
 Donatello, 1440
 Early Renaissance

3 *Spear Carrier (Roman copy of a Greek bronze statue)*
 Original by **Polyclitus**, c. 450 BCE
 Ancient Greek

4 *Apollo Belvedere (Roman copy of a Greek statue)*
 Artist unknown, c. 330 BCE
 Ancient Greek

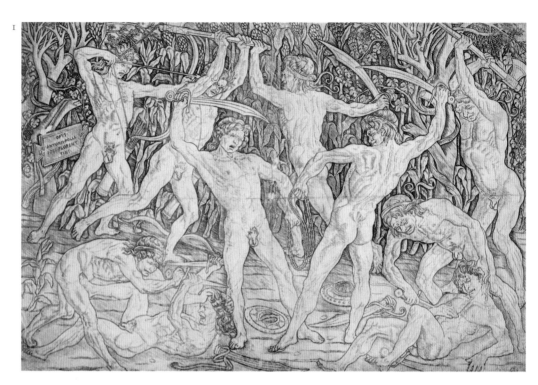

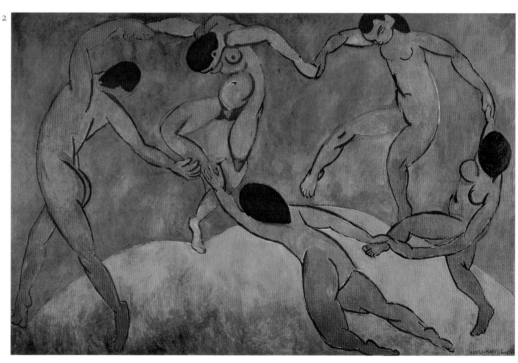

1 *Battle of the Nudes*
Antonio del Pollaiuolo, C. 1475
Early Renaissance

2 *The Dance*
Henri Matisse, 1910
Fauvism

3 *Elasticity*
Umberto Boccioni, 1912
Futurism

4 *Nude Descending a Staircase (No. 2)*
Marcel Duchamp, 1912
Cubism

5 *Laocoön*
**Hagesander, Polydorus,
and Athanodorus**, C. 25 BCE
Ancient Roman

The Body in Motion

Laocoön was a Trojan priest who warned against the dangers of the Greeks' wooden horse. As a punishment, the gods sent two giant snakes to crush him and his sons. The celebrated Roman statue of this attack, with its restless energy and violent emotion, created a sensation when it was unearthed in 1506. Michelangelo Buonarroti inspected it immediately and it has inspired artists for centuries. The lethal struggle in Antonio del Pollaiuolo's engraving displays a similar gift for depicting vigorous movement, though the artist learned this skill through the study of anatomy, rather than ancient art. Like Leonardo da Vinci, he is said to have carried out dissections on corpses. Henri Matisse hoped that his painting would have the look of a primitive, ritual dance, but he admitted that his chief inspiration came from the farandole—a dance that he witnessed at a Parisian nightclub. The pictures by Marcel Duchamp and Umberto Boccioni, meanwhile, owed much to the influence of photography. More specifically, they were inspired by the chronophotographs of Etienne Marey. In the 1880s, he devised a "photographic gun," which could track the path of moving objects in a series of superimposed images.

4

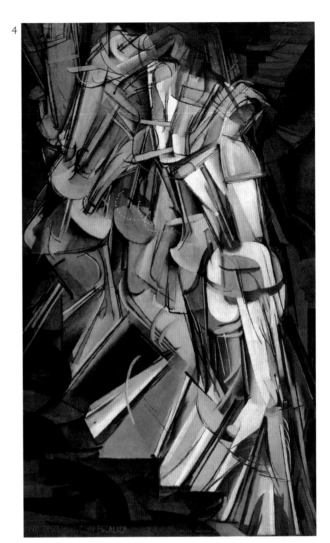

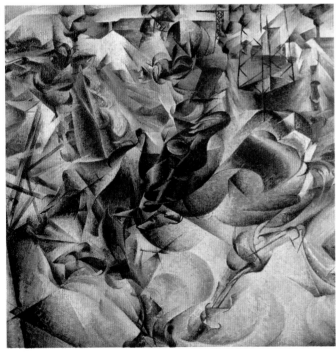

3

5

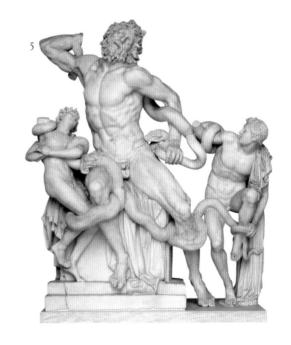

Landscape

Landscape has featured as a background element in paintings since antiquity. Natural details amounted to little more than symbols or motifs—a stylized rock was used to represent a mountain, while a tree symbolized a forest. This approach can be found in many cultures and the lack of realism continued in Western art for many centuries. It was not until the laws of perspective were applied more rigorously during the Renaissance that landscape backgrounds began to look increasingly realistic, but a subject of less importance than religion, history, mythology, or portraiture. Landscape was considered to be wasteful of an artist's abilities. The opposite was true in China, where landscape was important from early times, and the depiction of a beautiful scene carried deep meaning that went far beyond reflecting the details of a place.

The status of landscape painters in Europe rose in the seventeenth century in the Netherlands where landscape was popular—the genre comes from the Dutch word *landschap*. Rococo artists presented stylized pastoral beauty in the eighteenth century, reflecting an era when landscape design for grand estates was an expensive and fashionable trend for landowners. British artist Thomas Gainsborough complained of being "sick of portraits and wish very much to . . . paint landskips in quietness and ease." In America in the nineteenth century landscape painters such as Frederic Church portrayed the spectacular, wild beauty of the continent with patriotic enthusiasm, arguing that America's natural splendor was an artistic inspiration the Old World simply could not match. In Europe a revolutionary zeal surrounded natural realism and Gustave Courbet led the campaign against the prettified visions of Rococo nature. At the same time the graphic beauty of Japanese landscape prints were also becoming influential. The Impressionists championed the cause of open-air, natural, landscape painting. By the turn of the century, Paul Cézanne elevated landscape to the forefront of art, as he broke down the traditional use of perspective and offered a vision of the natural world that was to inspire the advent of modern art.

[top]
Cotopaxi
Frederic Church, 1855

[opposite page]
Niagara
Currier and Ives, 1857
Lithograph after a painting by
Frederic Church

Water

Water is as changeable and complex as life itself. Artists observe it in all its moods, from raging storms to tranquil lakes and streams. On the most basic level, it helps to convey a sense of place. The deep, rich coloring of the sea in paintings by Henri Matisse and Paul Cézanne conjures up the heat of the Mediterranean sun. By contrast, the overcast scene in John Constable's *Dedham Lock and Mill* is a perfect evocation of England's rainy climate, recalling the words of one critic, "I like the landscapes of Constable . . . but he makes me call for my greatcoat and umbrella." Water can also be portrayed in a less descriptive manner. However rough they might be, foaming waves are transformed by Ando Hiroshige into decorative patterns, flowing through his stylized compositions. In the Nile mosaic, meanwhile, the purpose was probably symbolic. This complex image, which may well be based on a painting from Alexandria, was installed in a public building in Praeneste, Italy. The section illustrating the annual flooding of the Nile was apparently included as an allegory, confirming that Egypt was a land of plenty.

1

2

3

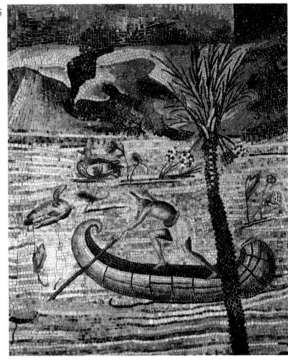

1 *Roofs of Collioure*
 Henri Matisse, 1905
 Fauvism

2 *Dedham Lock and Mill*
 John Constable, 1820
 Romanticism

3 *Coast View with Apollo and
 the Cumean Sibyl*
 Claude Lorrain, 1645–1649
 Baroque

4 *Fuji from the Sea of Satta*
 Ando Hiroshige, 1858
 Japanese, Edo period

5 *Flooding of the Nile*
 Artist unknown, c. 100 BCE
 Ancient Roman

6 *L'Estaque*
 Paul Cézanne, 1886
 Postimpressionism

1

2

3

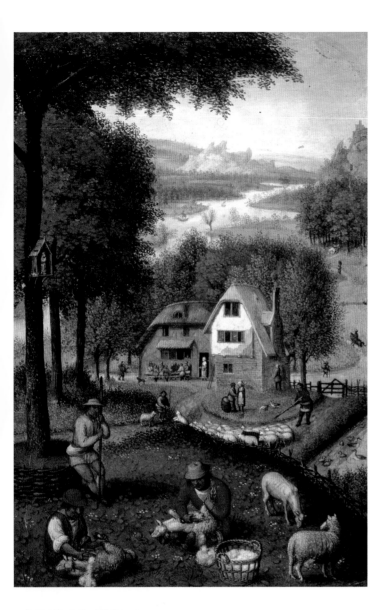

The Four Seasons

Depictions of the seasons have been popular since antiquity. In the West, the custom of portraying the seasons through landscape scenes, rather than with allegorical figures, harks back to medieval Books of Hours. These lavish prayer books, which listed the hours of major services and the dates of holy days, sometimes featured an illustrated calendar, showing appropriate activities for each month, with a landscape in the background. The theme was equally popular outside Europe. During the Momoyama period in Japan, for example, warlords decorated the screens and wall panels of their castles with themes of this kind. In the nineteenth century, landscape artists became increasingly interested in portraying the seasonal changes of the natural world. Charles-François Daubigny was a leading member of the Barbizon School—a group of French painters who are often hailed as precursors of the Impressionists—and one of the earliest advocates of painting in the open air. Italian painter Telemaco Signorini provides a charming outdoor painting of a rural terrace, and Wassily Kandinsky's snowscape shows the move toward abstraction in landscape painting in the early twentieth century.

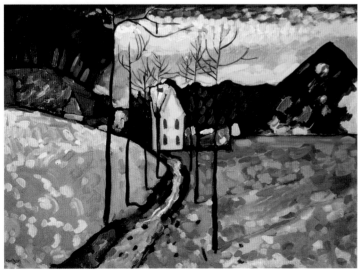

1 *Spring*
Charles-François Daubigny, 1857
Barbizon

2 *Settignano, September Morning*
Telemaco Signorini, c. 1892
Macchiaioli

3 *The Four Seasons with the Sun and the Moon*
Artist unknown, c. 1575
Japanese, Momoyama period

4 *Two Men Shearing Sheep, June, from a Book of Hours*
Simon Bening, c. 1540
Northern Renaissance

5 *Winter, 1909*
Wassily Kandinsky, 1909
Expressionism

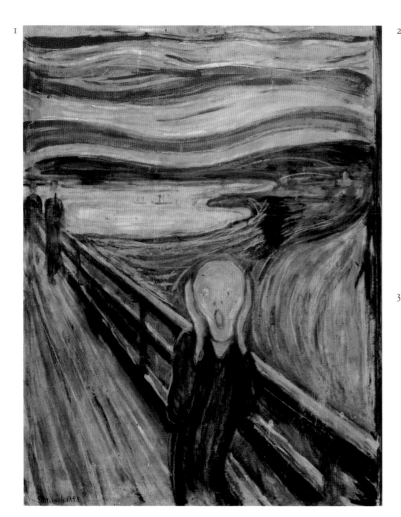

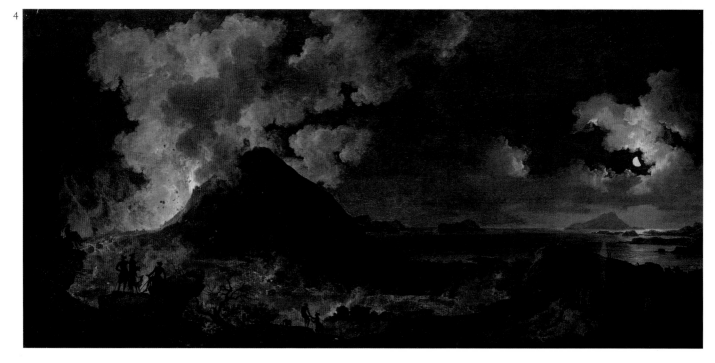

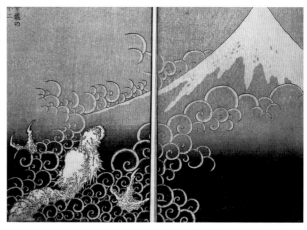

The Power of Nature

The awesome power of nature can be depicted for its beauty, as in the painting of a glowing rainbow, or the strongly graphic print of the monumental Mount Fuji. Nature also has violent power. Winslow Homer, after he moved to Maine in 1883, discovered the turbulent the sea as his favorite subject. In Caspar David Friedrich's painting the sea is a force of destruction—the smashed timbers of a wrecked ship are barely visible beneath massive slabs of ice. The artist is said to have drawn his inspiration from Sir William Parry's disastrous polar expedition in 1819–1820. In *Starry Night*, Vincent van Gogh shows a night sky convulsed with the swirling balls of energy from the stars. The eruption of a volcano is one of the most powerful of all natural events, shown dramatically in Pierre-Jacques Volaire's painting, and also an essential element of Edvard Munch's most famous work, *The Scream*. The dramatic sunset was the result of a violent volcano far away and Munch wrote at the time: "I stood there trembling with fear—and I felt how a long unending scream was going through the whole of nature."

5
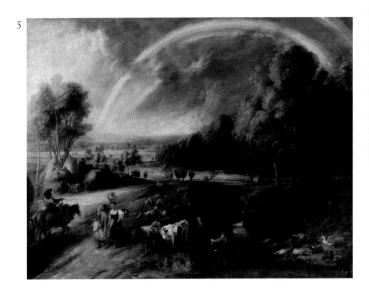

6
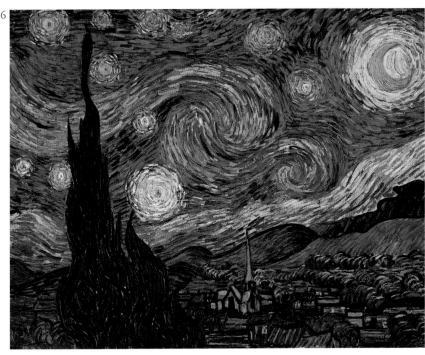

1 *The Scream*
Edvard Munch, 1893
Symbolism

2 *High Cliff, Coast of Maine*
Winslow Homer, 1894

3 *Dragon Ascending Mount Fuji, from "One Hundred Views of Mount Fuji"*
Katshusika Hokusai, 1835
Japanese, Edo period

4 *Eruption of Mount Vesuvius*
Pierre-Jacques Volaire, 1771
Rococo

5 *Landscape with Rainbow*
Peter Paul Rubens, c. 1639
Baroque

6 *Starry Night*
Vincent van Gogh, 1889
Postimpressionism

[following pages]
Shipwreck or *Sea of Ice*
Caspar David Friedrich, 1823–1824
Romanticism

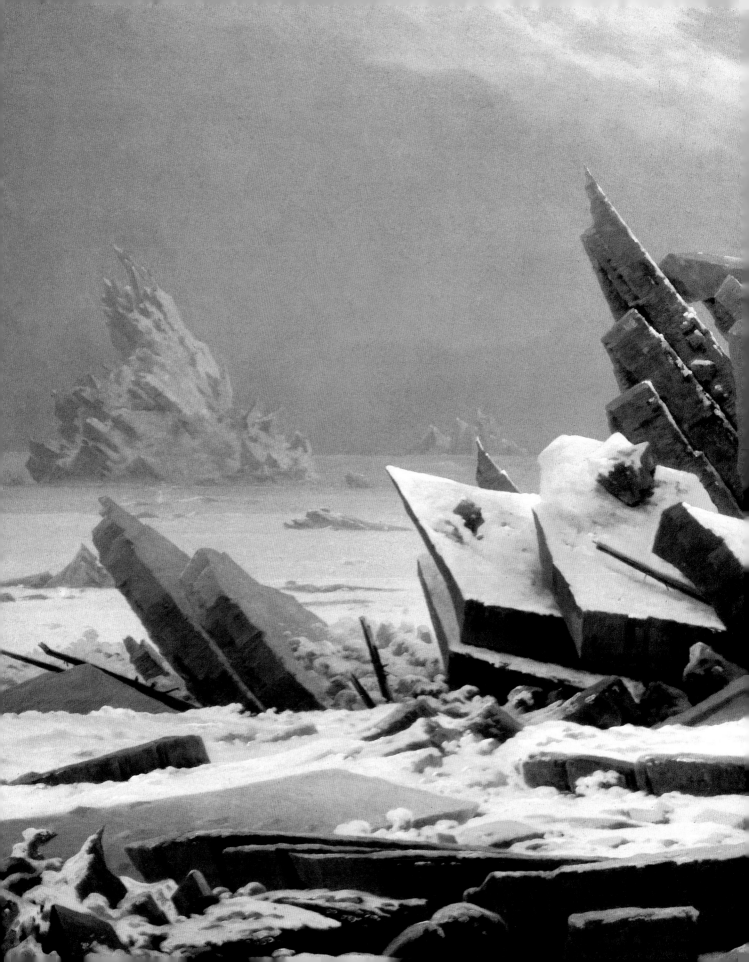

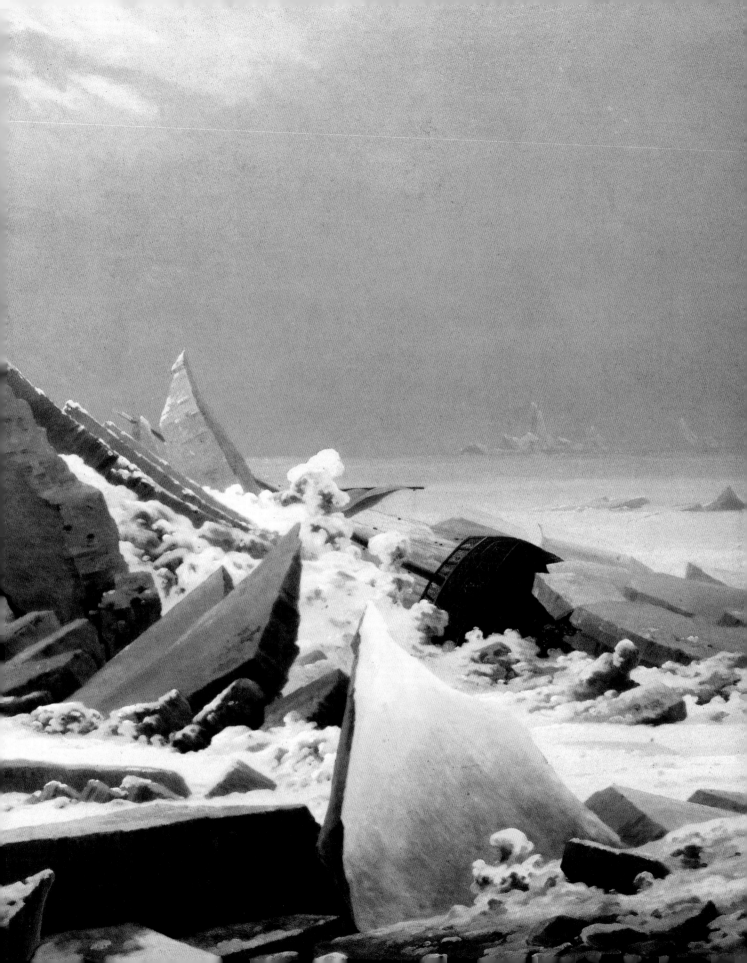

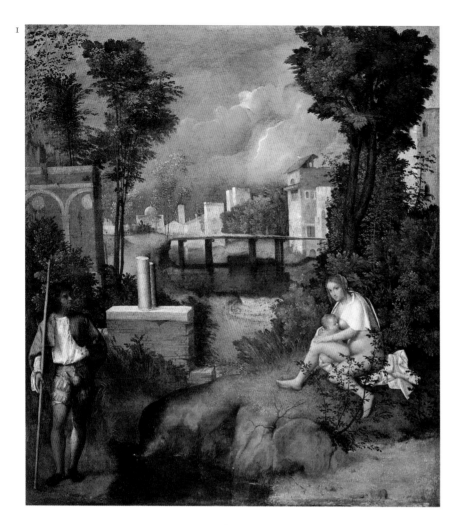

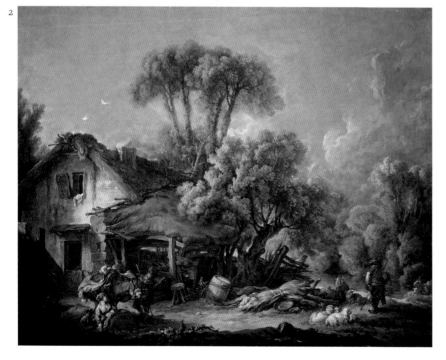

Figures in the Landscape

Figures can fulfill a variety of purposes in a landscape, though the most obvious one is scale. This is particularly evident in Asher Brown Durand's *Kindred Spirits*, where the tiny figures emphasize the spectacular nature of the scenery. Rockwell Kent employed a similar technique in his imposing views. He had a particular affection for wide-open spaces, seeking out the remoter areas of Greenland and Tierra del Fuego, as well as depicting his native America. Occasionally, the situation is reversed and the landscape reveals something about the figures. This may be the case with *The Tempest*. Scholars have sought in vain for the meaning of this picture, or signs of a relationship between the naked woman feeding her child and the watching soldier. The overgrown ruins and the stormy sky cannot provide an explanation for their presence, but they do add to the enigmatic and unsettling effect of the picture. The landscapes of François Boucher and Horishi Yoshida are both decorative, but where the Japanese print shows a graphic realism, Boucher's pastoral scene with ramshackle cottages shows the influence on his painting of his picturesque designs for tapestries and theatrical backdrops.

1 *The Tempest*
Giorgione, c. 1507
High Renaissance

2 *Morning*
François Boucher, 1764
Rococo

3 *Kindred Spirits*
Asher Brown Durand, 1849
Hudson River School

4 *Misty Day in Nikko*
Horishi Yoshida, c. 1940

5 *Snow Fields*
(Winter in the Berkshires)
Rockwell Kent, 1909

4

Rural Life

In the sixteenth century, Pieter Bruegel showed the everyday existence of peasants in his paintings of rural life. Through the centuries, artists, and in particular northern European artists, returned again and again to the subject of the life of farm workers and villagers as a rich source of inspiration. In the eighteenth century, when the pastoral ideal was prevalent in landscape art, rural life was transformed into a sanitized, picturesque ideal. Fashionable ladies chose to sit for their portraits dressed as a shepherdess or dairymaid, in order to bring this Arcadian image to life. As the nineteenth century evolved and artists became more interested in nature itself, as well as in the plight of the poor, their attention turned to the countryside in order to depict its reality. In France, Gustave Courbet and Jean-François Millet shocked the urban public with their powerful paintings of poverty and backbreaking work in the fields.

Vincent van Gogh was well acquainted with the hardship of rural life from his days as a lay preacher in the Netherlands, at the start of his career. *The Siesta* dates from the last year of van Gogh's life, when he lived in Provence in southern France, and was reworking some scenes from Millet—an artist he greatly admired. As usual, he was working in a near frenzy, producing almost 200 pictures in his final months, so his image of a brief respite from hard labor was conveyed with heartfelt conviction.

Arkady Plastov worked as a farmer before becoming a full-time artist in the Soviet Union in 1931. He was part of the movement of Social Realism, the state-sponsored art that was promoted in Stalinist Russia. For the most part, this produced formulaic pieces that were designed to glorify the achievements of Communism. Plastov transcended this style, painting an honest and vivid picture of life on a collective farm.

[top]
The Siesta
Vincent van Gogh, 1889–1890
Postimpressionism

[opposite page]
The Potato Harvest
Arkady Plastov, c. 1930–1940
Social Realism

Farm Work

Rural life is dominated by the seasons and in Western art the earliest images of farming were often linked to depictions of the seasons or individual months of the year, as in the Benedetto Antelami sculpture. In paintings of this kind the agricultural activities were often little more than picturesque accessories. Pieter Bruegel's *Haymaking*, for example, was one of a series of panels of *The Months*, produced to decorate the home of a wealthy merchant. Its principal focus was on the panoramic landscape, rather than the minutiae of rustic toil. By the nineteenth century there was a greater tendency to emphasize the strenuous labor that country life entailed. The load on Francesco Gioli's cart seems impossibly heavy, while Jean-François Millet's picture illustrates particularly backbreaking work. Gleaners had the thankless task of collecting the scraps that the other harvesters had left behind. They were the lowliest of all agricultural laborers and Millet highlighted their plight so graphically that the critics saw his picture as a form of political protest.

1 *Horses Trampling Grain, Representing the Month of July*
Benedetto Antelami, c. 1196
Romanesque

2 *Pisan Cart*
Francesco Gioli, c. 1880
Macchiaioli

3 *The Gleaners*
Jean-François Millet, 1857
Realism

4 *Haymaking (July)*
Pieter Bruegel the Elder, 1565
Northern Renaissance

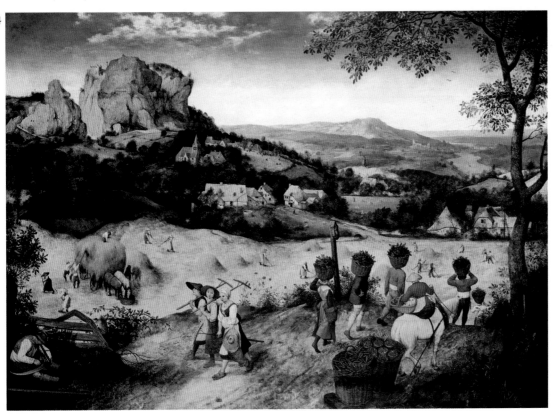

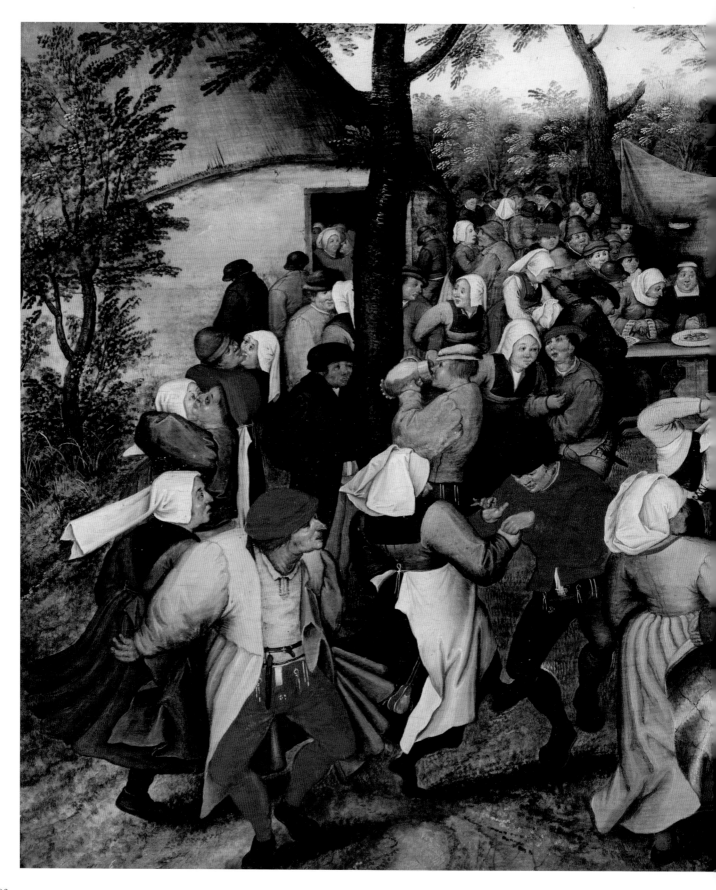

Village Life

Pictures highlighting rural activities such as dances, weddings, and the celebrations that took place on a saint's feast day or at a country fair, often displayed a coarse brand of humor. Peasants were shown brawling, getting drunk, or urinating in public. As such, these works were frequently categorized as "drolleries" created in part for the amusement of a more sophisticated audience. The artist who was most closely associated with this type of picture was Pieter Bruegel the Elder. The historian Karel van Mander claimed that Bruegel used to disguise himself as a peasant so that he could observe rustic festivities at close quarters. Other critics believed that the artist came from peasant stock. In fact, he was a learned man, in touch with some of the leading scholars of the day, and his peasant pictures were designed as moral allegories. In these, the actions of country folk symbolized a variety of sins and follies. His son, Pieter Brueghel the Younger, continued in the same vein, reworking many of his father's compositions.

Rustic Wedding
Pieter Brueghel the Younger, c. 1600
Northern Renaissance

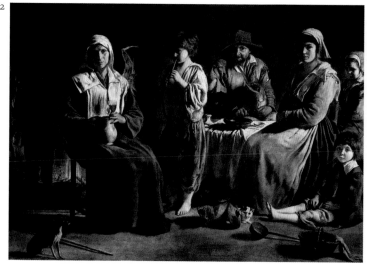

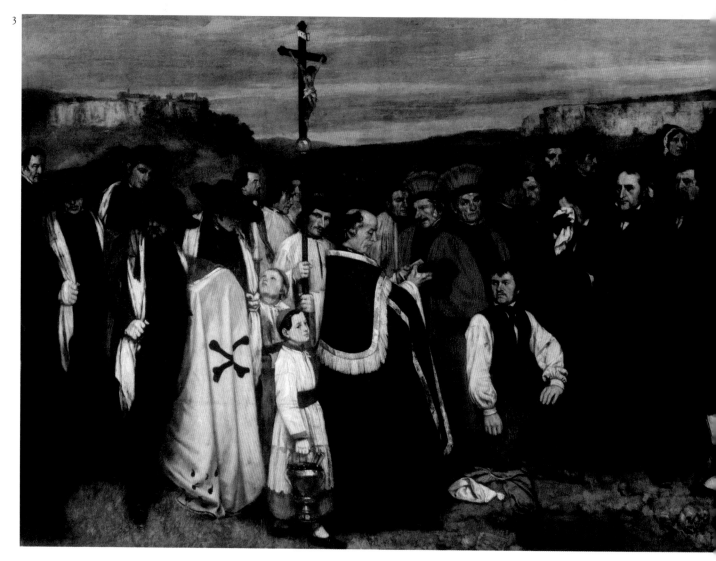

Poverty

The brothers Louis and Antoine Le Nain showed those who lived and worked in the countryside in the seventeenth century as serious and dignified in spite of their humble surroundings. They were painted in a style not dissimilar to pictures of merchants or professionals in the city. More than two hundred years later, Gustave Courbet's pictures deliberately highlighted the plight of poor rural workers. *Burial at Ornans* caused a scandal when it was exhibited in 1850. Critics, used to prettified views of rural life, were appalled by the unstinting realism of the scene, particularly as it was executed on a massive scale. There can be no doubt that Pierre Puvis de Chavannes saw rural poverty as a subject that should cause scandal and he used his work to show its reality. One critic claimed of *The Poor Fisherman* that "no other painting gives such a complete impression of the poverty here on this earth," and Paul Gauguin hailed it as a masterpiece. Puvis used simplified lines and muted colors to convey a mood of utter despair. All life and hope appear to have drained out of the landscape and its unfortunate inhabitants.

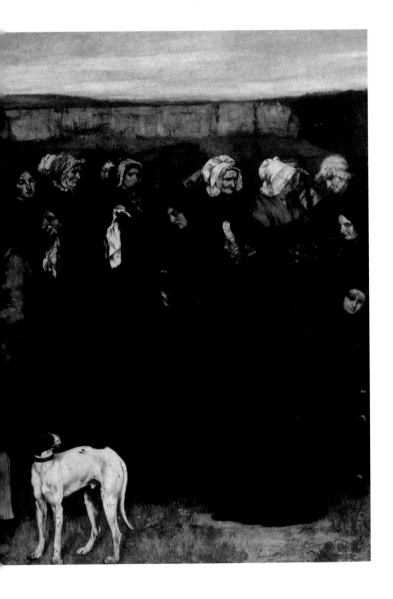

1 *The Poor Fisherman*
 Pierre Puvis de Chavannes, 1881
 Symbolism

2 *The Peasant Family*
 Louis or **Antoine Le Nain**, c. 1640
 Baroque

3 *The Burial at Ornans*
 Gustave Courbet, c. 1849–1850
 Realism

The City

Artists could not attempt city views before the development of perspective made it possible to show a sweeping cityscape. When the Renaissance era was celebrating classical architecture, and discovering the laws of perspective, an unknown artist created an *Ideal City*, making no attempt to portray a real place, but showing the perfection of buildings created with classical proportions and details. For centuries there was little demand for views of cities but, as with many developments in art, it was in the Netherlands in the seventeenth century, where art was commissioned by wealthy merchants and professionals who wanted it to depict their own lives, that artists looked to their urban environments as a subject for their work.

Jan Vermeer is believed to have used a camera obscura as an aid to achieving greater accuracy and naturalism in his work. He applied this to views of his own city and, as his *View of Delft from the Rotterdam Canal* shows, he gives the city a sense of reality and human scale. The work is impressive for its depiction of light, reflections in water, and vast, natural sky.

Perhaps the greatest of all city artists, Canaletto, who worked in the eighteenth century, gave his paintings of his beloved Venice as much attention to detail and reality as Vermeer, and yet provided a sense of the grandeur and spectacle of a city created to impress. A century later the Impressionists applied the same approach to painting cities as they were using to paint landscapes. They set up outside and worked fast and enjoyed city views that featured water, enhancing the sense of light and movement.

In the last century, with photography providing realistic views of cities and art moving away from what the eye sees, Piet Mondrian's approach to the city was to capture in abstract the energy, excitement, and vibrant music of 1940s New York. Manhattan's street grid, the pulse of traffic, the color of its lights, and the beat of American jazz all have a place in Mondrian's *Broadway Boogie Woogie*.

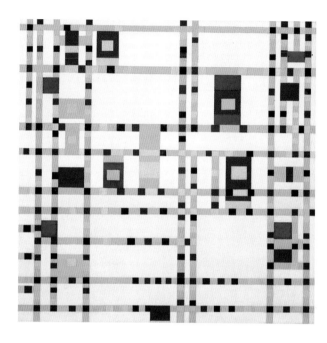

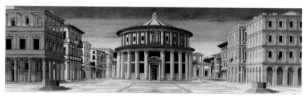

[top]
Broadway Boogie Woogie
Piet Mondrian, 1942–1943
50" x 50" (127 x 127 cm)
Oil on canvas, © 2005
Mondrian/Holtzman Trust c/o
HCR International Warrenton
Virginia USA

[bottom]
Ideal City
Artist unknown, c. 1470
Early Renaissance

[opposite page]
View of Delft from the Rotterdam Canal
Jan Vermeer, c. 1660
Dutch Seventeenth Century

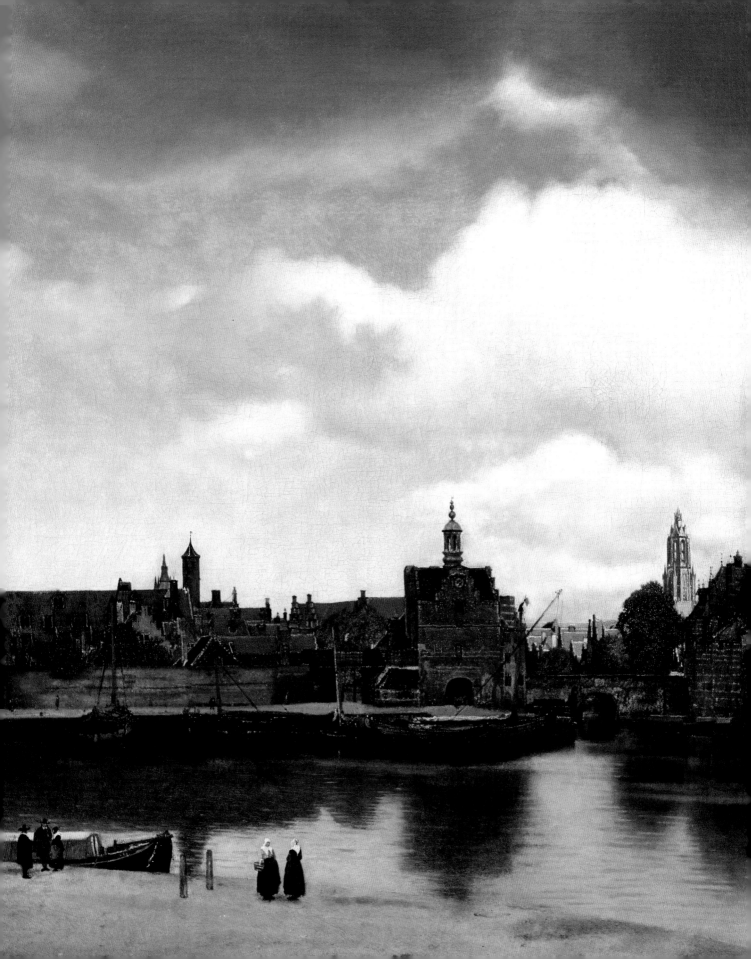

Venice

No city has attracted greater attention from artists than Venice. Many painters have made a career out of reproducing its charms, but the name that is most closely identified with the place is Antonio Canaletto. During the eighteenth century, demand for pictures of Venice was particularly high. For this was the heyday of the Grand Tour, when wealthy young aristocrats traveled throughout Europe as part of their education. Venice was invariably the highlight of the trip, drawing visitors from far and wide, and because many of these wanted a souvenir of their stay, prints of paintings of the city were extremely popular. One of the most sought-after of these was the *veduta*— a view of the city that was instantly recognizable yet also highly decorative. Canaletto was a peerless practitioner of this art. He had trained as a stage painter and this helped him to turn his views into colorful spectacles of Venetian life. His most popular subjects were of the carnival, when tourists flocked to the city, or the Piazza San Marco (Saint Mark's Square), which he painted from every conceivable angle.

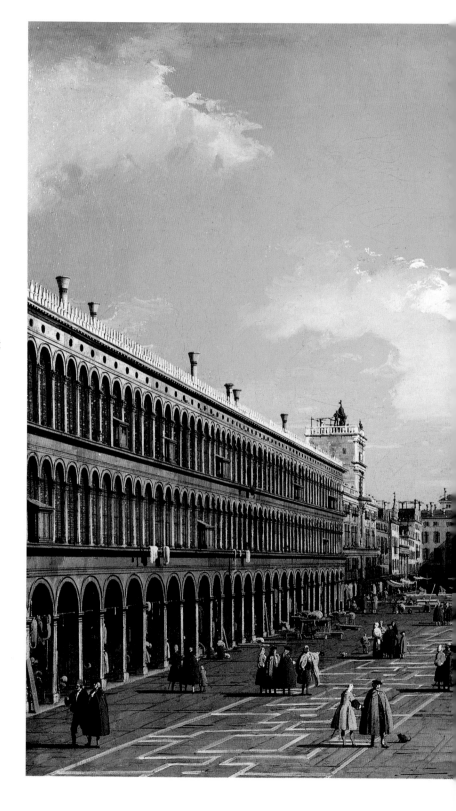

Piazza San Marco, Looking Eastwards
Antonio Canaletto, c. 1760

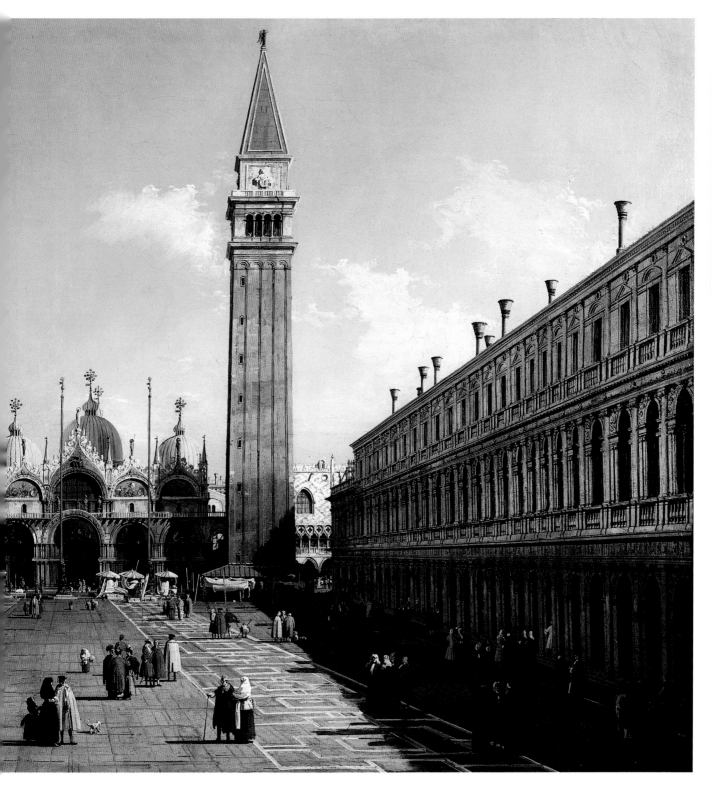

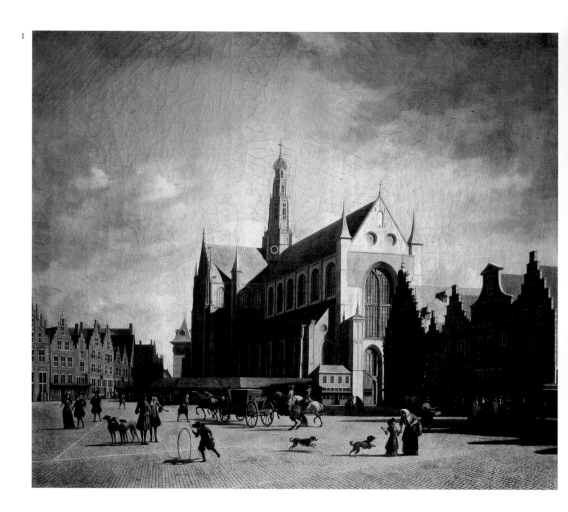

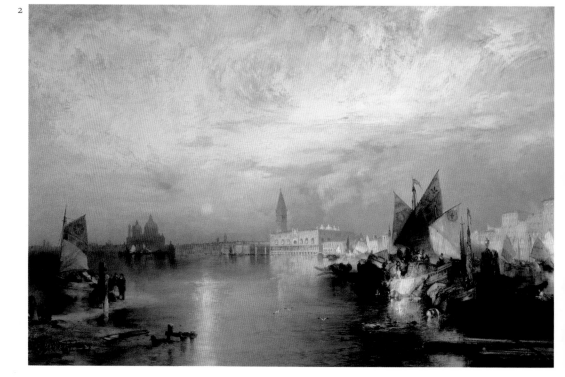

1 *Great Market in Haarlem*
Gerrit Berckheyde, 1693
Dutch Seventeenth Century

2 *Sunset Venice*
Thomas Moran, 1902

3 *London Bridge*
André Derain, 1906
Fauvism

4 *Red Square in Moscow*
Fyodor Aleksyev, c. 1801

Cityscapes

The hazy, atmospheric vistas of Venice drew visiting artists from all over Europe and beyond, including the American Thomas Moran. Fyodor Aleksyev was the first Russian artist to forge a reputation as a painter of city views. He trained as a landscapist, but gained invaluable experience creating townscapes during a three-year stay in Venice, when he studied the work of Antonio Canaletto at close quarters. He worked mainly in Saint Petersburg, but spent a year in Moscow after Emperor Paul I commissioned him to paint a series of views in 1800. In a similar manner, André Derain's visit to London in 1906 came at the instigation of his dealer, Ambroise Vollard. Impressed with the public reaction to Claude Monet's London pictures, Vollard hoped to repeat the success. During his stay, Derain concentrated mainly on depictions of the Thames, portraying it in vivid Fauvist colors. Gerrit Berckheyde preferred to remain close to home. He was a native of Haarlem and his affection for the Dutch city is obvious. There is no attempt to impress outsiders; only a sense of satisfaction in portraying his own bustling, well-ordered community.

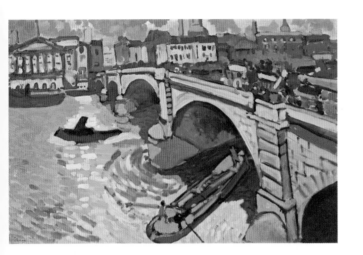

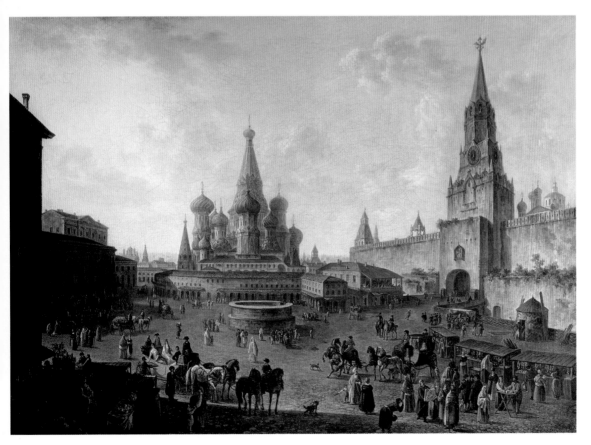

Urban Life

Urban life featured rarely in art as a subject until the seventeenth century. The one major exception to this is Ambrogio Lorenzetti's frescoes painted in the fourteenth century to decorate walls of the Palazzo Pubblico in Siena. Commissioned by the city governors, they represent striking civic pride and are unique, since no other subjects of this type exist from the period. They examine the effects of good and bad government in the city and the surrounding countryside, and contain a complex blend of allegory, landscape, and scenes of everyday activities. Allegory was a common aspect of art of the period. What is highly unusual is the depiction of urban life with the inclusion of a shoe-shop, a schoolroom, a tavern, and a group of construction workers. All this brings the city to life in a way artists had not previously attempted.

Dutch artists from the seventeenth century, who were proud to display their well-ordered society, enjoyed showing the intimate details of city life, the interiors of shops and houses, as well as scenes of street life and canal sides. Japanese artists focused on pleasurable urban activities in their prints of the eighteenth and nineteenth centuries. And the Impressionists celebrated scenes of open-air gatherings, from dances to public parks, in many of their works. Artists also turned their attention to poverty and depravity in the city, often portraying beggars and scenes of drunkenness. William Hogarth used London's rich diversity as the vivid backdrop for his satirical paintings and prints. The negative aspects of urban reality were also expressed in American art in the early years of the twentieth century by the Ashcan School, which highlighted the problems of overcrowding in New York slums, while Edward Hopper probed beneath the surface to illustrate the isolation of some city dwellers in bleak diners and automats.

*Effects of Good Government
in the City*
Ambrogio Lorenzetti, 1338–1339
Early Italian

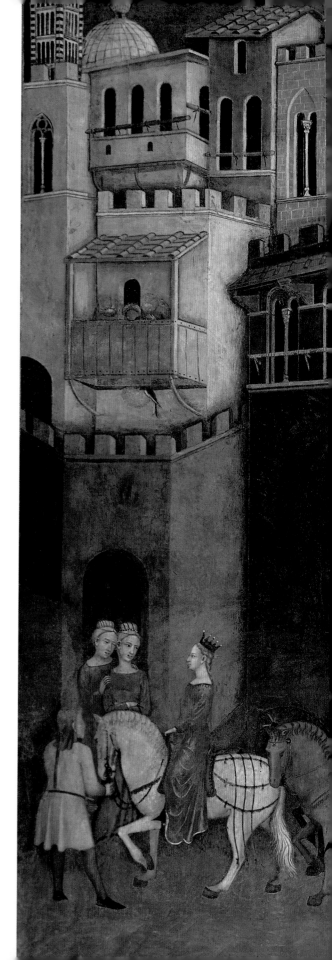

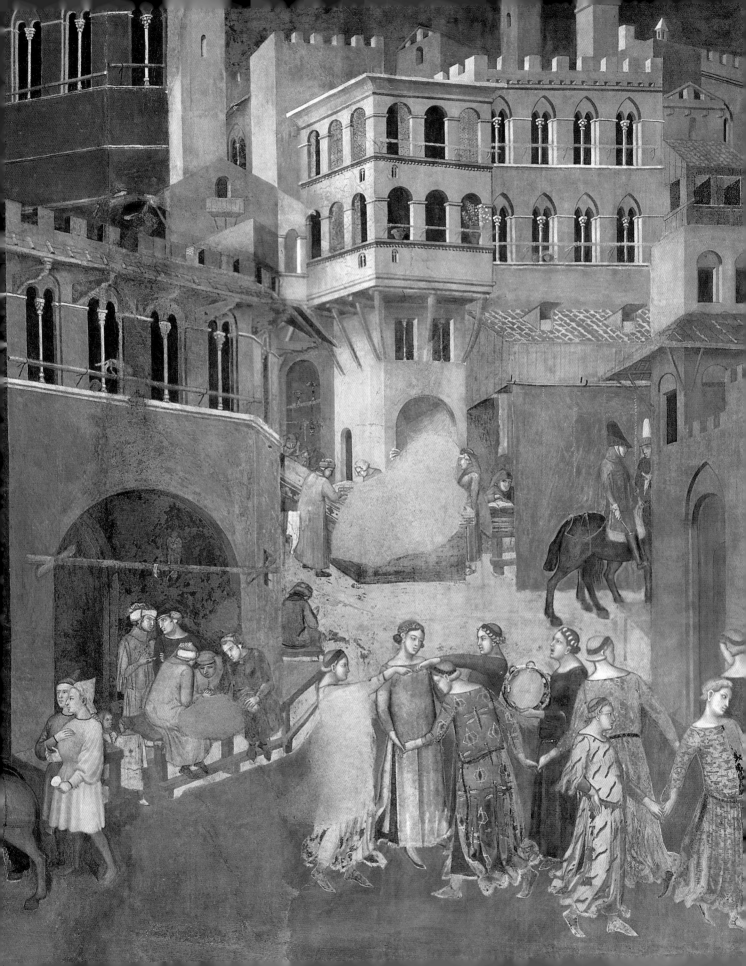

The Street

When American art began to free itself from overwhelming
European influences, it first did so through the medium
of landscape painting, specifically rural scenes. Then,
in the early years of the twentieth century, the focus shifted
to the cities. In New York, this fresh approach was pioneered
by the Ashcan School, which aimed to capture the
vibrant spirit of the city. One of its principal members was
John Sloan, who had a journalist's eye for depicting scenes
of everyday life. Edward Hopper was a great admirer
of Sloan's work, singling out Sloan's painting *Night Windows*
for praise in a published article and also creating his own
version of the subject. Hopper's paintings have an edge
of melancholy, highlighting the loneliness and isolation
that can affect the inhabitants of a big city. In the wake of the
Harlem Renaissance, several painters sought to illustrate
an African-American perspective on New York street culture.
One of the leading figures was William H. Johnson, who
taught at the Harlem Community Art Center. He drew some
of his inspiration from a nearby dance hall, the Savoy
Ballroom, where revelers liked to dress in the sharpest
fashions. In *Street Life* even the buildings and the sidewalk
seem to sway in time to an unseen rhythm.

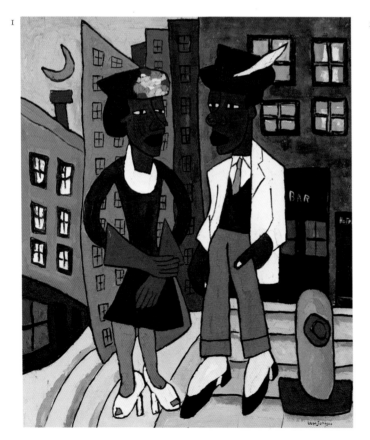

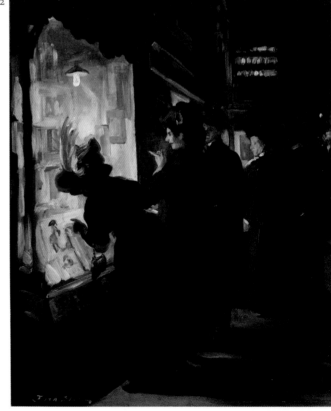

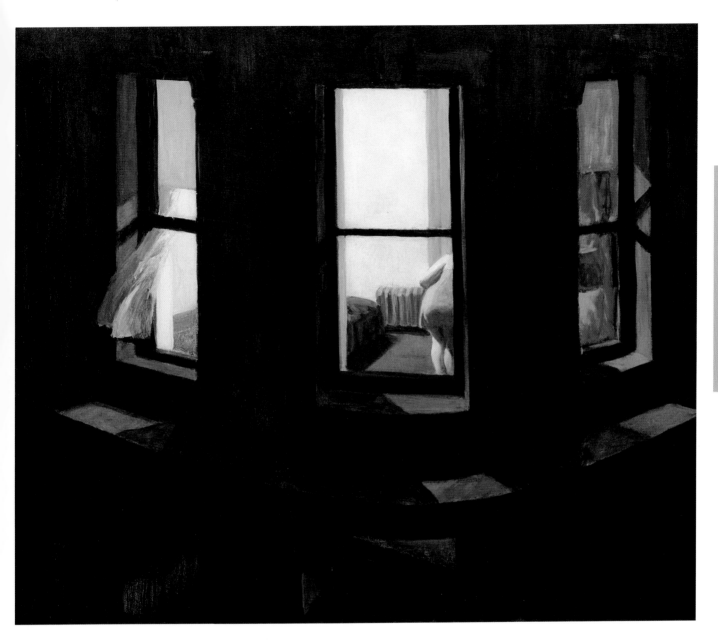

1 *Street Life*
William H. Johnson, 1940
American Regionalism

2 *Picture-Shop Window*
John Sloan, 1907
Ashcan School

3 *Night Windows*
Edward Hopper, 1928

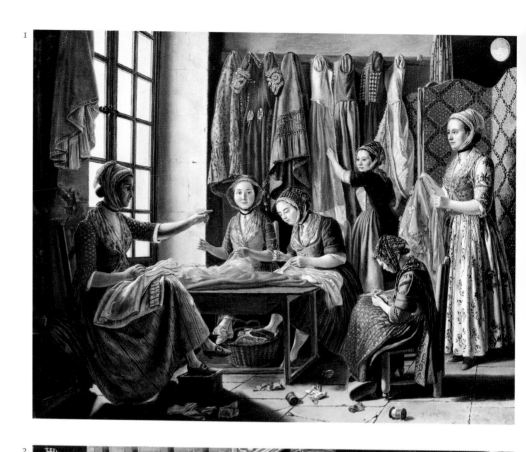

1 *Dressmaker's Shop in Arles*
Antoine Raspal, c. 1760
Rococo

2 *Scene of Pharmacy,*
from Avicenna's "Canon of Medicine"
Artist unknown, c. 1450
Early Renaissance

3 *The Spice Vendor's Shop*
Pietro Longhi, c. 1752
Rococo

4 *The Gersaint Shop Sign*
Jean-Antoine Watteau, 1720
Rococo

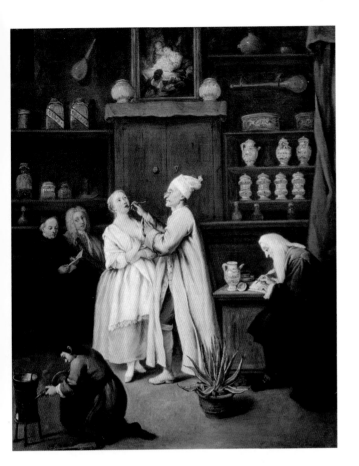

Stores

Avicenna, who lived in central Asia in the first century CE, was an outstanding medical expert whose *Canon of Medicine* was a standard text in the West as well as the East until the sixteenth century. This illustration from a fifteenth-century edition shows a pharmacist's open-fronted store, giving a rare glimpse of everyday life at this time. Pietro Longhi delved beneath the surface of Venetian life to provide an intimate portrayal of his home town, illustrating the working conditions of many professions. Here, the spice vendor's client seems reluctant to try out his wares. Jean-Antoine Watteau created this huge picture as a billboard for the premises it depicts, that of his friend Edme Gersaint, an art dealer. It is said to have been painted in just eight days. Gersaint is the figure holding up the painting by the mirror, while the young man in the center is thought to be a self-portrait of the artist. The atmospheric glimpse of a dressmaker's shop in eighteenth-century Provence shows the influence of Dutch painters in its lighting and subject, capturing a scene of ordinary life but executing it with exquisite detail.

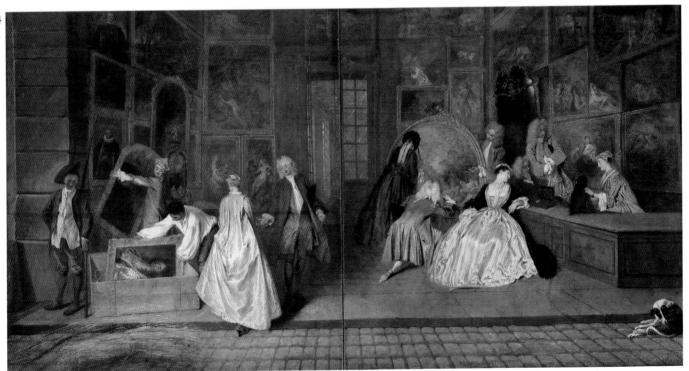

Working

Paintings of work scenes can provide invaluable historical detail of life in the city. Domenico Lenzi's *Corn Dealer* provides a rare illustration of the commercial dealing of agricultural produce in the fourteenth century. Mirabello Cavalori's depiction of a wool factory was produced for the private study of Francesco de' Medici. Its content is extremely accurate as Cavalori was the son of a dyer. Quentin Massys's painting is also meticulously detailed, though it is not quite what it seems. There is a subtle moral undercurrent. The scales are a symbol of the Last Judgement, when sins are weighed in the balance and, significantly, the sight of the money causes the woman to turn away from her prayer book. Fernand Cormon's painting was far from typical of his work, but the French government was sufficiently impressed to buy it from him. It presents a comparatively favorable picture of the working conditions during the smelting process in an iron forge—in contrast to contemporary artists who highlighted the horrors of work of this kind. As a result, Cormon was commissioned to decorate the Galerie des Machines at the 1900 World's Fair.

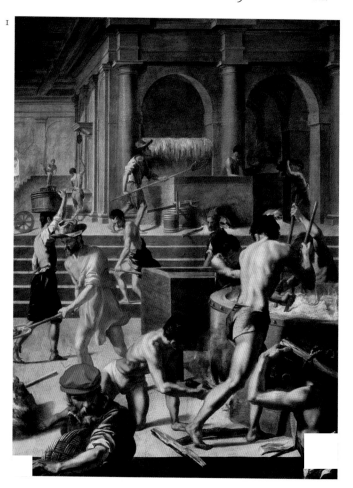

The Wool Factory
Mirabello Cavalori, 1570–1572
Mannerism

The Corn Dealer
Domenico Lenzi, c. 1300–1400
Early Italian

The Money Changer and His Wife
Quentin Massys, 1514
Northern Renaissance

An Iron Foundry
Fernand Cormon, 1893

Animals

Animals were one of the very first subjects that human beings ever depicted. Some of the finest European examples of prehistoric cave paintings can be found in the caves at Altamira in Spain and Lascaux in France and perhaps date from as early as 40,000 years ago. The animals are portrayed both alive and dead, and include deer, cattle, bison, and mammoths. The location of some of the paintings in deep, virtually inaccessible caves has given rise to the theory that they were designed for rituals that were performed to ensure good hunting. Animals certainly played a major part in the ritual practices of many ancient civilizations. They were frequently used as sacrifices, and were also often associated with the gods. In this context, animals feature prominently in Egyptian and Hindu art. From early times Christians often used animals as symbols.

Increasingly, artists reflected the important role that animals played, including as pets to adorn portraits, or as wild beasts in paintings of mythology and allegorical themes. Most notably animals featured in paintings showing agriculture and hunting, and the animals themselves became the main subjects in some works. Proud farmers and racehorse owners commissioned portraits of their prize animals to show the quality of their stock. Sometimes, these paintings were more lavish than the portraits of their own family members. By the nineteenth century, hunting and racing scenes had become hugely popular, providing employment for a considerable number of specialist artists.

Paulus Potter was one of the leading specialists in depicting animals as early as the seventeenth century. His work was celebrated and highly successful during his lifetime. Art collectors, intellectuals, and fellow artists recognized Potter as a master painter not only in his own country, the Netherlands, but also throughout Europe. They were impressed by the accuracy and by the scale of his pictures. Some of his ambitious paintings of cattle were life-size.

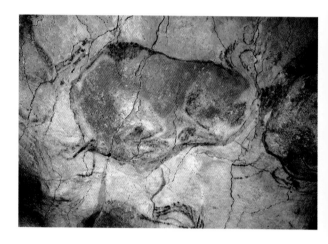

[top]
Bison
Artist unknown,
c. 16000–9000 BCE
Paleolithic

[opposite page]
Four Bulls
Paulus Potter, 1649
Dutch Seventeenth Century

Dogs

Dogs were domesticated in ancient times and they have played a significant role in art ever since. Often regarded as a guardian spirit in the ancient world, images of "lion dogs" were placed at the entrances to temples and other holy places, particularly in Asia. In Egypt, dogs were linked with pathfinder gods, helping dead souls find their way to the afterlife, while in the West they were conventional symbols of fidelity. As such, they were frequently portrayed on tomb effigies, lying obediently at the feet of their owners. In purely practical terms, dogs have been used chiefly for hunting. Some cave paintings feature canine creatures, while huge, mastiff-like dogs can be found on Assyrian carvings of lion hunts. In more recent times, of course, many dogs have been kept solely as pets, and their doting owners were only too willing to employ specialist animal painters to produce portraits of their loyal companions.

6

7

8

1 *Dog*
Artist unknown,
c. 100 BCE–300 CE
Colima

2 *Hunting Hares*
Artist unknown, c. 1000
Romanesque

3 *Hunting Dog*
Benvenuto Cellini, 1544
High Renaissance

4 *A Boy Catching Fleas on His Dog*
Gerard Ter Borch the Younger,
c. 1665
Dutch Seventeenth Century

5 *Sevres Figurine with Group of Children and a Dancing Dog*
Artist unknown, c. 1780
Neoclassicism

6 *Three Setters*
John Gifford, c. 1800

7 *Lady Blessingham's Dog*
Edwin Henry Landseer, 1832
Academic

8 *Orazio Hall's Dog*
Lorenzo Bartolini, 1840–1845
Neoclassicism

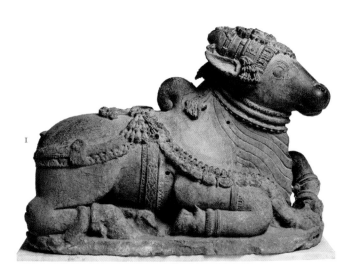

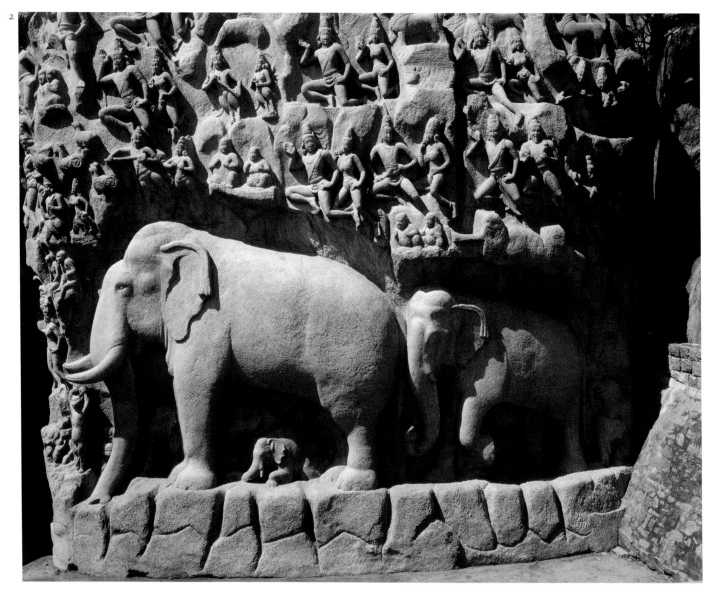

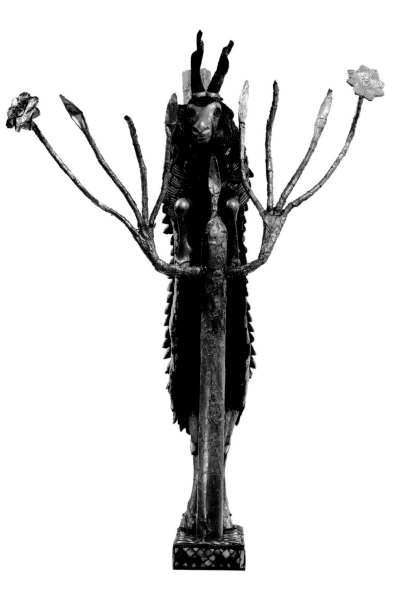

Animals in Ritual

Many of the earliest artworks featuring animals have ritual overtones, since ancient deities were frequently linked with animal forms. The most celebrated example, perhaps, is the so-called *Ram in a Thicket*, which was discovered in one of the royal tombs of Ur in what is now Iraq in the 1920s. It was given the name as an allusion to the passage in the Bible where Abraham—who was a native of Ur—was asked to sacrifice his son, but instead offered up "a ram caught in a thicket." In fact, the creature is more likely to be a goat standing on its hind legs eating the leaves of a tree, an animal that was associated with the Sumerian fertility gods, Tammuz and Ningirsu. The majestic elephant carvings form part of a monument at Mamallapuram, which is dedicated to Ganga, the goddess of the holiest of India's rivers, the Ganges. The figure of Nandi, the sacred bull ridden by the Hindu god Shiva, can be found in many temples in India. *Kozo, The Two-Headed Dog* is an empowering African sculpture known as a *nkisi*. Medicine is packed into a cavity on the creature's back or stomach and its power can be unleashed by a ritual specialist (*nganga*), using the appropriate invocations.

1 *Nandi, the Sacred Bull of Shiva*
Artist unknown, c. 1200–1250
Hinduism

2 *Two Large Elephants,*
from Descent of the Ganges
Artist unknown, c. 600–700
Hinduism

3 *Ram in a Thicket, from Ur*
Artist unknown,
c. 2600–2400 BCE
Sumerian

4 *Kozo, The Two-Headed Dog*
Artist unknown, c. 1880–1920
Congan

Horses

Horses featured prominently in many ancient cultures, particularly in relation to solar worship. The sun god was visualized as a charioteer, riding across the sky during the hours of daylight, chasing away the darkness. This concept can be traced back to Shamash, the Mesopotamian sun god, and was passed along to Greece, Rome, and India. *The Horses from a Quadriga* is probably related to this. In the East, the horse was also a sacrificial animal; for example, in China, when a ruler died, his animals were slaughtered and placed in his tomb. This ritual persisted until around the fifth century BCE, when the Confucians managed to halt the practice. After this, figurines of horses were interred in place of the real animals, and over the years these equine sculptures became increasingly sophisticated. Viktor Vasnetsov was a leading member of the Wanderers, a group of Russian artists who staged traveling exhibitions. He was a versatile painter, although his best-known pictures depicted scenes from Russian history, legend, and fairy-tales. Here, a solitary knight is confronted with a life-or-death decision about the road that he must take on his magnificent steed.

Young Nobleman on Horseback
Qian Xuan, 1290
Yuan dynasty

The Paladin (The Knight at the Crossroads)
Viktor Vasnetsov, 1882
Wanderers

Horse, from the Fusco Necropolis
Artist unknown, c. 825 BCE
Ancient Greek

Funerary Figure Representing a Horse
Artist unknown,
c. 206 BCE–CE 220
Han dynasty

The Horses from a Quadriga
Artist unknown, c. 150–250
Roman

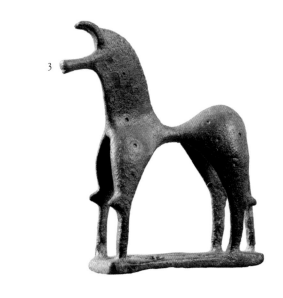

3

4

5

417

Birds

In many different cultures, birds have been treated as a symbol of the soul. In Egypt, the god Ba, who was depicted as a bird with a human head, personified the soul. In tomb paintings, Ba was frequently portrayed hovering above the figure of the mummy, and was also illustrated extensively in the Book of the Dead. Few artists have been as passionate about recording wildlife as Albrecht Dürer. His boundless curiosity led him to seek out every new phenomenon that he heard about. On one occasion, he made a lengthy excursion to a remote area of Zeeland so that he could examine a whale that had beached there. By the time he arrived, however, the creature had already been returned to the sea. When he did manage to portray an animal or a bird, his technique was faultless. Dürer acquired his parrot on a trip to Aachen, made so that he could study the bird more closely. He certainly made full use of it, for he included a parrot in one of his engravings of Adam and Eve, perching it on the Tree of Life to symbolize wisdom. Giambologna, a celebrated Mannerist sculptor, also made detailed and accurate use of his talents for this statue of an owl.

2

1

1 *Bird Finial*
 Artist unknown, c. 1900
 Senofu

2 *Parrot in Three Positions*
 Albrecht Dürer, c. 1500
 Northern Renaissance

3 *Toy Wagon in the Shape of a Bird*
 Artist unknown, c. 900–800 BCE
 Villanovan

4 *Owl*
 Giambologna, 1567
 Mannerism

5 *Wall painting from the Palace of
 Amenhotep III*
 Artist unknown, c. 1381–1363 BCE
 Ancient Egyptian

ANIMALS

Religion

Every religion has used art as an essential way to promote its beliefs—in manuscripts and books, in decorations and statues for temples and churches, and in paintings and prints for private viewing. The representation of the gods and other religious figures is of enormous importance for the history of art and is central to its development throughout many regions of the world, except those following the Islamic tradition, which forbids the representation of God.

Images of gods and holy figures are often featured in narrative works of art, telling the stories of the gods, depicting the beliefs of the faithful, and establishing visually important aspects of the religion. Stone relief and carvings in ancient civilizations across the world, as well as frescoes and decorations in Christian churches, gave followers insight to their religion and an understanding of the teachings of their priests.

The cult of the sun god Mithras flourished in ancient Persia, India, and Greece. For a time it was the official religion of the Roman Empire, and there are indications that the cult was carried across Europe by the Roman legions. The central image of Mithraism was the sacrifice of the sacred bull. The god is shown slitting the animal's throat, in an act that symbolizes the creation of the universe. As the creature dies, ears of corn and vines sprout from its blood, while the cloak of Mithras is transformed into the heavens. The force of evil, in the form of the snake and the scorpion, tries to prevent this by absorbing the blood of the bull.

The Hindu god Shiva appears here in his role as Nataraja, the Lord of the Dance. His dance was a ritual act emphasizing the way that he embodies cosmic energy, both in its creative and in its destructive forms. In one of its earliest guises, the dance was also used as a type of sympathetic magic, designed to promote good crops and harvests. This is related to Shiva's original manifestation as a fertility god.

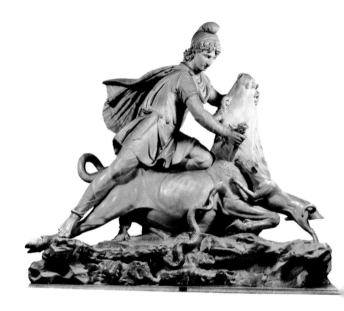

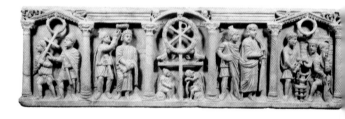

[top]
The God Mithras Slaying the Bull
Artist unknown, c. CE 50
Ancient Roman

[bottom]
Sarcophagus with Christian Symbols and Scenes
Artist unknown, c. 340
Early Christian

[opposite page]
Shiva Dancing in Front of His Bride
Artist unknown, c. 600–750
Hinduism

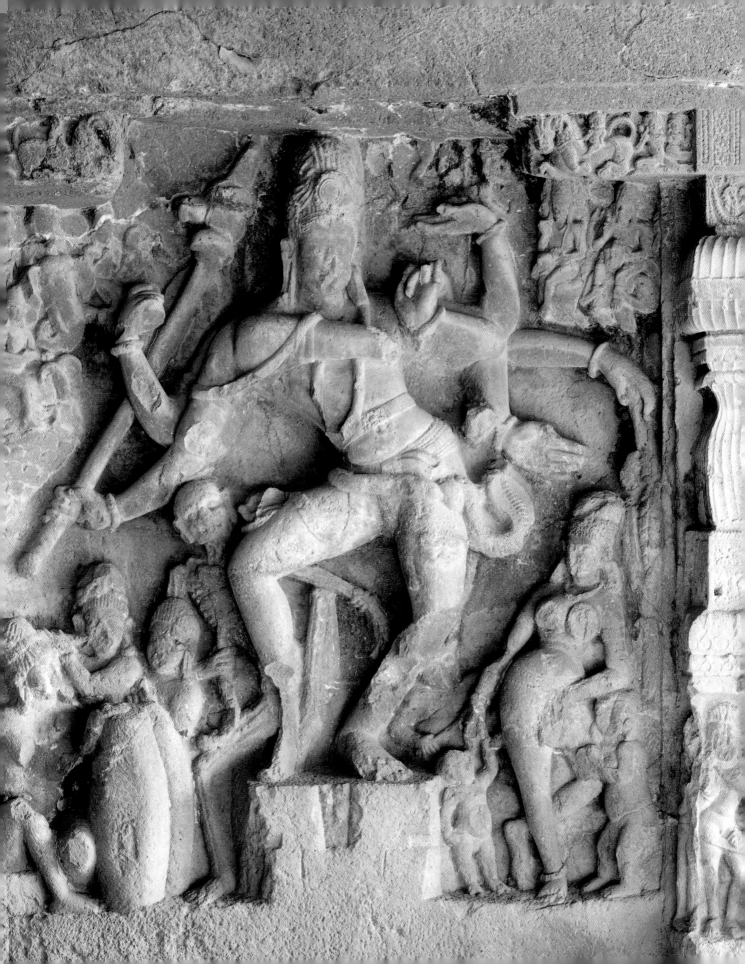

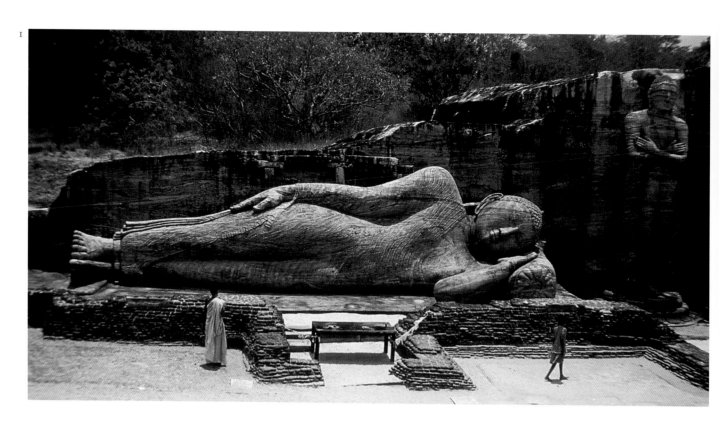

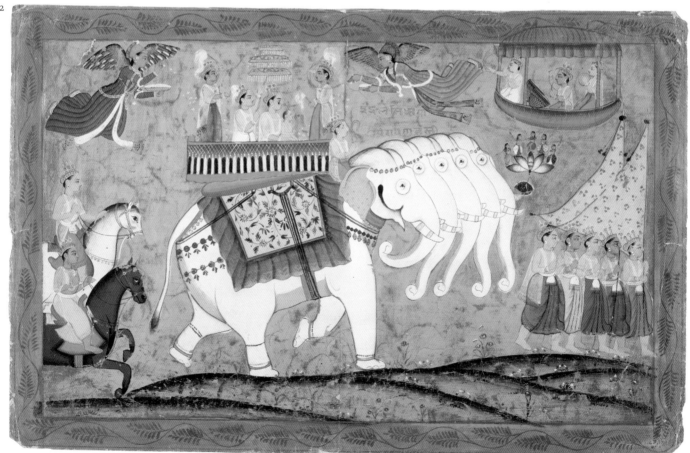

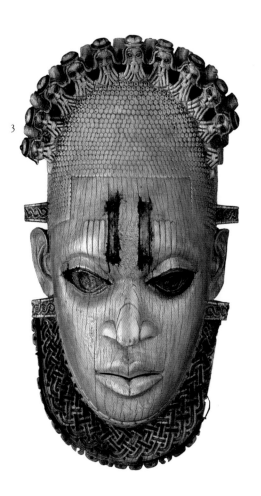

3

Sacred Icons

When creating sacred images of Buddha, artists used a variety of postures (*asanas*) and hand gestures (*mudras*) to illustrate his life and teachings. Depictions of the reclining Buddha relate specifically to the death of Shakyamuni (one of his names, meaning "Sage of the Shakyas"). According to tradition, he died in India, while lying on his side with his hand supporting his head. This pose is known as *mahaparinirvana*—"the great state beyond nirvana." Scholars believe this ivory mask from Benin may represent Idia, the mother of King Esigie. The vertical markings between her eyes indicate the source of her spiritual powers. The tiny heads in the crown are depictions of Portuguese traders who helped Esigie overcome his enemies. The king is thought to have worn the mask on his hip during royal memorial ceremonies. Indra is the Hindu sky god, who is often shown holding a thunderbolt. When depicted in his heavenly domain, he is often accompanied by *apsarases* (a form of angel) and enthroned on his elephant, Airavata. Elephants were traditional symbols of royal wisdom and sovereignty. Islamic artists, barred from portraying sacred figures, focused on the sacred text, turning calligraphy and the word of God into a religious artform.

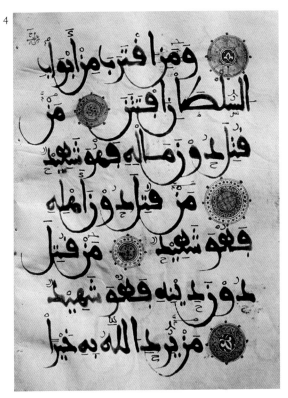

4

1 *Reclining Buddha*
 Artist unknown, c. 1100–1200
 Buddhism

2 *Celestial Procession with
 Indra Riding His Elephant*
 Artist unknown, c. 1740
 Indian

3 *Mask*
 Artist unknown, c. 1500–1600
 Benin

4 *Page of calligraphy from the Qu'ran*
 Artist unknown, 1100
 Islam

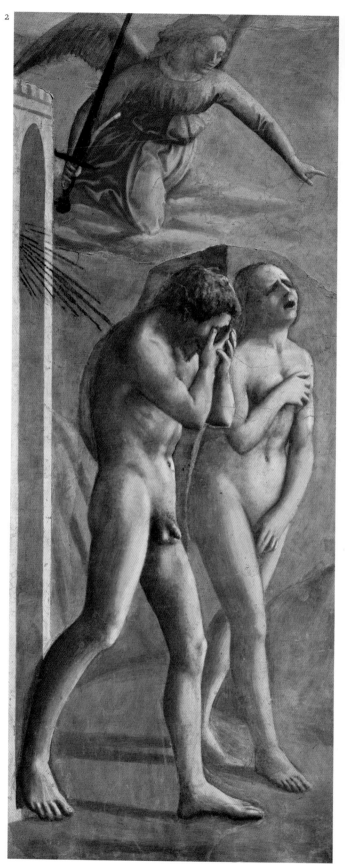

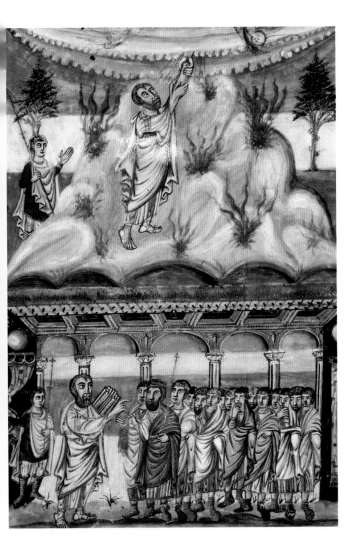

The Old Testament

Some of the earliest Christian paintings were produced for illuminated manuscripts of the Bible and other sacred texts. As these works were mainly intended for wealthy, educated individuals or religious houses, the pictures could depict complex themes such as the Creation or Moses and the Ten Commandments, as is shown in these splendid Gothic and Carolingian examples respectively. By contrast, images that were on public view as altarpieces and wall paintings in churches normally focused on a much smaller range of Biblical subjects. The story of Adam and Eve, depicted in this painting by Masaccio, was one of these. The Ghent Altarpiece is a notable exception to this rule. Its complex central panel shows an assembly of patriarchs, prophets, and saints paying homage to the Mystic Lamb (a symbol of Christ's sacrifice and the Mass) and the Fountain of Life (symbolizing Christian redemption). In modern times, some Old Testament Biblical subjects have been taken out of their religious context. Judith was a Jewish heroine who saved her people by cutting off the head of Holofernes, an Assyrian general. Along with the tale of Salome and the head of John the Baptist, this subject became popular with artists who were connected to the Symbolist and Art Nouveau movements because it combined two of their chief obsessions—the severed head and the femme fatale. Gustav Klimt's *Judith* is shown as a sexual predator, rather than a holy icon, and her ornate choker underlines the theme of decapitation.

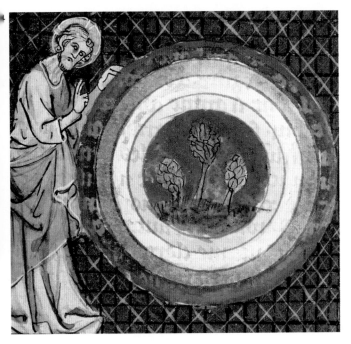

1 *Judith*
Gustav Klimt, 1901
Art Nouveau

2 *Expulsion of Adam and Eve*
from Paradise
Masaccio, c. 1427
Early Renaissance

3 *Moses Receives the Tablets of the Law,*
from the Moutier-Grandval Bible
Artist unknown, 834–843
Carolingian

4 *God Creates Earth,*
from the "Petite Bible Historiale"
Artist unknown, c. 1300–1350
Gothic

[following pages]
Adoration of the Mystic Lamb,
from the Ghent Altarpiece
Jan van Eyck, 1432
Northern Renaissance

RELIGION

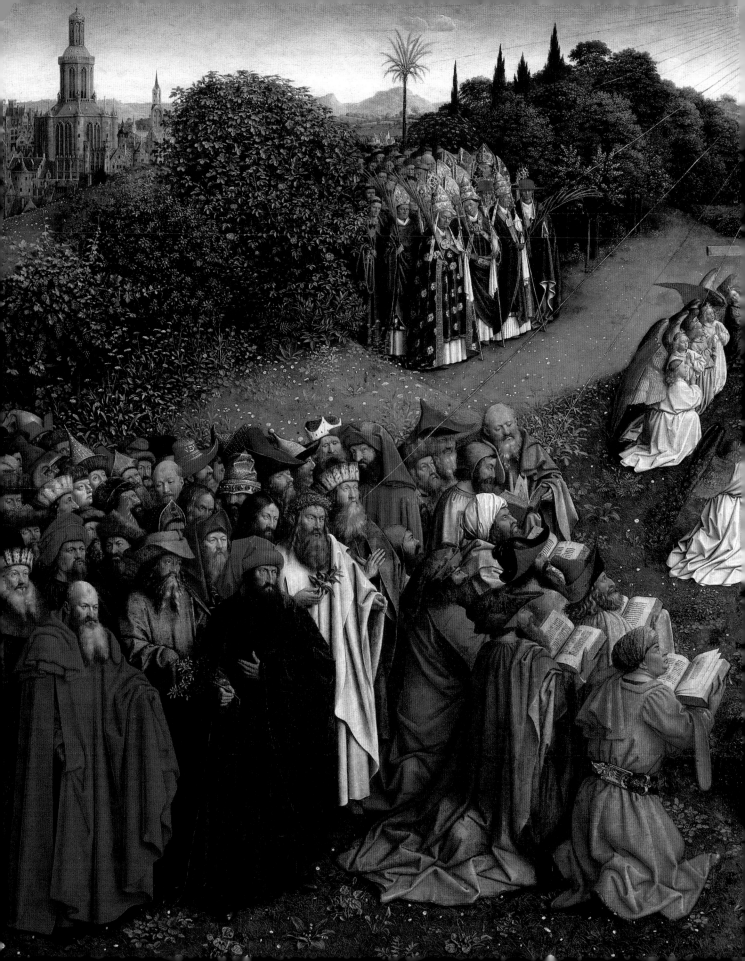

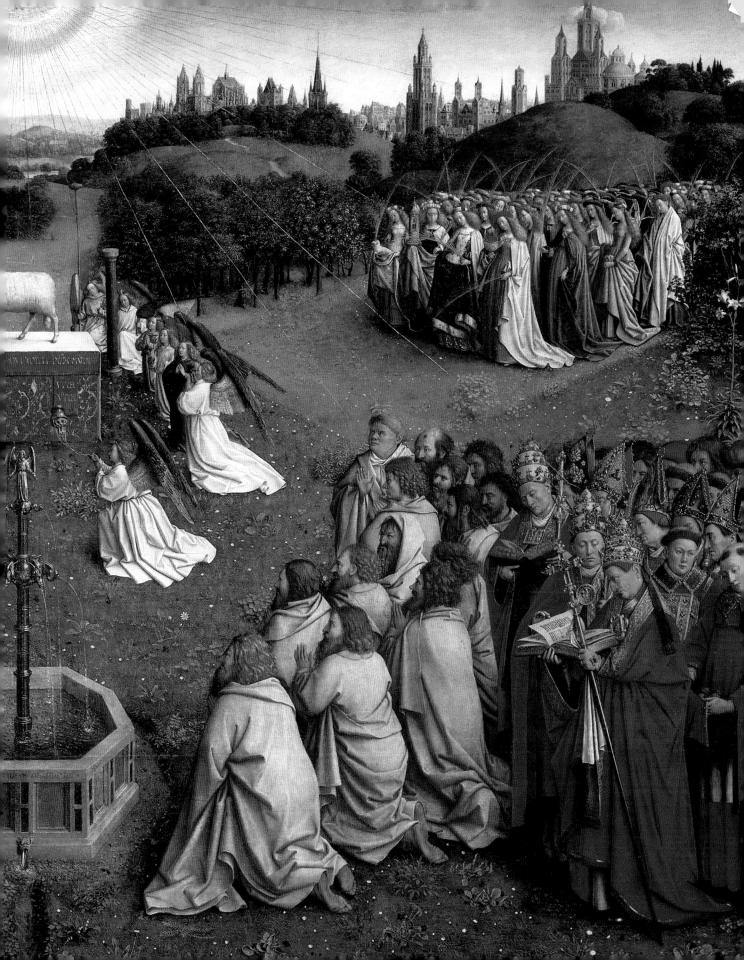

The Birth of Christ

From the Middle Ages onwards, a growing desire to celebrate the mother figure of the Christian faith inspired countless images of Mary. One of the most popular themes was the Annunciation, where the archangel Gabriel announced to the Virgin that she was to bear a son. The domestic setting provided opportunities for some individual touches—here, Lorenzo Lotto has shown that the sudden arrival of the angel frightens a cat. The Nativity was an obvious and important choice of subject for painters and creates a dramatic nocturnal scene, here depicted by Federico Barocci. Devotional pictures of the Virgin and Child were always in high demand and artists varied the image by using a range of symbols to emphasize different aspects of Mary's character. She was free from all sin and this is often expressed by the use of roses, as in this painting by Stefan Lochner. Mary's lack of sin is like a "rose without thorns," a reference also to the legend that the roses in the Garden of Eden had no thorns.

1 *Annunciation*
 Lorenzo Lotto, c. 1527
 High Renaissance

2 *Nativity*
 Federico Barocci, 1597
 Baroque

3 *Madonna of the Rose Bower*
 Stefan Lochner, 1435–1440
 International Gothic

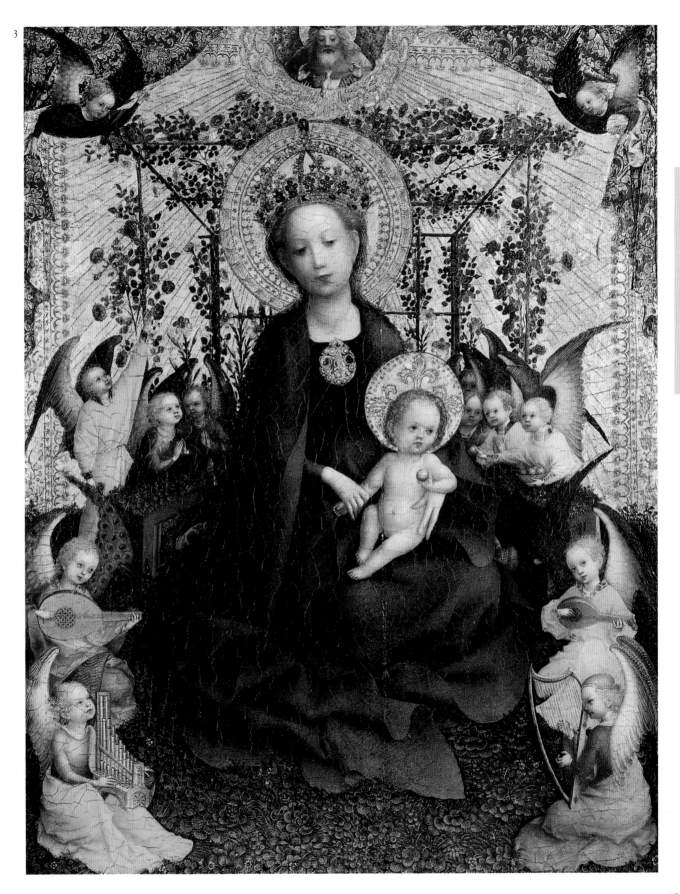

Parables

The parables, told by Christ to explain the importance of humanitarian and religious behavior, are among the most vivid and compelling narratives in the New Testament. Illustrating these moral tales gave artists an opportunity to produce complex paintings with deep meaning. Artists could also provide their own interpretations of popular and familiar themes. Rembrandt van Rijn painted his version of *The Return of the Prodigal Son* near the end of his life when he was living in extreme poverty—a fact that lends added poignancy to his portrayal of the destitute son returning to his father for forgiveness after squandering his inheritance. As a personification of the repentant sinner, the theme was very popular with artists, who depicted it either as a single scene or a story cycle. Flemish artist Pieter Bruegel used the parable of the blind leading the blind to comment on the religious strife—the conflict between Catholic and Protestant beliefs—that was tearing his homeland apart when he created the painting. One of the men has a lute (representing Protestant Lutheranism) while another has a rosary (representing Catholicism). Significantly, all the blind men are heading away from the church and are bound for a fall.

1 *Return of the Prodigal Son*
Rembrandt van Rijn, c. 1669
Dutch Seventeenth Century

2 *Parable of the Blind Leading the Blind*
Pieter Bruegel the Elder, 1568
Northern Renaissance

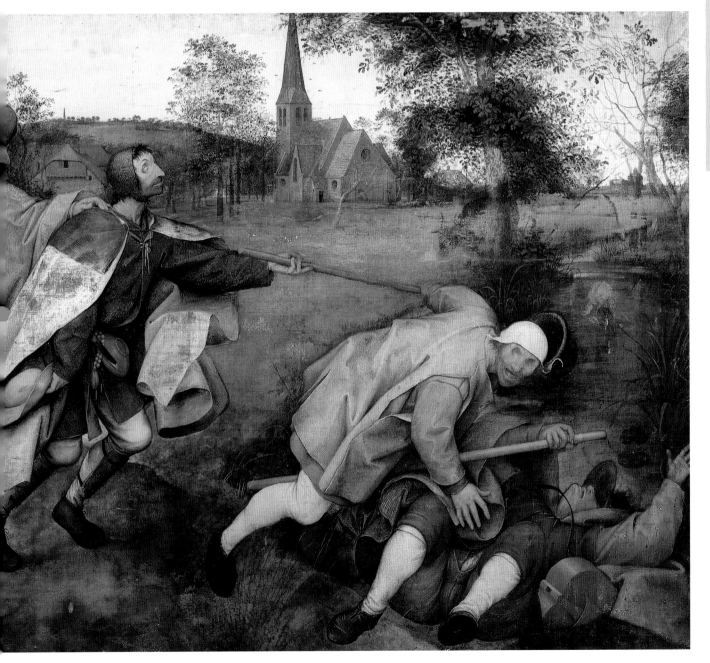

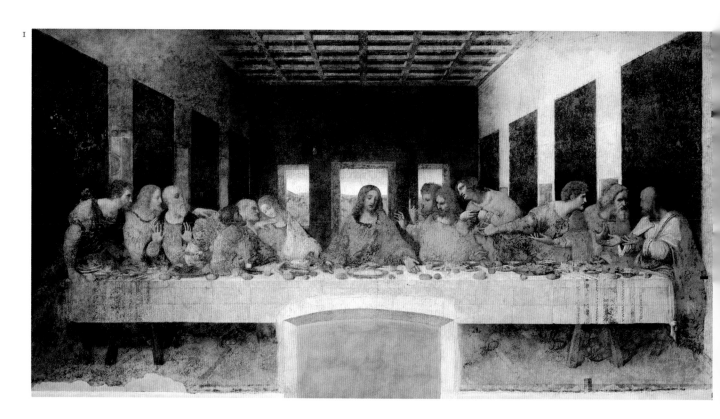

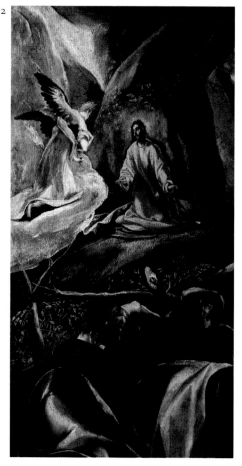

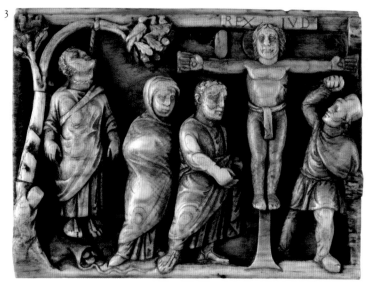

1 *Last Supper*
 Leonardo da Vinci, 1497
 High Renaissance

2 *Agony in the Garden*
 El Greco, c. 1600–1605
 Mannerism

3 *Crucifixion of Christ*
 Artist unknown, c. 425
 Early Christian

4 *Christ*
 Georges Rouault, 1952

5 *Lamentation over the Dead Christ*
 Giotto di Bondone, c. 1306
 Early Italian

6 *Resurrection*
 Piero della Francesca, 1463–1465
 Early Renaissance

The Death of Christ

The events surrounding the death of Christ provide the most compelling and emotive of all Christian themes. Leonardo da Vinci's celebrated version of the last supper, where Jesus announced to his disciples that one of them would betray him, was commissioned for the refectory of a monastery church, where the monks could reflect on the theme while they ate. El Greco's dramatic depiction of Christ foreseeing his brutal death in the garden of Gethsemane shows the moment when "an angel came from heaven to strengthen him." In Georges Rouault's painting, Christ's nose and brow suggest the shape of the Cross. The Early Christian *Crucifixion of Christ* shown here includes Judas, who has hanged himself out of remorse for betraying Christ. Giotto di Bondone's *Lamentation over the Dead Christ* was one of his most moving works—notable for the weeping angels who hover in despair above the body. The *Resurrection* completes the sequence. In Piero della Francesca's version, Christ steps out of the tomb holding a banner of triumph. His victory over death is symbolized by the foliage in the background—on the left the branches are bare and lifeless while on the other side they are covered in an abundance of leaves.

5

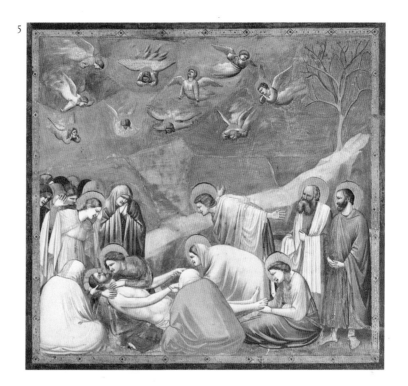

6

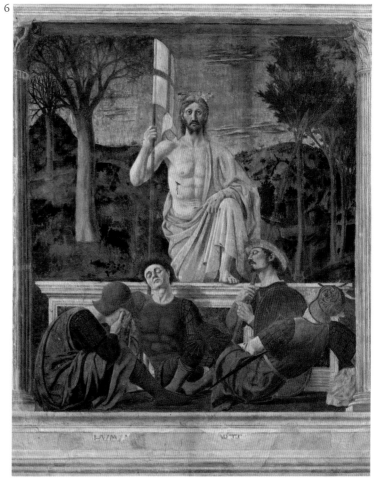

4

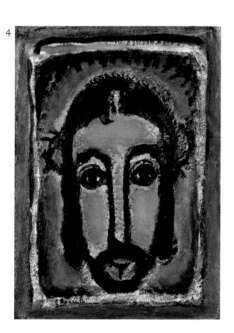

The Last Judgement

The Last Judgement, where Christ
described the day of judgement when
the dead would rise from their graves
to be consigned either to heaven or hell,
frequently took the form of an epic wall
painting situated prominently in a church
so that the congregation could muse over
their fate as they listened to a sermon.
The central figure of Christ was usually
portrayed as serene and majestic,
as in the version by Giotto di Bondone,
although he could also be wrathful,
as in Michelangelo Buonarroti's powerful
depiction. Michelangelo included a self-
portrait, in the guise of Saint Bartholomew,
who was flayed alive. The martyr can
be seen holding his empty skin by
Christ's left foot. The struggle between
good and evil at the moment of judgement,
with the virtuous aided by angels on their
journey to heaven while the damned are
dragged down to hell, has inspired some
of the most complex and awe-inspiring
of Christian paintings.

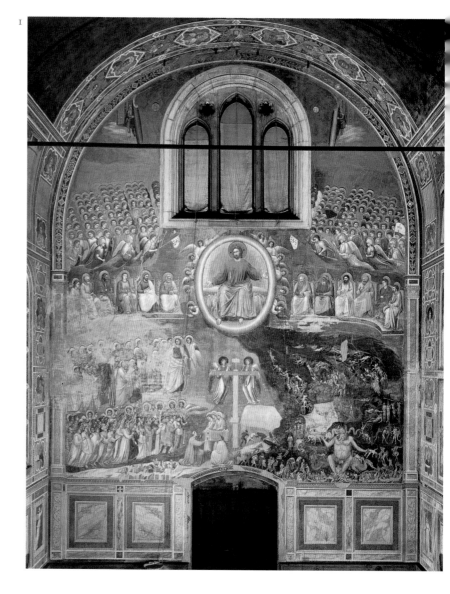

1

1 *Last Judgement*
 Giotto di Bondone, c. 1306
 Early Italian

2 *Last Judgement*
 Michelangelo Buonarroti,
 1536–1541
 Mannerism

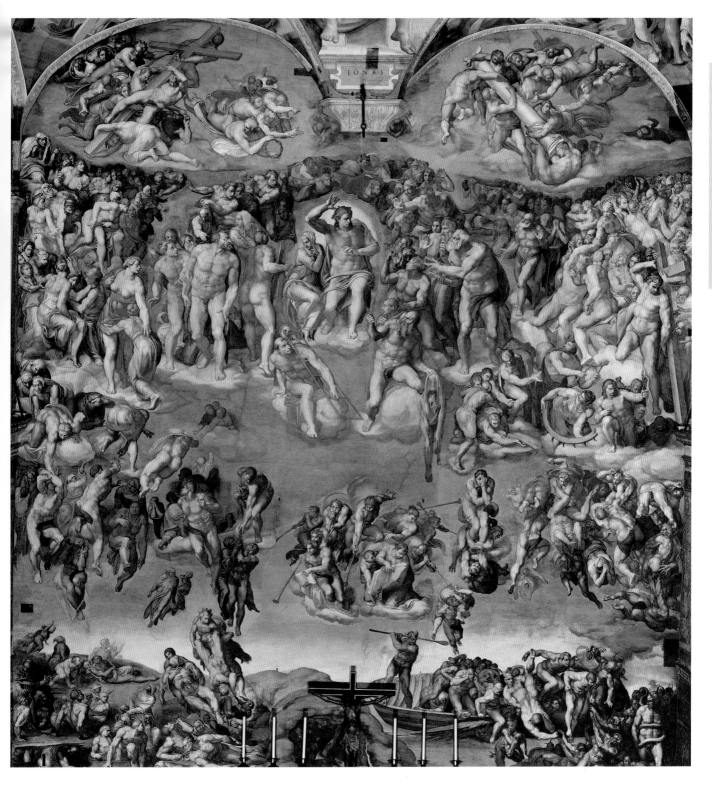

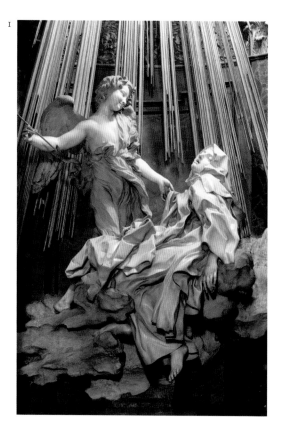

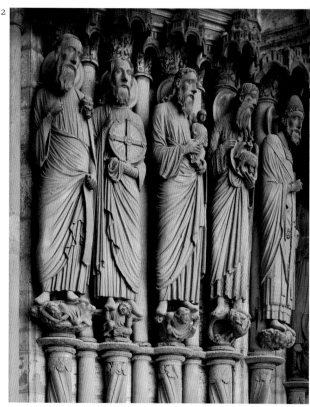

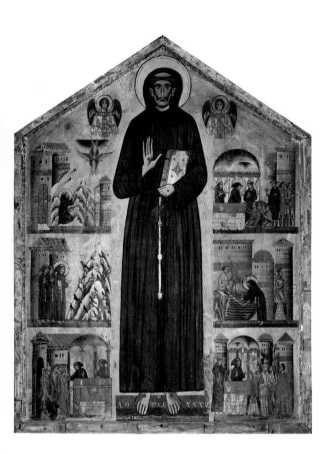

Saints

Pictures of saints were frequently commissioned by the churches that were dedicated to them, or by wealthy patrons who shared their name. Many of the earliest versions were narrative paintings featuring several episodes from the saint's life. Bonaventura Berlinghieri's painting was executed in 1235, just nine years after Saint Francis's death, making it the oldest known image of the saint. Most depictions of saints focused on their miracles or their martyrdoms. Two of the figures shown here are in the grip of visions. Saint Paul was converted when he was struck by a blinding shaft of light on the road to Damascus. True to form, Michelangelo da Caravaggio emphasized the human context of the holy event: Paul's attendant is more concerned with soothing the terrified horse than in tending to his stricken master. Saint Theresa, meanwhile, experienced a vision of an angel plunging a golden spear into her heart. This dramatic affirmation of God's love carried echoes of the pagan legend of Cupid and his arrows. In Perugino's painting, Saint Peter is not only given the keys of heaven, but is also confirmed as the head of the Christian Church. This is symbolized by the imaginary building in the background, flanked by two triumphal arches.

1 *Ecstasy of Saint Theresa*
Giovanni Lorenzo Bernini,
1647–1652
Baroque

2 *Saints from the Portal of the Kings, Chartres Cathedral*
Artist unknown, c. 1220
Gothic

3 *Christ Giving the Keys to Saint Peter*
Perugino, c. 1480–1482
Early Renaissance

4 *Saint Francis and Scenes from His Life*
Bonaventura Berlinghieri, 1235
Early Italian

5 *Conversion of Saint Paul*
Michelangelo da Caravaggio,
1600–1601
Baroque

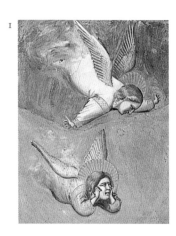

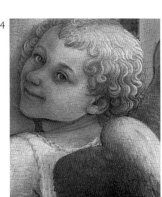

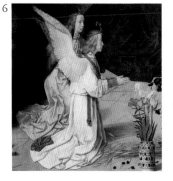

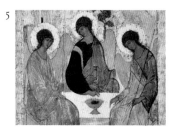

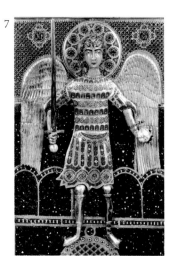

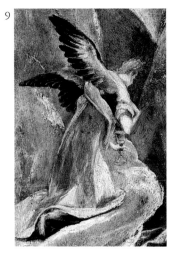

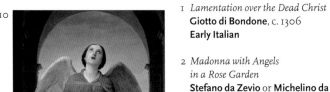

1 *Lamentation over the Dead Christ*
Giotto di Bondone, c. 1306
Early Italian

2 *Madonna with Angels
in a Rose Garden*
Stefano da Zevio or **Michelino da
Besozzo**, c. 1410
International Gothic

3 *Maestà (The Madonna in Majesty)*
Duccio di Buoninsegna, 1308–1311
Early Italian

4 *Madonna and Child with Two Angels*
Fra Filippo Lippi, 1465
Early Renaissance

5 *Holy Trinity*
Andrei Rublev, c. 1410–1420
Byzantine

6 *Portinari Triptych*
Hugo van der Goes, 1476–1479
Northern Renaissance

7 *Icon of the Archangel Michael*
Artist unknown, c. 900–1000
Byzantine

8 *Annunciation*
Simon Vouet, c. 1645–1649
Baroque

9 *Agony in the Garden*
El Greco, c. 1600–1605
Mannerism

10 *Sacred Music*
Luigi Mussini, c. 1875
Academic

11 *The Damned Sent to Hell*
Luca Signorelli, 1499–1504
Early Renaissance

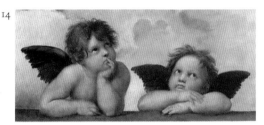

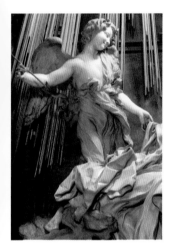

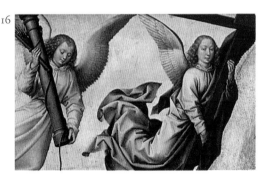

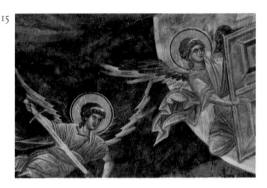

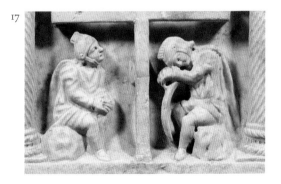

Angels

Angels take their name from the Greek word *angelos* (messenger), reflecting their primary role as informants delivering the word of God. In visual terms, these divine beings had some precedents in the winged messenger-spirits that featured in the art of the ancient civilizations of Babylon and Assyria. Angels also played a crucial role in the war against evil, frequently led in this by the archangel Michael. He was often portrayed as a holy warrior, dressed in armor and bearing a sword or spear. Michael was also the angel who weighed human souls, and in this guise he appears in pictures of the Last Judgement holding a pair of scales. There are different orders of angels, but the type most commonly found in art is the cherubim. In the Bible they were described in adult terms—carrying God aloft and guarding the entrance to the Garden of Eden—but painters often portrayed them as children.

Annunciation
Fra Angelico, 1435–1440
Early Renaissance

Ecstasy of Saint Theresa
Giovanni Lorenzo Bernini,
1647–1652
Baroque

The Sistine Madonna
Raphael, 1513–1514
High Renaissance

5 *Death of the Virgin*
Artist unknown
Byzantine

6 *Last Judgement*
Hans Memling, 1467–1471
Northern Renaissance

7 *Sarcophagus with Christian Symbols and Scenes*
Artist unknown, c. 340
Early Christian

14

15

16

17

Mythology

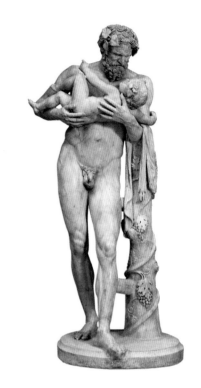

Scenes from classical mythology have provided Western artists with one of their most important and enduring sources of inspiration. As an artistic theme, mythology probably ranks second in popularity only to religious art. The stories of the gods became so well known that artists used them in an endless variety of ways—as the models for philosophical theories, for moralizing parables, for visions of ideal beauty, or even for prurient titillation. The stories of the Greek and Roman gods and heroes were widely studied during the Renaissance and Baroque eras. Whenever ancient statues and other treasures were unearthed they made a profound impression on artists of these periods.

The Greek god Zeus (Jupiter in Roman mythology) was the god of gods, the ruler of Mount Olympus, and important as the god of peace, justice, and order. Heracles (Hercules in Roman mythology) was the ultimate Greek hero who undertook twelve feats of near-impossible difficulty to become immortal. He defeated the murderous giant Antaeus by discovering that lifting the colossus off the ground, away from contact with his mother, the Earth, destroyed his strength. Dionysus (Bacchus in Roman mythology) was the god of wine. The satyrs, mythological figures with animal tails and legs, were lustful, indulgent creatures, and followers of Dionysus. In classical times the young god was also represented being held by the aged satyr Silenus, who cared for Bacchus as a child and became his constant companion.

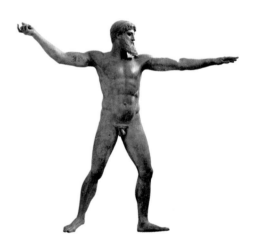

Artists from all areas of the world drew inspiration from ancient mythologies, often told in epic poems such as the Latin writer Ovid's *Metamorphoses* or the Indian story of the *Ramayama*. These tales offered amorous adventures, dramatic battles, horrendous demons, and virtuous deeds. Works of art based on mythology, while showing extraordinary scenes and situations involving the gods, carried intellectual and moral integrity, were easily understood, and were relevant to all areas of human experience. The adventures of heroes, heroines, goddesses, and gods provided symbolic figures that inspired awe and fascination—perfect subjects for art.

[top]
Silenus Holding the Young Bacchus
(Roman copy of a Greek statue)
Original attributed to **Lysippus**,
c. 350 BCE
Ancient Greek

[bottom]
Zeus (or Poseidon)
Artist unknown, c. 450–425 BCE
Ancient Greek

[opposite page]
Hercules and Antaeus
Antonio del Pollaiuolo, c. 1470
Early Renaissance

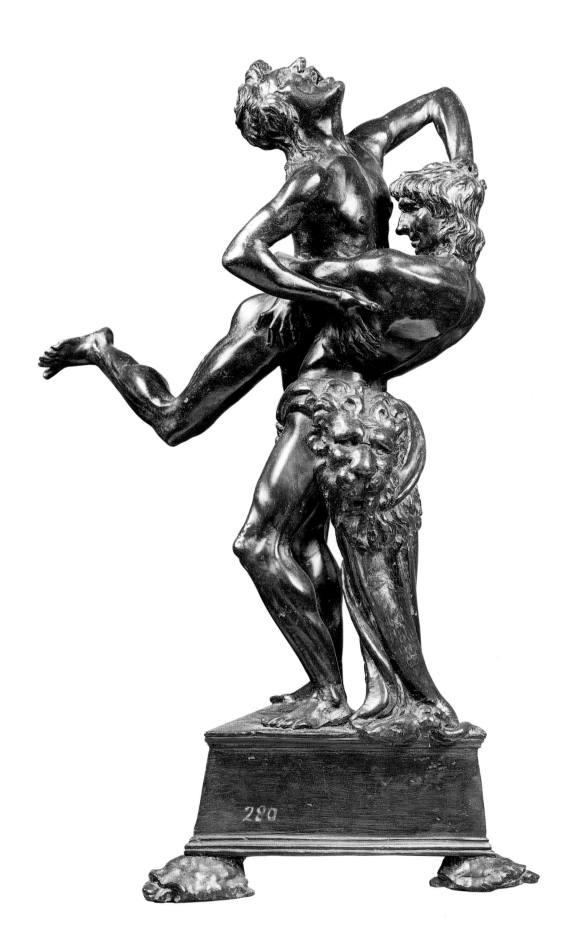

Venus

The legend of Venus, the goddess of love, tells that she rose, fully formed, out of the sea. In some versions of the story she was carried ashore on a giant shell, while others relate that she emerged from the foaming waves. The Greek form of the goddess's name is Aphrodite, from *aphros* or "foam." Sandro Botticelli's picture, commissioned by the Medici family, translated the myth into a philosophical allegory. In this, Venus represented *Humanitas*, an idealized union of spiritual and sensual love. On the left is Zephyr, the west wind, who uses his powerful breath to propel the shell. He is entwined with Chloris, the goddess of flowers. Together they symbolize physical passion. On the other side a maiden personifying Spring is about to cover the nakedness of Venus. Perhaps the most famous of all images of Venus is the Ancient Greek statue of the goddess discovered on the island of Melos in 1820. This inspired artists to present the goddess as the ideal of a female nude. Paintings such as the one by William Adolphe Bouguereau use mythology as a serious pretext for sensual, and even erotic, art.

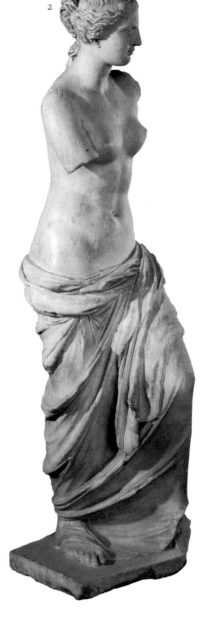

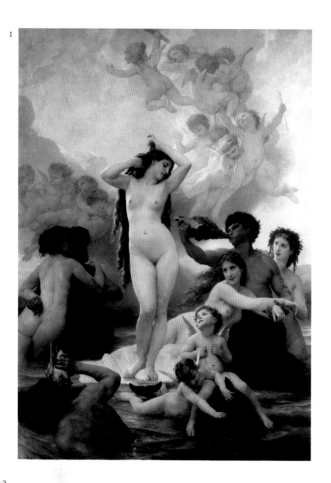

1 *Birth of Venus*
 William Adolphe Bouguereau,
 1879
 Academic

2 *The Venus of Milo*
 Artist unknown, c. 200–100 BCE
 Ancient Greek

3 *Birth of Venus*
 Sandro Botticelli, c. 1484
 Early Renaissance

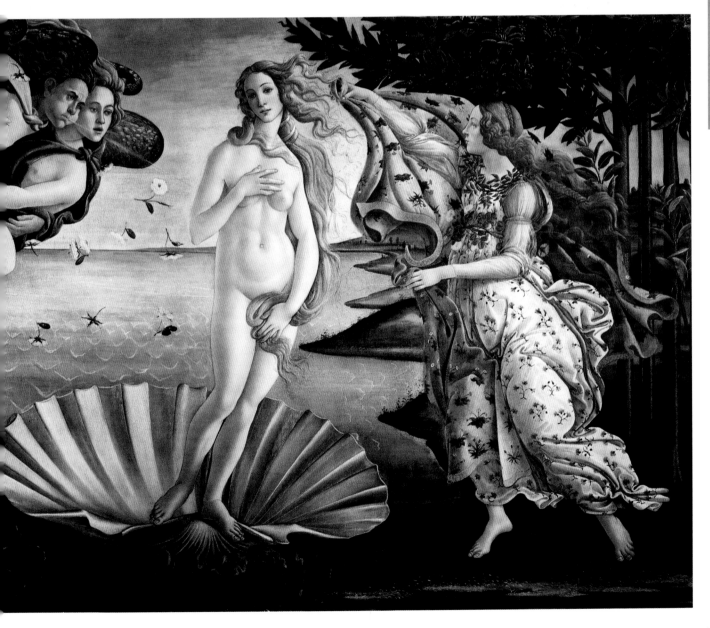

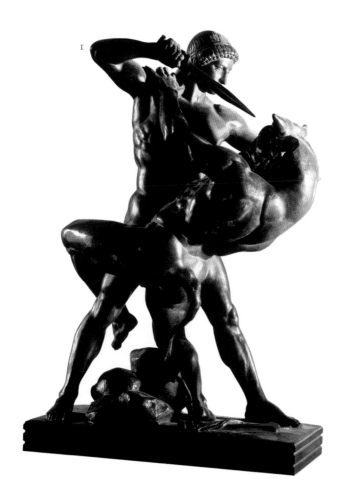

Beasts

Ancient mythology contains many references to mythological beasts and much of the drama and action of the legends depends on these powerful and terrifying creatures. Antoine-Louis Barye, who specialized in sculptures of animals, depicted one of the most famous of these—the minotaur, a ferocious creature, half man and half bull, that dwelt in the Labyrinth in Crete. The hero Theseus had to kill it in order to rescue his beloved Ariadne. Medusa was a lethal Greek monster, one of three terrible sisters known as the Gorgons. They had snakes for hair and their gaze turned men to stone. Medusa was eventually slain by Perseus, who cut off her head and placed it on his shield. As he did so, the winged horse Pegasus sprang up from the gorgon's corpse. Centaurs, part horse and part human, were usually savage beasts, though one centaur, Chiron, displayed more positive qualities. Chiron was renowned in mythology for his great wisdom. As a result, he was given the responsibility of educating Achilles.

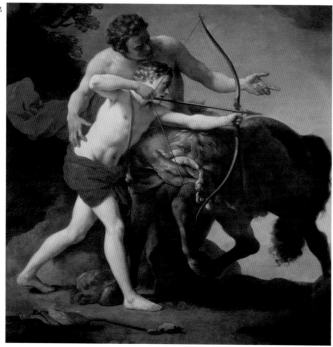

1 *Theseus and the Minotaur*
Antoine-Louis Barye, 1843
Academic

2 *The Education of Achilles*
**Louis-Jean-François Lagrenée
the Elder**, c. 1790
Neoclassicism

3 *Medusa*
Michelangelo da Caravaggio,
1598–1599
Baroque

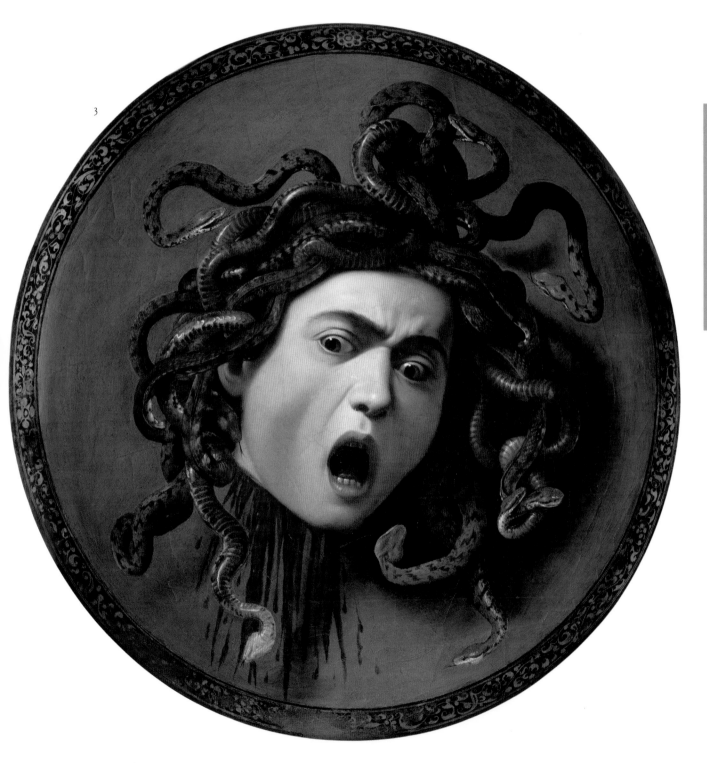

3

Icarus

According to legend, the inventor Daedalus and his son Icarus were imprisoned together on the island of Crete. In a bid to escape, Daedalus made two pairs of wings using feathers and wax, but warned Icarus not to fly too close to the heat of the sun. The headstrong youth ignored this advice. As he soared higher and higher, the wax slowly melted and Icarus plummeted into the sea and drowned. The theme was popular during the Renaissance, when it was used to illustrate the danger of pride. Pieter Bruegel's treatment is unusual because of the low-key depiction of Icarus. The boy's flight has been miraculous, but his death barely causes a ripple in the tide of human affairs. As his legs disappear into the sea, the ploughman and the fisherman go about their business as the sun sets in the sky. Henri Matisse reduced the myth to its most basic form, portraying it as a decorative cut-out in his *Jazz* series. Many of the illustrations for this book were produced during World War II when the theme of fallen aviators had an added poignancy. The bright flashes that surround the figure of Icarus have been interpreted as bursts of anti-aircraft shellfire.

1 *Icarus, from the Jazz series*
Henri Matisse, 1943–1947

2 *Landscape with the Fall of Icarus*
Pieter Bruegel the Elder, 1567–1568
Northern Renaissance

وزكودد زاظله عدأنارطه ازبعد شده زود بريدآيد دجهاز سبيده حيرد و زرد خورد و طعه ابا شد

اندر صورت سیمرغ

سیمغ اندردمارمحيط باند اندرجوزها بردکجظاشتوا و مژم بدارجای بنسند و هوا يجو وردلذ

Eastern Mythology

Rama is the hero of the Indian epic of the *Ramayana*. In one episode his wife was carried off to Sri Lanka by a powerful demon, Ravana. Immediately Rama set out to rescue her, aided by an army of monkeys. These were led by Hanuman, the Hindu ape-god who epitomized loyalty and duty. After Rama killed Ravana the lethal arrow returned magically to his quiver. In Persian mythology, the Simurgh is a mystical creature that has the ability to heal the most grievous wounds. Initially it was depicted as a griffin (a lion's body with an eagle's head), but later images portray it as a gigantic bird with magnificent plumage. The Simurgh is as old as creation itself and is renowned, above all, for its immense wisdom. It lived for eons amid the branches of the Tree of Knowledge before seeking seclusion on the Persian mountain of Alburz. The tragic tale of Layla and Majnun, the lovers who could never be united, was a favorite of eastern storytellers. The most famous version, perhaps, was produced in the twelfth century by the poet Nazami who included it in his *Khamsa*, an anthology of legends.

1 *Simurgh (Bird Akin to the Phoenix) on an Island, from "Advantages to be Derived from Animals" by Ibn Bakhtishu*
Artist unknown, 1297–1300
Persian

2 *Rama on Hanuman Fighting Ravana*
Artist unknown, c. 1820
Indian

3 *The Death of Majnun on Layla's Grave, from the "Khamsa" by Nazami*
Artist unknown, 1494–1495
Herat School

Allegory

An allegory portrays an abstract idea through symbolic figures and creatures. It is a device used in literature and drama, as well as in the visual arts. "Truth," "wisdom," "chastity," "evil," and "liberty" are examples of the types of abstract ideas that can be shown in allegorical form as a person, a plant, or a creature. The Statue of Liberty standing with her arm raised above the Hudson River in New York is one of the most famous of all allegorical figures. Sent to the United States by the people of France, she represents freedom from oppression.

In a second-century burial chamber unearthed below the Vatican, some of the earliest-known Christian mosaics show that pagan and Christian worship co-existed in the city. Christ is shown ascending into heaven as if he is the sun god Helios, who rode his chariot on a daily journey across the sky. Sun worship was still important at this time and using allegory to show the god of the sun as the Son of God was a useful way of representing both beliefs.

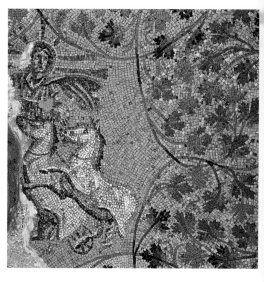

Symbolic figures can also stand for a nation, a city, or the spirit of a place. This harks back to the pagan belief that the gods resided in natural features. River gods were traditionally portrayed as old men with long, straggly beards and a crown of reeds. Giambologna adapted this figure in the sixteenth century to create an enormous mountain god rising out of the earth. Commissioned by the Medici family, the colossus represents the Apennine mountain range, which runs down the backbone of Italy, and functions a powerful symbol of the Medici's strength and power as rulers of Tuscany.

Another use of allegory is to portray a sitter in the guise of a classical figure in order to stress aspects of their personality. Jean-Marc Nattier's eighteenth-century portrait of the aristocrat Marie Adelaide shows her as Diana the huntress, as identified by her bow and arrows. Diana represents chaste virtue, so the intent of the patron and artist is to compliment the character of the sitter.

[top]
Fountain of the Apennines
Giambologna, 1580
Mannerism

[bottom]
Christ as the Sun God Helios, from the Tomb of Julii
Artist unknown, c. 200–300
Early Christian

[opposite page]
Marie Adelaide of France Represented as Diana
Jean-Marc Nattier, 1745
Rococo

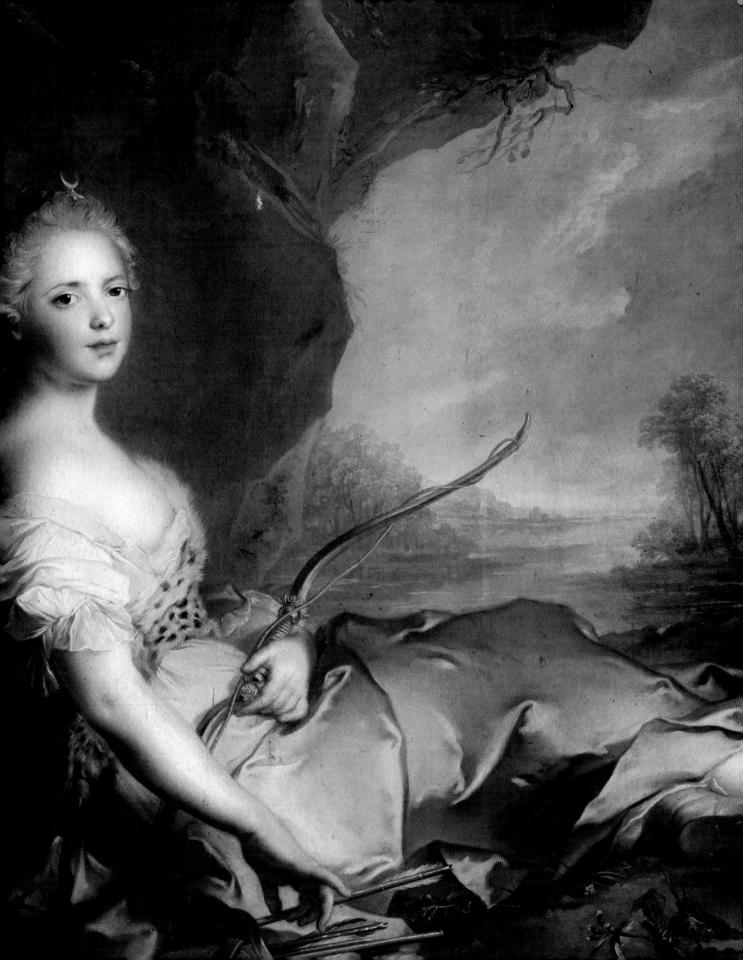

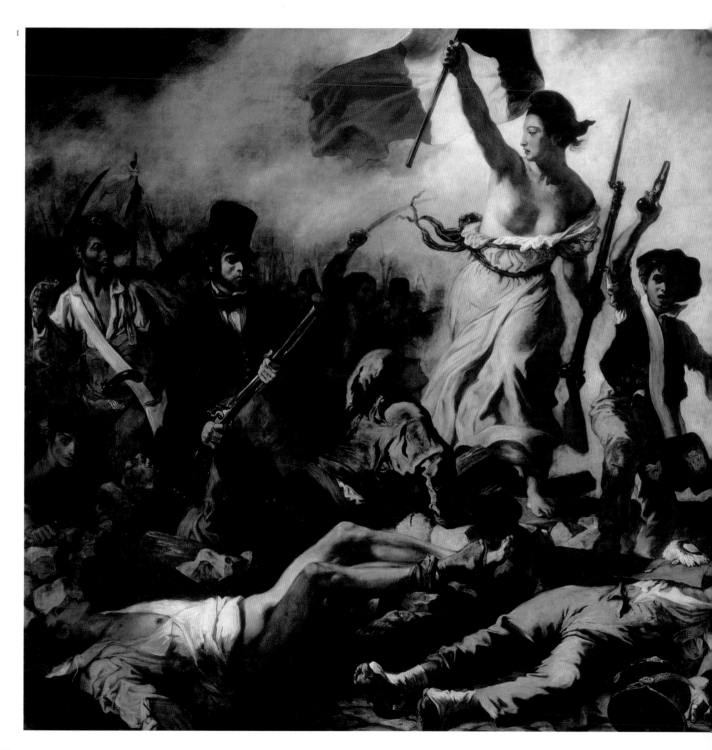

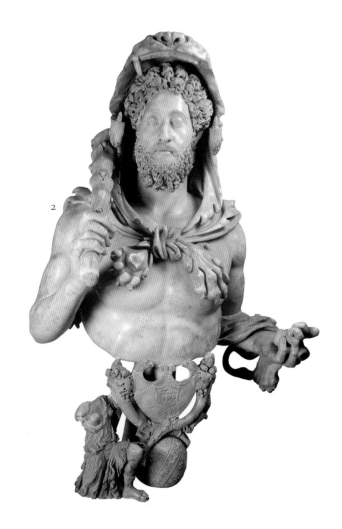

Civic Allegory

Allegory is used to highlight the role of civic institutions and commemorate national events. A court house, for example, will often be decorated with an allegory depicting the holder of the scales of justice. Invariably portrayed as a woman, as in this version by Jacobello del Fiore, produced for the Doge's Palace in Venice, Justice holds a sword, representing power, and a pair of scales, signifying impartiality. Civic allegories were frequently commissioned by the state to underline the moral significance of major events. Eugène Delacroix's picture was an important state commission to commemorate the July Revolution of 1830 when Emperor Charles X was ousted from power. Liberty leads the people to freedom wearing her symbolic red cap—a reference to the cap given to freed slaves in ancient Rome. Critics found the personification of Liberty far too realistic and politicians saw the dramatic painting as politically provocative. As a result, the French government quietly removed it from public view. The bust of the Roman emperor Lucius Commodus was also controversial. Obsessed with power in the latter part of his reign, he renamed Rome *Colonia Commodiana,* "the Colony of Commodus," and declared himself the reincarnation of Hercules. He is shown here with the hero's usual attributes—a club and lion's skin.

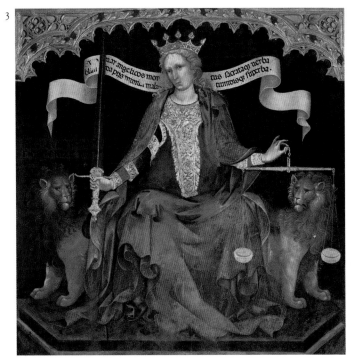

1 *Liberty Leading the People, July 28, 1830*
Eugène Delacroix, 1830
Romanticism

2 *Bust of Commodus as Hercules*
Artist unknown, c. 190–192
Imperial Roman

3 *Justice*
Jacobello del Fiore, 1421
International Gothic

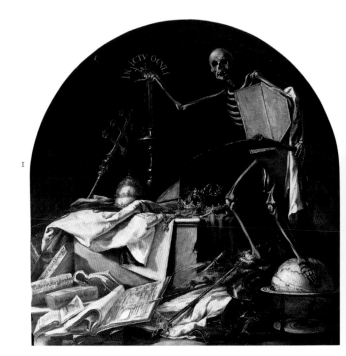

1 *Allegory of Death*
 Juan de Valdes Leal, 1672
 Baroque

2 *Garden of Love*
 Peter Paul Rubens, c. 1630–1632
 Baroque

3 *Melancholia*
 Albrecht Dürer, c. 1514

4 *Innocence Preferring Love to Wealth*
 Pierre-Paul Prud'hon, 1804
 Neoclassicism

5 *The Inspiration of the Epic Poet*
 Nicolas Poussin, c. 1630
 Baroque

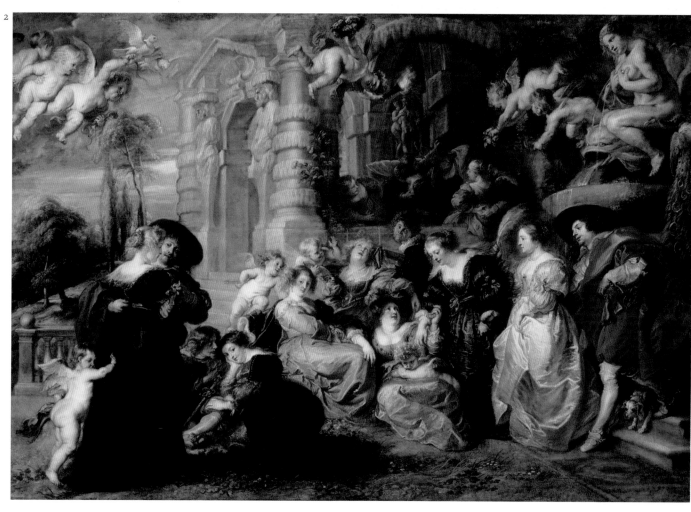

Personal Allegory

Paintings using personal allegory as a central theme consider human fears, inspirations, and desires. For artists this was a useful device when considering complex and emotive subjects such as death and sexual love, as well as moral dilemmas. In Pierre-Paul Prud'hon's painting the figure representing Innocence, identified by her white dress, is forced to choose between material wealth and the love-god in her arms. The warmth of her embrace hints strongly at her decision. Nicolas Poussin's painting symbolizes literary inspiration, represented by Apollo, leader of the Muses (center), and Calliope, muse of epic poetry (left). The human condition of melancholia was an important theme from ancient times. For Renaissance philosophers, melancholy was personified as the winged daughter of Saturn, who presided over introspective and contemplative pursuits, and was frequently portrayed in a state of despondency at her failure to achieve her intellectual goals.

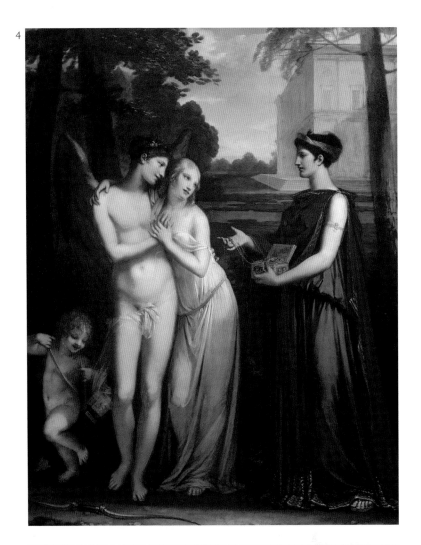

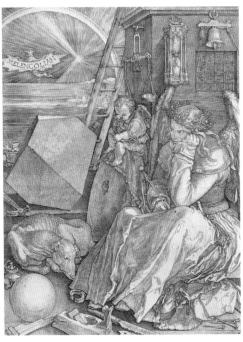

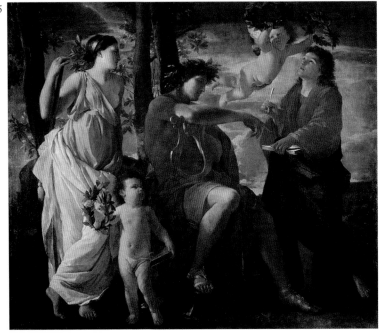

Fantasy

Fantasy has been an ever-present feature of art, with each generation of artists interpreting the theme in its own distinctive manner, from the demons of ancient civilizations, through the dragons and spirits of Eastern art, to the psychological imaginings of the Surrealists in the twentieth century. During the Middle Ages, the prevailing fashion was for grotesque distortions of human and animal forms. These figures filled the margins of illustrated manuscripts, while the carved equivalents were the gargoyles and misericords featured in church architecture. Sermonizing painters loved to provoke their public with terrifying visions of hell and damnation. The most imaginative artist in this field was Hieronymus Bosch. His repertory included hollow men with eggshell bodies, demons with tree-like limbs, and man-eating birds with long, spiky beaks. These kinds of torments were echoed in the works of other cultures. Japanese painters, in particular, created a richly inventive array of demons, ghosts, and dragons.

Fantasy was not always linked with terror. Renaissance artist Giuseppe Arcimboldo enjoyed a successful career producing novelty pictures in which a human head was composed out of an assemblage of fruit, flowers, or vegetables. The Surrealists hailed him as one of the precursors of their movement. The Romantics also placed great emphasis on fantasy and the imagination. This love of fantasy explains their fascination with fables and fairies, folklore and myths.

In the twentieth century Marc Chagall developed a magical strain of fantasy, drawing inspiration from the Jewish and Russian folklore of his childhood. His visually stunning fantasies draw inspiration from many of the avant-garde movements, but they can be, at the same time, idealistic and romantic. Love involves the physical combining of a man and woman, and he floats his figures in their ecstasies. His mythical ideal village is one where man and beast live in harmony. He was greatly admired by the Surrealists, who based their own fantasies on the exploration of dreams and the human psyche to produce the most fantastical art ever created.

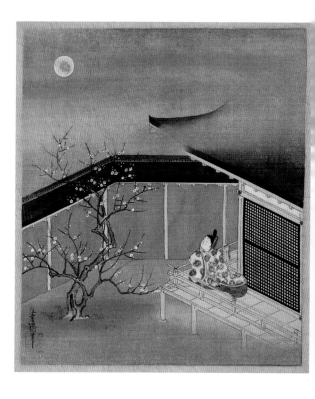

[top]
A Demon Flees from the Thunder God
Kano Josen Chikabobu, c. 1800
Japanese, Edo period

[opposite page]
Birthday
Marc Chagall, 1915

456

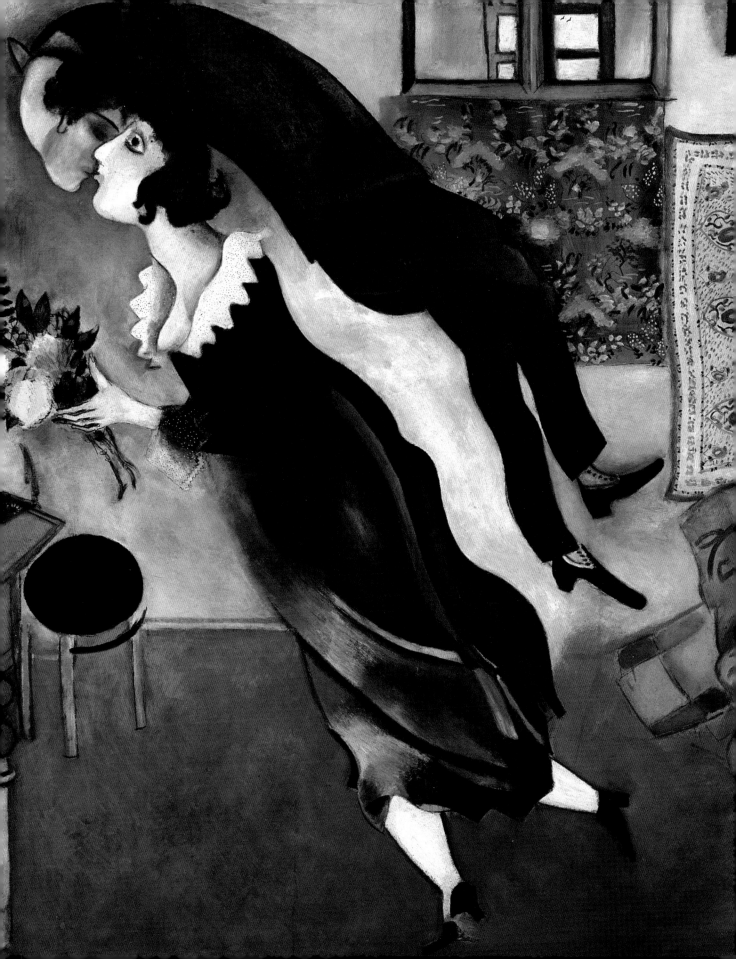

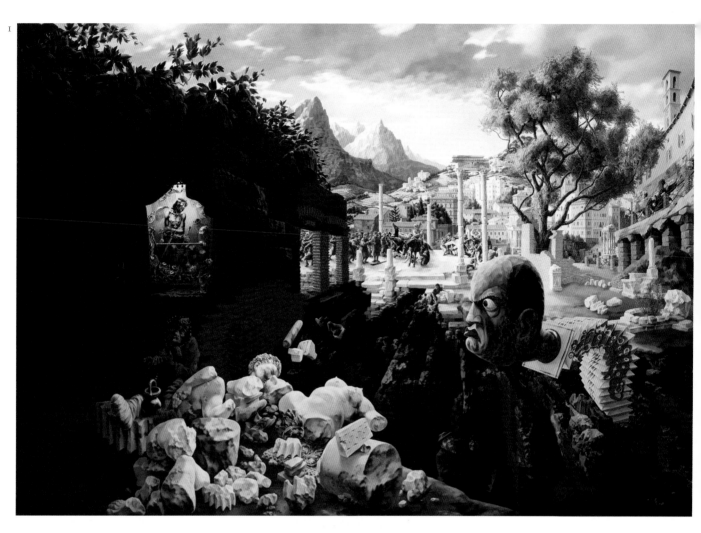

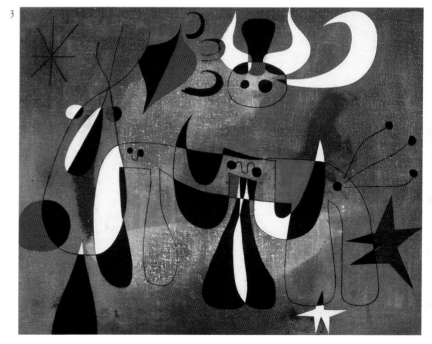

458

Surrealism

The guiding principle at the heart of Surrealism was a desire to produce art that was free from the restraints of reason, aesthetics, and morality. In pursuing this aim, painters adopted a wide variety of styles. Some produced pictures that resembled hallucinations or dreams in which individual figures or objects were depicted in a startlingly realistic manner, but were juxtaposed in a way that defied rational analysis. Other artists produced semi-abstract works by deliberately suppressing conscious control over their compositions, so that the workings of the subconscious would reveal themselves in their automatic drawings. Joan Miró and Yves Tanguy were leading exponents of this second approach. As the latter remarked, "I found that if I planned a picture beforehand, it never surprised me, and surprises are my pleasure in painting." Miró, meanwhile, created whimsical, biomorphic shapes, coupled with more recognizable signs, such as the moon and stars in this picture. With his bizarre heads, composed of animals, fruit, flowers, and fish, Giuseppe Arcimboldo was hailed as a sixteenth-century precursor of the Surrealists, and was highly admired by them. A Russian-born painter, Peter Blume, pioneered the style in the USA. *The Eternal City* was his most controversial painting, dealing with the rise of fascism in Italy, portraying Mussolini as a monstrous jack-in-the-box.

4

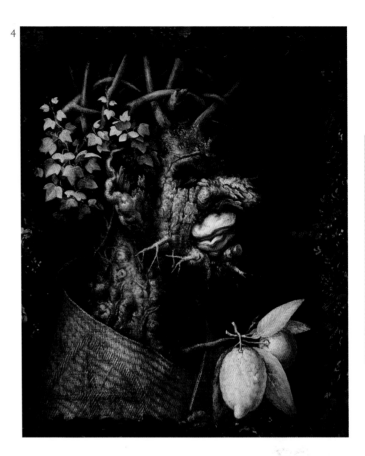

5

The Eternal City
Peter Blume, 1937
Surrealism

2 *Mama, Papa is Wounded!*
(Maman, Papa est Blessé!)
Yves Tanguy, 1927
Surrealism

3 *Personages in the Night*
Joan Miró, 1950
Surrealism

4 *Winter*
Giuseppe Arcimboldo, 1573
Mannerism

5 *The Empire of Light II*
René Magritte, 1950
Surrealism

Death

Deaths, and in particular funerals, have long provided a major focus for artistic activity, since it was through art that the dead were often remembered and honored. From the earliest times, a portrait was usually an important part of a funerary ritual. The magnificent gold mask of the young Pharaoh Tutankhamen was buried with him alongside sumptuous gold coffins, furniture, vases, jewelry, and sculpture to accompany him to the afterlife. The Etruscans, too, maintained an elaborate cult of the dead. Some of their tombs resembled subterranean palaces, filled with furniture, pottery, and frescoes of banqueting scenes. On their sarcophagi, the dead are portrayed as living beings, participating in their final feast.

Commemorative art in later times was no less significant and Western churches are filled with the elaborate tombs of rulers, commanders, and religious leaders, as well as artists, statesmen, soldiers, and businessmen. El Greco's painting of his burial was designed to hang directly above the Count of Orgaz's tomb, so it appeared as if his body was being lowered into its resting place. The picture shows a miracle in progress. This Spanish aristocrat gained such a reputation for piety during his lifetime that it was believed that Christ decided to reward him. While his funeral was in progress, the heavens opened and Saints Stephen and Augustine came down to assist in the ceremony. Saint Stephen is identified by an image of his martyrdom by stoning, shown on his vestment. This is typical of Christian art, where saints often carry symbols of their martyrdom as a form of identification for the viewer.

In the center of the picture, an angel cradles the Count's soul, which is being carried up to heaven. In Christian art, the precise moment of death was sometimes illustrated by a tiny human figure, representing the soul, issuing from the mouth of the deceased, and being gathered up by angels. This type of image was usually reserved for saints.

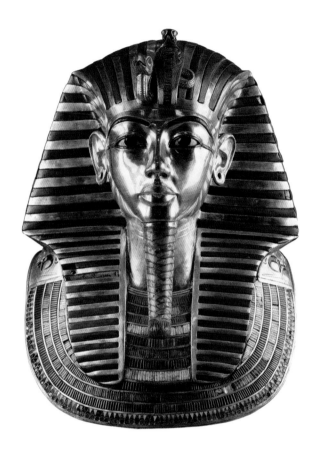

[top]
Tutankhamen's Funerary Mask
Artist unknown, c. 1330 BCE
Ancient Egyptian

[opposite page]
The Burial of Count of Orgaz
El Greco, 1586–1588
Mannerism

Murder

Jean-Paul Marat was a leading figure of the French Revolution, but the mass executions that he authorized made him a target for bloody revenge. In 1793, he was assassinated in his bath by Charlotte Corday. Jacques-Louis David, who was closely involved in the revolutionary cause, took the opportunity to portray him as a martyr. Marat's pose echoes pictures of the dead Christ and David was careful to remove his disfiguring skin condition. He also played down the violence of his death, discreetly keeping the knife, the wound, and the blood half hidden in shadows. By contrast, Artemisia Gentileschi's depiction of *Judith Beheading Holofernes* could not be more graphic. The Jewish heroine slaying an enemy general had been portrayed by artists since the Middle Ages, as a symbol of virtue overcoming vice. Gentileschi was raped in her youth and her several versions of the theme have been interpreted as a form of artistic revenge against her male aggressor. In a very different vein, René Magritte's painting is a surreal take on a murder mystery, posed as if the figures are actors on a stage. The man casually listening to the gramophone appears to be the murderer, but Magritte leaves the viewer to concoct his or her own storyline.

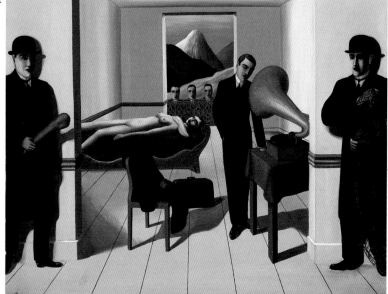

1 *Marat Assassinated in his Bath*
Jacques-Louis David, 1793
Neoclassicism

2 *The Menaced Assassin*
René Magritte, 1926
Surrealism

3 *Judith Beheading Holofernes*
Artemisia Gentileschi, 1611–1612
Baroque

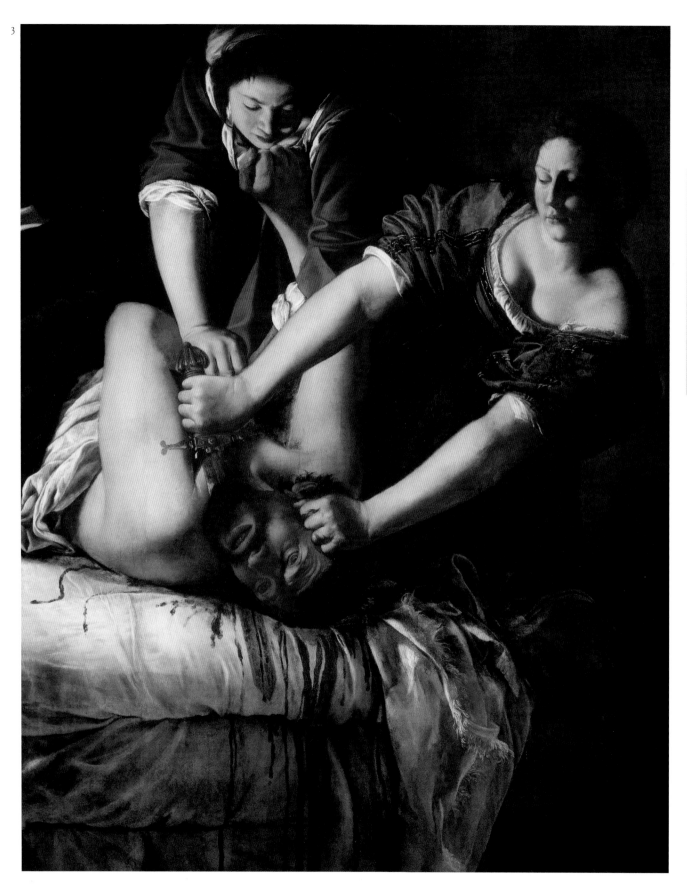

Literature

Before the advent of printing, stories were repeated at gatherings by professional storytellers or sung in ballads by wandering minstrels. During the Middle Ages artists frequently depicted the themes of chivalry and courtly love that featured strongly in such songs and stories. The legends of King Arthur offered the richest source of material, but there was also a taste for allegorical romances, typified by the *Roman de la Rose* and René d'Anjou's *Le Livre du Coeur d'Amour Epris*. The appeal of these tales endured as an inspiration for artists through history.

Romances were equally admired in Japan, where Murasaki Shikibu's *Tale of Genji* proved a popular subject for artists. Written in the eleventh century for the enjoyment of high-ranking women, the story presents a vivid picture of life at court during the Heian period of the first and second centuries. Its success proved enduring. The example here comes from a shell game box created in the Edo period. Scenes from the book were painted on both the box and the individual shells. The game itself symbolized marital fidelity and was often given as a wedding present. From ancient times in China, artists were often also poets, combining their words in calligraphy with ink illustrations in beautiful albums created for the intellectual elite. Many epic mythological poems from such Eastern cultures as Persia and India were beautifully illustrated in handwritten manuscripts.

The works of Dante Alighieri, the late-Medieval Italian writer, were often illustrated in manuscripts that were as magnificent as those of the Bible. During the Renaissance, both Dante himself and scenes from his works were often featured in paintings. Other writers such as William Shakespeare and Miguel de Cervantes have inspired artists as diverse as William Blake and Pablo Picasso to feature their stories and characters in their art.

[top]
Midas's Daughter Turned to Gold,
from Nathanial Hawthorne's "A
Wonder Book for Boys and Girls"
Walter Crane, 1892
Symbolism

[opposite page]
Game Box Decorated with
Scenes from the "Tale of Genji"
Artist unknown, c. 1600–1800
Japanese, Edo period

465

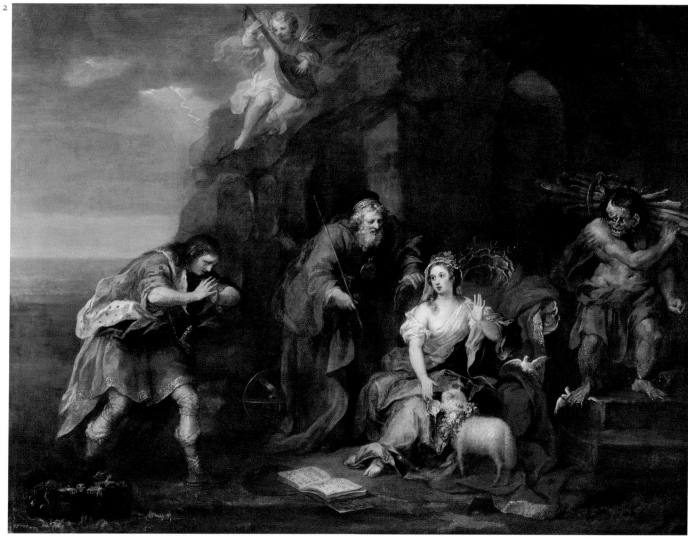

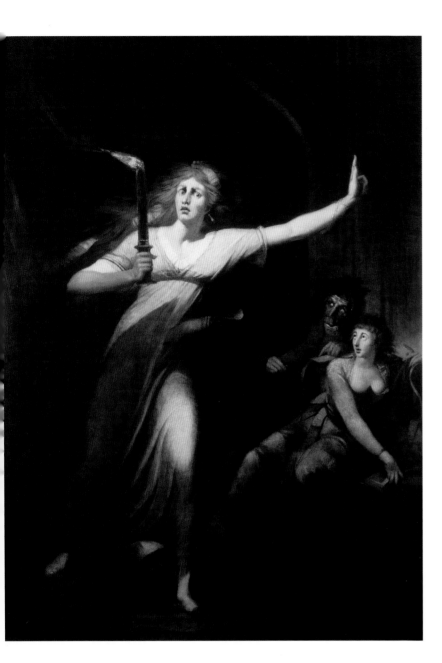

William Shakespeare's Plays

Shakespeare's work became an important source of artistic inspiration in the eighteenth century, as part of a deliberate move to raise the status of British art. William Hogarth led the campaign, bemoaning the fact that there was no national school of painting, and that the most lucrative and prestigious commissions always went to foreign artists. John Boydell, a wealthy publisher who became Lord Mayor of London, devised a practical plan. In the 1780s he founded the Shakespeare Gallery to house a permanent exhibition of artworks depicting scenes from the plays. These could be reproduced as engravings, introducing English art to a wider market. Boydell commissioned the leading artists of the time, one of whom was Henry Fuseli. In true Romantic fashion, Fuseli was particularly interested in dreams and fantasy. Here, he depicts a guilt-ridden Lady Macbeth, confessing her heinous crimes while sleepwalking. Puck, the mischievous hobgoblin from *A Midsummer Night's Dream*, became one of the most popular Shakespearean subjects. He was traditionally portrayed sitting on a mushroom because this was how he made his entrance in nineteenth-century stage productions of the play.

Puck
Harriet Hosmer, 1856

Scene from Shakespeare's "Tempest"
William Hogarth, c. 1735
Rococo

Lady Macbeth Sleepwalking
Henry Fuseli, c. 1784
Romanticism

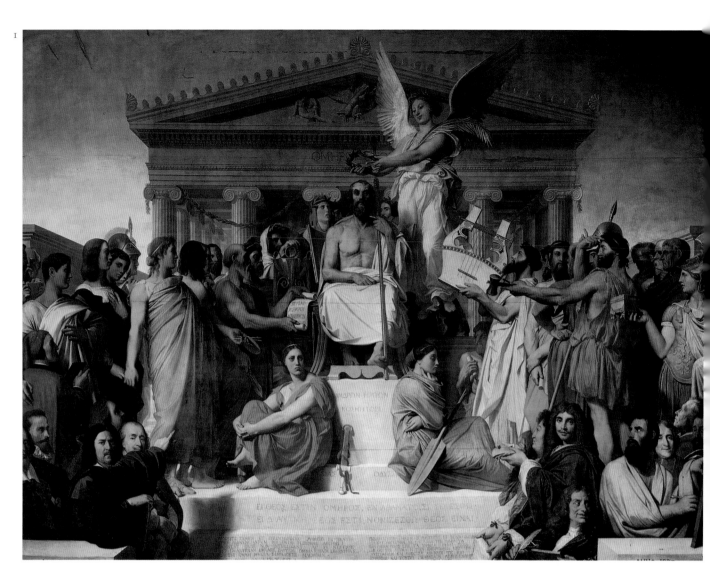

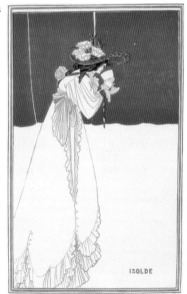

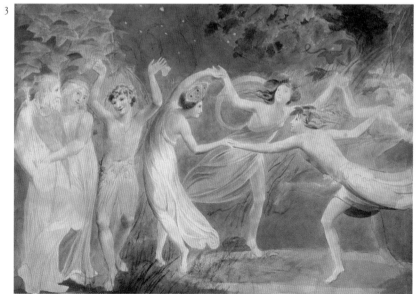

Apotheosis of Homer
Jean-Auguste-Dominique Ingres,
1827
Neoclassicism

Isolde
Aubrey Beardsley, 1899
Art Nouveau

Oberon, Titania, and Puck with Dancing Fairies
William Blake, c. 1785
Romanticism

"Buy from Us with a Golden Curl," from "Goblin Market and Other Poems" by Christina Rossetti
Dante Gabriel Rossetti, 1862
Pre-Raphaelite

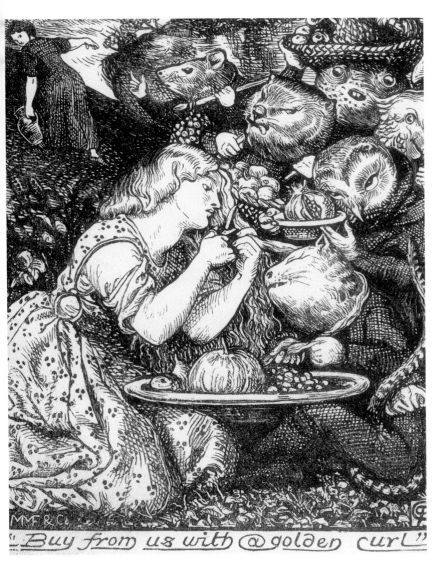

Nineteenth-Century
Images of Literature

Literature had always provided a rich source of inspiration for artists, but the sheer diversity of this material increased dramatically in the nineteenth century. The continued success of Neoclassicism ensured that authors from the ancient world were feted. Jean-Auguste-Dominique Ingres's painting was virtually a manifesto for the movement, paying homage to the author of the *Iliad* and the *Odyssey*. Some artists had a talent for both writing and painting. William Blake is most famous for illustrating his own, remarkable poems, though he did also tackle some subjects from other writers, such as Milton, Dante, and Shakespeare. It is hardly surprising that he chose to depict one of the fairy scenes from *A Midsummer Night's Dream*. Blake was a firm believer in the tiny creatures, and left a detailed description of a fairy funeral that he claimed to have witnessed in his garden. Dante Gabriel Rossetti was also a poet, though his sister Christina was far more famous in this field. Included here is an illustration from her *Goblin Market*, where a young girl buys some magical fruit with a lock of her hair. At the end of the century, Aubrey Beardsley gained a scandalous reputation for his strange, erotically charged drawings of literary subjects.

History

In Western art, the term "history painting" does not simply refer to images of the past. Deriving from the Italian term *istoria* (story), it refers to any picture that presents morally uplifting ideas or emotions in a grand manner. In practice, it was applied to scenes from the Bible, classical mythology, or great literature, as well as historical events. The European academies, which supervised education and maintained artistic standards for several centuries, asserted that this was the highest branch of the arts.

Images of historical events are frequently employed in public art, a tradition that goes back many centuries. Political regimes throughout the world have often used sculpture to glorify their achievements, instill a sense of national pride, and celebrate victories, heroes, and statesmen. The scenes portrayed on Trajan's Column typify this trend. Trajan, who ruled in the early second century, was one of the greatest of the Roman emperors, and his deeds were commemorated on this massive monument in the heart of the city. In particular, his victorious campaigns in Dacia (now part of Romania) were depicted in a continuous, winding spiral around the column. The effect is almost cinematic. Trajan's ashes were deposited in the base of the monument and, for many years, there was a statue of the emperor at its summit.

Another important tradition was painting an historic scene at a time when its relevance had enormous impact. Jacques-Louis David's *Oath of the Horatii* is an example of this kind of statement. It was painted in the years leading up to the French Revolution of 1789, when there was growing dissatisfaction with the monarchy. David, who was to play a significant role in the uprising, caught the mood of the times. The *Oath* is set in ancient Rome, where three brothers are about to sacrifice their lives to defend the Republic. The themes of patriotism and self-sacrifice struck a revolutionary chord. When the painting was exhibited in public, David's contemporaries rightly saw it as a call to arms.

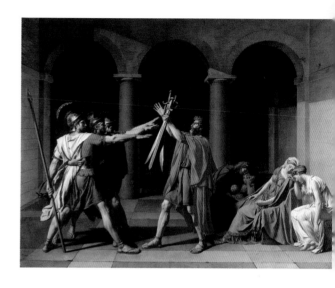

[top]
The Oath of the Horatii
Jacques-Louis David, c. 1784
Neoclassicism

[opposite page]
Trajan's Column
Artists unknown, 113–116
Imperial Roman

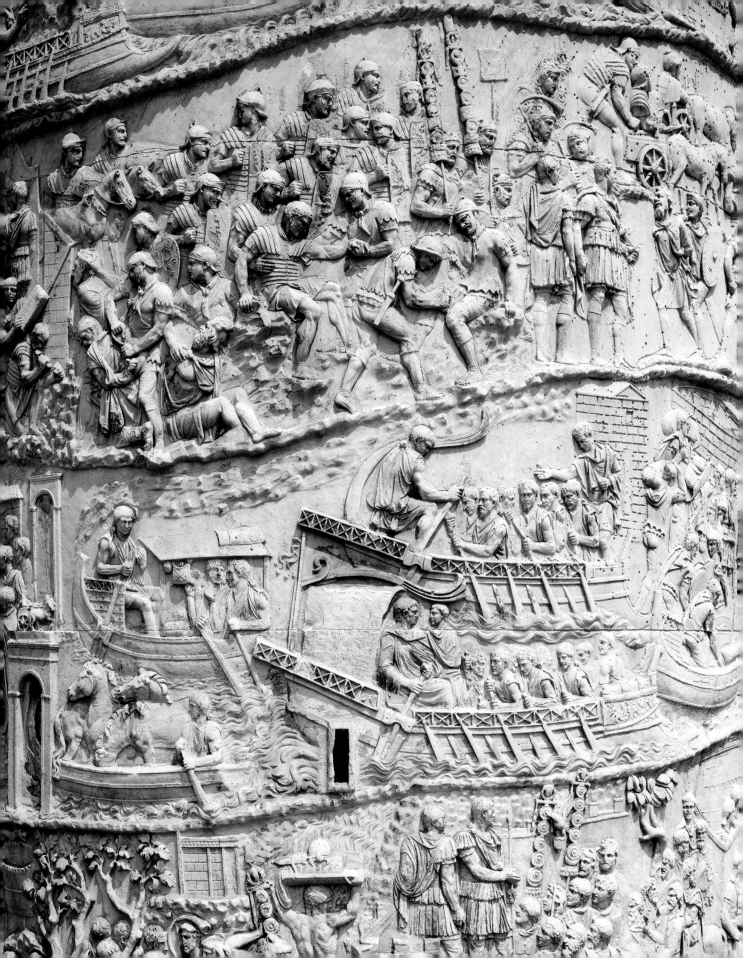

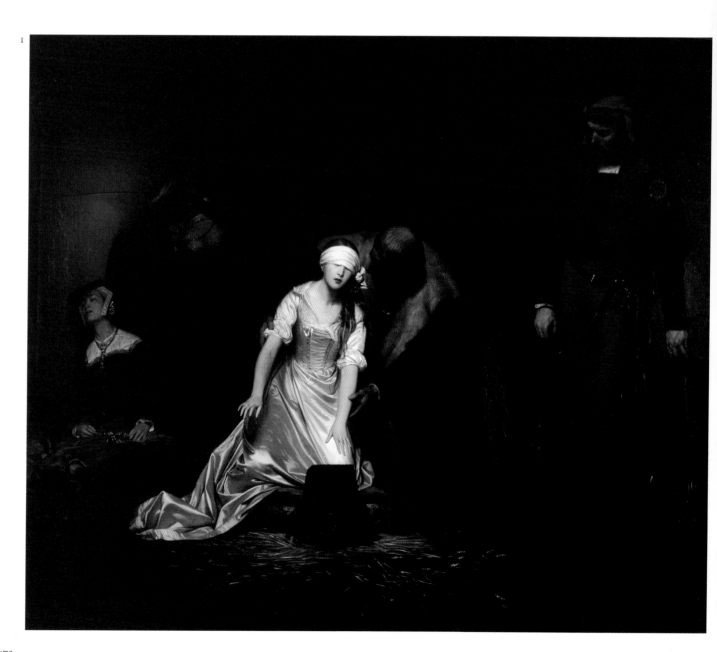

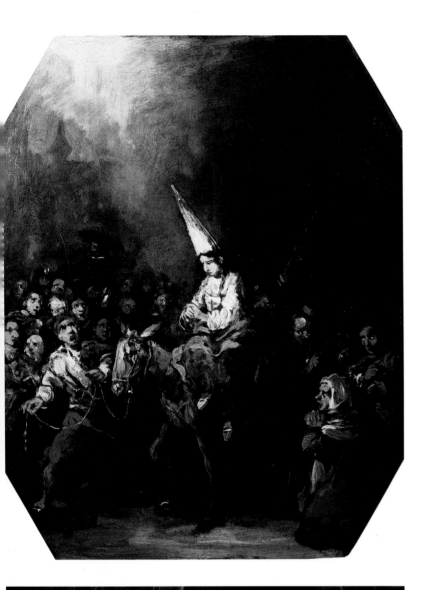

Victims of History

In the nineteenth century, there was a growing tendency for artists to concentrate on personalities rather than the great events of history. Often the results were highly sentimental. The work of Paul Delaroche typifies this trend. Although a Frenchman, he frequently selected subjects from English history, favoring episodes that were particularly poignant—Oliver Cromwell gazing down at the executed corpse of King Charles I, the doomed Princes facing execution in the Tower of London. *The Execution of Lady Jane Grey* concentrates on an unfortunate woman caught up in the maelstrom of Tudor politics. She ruled England reluctantly for just a few days before falling from power. Delaroche places a spotlight on her as if her execution is a melodrama played out on the stage. The fate of Egypt's Queen Cleopatra was also a popular theme, particularly in seventeenth-century Italy. Most artists used the Greek historian Plutarch as their source but fact mingled freely with fiction, especially in the fanciful depictions of her suicide. Eugenio Lucas y Padilla was influenced by Francesco de Goya, and imitated the great artist in his use of the theme of the Spanish Inquisition. Goya himself suffered at the hands of the Catholic Church.

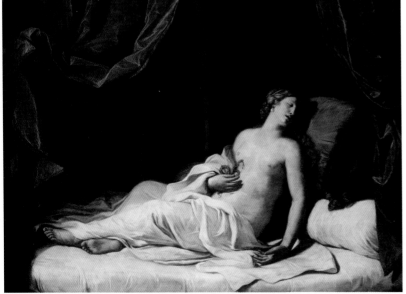

1 *The Execution of Lady Jane Grey*
 Paul Delaroche, c. 1834
 Academic

2 *A Woman Condemned by the Inquisition*
 Eugenio Lucas y Padilla, c. 1850

3 *The Dying Cleopatra*
 Il Guercino (Francesco Barbieri), c. 1648
 Baroque

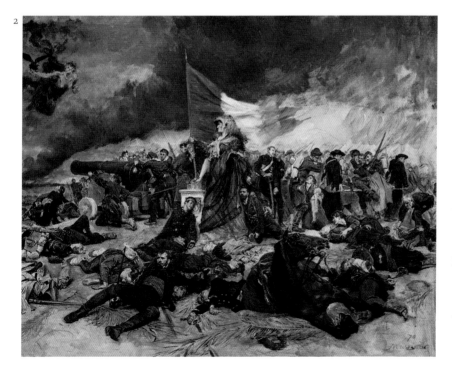

Recording Historic Events

Giuseppe Garibaldi was the driving force behind Italian unification. In his youth, he joined the failed republican uprising of 1834 before fleeing to South America, where he became involved in guerrilla fighting. On his return to Italy, he played an important role in the *Risorgimento,* the nationalist "resurgence" movement that united the country under Victor Emmanuel II. As a national hero, Garibaldi retired to the island of Caprera in 1870. Ernest Meissonier's picture casts a French perspective on the Franco-Prussian War, a terrible conflict in which Garibaldi had fought. It culminated in a siege when Paris was encircled and starved into submission. Meissonier had built a reputation as a painter of rather decorous military scenes, but the realities of war instilled a new passion into his work. Napoleon was highly conscious of his public image and employed the finest French artists of the day so that he could record his own version of history. Here, he is shown touching the sores of plague victims during one of his campaigns. This was designed to illustrate his compassion, while also hinting that he might have healing powers. Thomas Couture's picture, showing the decadence of Rome before the collapse of the empire, received great acclaim at the Paris Salon of 1847, though it was only the classical setting that made the lurid subject matter respectable.

1 *Garibaldi at Caprera*
Vincenzo Cabianca, c. 1870
Academic

2 *The Seige of Paris*
Ernest Meissonier, 1870–1871
Academic

3 *The Romans of the Decadence*
Thomas Couture, 1847
Academic

4 *Napoleon Visiting the Plague Victims at Jaffa, March 11, 1799*
Antoine-Jean Gros, 1804
Romanticism

3

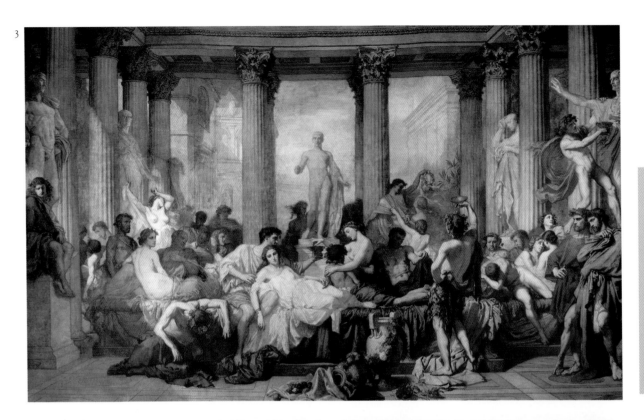

4

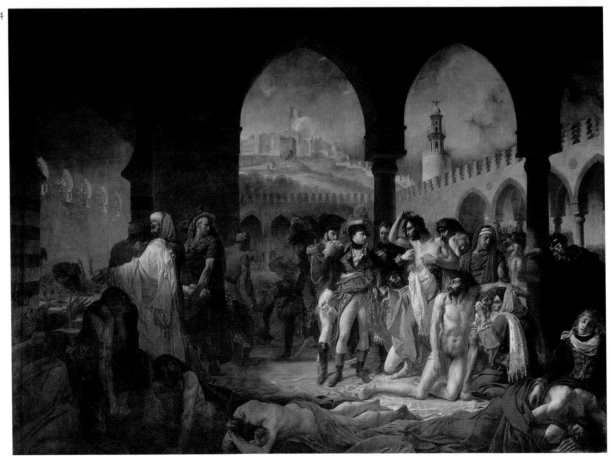

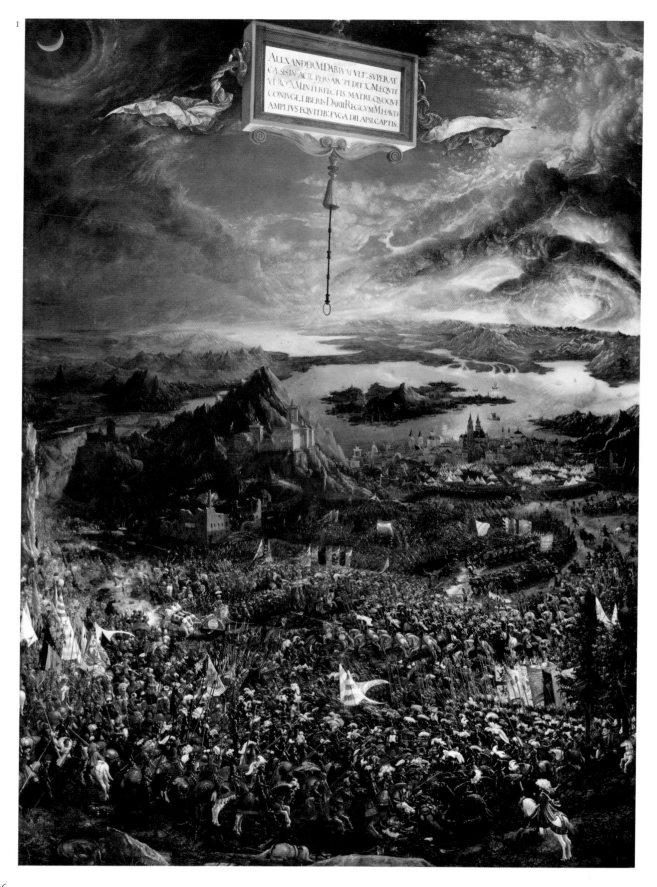

ALEXANDER M. DARIVM VLT. SVPERAT
CA. SIS IN ACIE PERSAR. PEDIT. CM. EQVIT
VERO. XM. INTERFECTIS. MATRE. QVOQVE
CONIVGE. LIBERIS DARII REGIS CVM M. HAVD
AMPLIVS EQVITIB. FVGA DILAPSI. CAPTIS.

Ancient History

The depiction of events from ancient history was for centuries one of the most prestigious themes in Western art. Historical accuracy was a low priority, however, and many of these pictures were more revealing about the present than the past. Albrecht Altdorfer's spectacular battle scene, for example, was one of a series produced for the Duke of Bavaria that contained thinly disguised references to a recent German victory at the Battle of Pavia (1525). Guillam van Haecht specialized in pictures of art collections, using this as the basis for his imaginary scene. According to legend, Alexander commissioned Apelles to paint his mistress, but the couple fell in love during the sittings, so Alexander gave her to the artist. Karl Pavlovich Bryollov's dramatic painting created a stir at exhibitions in Italy and France, and inspired Sir Edward Bulwer-Lytton to write his celebrated novel *The Last Days of Pompeii* (1834). Giambologna's statue shows one of the most popular of all ancient subjects in art, and relates to the legend that Rome, when it was founded, suffered from a shortage of women. This prompted a raid on the neighboring Sabines and the rape of their women, as well as their removal to Rome.

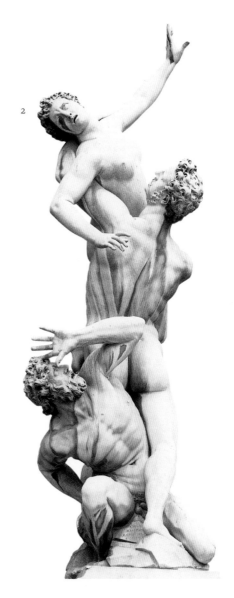

2

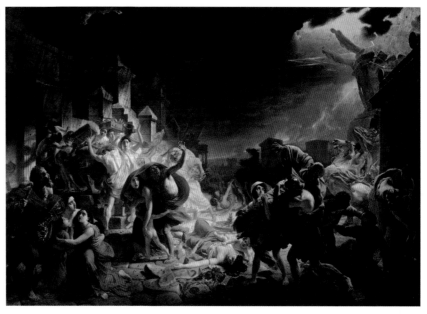

3

Victory of Alexander over Darius, King of the Persians
Albrecht Altdorfer, 1529
Northern Renaissance

Rape of the Sabine Woman
Giambologna, 1582
Mannerism

The Last Day of Pompeii
Karl Pavlovich Bryollov, 1828–1833
Academic

[following pages]
Alexander the Great Visiting the Studio of Apelles
Guillam van Haecht, 1628
Dutch Seventeenth Century

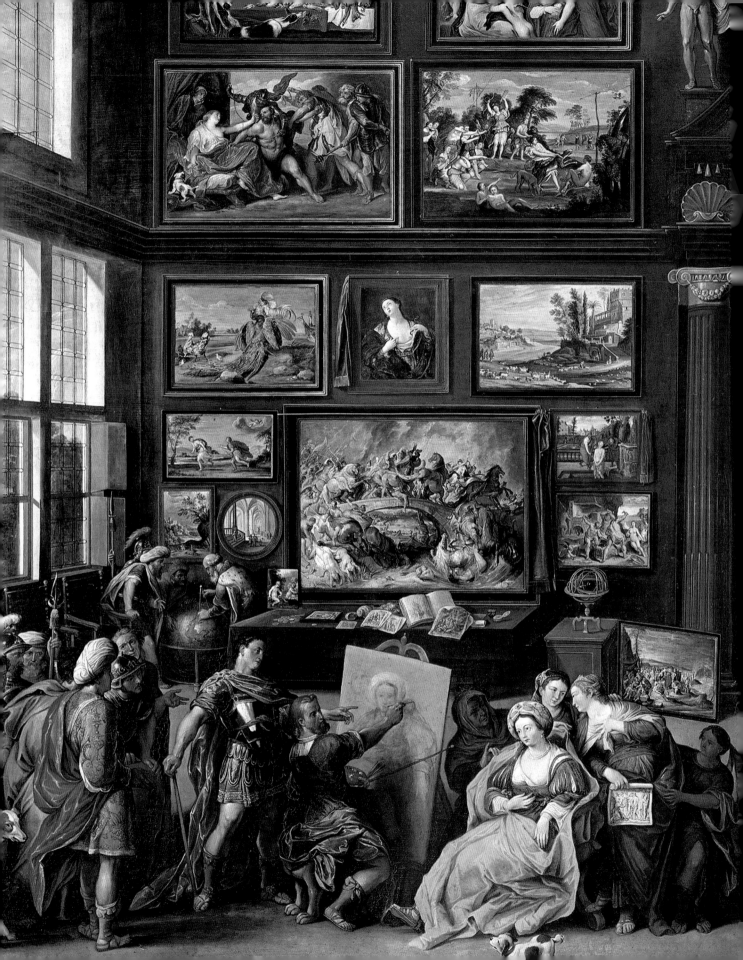

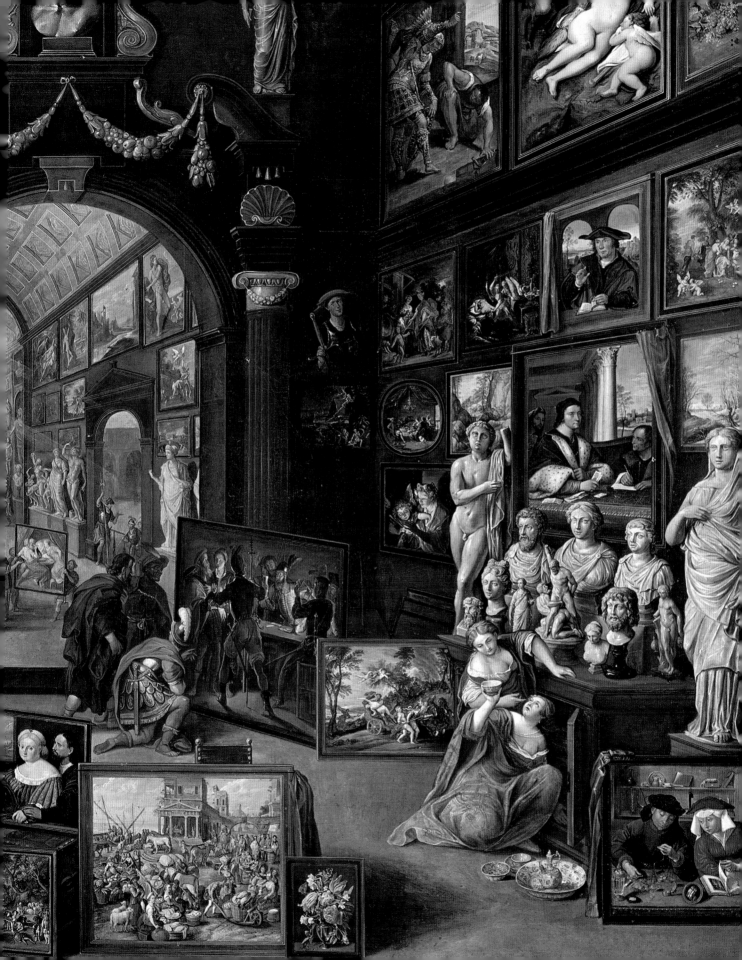

Politics

Politicians and rulers have traditionally been aware of the ways art could serve them. Throughout history, great statesmen and women, kings and queens, powerful family dynasties, and manipulative courtiers have used art to promote themselves and their cause, to celebrate their achievements, and to try to ensure public esteem. This tradition is as old as art itself. One of the earliest examples is the *Palette of Narmer*, an ancient slate carving. When Pharaoh Narmer united the two kingdoms of Egypt his feat was recorded on the palette, which Narmer presented to the temple at Hieraconopolis, where it served as a permanent reminder of his achievement. The ancient stele of Naram-Sin commemorates the victory of this Akkadian king over his neighbors, the mountain people of western Iran. Naram-Sin was revered as a god by his subjects, hence his greater stature on the stele; his horned helmet symbolizes divine power. In the carving, he pays homage to the sun god, in gratitude for his triumph.

Of course, political art can also be critical of those in authority. In the West, the most potent examples often appeared in graphic art. The savage barbs of James Gillray terrified English politicians in the eighteenth century, while Honoré Daumier's notorious nineteenth-century cartoon of the French king Louis-Philippe, portraying him as a mountainous glutton, earned the artist a spell in prison. In the twentieth century, when art was often used as a form of protest against political movements, some regimes felt the power of art was so great that they did their best to restrict artistic freedom. In Soviet Russia and other communist countries, Social Realism was promoted as the only acceptable form of public art; its purpose was to glorify Stalin and the Soviet state. Similarly in Nazi Germany, avant-garde modern art was branded "degenerate," and a bland form of retrospective academic art, National Socialist art, was installed in its place. Both nations lost their finest artists, who fled abroad as a result.

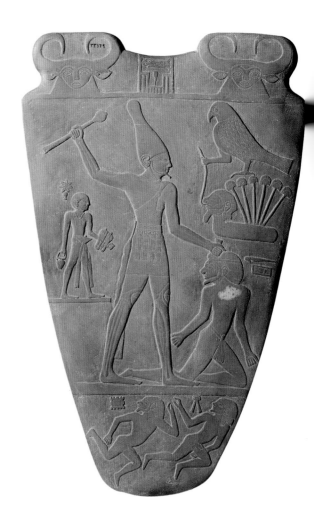

[top]
The Palette of Narmer
Artist unknown, c. 3150–3125 BCE
Ancient Egyptian

[opposite page]
*Stele with the
Victory of King Naram-Sin*
Artist unknown, c. 2250 BCE
Akkadian

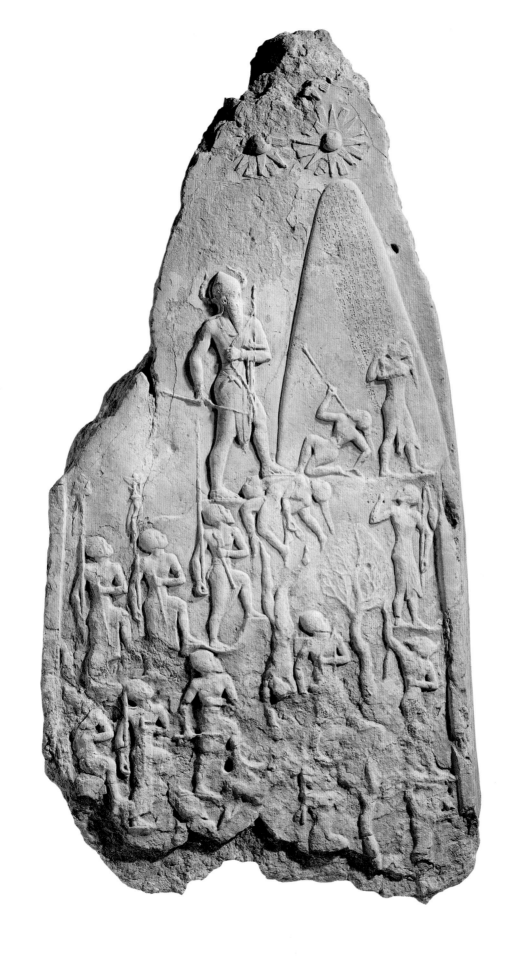

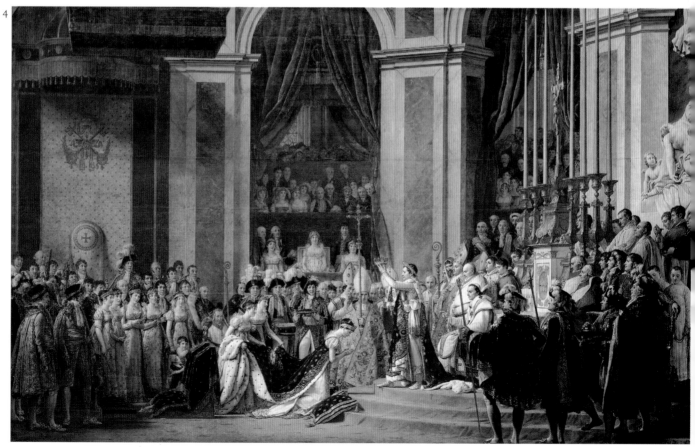

Royalty

The most powerful politicians through history have been the kings and queens who ruled with absolute control over their nations, often claiming divine power as well. Egyptian pharaohs were living gods whose magnificent tombs were decorated with their images to ensure their ongoing success in the afterlife. Queen Idia's memorial sculpture was used for its spiritual powers, to ensure her support of the rulers who followed her. The young Ottoman prince, seen riding in a romantic image of the aristocratic life, reflects a culture where royalty often enjoyed the distinction of being included in great epic stories telling of their exploits. The rulers of Europe also elevated their status, often through the use of magnificent paintings. No monarch epitomizes this process better than Elizabeth I of England. Her pictures are cult images, showing her as a legend rather than as a woman. Always her face is idealized and her clothing sumptuously bejeweled. Napoleon ensured that every highlight of his reign was recorded for posterity. The depiction of his coronation showing him crowning Josephine as the Empress was just such an occasion. It was all the more important because he had persuaded Pope Pius VII (seated behind Napoleon) to journey to Notre Dame cathedral in Paris to participate in the ceremony and add his divine blessing to an all-powerful monarch.

5

6

Queen Idia, Mother of Oba Esigie
Artist unknown, c. 1500–1525
Benin

King Thutmose IV, Kneeling and Making Offerings
Artist unknown, c. 1350 BCE
Ancient Egyptian

Portrait of Elizabeth I
Artist unknown, c. 1580–1600

The Coronation of Napoleon
Jacques-Louis David, 1805–1807
Neoclassicism

5 *A Royal Wedding, from the Codex Feudorum*
Artist unknown, c. 1100–1200

6 *A Young Prince on Horseback*
Artist unknown, c. 1600
Ottoman/Tabriz

Politicians

Portraits on coins were an important symbol of authority, particularly in an age where very few people were likely to see their ruler in the flesh. Roman emperor Claudius was a reluctant leader, preferring scholarship to power, but the position was forced on him as the last surviving member of the imperial line. He is best remembered for launching the invasion of the isles of Great Britain in CE 43. The coin also features his second wife, Agrippina, who is thought to have poisoned him with a dish of mushrooms. Niccolò Machiavelli was a statesman, historian, and dramatist, but his fame will always rest on his writing *Il Principe* (*The Prince*), a controversial treatise on the art of government. Written in 1513, after he had fallen from office, it supports the most cynical, political expediency, in which the ends always justify the means. Aleksandr Gerasimov produced some fine landscapes and flower pictures, but his artistic standing is most closely associated with propagandist portraits of the highest-ranking politicians of the Soviet Union. Vladimir Lenin, the father of the revolution, is shown as both an heroic leader and a man of the people as he gives a passionate speech. In his role as President of the Russian Academy of Arts (1947–1957), Gerasimov himself played a political role in stifling any experimental art in the Soviet Union.

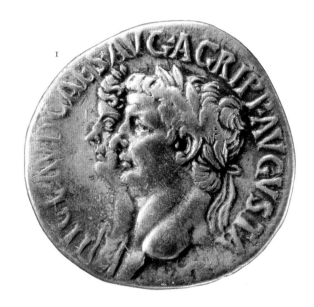

1 *Coin of the Emperor Claudius*
 Artist unknown, CE 50–51
 Ancient Roman

2 *Lenin on the Stand*
 Aleksandr Gerasimov, 1947

3 *Portrait of Niccolò Machiavelli*
 Santi di Tito, c. 1572
 Mannerism

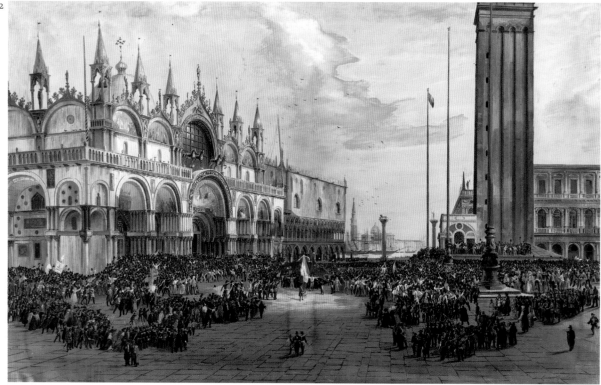

People in Politics

In February 1917, the Russian Revolution launched the most significant social upheaval of the twentieth century. The Tsar was removed from power and a provisional government formed. This was rapidly superseded by the Bolsheviks, led by Lenin and Trotsky. However, their radical policies were opposed by both the Mensheviks and the Tsarists, and the country was effectively in a state of civil war until 1921. Boris Kustodiev's painting dates from this turbulent period. In contrast to the revolutionary fervor that sweeps through Kustodiev's painting, Nicolas Lancret's picture is a stately affair. The Frenchman was a pupil of Jean-Antoine Watteau, and is best remembered for his wistful romances with costumed figures, painted in the manner of his master. As this parliamentary scene confirms, however, he was equally capable of sober restraint. In Luigi Querena's picture, meanwhile, the prevailing mood is one of patriotism. During Italy's long struggle for independence, the tricolor became a potent symbol of national unity and it continued to feature prominently in many paintings. In Querena's scene, the massive flag is about to be raised in front of Venice's most famous landmark.

Bolshevik, 1920
Boris Kustodiev, 1920
Social Realism

The People of Venice Raise the Tricolor in Saint Mark's Square
Luigi Querena, c. 1888

Solemn Session of the Parliament for King Louis XIV, February 22, 1723
Nicolas Lancret, c. 1723

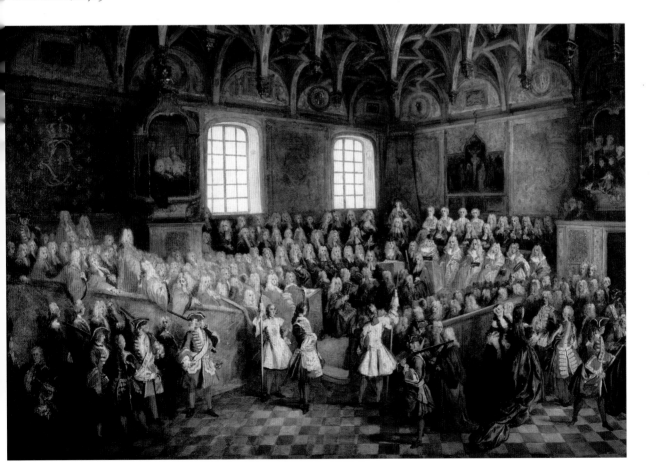

War

Beginning in antiquity, the portrayal of war became an occasion for the triumphant celebration of courageous conquest, showing the achievements in victory of a nation, ruler, or commander. More realistic scenes of warfare occurred mainly in works of art concerned with illustrating mythology, legend, and epic poetry.

Diego Velázquez's *Surrender of Breda* was one of a series of twelve paintings commemorating Spanish military victories. The Spanish army stands on the right with their proud row of lances, held rigidly upright, underlining the discipline and efficiency of the Spanish forces, in a telling contrast to the bedraggled weaponry of the defeated Dutch army on the left. In the center, the victorious Spanish commander lays a consoling hand on the shoulder of his foe as he receives the key to the town of Breda. The painting suggests that war is a civilized and honorable business, where glory can be achieved without apparent suffering.

In stark contrast, Francisco de Goya's painting focuses on the brutality of conflict, and was painted at a time when artists were beginning to use their work to express their personal concerns and moral outrage. It illustrates an episode from the Peninsular War (1808–1814), when Napoleon's armies occupied Spain. Following an uprising in Madrid, the French rounded up innocent civilians and put them to death.

Goya's scene is as artful as the Velázquez painting. He focuses on the individual in white to make the suffering seem more personal, in contrast to the faceless and anonymous row of executioners. The man holds out his arms, in a pose that is deliberately reminiscent of the crucified Christ. His size underlines his importance. In the painting, he is shown kneeling, but if he were standing, he would dwarf the other figures. In addition to this picture, Goya produced a harrowing series of prints, *The Disasters of War*, which depict the atrocities committed by both sides. In these images, war is no longer about heroism and glory, but about murder and torture.

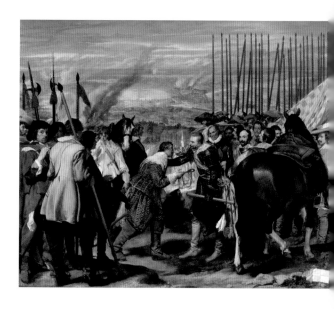

[top]
The Surrender of Breda
Diego Velázquez, c. 1634–1635
Baroque

[opposite page]
The Third of May 1808
Francisco de Goya, 1814

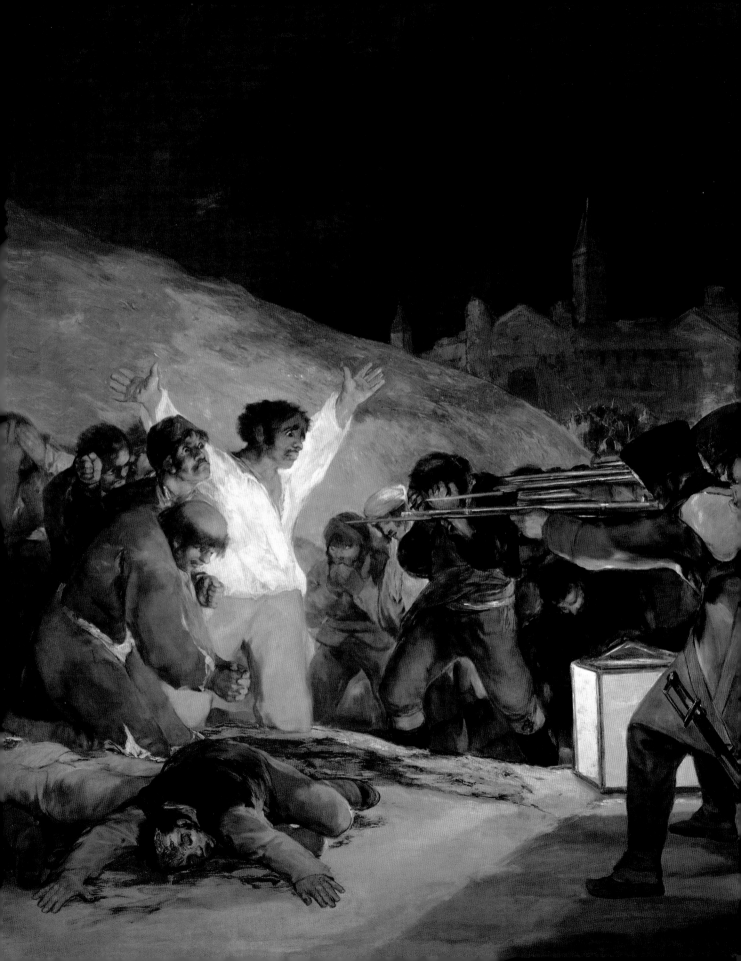

Soldiers

Most pictures of warfare have focused on battle scenes, partly because victorious leaders like to have a record of their triumphs, and partly because they offer greater scope for dramatic compositions. However, a number of artists have focused more closely on the soldiers themselves, much to the relief of historians, who can glean more information from documentary pictures of this kind. One of the earliest examples is a unique find that the archaeologist Heinrich Schliemann discovered at Mycenae in 1874. On an ancient vase, soldiers wear two different types of armor. Some have horned helmets, others wear crested headgear, but all carry small shields and spears. The horned helmets are particularly intriguing, given that some prehistoric gods were depicted as men with horns. From a considerably later date, the Bayeux Tapestry has also provided historians with much food for thought. Running to a length of some 230 feet (70 meters), it was designed to illustrate the Norman Conquest of England in 1066. It is of particular interest because it covers the entire campaign, from the original dispute to the final outcome. Along the way, it shows how the Normans constructed their ships, what armor they wore, and what tactics they employed.

1

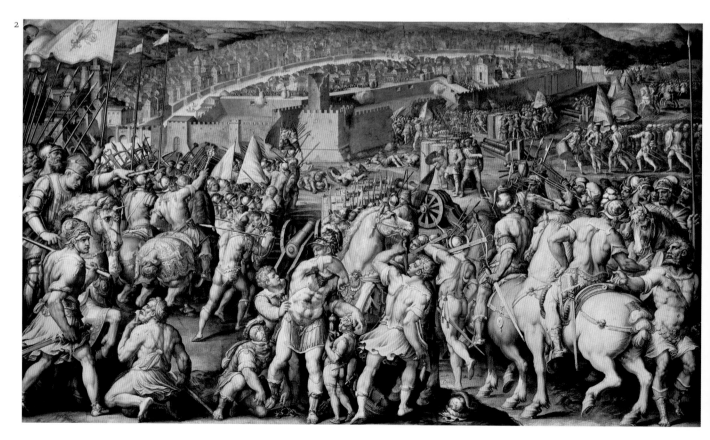

2

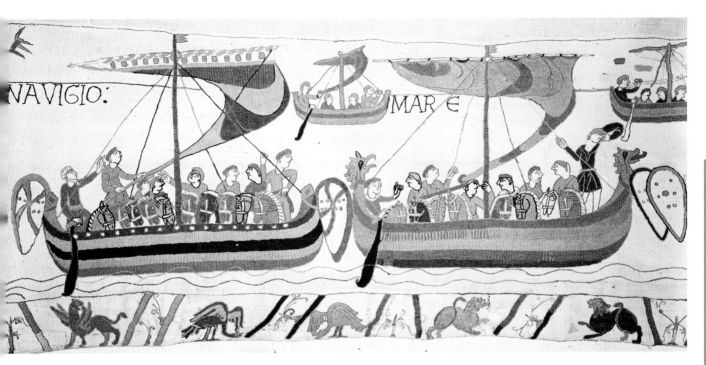

1 *Vase with Warriors*
Artist unknown, c. 1200 BCE
Mycenaean

2 *Taking of Pisa*
Giorgio Vasari, c. 1563–1565
Mannerism

3 *Wiliam Duke of Normandy's Fleet Crossing the Channel, from the Bayeux Tapestry*
Artist unknown, c. 1066–1097
Romanesque

4 *An Army on the Move*
Artist unknown, c. 1480
Gothic

Social Protest

The poor and underprivileged were subjects for art from early times, but in these early images the artist was portraying an aspect of society rather than expressing concern or protest. In the eighteenth century, William Hogarth was among the first artists to express his opinions on social questions in his satirical series of paintings and prints. By the nineteenth century, social protest became a strong element in the work of many artists. Increasingly independent from wealthy patrons, state commissions, and the church, artists were able to choose their own subjects. At the same time, the style of painting was increasingly realistic and perfectly suited to showing the harsh realities of life. It was an era in Europe of great social upheaval, industrialization, and revolution. Inevitably, many artists turned away from elegant portraiture and beautiful landscapes, and instead used their work to express their outrage at the oppression of the poor, be they farm workers, miners, or factory laborers.

By the twentieth century, painters were adopting stances as radical as their avant-garde techniques. Pablo Picasso argued for artists to adopt a proactive role, declaring that art "is not done to decorate apartments; it is an instrument of war for attack and defence against the enemy." *Guernica* was his impassioned response to a military atrocity, when fascist forces bombed the Spanish Basque capital, causing widespread civilian casualties. Using Cubist distortions and images inspired by bullfights, he accentuated a sense of horror and confusion in empathy for those whose lives had been shattered. Picasso's aim was to shock those who viewed his painting into acting to support the cause of the Republicans in the Spanish Civil War.

Another Spanish painter, Salvador Dalí, in the same year, produced a gruelling condemnation of the horrors of a nation torn apart by internal conflict. *Soft Construction with Boiled Beans: Premonition of Civil War* uses the techniques of Surrealism. A colossal central figure, part skeleton, part living, is both victim and aggressor, tearing asunder its own diseased limbs.

[top and following pages]
Guernica
Pablo Picasso, 1936
Cubism

[opposite page]
Soft Construction with Boiled Beans
Salvador Dalí, 1936
Surrealism

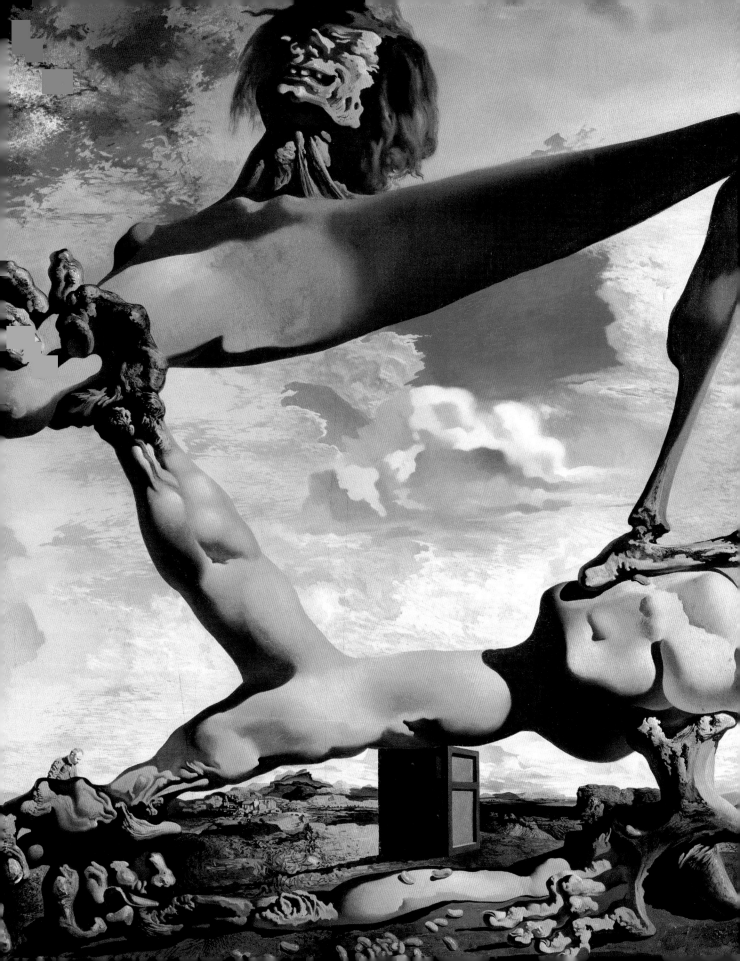

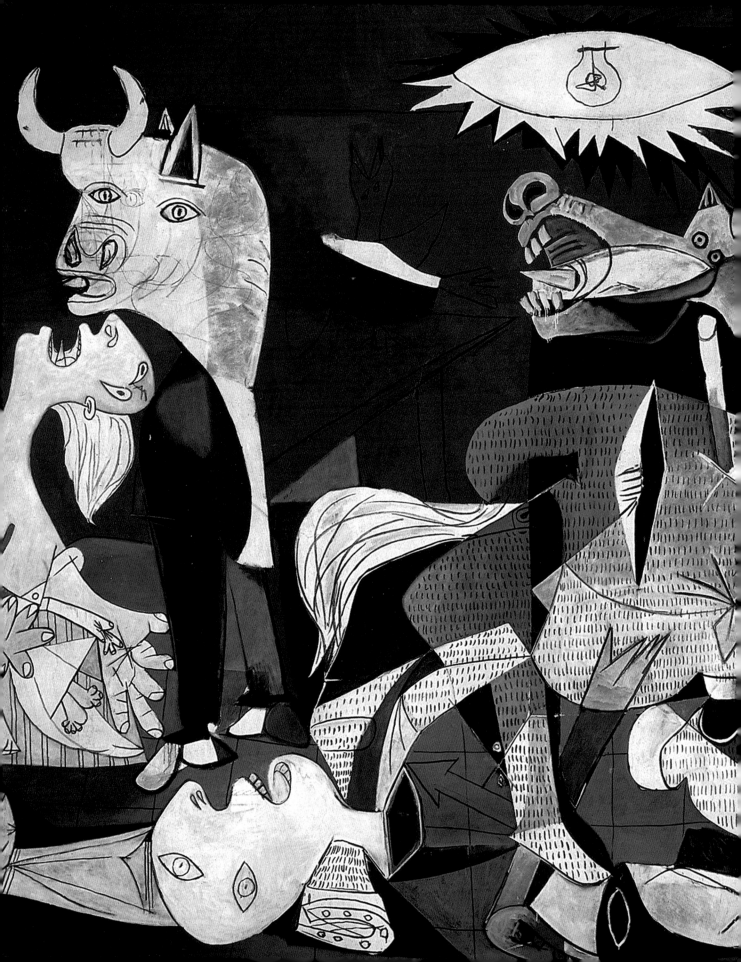

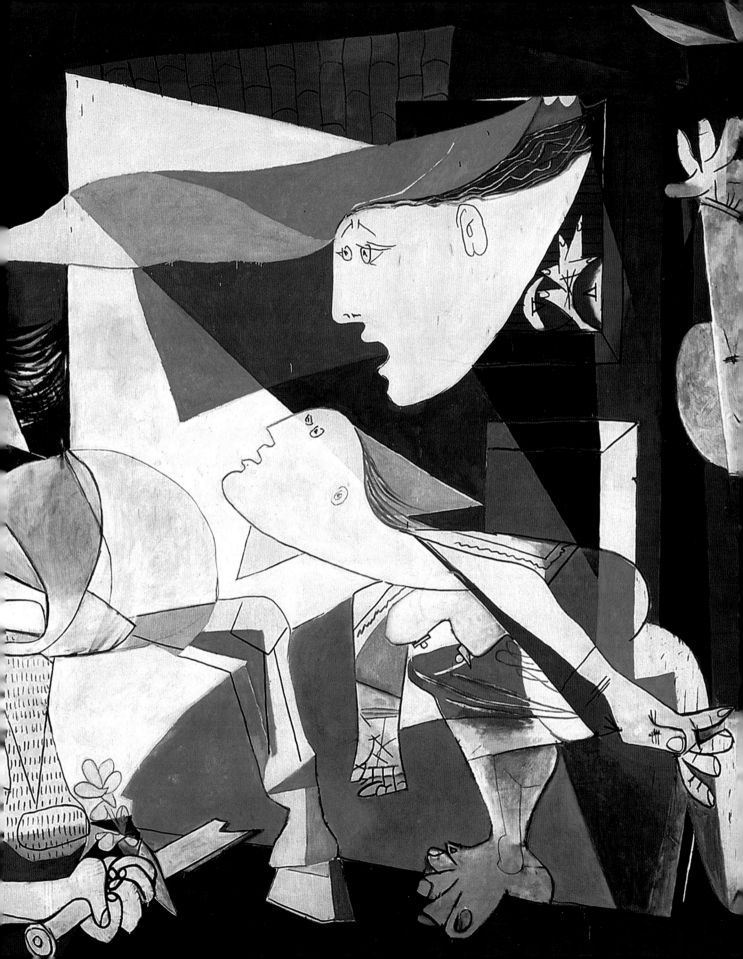

Nineteenth Century

The Raft of the Medusa is a seminal masterpiece of the Romantic movement, highlighting a major political scandal. It centered on a maritime disaster, comparable in some ways with the sinking of the Titanic. In 1816, the *Medusa* (a French frigate) ran aground. This situation was exacerbated by the incompetence of the crew and a shortage of lifeboats. Many died from sunstroke, starvation, and even cannibalism. Théodore Géricault went to extraordinary lengths to capture the horror of the event. He spoke to survivors, sketched dying patients at a local hospital, as well as the heads of guillotined criminals. The government, which shouldered much of the blame for the tragedy, was too embarrassed to purchase the picture, but Géricault was able to make a profit by exhibiting it privately in Paris, London, and Dublin. Popular uprisings were all too common in nineteenth-century Paris. The revolution of 1848 forced King Louis Philippe to abdicate, and ushered in the Second Republic. The Commune was an even bloodier affair that followed the disastrous French defeats in the Franco-Prussian War and the devastating siege of Paris. A new uprising was launched, but was violently suppressed. The image of a humble conscript forced to go to war is a poignant understatement in its social protest.

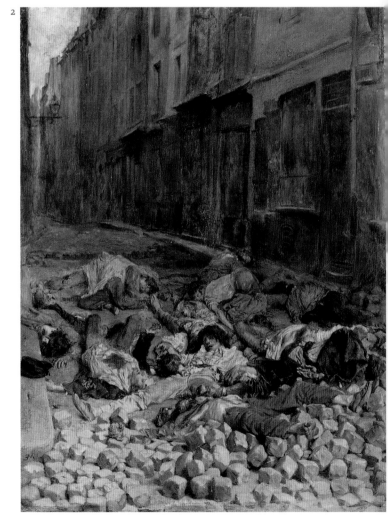

1 *Departure of the Conscript*
Girolamo Induno, c. 1870

2 *Remembrance of Barricades in June, 1848*
Ernest Meissonier, 1848
Academic

3 *The Commune: Paris Street in 1871*
Maximilien Luce, 1903

4 *The Raft of the Medusa*
Théodore Géricault, 1819
Romanticism

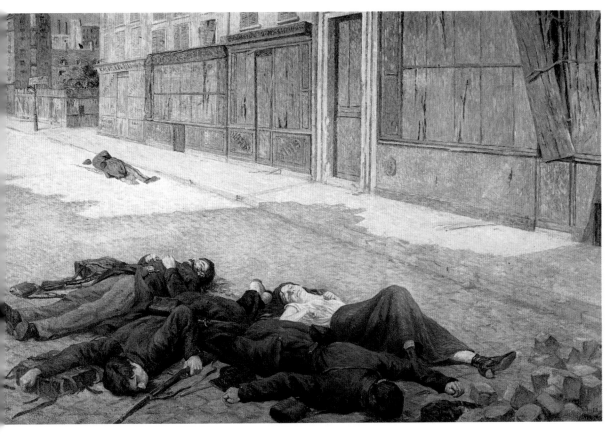

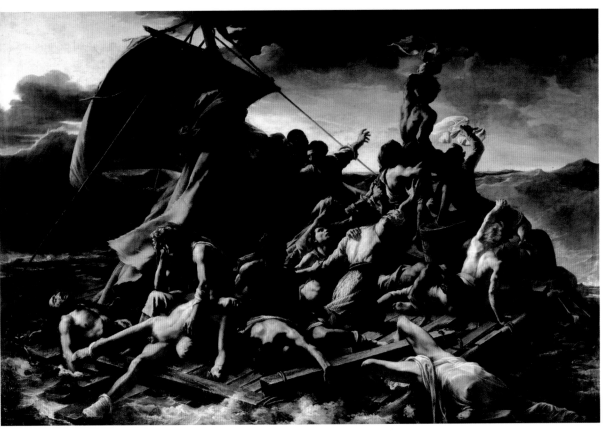

Twentieth Century

La Vie is the largest and most complex painting from Pablo Picasso's "Blue Period" (1901–1904). During these years, before he became famous, the artist lived in poverty and despair—a mood that was reflected in the bleak, icy coloring of his pictures at this time, some of which reflect social concerns. His paintings of traveling clowns and tumblers, for example, display a genuine sympathy for society's outcasts. At the same time, much of his depression was caused by the suicide of an old friend, Carlos Casagemas, following an unhappy love affair. The male figure in *La Vie* is a portrait of Casagemas and, although the rest of the allegory is hard to decipher, there is no doubting its pessimistic tone. Such is his versatility that Hans Erni has been dubbed "the Swiss Picasso." After working successfully as an abstract artist, he branched out into fields that are generally more accessible—designing murals, posters, and even stamps. After World War II, he began producing work for the United Nations, dealing with world issues. His warning against nuclear conflict, pictured here, was created at the height of the Cold War. In 1949, the Soviets exploded their first atomic bomb; the KGB was formed in 1954 and, later that same year, Vietnam was partitioned.

ATOMKRIEG NEIN

MOUVEMENT SUISSE DE LA PAIX · SCHWEIZERISCHE BEWEGUNG FÜR DEN FRIEDEN · MOVIMENTO SVIZZERO PER LA PACE

1 *Atomic War—No*
Hans Emi, 1954

2 *La Vie (Life)*
Pablo Picasso, 1903

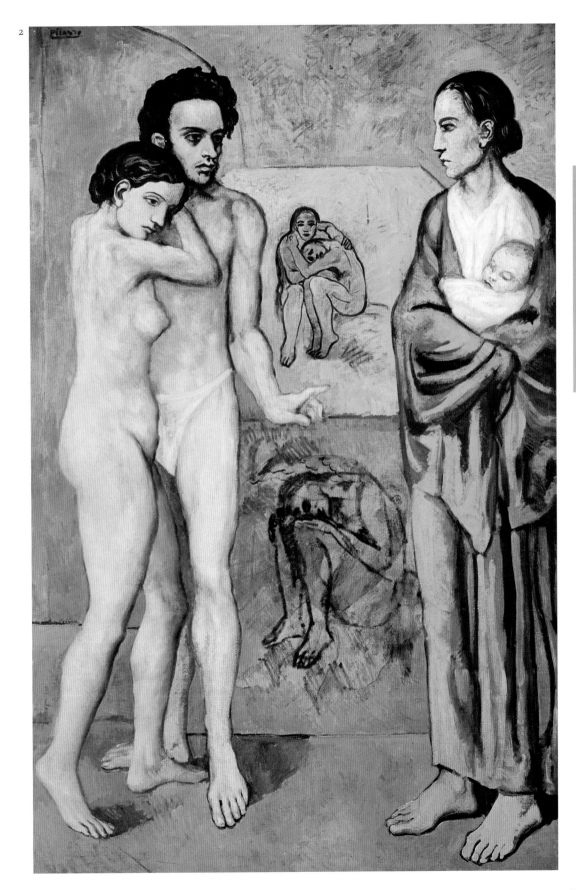

Abstraction

As the nineteenth century ended, the world of art was undergoing radical changes in terms of style. Artists were experimenting with ways of depicting the world that completely altered traditional approaches. Mirroring reality or capturing a moment was no longer the aim. The marks made by an artist had their own validity and the way they interacted to create a composition became an end in itself. In the first decades of the new century abstraction became the focus of creation for several artists.

Although France is acknowledged to be a center of radical change in art at this time, major developments also evolved in Germany and Russia. Wassily Kandinsky, a Russian living in Munich, wrote in 1912: "Color is the keyboard. The eye is the hammer. The soul is the piano, with its many strings. The artist is the hand that purposefully sets the soul vibrating by means of this or that key." At this time he produced *First Abstract Watercolor,* a loose and sketchy composition of watery colors and dark lines, reminiscent of nothing real, and best described in terms usually associated with music—rhythmic, tonal, improvised, evocative. From this beginning a new style in art evolved that was to encompass the work of artists such as Piet Mondrian, Jackson Pollock, Mark Rothko, and Victor Vasarely.

The Russian Kasimir Malevich hastened the march toward total abstraction. After experimenting with Cubism and Futurism, he founded the Suprematist movement, which deliberately rejected all natural or imaginary forms in favor of basic, geometric shapes. Through this, Malevich hoped to establish "the supremacy of feeling in creative art." His *White on White* was the purest manifestation of his views. In this, two squares were painted in the same hue, and could be differentiated mainly by the gesture preserved in the artist's brushwork.

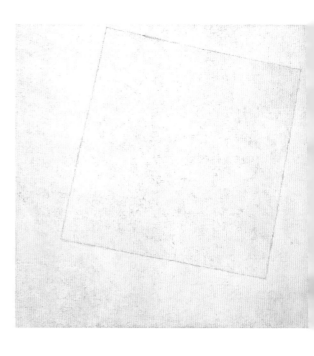

[top]
White on White
Kasimir Malevich, 1918
Suprematism

[opposite page]
Landscape
Wassily Kandinsky, 1913
Expressionism

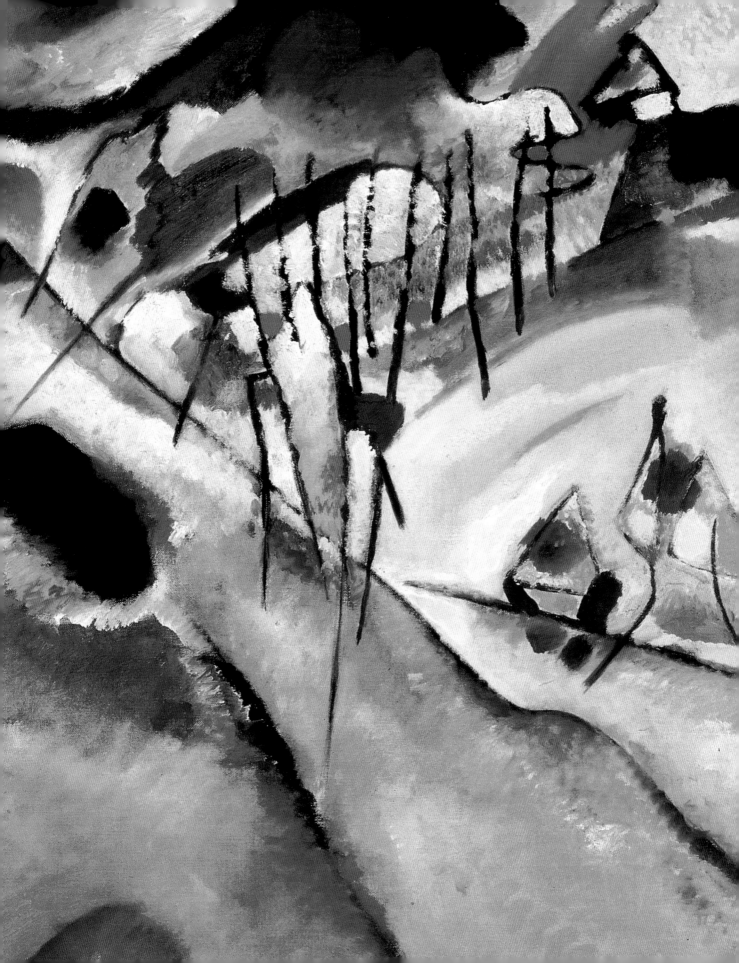

Painting

The journey towards abstraction began in earnest in the opening years of the twentieth century, as artists searched for new ways of depicting the world around them. Henri Matisse and the Fauves made color the focus of their experiments, using it for emotional or decorative effect, rather than as a means of making objects appear realistic. Pablo Picasso made groundbreaking changes to the depiction of form and space. In *Les Demoiselles d'Avignon*, the key influence came from primitive art. The three women on the left of the work were painted at the start of 1907 when Picasso was inspired by ancient Iberian carvings from the pre-Roman period, while the other two were completed a few months later when his interest had shifted toward African art. If artists removed all representational elements from their work, they had to look for new sources of inspiration. Sometimes they found this in the act of painting itself. Franz Kline developed his distinctive style after seeing his own brushwork magnified through a projector. Jackson Pollock, meanwhile, placed his canvases on the ground and then improvized rapidly on top of them—pouring, dripping, splashing, and manipulating the paint with a variety of implements.

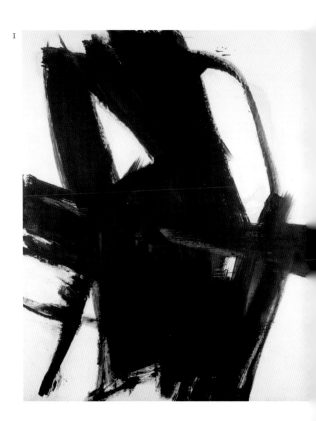

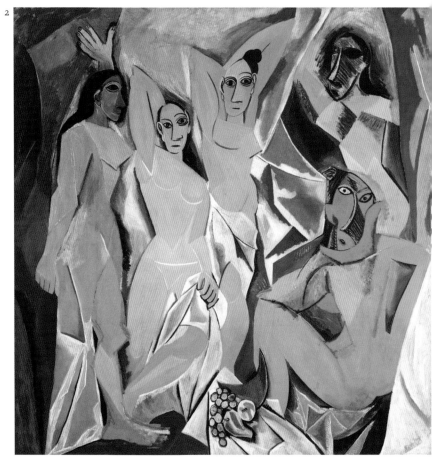

1 *Merce C.*
Franz Kline, 1961

2 *Les Demoiselles d'Avignon*
(The Avignon Street Girls)
Pablo Picasso, 1907
Cubism

3 *Full Fathom Five*
Jackson Pollock, 1947
Abstract Expressionism

4 *Woman in a Japanese Robe*
Beside Water
Henri Matisse, 1905
Fauvism

4

Sculpture

Although he was recognized for his paintings, Amadeo Modigliani began his career as a sculptor. Under the influence of his mentor, the Romanian sculptor Constantin Brancusi, and African and Oceanic carvings, he produced a series of sleek, elongated heads that have a serene, hypnotic quality. Modigliani abandoned sculpture in 1915, largely because the stone dust was damaging his lungs, though his paintings continued in a similar vein. Henry Moore also had a profound admiration for the powerful simplicity of primitive art, and he was able to harmonize his sculpting with his materials, allowing the shape or grain of a piece of wood to dictate the form of a limb or a posture in his figures. The Swiss-born sculptor Jean Tinguely brought a sense of fun and adventure to the field of abstraction. Among other things, he produced machine-like assemblages of items of junk that were programed to self-destruct. The most spectacular example was his *Homage to New York,* which misfired and ran amok in the garden of the Museum of Modern Art in 1960. Triumphantly Tinguely declared that "it was a machine that had rejected itself in order to become humor and poetry."

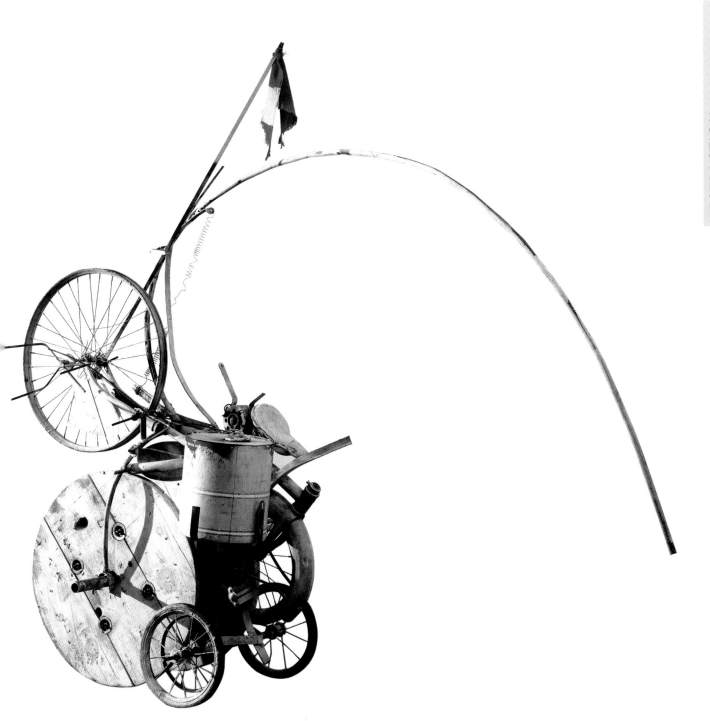

ABSTRACTION

505

GLOSSARY OF ART STYLES

Abstract Expressionism
The term Abstract Expressionism was first used by Robert Coates in the March issue of the *New Yorker* in 1936. The highly successful, and internationally acclaimed, American artists who took this name for their work placed American art at the center of modern abstract painting in the 1940s and 1950s. The work was not all abstract, nor expressive, but the artists had a common, radical vision of rebellion, spontaneity, improvization, and the freedom of the individual.

Academic
Academies were associations of artists set up to maintain professional standards and look after the interests of their members. In the modern world, the first academies appeared in Renaissance Italy and were designed principally to free artists from the restrictions imposed by the guilds. However, with the foundation of the Académie Royale de Peinture et de Sculpture (the French Academy) in 1648, academies were often used as a means of control. During the nineteenth century, artists rebelled against this situation and "academic" became a pejorative term, implying that the work in question was bland but respectable.

Akkadian
A Semitic-speaking people who settled in Mesopotamia (part of present-day Iraq). Their most powerful ruler was Sargon I, who in c. 2370 BCE founded his capital at Akkad or Agade, not far from Babylon. The Akkadians drew many of their artistic influences from the Sumerians. Their finest artworks were sculptures and stone reliefs.

Alaca Huyuk
The site of a remarkable royal cemetery, situated in Anatolia (in present-day Turkey). The tombs date back to around 2500 BCE. Their contents displayed a high degree of metallurgical expertise.

Amlash Culture
A culture that thrived in a mountainous region to the southwest of the Caspian Sea (in present-day Iran). It reached its peak in the ninth century BCE. The style of their pottery has close affinities with the neighboring cultures of Marlik, Elam, and Luristan.

Ancient Egyptian
Egyptian art usually served a specific function—much of it was aimed at easing the passage of the dead in their journey to the afterlife. In visual terms, figures are often depicted in a flat, two-dimensional manner. However, they are not shown in strict profile and often the figure will have two left feet, or the torso will be turned toward the viewer. Traditionally, Egyptian art is divided into three historical periods: the Old Kingdom (2686–2181 BCE), the Middle Kingdom (2040–1786 BCE), and the New Kingdom (1567–1085 BCE). The golden age of Egyptian art is generally thought to coincide with the rule of the eighteenth dynasty (1567–1320 BCE), at the start of the New Kingdom.

Ancient Greek
The art of ancient Greece has exerted a profound influence on Western civilization. For centuries, it was revered as the supreme form of artistic expression and European painters and sculptors did their best to emulate it. Greek art is divided into four main phases: the Geometric period (late eleventh to late eighth century BCE), which takes its name from the designs on vases; the Archaic period (late eighth century to 480 BCE), which produced the first known large statues in Greece; the Classical period (480–323 BCE), the high point of Greek art, also notable for its figurines, lavish gold jewelry, and painted vases; and the Hellenistic period (323–27 BCE).

Ancient Persia
The Persians, an Indo-European people, settled in the area of present-day Iran in the second millennium BCE. The Achaemenid dynasty (559–333 BCE) established a powerful empire, which fell to Alexander the Great. The great palace at Persepolis, founded by Darius in c. 518 BCE, was decorated with a series of massive relief carvings and gateway figures. Achaemenid craftsmen also produced fine work in gold, silver, and bronze.

Ancient Roman
Roman culture was strongly influenced by the art of ancient Greece. This trend escalated after the Greek states were absorbed into the Roman empire, following which shiploads of Greek art were carried off as booty. Especially in the Imperial period, from the first century CE onwards, the Romans made countless replicas of the best pieces, indeed some of the most famous Greek statues are known only through Roman copies. In the Romans' own work, the most original feature was a striking taste for realism. Where Greek figures were generally idealized, Roman portrait busts displayed a relish for physical imperfection.

Arabic
Arabic civilization predated the rise of Islam. Although initially nomadic, the ancient Arabs founded important cities, such as Petra and Palmyra, which were influenced by the culture of classical antiquity. With the spread of Islam in the seventh century, Arab power increased as large tracts of Byzantine, Sassanian, and Persian territory were occupied. Arabs also dominated the first great Islamic dynasty, the Umayyads, who ruled from 661 to 750.

Art Nouveau
A popular, decorative style that emerged in the late nineteenth century and affected most branches of the arts. It was characterized by sinuous, flowing lines, which were often based loosely on flower or plant forms. The style derived from a number of sources—in particular, the linear stylizations that could be found in Japanese prints. The term "Art Nouveau" ("New Art") was borrowed from a shop in Paris.

Ashcan School
An important group of American painters who worked in New York in the early years of the twentieth century. Their aim was to cast off European influences and create a modern, purely American form of art. Much of their subject matter came from the grittier side of urban life, particularly New York's overcrowded slums, and this earned them the tag "the Ashcan School."

Assyrian
The Assyrians were a major force in the Middle East, emerging in the third millennium BCE and flourishing until 609 BCE. They originated from the city-state of Ashur (or Assur), which was situated near the modern city of Mosul in Iraq. Assyrian culture is sometimes divided into three periods—Old Assyrian, Middle Assyrian, and **Neo-Assyrian**. Technically, these terms relate to different stages of the Assyrian language, but they can also be applied to artistic periods. The Assyrians' supreme achievements came in the field of stone sculpture, although some remarkable ivory carvings have also been discovered.

Assyro-Babylonian
This term reflects the close links between Assyria and its southern neighbor, Babylonia. Even though they were at war for much of their existence, the two shared close cultural links. Indeed, some authorities regard Assyrian art as a direct offshoot of Babylonian art.

Aztec
The Aztecs arrived in Mexico in the thirteenth century, settling by Lake Texoco. The Aztecs' religion involved human sacrifice on an industrial scale, and many of their artworks were geared toward this gruesome practice. In addition, they produced monumental sculptures, such as the great Calendar Stone, mosaics using turquoise and other semi-precious stones, jewelry, and elaborate feather-work objects.

Babylonian
Babylonia was a powerful state in ancient Mesopotamia, situated in modern-day Iraq. It came to prominence during the reign

f Hammurabi the Lawgiver (1792–1750 BCE). The Ishtar Gate, with its glazed blue tiles and its animal decorations, offers the best evidence of Babylonian achievements. They also produced a wealth of cylinder seals, adorned with miniature engravings.

Barbizon School
An influential group of French landscape painters, often hailed as precursors of the Impressionists. They took their name from a village at the edge of the Forest of Fontainebleau in central France, where many of them worked or settled from the 1830s onward. The Barbizon painters never formed an official group with joint exhibitions or a manifesto, but they were united in their opposition to the artificiality of academic landscapes. Like the Impressionists, they believed in painting directly from nature in the open air. This was to keep their images as fresh and realistic as possible. However, the difference was that they usually finished their pictures in the studio.

Baroque
The term for the prevailing style in Western Europe in the seventeenth century appears to derive from *barroco*, a Portuguese word for an irregularly shaped pearl, and was probably meant originally as a form of criticism. The style developed in Rome—partly as a reaction against the artificiality of Mannerism, and partly to provide a dynamic new medium for Catholic artists in the work they were producing for the Counter Reformation. Drama, movement, and grandeur were the watchwords of the new style. This was achieved through striking color contrasts and the vigorous, almost theatrical poses of the figures. The Baroque proved notably less popular in Northern Europe.

Benin
A powerful kingdom situated in present-day Nigeria, which flourished from the fourteenth to the seventeenth century. It was renowned, in particular, for its fine metalwork, most notably a series of royal heads made of bronze or brass.

Byzantine
The Byzantine empire was formed in CE 330 when Constantine the Great, having united the Roman empire, transferred its capital from Rome to Byzantium, which he renamed Constantinople. The empire's artistic influence was considerable, extending from Italy to Russia. The most important Byzantine artworks came in the form of mosaics, ivory carvings, and icons (sacred paintings). The last were always highly stylized, since naturalism and individuality were discouraged in religious art.

Carolingian
The term derives from the first Holy Roman Emperor, Charles the Great or Charlemagne, who ruled from 800 to 814, instigating a wide-ranging revival of the arts at his court in Aachen. The finest surviving products of the period are a series of illuminated manuscripts, which combine classical, Celtic, and Byzantine influences.

Celtic
The Celtic tribes of central Europe were pushed by the Romans in the first century to Britain, Ireland, Scandinavia, and other regions of north-western Europe, where they produced a distinctive style of art that was influential from the first to the tenth century. Pottery, woodwork, jewellery, weapons, and stone crosses feature in Celtic art, which is richly decorated with semi-abstract designs.

Colima
The name of the modern state in western Mexico is also used to describe the ancient artifacts discovered in the area. Some of the earliest examples come from the Capacha complex, a shaft tomb dating back to 1500 BCE. Many of the finds in Colima were pottery figures and vessels depicting men with clubs or animal effigies.

Cubism
A revolutionary art movement developed in Paris in the early twentieth century. Cubism was the joint creation of Pablo Picasso and Georges Braque, who together produced a style of painting that abandoned traditional ideas about perspective, space, and modeling. Instead, they portrayed their chosen subjects from several different viewpoints at the same time, breaking the forms down into planes—or "cubes," as one critic described them, giving the movement its name—and then rearranging these into an alternative version of reality. Cubism went through two distinct phases. Analytical Cubism (1909–1911) focused on the process of breaking down ("analyzing") objects into a series of near-abstract, fragmented shapes, while Synthetic Cubism (1912–1914) reversed this process by building up the images from pre-existing elements.

Cycladic
Bronze Age art (c. 2700–c. 1400 BCE) produced in the Cyclades, a group of islands in the Aegean. These islands are best known for a range of small-scale, marble statuettes, which have a pared-down, minimalistic appearance. Cycladic art has proved an inspiration to modern sculptors.

Dada
An influential modern movement that cut across many branches of the arts, flourishing principally between 1915 and 1922. In essence, the energy of Dadaist artworks stemmed from an unbridled sense of anarchy and a taste for nihilistic shock tactics, which themselves grew out of the cynicism and anger spawned by the horrors of World War I. The movement was founded in 1915 in the Swiss city of Zurich by a group of artists and writers who organized unconventional events at the Cabaret Voltaire—nonsense poems, "abstract" dances, and displays of avant-garde art. They chose the name "*Dada*" (French for "rocking horse") to convey the whimsical, childlike nature of the movement. Dada spread through Europe but had begun to lose its impetus by 1922. It provided an important source of inspiration for Surrealism and Pop Art.

Dutch Seventeenth Century
The golden age of Dutch art. After gaining its independence from Spain, the country exuded a new self-confidence, which was reflected in a strong art market. This was dominated by a wealthy merchant class, who wanted landscapes, still lifes, and scenes of everyday life, rather than grandiose histories and allegories. The towering genius of the age was Rembrandt van Rijn, who produced moving Biblical scenes, groundbreaking portraits, and superlative etchings.

Early Christian
This earliest phase of Christian art, dating from c. 300 to c. 700, was very low-key. Some of the earliest examples were simple wallpaintings in subterranean burial galleries near Rome. Later, more elaborate images were produced in mosaics, carvings on sarcophagi, and illuminated manuscripts.

Early Italian
After the fall of Rome, Italy was no longer a political or artistic entity. Control passed to individual city-states, each of which developed its own tradition. Various invaders—among others, the Goths, the Lombards, the Saracens, and the Carolingians—influenced many of these traditions. By far the greatest influence, however, came from Byzantium. The Byzantine style, with its emphasis on elegant stylization, can be detected in much of the religious art of the twelfth, thirteenth, and fourteenth centuries in the peninsula. The transition from Early Italian to the art of the **Early Renaissance** is linked to the growth of naturalism, when Italian painters tried to make their religious scenes appear more realistic.

Early Renaissance
The most influential movement in Western art, the Early Renaissance shaped the course of painting for several centuries. The term means "rebirth," referring to the revival of interest in the art and values of the ancient world. The ability to depict the human form accurately, and to

place figures convincingly in their settings, were central to the achievements of the Renaissance. The period also witnessed the emergence of a different type of subject matter. During the Middle Ages, most pictures were produced for the Church. However, as classical texts became more available following the invention of printing, a greater taste for secular themes appeared. Artists had no examples of classical painting to work from, but they could draw inspiration from descriptions in classical texts, or from the poses of antique statues, reliefs, gems, etc, and use classical gods in allegories.

Eastern Zhou Dynasty
In China, the Zhou dynasty ruled from 1027 to 256 BCE. Within this time frame, the Eastern Zhou refers to the period between 771 and 486 when the capital was moved to the eastern city of Luoyang. In artistic terms, the era was most notable for its bronze ceremonial vessels and sculptures of animals. The teachings of Confucius (551–479 BCE) also had a significant impact upon the arts.

Etruscan
The Etruscans settled in central Italy in the first millennium BCE. They established an extensive network of trading contacts and founded several cities, but the combined hostility of Rome and the Celts led to their extinction in the second century BCE. Their art has done little to solve the mystery of their origins, since it combines a unique mixture of Italian, Greek, and oriental influences. Etruscan burial chambers offer a vivid impression of their culture—for example, the remarkable frescoes of hunting and wrestling scenes at Tarquinia.

Expressionism
The Expressionists used distortions of line and color as a means of conveying heightened emotion. They formed a wide-ranging movement in the early years of the twentieth century although, prior to this, the style had several major forerunners. In particular, Vincent van Gogh, Edvard Munch, and James Ensor all expressed mental turmoil by injecting a sense of neurotic energy into their portrayal of natural forms. As a movement, Expressionism reached its peak in Germany, where it was spearheaded by two avant-garde groups, *Die Brücke* ("The Bridge") and *Der Blaue Reiter* ("The Blue Rider"). Expressionism also had a profound effect on German cinema, and it remained a potent force in the country until the rise of the Nazis, who deemed it "degenerate."

Fauvism
An avant-garde movement that emerged in France in the early years of the twentieth century. Led by Henri Matisse, the group experimented with bright, intense colors that looked unrealistic, but created decorative effects or a strong, emotional impact. These vivid tones prompted one critic to dub them "*les fauves*" ("the wild beasts"). The style was formulated in the heat of the Mediterranean sun and enjoyed its greatest public exposure at two keys exhibitions: at the Salon d'Automne in 1905 and the Salon des Indépendants in 1906. After this, the movement gradually petered out. For most of the artists who participated in this movement, Fauvism marked an experimental phase in their careers rather than a long-term commitment.

Futurism
A modern art movement that flourished mainly in Italy in the early twentieth century. It was founded in 1909 by Tommaso Marinetti, who published its manifesto (the first of several issued by the group) in a French newspaper. The Futurists wished to celebrate speed, modernity, and technology, while also sweeping away the artistic values of the past. Some even welcomed the outbreak of war as a means of purging old cultural baggage. Futurist ideas affected several branches of the arts—sculpture, music, poetry, dance, and photography—and these were often brought together in dynamic, if unpredictable performances. In painting, its style was strongly influenced by Cubism and photography; fragmented forms and the blurring effects of motion photography were both employed to convey a sense of speed or violent movement. The principal members of the group were all Italian. The movement began to peter out during World War I in Italy.

Gothic
A major artistic style that flourished in Europe from the mid-twelfth to the sixteenth century. The term relates primarily to architecture, where the characteristic features were pointed arches and window tracery, flying buttresses, and rib vaults. The term "Gothic" was originally used in a derogatory sense, implying that the artworks in question were so dreadful that Goths (that is, barbarians) must have devised them. Despite this, the style was revived periodically, particularly during the nineteenth century. The term may be used as a general description of painting of the period; for more specific features see **International Gothic**.

Group of Seven
An influential group of landscape painters who played a key role in the development of a national school of painting in Canada. The group was founded in 1920, when it held its first official exhibition at the Art Gallery of Toronto. From the outset, the Seven were determined to draw their main inspiration from the Canadian countryside, and to resist outside influences from Europe and the United States. In a bid to underline their solidarity, they took part in communal sketching expeditions and painted in a similar style, notable for its bold, Expressionistic flourishes and brilliant coloring. The Group of Seven exhibited together until 1931.

Han Dynasty
This dynasty presided over one of the most glittering epochs in Chinese history (206 BCE–CE 221). In military terms, the empire made considerable territorial gains, while the spread of Confucianism and the introduction of Buddhism created a new spiritual focus in the arts. Great advances were made in the field of sculpture. Monumental sculpted reliefs were produced for Han tombs, together with a wealth of three-dimensional figures. The most impressive examples depicted animals, such as horses, lions, and bears. It appears that the development of painting also made great strides, both in frescoes and on small lacquer objects, although very little has survived.

Harappa
One of the twin capitals of the **Indus Valley** civilization (together with Mohenjo-Daro). Harappa may well have been the most important of all the settlements in the region, and the name is sometimes used as a synonym for the Indus Valley culture. However, the archaeological value of the site was compromised severely in the 1850s when it was looted for bricks during the construction of a nearby railway.

Herat School
An important tradition of painting at Herat, in Persia (now Iran). This began during the reign of Shah Rukh (1405–1446), who gathered a talented group of miniature painters at his court. In 1507, the Uzbeks conquered Herat, but it remained a major center even under the new Safavid dynasty (1502–1736), which moved the capital to Tabriz.

High Renaissance
The brief period (c. 1500–c. 1520) when the various ideals that artists had been pursuing since the time of Giotto (c. 1270–1337) finally came to fruition, producing the supreme masterpieces of the movement. During the early years of the Renaissance, the key developments took place in Florence. After 1500, however, Rome took center stage. The ambitious new pope, Julius II, was determined to make the city a cultural, as well as a political stronghold. Artists flocked there, among them the three greatest masters of the Renaissance: Leonardo da Vinci, Michelangelo, and Raphael. In their paintings, they demonstrated a full understanding

of the lessons of antiquity, combining this with their own unique talents. The quality of their work was reflected in their status. Barely a generation earlier, painters had been regarded as little more than craftsmen, but the leading masters of the High Renaissance were acknowledged as geniuses.

Hudson River School
A loose association of American landscape artists who worked in the Hudson River Valley and its surrounding area—the Catskills, the Adirondacks, and the White Mountains. The group was both patriotic and Romantic, proudly focusing on the most awe-inspiring qualities of their homeland.

Imperial Roman See Ancient Roman

Impressionism
An immensely influential style and movement, one of the cornerstones of modern art. Impressionism originated in France, where a group of like-minded artists who felt excluded from official venues decided to exhibit their work together. The first show (1874) attracted a storm of criticism, much of it directed against Claude Monet's *Impression: Sunrise*. One reviewer mockingly dubbed the group "Impressionists" and the name stuck. In contrast to the histories and allegories that were preferred at the Salon, the Impressionists were determined to paint scenes from modern life. Accordingly, they depicted the minutiae of Parisian life, from dance halls to railway stations, from boating scenes to seedy bars. When this principle was applied to painting landscapes, the results were more radical. In trying to capture a precise moment with specific light and weather conditions, they had to work very quickly, developing a style that looked very different from conventional landscape painting. This reached its most extreme form in the pictures of Monet, who painted the same subject over and over again to record subtle changes in its appearance. In effect, he was painting light itself.

Indian
One of the world's earliest civilizations flourished in the Indus Valley in the third millennium BCE. After it disappeared, there was a lengthy gap before Emperor Ashoka (d. 232 BCE) of the Maurya dynasty established the next major regime in the area. He was a convert to Buddhism, and erected a series of monumental pillars to commemorate the wise man's career. Sculpture remained the dominant art form in India, with some of the finest examples originating in Mathura, near present-day Delhi. Religious sculptures were also produced for shrines in caves. These came in two forms: *chaityas* (preaching halls) and *viharas* (living quarters). The most spectacular complex of caves is at Ajanta, western India. Some caves also contained frescoes, although India is better known for its miniature painting. The oldest examples date back to the eleventh century, while the most exquisite miniatures were produced at the Mughal and Rajput courts.

Indus Valley
The Indus Valley was one of the cradles of civilization. From the third millennium BCE, a group of settlements grew up in the area, covering a sizeable part of modern-day Pakistan, northern India, and Afghanistan. These settlements took the form of complex, well-organized cities, with capitals at Harappa and Mohenjo-Daro. The Indus people had their own form of writing and produced some notable artworks. Their trading seals, with distinctive animal designs, prefigure some elements of Hindu art and culture. In addition, they produced painted pottery and sculpture.

International Gothic
A medieval style in painting, illuminated manuscripts, and the decorative arts that flourished in the late fourteenth and early fifteenth century. It was genuinely international, reflecting the increased movement of artists among major centers of patronage. The style displayed a courtly elegance, with slender, elongated figures that lacked the anatomical precision of Renaissance art.

Japanese, Edo period
This period of Japanese history, dating 1603–1868, was one of stability and peace during which art flourished. Edo (Tokyo in modern Japan) and Osaka were the cultural centers. Woodblock prints were the greatest artistic achievement of the period. Created from the late seventeenth century, these prints were hugely popular in Japan, and highly influential on artists throughout the world after Japan's cultural isolation ended in the mid-nineteenth century.

Japanese, Momoyama period
During this brief but illustrious period (1573–1615), Japan was unified by two warlords, who fostered a taste for lavish painting with gold foil in murals or on sliding door panels.

Macchiaioli
An influential group of Italian painters who were active mainly in Florence in the 1850s and 1860s. Their principal aim was to banish the staleness of academic art, producing pictures that were fresh and original. A characteristic traits of their work, the use of *macchie* (bright patches of color), led to their name, *macchiaioli* (spot makers).

Mannerism
A sixteenth-century style that grew out of the final phase of Renaissance art and formed a transition to the Baroque. It takes its name from the Italian word *maniera* (style or stylishness). At its best, Mannerist art could be extremely elegant and refined while, at other times, compositions could appear strained and artificial. Elongated figures and unusual colors or lighting effects were typical characteristics of the style. In addition, painters looked for unconventional composition, pushing the principal figure to the back or the side of the scene. The style was criticized for neglecting the religious message that church art was meant to convey.

Medieval
Coming from the Latin words *medius* ("middle") and *aevum* ("age"), this is the adjective relating to the Middle Ages. The term is used very loosely for the period leading up to the Renaissance—for art of the eleventh to fifteenth centuries. See also **Romanesque** and **Gothic**.

Mesolithic-Neolithic
The transitional period between the Mesolithic (Middle Stone Age) and Neolithic (New Stone Age) eras. The names indicate that humans were using stone, rather than metal, for their tools and weapons. Rock art, both painted and engraved, was still being produced and pottery was intoduced in the Neolithic era.

Mesopotamian/Akkadian
See **Akkadian**

Ming Dynasty
In 1368, the Mongols of the Yuan dynasty were ousted from power and the long rule of the Ming dynasty (1368–1644) began. This signaled a return to traditional values in many areas of Chinese life. In the arts, the period was notable above all for the superb quality of its porcelain. In the field of painting, the era was dominated by two groups of landscape painters, the Che School and the Wu School.

Minoan
The Bronze Age art of Crete (c. 3000–c. 1100 BCE), taking its name from the legendary ruler Minos. There is much that remains mysterious about this ancient civilization—its script has not yet been deciphered—but the excavation of a series of royal palaces has revealed a highly sophisticated culture. The Minoans produced elaborate wall paintings, small-scale sculpture, and superbly decorated stone vases and pottery, with intricate curvilinear designs and marine motifs.

Mughal
A dynasty of Muslim emperors who ruled India from 1526 to 1757. There was a great flowering of the arts during this period, particularly in the fields of architecture and

painting. The Taj Mahal was built during the reign of Shah Jahan (1628–1658). Miniature painting also flourished, especially during the rule of Jahangir (1605–1627). The Mughal style was influenced by the traditions of Persian art, and was notable for a growing sense of naturalism. Under Jahangir, illuminated manuscripts were gradually superseded by *muraqqas*—self-contained, decorative albums of miniature paintings.

Mycenaean
The Late Bronze Age culture of Greece and most of its islands during the period from c. 1600 to c. 1100 BCE. It takes its name from the fortress-city of Mycenae in the eastern Peloponnese, which was excavated in the 1870s. According to legend, this was the capital of Agamemnon, the king who led the war against Troy. Mycenaean art drew many of its influences from the Minoan culture of Crete, though it also produced remarkable metalwork, much of it in gold.

Nasca
This culture emerged in southern Peru in the second century BCE, having developed from the neighboring Paracas civilization. In both cultures, the main artistic wares were polychrome pottery. Nasca vessels, which were produced until around the seventh century CE, were decorated with a colorful range of birds, animals, and demons.

Neo-Assyrian
The third and final period of Assyrian art, lasting from around 1000 to 609 BCE. During this era, the Assyrian empire reached its peak, eventually extending from Iran to the Mediterranean. Artistically, too, this was a rich period, particularly in the field of stone carving, where notable examples include monumental guardian figures (winged bulls with human heads) and low-relief carvings of hunting scenes. The finest of these, showing King Ashurbanipal at a lion hunt, was produced for his palace at Ninevah. See also **Assyrian**.

Neoclassicism
The word "Neoclassicism" ("New Classicism") indicates a desire to recapture both the spirit and the look of the artworks of ancient Greece and Rome. This tendency has occurred periodically throughout the history of Western art, but the term refers specifically to an international art movement that flourished in the late eighteenth and early nineteenth century. In part, it drew inspiration from the recent discoveries at Herculaneum (1737) and Pompeii (1748), which brought the ancient world to life, and from the hugely influential books by Edward Gibbon (*Decline and Fall of the Roman Empire*, 1773) and Johann Winckelmann (a study on Greek sculpture). The Neoclassical style was also seen as an antidote to the frivolity of Rococo art.

Northern Renaissance
The achievements of the Italian Renaissance were gradually transmitted to northern Europe, but only in a haphazard fashion by individual artists. The key figure in this process was Albrecht Dürer (1471–1528), who traveled to Italy specifically so that he could learn the secret of perspective. His Italian experience helped him to make his figures more realistic and encouraged him to paint the nude, a subject that was still highly uncommon in the north. However, many northern artists found it hard to digest the new trends, and produced an odd, hybrid style.

Nuraghic
The Nuraghic culture flourished on the island of Sardinia c. 1800–1000 BCE. It took its name from the local *nuraghe*, stone towers of a distinctive form. The local craftsmen were noted for their bronzework.

Op Art
A modern movement in abstract art that drew its inspiration from optical effects and illusions. The term Op Art—short for Optical Art—was coined in 1964, when it appeared in the American magazine *Time*. It gained further currency in the following year, after the success of "The Responsive Eye" exhibition in New York. Op Art became hugely popular with the public in the late 1960s, when there was a widespread interest in psychedelic effects. Its influence extended beyond fine art, to the realms of fashion and commercial packaging.

Ottoman
Founded by Othman or Osman I (c. 1258–c. 1326), the Ottoman dynasty rose to command a powerful Islamic empire, which remained a considerable political force until the end of World War I. Initially, Osman's domain was in northwestern Anatolia in Turkey, but his successors extended Ottoman territories from the Red Sea to the Crimea. The scope of Ottoman art is enormous, but the most distinctive triumphs were in the fields of ceramics, luxury textiles, and carpets.

Ottonian
A Germanic style of art that flourished during much of the tenth and eleventh centuries and takes its name from the Holy Roman Emperor Otto the Great. The Ottonians are best remembered for their metalwork and for some fine illuminated manuscripts.

Paleolithic
The Paleolithic (Old Stone Age) period signaled the emergence of humankind. In its final stage, cave painting began to flourish.

Persian
The Arab conquest of Persia (638–642) brought the country into the sphere of Islamic art. Its later history is very complex, but from an artistic perspective the three dominant forces were the Seljuks, the Timurid Dynasty (1370–1500), and the Safavids (1502–1736). Persian painters gained renown for their supreme skill at decorating manuscripts and books, both with calligraphy and miniatures. The most popular subjects for illustration were the *Shah Nameh* (or *Shahnama*, "Book of Kings")—the Persian national epic—and the *Khamsa* ("Five Poems") of Nizami.

Great strides were also made in the art of ceramics, especially after Islamic potters refined the technique of underglaze painting.

Polynesian
The terms relates to a collection of islands in the Pacific, spread as far apart as Hawaii, New Zealand, and Easter Island. The majority of the artworks consist of woodcarvings, apart from Easter Island, where the scarcity of trees prompted the islanders to create their celebrated stone heads. The Maoris, meanwhile, were fascinated by densely packed, curvilinear patterns used on carved house posts, canoes, and in tattoos.

Pop Art
A modern art movement that was at its peak in the late 1950s and the 1960s. Pop artists drew their inspiration from the most ephemeral aspects of consumer society—advertisements, comics, and commercial packaging. These were often turned around, so that a mass-produced image became a piece of fine art. Some read such artworks as comments on the throwaway culture of consumerism, but they can also be viewed as a reaction against the pretensions of the art world. The term was coined by the critic Lawrence Alloway.

Postimpressionism
Never a specific style or movement; instead, the term was used as a convenient way of describing a number of artists who went through an Impressionist phase, before moving on to develop a different style. The term itself was coined by the critic Roger Fry, who used it for the title of an exhibition that he staged in London in 1910. In most cases, the Postimpressionists were dissatisfied with the Impressionist emphasis on capturing fleeting moments. Instead, they wanted to create something enduring.

Qing Dynasty
This lengthy period (1644–1911) relates to the last of the imperial dynasties in China, before the country became a republic in 1912.

...t is celebrated, above all, for the extraordinary refinement of its porcelain. In painting, the key figures were the Individualists—a group of artists who reinvigorated traditional Chinese forms.

Realism

An influential art movement that emerged in France in the 1840s. It was founded by Gustave Courbet, who staged a controversial one-man show entitled "Realism" at the 1855 World Fair. He objected to the stranglehold that the academies, with their pretentious historical and allegorical pictures, were exerting over the arts. Courbet's huge, non-idealized canvases of country life caused uproar, provoking claims that he was deliberately promoting ugliness and political unrest. Similar claims were leveled against his fellow Realists.

Rococo

A graceful and elegant style that emerged in France c. 1700, and that became the dominant force in European art for much of the eighteenth century. Its name appears to come from rocaille, a decorative shell-work pattern that was widely used by architects and designers. In the first instance, Rococo developed as a reaction against the heavy, grandiose forms of the Baroque. It proved particularly popular at courts like Versailles, where artists produced paintings that were lighthearted, sensual, and frivolous for their royal patrons. The style was already out of favor by the time of the French Revolution (1789).

Romanesque

An international style of architecture but also painting and sculpture (often architectural) that dominated Europe throughout the eleventh and twelfth centuries, before giving way to Gothic. As the name suggests, the style was seen as a continuation of Roman traditions. In sculpture, figures and decoration are monumental, but often highly stylized. There was also a taste for working in lavish materials, such as gold, silver, and ivory.

Romanticism

A complex, multifaceted movement that originated in the late 1700s and blossomed fully in the following century. In its simplest guise, it developed as a reaction against reason and order—the guiding principles that lay behind both the Enlightenment and the Neoclassical movements. In their place, it exalted individuality, emotion, and the power of the imagination. The Romantics looked back to the Middle Ages with the same passion that Neoclassical painters reserved for the ancient world. The emphasis on imagination and the irrational also gave rise to a taste for subjects dealing with madness, horror, and the supernatural, as well as the important themes of the vulnerability of the individual and the poor in society.

Sassanian

The Sassanians ruled Persia from CE 224 to 642, establishing an empire that extended from Syria to northwest India. They produced remarkable rock sculptures, metalwork vessels in the shape of animals and birds, and royal hunting scenes or figures from the Zoroastrian religion. The Sassanians also introduced silk-weaving techniques into Persia.

Shang Dynasty

Emerging during the Bronze Age, this culture (c. 1500–1050 BCE) witnessed the growth of the first settled civilization in China, in the Yellow River basin. The origins of the dynasty are still unclear, but its most important artworks were discovered at the city of Anyang, which was the Shang capital from 1384 to 1111 BCE. The finest of these consisted of a series of bronze ritual vessels and jade carvings.

Sumerian

Situated in Lower Mesopotamia (now part of Iraq), Sumer dates back to c. 3400 BCE, and the Sumerians are credited with the invention of writing. The most compelling evidence of Sumerian artistic achievement came from the excavation of the royal tombs at Ur.

Sumero-Akkadian

The Sumerians and Akkadians were neighboring peoples in Mesopotamia. During the reign of Sargon I, the Sumerian city-states were overrun and gradually absorbed into the Akkadian empire.

Suprematism

A short-lived abstract art movement in Russia. It was founded in 1915 by Kasimir Malevich, who announced his ambition of "freeing art from the burden of the object." In his determination to break away from all figurative forms, he concentrated on geometrical shapes, such as the straight line and the square, since these were made by humans and did not exist in nature. Malevich's experiments culminated in a series of White on White pictures.

Surrealism

A modern art movement that flourished principally in the 1920s and the 1930s. The Surrealists wanted to produce a revolutionary form of art that delved beneath the surface of mundane reality, tapping into humanity's most fundamental dreams and desires. The poet Guillaume Apollinaire coined the term in 1917, urging artists to explore their "interior universes." This notion was developed by André Breton, the author of the Surrealist manifesto (1924), who called for them "to resolve the previously contradictory conditions of dream and reality into an absolute reality, a super-reality." Painters employed very different techniques in pursuing these aims. Some produced pictures that looked startlingly real, but made no rational sense (like a form of hallucination), while others tried to bypass the conscious mind by basing pictures on automatic drawings or chance.

Symbolism

An international art movement that emerged in France in the late nineteenth century. It developed as a reaction against the Realist and Impressionist movements, which were concerned primarily with what an artist can see. By contrast, the Symbolists were anxious to reintroduce the emotions, the imagination, and the intellect as legitimate sources for artistic themes. In 1886, the poet Jean Moréas published a Symbolist manifesto in Paris, but variants of the movement developed in most European countries. The style and approach of Symbolist painters varied enormously. Some opted for mysterious and sensual subjects, such as the femme fatale; some hinted at a precise storyline where none existed; and others used simplified forms and symbolic colors to create their effects.

Tang Dynasty

In China, the heyday of the Tang rulers (CE 618–906) was a period of immense political and economic expansion that led to a general upsurge in all the arts. The most remarkable advances came in ceramics, where figures and vessels of earthenware were enriched with brightly colored lead glazes.

Wanderers

An exhibiting body of artists in pre-revolutionary Russia. Its official title was The Society of Traveling Art Exhibitions, but the group soon became better known as the Wanderers or the Itinerants (Peredvizhniki). This reflected their aim of bringing art to the people by staging exhibitions that toured throughout the Russian provinces. They preferred to paint pictures that would be meaningful to most people—realistic scenes of rural life, landscapes, portraits, even political works—rather than the rarefied mythologies and allegories that academic artists turned out. The group was active from 1870 to 1923.

Yuan Dynasty

Period of Chinese history and art (1260–1368) when the country came under the sway of the Mongols, led by Genghis and Kublai Khan. The period was notable for the high quality of its landscape painting.

INDEX OF ARTISTS

MANUSCRIPT REFERENCES

ACKNOWLEDGEMENTS

This book was conceived, edited, and produced by Barbara Marshall Ltd and SCALA GROUP spa. All rights reserved.

The Publishers would like to thank Atelier Works, London, for their invaluable contribution to the making of this book.

Special thanks go to our Researcher, Dr. Annabel Hendry, and to the staff of the Fitzwilliam Museum Library, Cambridge, UK.

The majority of illustrations were provided by SCALA GROUP spa, the largest source of color transparencies and digital images of the visual arts in the world: Offline/online professional libraries of art, travel and culture, color images for reproduction, multimedia databases, publishers of CD-Rom, DVD and illustrated art and guide books, broadband educational and edutainment, exclusive worldwide representatives for image licensing of the Museum of Modern Art, New York, and many more main museums and institutions.

The Publishers would like to thank the museums, collectors, archives, and photographers for permitting reproduction of their work. Every effort has been made to trace all copyright owners, but if any have been inadvertently overlooked, the Publishers will be pleased to make the necessary arrangements at the first opportunity.

Picture credits

Copyright credits